THE WORLD'S CLASSICS

THE LIVES OF THE ARTISTS

GIORGIO VASARI (1511–74) was born in Arezzo, a town in central Italy. He was apprenticed at an early age to Michelangelo in Florence and became an ardent follower and admirer of his master's style. While in Florence, Vasari worked in the shops of Andrea del Sarto and Baccio Bandinelli and studied with members of the Medici family, establishing a relationship with the ruling class of what would eventually become the Grand Duchy of Tuscany that would endure throughout Vasari's life. In 1549–50, the first Torrentino edition of the *Lives* appeared. While Vasari continued to work on the second and definitive edition of the *Lives* after 1563, he also initiated a number of important architectural projects in Tuscany, designing the Uffizi Palace and remodelling Pisa's Piazza dei Cavalieri, as well as becoming a major force behind the foundation of the Florentine Academy of Design. He was also involved in remodelling the churches of Santa Maria Novella and Santa Croce in Florence as well as decorating the ceiling of the Sala Grande in Florence's Palazzo Vecchio. Finally, in 1568, the second revised and enlarged Giuntina edition of his *Lives* appeared. It was praised by Vasari's contemporaries and quickly became the single most important secondary source in the history of Italian Renaissance art, containing not only a wealth of facts and attributions but entertaining anecdotes about the private lives of the greatest artists of the Italian Renaissance.

JULIA CONAWAY BONDANELLA is Associate Director of the Honors Division at Indiana University. She is the author of *Petrarch's Dream Visions and Their Renaissance Analogues*; co-editor of *The Macmillan Dictionary of Italian Literature*; co-editor and co-translator of *The Italian Renaissance Reader*; and translator and co-editor of *Rousseau's Political Writings*.

PETER BONDANELLA is Professor of Italian at Indiana University, where he teaches Renaissance literature and cinema, and is Director of the Center for Italian Studies. He is the author of *Machiavelli and the Art of Renaissance History*, *Francesco Guicciardini*, and *Italian Cinema: From Neorealism to the Present*; editor of *Federico Fellini: Essays in Criticism*; co-editor of *The Macmillan Dictionary of Italian Literature*; co-translator of *The Portable Machiavelli*, *The Decameron*; and editor and co-translator of Machiavelli's *The Prince* (World's Classics).

THE LIVES OF THE ARTISTS

GIORGIO VASARI (1511–74) was born in Arezzo, a town in Tuscan Italy. He was apprenticed at an early age to Michelangelo ... He later became an architect, follower and admirer of his master Andrea del Sarto ...

THE WORLD'S CLASSICS

▬▬

GIORGIO VASARI

The Lives
of the Artists

▬▬

Translated with an Introduction and Notes by
JULIA CONAWAY BONDANELLA
and
PETER BONDANELLA

Oxford New York
OXFORD UNIVERSITY PRESS

For Doreen, Heidi,
Barry, and Bruce

Oxford University Press, Walton Street, Oxford OX2 6DP

Oxford New York
Athens Auckland Bangkok Bombay
Calcutta Cape Town Dar es Salaam Delhi
Florence Hong Kong Istanbul Karachi
Kuala Lumpur Madras Madrid Melbourne
Mexico City Nairobi Paris Singapore
Taipei Tokyo Toronto

and associated companies in
Berlin Ibadan

Oxford is a trade mark of Oxford University Press

Translation and editorial material © Julia Conaway
Bondanella and Peter Bondanella 1991

First published as a World's Classics paperback 1991

British Library Cataloguing in Publication Data

Data available

Library of Congress Cataloging in Publication Data
Vasari, Giorgio, 1511–1574.
[Vita de' più eccellenti architetti, pittori et scultori italiani.
English. Selections]
The lives of the artists/Giorgio Vasari; translated with an
introduction and notes by Julia Conaway Bondanella and Peter
Bondanella.
p. cm.—(The World's classics)
Translation of 36 of the lives found in Vita de' più eccellenti
architetti, pittori et scultori italiani.
Includes bibliographical references.
1. Artists—Italy—Biography. I. Bondanella, Julia Conaway.
II. Bondanella, Peter E., 1943- . III. Title. IV. Series.
N6922.V2213 1991 709'.2'245—dc20 90–48810
[B]

ISBN 0-19-281754-X

7 9 10 8

Printed in Great Britain by
BPC Paperbacks Ltd.
Aylesbury, Bucks

CONTENTS

The Lives of the Most Excellent Painters, Sculptors, and Architects, Written by Giorgio Vasari, Painter and Architect of Arezzo, Revised and Extended by the Same, Along with Their Portraits, and with the Addition of the 'Lives' of Living Artists and Those Who Died Between the Years 1550 and 1567

PART ONE

PART TWO

INTRODUCTION

Giorgio Vasari was born of relatively humble stock in the little town of Arezzo, most famous today for the magnificent fresco cycle on the Legend of the True Cross done in the main cathedral by Piero della Francesca. According to Vasari's own testimony, his ancestry included at least one potter (*vasaro* or *vasaio*). Arezzo was part of the Florentine Republic's provincial territory, and this fact eventually guaranteed young Giorgio relatively easy access to the artistic circles of the capital city. In 1524, his father Antonio Vasari, who encouraged his interest in drawing, persuaded Cardinal Silvio Passerini, the representative of the newly elected Medici Pope, Clement VII, who was then passing through the city, to take the boy to Florence to be apprenticed as an artisan. Years later, in his *Lives*, Vasari was to boast that Luca Signorelli (the cousin of Giorgio's grandfather) stayed with his family in Arezzo in 1520 and gave him some of his first lessons. By Vasari's own account, he was first placed with Michelangelo in Florence (although this story is disputed), and after Michelangelo's departure for Rome, he was apprenticed to both Andrea del Sarto and Baccio Bandinelli. He also studied with two Medici offspring—Ippolito and Alessandro—the latter of whom was assassinated in 1537, dashing young Giorgio's early hopes for steady patronage. During these formative years, Vasari became close friends with Pontormo's best student, Rosso Fiorentino, as well as with Francesco Salviati.

Between the assassination of Duke Alessandro and the publication of the first edition of the *Lives* in 1550 (known in the critical literature on Vasari as the Torrentino edition), Vasari slowly built his reputation as an artist, working in various Italian cities. In 1541, he travelled to Venice, and by the time he had returned home, he had encountered the works of Giulio Romano, Correggio, and Titian. Back in Rome around 1543, Paolo Giovio (1483–1552), an important

scholar and historian at the papal court with close ties to the
Medici family, suggested to Vasari during a conversation over
dinner that he should write biographies of the great Italian
artists.[1] Vasari enthusiastically began writing his *Lives*, even
though only a few years later, in 1546, he received his first
major commission. He was to decorate the main hall in the
Palazzo della Cancelleria, a large palace owned by the influ-
ential Farnese family. He apparently completed the elaborate
fresco decorations in one hundred days with the assistance of
an army of other artists, so that the hall has become known as
the Sala dei Cento Giorni (The Hall of the One Hundred
Days).

Vasari completed the first edition of his *Lives* in 1550. It is
not known exactly how many copies of this first edition were
printed by the Flemish typographer Laurens Lenaerts van der
Beke (known in Florence as Lorenzo Torrentino), but the
book earned Vasari the praise of his peers and the gift of a
sonnet from the century's greatest artist and lyric poet,
Michelangelo Buonarroti.[2] During this same year, he also
married a girl from Arezzo.

Soon, Vasari began to receive more and more important
commissions from both the popes and Duke Cosimo de'
Medici of Florence, who became his most faithful patron and
friend. For Cosimo, Vasari began the remodelling of the
Palazzo Vecchio, decorating its main halls with a series of
allegorical and historical scenes; he also began the construction
of the governmental offices known today as the Uffizi (where
Florence's most precious art collection, originally the property
of the Medici family, is now located). With Cosimo's support,
Vasari established the Florentine Academy of Design in 1562.
When Michelangelo was buried in his native city in 1564,
Vasari was asked to prepare the decorations for the ceremonies

[1] While this conversation has traditionally been dated as having taken place
in 1546, the latest comprehensive study of Vasari's life, T. S. R. Boase's
Giorgio Vasari: The Man and the Book (Princeton, NJ: Princeton University
Press, 1979), p. 44, argues that the date must be moved back to 1543.

[2] For the text of the sonnet, 'If you had with your pen or with your
colour', see Creighton Gilbert, trans. and ed., *The Complete Poems and Selected
Letters of Michelangelo* (New York: Vintage, 1963), p. 156.

and to design the tomb in the Church of Santa Croce. Somehow in the midst of all these important architectural and artistic commissions, only one of which would have occupied a lesser man, Vasari found the time to revise and rework his enormous collection of artists' biographies and to publish the second and definitive edition of the *Lives* in 1568 with the Florentine typographer Jacopo Giunti (known today as the Giuntina edition).

The sheer number and scope of Vasari's major architectural projects is impressive and testifies to the same titanic energy that served him so well in the composition of his biographies. They include the construction of the corridor over the Arno river linking the governmental offices of the Uffizi and the grand duke's residence in the Palazzo Pitti; the remodelling of the churches of Santa Maria Novella and Santa Croce (which resulted in major modifications to the medieval character of both edifices); the decoration of the ceilings of the Sala Grande in the Palazzo Vecchio and other private rooms there; and the remodelling of Pisa's Piazza dei Cavalieri.

At his death in 1574, Vasari enjoyed the respect and admiration of his patrons and peers as a skilful architect, an accomplished painter (even if subsequent generations would share Michelangelo's doubts about his inspiration in this field), and a faithful courtier and servant of the Medici family. But his greatest gift to posterity is his magnificent historical work on the lives of the major Italian artists of the Renaissance.

When Vasari initiated his *Lives*, he was faced with formidable obstacles. The few books on art available when he began writing were largely unsystematic, and no true reference works existed to guide him through the bewildering number of artists and works from the time of Cimabue to his own day. It would not be overestimating his achievement to state that Giorgio Vasari virtually invented the discipline of art history.

Lacking the enormous scholarly apparatus of learned tomes, articles, and catalogues available to art historians today, Vasari was forced to rely upon his historian's mind and his acute visual memory. He conceived the historian's primary task to be that of making distinctions among artists by the quality and style of their works and of explaining the evolution of Italian

Renaissance art with a theory of its organic development. The final edition of the *Lives* was structured by Vasari's enduring theory of the three-stage development of art in Renaissance Italy. A first stage, marking the rebirth of great art after the demise of classical civilization, was set into motion by the innovative stylistic discoveries of Cimabue and Giotto. Subsequently, more sophisticated techniques of design and perspective led to a second stage of increased artistic skill, reflecting more rigorous rules of painting, sculpture, and architecture. This intermediate step in the path towards absolute perfection was dominated by the figures of Ghiberti, Brunelleschi, Donatello, and Masaccio. Finally, several centuries of growth and development culminated in the superlative perfection of a third period dominated by the genius of Leonardo, Raphael, and, above all others, the towering figure of Michelangelo Buonarroti. Vasari's interpretation of his subject matter was documented and argued so persuasively that it has, in large measure, remained that dominant view of Italian Renaissance art ever since. Few artists he criticized have been definitively rehabilitated, and almost all the figures he selected for particular praise have remained those most popular with collectors, scholars, and visitors to the major museums of the world.

In truth, Vasari's *Lives* has appealed to successive generations of fascinated readers because his biographies transcend a dry, factual accounting of names, dates, and titles. Vasari was a skilful storyteller whose anecdotes could reveal the personality of an artist in vivid terms, and it is his unusual ability to combine his command of Italian prose with his mastery of the subject matter that has guaranteed him an audience for over four centuries. His style echoes the lessons he learned from reading widely in the vernacular prose literature of his times, including the witty and entertaining *novelle* of Giovanni Boccaccio, Franco Sacchetti, or Matteo Bandello that he not only cited on occasion in his biographies but which also served him as models of excellence in style.

Even when Vasari's critical judgement failed him (which was seldom), his skill in recounting memorable anecdotes from the lives of his subjects was unsurpassed. Contemporary readers may quibble with his attributions, but few would wish

to set aside his entertaining accounts that give us lasting insight into the men behind the masterpieces they produced. As the initiator of a learned tradition of discourse on Renaissance art, Vasari's vocabulary is in some respects limited. For example, he employs the adjective 'beautiful' over and over again, much to the despair of all his translators. Yet his clear view of the parameters of Italian Renaissance art, his brilliant insights into the larger outlines of its development, and his encyclopaedic knowledge of all its major and minor practitioners counterbalance deficiencies which seem trivial in comparison.

Although Vasari could not rely upon a pre-existing and systematic technical vocabulary with which to discuss the various artists, period styles, and techniques he was obliged to treat across several centuries, his terminology is, nevertheless, remarkably consistent. In the first place, as a critic with a craftsman's knowledge of how these arts were practised, Vasari defines *disegno* ('design', 'drawing', or 'draughtsmanship' depending upon its context) as the basis of all good art. Practising artists, sculptors, and architects required this fundamental skill in order to succeed in achieving art's fundamental goal, that of imitating the natural and the human worlds. But Vasari's practical emphasis upon design also reflects his philosophic belief that an artist should possess a clear conception of the *idea* underlying whatever he was depicting. Vasari was raised in the shop system, and he firmly believed in the value of artistic education. Up to a point, good artists could be produced by years of patient training and apprenticeship with veteran masters. However, skill in design derived not simply from the experience of working with master teachers; it also depended upon the artist's technical knowledge. Vasari claims, for example, that Titian's genius was marred by his lack of a sense of good design. In other words, Titian lacked a sound knowledge of human anatomy which was fundamental to the reproduction of the human figure, a crucial element in the period's art. A command of the principles of proportion and perspective were also basic requirements for excellence in art, and perspective, in particular, was a technique developed during the second stage of Renaissance art which Vasari explains in the lives of Paolo Uccello and Filippo Brunelleschi.

None the less, Vasari was opposed to any artistic style that exhibited pedantic book learning, academic exercise, or unusual, laborious effort. As a result, one of the highest compliments he pays to an artist is that his works possess *grazia* or grace. Vasari's emphasis on this ephemeral quality (perhaps best embodied in the painting of Raphael) probably reflects the influence of Baldesar Castiglione (1478–1529), whose *Book of the Courtier* (1528) argued that social behaviour should be governed by the ideal of *sprezzatura* or a kind of studied nonchalance. True art, according to Castiglione, was art which did not reveal itself to be art and was produced effortlessly and without obvious signs of study and emphasis upon technique. Sound training was insufficient, in Vasari's opinion, to explain the appearance of such original geniuses as Michelangelo. Great talent improves with training and education, but no amount of such training and education can automatically produce a masterpiece.

Vasari does not employ the contemporary Italian word *artista* ('artist') in his *Lives*, nor does he consistently use the perhaps more accurate term *artigiano* ('artisan').[3] Instead, he usually refers to his subject as an *artefice* ('artificer', from the Latin *artifex*, often used to refer to God the Creator in theological writings). Vasari's artist was both a humble craftsman or artisan *and* a divine artificer, a 'maker' in the image of his Supreme Creator, and it is primarily Vasari's revolutionary interpretation of the artist's stature in the Renaissance that transformed his social status from that of mere craftsman into that of the titanic figure of divine genius typified by such men as Michelangelo and Raphael. Moreover, Vasari avoids borrowing the literary word *stile* ('style', derived from the Latin *stilus*, the Roman writing instrument), referring to the manner

[3] An excellent discussion of the philosophical implications of these terms may be found in James V. Mirollo's *Mannerism and Renaissance Poetry: Concept, Mode, Inner Design* (New Haven, Conn.: Yale University Press, 1984), in a section entitled 'Vasari's Language and Thought in the *Lives*', pp. 4–10; in Boase's *Giorgio Vasari: The Man and the Book*, pp. 119–28; or in David Summer's *Michelangelo and the Language of Art* (Princeton, NJ: Princeton University Press, 1981). Our discussion of Vasari's terminology is deeply indebted to these excellent books.

in which a literary work was composed, and prefers, instead, the word *maniera* (derived from the Latin *manus* or *manualis*, meaning literally 'the hand' or 'of the hand').[4] Most translators render this word in Vasari as either literally 'manner', with the sense of 'style', or by the word 'style'. Vasari employs the term to indicate not only the personal style of a particular artist but also that of an entire period as well. And it is in Vasari's constant usage of the Italian word *maniera* that we may also discover the nucleus of the eventual definition of a Mannerist period style subsequent generations of art historians would employ in referring to various artists of the High Renaissance.

Quite naturally, Vasari's extensive biographies contain errors of fact that contemporary art historians have gleefully pounced upon. He knew little of Byzantine art (which he identifies as 'Greek' art) and cared little for the Gothic style (which he disparages as 'German' style). His attributions are, considering the scope of his work, amazingly accurate, but they contain a number of factual errors of dating and attribution. Vasari seems not to have seen some extremely important and seminal works, such as Giotto's frescos in the Arena Chapel at Padua, and he is sometimes puzzled by artists and works that seem to deviate from his own conception of beauty, particularly those from Siena or Venice. Although he normally attempted to check and verify his sources, when any existed, Vasari could sometimes accept as accurate stories which enlivened his narrative at the expense of historical truth. Such is the case in his engrossing account of how Andrea del Castagno murdered Domenico Veneziano, which constitutes an entertaining study of ambition and crime but is regrettably belied by the archival records.[5] In spite of the fact that the second edition of his *Lives* was enlarged, revised, and expanded, permitting Vasari to modify some of his original judgements, there seems to be no doubt that he was convinced of the superiority of Tuscan art over all other provincial

[4] Mirollo, p. 5.
[5] Contemporary documents prove that Andrea del Castagno died from the plague in 1457, while Domenico Veneziano lived until 1461.

expressions of art and that he was blinded, in part by the understandable prestige of its illustrious tradition, to some of the particular merits of artists in other regions of the Italian peninsula.

In spite of the objections professional art historians have raised against Vasari's attributions, his value judgements, and his sometimes cavalier approach to problems of chronology, no single human being before or since has succeeded in composing such a majestic and visionary synthesis of such a dynamic and important artistic heritage. All those who love great art are in his debt and are even today influenced by his taste, his critical judgements, and even his prejudices. Too often read as merely a collection of biographical facts and artistic attributions, Vasari's *Lives* deserves, instead, to be considered as one of the precious masterpieces of Italian Renaissance prose, a book worthy of being placed beside *The History of Italy* by Francesco Guicciardini, Castiglione's *Book of the Courtier*, Machiavelli's *Prince*, and Ariosto's *Orlando Furioso*. Even more than these other acknowledged masterpieces of Italian literature and social thought, Vasari's *Lives* has dominated the visual imagination of subsequent generations and has taught all of us something about the nature of human artistic experience.

NOTE ON THE TRANSLATION

Translating Giorgio Vasari's *Lives* presents a number of problems familiar to translators working with Italian Renaissance texts. In the first place, its voluminous length necessitates abridgement to fit into the normal format of the contemporary paperback book. This new translation and critical edition has attempted to include as many artists as possible, given the limitations of space, artists whose works have traditionally been considered the greatest expressions of various periods and styles. Many of the lives included here are translated and annotated in their entirety, but others are not. The reader will be warned of a cut in the text by an elision and frequently also by an explanatory note. Paring down the enormous volume of material written by Vasari was not the least of our tasks in preparing this critical edition, and it is our hope that our readers will agree with the necessity of abbreviating some longer lives in order to make space for still others.

A number of English translations of Vasari's *Lives* have appeared in the past century but few, we believe, will provide the reader with as much useful critical information as this edition. As far as possible, we have attempted to identify the works discussed by Vasari and to note their present location (in some cases, they no longer exist). This crucial information is usually lacking in other translations. Likewise, all biographical references have been annotated. Vasari's prejudices are well known, especially his preference for Florentine art over that produced in either Siena or Venice, and his sometimes puzzled attitude towards many of his Mannerist contemporaries. Some recent abbreviated translations have, however, edited the *Lives* in such a manner that Vasari's prejudices have been emphasized. In fact, despite his clearly stated preferences, Vasari's complete collection of lives devotes a substantial amount of space to both Sienese painters and Mannerists, even

if the Venetians are clearly slighted in terms of their numerical representation. We hope it is one of the present edition's merits that it offers an ample selection of lives from these artistic traditions.

We have also translated the most important sections of Vasari's complete work. Although the long introductory sections treating the three major divisions of the arts—painting, sculpture, and architecture—have been omitted, the prefaces to the three main divisions of the *Lives* are included. These introductions provide the philosophical and historical underpinning of the work and present Vasari's vision of a 'rebirth' of the arts in its most persuasive form. Thirty-four of Vasari's biographical chapters deal primarily with the life of a single artist. None the less, in a few cases—such as the chapter devoted to Andrea del Castagno and Domenico Veneziano, or that treating Properzia de' Rossi—several artists are treated together. It was also Vasari's common practice to provide some minimal information about an artist's pupils at the end of his biography, a practice resulting in his discussion of more than 34 individual artists. For the most part, our editorial selection was governed by obvious criteria—artists considered by both Vasari and posterity as the most seminal influences upon Renaissance art had, of necessity, to be included. But it is also sometimes the case that Vasari's crucial remarks on certain subjects may be placed in the biography of an artist of not quite the first rank, as in his life of Luca della Robbia, where he discusses originality, or in the chapter devoted to Properzia de' Rossi, where he treats the vexing problem of female artists. Finally, this edition also includes the conclusion Vasari directed to his fellow artists.

The various problems involved in translating Vasari's technical vocabulary have already been discussed in the introduction to the volume. The reader should bear in mind that in this translation, we have attempted to render these words by their meaning in a particular context. Thus, *disegno* can be translated into English as the more abstract 'design' or 'art of design', while in other contexts, it may mean 'draughtsmanship' or the more concrete 'drawing'. The term 'artist' is rarely employed by Vasari, who most frequently uses the term *artefice* or

'artificer', which combines some of the implications of both 'artisan' and the contemporary sense of the word 'artist'. Contemporary English usage precludes the somewhat clumsy term 'artificer' in a translation of this sort, but the reader should bear in mind when he encounters the term 'artisan' in the translation that these words have been chosen to render his meaning, not his precise vocabulary.

A number of major critical editions of Vasari's works have been published during the past century. Especially important are those edited by Gaetano Milanesi (1906), Carlo L. Ragghianti (1942–9), and Paola Barocchi (1962, 1967–), as well as that by Paolo Della Pergola, Luigi Grassi, and a number of other editors (1967). We have consulted all of these editions in preparing this English translation and critical edition but have usually followed the Italian text included in this last nine-volume edition, since it incorporates the previous important editions and provides the most up-to-date information on the artistic works.

SELECT BIBLIOGRAPHY

Alberti, Leon Battista, *On Painting*, trans. John R. Spencer (New Haven, Conn.: Yale University Press, 1970).

Barocchi, Paola, *Vasari pittore* (Florence: G. Barbèra, 1964).

Barolsky, Paul, *Infinite Jest: Wit and Humor in Renaissance Art* (Columbia, Mo.: University of Missouri Press, 1978).

—— *Michelangelo's Nose: A Myth and its Maker* (University Park, Pa.: The Pennsylvania State University Press, 1990).

Boase, T. S. R. *Giorgio Vasari: The Man and the Book* (Princeton, NJ: Princeton University Press, 1971).

Bondanella, Julia Conaway, and Musa, Mark, ed. and trans., *The Italian Renaissance Reader* (New York: New American Library, 1987).

Bondanella, Peter, and Bondanella, Julia, ed., *The Macmillan Dictionary of Italian Literature* (London: Macmillan, 1979).

Brucker, Gene, ed., *The Society of Renaissance Florence: A Documentary Study* (New York: Harper, 1971).

Burckhardt, Jacob, *The Civilization of the Renaissance in Italy*, 2 vols. (New York: Harper, 1975).

Burke, Peter, *Tradition and Innovation in Renaissance Italy: A Sociological Approach* (London: Fontana, 1972).

Carden, Robert W., *The Life of Giorgio Vasari* (New York: Holt, 1911).

Cellini, Benvenuto, *The Treatises of Benvenuto Cellini on Goldsmithing and Sculpture*, trans. C. R. Ashbee (New York: Dover, 1967).

Cennini, Cennino d'Andrea, *The Craftman's Handbook: The Italian 'Il Libro dell'Arte'*, trans. Daniel V. Thompson (New Haven, Conn.: Yale University Press, 1933; rpt. New York: Dover, 1960).

Cole, Bruce, *Italian Art 1250–1550: The Relation of Renaissance Art to Life and Society* (New York: Harper, 1987).

—— *The Renaissance Artist at Work: From Pisano to Titian* (New York: Harper, 1983).

Garin, Eugenio, *Portraits from the Quattrocento* (New York: Harper, 1972).

Gealt, Adelheid M., *Looking at Art: A Visitor's Guide to Museum Collections* (New York: Bowker, 1983).

Gilbert, Creighton, ed., *Italian Art 1400–1500* (Englewood Cliffs, NJ: Prentice-Hall, 1980).

Giorgio Vasari: La Toscana nel '500 (Florence: Edam, 1981).

Gundersheimer, Werner L., *Ferrara: The Style of a Renaissance Despotism* (Princeton, NJ: Princeton University Press: 1973).

Hale, J. R., ed., *A Concise Encyclopaedia of the Italian Renaissance* (New York: Oxford University Press, 1981).

——— ed., *Renaissance Venice* (London: Faber & Faber, 1974).

Hall, James, *Dictionary of Subjects and Symbols in Art*, rev. edn. (London: John Murray, 1984).

——— *A History of Ideas and Images in Italian Art* (New York: Harper, 1983).

Hartt, Frederick, *History of Renaissance Art: Painting, Sculpture, Architecture* (New York: Abrams, 1969).

Heller, Agnes, *Renaissance Man* (London: Routledge & Kegan Paul, 1978).

Mirollo, James V., *Mannerism and Renaissance Poetry: Concept, Mode, Inner Design* (New Haven, Conn.: Yale University Press, 1984).

Murray, Peter, *The Architecture of the Italian Renaissance* (London: Thames and Hudson, 1986).

——— *An Index of Attributions made in Tuscan Sources before Vasari* (Florence: Leo S. Olschki, 1959).

Partner, Peter, *Renaissance Rome 1500–1559: A Portrait of a Society* (Berkeley, Calif.: University of California Press, 1976).

Pope-Hennessy, Sir John, *Introduction to Italian Sculpture*, 3 vols. (London: Phaidon, 1986).

Schlosser, Julius, *La letteratura artistica*, 3rd rev. edn., ed. Otto Kurz (Florence: La Nuova Italia, 1964).

Stinger, Charles L., *The Renaissance in Rome* (Bloomington, Ind.: Indiana University Press, 1985).

Studi vasariani: atti del convegno internazionale per il IV centenario della prima edizione delle 'Vite' del Vasari (Florence: Sansoni, 1952).

Summers, David, *Michelangelo and the Language of Art* (Princeton, NJ: Princeton University Press, 1981).

Thompson, Daniel V., *The Materials and Techniques of Medieval Painting* (New York: Dover, 1956).

Vasari, Giorgio, *Artists of the Renaissance: A Selection from 'Lives of the Artists'*, trans. George Bull (New York: Viking Press, 1978). (Illustrated version of an earlier edition of *Lives of the Artists: Volume I* listed below.)

——— *Lives of the Artists*, trans. George Bull, 2 vols. (Harmondsworth: Penguin, 1987).

—— *The Lives of the Painters, Sculptors, and Architects*, trans. Gaston Du C. de Vere, Introduction by Kenneth Clarke, ed. Michael Sonino, 3 vols. (New York: Abrams, 1979 (translation done in 1912)).

—— *The Lives of the Painters, Sculptors, and Architects*, trans. A. B. Hinds, ed. William Gaunt, 4 vols. (London: Dent, 1963).

—— *Vasari on Technique*, ed. Louisa Maclehose and G. Baldwin Brown (London: Dent, 1907; rpt. New York: Dover, 1960).

—— *La vita di Michelangelo, nelle redazioni del 1550 e 1568*, ed. Paola Barocchi, 5 vols. (Milan: Ricciardi, 1962).

—— *Le vite de' più eccellenti pittori, scultori e architettori nelle redazioni del 1550 e 1569*, ed. Paola Barocchi, 7 vols. to date (Florence: Studio per Edizioni Scelte, 1967–).

—— *Le vite de' più eccellenti pittori, scultori e architettori*, ed. Gaetano Milanesi (Florence: Sansoni, 1906; reissued 1978–81).

—— *Le vite de' più eccellenti pittori scultori e architettori*, ed. Paola Della Pergola, Luigi Grassi, Giovanni Previtali, *et al.*, 9 vols. (Novara: Istituto Geografico de Agostini, 1967).

—— *Le vite de' più eccellenti pittori, scultori e architettori*, ed. Carlo Ludovico Ragghianti (Milan: Rizzoli, 1942–9).

Il Vasari storiografo e artista: atti del congresso internazionale nel IV centenario della morte (Florence: Istituto Nazionale di Studi sul Rinascimento, 1976).

Wackernagel, Martin, *The World of the Florentine Renaissance Artist: Projects and Patrons, Workshop and Art Market*, trans. Alison Luchs (Princeton, NJ: Princeton University Press, 1981).

A CHRONOLOGY OF
GIORGIO VASARI

1511 Born in Arezzo on 30 July.

1524 Presented to Cardinal Silvio Passerini; moving to Florence,
 he claims to have first studied under Michelangelo; when
 Michelangelo leaves Florence for Rome, he enters the
 workshops of Andrea del Sarto and Baccio Bandinelli and
 studies with Ippolito (1511–35) and Alessandro (1512–37)
 de' Medici.

1527 Returns to Arezzo after the expulsion of his Medici
 patrons from Florence, a result of the Sack of Rome by
 the German troops of the Emperor Charles V; his father
 dies of the plague in Arezzo; his first efforts as a painter are
 praised by Rosso Fiorentino.

1529 After a brief return to Florence and a visit to Pisa during
 the siege of Florence by Medici forces, he goes to Bologna.

1530 On 24 February, he witnesses the coronation of Emperor
 Charles V by Pope Clement VII in Bologna.

1531 Follows his patron, Cardinal Ippolito de' Medici, to
 Rome.

1532 Returns to Florence to be with his former school
 companion Alessandro de' Medici, now Duke of Florence.

1535 Cardinal Ippolito de' Medici dies.

1537 On 5 January, Duke Alessandro is assassinated; Cosimo,
 son of Giovanni delle Bande Nere and Vasari's future
 patron, succeeds him; Vasari returns to Arezzo.

1538 Returns to Rome.

1539 Cosimo de' Medici marries Eleonora of Toledo; Vasari
 works in Bologna.

1541 Travels to Venice on the invitation of Pietro Aretino; for
 the first time he is introduced to the work of Giulio
 Romano (Mantua), Correggio (Parma) and Titian
 (Venice); he executes several paintings in Venice from
 sketches by Michelangelo.

1542 Returning to Arezzo, he begins the frescos in his home there.

1543 In Rome, Paolo Giovio suggests that Vasari undertake the writing of his *Lives*; Michelangelo advises him to concentrate upon architecture; he leaves Rome for Lucca and Florence.

1545 Visits Naples.

1546 Receives the commission from the Farnese family to decorate the Sala dei Cento Giorni in Rome's Palazzo della Cancelleria with scenes from the life of Pope Paul III (Farnese).

1547 On 8 July, reports that a version of his *Lives* is complete in manuscript form.

1549 Vincenzo Borghini receives the index of the *Lives*.

1550 In January, marries Niccolosa Bacci from Arezzo; in May, the first Torrentino edition of the *Lives* appears, which treats no living artist except Michelangelo.

1553 In Rome, works on the Villa Giulia for Pope Julius III.

1554–5 After the defeat of his opponents on the battlefield, Cosimo de' Medici becomes Vasari's lifelong patron, beginning with the remodelling of the Palazzo Vecchio in Florence and its decoration with allegorical and historical scenes.

1557 Settles into a home in Florence in Borgo Santa Croce.

1560 Begins the construction of the Uffizi; in the same year shows his design for the Sala dei Cinquecento to Michelangelo.

1561 Begins the remodelling of Pisa's Piazza dei Cavalieri, a project he completes in 1569.

1562 He is a major force behind the foundation of the Florentine Academy of Design.

1563 Visits Arezzo, Cortona, Perugia, Assisi, and Venice and begins the revision of his *Lives*.

1564 Given charge of the decorations for the funeral of Michelangelo, he designs the artist's tomb in Santa Croce which is executed by other artists.

1565 Initiates the construction of the corridor which connects the Palazzo Pitti to the Palazzo Vecchio by passing over

the Arno in Florence; he also remodels Florence's Santa Maria Novella and completes his decoration of the ceiling of the Sala Grande in the Palazzo Vecchio.

1566 Begins a journey around Italy to collect new material for his second edition of the *Lives*; after his return to Florence, he remodels the church of Santa Croce in Florence.

1568 The second revised and enlarged Giuntina edition of the *Lives* appears.

1570 Goes to Rome, called by Pope Pius V, to decorate a number of chapels.

1571 Receives the Knighthood of the Golden Spur of the Order of Saint Peter from Pope Pius V after working on the Sala Regia in the Vatican.

1572 Begins the frescos on the cupola of Florence's Duomo and unveils the large frescos on the walls of the Palazzo Vecchio; called to Rome by Pope Gregory XIII, he returns to work on the Sala Regia.

1574 While working on the frescos of the Florentine Duomo's cupola, Giorgio Vasari dies in Florence.

The Lives of the Artists

The Lives of the Artists

PART ONE

Preface to the Lives*

I know it is an opinion commonly accepted among almost all writers that sculpture, as well as painting, was first discovered in nature by the peoples of Egypt; and that some others attribute to the Chaldeans the first rough carvings in marble and the first figures in relief; just as still others assign to the Greeks the invention of the brush and the use of colour. But I would say that design, the basis of both arts, or rather the very soul which conceives and nourishes within itself all the aspects of the intellect, existed in absolute perfection at the origin of all other things when God on High, having created the great body of the world and having decorated the heavens with its brightest lights, descended with His intellect further down into the clarity of the atmosphere and the solidity of the earth, and, shaping man, discovered in the pleasing invention of things the first form of sculpture and painting.* Who will deny that from man, as from a true model, statues and sculptures were then gradually carved out along with the difficulties of various poses and their surroundings, and that from the first paintings, whatever they might have been, derived the ideas of grace, unity, and the discordant harmonies produced by light and shadows? Thus, the first model from which issued the first image of man was a mass of earth, and not without reason, for the Divine Architect of Time and Nature, being all perfect, wished to demonstrate in the imperfection of His materials the means to subtract from them or add to them, in the same way that good sculptors and painters are accustomed to doing when by adding or subtracting from their models, they bring their imperfect drafts to that state of refinement and perfection they seek. . .*

I am convinced that anyone who will discreetly ponder this matter will agree with me, as I said above, that the origin of these arts was Nature herself, that the inspiration or model was

4 PREFACE TO THE *LIVES*

the beautiful fabric of the world, and that the Master who taught us was that divine light infused in us by a special act of grace which has not only made us superior to other animals but even similar, if it is permitted to say so, to God Himself. And if in our own times (as I hope to show a little further on through numerous examples), simple children, crudely brought up in the woods and prompted by their liveliness of mind, have begun to draw by themselves, using as their models only those beautiful pictures and sculptures in Nature, is it not much more probable and believable that the first men—being much less further away from the moment of their divine creation, more perfect, and of greater intellect, taking Nature as their guide, with the purest of intellects as their master, and the world as their beautiful model—originated these most noble arts, and, improving them little by little, finally brought them from their humble beginnings to perfection? . . . *

But because after carrying men to the top of her wheel, either for amusement or out of regret Fortune usually returns them to the bottom, it came to pass that almost all of the barbarian nations in various parts of the world rose up against the Romans, and, as a result, not only did they bring down so great an empire in a brief time but they ruined everything, especially in Rome itself. With Rome's fall the most excellent craftsmen, sculptors, painters, and architects were likewise destroyed, leaving their crafts and their very persons buried and submerged under the miserable ruins and the disasters which befell that most illustrious city. Painting and sculpture were the first to go to ruin, since they are arts that serve more to delight us than anything else; and the other one, that is architecture, since it was necessary and useful to the welfare of the body, continued, but no longer in its former perfection and goodness. Had it not been for the fact that painting and sculpture represented to the eyes of those being born the men who one after another had been immortalized by their work, the very memory of one or the other of these arts would soon have been erased. Some men were commemorated by images and by inscriptions placed upon private or public buildings, such as amphitheatres, theatres, baths, aqueducts, temples, obel-isks, coliseums, pyramids, arches, reservoirs, and treasuries,

and finally upon their tombs; a large number of these was destroyed by brutish barbarians, who possessed nothing human except the physical appearance and name....*

But among all the things mentioned, what was the most infinitely harmful and damaging to those professions, even more so than the things noted earlier, was the fervent zeal of the new Christian religion, which, after a long and bloody struggle, had finally overthrown and annihilated the ancient religion of the pagans by the number of its miracles and the sincerity of its actions. Then, with the greatest fervour and diligence, it applied itself to removing and eradicating on every side the slightest thing from which sin might arise; and not only did it ruin or cast to the ground all the marvellous statues, sculptures, paintings, mosaics, and ornaments of the false pagan gods, but it also did away with the memorials and testimonials to an infinite number of illustrious people, in whose honour statues and other memorials had been constructed in public places by the genius of antiquity. Moreover, in order to build churches for Christian worship, not only did this religion destroy the most honoured temples of the pagan idols, but, in order to ennoble and adorn St Peter's with more ornaments than it originally possessed, it plundered the columns of stone on the Tomb of Hadrian, now called the Castel Sant'Angelo, as well as many other monuments which today we see in ruins. And although the Christian religion did not do such things out of any hatred for genius but, rather, only to condemn and eradicate the gods of the pagans, the complete destruction of these honourable professions, which lost their techniques entirely, was nevertheless the result of its ardent zeal, ...*

Up to now, I believe I have discussed the beginnings of sculpture and painting, perhaps at greater length than was necessary here; I have done so not so much because I was carried away by my love for the arts but more because I was moved by the welfare and common advantage of our own artists. Once they have seen how art reached the summit of perfection after such humble beginnings, and how it had fallen into complete ruin from such a noble height (and consequently how the nature of this art resembles that of the others,

which, like human bodies, are born, grow up, become old, and die), they will now be able to recognize more easily the progress of art's rebirth and the state of perfection to which it has again ascended in our own times....*

THE END OF THE PREFACE TO THE LIVES

The Life of Cimabue, Florentine Painter

[c.1240–1302?]

The endless flood of misfortunes which swept over and drowned
the wretched country of Italy had not only destroyed every-
thing that could really be called a building but, even more
importantly, had completely wiped out its population of
artists, when, in the year 1240, as God willed it, there was
born in the city of Florence to the Cimabue, a noble family of
those times, a son Giovanni, also named Cimabue,* who shed
first light upon the art of painting. While he was growing up,
he was judged by his father and others to have a fine, sharp
mind, and he was sent to Santa Maria Novella to a master, a
relative who was teaching grammar there to the novices, so
that he could be trained in letters. But instead of paying
attention to his literary studies, Cimabue, as if inspired by his
nature, spent the whole day drawing men, horses, houses, and
various other fantasies in his books and papers. And Fortune
was favourable to his natural inclination, because some Greek
painters were summoned to Florence by the rulers of the city
for no other purpose than to revive in Florence the art of
painting which was at that time not so much in disarray as
completely lost. Among the other projects they undertook in
the city, they began the Gondi Chapel, which can be seen in
Santa Maria Novella where it is located next to the principal
chapel, even though its vaults and its walls have been almost
completely consumed by the ravages of time. And so Cima-
bue made a beginning in the art which pleased him, often
staying away from school to spend the entire day in observing
those masters in their work. As a result, both his father and
those painters judged him to be so skilled in painting that he
could hope to be quite successful if he were to devote himself
to this profession, and it was no small satisfaction for Cimabue

that his father was in agreement with them. And continuous practice so greatly enhanced his natural talent that in a short time he far surpassed in both design and colouring the style of the masters who taught him, who cared little about making any progress, and who fashioned their works in the way we see them today: that is, not in the fine, ancient style of Greece but rather in that awkward, modern style of their times.* And although Cimabue imitated these Greeks, he greatly improved upon their painting, removing from it a good deal of their awkwardness; he honoured his native city with his name and the works he created, such as the altar dossal at Santa Cecilia and a panel of Our Lady in Santa Croce, which was and is still suspended from one of the pillars at the right side of the choir. Afterwards, he did a small panel against a gold background of Saint Francis, and he drew him, as best he knew how, from Nature—which was a novel thing in those times—and around the saint he painted all the stories of his life in twenty little pictures filled with small figures against a gold background. Having then undertaken a large panel for the monks of Vallombrosa in the abbey of Santa Trinita in Florence, he worked diligently in order to justify the fame he had already earned; he demonstrated in this work greater powers of invention along with a beautiful style in the pose of a Madonna whom he depicted holding Her son in Her arms, while a multitude of angels surrounded Her in adoration against a gold background. When this panel was completed, it was placed by the monks on the high altar of their church. Later removed from this location in order to make room for the panel by Alesso Baldovinetti that remains there today, it was placed in a minor chapel on the left side of this church. Then, working in fresco at the hospital of the Porcellana on the corner of the Via Nuova which leads into Borgo Ognissanti, Cimabue painted an Annunciation on one side of the façade with the main door in the middle, and on the other, Jesus Christ with Cleophas and Luke in life-size figures; he abandoned the old methods in this work and made the draperies, garments, and other things a bit more alive, more natural, and softer than the style of those Greeks, whose works were full of lines and profiles both in mosaics and in paintings. Their

rough, awkward, and commonplace style, owing nothing to study, had been taught according to custom by one artist to another for many, many years without the painters of those times ever thinking of improving their design by the beauty of colouring or some other innovation.

After this, Cimabue was called on once again by the same Father Superior who had asked him to do the work at Santa Croce, and he completed for him a large crucifix on wood which can still be seen in the church today, and since the Father Superior felt he had been well served, he took Cimabue to San Francesco, their monastery in Pisa, in order for him to do a panel of Saint Francis. The people there considered this panel a most rare thing, since they recognized in it a certain special excellence both in the attitude of the head and in the folds of the draperies which had not previously been achieved in the Greek style by any artist who had ever worked on anything, not only in Pisa but in all of Italy. For the same church, Cimabue then painted a large panel containing an image of Our Lady with Her Son in Her arms surrounded by a host of angels on a gold background. Not long afterwards this work was removed from its original location in order to build the marble altarpiece which is there now, and it was placed inside the church on the left side near the door. For this work, Cimabue was greatly praised and rewarded by the Pisans. In this same city of Pisa, at the request of the man who was then the Abbot of San Paolo in Ripa d'Arno, Cimabue did a small panel of Saint Agnes surrounded by small figures containing scenes from her life, and today this panel is above the Altar of the Virgins in the same church.

These works, therefore, made the name of Cimabue well known to all, and because of this he was brought to Assisi, a city in Umbria, where together with some Greek masters he painted a number of the vaults in the Lower Church of San Francesco and, on the walls, the lives of Jesus Christ and Saint Francis. In these paintings he far surpassed those Greek painters, and gaining courage from this, he began to paint frescos in the Upper Church by himself. In the apse over the choir he painted on the walls various stories about Our Lady—that is to say: Her death; the occasion when Her soul is

carried up to heaven by Christ on a throne of clouds; and when She is crowned by Christ in the midst of a choir of angels with a large number of male and female saints standing below—a work today consumed by time and dust. Likewise, he then painted many stories in the intersections of the vaults (five in number) of the same church. In the first vault above the choir, he painted the Four Evangelists larger-than-life and depicted them so well that even today something good can be recognized in them, and the freshness of the flesh tones shows how, through Cimabue's labours, the art of working in fresco began to make progress. He painted the second intersection with gold stars on a field of ultramarine blue. In the third he did several tondos of Jesus Christ, His mother the Virgin Mary, Saint John the Baptist, and Saint Francis (that is, there was one of these figures in every tondo and a medallion in each of the four sections of the vault). And between the third and fifth intersections of the vault, he painted the fourth with golden stars against an ultramarine ground, as he had done in the second. In the fifth intersection, he painted the four Doctors of the Church, and near each one of them a member of one of the major religious orders—certainly a laborious task but carried out with infinite care. When he had finished the vaults, Cimabue frescoed the upper walls of the left side of the whole church, working towards the main altar, between the windows and up to the vaults, painting eight stories from the Old Testament, starting from the very beginning of Genesis and following with the most notable events. And in the spaces surrounding the windows up to where they terminate in the corridor which runs completely around inside the church walls, he painted the rest of the Old Testament in eight other stories. And opposite this work in another sixteen corresponding stories, Cimabue painted the events in the lives of Our Lady and Jesus Christ. And on the wall below over the main door and around the rose window, he painted the Ascension of Our Lady into Heaven and the Pentecost. This truly great work, so richly and finely executed, must have astounded the world in those times, in my opinion, especially since painting had been for so long obscured in such darkness, and as for me, when I saw the work again in 1563, it seemed

extremely beautiful, considering how Cimabue was able to show forth so much light amid so many shadows. But of all these frescos, it is worth mentioning that those on the vaults less damaged by dust and other accidents are much better preserved than the others. Once these works were completed, Giovanni set his hand to painting the lower walls—that is, those below the windows—and he painted a number of things there, but since he was called away to Florence on some business, he did not continue his work, and Giotto completed it, as will be discussed in the proper place.

After Cimabue returned to Florence, he himself painted with the most skilful design three small arches on the life of Christ in the Cloister of Santo Spirito, where the entire wall opposite the church was painted in the Greek style by other masters. And during this same period, he sent some of the things he completed in Florence to Empoli, where they are still in the parish church of that town and held in great veneration. Then for the church of Santa Maria Novella, he painted the panel of Our Lady, which is hanging high up between the Rucellai Chapel and the Bardi di Vernio Chapel.* This work was larger than any human figure which had been painted up to that time, and some of the angels around it show that although Cimabue still had the Greek manner, he was gradually approaching, in some ways, the lines and style of modern times. As a result, this work so astonished the people of the day, since they had seen nothing better until then, that they carried it with great rejoicing and with the sounding of trumpets from Cimabue's home to the church in a solemn procession, and Cimabue himself was greatly rewarded and honoured. It is said (and we can read about this in the memoirs of old painters) that while Cimabue was painting this same panel in certain orchards near Porta San Piero, old King Charles of Anjou passed through Florence, and that among the many acts of welcome paid to him by the men of the city was that of taking him to see Cimabue's panel. And since it had not yet been viewed by anyone, when it was unveiled to the king, all the men and women of Florence ran to see it in the biggest crowd of people in the world and with the greatest joy. Because of the merriment that occurred there, the

neighbours called the district Borgo Allegri [Merry Quarter], and with the passing of time it was included within the city walls and has retained this same name ever since.* In San Francesco at Pisa, where Cimabue completed some other things (as I mentioned earlier), there is a tempera panel by his hand in a corner of the cloister near the entrance to the church which contains a Christ on the Cross surrounded by several weeping angels who are holding in their hands certain words which are written above Christ's head and are directed towards the ears of Our Lady, who stands weeping on the right, and towards Saint John the Evangelist, who stands grief-stricken on the left. And the words to the Virgin are: 'Mulier ecce filius tuus'; those to Saint John are: 'Ecce mater tua.' And the words held by another angel say: 'Ex illa hora accepit eam discipulus in suam.' This demonstrates how Cimabue had begun to shed light and open the way for invention by combining his art with speech in order to help express his conception. This was indeed something fanciful and new.

Since Cimabue had by now acquired a great name and much profit by means of these works, he was taken on as an architect by the company of Arnolfo Lapi, a highly skilled architect of the period, for the construction of Santa Maria del Fiore in Florence. But since he had lived sixty years, he finally passed to the next life in the year 1300, having very nearly brought back to life the art of painting. He left behind many disciples, including among others Giotto, who was later to become an excellent painter and who lived after Cimabue's death in his master's house on Via del Cocomero. Cimabue was buried in Santa Maria del Fiore with this epitaph, written for him by one of the Nini family:

> Cimabue believed he held the field in painting,
> And while alive he did; but now the heavenly stars
> Are his.*

I should not neglect to say that Cimabue's fame would have been even greater had it not competed with that of his disciple Giotto, as Dante demonstrates in his *Comedy* where in the

eleventh Canto of *Purgatory*, alluding to the same inscription
on the tomb, he states:

> Once Cimabue thought to hold the field
> As painter; Giotto now is all the rage,
> Dimming the lustre of the other's fame.*

In an interpretation of these lines, a commentator of Dante
who wrote during Giotto's lifetime and ten or twelve years
after the death of Dante—that is, around the year of Our
Lord 1334—writes these exact words when speaking of Cima-
bue: 'Cimabue of Florence was a painter who lived during the
author's own time, a nobler man than anyone knew, but he
was as a result so haughty and proud that if someone pointed
out to him any mistake or defect in his work, or if he had
noted any himself (as happened many times, since an artisan
may err because of a defect in the materials he uses or because
of some shortcoming in the tools with which he works), he
would immediately destroy the work, no matter how precious
it might be. Giotto was and ìs, the greatest among the painters
of the same city of Florence, and his works in Rome, Naples,
Avignon, Florence, Padua, and in many other parts of the
world bear witness to this, etc.' Today, this commentary is in
the hands of the Most Reverend Don Vincenzio Borghini,*
Prior of the Innocenti, a man famous for his nobility,
kindness, and obvious learning but also equally a lover and
connoisseur of all the fine arts who well deserved being
selected by Lord Duke Cosimo as his representative in our
Academy of Design.

But, to return to Cimabue, Giotto truly eclipsed Cimabue's
fame just as a great light eclipses a much smaller one. Hence,
Cimabue was, in one sense, the principal cause of the renewal
of the art of painting, but Giotto, though his follower,
inspired by a praiseworthy ambition and helped by Heaven
and his own natural talent, was the man whose thoughts rose
even higher and who opened the gates of truth to those
painters who have subsequently brought the art of painting to
that level of perfection and grandeur at which we see it in our
own century. As a result, the daily sight of the marvels,
wonders, and impossible feats by the workmen in this art has

now brought us to the point that no matter what men may do, though it may seem more godlike than human, no one is amazed by it at all. And those artists who strive in a praise-worthy manner are fortunate if, rather than being praised and admired, they are not, instead, reproached and many times brought to shame.

Cimabue's portrait by the hand of Simone of Siena may be seen in the chapter-house of Santa Maria Novella, executed in profile within the narrative of the Faith as a figure with a thin face, a pointed, reddish beard, wearing a hood, according to the custom of those times, which is wrapped around the head and throat in a beautiful fashion. The one standing next to him is the very same Simone, the master who created the work, who painted himself using two mirrors facing each other in order that he might portray his own head in profile. And that soldier in armour standing between them is said to be Count Guido Novello, then lord of Poppi.* I only need to add of Cimabue that in the beginning of a book of ours where I have gathered together drawings by all those who have produced sketches from his time to the present, a few little things in his hand, similar to miniatures, can be seen, which today may perhaps seem rather more crude than otherwise, but which reveal just how greatly the art of design improved as a result of his work.*

THE END OF THE LIFE OF CIMABUE

*The Life of Giotto, Florentine Painter, Sculptor, and Architect**

[1266/7–1337]

That very same debt painters owe to Nature, which continu-
ously serves as an example to those who strive always to do
their best by selecting her best and most beautiful parts in
order to reproduce and imitate them, is also owed, in my
opinion, to Giotto, the Florentine painter; for when the
methods and outlines of good painting had been buried for so
many years by the ruins of war, he alone, although born
among inept artists, revived through God's grace what had
fallen into an evil state and brought it back to such a form that
it could be called good. And it was truly an extraordinary
miracle that such an ignorant and incompetent age could have
inspired Giotto to work so skilfully that drawing, of which
men during those times had little or no knowledge, came fully
back to life through his efforts. In any case, the birth of this
great man took place in the year 1267 at the village of
Vespignano in the Florentine countryside some fourteen miles
from the city, since his father (called Bondone) was a tiller of
the soil and a humble person. When this man had this son, to
whom he gave the name Giotto, he raised him properly and
according to his station in life. And when he had reached the
age of ten, after having shown an extraordinary liveliness and
quickness of intellect in all his actions even while still a
child—so that he delighted not only his father but everyone
there at the farm and beyond it who was acquainted with
him—Bondone gave him some sheep to watch over. And
while they wandered about the farm, grazing in one place or
another, Giotto, led on by his natural inclination towards the
art of drawing, would continually sketch something from the
world of nature or something that he had imagined upon flat

stones or upon the ground or sand. One day Cimabue* was going about his business between Florence and Vespignano, and he came upon Giotto who, while his sheep were grazing, was sketching one of them in a lifelike way with a slightly pointed rock upon a smooth and polished stone without having learned how to draw it from anyone other than Nature. This caused Cimabue to stop in amazement, and he asked Giotto if he would like to come to work with him. The young child replied that if his father would allow it, he would willingly do so. Cimabue therefore asked Bondone, and he lovingly gave his consent and allowed Cimabue to take Giotto to Florence. After his arrival there and in a brief time, helped by his natural talent and Cimabue's teaching, not only did the young boy equal the style of his master, but he became such an excellent imitator of Nature that he completely banished that crude Greek style and revived the modern and excellent art of painting, introducing good drawing from live natural models, something which had not been done for more than two hundred years. And even if someone had tried it, as I said earlier, none of them had succeeded as happily or as completely as Giotto. Among his drawings which can still be seen today was one in the Chapel of the Palace of the Podestà in Florence of Dante Alighieri, his contemporary and greatest friend, and no less famous a poet during this period than Giotto was a painter. Giotto was also praised highly by Messer Giovanni Boccaccio in the preface of his novella about Messer Forese da Rabatta and Giotto himself.* In the same chapel there are the portraits, also by Giotto's hand, of Ser Brunetto Latini, Dante's teacher, and of Messer Corso Donati, an important citizen of those times.

Giotto's first paintings were in the chapel of the high altar in the Badia of Florence, where he did many things which were held to be beautiful, but especially an Annunciation, because in this work he vividly expressed the fright and dread with which Gabriel's greeting filled the Virgin Mary. Full of the greatest fear, She seems as if She wishes to run away. Likewise from Giotto's hand is the panel on the high altar of the same chapel, where it has been kept until the present day more out of a certain respect for the work of such

a great man than for any other reason. And in Santa Croce there are four chapels by his hand: three between the sacristy and the main chapel and one on the other side. In the first of the three, that of Messer Ridolfo de' Bardi, which is the one where the ropes for the bells are located, there is the life of Saint Francis, at whose death a good number of friars demonstrate very appropriately the effects of weeping. In the other chapel, which belongs to the Peruzzi family, there are two stories from the life of Saint John the Baptist, to whom the chapel is dedicated, wherein the dancing and leaping of Herodias and the prompt service of some ready servants at the table appear in a very lively fashion. In the same chapel are two miraculous stories from the life of Saint John the Evangelist: that is, when he raised Drusiana from the dead and when he was carried up into heaven. In the third chapel, which belongs to the Giugni and is dedicated to the Apostles, there are stories about the martyrdoms of many of them painted by Giotto's hand. In the fourth, which is on the other side of the church towards the north and, belonging to the Tosinghi and the Spinelli family, is dedicated to the Assumption of Our Lady, Giotto painted the Birth of the Virgin, the Betrothal, the Annunciation, the Adoration of the Magi, and the occasion when the Virgin brought Christ as a young child to Simeon—a most beautiful work, because aside from the great affection which is evident in the old man who receives Christ, the gesture of the Child, who is frightened of him and who stretches out His arms and turns towards His mother, could not be more tender nor more beautiful. Then in the scene of the death of Our Lady, the Apostles are painted along with a great number of angels with torches in hand in a very beautiful manner.

In the Baroncelli Chapel in the same church, there is a panel in tempera by Giotto's hand, where the Coronation of Our Lady is executed with a great deal of diligence along with a very large number of small figures and a chorus of angels and saints very carefully wrought. Giotto's name and the date are written in golden letters on this work, and artists who will reflect upon when it was that Giotto, without any knowledge of proper style, laid the foundations for the proper method of

drawing and colouring, will be forced to hold him in the highest veneration. In the same church of Santa Croce there still stands, above the marble tomb of Carlo Marsuppini of Arezzo, a Crucifix with Our Lady, Saint John, and Mary Magdalene at the foot of the cross, and on the other side of the church, directly opposite this work, there is an Annunciation above the tomb of Leonardo Bruni of Arezzo facing the high altar, which has been repainted by modern painters in a way that shows the poor judgement of whoever had it done. In the refectory there is a Tree of the Cross, stories from the life of Saint Louis, and a Last Supper by Giotto's own hand, and on the cabinets of the sacristy there are a number of stories with small figures from the lives of Christ and Saint Francis. At the Carmine Church in the Chapel of Saint John the Baptist, Giotto also painted the entire life of that saint divided into several different pictures; and in the Palazzo della Parte Guelfa in Florence, there is a perfectly painted fresco cycle on the history of the Christian faith, and in it is the portrait of Pope Clement IV who created that magistracy, bestowing upon it his coat of arms which it has retained ever since.

After these works, Giotto left Florence for Assisi to finish the work begun by Cimabue, and while passing through Arezzo he painted the Chapel of Saint Francis above the baptistery in the parish church, as well as lifelike portraits of Saint Francis and Saint Dominic on a round pillar near a very beautiful ancient Corinthian capital; and inside a little chapel in the Duomo outside Arezzo, he did the Stoning of Saint Stephen with an excellent composition of figures. When he had completed these works, he went on to Assisi, a city in Umbria, where he had been summoned by Fra Giovanni di Muro della Marca, then General of the Friars of Saint Francis, where in the Upper Church under the passage-way that is across from the windows and on the two sides of the church he frescoed thirty-two stories from the life and deeds of Saint Francis—that is, sixteen on each wall—which were so perfect that they earned him great fame. And in truth, great variety is evident in this work, not only in the gestures and postures of the figures but also in the composition of all the scenes, not to mention the fact that it is a most beautiful sight to see the

variety of clothes in those times and certain imitations and observations of things in Nature. And among these scenes, an especially beautiful one concerns a thirsty man whose desire to drink is clearly evident and who drinks from a spring kneeling down upon the ground with such great and truly marvellous emotion that it almost seems as if he is a real person drinking. There are also many other things most worthy of consideration there which I shall omit in order to be brief. Suffice it to say that from this work Giotto acquired great fame for the excellence of his figures and for the order, proportion, liveliness, and ease he naturally possessed, qualities he had greatly improved through study and knew how to exhibit clearly in all his works. For besides the natural talents Giotto possessed, he was very studious and always went about thinking up something new and drawing upon Nature, and he therefore deserved to be called a disciple of Nature rather than of other masters.

Once the above-mentioned stories had been finished, Giotto stayed in the same place, but in the Lower Church, and painted the upper section of the walls around the high altar, where the body of Saint Francis lies, and all four angles of the vault above it, displaying in all of the work there charming and original inventions. In the first angle, Saint Francis is glorified in Heaven surrounded by the virtues required for anyone who wishes to exist perfectly in God's grace. On one side, Obedience places upon the neck of a friar who kneels before her a yoke, the reins of which are pulled towards Heaven by hands, and indicating silence with one finger upon her mouth, she keeps her eyes towards Jesus Christ, who is bleeding from His side. In the company of this virtue are Prudence and Humility, in order to demonstrate that where there is true obedience, that humility and prudence which make everything function properly always exist. In the second angle is Chastity, who, standing upon an impregnable fortress, is not won over by the kingdoms, crowns, or palms offered to her by some. At her feet are Purity who washes the naked, and Fortitude, who is bringing other people to be washed and cleansed. Near Chastity on one side is Penitence who chases away a winged Cupid with a whip and puts Impurity to

flight. In the third is Poverty, who goes along barefoot treading upon thorns and has a barking dog behind her, while nearby there is a putto who throws stones at her and another who is pressing thorns into her legs with a stick. And we see this figure of Poverty being wed to Saint Francis while Christ holds her hand in the mystical presence of Hope and Charity. In the fourth and last of these angles is a figure of Saint Francis in glory, dressed in the white tunic of a deacon and seated in triumph in Heaven amid a multitude of angels, who form a chorus around him holding a banner displaying a cross and seven stars; and above them on high is the Holy Spirit. Inside each of these vault angles are Latin words which explain the scene. Besides the four vault angles I have mentioned, there are likewise some extremely beautiful paintings on the side walls which should be held in great esteem both for their obvious perfection and for the great care taken in their execution which has kept them fresh until the present day. Among these scenes is a well-made portrait of Giotto himself, while above the sacristy door, by Giotto's own hand, is a portrait, also in fresco, of Saint Francis receiving the stigmata, a work so full of affection and devotion that it seems to me the most excellent of the paintings Giotto did there, although they are all truly beautiful and worthy of praise.

Once Giotto had finally completed the portrait of Saint Francis, he returned to Florence, and upon his arrival, he painted with extraordinary care a panel to send to Pisa of Saint Francis standing on the terrible rock of Vernia, for besides composing certain landscapes full of trees and rocks, which were novelties in those times, Giotto conveys in the attitude of Saint Francis, who readily receives the stigmata while kneeling, a burning desire to receive it and a boundless love towards Jesus Christ, who is in the air above, surrounded by seraphim, and grants the stigmata to him with such lifelike affection that it would be impossible to imagine anything better. In the lower part of the same panel painting are three scenes from the life of the same saint which are very beautiful. This panel, which can still be seen today hanging from a pillar beside the high altar of the church of San Francesco in Pisa, was held in great veneration as a memorial to such a man, and it was the

reason why the Pisans, having just completed the building of
their Campo Santo according to the designs of Giovanni di
Nicola Pisano, as I have already described,* gave Giotto the
task of painting part of the interior. Just as the outside walls of
the buildings were overlaid with marble and carvings done at
great expense, the roof covered with lead, and the interior
filled with pillars and antique tombs built by the pagans and
brought to that city from various parts of the world, so the
inside walls were to be decorated with the noblest paintings.
Having therefore come to Pisa for this commission, Giotto
began by painting on one wall of this Campo Santo six great
scenes in fresco from the life of patient Job.* Giotto quite
judiciously determined that the marble on the part of the
building in which he was to work faced the sea and was
sweating because of the sirocco wind, so that all the marble
was continuously damp and, like most of the walls of Pisa,
exuded a powdery saline substance which eats away and fades
their colours and pictures. And so in order to preserve his
work for as long as possible, wherever he wanted to work in
fresco he first laid an *arriccio*, what we would call an *intonaco*
or an inlay of plaster undercoating made of lime, gypsum,
and crushed brick dust mixed together so that the paintings
applied to the plaster would be preserved up to the present
day.* And they would have been preserved even better if
those who were supposed to care for them had not carelessly
allowed them to be damaged by the humidity, for the lack of
precautions which could easily have been taken caused those
paintings to suffer from the humidity and to be ruined in
certain places, where the flesh tones grew black and the
intonaco peeled off. Besides this, it is in the nature of gypsum,
when mixed with lime, to deteriorate with age and to
decompose; its colours are, as a result, necessarily ruined later
on, even if at the beginning it seems to have set firmly and
well.

Besides the portrait of Messer Farinata degli Uberti, these
scenes contain many beautiful figures and above all certain
peasants, who in bringing the sad news to Job, could not have
been more sensitive, nor could they have expressed their
sorrow any more sincerely. Likewise, the figure of a servant

holding a fan of branches and standing by Job, who is afflicted
with sores and abandoned by practically everyone, is also
extraordinarily graceful: and however well the servant may be
painted in all details, the pose he strikes is marvellous, as with
one hand he brushes away the flies from his leprous and
stinking master, and with the other holds his nose in disgust so
as not to smell the stench. Similarly, other figures in these
stories, as well as the heads of the men and women, and the
delicate draperies, are so beautiful that it is no wonder this
work earned him such fame in Pisa and beyond that Pope
Benedict IX, who had planned to have several paintings done
for Saint Peter's, sent one of his courtiers from Trevisi to
Tuscany to ascertain what kind of man Giotto was and what
his paintings were like.* Once this courtier had come to see
Giotto and to find out what other excellent masters of paint-
ing and mosaics lived in Florence, he spoke to many masters in
Siena. Then, after he had collected drawings from them, he
moved on to Florence, and having gone one morning to
Giotto's shop while the artist was at work, he explained the
pope's intentions and how he wanted to evaluate Giotto's
work, finally asking him for a small sketch to send to His
Holiness. Giotto, who was a most courteous man, took a sheet
of paper and a brush dipped in red, pressed his arm to his side
to make a compass of it, and with a turn of his hand made a
circle so even in its shape and outline that it was a marvel to
behold. After he had completed the circle, he said with an
impudent grin to the courtier: 'Here's your drawing.' The
courtier, thinking he was being ridiculed, replied: 'Am I to
have no other drawing than this one?' 'It's more than suffi-
cient,' answered Giotto, 'Send it along with the others and
you will see whether or not it will be understood.'

Realizing that this was all he was going to obtain, the
envoy left Giotto rather dissatisfied, thinking he had been
tricked. Nevertheless, in sending the other drawings and the
names of the artists who had done them to the pope, he also
included that of Giotto, recounting the method he had used in
making his circle without moving his arm and without the
use of a compass. As a result, the pope and many of his
knowledgeable courtiers realized just how far Giotto surpassed

all the other painters of his time in skill. When this episode
became widely known, it gave rise to a proverb which is
still in use today when referring to stupid people: 'You are
rounder than Giotto's O.' This proverb may be considered
delightful, not only for the incident which gave rise to it but
even more so because of its meaning, which involves the
ambiguity the word 'tondo' takes on in Tuscany, where it
refers not only to a perfect circular figure but also to dullness
and crudeness of wit.

Thus, the pope had Giotto brought to Rome, where he
honoured him a great deal and recognized his genius, and he
had him paint five scenes from the life of Christ in the apse of
Saint Peter's, as well as the principal panel for the sacristy, all
of which were completed by Giotto with such great care that
there never issued forth from his hands a more polished work
in tempera. Giotto therefore richly deserved the reward of six
hundred golden ducats that the pope, who considered himself
well served, gave him, besides doing him many other favours,
so that it became the talk of all Italy.

At this time in Rome—to include something worthy of
being remembered that concerns art—there was a great friend
of Giotto's, Oderisi da Gubbio, a splendid illuminator of those
times, who had, for that reason, been brought to Rome by the
pope and who illuminated many books for the palace library
which have been, in large measure, destroyed by time. There
are a few things from his very hand in my book of antique
drawings, for in truth he was a worthy man, although Franco
Bolognese was an even better illuminator, who for the same
pope and the same library drew a number of most excellent
things in the same style at the same time, as can be seen from
my book, wherein I have drawings made by him for paintings
and miniatures. And among these is a very well-drawn eagle
and a very handsome lion tearing apart a tree. Dante mentions
these two fine illuminators in the eleventh canto of the
Purgatory, where he discusses the vainglorious, with these
verses:

> 'Oh!' I said, '*you* must be that Oderisi,
> honour of Gubbio, honour of the art
> which men in Paris call "Illuminating".'

'The pages Franco Bolognese paints,'
he said, 'my brother, smile more radiantly;
his is the honour now—mine is far less.'*

After the pope had observed his works and was enormously
pleased by Giotto's style, he ordered Giotto to decorate the
whole interior of Saint Peter's with scenes from the Old and
New Testaments. Therefore, Giotto began and painted in
fresco an angel seven armslengths high above the organ and
many other paintings; some of these have been restored by
others in our own day, and during the rebuilding of the walls,
others have been either destroyed or moved from the old
building of Saint Peter's to the space under the organ,
including a painting of Our Lady upon the wall which, so that
it might not be destroyed, was cut out from the wall and
bound with beams and iron bars, and in this manner taken
away; later, because of its beauty, it was built into a place
chosen out of his piety and love for beautiful works of art by
Messer Niccolò Acciaiuoli, a Florentine doctor who richly
adorned this work of Giotto with stuccoes and other modern
paintings. Also by Giotto's hand was the Navicella mosaic
located above the three doors of the portico in the court-
yard of Saint Peter's, which is a truly miraculous work
and rightly praised by all fine minds, for in it, besides the
design, there is the grouping of the Apostles who are
struggling in various ways because of the storm at sea, while
the winds fill a sail set in such relief that a real sail would
behave no differently. And yet it would be difficult to create a
harmony among the pieces of a stained glass window like the
one between the white areas and shadows of this huge sail,
which a painter striving for all he was worth with a brush
could have equalled only with the greatest difficulty. Besides
this, there is a fisherman who is fishing with a rod and line
upon a cliff, whose pose reveals the extreme patience charac-
teristic of that craft and whose face expresses the hope and
desire for a catch. Under this work are three small arches done
in fresco about which I shall say nothing more, since they have
been for the most part ruined. Clearly, the praise universally
given this work by other artists is justly deserved.

Then having painted in Santa Maria sopra Minerva, a church of the Dominican preachers, a large coloured crucifix in tempera on a panel, which was at that time highly praised, Giotto returned home, since he had been away for six years. But not long afterwards Pope Clement IX was elected pope at the death of Pope Benedict IX, and Giotto was forced to accompany this pope to where he held his court in Avignon to execute several works.* Once there, he painted many very beautiful panels and frescos not only in Avignon but in many other places in France, which greatly pleased the pontiff and all his court. When he was sent home, he was given his leave with great affection and many gifts, and he therefore returned home no less wealthy than honoured and famous, and among the other things, he took with him the portrait of that pope, which he then gave to Taddeo Gaddi his pupil.

Giotto's return to Florence took place in the year 1316. But he was not allowed to stay for long in Florence, because he was brought to Padua to work for the Della Scala rulers, and he decorated an extremely beautiful chapel in the Santo, a church built in those times. From there he went to Verona, where he did several pictures for Messer Cane in the palace, and, in particular, that gentleman's portrait, as well as a panel painting for the friars of San Francesco. When these works were complete and while he was returning to Tuscany, he was obliged to stop in Ferrara and paint in the service of the Este rulers in their palace and in the church of Sant'Agostino, where some things can still be seen today. Meanwhile, when Dante the Florentine poet heard that Giotto was in Ferrara, he arranged things in such a way that he brought Giotto to Ravenna where he was living in exile, and inside the Church of San Francesco he had him paint for the Polenta rulers some scenes in fresco which are reasonably good. Going then from Ravenna to Urbino, he also finished a few works there. Then, since he was obliged to pass through Arezzo, he could not refuse to please Piero Saccone, who had been exceptionally kind to him, and therefore painted upon a pillar in the main chapel of the bishop's palace a fresco of Saint Martin, who, cutting his cloak in half, gives half to a poor man standing before him almost completely naked. After this in the abbey

of Santa Fiore, he executed a large wooden crucifix in tempera
which is still in the middle of that church today, and he finally
returned to Florence, where among the other things, which
were numerous, he painted several works both in fresco and in
tempera for the convent of the nuns of Faenza, who no longer
exist today since that convent has fallen into ruins. Likewise,
in 1322 (the year before, to his great sorrow, his close friend
Dante passed away), Giotto went to Lucca, and at the request
of Castruccio, then Lord of his native city, he executed a panel
inside the church of San Martino showing a Christ in Heaven
along with the four patron saints of the city—that is, Saint
Peter, Saint Regulus, Saint Martin, and Saint Paulinus—who
seem to be recommending a pope and an emperor who,
according to the belief of many, are Frederick of Bavaria and
the antipope Nicholas V. Some people also believe that Giotto
designed the castle and the impregnable fortress of Giusta at
San Frediano in the same city.

Afterwards, when Giotto returned to Florence, King
Robert of Naples wrote to his first son, King Charles of
Calabria (who was in Florence) to do anything he could to
send Giotto to Naples, since after he finished building the
convent and royal church at Santa Chiara, he wanted Giotto
to decorate it with the noblest paintings.* So Giotto, when he
found himself summoned by so famous and celebrated a ruler,
was therefore more than happy to go and serve King Charles,
and once he reached Naples, he painted many scenes from the
Old and New Testaments in some of the chapels of this
convent. And it is said that the scenes from the Apocalypse,
which Giotto did in one of these chapels, were devised by
Dante, just like those in Assisi, which likewise received such
high praise and which have already been sufficiently discussed
above. And although Dante was already dead by that time,
they could have already discussed such matters, as friends often
do.

But, to return to Naples, Giotto did many works in the
Castel Nuovo, especially the chapel which greatly pleased the
king, who admired Giotto so much that while the artist was
at work, he would often stay with him, since the king took
pleasure in seeing Giotto paint and hearing him talk. And

Giotto, who was always ready with some clever remark or a witty retort, amused him with painting and pleasant, clever conversation. One day when the king announced to Giotto that he wanted to make him the first man in Naples, Giotto replied: 'That must be why I am living near the Porta Reale city gate—to be the first in Naples.' On another occasion, the king said to him: 'Giotto, now that it is so hot, I would put aside my painting for a while if I were you.' And Giotto answered: 'I certainly would too, if I were you.'

Since Giotto was very grateful to the king, he painted a goodly number of pictures for him in a hall which King Alfonso demolished in order to build his castle, as well as in the church of the Incoronata, and among the paintings in this hall there were portraits of many famous men, including that of Giotto himself. One day on a whim, the king had asked Giotto to paint his kingdom for him, and according to what they say, Giotto painted him an ass with a pack-saddle on its back, and, lying by its hooves, another new pack-saddle, which the ass seems to desire as he sniffs at it, and on both pack-saddles were the royal crown and the sceptre of power. And when the king asked Giotto what this picture meant, Giotto replied that it represented his subjects and his kingdom, since they desired a new ruler every day.

When Giotto left Naples for Rome, he stopped at Gaeta, where he was obliged to paint in the church of the Annunziata some scenes from the New Testament, which have been damaged by the passage of time, but not to such an extent that it is impossible to see quite clearly Giotto's own portrait next to a very handsome and large crucifix. When this project was completed, he first remained for a few days in Rome in the service of Lord Malatesta, to whom he could not refuse this favour, and then he went to Rimini, the city which this same Lord Malatesta ruled, and there in the church of San Francesco he painted a great number of works which were later torn down and destroyed by Gismondo, the son of Pandolfo Malatesta, who completely rebuilt the church.* Giotto also painted a fresco of the life of the Blessed Michelina in the cloister of the same church opposite its façade, which was one of the most beautiful and excellent things Giotto ever did

because of the many and beautiful details he worked into it. Besides the beauty of the draperies and the grace and liveliness of the heads, which are marvellous, there is a young woman as beautiful as a woman can be, who, to free herself from a false accusation of adultery, is swearing upon a book in a stupendous action, staring directly into the eyes of her husband, who has forced her to take the oath because of his suspicion over the dark-skinned son to whom she has given birth and who he is incapable of believing could possibly be his own. While her husband's expression shows his scorn and distrust, the woman moves those who gaze upon her very intently to recognize through the compassion in her face and eyes her innocence and simplicity and the wrong that he has done by forcing her to take an oath and by accusing her falsely as a whore in public. Giotto expressed these same powerful emotions in the figure of a man ailing from a number of sores, for all of the women around him, offended by the stench, turn away, twisting their bodies in disgust in the most graceful manner imaginable. Then, in another painting, the foreshortening seen in a crowd of deformed beggars is very praiseworthy and should be held in high esteem by artists, for the first principles and the method of creating foreshortenings are derived from these figures, not to mention the fact that they are, although they are the first, reasonably well executed. But more important than all the other details of this work is the marvellous attitude of the above-mentioned Blessed Michelina towards certain usurers who are handing over the money from the sale of her possessions that she will give to the poor, for her face expresses contempt for the money and other worldly possessions which seem to disgust her, and those of the usurers represent the very image of avarice and human greed. Similarly, the figure of the man counting the money, while apparently making signs to the notary who is writing, is very beautiful, for even though he has his eyes fixed on the notary, he keeps his hands over the money, betraying his affection for it, his avarice, and his distrust. Also worthy of infinite praise are three figures in the air, representing Obedience, Patience, and Poverty, who are holding up Saint Francis's habit, above all for the natural folds in their

garments, which show that Giotto was born to give birth to
the art of painting. Besides this, Giotto painted a very realistic
portrait of Lord Malatesta on a ship in this work which seems
very lifelike, along with some sailors and several other people,
all of whom in their liveliness, their emotions, and their
poses—particularly one figure who spits into the ocean while
he is speaking to some of the others and putting one hand to his
face—demonstrate the artist's skill. And among all the works
painted by this master, this certainly can be said to be one of
his best, because there is no single figure in such a great
number of them which does not exhibit the greatest technical
skill or which is not depicted in an imaginative pose. It is
therefore no wonder that Signor Malatesta did not fail to
reward Giotto magnificently and to praise him.

Once he had completed his work for this ruler, Giotto
painted Saint Thomas Aquinas reading to his friars outside the
door of the church at the request of a Florentine prior then
living in San Cataldo of Rimini. He then left Rimini and
returned to Ravenna, where in the church of San Giovanni
Battista he frescoed a highly praised chapel. Afterwards, when
he returned to Florence with the greatest honour and a good
deal of money, he painted in San Marco a crucifix larger than
life-size in tempera on wood against a gold background,
which was placed on the right side of the church, and he did
another similar to this one for Santa Maria Novella, on which
his pupil Puccio Capanna worked with him, which today still
hangs over the main door on the right above the tomb of the
Gaddi family at the entrance to the church. And over the altar
screen in the same church, Giotto did a Saint Louis for Paolo
di Lotto Ardinghelli, at the foot of which he painted life-size
portraits of the donor and his wife.

In the following year of 1327, when Guido Tarlati da
Pietramala, bishop and ruler of Arezzo, died at Massa di
Maremma while he was returning from Lucca where he had
been to visit the emperor, his body was brought to Arezzo to
be honoured at a most dignified funeral. Piero Saccone and
Dolfo da Pietramala, the bishop's brothers, resolved to have
a marble tomb built for him that would be worthy of the
greatness of a man who had been both a spiritual and temporal

ruler and leader of the Ghibelline faction in Tuscany. And so
they wrote to Giotto, asking him to design a magnificent
tomb, as dignified as possible, and, sending him the measure-
ments, they then begged him to put them in touch with a
sculptor who was, in his opinion, the most excellent of all
the sculptors in Italy, for they relied completely upon his
judgement. Giotto, who was a courteous man, drew the
design and sent it to them, and the tomb was built according
to this plan, as will be related in the proper place.* And
because this same Piero Saccone admired Giotto's skill beyond
measure, when he captured Borgo di San Sepolcro not long
after he received this design, he carried back from that town to
Arezzo a panel by Giotto's hand containing small figures,
which later fell to pieces. Baccio Gondi, a Florentine gentle-
man who is a lover of these noble arts and of every skill, was
then commissioner at Arezzo, and he searched with great
diligence for the fragments of this panel, and after locating
some of them, he brought them to Florence, where he holds
them in great veneration, along with some other things he has
by the hand of Giotto, who completed so many works that it
would be unbelievable to hear them all described.

And not many years ago, I found myself at the hermitage of
Camaldoli where I have done many works for those reverend
fathers, and in a cell where I was taken by the Most Reverend
Don Antonio da Pisa, then General of the Congregation of
Camaldoli, I saw a small crucifix against a gold background
with Giotto's name written upon it in his own hand which
was very beautiful; this crucifix, according to what the
Reverend Don Silvano Razzi (a Camaldolite monk) tells me,
is kept today in the Monastery of the Angeli in Florence in the
prior's cell, where it is considered a most unusual thing indeed
because it is from the hand of Giotto, along with a very
beautiful little painting from the hand of Raphael of Urbino.

For the Umiliati friars of Ognissanti in Florence, Giotto
painted a chapel and four panels, and among them one of Our
Lady surrounded by many angels with Her child in Her arms,
and a large wooden crucifix, from which Puccio Capanna
took the design for making many copies throughout Italy,
since he was greatly practised in Giotto's style. When this

book on the lives of painters, sculptors, and architects was
printed the first time, there was a small tempera panel in the
transept of the same church painted with infinite care by
Giotto in which he depicted the Death of Our Lady sur-
rounded by the Apostles and with a Christ who is receiving
Her soul into His arms. This work has been highly praised by
painters, particularly by Michelangelo Buonarroti, who, as is
related elsewhere, affirmed that the propriety of this painted
scene could not be closer to the truth of the matter than it
had been rendered. This little panel, I think, attracted greater
attention after my book of lives appeared in print, and it was
perhaps carried off by someone whose love of art and piety, as
our poet remarks, turned ruthless when it seemed to him that
the painting was valued too little.* And in those times it was
truly a wonder that Giotto could have painted so gracefully,
especially considering that in certain respects he had learned
his craft without having a teacher.

After all this, on the ninth day of July during the year 1334,
Giotto set his hand to the bell tower of Santa Maria del Fiore:
once they had excavated down around twenty armslengths, a
foundation made of a bed of heavy stones was laid where
water and gravel had been removed. Upon this bed of stones
he then put up a good twelve armslengths of concrete support,
and then did the rest, that is, another eight armslengths, in
masonry. The archbishop of the city attended this inaug-
uration ceremony, and in the presence of all the clergy and
magistrates, he solemnly laid the first stone. Continuing the
construction according to the above-mentioned plan, which
was in the German style that was customary in those days,
Giotto designed all the details for its decoration, marking out
very carefully upon the model in white, black, and red colours
where all the marbles and the friezes were supposed to go.
Around the base it measured some one hundred arms-
lengths—that is to say, twenty-five armslengths on each side.
Its height was one hundred and forty-four armslengths. And if
what Lorenzo di Cione Ghiberti has written is true—and
I hold it to be absolutely true—Giotto not only made the model
for this bell tower but also its marble sculpture and some of
those marble scenes in relief, which represent the beginnings

of all the arts. The same Lorenzo affirms that he saw models of reliefs from Giotto's own hand and in particular the reliefs for this project; and this can easily be believed, since design and invention are the father and mother of all the arts and not of a single one alone.

According to Giotto's model, this bell tower was supposed to have as its finishing touch above what is now visible a point or, rather, a four-sided pyramid fifty armslengths high, but since it was a German construction in the old style, modern architects have always advised against adding this, believing it to be better as it now stands. And for all these works, Giotto was not only made a Florentine citizen but he was also paid one hundred gold florins a year by the Commune of Florence, which was a great fortune in those days; and he was named superintendent of this project which was carried on after him by Taddeo Gaddi, since Giotto did not live long enough to see it finished.

Then, while the work on the bell tower was progressing, he did a panel for the nuns of San Giorgio, and in the Badia of Florence on an arch over the doorway inside the church, he painted three half-length figures now covered with whitewash to lighten the church. And in the Great Hall of the Podestà in Florence, he painted a representation of the Commune being robbed by many people; the Commune is depicted in the form of a judge seated with sceptre in hand, while above his head are the balanced scales of justice which he administers, assisted by four virtues—Fortitude with the soul; Prudence with the laws; Justice with arms; and Temperance with words— a beautiful painting, appropriate and realistic in its conception.

Then Giotto once again went to Padua, where besides the many other works and chapels he painted there, he did a Worldly Glory on the site of the Arena which earned him much honour and profit.* He also worked in Milan upon several things which are scattered around that city and which are to this very day held to be of exceptional beauty. Finally, having returned from Milan, after having created during his life so many and such beautiful works and having lived no less the life of a good Christian than he had that of a great painter, only a brief time passed before Giotto rendered his soul up to

God in the year 1336, to the great sorrow of all his fellow citizens, even those who had not known him but had only heard about him; and he was buried as his talents deserved, with the greatest honour, as someone who had been loved during his life by everyone, especially by excellent men in every profession. Besides Dante, of whom we have spoken above, he and his works were highly esteemed by Petrarch to the extent that we can read in his testament how Petrarch left to Signor Francesco da Carrara, the ruler of Padua, among other things Petrarch held in veneration, a painting from Giotto's own hand of Our Lady, which he considered a rare thing and a most pleasing one to him. And the words of that part of the will read as follows: 'I now turn to the disposition of my other belongings; and to My Lord of Padua mentioned earlier, both because he does not suffer from want by the grace of God and also because I possess nothing else worthy of him, I leave my portrait, or rather my scene of the Blessed Virgin Mary by the renowned painter Giotto, which was given to me by my friend Michele Vanni of Florence, the beauty of which the ignorant do not understand, while masters of the art are amazed by it: to My Lord, then, I leave this image in the hope that the Blessed Virgin Herself may intercede for him with Her Son Jesus Christ...' And the same Petrarch in one of his Latin epistles from the fifth book of his *Familiar Letters*, makes this statement: 'Moreover (to move from ancient to modern times, from abroad to our own land), I have known two painters worthy of greatness and not merely for their beautiful style: Giotto, a citizen of Florence, whose fame is boundless among the moderns; and Simone [Martini] from Siena. I have also known sculptors...'

Giotto was buried in Santa Maria del Fiore on the left side of the entrance into the church, where there is a slab of white marble in memory of this great man. And as was mentioned in the life of Cimabue, a commentator on Dante who lived in Giotto's time said: 'Giotto was, and is, the greatest among the painters from the same city of Florence, and his works in Rome, Naples, Avignon, Florence, Padua, and other parts of the world bear witness to this.'* ... Giotto was, as has already been noted, a very clever and charming man, extremely witty

in his remarks, some of which are still remembered in this city, for besides the one of which Messer Giovanni Boccaccio writes, Franco Sacchetti recounts many very fine remarks in his *Three Hundred Tales*. It is no hardship for me to write some of them down with the exact words used by this Franco, so that along with the narration of his novella we can also see some of the ways in which people spoke and expressed themselves in those days. Accordingly, he says in one of his tales, to provide a heading with the proper title: 'A man of little importance gave Giotto the great painter his shield to paint. Making a joke of it, he paints it in such a way that the man remains confused. Novella.'*

Everyone must already have heard of Giotto and how far he surpassed all others as a painter. A crude fellow had heard of his renown, and since he needed to have his shield painted, perhaps to perform some feudal service, he immediately went to Giotto's workshop with the man who was carrying the shield behind him, and when he reached the shop where he found Giotto, he said: 'God save you, Master. I would like you to paint my arms on this shield.' Sizing up the man and his manners, Giotto said nothing but 'When do you want it?' And the man told him. Giotto then said: 'Leave it to me.' The man left, and when Giotto was alone, he thought to himself: 'What does this mean, could he have been sent to me as a joke? Whatever the case may be, no one has ever brought me a shield to paint before, and the man who brought it is a dim-witted little man, asking me to paint his coat of arms as if he were from the royal house of France. I'll certainly make him an unusual coat of arms!'

And so thinking this over, Giotto set the shield in front of himself, designed something he thought appropriate, and told one of his pupils to complete the painting, and this was done. The painting showed a small helmet, a gorget, a pair of armlets, a pair of iron gloves, a pair of cuirasses and greaves, a sword, a knife, and a lance. When the worthy man (about whom no one knew anything) returned, he came up and enquired: 'Master, is my shield painted?' Giotto replied: 'It certainly is, go and bring it here.' When the shield arrived, this would-be gentleman began to stare at it and said to Giotto: 'What's this mess you've daubed on it?' Giotto answered: 'You'll think it is a handsome mess when you pay for it.' The man said: 'I wouldn't pay four cents for this.' Then Giotto said: 'What did you tell me to paint?' And the man answered: 'My arms.' Giotto said:

'And aren't they all there? Is any single one missing?' The man said: 'There certainly is.'

Then Giotto went on: 'Well, that's too bad, God damn you—you must really be a great fool, since if anybody asked you who you were, you'd hardly know what to say! And you come here and tell me: "Paint my arms." If you were one of the Bardi family, that would be enough. What arms do you bear? Where do you come from? Who were your ancestors? Tell me, aren't you ashamed of yourself? At least begin by making some progress in the world before you start talking about arms as if you were the Duke of Bavaria! I put every sort of arm on your shield for you; if I left anything out, tell me and I'll have it painted.' The man replied: 'You insult me, and you have ruined my shield', and he left Giotto and went to the inspector to issue a summons against him. Giotto appeared and issued a summons against the man, demanding two florins for the painting, the same amount he was being sued for. When the officials had heard their cases, which Giotto argued much better than the other man, they decided that the man should take his shield as it was painted and give six lire to Giotto, since he was in the right. Therefore, he was obliged to take the shield and pay, and he was released. In this manner, a person who did not know his place had it pointed out to him.

It is said that when Giotto was still a young man with Cimabue, he once painted upon the nose of a figure that Cimabue had completed a fly which looked so natural that when his master returned to continue his work, he tried more than once to drive the fly away with his hand, convinced that it was real, before he realized his mistake. I could relate many other pranks played by Giotto and many of his witty retorts, but I want these to suffice here, since they treat matters pertinent to art, leaving the rest to Franco and other writers.

Finally, so that Giotto's memory might live on not only in the works which issued forth from his hands but also in the works created by the writers of those times—since he was the one who rediscovered the true method of painting after it had been lost for many years before him—his bust, carved in marble by Benedetto da Maiano, a most excellent sculptor, was placed in Santa Maria del Fiore along with the following verses composed by that divine man, Messer Angelo Poliziano. This was done by public decree and with the

support and special affection of Lorenzo de' Medici the
Magnificent, who admired the skills of this great man, in
order that all men who excelled in any profession whatsoever
after Giotto could hope to win from others the kind of
memorials which Giotto so completely deserved and earned
because of his special excellence:

I am that man by whose deeds painting was raised from the dead, my
hand as ready as it was sure.
 Nature lacked what my art lacked.
 No one was allowed to paint anything better or more completely.
Do you admire a beautiful tower resounding with sacred sound? By
my design this tower also reached for the stars. But I am Giotto, why
cite such deeds? My name alone is worth a lengthy ode.

In order that those who come after may see sketches from
the hand of Giotto and may more fully recognize in them this
man's excellence, there are, in our previously mentioned
book, several marvellous examples which were discovered by
me with no less care than trouble and expense.

THE END OF THE LIFE OF GIOTTO

The Life of Simone [Martini] of Siena
[c.1284–1344]

Truly happy are the men who are by nature inclined to those arts which can bring them not only honour and great profits but, what is more important, fame and an almost everlasting reputation; even happier are those who in addition to this inclination exhibit from infancy a gentility and civility of manners which make them most pleasing to all men. But happiest of all, finally, are those (speaking of artists) who, in addition to having a natural inclination towards the good as well as noble habits resulting from both their nature and education, live in the time of some famous writer from whom, in return for a small portrait or some other kind of gift of an artistic nature, they may on occasion receive, through his writings, the reward of eternal honour and fame. Such a thing should be especially desired and sought after by those most excellent artists who work in the field of design, for their works, being executed upon surfaces within a field of colour, cannot possess the eternal duration that bronze casting and marble objects bring to sculpture or buildings to architects. It was thus Simone's greatest good fortune to live in the time of Messer Francis Petrarch and to happen to find this most amorous poet at the court of Avignon, since he was anxious to have a picture of Madonna Laura by the hand of Maestro Simone; for that reason, when he received a painting as beautiful as he had wished, he immortalized Simone in two sonnets, one of which begins in this fashion:

> No matter how hard Polyclitus looked,
> And all the others famous for that art,

while the other begins like this:

> When Simone first received that high idea
> Which for my sake he used his drawing pen,*

And in truth, these sonnets and the mention made of Simone in one of Petrarch's letters on familiar matters in book five, which begins 'I am nobody',* have given the poor life of Maestro Simone greater fame than all his works did or ever will do, for the time must come, whenever it may be, when they will disappear, while the writings of such a great man will endure for all time.*

Simone Memmi* of Siena was, in any case, an excellent painter, singular in his time and greatly esteemed at the court of the pope, for after the death of Giotto, his master, whom he had followed to Rome when he executed the Navicella in mosaic as well as other works, Simone copied Giotto's style* in a Virgin Mary on the portico of Saint Peter's and in the figures of Saint Peter and Saint Paul painted near where the bronze pine cone stands upon a wall between the arches of the portico on the outside. Simone was praised for this style, above all for having placed in this work the portrait of a sacristan of Saint Peter's who is lighting some lamps for these figures in a most expeditious manner, and as a result he was called with the greatest urgency to the pope's court in Avignon,* where he worked on so many paintings, both in fresco and on panels, that his works equalled the reputation which had preceded him there. Since he returned to Siena in high standing and was therefore in great favour, he was allowed by the Signoria to paint a fresco of the Virgin Mary surrounded by many figures in their palace, a work which he completed to perfection, with the greatest praise and profit.* And to show that he was no less adept at working upon panels than in fresco, Simone painted in the same palace a panel which later caused him to receive commissions for two others in the Duomo, as well as the painting of Our Lady with the baby Jesus in Her arms in a most beautiful pose over the door of the Opera del Duomo; in this last painting, some angels in flight are gazing down upon some saints standing around Our Lady and holding up a banner in the air, and they all form a very handsome composition and a grand decoration. After completing these works, Simone was brought to Florence by the General of [the Brothers of] Saint Augustine, for whom he worked on the chapter house of Santo Spirito, demonstrating

remarkable powers of invention and judgement in the figures
and horses he painted there, as well as in the scene of the
Passion of Christ, in which everything he created with such
ingenuity reflects his discretion and exquisite grace. The
thieves upon the cross are seen as they breathe their last, and
the soul of the good thief is carried up into Heaven with
rejoicing by angels, while that of the evil thief is rebuked and
taken down by devils to the torments of Hell. Simone also
shows similar powers of invention and judgement in the poses
and bitter weeping of some of the angels around the cross. But
the thing which above all others is most worthy of consid-
eration is the sight of these spirits who visibly cleave the air
with their shoulders, for they sustain the motion of their flight
while practically turning around. But this work would pay
much greater tribute to Simone's tremendous skill if, besides
being worn away by time, it had not been ruined in the year
1560 by the monks who, unable to use the chapter house
because it was badly damaged by humidity, pulled down
the little that remained of the paintings of this artist in con-
structing a vault to replace a worm-eaten scaffold. Around the
same time, Simone painted in tempera a panel of Our Lady
and Saint Luke with other saints, which is now in the Gondi
Chapel in Santa Maria Novella and signed with his name.

 Then Simone worked very successfully upon three walls of
the chapter house of the same Santa Maria Novella. On the
first, which is over the entrance, he did the life of Saint
Dominic; over the second, which leads towards the church, he
represented the religious order of Saint Dominic combating
heretics depicted as if they were wolves attacking some sheep
defended by a number of black and white dogs who repel and
kill the wolves.* Also pictured are a number of heretics who,
being converted in the theological disputations, tear up their
books and, repentant, are confessing, while their souls are
passing through the gates of Paradise, where there are many
small figures doing various things. In Heaven, the glory of the
saints and Jesus Christ can be seen, and in the world down
below, earthly delights and vain pleasures reside among a
group of human figures, most especially a number of ladies
who are seated. Among these ladies is Petrarch's Madonna

Laura drawn from life and dressed in green, with a small flame
of fire between her breast and her throat. There is also the
Church of Christ guarded by the Pope, the Emperor, the
King, the Cardinals, the Bishops, and all the Christian rulers,
while among them, beside one of the Knights of Rhodes,
Messer Francis Petrarch is depicted in a life-size portrait which
Simone painted in order to renew with his paintings the fame
of the man who had made him immortal.* To represent the
Church Universal, he painted the church of Santa Maria del
Fiore—not as it stands today but as he had copied it from the
model and plan left behind by the architect Arnoldo* as a
guide to those who were to continue the construction after
him. Due to the neglect of those in the Works Department of
the cathedral, as was mentioned elsewhere, no memory of
these models would have survived if Simone had not depicted
them in this work. On the third wall, that of the altar, he
painted the Passion of Christ, who is leaving Jerusalem with
the cross upon His shoulder and going to Mount Calvary,
followed by a great crowd of people; when Christ reaches
Calvary, He is to be seen raised upon the cross between the
thieves along with the other pertinent details that accompany
this scene. I shall remain silent about the goodly number of
horses there, the casting of lots by servants from the court for
Christ's garments, the release of the holy Church Fathers from
Limbo, and all the other deliberate inventions which would be
judged most excellent not only by a master of that period, but
also by a modern painter. Although he takes on the task of
using all the walls completely, with the most accurate powers
of observation he places the various scenes on a mountain top
in each of them and does not divide the scenes with ornamen-
tation, like older painters and many modern painters, who on
four or five occasions place the earth above the sky, as in the
main chapel of this same church and in the Campo Santo of
Pisa. There, where Simone painted many works in fresco, he
was forced against his will to employ such divisions, since the
other painters who had worked there, such as Giotto and
Buonamico his master,* had begun to paint their scenes with
this defective structure.

Following the style employed by others in the Campo

Santo as the lesser of two evils, Simone then executed above
the main door inside a fresco painting of Our Lady, who is
carried up to Heaven by a chorus of angels singing and play-
ing so naturally that they exhibit all the various expressions
musicians usually make when singing or playing, such as
bending an ear towards the sound, opening the mouth in
various ways, raising the eyes to the sky, puffing up the
cheeks, swelling the throat—in short, all the actions and
movements involved in music. Under this Assumption, in
three pictures Simone did a number of scenes from the life of
Saint Ranieri of Pisa. In the first, he is a young boy, and
several young girls, dancing to the sound of his psalter, are
very beautiful because of the expressions on their faces and the
decoration of the clothes and headgear worn in those times.
This same Ranieri is then seen as he is rescued from such
lasciviousness by the Blessed Hermit Albert: he stands in tears
with his face down and eyes that are bloodshot from weeping,
completely repentant of his sin, while God in the air, sur-
rounded by a celestial light, appears to forgive him. In the
second picture Ranieri is shown distributing his property to
God's poor, then climbing aboard a ship, while around him
stands a mob of poor and crippled people, women and little
children, very lovingly pushing themselves forward to entreat
and thank him. And in the same picture, this saint is seen after
he has received the pilgrim's garment in the temple, standing
before Our Lady, who is surrounded by many angels, as She
shows him that he shall find peace within Her bosom in Pisa,
and all of the figures here have great liveliness and beautiful
expressions in their features. In the third painting Simone
depicts the saint when he has returned from beyond the seas
after seven years and proves that he has spent three forty-day
periods in the Holy Land, and when standing in the choir
listening to the holy services in which many young boys are
singing, Ranieri is tempted by the Devil, who is seen to be
driven away by the saint's obviously steadfast resolve not to
offend God, which is assisted by a figure Simone created
to represent Constancy, who forces our ancient adversary
to depart, not only in a complete state of confusion but also,
through beautiful and fanciful invention, in a state of great fear,

holding his hands to his head as he flees and walking with his face downcast and as close as possible to his shoulders, while saying (for the words which issue from his mouth can be seen written out) 'I can do no more!' Finally in this picture, there is a scene where Ranieri, kneeling on Mount Tabor, miraculously sees Christ in Heaven along with Moses and Elijah. All the details of this work and others which will not be mentioned show that Simone was most charming and original and understood the proper method of composing graceful figures in the style of those times. When he had completed these scenes, he painted two tempera panels in the same city, assisted by his brother Lippo Memmi, who had also helped in painting the chapter house of Santa Maria Novella and other works. . . .*

As that book of ours mentioned earlier reveals, Simone did not excel in design, but he possessed a natural talent for invention and was very fond of drawing from life, and in this respect he was considered the best master of his day, causing Lord Pandolfo Malatesta to send him all the way to Avignon to paint the portrait of Messer Francis Petrarch, at whose request he then painted the portrait of Madonna Laura, which Petrarch praised so highly.*

THE END OF THE LIFE OF SIMONE [MARTINI], SIENESE PAINTER

The Life of Duccio, Sienese Painter*
[c.1255–c.1316]

No doubt those who are the inventors of anything notable attract the greatest attention from historians, and this occurs because new inventions are more closely observed and held in greater amazement, due to the pleasure to be found in the newness of things, than any number of improvements made later by anyone at all in bringing these things to their ultimate state of perfection. For that reason, if no beginning were ever made, the intermediate stages would show no improvement, and the end result would not turn out to be the best and of marvellous beauty.

Duccio, a highly esteemed Sienese painter, therefore deserves the praise of those who followed after him for many years, since he began with figures in chiaroscuro the inlaid marble floor of the Duomo in Siena on which modern artists have created the marvels we can see there today. This Duccio applied himself to the imitation of the old style* and, with the soundest judgement, he gave honest shapes to his figures which he executed in a most excellent fashion, given the difficulties of this art. Imitating paintings in chiaroscuro, Duccio, with his own hand, organized and designed the beginnings of this floor, and in the Duomo he executed a panel which was then placed upon the main altar but later removed and replaced by the tabernacle of the body of Christ which is still seen there. According to what Lorenzo di Bartolo Ghiberti writes, this panel contained a Coronation of Our Lady, worked somewhat in the Greek fashion, but combined with a good deal of the modern style. And since this same altar stood alone by itself, the panel was painted on both the back and the front, and on the reverse side Duccio painted with great care the main scenes from the New Testament in small but very

beautiful figures. I have tried to discover where this panel is located today, but in spite of my very diligent efforts, I have been unable to happen upon it or to learn what the sculptor Francesco Di Giorgio* did with it when he restored in bronze the above-mentioned tabernacle as well as the marble decorations which are on it.*

THE END OF THE LIFE OF DUCCIO, SIENESE PAINTER

PART TWO

PREFACE TO PART TWO

Preface to Part Two

When I first began to recount these lives, it was not my intention to compile a list of artists or to make an inventory, let us say, of their works, nor did I ever think it was a worthy goal in these lives of mine (which, if not admirable, have certainly proven to be a lengthy and painstaking project) to rediscover their number, names, and places of birth or to indicate in which cities and in what precise location these paintings, sculptures, or buildings are presently to be found; this I could have accomplished in a simple index without interjecting my own judgements anywhere. But I have come to realize that writers of histories, those who by common consent have the reputation of having written with the best judgement, not only have not remained content with merely narrating events but have gone about investigating with every care and even greater curiosity the methods, manners, and means that these valiant men have employed in the management of their artistic enterprises; and they have taken pains to explore their errors as well as their successes and remedies, and the prudent decisions they sometimes made in handling their affairs, and, in short, all those ways in which wisely or foolishly, with prudence, compassion, or magnanimity, such men have behaved. These are like the methods of those writers who realize that history is truly the mirror of human life—not merely the dry narration of events which occur during the rule of a prince or a republic, but a means of pointing out the judgements, counsels, decisions, and plans of human beings, as well as the reason for their successful or unsuccessful actions; this is the true spirit of history, that which truly instructs men on how to live and act prudently, and which, along with the pleasure derived from observing events from the past as well as the present, represents the true goal of history.* For this reason, since I have undertaken to write the history of these

most noble artists in order to serve these arts in so far as my powers allow, as well as to honour them, I have tried as best I can, imitating such worthy men, to hold to the same methods. And I have endeavoured not only to tell what such men did but, as I narrate, to pick out the better works from the good ones, and the best works from the better ones, noting with some care the methods, colours, styles, traits, and inventions of both painters and sculptors. To inform those readers who would not know how to do so for themselves, I have investigated as carefully as I knew how the causes and origins of their styles as well as the improvement or decline of the arts which have occurred in various times and among different peoples.* And since at the beginning of these *Lives*, I spoke of the nobility and the antiquity of these arts in so far as it was necessary at that point, I left aside many details from Pliny and other authors I might have made use of, had I not wanted (perhaps contrary to the opinion of many) to leave each reader free to observe for himself the visions of others at their proper source. It seems to me it is now advisable to do what was not appropriate for me to do earlier, if I wished to avoid tediousness and length—mortal enemies of close attention—that is, to disclose more carefully my thoughts and intentions, and to demonstrate my reason for dividing this body of lives into three sections.

It is certainly true that although greatness in the arts is achieved by some artists through hard work, by others through study, by others through imitation, and by still others through a knowledge of all the sciences which assist these arts, there are some artists who succeed through most or all of the above-mentioned qualities. Nevertheless, as I have spoken sufficiently in the individual lives about the methods of art, its styles, and the reasons for good, better, and pre-eminent workmanship, I shall now discuss these matters in general terms, more particularly, the quality of the times rather than the individuals whom I have divided and separated into three groups—or periods, if you will—beginning from the rebirth* of these arts and continuing down to the century in which we live, avoiding the minute details and clarifying the obvious differences which can be recognized in each of them. Conse-

quently, in the first and most ancient period, the three arts may be seen to exist in a state very far from their perfection; and although they may have possessed some good qualities, they are accompanied by so many imperfections that they certainly do not deserve great praise. Still, since they provided, if nothing else, a beginning as well as the method and style for the better art which subsequently followed, it is impossible not to speak well of them and to attribute to them a bit of glory which, if they are to be judged according to the perfect rules of art, the works themselves did not deserve. In the second period there is a clear improvement in invention and execution, with better design and style, and greater accuracy; and so, artists cleaned away the rust of the old style, along with the awkwardness and lack of proportion typical of the coarseness of those times which was the cause. But who would dare to say that in this second period there existed a single artist perfect in every respect? And who has brought things up to the standards of today in invention, design, and colouring? And who has observed in their works the soft shading away of figures with dark colouring, so that light remains shining only on the parts in relief, and, likewise, who has observed in their creations the perforations and exceptional finishes of the marble statues which can be seen today? This kind of praise clearly belongs to the third period, and I may safely declare that its art has achieved everything which could possibly be permitted to an imitator of Nature, and that this period has risen so high that there is more reason to fear its decline than to expect further advances.

Having considered these matters carefully in my own mind, I believe this to be a property and a particular character of these arts—that from humble beginnings, they very gradually improve, and finally reach the summit of perfection. I am led to believe this by having observed almost the same occurrence in other fields of learning, and the fact that there exists a certain relationship between all the liberal arts provides no small argument that it is true. But in the painting and sculpture of former times, something quite similar must have happened, for if their names were changed, their cases would be exactly alike. None the less, if we must trust those who

lived closer to those times and were able to see and judge
the labours of ancient artists, it is evident that the statues of
Canacus were very wooden, lacking any vitality or movement
whatsoever, and were therefore very far from being lifelike,
while those of Calamides were said to be the same, even if
they were somewhat more delicate than those of Canacus.
Then there came Myron, who did not imitate the truth of
Nature at all but nevertheless gave his works so much
proportion and grace that they can quite reasonably be called
beautiful. In a third stage followed Polycletus and other
celebrated artists, who, as is recounted (and as we must
believe), produced completely perfect works of art. This same
progression must have occurred in painting as well, for it has
been claimed (and must readily be believed) that the paintings
of those artists who painted only with a single colour—and
who were therefore called monochromatists—did not attain a
high level of perfection. Subsequently, in the works of Zeuxis,
Polygnotus, Timanthes, and others who employed only four
colours in their paintings, their lines, outlines, and forms were
praised, although without a doubt they still left something to
be desired. But then in the works of Erione, Nichomachus,
Protogenes, and Apelles everything is so perfect and beautiful
that one cannot imagine anything finer, since these artists not
only painted most excellent forms and bodily movements but
also emotions and passions of the soul. However, let us set this
topic aside, since we are obliged to refer to other writers who
frequently do not agree in their judgements or, what is worse,
even on their dates—even though we have followed the best
authors—and let us come to our own times, where we have
the eye, a far better guide and judge than the ear.*

To begin with only one of these arts, is it not evident how
far architecture improved and progressed from the time of
Buschetto the Greek to Arnolfo the German or Giotto? The
buildings of those times reflect this in their pillars, columns,
bases, capitals, and all their cornices with their deformed
ornaments—such as those in Florence's Santa Maria del Fiore,
the façade outside San Giovanni, San Miniato al Monte, the
bishop's palace of Fiesole, Milan's Duomo, Ravenna's San
Vitale, Rome's Santa Maria Maggiore, and the old Duomo

outside of Arezzo—where except for a few good elements remaining from fragments of ancient buildings, there is nothing possessing order or good form. But those men [Arnolfo and Giotto] certainly made considerable improvements in architecture, and under their guidance it made no small progress, for they brought back better proportion and constructed their buildings not only with stability and strength but also with some measure of decoration. Nevertheless, their decorations were confused and very imperfect and, if I may say so, not greatly ornamental, because in their columns they failed to observe that measure and proportion which art required, nor did they distinguish between the Doric, Corinthian, Ionic, or Tuscan orders, mixing them together, following their rules without rules, and constructing them extremely thick or very thin, as they preferred. And all their inventions were derived in part from their own minds and in part from the ancient monuments they observed; and they made their plans extracted in part from the good and in part from the additions of their own imagination, so that when their walls were erected, they possessed a different form. Nevertheless, anyone who compares their works to those which came before them will observe that they were better in every respect and will see some things that do not cause any kind of displeasure in our own day, such as some of the little temples of brick covered with stucco at San Giovanni in Laterano in Rome.

I could say the same thing about sculpture, which, in the first period of its rebirth, possessed some very good qualities after having abandoned the awkward Greek style, which was so crude that it was closer to quarry work than to the skill of artists, since its statues—which can, in the strict sense of the word,* be called statues—were entirely devoid of folds, poses, or movement of any kind. Then, after Giotto had greatly improved the art of design, figures in marble and stone also improved, such as those done by Andrea Pisano, Nino his son, and other pupils of his, who were much better than their predecessors, since they gave their statues more movement and rendered them with much better poses, as in the work of the two Sienese, Agostino and Agnolo, who built, as was

mentioned earlier, the tomb of Guido, Bishop of Arezzo, or
that of the Germans who created the façade at Orvieto. Thus,
in this period sculpture can be seen to have improved a little:
the figures were given somewhat better forms, and the folds
in the garments hung more beautifully; some of the heads had
more interesting expressions, and certain of the poses were less
rigid. In short, those artisans had begun to find the good, but
they nevertheless failed to attain it in countless ways, since in
those days design had not reached its full perfection, nor were
there many good works to be seen and imitated. As a result,
those masters who lived in this period and who have been
placed by me in the first part [of my *Lives*] deserve praise and
should be given recognition for what they accomplished,
especially if we consider that along with the architects and
painters of those times, they had no assistance from their
predecessors and had to find their way by themselves; and any
beginning, no matter how small, is always worthy of no small
praise.

Painting did not enjoy much better fortune in those times,
except for the fact that since it was used for the devotional
practices of the people, more painters existed, and, as a result,
painting made more obvious progress than the other two arts.
Thus, we can see how the old Greek style, first with the
progress made by Cimabue and then with the assistance of
Giotto, was completely set aside, while a new style was born
from it which I would willingly call Giotto's style, since it
was discovered by him and his pupils and then universally
venerated and imitated by everyone. And in this style we can
see how the outline completely enclosing the figures, those
eyes with their lustreless staring, the feet standing on tiptoe,
the pointed hands, the absence of shadows, and the other
monstrosities of those Greeks have all been abandoned, giving
place to genuine gracefulness in the heads and softness in the
colouring. And Giotto in particular improved the poses of
his figures and began to exhibit the ability to endow his
heads with liveliness, while giving his garments folds, which
brought them closer to nature than those before his time,
and he discovered something of the art of diminishing and
foreshortening his figures. Besides this, he was the first to

express emotions in his works, in which we can recognize to some extent fear, hope, anger, and love; he brought a softness into his style lacking in earlier paintings, which were coarse and rough. And if he failed to execute his eyes with that beautiful movement that they have in life, his weeping figures with delicacy, his hair and beards with softness, his hands with their natural joints and muscles, and his nudes like real bodies, the obstacles confronting his art and the fact that he had not observed better painters than himself must excuse him. And in that period of artistic poverty, everyone can grasp the soundness of judgement in his scenes, his observation of human expression, and his easy obedience to a natural style, because it is also evident that his figures fulfil their purpose, showing in this way that Giotto's judgement was very good, if not perfect.

The same thing is evident in the painters who followed him, as in Taddeo Gaddi's colouring, which is sweeter and more forceful, in his improved flesh-tones and the colours of his garments, and in the more robust movements of his figures. It is evident in the decorum of the narratives composed by Simone [Martini] of Siena, and in the work of Stefano Scimmia and his son Thomas, whose work brought great improvement and excellence to drawing as well as great powers of invention to perspective, and to the shading and blending of colours—all the while keeping to Giotto's style. Similar skill and dexterity were shown by Spinello Aretino, his son Parri, Jacopo di Casentino, Antonio Veneziano, Lippi, Gherardo Starnini, and other painters who worked after Giotto, following his expressions, outlines, colouring, and style, even making some small improvements but not so many that they showed a desire to aim for another standard.

Anyone considering my argument will notice that up to this point, these three arts remained quite sketchy and lacked much of the perfection they deserved; and, certainly, if greater progress had not followed, this improvement would have been of little use and would not merit much attention. I do not want anyone to think I am either so crude or so lacking in judgement that I do not recognize the fact that the works of Giotto, Andrea Pisano, Nino, and all the others I have



grouped together in the first part of my book because of the similarity in their style—when compared to the works of those artists who came after them—do not deserve extraordinary or even modest praise. I was well aware of this when I praised them. But anyone who will consider the nature of the times in which they lived, the scarcity of artisans, and the difficulty of finding good assistants will hold their works to be not only beautiful (as I have stated) but miraculous, and will take infinite pleasure in observing the first principles and those sparks of beauty which began to reappear in painting and sculpture.

The victory Lucius Marcius earned in Spain was certainly not so great that the Romans did not experience even greater ones.* But having considered the time, the place, the circumstances, the participants, and their number, they held this victory to be stupendous, and even today, it deserves the boundless and lavish praise which writers bestow upon it. Thus, for all the reasons stated above, it seemed to me that these artists deserved not only to be carefully described by me but also praised with the admiration and certainty I have felt. And I think that my fellow artists will not find it annoying to have learned about their lives and to have considered their styles and methods, and perhaps they will derive no little benefit from it. This would please me a great deal, and I would consider it a fitting reward for my labours in which I have sought only to give them, in so far as I could, something that is both useful and delightful.

Now that we have, in a manner of speaking, taken these three arts away from their nursemaids and taken them through their childhood, there comes the second period, during which everything will be seen to improve enormously. Inventions are more abundant in figures and richer in ornamentation; and design is more firmly established and more natural and lifelike; and besides the finishing touches in works executed with lesser expertise but more thoughtful diligence, the style is lighter, and the colours more charming, so that very little remains to be done to bring all these details to the complete state of perfection where they imitate exactly the truth of Nature. First of all, through the study and diligence

of the great master Filippo Brunelleschi, architecture redis-
covered the measurements and proportions of the ancients,
both in round columns and square pillars as well as in rough
and smooth exterior corners; architecture, at that time, made
distinctions between the different architectural orders, and
revealed the differences between them. It required that they be
designed according to rules, that they be pursued with greater
orderliness, and that they be partitioned by measurements.
The power of design increased and its methods improved,
bestowing upon these works a pleasing grace and making
manifest the excellence of this art. Architecture rediscovered
the beauty and variety of capitals and cornices in such a way
that the plans for churches and other edifices were obviously
well conceived and the buildings themselves became more
ornate, magnificent, and most beautifully proportioned; this is
evident in the stupendous construction of the dome of Santa
Maria del Fiore in Florence and the beauty and grace of its
lantern, in the ornate, varied, and graceful church of Santo
Spirito, in the no less beautiful edifice of San Lorenzo, and in
the most extraordinary invention of the octagonal temple of
the Angioli, in the airy church and convent of the Badia at
Fiesole, and in the magnificent and grandiose beginnings of
the Pitti Palace. Other examples may be found in the
commodious and grandiose edifice constructed by Francesco
di Giorgio, the palace and church of the Duomo in Urbino,*
as well as in the strong, magnificent castle of Naples, or the
impregnable castle of Milan, not to mention many other
noteworthy buildings from this period. All in all, these works
may safely be described as both beautiful and good, although
they do not yet exhibit that refinement and exquisite grace
(particularly in their cornices); nor that special elegance and
lightness in the carving of leaves and real tips in the foliage;
nor other perfections that came later, as we shall observe in
the third part, which will follow with an account of those
architects who executed everything with perfect grace, finish,
ease, and skill, unlike the older architects, whose works none
the less can safely be called beautiful and good. I would still
not call them perfect because having observed the later
improvements in this art, it seems reasonable to me to affirm

that they were lacking in something. There were some miraculous works which have not been surpassed even in our own times, nor perhaps will they ever be in times to come, such as the lantern on the dome of Santa Maria del Fiore and, in terms of size, the dome itself, where Filippo [Brunelleschi] possessed the courage not only to equal the ancients in the main part of the building but also to surpass them in the height of its walls. However, we are discussing the entire period as a whole, and one should not argue from the perfection and special excellence of a single work that the entire period was excellent.

I would say the same about painting and sculpture as well, in which we may still see even today some most exceptional creations by the masters of this second period, such as the works in the Carmine by Masaccio, who painted a naked man shivering from the cold and other lively and spirited works. But as a general rule, these artists did not reach the perfection of those in the third, which we shall discuss at the proper time, since we must now deal with artists of the second period, and the sculptors first of all. These men moved so far from the style of the first period, and they improved upon it so much that they left little for the third to accomplish. And their style contained so much more grace, so much more life, so much more order, design, and proportion that their statues began to seem as if they were living beings and not mere statues, like those of the first period.

The works which were produced during this period of stylistic renewal bear witness to this change, as will be seen in this second part, where the figures of Jacopo della Quercia possess more movement, more grace, better design and care, while those of Filippo reflect a more careful investigation of the muscles, better proportion, and finer judgement, and the same could be said for the works of their pupils. But Lorenzo Ghiberti in his work on the doors of San Giovanni added even more of these qualities, displaying invention, order, style, and design, so that it seems as if his figures move and breathe. Although Donatello lived in their period, I could not decide whether or not to place him among the third group of artists, since his works are comparable to excellent ancient ones. In

any case, I must say that he can be called an example for other artists in the second period, since he himself possessed all the qualities divided among many others, for he imparted to his figures a sense of movement, giving them such liveliness and animation that they can stand comparison with both modern works and, as I have said, those of the ancients.

And painting made the same improvement in these days as sculpture did, for here the most excellent Masaccio completely abandoned the style of Giotto and found a new style for his heads, clothes, houses, nudes, colourings, and foreshortenings. And he gave birth to that modern style which has been followed from those times down to our own day by all our artists and which has been enriched and embellished from time to time with greater grace, better invention, and finer decoration. This will be made evident in detail in the lives of the artists, where we shall recognize a new style in the colouring, foreshortening, and natural poses; a more highly expressive depiction of feelings and physical gestures combined with an attempt to make their designs reflect the reality of natural phenomena; and facial expressions which perfectly resemble men as they were known by the artists who painted them. In this way, these artists attempted to produce what they saw in Nature and no more; in this way, their works came to be more highly regarded and better understood; and this gave them the courage to establish rules for perspective and to make their foreshortenings exactly like the proper forms of natural relief, while proceeding to observe shadow, light, shading, and other difficult details, and to compose their scenes with greater similitude; and they tried to make their landscapes more similar to reality, as well as their trees, grass, flowers, skies, clouds, and other natural phenomena. They did this so well that it can be boldly declared that these arts were not only improved but were brought to the flower of their youth, giving promise of bearing fruits to follow and, in a short while, of reaching their age of perfection.

And now, with God's help, we shall begin the life of Jacopo della Quercia from Siena, and then other architects and sculptors until we reach Masaccio, who was the first to improve design in painting, where we shall show how great a

debt is owed to him for painting's new rebirth. I have selected Jacopo as a worthy beginning for this second part, according to the order of styles,* and I shall proceed to teach in the lives themselves the difficulties presented by the beautiful, exacting, and most venerable arts.

THE END

The Life of Jacopo della Quercia, Sienese Sculptor

[c.1374–1438]

Jacopo was in fact the son of Master Piero di Filippo from La Quercia, a place in the Sienese countryside,* and he was the first sculptor after Andrea Pisano, Orcagna, and the others discussed above, who, by working at sculpture with greater care and diligence, began to show that it was possible to come even closer to Nature, and he was also the first to give to other sculptors the courage and hope that they would be able, in some ways, to equal Nature. The first of his works worthy of notice was done by him in Siena, when he was nineteen years old, under the following circumstances. When the Sienese fielded an army against the Florentines under the command of the two captains Gian Tedesco, the nephew of Saccone da Pietramala, and Giovanni d'Azzo Ubaldini, Giovanni d'Azzo became ill in the field, and after he was taken back to Siena, he died.* The Sienese were greatly sorrowed by his death, and as a result, for his burial services, which were very grand, they had a wooden structure built in the form of a pyramid upon which they placed an equestrian statue of Giovanni himself which was larger than life and sculpted with great judgement and inventiveness by Jacopo's own hand; in the course of his work, Jacopo discovered something which had never before been done—a way of constructing the framework for the horse and the figure of the rider out of pieces of wood and flat planks nailed together, tied up with straw and tow, then bound together very tightly with ropes, and finally covered with a layer of clay mixed with a cement composed of linen cloth, paste, and glue. This method was and still is the best actual means, among all the others available, for constructing such things, because, with such structures, although they

appear heavy, they nevertheless turn out to be light once they are completed and dried, and when painted white, they resemble marble and are very pleasing to the eye, much as was this work by Jacopo. In addition, statues executed in this fashion with the same combination of materials do not develop cracks, as they would if they were made only with pure clay. And today the models for sculpture are produced in this way with the greatest possible convenience for the artists, who, by means of such models, always have an example in front of them as well as the proper measurements for the sculpture they are creating. Thus, they should be under no small obligation to Jacopo, who was, as people claim, the inventor of the method. After this statue, Jacopo also created in Siena two lime-wood panels, carving upon them figures, beards, and hair with such patience that they were a marvel to behold. And after these panels, which were placed in the Duomo, he completed some marble prophets of moderate size which stand upon the façade of the same Duomo. He would have continued to work upon this project if the plague, famine, and civil discord among the Sienese had not started too many riots and finally driven out Orlando Malavolti,* through whose favour Jacopo was honourably employed in his native city.

Jacopo therefore left Siena, and through the efforts of several friends, he went to Lucca and to Paolo Guinigi, who was the city's ruler, and for Guinigi's wife, who had died recently, he built a tomb in the Church of San Martino. On its base, Jacopo executed some marble putti holding up a garland, who are so beautifully finished they seem to be of flesh and blood, while on the sarcophagus placed on top of the base, he created, with infinite care, the image of Paolo Guinigi's wife who was buried inside, and at her feet, in the same stone, he carved a dog in full relief, representing the fidelity she had shown her husband. After Paolo left Lucca, or, rather, was driven out, in the year 1429, the city was freed, and the sarcophagus was removed from this location and almost completely ruined, because of the hatred the people of Lucca felt toward the memory of the Guinigi.* Yet, the reverence which they felt for the beauty of the figure and for its many

decorations restrained them and caused them shortly there-
after to place the sarcophagus and the figure with great care
before the entrance into the sacristy, where they now stand,
and the Guinigi Chapel became the property of the com-
munity.

Meanwhile, Jacopo had learned that in Florence, the Arte
della Calimala* wished to have executed in bronze one of the
doors of the temple of San Giovanni, where Andrea Pisano
had completed the first, as we said earlier.* Jacopo went to
Florence to introduce himself, taking fully into consideration
the fact that this commission was to be given to the artist who
would prove his worth and his talent by fashioning a single
one of these narrative scenes in bronze.

Hence, after Jacopo came to Florence, he not only made
the model but completely finished and polished a very well-
conceived narrative scene, which pleased everyone so much
that if his competitors had not been the most excellent
Donatello and Filippo Brunelleschi, who in truth surpassed
Jacopo with their own models, he would have been selected
to undertake that very important work. But since the affair
turned out otherwise,* Jacopo went to Bologna where, with
the support of Giovanni Bentivoglio, the trustees of the
Works Department of San Petronio gave him the project of
constructing the main door of that church, which he then
proceeded to decorate in the German manner to avoid chang-
ing the style in which the building had already been started; he
filled the empty spaces between the pillars supporting the
cornice and the arch with lovingly worked narrative scenes in
the space of the twelve years he spent on this project, and he
himself created all the foliage and decoration on this same
door with the greatest possible care and study. On the pillars
which support the architrave, cornice, and arch, there are five
scenes per pillar and five scenes on the architrave, making a
total of fifteen scenes. In all of them he carved in bas-relief
scenes from the Old Testament—that is, from God's creation
of man down to the Flood and Noah's Ark—making a
tremendous improvement in the art of sculpture, since from
antiquity until the present, no artisans had ever existed who
had produced anything in bas-relief, with the result that this

method of sculpture had been completely lost rather than merely misplaced.

Upon the arch of this door he carved three life-size marble figures all in full relief, namely, a very beautiful Madonna with the Child in Her arms, Saint Petronius, and another saint,* all well arranged in beautiful poses. As a result, the people of Bologna, who thought it impossible to create a work in marble equal to, much less better than, the one executed by Agostino and Agnolo of Siena in the old style for the high altar of San Francesco in their city, discovered they were mistaken when they saw this work, which was far more beautiful. After this, as Jacopo had been requested to return to Lucca, he went there most willingly, and in San Frediano, for Federigo di Maestro Trenta del Veglia, he carved upon a marble panel a Virgin with Her son in Her arms, Saint Sebastian, Saint Lucy, Saint Jerome, and Saint Sigismund with good style, grace, and composition, and below upon the predella in half relief, under each saint, he placed scenes from his or her life, which were very lovely and pleasing, since Jacopo had used great skill in making the figures recede on various planes and in reducing in size those which were furthest away. In this way, he greatly encouraged others to acquire grace and beauty for their own works with new methods, carving in bas-relief upon two large tombstones lifelike portraits of Federigo, the donor of the work, and his wife. On these stones are these words: 'Jacopo Master Sculptor of Siena created this work in 1422.'

When Jacopo then came to Florence, the trustees of the Works Department of Santa Maria del Fiore, on the basis of the good reports they had received about him, gave him the project of making a marble frontispiece which is over the door of that church leading towards the Nunziata; and there he represented in a mandorla the Virgin who is being carried towards Heaven by a choir of angels, who are playing and singing with the most beautiful movements and in the most beautiful poses, so that it looked as if there were motion and boldness in their flight, something that had never been seen up to that time.* Similarly, the Virgin is clothed with so much grace and modesty that She could not be depicted any

better, since the folds of the draperies are beautiful and soft, and it looks as if the borders of Her garments, which conform to the body of the figure, disclose even as they cover every turn of the limbs. Under this Madonna there is a Saint Thomas receiving Her girdle.* In short, all this work was completed by Jacopo in four years at that higher level of perfection he had attained, for besides his natural desire to do well, the rivalry with Donatello, Filippo Brunelleschi, and Lorenzo Ghiberti, some of whose highly praised works had already appeared, spurred him on even more to complete what he was undertaking. The results were so excellent that even today this work is regarded by modern artists as something most rare. On the other side of the Virgin, facing Saint Thomas, Jacopo carved a bear climbing up a pear tree. Just as many things were said at that time about this whimsical creation, so we could add some others, but I will remain silent in order to leave everyone free to think or believe whatever he pleases about this invention.

After this, since Jacopo wished to see his native city again, he went back to Siena, and after he had arrived there, he seized the opportunity, following his intention, of leaving behind something that would honour his memory. And since the Signoria of Siena had determined to construct an extremely rich ornament in marble for the water which Agnolo and Agostino of Siena had brought into the piazza in the year 1343, they comissioned Jacopo to undertake this work for the price of two thousand, two hundred gold *scudi*, whereupon he created a model and had the marble brought in, set to work, and finished sculpting it to the great satisfaction of his fellow citizens, who no longer called him Jacopo della Quercia but, from then on, always Jacopo della Fonte.* In the centre of this work he carved the Virgin Mary in glory, the special protectress of the city, somewhat larger than the other figures and with a graceful and original style. Then around Her he carved the Seven Theological Virtues, whose delicate and pleasing heads he created with beautiful expressions and certain techniques, showing that he had begun to discover good style. Overcoming the difficulties of the art and bestowing grace upon the marble, he abandoned the old style which until

that time had been employed by sculptors, who created their figures as a whole and without the slightest grace, in contrast to Jacopo who created his figures with a softness and a flesh-like quality and finished his marble with patience and delicacy. In addition, he carved a number of narrative scenes from the Old Testament—namely, the creation of our first parents and the eating of the forbidden apple—where in the figure of the woman we can see a facial expression so beautiful, as well as a grace and pose that is so reverent towards Adam as she hands him the apple, that it does not appear possible for him to refuse her. Besides this, the rest of the work is filled with extremely beautiful inventions and embellished with the most beautiful little children and other decorations of lions and wolves, which were emblems of the city; and all of it was executed by Jacopo with loving attention, skill, and judgement in the space of twelve years. Also by his hand are three very beautiful bronze narrative scenes in half relief from the life of Saint John the Baptist, which are placed around the Baptistery of San Giovanni below the Duomo, as well as some other bronze figures an armslength high and also in full relief, placed between the above-mentioned scenes, which are truly beautiful and worthy of praise.* Because of the excellence of these works, as well as the goodness and orderliness of his life, Jacopo deserved to be made a knight by the Signoria, and not long afterwards, a trustee of the Works Department of the Duomo. He performed his duties so well that the building was never managed any better before or since, even though he lived only three years after he received the office, and he made many useful and valuable repairs. And even if Jacopo was only a sculptor, he nevertheless designed reasonably well, as is shown by some of his drawings which are contained in our book and appear to have come from the hand of a miniaturist rather than that of a sculptor. And I received his portrait, which can be seen above,* from Master Domenico Beccafumi, the Sienese painter, who recounted to me many details about the talent, goodness, and kindness of Jacopo who, worn out by his labours and continuous work, died at last at the age of sixty-four and was mourned and honourably buried in his native city of Siena not only by his friends and relatives but

also by the whole city. And to tell the truth, he was most fortunate that his great skill was recognized in his native city, for it rarely occurs that men of ability are universally loved and honoured in their native lands. . . .*

THE END OF THE LIFE OF JACOPO, SIENESE SCULPTOR

GIACOPO DELLA QUERCIA

so by the whole city. And to tell the truth, he was most
fortunate, that his great skill was recognized in his own lifetime
for it rarely occurs that men of ability are universally loved
and h...

THE END OF THE LIFE OF JACOPO
SIENESE SCULPTOR

The Life of Luca della Robbia, Sculptor
[c.1400–1482]

Luca della Robbia, the Florentine sculptor, was born in the
year 1388,* in the home of his ancestors which stands under
the church of San Bernaba in Florence, and he was well
brought-up so that he not only learned to read and write, but
also to keep accounts whenever necessary, following the
custom of most Florentines. And afterwards he was sent by his
father to learn the goldsmith's trade from Leonardo di Ser
Giovanni,* who was then considered the most skilful master
of that profession in Florence. Under his direction, therefore,
Luca learned how to design and to work in wax, and as his
confidence increased, he began to make objects in marble and
bronze, and because these objects turned out very well indeed,
he devoted himself so completely to sculpture, altogether
abandoning the goldsmith's craft, that he did nothing else but
chisel all day long and sketch at night. And he did this with
such zeal that on many occasions at night when his feet
became cold, in order not to leave his sketching, he would
warm them up by placing them in a basket of wood shav-
ings—that is, the kinds of shavings carpenters remove from
boards when they work them with a plane. I am not in the
least surprised by this, since no one ever becomes excellent in
any profession whatsoever unless he learns while still a boy to
endure heat, cold, hunger, thirst, and other discomforts; those
people, therefore, who think it is possible to attain an
honourable rank with all the comforts and conveniences in the
world are sadly mistaken: it is achieved by staying up late and
working constantly, not by sleeping!

Luca was barely fifteen years old when, along with other
young sculptors, he was brought to Rimini to carve some
figures and other decorations in marble for Sigismondo di

LUCA DELLA ROBBIA 67

Pandolfo Malatesta, the ruler of that city, who at that time had
built a chapel in the church of San Francisco and a tomb for
his dead wife.* In this work, Luca proved his skill in several
bas-reliefs that can still be seen today, before he was recalled to
Florence by the trustees of the Works Department of Santa
Maria del Fiore, where, following Giotto's design, he carved
five scenes in marble for their bell tower on the side facing the
church which had been left unfinished, right beside the scenes
of the sciences and the arts already executed, as I mentioned
earlier, by Andrea Pisano.* In the first, Luca carved Donatus,
who is teaching grammar; in the second, Plato and Aristotle
for philosophy; in the third, a man playing a lute for music;*
in the fourth, Ptolemy for astrology; and in the fifth, Euclid
for geometry. In their finish, grace, and design, these scenes
surpassed in good measure those completed by Giotto who, as
I have said, depicted Apelles with his brush for painting and
Phidias carving with his chisel for sculpture. Because of this, in
the year 1405, the trustees, who were persuaded not only by
Luca's merits but also by Messer Vieri de' Medici, then a very
prominent and popular citizen who greatly admired Luca,
gave Luca the project of designing the marble decoration for
the organ which was being constructed on a gigantic scale and
was to be placed above the door of the sacristy of this same
church.* In the base of this work, Luca carved a number of
scenes with musical choirs singing in various ways; and he put
so much effort into this work and it came out so well that
even though it was sixteen armslengths high, the singers'
throats swelling, the musical director beating his hands on the
shoulders of the younger singers, and, in short, various ways
of playing, singing, dancing, and other delightful actions
which produce the pleasure of music can be seen. Then, above
the framework of this decoration, Luca created two figures of
gilded metal—that is, two nude angels—which were so well
finished, just like the rest of the work, that they were con-
sidered rare indeed. None the less, Donatello, who later carved
the decoration for the other organ facing Luca's, completed
his work with much more judgement and skill than Luca had
employed (as will be discussed in the proper place), by
executing that work in an almost entirely rough-hewn and

unpolished form, so that from a distance it would look better
than Luca's (as it does). Although Luca's work was done with
excellent design and care, its fine polish and finish none the less
cause the eye to lose sight of it at a distance, where it cannot
be seen as well as Donatello's work, which is sometimes only
roughed out.

Artists should pay close attention to this, since experience
makes it clear that from a distance all things—whether paint-
ing, sculpture, or any other similar thing—have greater
boldness and force if they are well roughed out rather than
well finished; because of the effects of distance, it also often
seems that rough sketches, which are created in an instant of
artistic frenzy, express the idea behind them in a few strokes,
whereas on the other hand, great effort and too much
diligence may sometimes diminish the power and knowledge
of those who never know when to pull their hands away from
the works they are creating. And anyone who knows that the
arts of design (to avoid speaking only of painting) are akin to
poetry also knows that just as poems dictated during a poetic
frenzy are the truest, the finest, and the best when compared
to those produced with great effort, so the works of men who
excel in arts of design are best when they are created by a
single stroke from the force of this frenzy rather than when
they are produced little by little according to the inspiration of
the moment with great effort and labour. The artist who from
the very beginning has, as he should, a conception of what he
desires to create, always moves resolutely towards perfection
with the greatest ease. Nevertheless, since all talents are not of
the same stamp, there are some artisans, though they are rare,
who do not do well unless they work slowly. And to make no
mention of painters, it is said that among poets, the most
reverend and learned Bembo* sometimes works many months
and even years in writing a sonnet, if we can believe those
who affirm this; thus, it is no great surprise that this sometimes
occurs with some of the men in our own arts. But for the
most part the contrary is the rule, as we said above. In the
same way, the vulgar prefer a certain external and obvious
delicacy, in which diligence conceals the lack of essential
qualities, to a work of good quality completed with reason

and judgement but not so polished and smooth on the out-
side.*

But, to return to Luca, after he had completed this work,
which was very pleasing, he was commissioned to do the
bronze door of the same sacristy,* which he divided into ten
panels—that is, five on each side—placing a man's head in the
decoration of each corner panel. He varied each head, making
some young, others old, still others middle-aged; some were
bearded, while others were clean-shaven, but, basically, they
were in different ways all handsome for their type, and the
framework of this work was, as a result, very ornate indeed. In
the scenes for the panels, beginning from the top, Luca then
made an exquisitely beautiful Madonna with Her son in Her
arms on one side, and on the other, a figure of Jesus Christ
coming out of the tomb. Under these two panels in each of
the first four panels, there is a figure—one of the Evan-
gelists—and under them the Four Doctors of the Church, who
are writing in various poses. And all this work is so precise and
polished that it is a marvel, and it makes clear the fact that
Luca profited a great deal from having been a goldsmith. But
after completing these works, Luca had calculated how much
time he had spent in finishing them and how little he had
earned from them, and he knew just how little profit he
derived from them and how much labour had gone into
them; thus he made up his mind to abandon marble and
bronze and to see if he might gain more from other methods.
When he realized that clay could be worked more easily and
with less strain and that he only lacked a means of preserving
works created with clay over a long period, he followed his
inspiration so that he eventually found a method of protecting
these works from the ravages of time. Hence, after experi-
menting with many materials, he discovered that by coating
them with a glaze composed of tin, lead oxide, antimony, and
other minerals and compounds, which was baked in the fire of
a special furnace, he produced a very handsome effect and
created earthen works that were almost imperishable. For
this technique, of which Luca was the inventor, he received
great praise and all the centuries that followed him are in his
debt.*

Having succeeded, then, in discovering exactly what he was
looking for, he wanted his first works to be those which are in
the arch above the bronze door he had made for the sacristy
under the organ of Santa Maria del Fiore; he created a
Resurrection of Christ which was so beautiful that it was
admired as a truly unique work when it was installed there.
This prompted the same trustees to ask Luca to fill the arch
above the other sacristy, where Donatello had decorated the
organ, in the same style with similar figures and works in
terracotta, and there Luca created a very beautiful Christ
ascending to Heaven.

Now this beautiful technique of his, which was so pleasing
and useful, most especially for locations where there is water
and can be no paintings because of the humidity or something
else, did not satisfy Luca, and he set about trying to improve
it. Although at first he had completed clay works only in
white, he added to his technique the means of rendering them
in colours, to the boundless amazement and delight of every-
one. Among the first to have Luca create works in coloured
clay was the Magnificent Piero di Cosimo de' Medici, who
asked him to cover with various fanciful decorations in half
relief both the vaulting and floor of a study in the palace built
by his father Cosimo (as I shall later discuss), which was
unique and very useful in the summer. It is certainly a won-
der that although the technique was extremely difficult and
required great caution in baking the clay, Luca brought these
works to such a level of perfection that both the vaulting and
the floor seem to be made of a single piece rather than of
many. After the fame of these works spread not only all over
Italy but throughout Europe as well, there were so many
people who requested them that the Florentine merchants
sent them all over the world and kept Luca working con-
stantly, to his great profit. And because he alone could not
meet the demands, he took his brothers Ottaviano and
Agostino away from their chisels and set them to doing this
kind of work, in which they earned, together with him, a
great deal more than they had ever earned from their chisels.
And besides the works they sent to France and Spain, they did
many things in Tuscany and particularly at the Church of San

Miniato al Monte for Piero de' Medici, where they created extremely beautiful octagonal ornaments for the vaulting of the marble chapel which rests upon four columns in the middle of the church. But the most memorable work of this kind which came from their hands was the vaulting of the Chapel of San Jacopo in the same church where the Cardinal of Portugal is buried.* Even though the chapel has no lateral surfaces, they placed at its corners four round tondos containing the Four Evangelists and in the middle of the vault the Holy Spirit in a tondo, filling the empty spaces with tiles which wind around the vault and gradually diminish towards the centre in such a way that it is impossible to see better work of this kind or to see anything assembled and built with more care. Then in a little arch above the door of the church of San Piero Buon Consiglio, which is below the Old Market, Luca placed Our Lady surrounded by some lively angels, while over the door of a little church near the church of San Piero Maggiore, in a tondo, he placed another Madonna and some angels considered to be very beautiful. And also in the chapter house of Santa Croce. built by the Pazzi family under the direction of Filippo di Ser Brunellesco, Luca did all the glazed figures seen there, both inside and outside. And it is said that Luca sent to the king in Spain some very beautiful figures in full relief along with some works in marble. In Florence he also created for Naples, with the assistance of his brother Agostino, the marble tomb for the infant brother of the Duke of Calabria, along with many glazed ornaments.

After these projects, Luca sought to discover a method of painting figures and scenes on a flat surface in terracotta in order to give more life to his paintings, and he experimented with this on a tondo, which he placed above the tabernacle of the four saints on the side of Orsanmichele; on its flat surfaces, he represented in five places the tools and insignia of the Builders' guilds with extremely beautiful decorations. He made two other tondos in relief for the same location, one of Our Lady for the Apothecaries' Guild and another for the Merchants' Guild with a lily above a bale [of wool] surrounded by a garland of flowers and leaves of various types, so well designed that they seem real and not made of

coloured terracotta. Then, for Messer Benozzo Federighi, Bishop of Fiesole, in the church of San Brancazio, he built a marble tomb with this same Federigo lying upon it, sculpted from life, and three other half-length figures. In decorating the pillars of this work, he painted on a flat surface some garlands with clusters of fruit and leaves so lifelike and natural that they could not be better rendered on a panel with brush and oil; and indeed, this work is marvellous and quite unique, since in it Luca created the lights and shadows so well that it hardly seems possible to have done so from the fire.*

And if this artisan had lived longer than he did, we would have seen even greater works issue forth from his hands, because shortly before he died, he had begun to create scenes and painted figures upon flat surfaces, some of which I saw in his home and which make me believe that he would have easily succeeded with them had not death, which almost always carries off the best of men when they are about to make some improvement in the world, deprived him of life before his time. . . .*

If I have gone into more detail on this subject than perhaps seems necessary, I trust everyone will excuse me, but since Luca discovered these new kinds of sculpture which the ancient Romans, as far as we know, did not possess, it was necessary for me to speak of them at length as I did. And if, after narrating the life of the elder Luca, I have more briefly recounted some details about his descendants who lived down to our own times, I have done so in order not to have to return to this material again. Thus Luca, passing from one kind of work to another, and from marble to bronze and from bronze to clay, did so not because of laziness or because, as many others are, he was capricious, unstable, or discontented with his craft, but rather because he felt himself drawn by Nature to new techniques and by his need for a kind of work, according to his taste, which would be less fatiguing and more profitable. Thus the world and the arts of design were enriched by a new art, both useful and very beautiful, while he earned for himself glory and perpetual and immortal praise. Luca was a very good and graceful draughtsman, as is evident in some pages from our book, highlighted with white lead. In

one of them there is his portrait done by his own hand with
great care as he was looking at himself in a mirror.

HERE ENDS THE LIFE OF LUCA DELLA ROBBIA, SCULPTOR

The Life of Paolo Uccello, Florentine Painter*
[1397–1475]

Paolo Uccello would have been the most delightful and in-
ventive genius in the history of painting from Giotto's day to
the present, if he had spent as much time working on human
figures and animals as he lost on problems of perspective; for
although these things are ingenious and beautiful, anyone
whose pursuit of them is excessive wastes hour after hour,
exhausts his native abilities, and fills his mind with difficulties,
quite often turning a fertile and effortless talent into one that is
sterile and overworked; and anyone who pays more attention
to perspective than to human figures achieves an arid style
full of profiles, produced by the desire to examine things in
minute detail. Besides this, such a person frequently becomes
solitary, eccentric, melancholy, and impoverished like Paolo
Uccello who, endowed by Nature with a meticulous and
subtle mind, took pleasure only in the investigation of certain
problems of perspective which were difficult or impossible,
and which, however original and vexing, nevertheless hin-
dered him so much in painting figures that as he grew older,
he grew even worse. There is no doubt that anyone who
does violence to his nature with fanatical study may well
sharpen one corner of his mind, but nothing that he creates
will ever appear to have been done with the natural ease and
grace of those who place each brush-stroke in its proper place
and, with moderation, considerable intelligence, and good
judgement, avoid certain subtleties which soon encumber their
works with an overworked, difficult, arid, and ill-conceived
style which more readily moves those who observe them to
compassion than to wonder. Since an artist's talent can be
exercised only when his intelligence has this desire to operate
and his artistic inspiration is aroused, only then can his

splendid, divine powers and marvellous conceptions issue forth.

Paolo, then, without ever pausing for a moment, was always pursuing the most difficult aspects of art, so that he perfected the method of drawing perspectives from the ground-plans of houses and the profiles of buildings all the way up to the summits of their cornices and roofs by way of intersecting lines, by foreshortening and diminishing them at the centre after having first fixed the point of view he desired, either high or low on the plane. And in short, he worked so diligently upon these difficulties that he introduced a method and rules for placing figures firmly upon planes where they stand, while foreshortening them little by little and making them recede and diminish in proportion, something which had previously been done only in a haphazard way. Similarly, he discovered a method of designing the intersections and arches of vaults, of foreshortening floors by the length of the receding beams, and of painting rounded columns in such a way that in a sharp corner angle on the wall of a house, they would bend, and, drawn in perspective, they would break up the corner angle in a straight line.

Because of his interests, he was reduced to living alone inside his home with few conveniences, as if in the wild, for weeks and months without allowing himself to be seen. And although these matters were challenging and vexing, if he had spent that time in studying figures, which he drew with a rather good sense of design, he would eventually have brought them to perfection. But by wasting all his time on these notions, he found himself during the course of his life more impoverished than renowned. Thus, when Paolo showed his close friend, Donatello the sculptor, the *mazzocchi** with their points and sides drawn in perspective from a variety of viewpoints, and spheres with seventy-two facets in the shape of diamonds with wood chips twisted around the rods in each facet, as well as other oddities that consumed and wasted his time, Donatello would often say: 'Ah Paolo, this perspective of yours makes you abandon the certain for the uncertain: these things are of no use except to artists who work in intarsio,* where they fill their decorations with wood

chips and round or square spirals and other such details.'

Paolo's first paintings were done in fresco in an oblong niche painted in perspective at the Hospital of Lelmo: that is, a picture of Saint Anthony the Abbot standing between Saints Cosmas and Damian. At Annalena (a convent), he did two figures; and in Santa Trìnita, upon the left door inside the church, he painted in fresco scenes from the life of Saint Francis: that is, the Saint receiving the stigmata; protecting the Church which he carries on his shoulders; and conferring with Saint Dominic.* He then worked in Santa Maria Maggiore on a chapel next to the side door leading to San Giovanni, where the panel and predella of Masaccio* stands, painting in fresco an Annunciation in which he created a house worthy of consideration—an original and difficult achievement in those times, since it was the first work in good style which showed artists how lines could be made to recede in perspective with grace and proportion; how a restricted and tiny space on a flat surface might appear to be distant and vast; and how those who know how to do this with judgement and grace, using colour to add shadows and light in the proper places, create an illusion for the eye making the painting seem as if it were real and in full relief. And this was not enough for Paolo, who also wanted to display even greater difficulties in some columns foreshortened by means of perspective, which bend around and break the sharp angle of the vaulting where the Four Evangelists are found. This was considered to be a beautiful and difficult achievement, and in truth, Paolo displayed great ingenuity and talent in his profession.

Paolo also worked in a cloister at San Miniato, outside of Florence, painting the lives of the Church Fathers partly in *terra verde** and partly in colour. In these works Paolo did not consistently follow the practice of employing a single colour as must be done in painting scenes, for he painted the fields blue, the cities a red colour, and the buildings whatever colour struck his fancy, and in doing so he committed an error, because things that appear to be made from stone cannot and should not be tinted with another colour. It is said that while Paolo was working upon this painting, an abbot who was then living in that cloister gave him nothing but cheese to eat.

And when this began to annoy him, since he was a timid man, Paolo resolved not to return to work there; thus, whenever the abbot sent someone to look for him, and Paolo heard that the monks were asking for him, he avoided being at home, and if he happened to meet any of the members of this order around Florence, Paolo would run away from them as fast as he could. One day, two of them who were more curious and younger than Paolo* caught up with him and asked why he had not returned to complete the work he had begun and why he ran away whenever he caught sight of a monk. To this Paolo responded: 'You have ruined me so that not only do I run away from you, but I can't associate with the carpenters or even pass by where they are at work, and all of this is the result of your abbot's lack of discretion, for between his pies and soups that are always made with cheese, he's stuffed me with so much cheese that since I am already made of nothing but cheese, I'm afraid they'll use me for putty; and if I go on like this, I won't any longer be Paolo but Cheese!' After the monks left Paolo, roaring with laughter, they explained all this to the abbot, who had Paolo brought back to work and ordered something else for his meals besides cheese.

Afterwards, Paolo painted the altarpiece of Saints Cosmas and Damian for the chapel of San Girolamo de' Pugliesi in the Carmine Church. In the house of the Medici, he painted in tempera on canvas a number of scenes of animals, which always delighted him, and in order to do them well he studied them very carefully; and what is more, he always kept around his home paintings of birds, cats, dogs, and every kind of strange animal for which he could obtain a drawing, since his poverty prevented him from keeping live animals. And because he loved birds most of all, he was given the nickname of Paolo Uccello [Paolo of the Birds]. And in this same house, among the various scenes of animals, he painted some lions fighting among themselves, with such frightful movements and ferocity that they seemed alive. But among the other rare things he did was a scene in which a serpent, doing battle with a lion, shows, with vigorous movements, its ferocity and the poison which it spits from its mouth and eyes, while a nearby peasant girl keeping watch over an ox is painted with the most

beautiful foreshortening. The drawing for this painting, in
Paolo's own hand, is in our book of drawings, as is another
similar one showing the peasant girl, fearful and in flight,
running away from these animals. The same drawing also
contains some very lifelike shepherds and a landscape con-
sidered very beautiful in its day. And in other canvases, Paolo
painted several scenes of soldiers of the period on horseback in
review, with a number of portraits drawn from life.*

Paolo was then commissioned to paint some scenes in the
cloister of Santa Maria Novella.* The first of these is located at
the entrance from the church into the cloister: the Creation of
the Animals, with a varied and infinite number of creatures
from the earth, the waters, and the skies. And because Paolo
was extremely creative and, as we have mentioned, he greatly
delighted in drawing animals well, he represented in several
lions about to attack each other the degree of pride they
possess, as well as the swiftness and the fear of a number of
stags and deer; in addition, he also painted birds and fish with
very realistic feathers and scales. He painted the Creation of
Man and Woman and their sin with a beautiful style, carefully
wrought and well executed. And in this same work, he took
great delight in the colouring of the trees, which at that time
was not normally done very well; he was thus the first painter
who won renown among the older painters for his landscapes,
which he worked on and brought to greater perfection than
had any other painter before him. None the less, there were
those who came afterwards who produced more perfect ones,
because despite all his efforts, Paolo was never able to give his
works that softness or harmony which has been bestowed
upon works in our own times by colouring them with oil. But
it is notable that Paolo used the rules of perspective to
foreshorten and draw things exactly as they were, painting
everything that he saw—that is, ploughed fields, ditches, and
other details from Nature in that dry, sharp style of his—and
if he had selected the best of these details and had placed in his
work only those parts which come out well in painting, they
would have been completely perfect.

Once he had completed this project, he worked in the same
cloister, using two scenes designed by other artists. And lower

down, he painted the Flood with Noah's Ark, and in this scene, he rendered the dead bodies, the storm at sea, the fury of the winds, the flashes of lightning, the uprooting of trees, and the terror of the men with such great pains, artistry, and diligence that it can hardly be described. And in perspective, he painted a foreshortened dead body with a crow pecking out its eyes, and a drowned child whose body, bloated with water, forms a large arch. He also depicted in this work a variety of human emotions; for example, two men who are fighting on horseback with little fear of the water, or a man and a woman who are riding on an ox with an extreme fear of death, for as its hindquarters are being covered with water, they both despair of saving themselves. This entire work was of such a special quality and excellence that it acquired Paolo great fame. As usual, he diminished his figures by means of lines in perspective, and he painted *mazzocchi* and other things in this work which are certainly very beautiful.

Under this scene he then painted the Drunkenness of Noah along with the scorn of Ham, his son (for whom he used the portrait of his friend Dello, a Florentine painter and sculptor), and he showed Noah's other two sons, Shem and Japheth, who cover him up, revealing to him his shame. Similarly, he painted in perspective a wine-cask curving around on every side, which was considered very beautiful, as well as a trellis full of grapes, whose lattice-work of squared timbers diminishes towards a vanishing point. But here Paolo made a mistake, for the diminishing lines on the lower plane, where the feet of the figures are placed, go along the lines of the trellis, and those of the wine-cask do not follow the same receding lines. I am truly astonished that such an accurate and careful painter could make such an obvious mistake. He also painted the Sacrifice of Noah, with the open ark drawn in perspective with the groups of perches in the upper part divided in regular rows where the birds who were accommodated there are flying away in flocks more properly foreshortened. In the air above the sacrifice which Noah and his sons offer appears God the Father; and of all the figures Paolo drew in this work this one is the most difficult, for God is flying towards the wall with His head foreshortened, and He

possesses such force that His figure in relief seems to be
bursting it open and forcing its way through. Besides this,
Noah is surrounded by countless types of beautiful animals. In
short, Paolo imparted to this work such softness and grace that
it is without question superior to and better than all his other
works, and as a result he won great praise for it not only then
but in the present day.

In Santa Maria del Fiore, Paolo painted in commemoration
of the Englishman Giovanni Acuto,* the Florentine com-
mander, who died in the year 1393, a horse in *terra verde*.
Considered a very fine work, and being of extraordinary size,
it showed the image of the commander on the horse in
chiaroscuro with the colouring of *terra verde*, and was placed
within a frame ten armslengths high in the middle of one wall
of the church. There Paolo drew in perspective a large
sarcophagus, as if the body were inside, and above it he placed
the image of the man in his commander's armour astride a
horse. This work was and is still considered to be a most
beautiful painting of this type, and if Paolo had not repres-
ented the horse as moving his legs on only one side—some-
thing horses cannot naturally do, since they would fall—this
work would have been perfect, because the proportions of
that horse, which is huge, are quite beautiful. (Perhaps he
made this error because he was unaccustomed to riding on
horseback, nor was he as familiar with horses as with other
animals.) On the pedestal is the inscription: 'PAVLI VCCELLI
OPVS.'

At the same time and in the same church, Paolo painted in
colour the clock-face over the main door inside the church,
with four heads in the corners coloured in fresco. Then, in
terra verde, he also worked upon the loggia which faces west
overlooking the garden of the Monastery of the Angeli,
placing under each of the arches a scene from the works of
Saint Benedict the Abbot, including the most notable events
from his life up to his death. Among the many beautiful things
in this work, there is one in which a monastery is destroyed by
the work of a demon, with a dead monk lying under its stones
and beams. No less remarkable is the fear shown by another
monk, whose garments gracefully flutter around his naked

body as he swings around. This aroused the inspiration of other artists in such a way that they have always imitated this stylistic device. And just as beautiful is the figure of Saint Benedict where, with dignity and piety in the presence of his monks, he revives the dead friar. Finally, there are elements in all these scenes that should be examined, and especially in certain places where they are drawn in perspective up to the tiles and gutters of the roof. And in the scene of Saint Benedict's death, while his monks perform the funeral services and mourn him, some sick and decrepit people who have come to view the saint are drawn most beautifully. And furthermore, among the many loving and devout followers of this saint, there is an old monk with crutches under his arms who expresses a wonderful emotion and, perhaps, the hope of regaining his health. In this work, there are no coloured landscapes, nor many houses or difficult perspectives, but it displays excellent design and some very good work. In many Florentine homes, a number of pictures in perspective painted by Paolo's hand are used for decorating the sides of couches, beds, and other small things; and particularly in Gualfonda, upon a terrace in the garden that used to belong to the Bartolini family, there are four scenes painted on wood by his hand which are full of battle scenes—that is, horses and armed men, fitted out in the beautiful manner of those times; and among the men are portraits of Paolo Orsini, Ottobuono da Parma, Luca da Canale, and Carlo Malatesta, the ruler of Rimini, all military commanders of the period. And since these paintings had been damaged and were deteriorating, they were restored in our own day by Giuliano Bugiardini,* who did them more harm than good.

When he was working there Donatello brought Paolo to Padua, where he painted over the entrance to the home of the Vitali family some giants in *terra verde*, which—according to what I have discovered in a Latin letter written by Girolamo Campagnola to Messer Leonico Tomeo, the philosopher—were so beautiful that Andrea Mantegna held them in highest esteem.* Paolo did the vaulting for the Peruzzi home in fresco with triangular sections in perspective, and in the corner panels he painted the four elements, and in each one he placed

an appropriate animal: a mole for the earth, a fish for water, a salamander for fire, and a chameleon (which lives on air and takes on every colour) for the air. And since he had never seen a chameleon before, he painted a camel which opens its mouth and swallows air, filling its stomach with it; he certainly showed great simplicity in referring with the word 'camel' to an animal more like a green lizard, all dry and small, while depicting a large and ungainly beast.*

Paolo's efforts in painting were truly great, and he drew so much that, according to what I have learned myself from them, he left behind for his relatives chests full of designs. But although it is a good thing to sketch designs, it is none the less better to translate them into works of art, since works of art have a longer life than drawings on paper. And in our book of drawings there are a number of sketches of figures, perspectives, birds, and animals—all marvelously beautiful—but the best of all is a *mazzocchio* drawn only in outline, so handsome that nothing but Paolo's patience could have executed it. Even though he was a strange person, Paolo loved skill in his fellow artists, and so that he might preserve their memory for posterity, he drew five distinguished men with his own hand upon a long panel which he kept in his home to honour their memory: one was the painter Giotto, representing the light and beginning of that art; the second was Filippo di Ser Brunellesco for architecture; next came Donatello for sculpture; he himself was fourth for perspective and for animals; and for mathematics he painted his friend Giovanni Manetti, with whom he frequently conferred and discussed the problems of Euclid.*

It is said that when Paolo was assigned the task of painting above the door of the church of San Tommaso in the Old Market a fresco showing this same saint examining the wound in Christ's side, he took the greatest possible pains with this work, declaring that he wished to demonstrate in it how much he was worth and how much he knew. And so he had a screen of planks constructed so that no one could see his work until it was completed. So, one day, Donatello, running into him when he was all by himself, asked him: 'And what kind of work is this that you're keeping hidden like that?' To this

question, Paolo replied: 'You'll just have to wait and see.'
Donatello did not want to press him to say anything more,
expecting that when the time came he would witness, as he
usually did, some miracle. Later one morning when Donatello
was in the Old Market to buy some fruit, he saw Paolo
uncovering his work. Greeting him courteously, Donatello
was asked by Paolo, who was curious to hear Donatello's
opinion, what he thought of this work. After Donatello had
looked over the painting very carefully, he declared: 'Ah,
Paolo, now that it ought to be covered up, you're uncovering
it instead!'

Greatly distressed by this, Paolo felt that his latest effort had
only brought him criticism, rather than the praise he expected,
and as if he had been humiliated, he did not have the courage
to leave his house any longer and closed himself inside,
devoting himself to perspective, which always kept him in
poverty and obscurity until his death. And thus, having
grown very old without deriving much happiness from his
old age, he died in the eighty-third year of his life, in 1432,
and was buried in Santa Maria Novella.*

He left behind a daughter, who knew how to draw, and a
wife, who used to declare that Paolo stayed at his desk all
night, searching for the vanishing points of perspective, and
when she called him to bed, he used to say to her: 'Oh, what a
sweet thing this perspective is!' And in truth, if it was sweet to
him as a result of his work, it was also no less dear and useful
to those artists who employed it after him.

THE END OF THE LIFE OF PAOLO UCCELLO,
PAINTER

The Life of Lorenzo Ghiberti, Sculptor

[c.1381–1455]

There is no doubt that in every city, those individuals whose talents achieve some fame among their fellow men become, in most instances, a holy light of inspiration for many others, both those who are born after them as well as those who live in their own age, and they also receive infinite praise and extraordinary rewards during their own lifetime. There is nothing which more arouses men's minds or causes them to consider less burdensome the discipline of their studies than the prospect of the honour and profit that is later to be derived from the exercise of their talents, for these benefits make difficult undertakings seem easier for everyone, and men's talents grow more quickly when they are exalted by worldly praise. Countless numbers of people, who see and hear others being praised, take great pains in their work to put themselves in a position to earn the rewards they see their compatriots have deserved. Because of this in ancient times, men of talent were either rewarded with riches or honoured with triumphs and statues. But since it rarely happens that talent is not persecuted by envy, it is necessary to do one's utmost to overcome envy through absolute pre-eminence or to become vigorous and powerful in order to endure under such envious attacks. Lorenzo di Cione Ghiberti (also known as Lorenzo di Bartoluccio) knew how to do so very well, thanks to both his merits and his good fortune, for Donatello the sculptor and Filippo Brunelleschi, the architect and sculptor, both superb artists, declared him their equal and recognized him to be a better master in casting than they were themselves, although common sense might have led them to maintain the contrary. This was truly an action that redounded to their glory, but to the confusion of many other presumptuous men who set to

work and seek to usurp the rank earned through the talent of others, and who, after straining for a thousand years to produce a single work without any success, trouble and frustrate the work of others by their malice and envy.

Lorenzo was the son of Bartoluccio Ghiberti,* and from his earliest years he learned the craft of goldsmithing from his father, who was an excellent master and taught him this trade, with which Lorenzo was so taken that he was very much better at it than his father. But he took far greater pleasure in the arts of sculpture and design, and sometimes he used colours or cast small figurines in bronze and finished them with much grace. He also delighted in making copies of the dies of antique medals, and in his time drew portraits of many of his friends. And while he was working with Bartoluccio and seeking to acquire proficiency in his profession, the plague broke out in Florence during the year 1400, according to what he himself recounts in a book he wrote to discuss issues concerning the arts, which is in the possession of the Reverend Messer Cosimo Bartoli, a Florentine gentleman.* In addition to the plague, a number of civil disorders and other troubles arose in the city, and Lorenzo was forced to leave Florence and to accompany another painter into Romagna, where in Rimini* they painted a room for Signor Pandolfo Malatesta as well as many other works which were completed by them with infinite care and to the satisfaction of that lord, who while still a young man took great pleasure in matters of design. In the meanwhile, however, Lorenzo never ceased studying design or working in relief in wax, stucco, and other similar materials, for he realized full well that such ready-made small reliefs are a sculptor's means of drawing designs, and that without these methods it is impossible to bring any work to perfection.

Now Lorenzo had not been away from his native city long when the plague ceased, and the Signoria of Florence along with the Merchants' Guild (seeing that the art of sculpture boasted many excellent craftsmen at that time, both foreign and Florentine), decided that they should build the other two doors of San Giovanni, the oldest church and the principal cathedral in the city, a project they had already discussed

many times previously. And they agreed among themselves to
make it known to all the greatest masters in Italy that they
should come to Florence to compete in producing a bronze
panel, as a sample of their work, similar to one of those
Andrea Pisano had already created for the first door.*
Bartoluccio wrote about this decision to Lorenzo, who was
then working in Pesaro, urging him to return to Florence
to prove his worth, since this was an opportunity to make
himself known and to show his skill, besides the fact that
he would make such a profit from it that neither of them
would ever again have to work on pear-shaped earrings.
Bartoluccio's words stirred Lorenzo's spirit to such an extent
that no matter how great the kindness Signor Pandolfo, his
painter friend, and the entire court showed him, Lorenzo took
his leave from that lord and the painter, who allowed him to
depart with great annoyance and displeasure, their promises
and offers of higher wages working to no avail. To Lorenzo,
every hour's delay in going to Florence seemed an eternity; he
therefore departed happily and went off to his native city.

Many foreigners had already shown up and had presented
themselves to the consuls of the guild, who chose seven
masters from their number—three Florentines and the others
Tuscans—and it was agreed that they would receive a salary
and that within a year each one of them would have com-
pleted, as a sample of their skill, a scene in bronze of the same
size as those in the first door. And they determined that the
artisans would work on the story of Abraham sacrificing Isaac,
his son, a scene in which they thought the masters would have
to demonstrate all the difficulties of their craft, since this story
would include landscapes, nudes, clothed figures, and animals,
and since they could execute the major figures in full relief, the
secondary figures in half relief, and the minor figures in low
relief. The competitors for this work were the Florentines
Filippo di Ser Brunellesco, Donatello, and Lorenzo di Barto-
luccio, as well as Jacopo della Quercia from Siena, Niccolò
d'Arezzo, Jacopo's pupil, Francesco di Valdambrino, and
Simone da Colle, called Simone de' Bronzi.* Before the
consuls, they all promised to deliver their scenes within the
allotted time, and as each artisan set to work, with careful

preparation, he employed every bit of his strength and knowledge to surpass the others, keeping what he was doing a closely guarded secret so that others could not produce anything similar. Only Lorenzo (with the guidance of Bartoluccio, who made him take great pains in producing many models before deciding to use any one of them) continuously brought the townspeople to see them, and sometimes even foreigners who were passing through the city (if they had any understanding of the craft), in order to hear their opinions. This advice was the reason why he executed a model which was very well worked out and which was without any defect whatsoever. And so, when he had made the moulds and cast the work in bronze, it came out extremely well, and then he and his father Bartoluccio polished it up with such love and patience that it could not have been executed or finished any better.

Now, when the time arrived for the scenes to be compared, his panel and those of the other masters that had been completed were handed over for judgement to the Merchants' Guild, since once they had been viewed by all the consuls and by many other townspeople, there existed a diversity of opinion on those works. There were many foreigners in Florence—some painters, others sculptors and goldsmiths—who were summoned by the consuls to render a judgement upon these works, along with others engaged in the profession who actually lived in Florence. They numbered thirty-four people, each one most skilled in his particular trade. And regardless of how many differences of opinion there were among them, some preferring the style of one master and some preferring the style of another, they were nevertheless in agreement that Filippo di Ser Brunellesco and Lorenzo di Bartoluccio had composed and finished their panels better, with a greater number of finely wrought figures than Donatello, even though Donatello had also displayed in his own panel an admirable sense of design.* In the panel by Jacopo della Quercia, the figures were good but they lacked a certain finesse, although they were executed with a sense of design and some care. The work of Francesco di Valdambrino displayed good heads and was well finished, but the

composition was confused. The panel by Simone da Colle was
beautifully cast, since that was his craft, but it was not well
designed. The sample of Niccolò d'Arezzo's work, which was
completed with good skill, contained stunted figures and
was badly polished. Only the scene which Lorenzo offered as
an example of his work, which can still be seen inside the
audience chamber of the Merchants' Guild, was completely
perfect in every detail: the entire work possessed a sense of
design and was beautifully composed; the figures in his style
were lively and gracefully executed in the most beautiful
poses; and the work was finished with such care that it seemed
not cast and polished with iron tools but, rather, created by a
breath. When Donatello and Filippo saw the care Lorenzo
lavished upon his work, they drew off to the side and,
speaking between themselves, decided that the work ought to
be given to Lorenzo, since in their opinion, both the public
good and the private interest would be best served in this way.
And so Lorenzo, still a young man who was not yet past the
age of twenty, would have the opportunity of realizing in the
production of this work the great promise of the beautiful
scene, which, in their judgement, he had executed better than
all the other artisans, and they declared that it would have
been far more malicious to take the work away from him than
it was generous to bestow it upon him.

Thus, Lorenzo began the work on those doors* for the
entrance facing the Office of the Works Department of San
Giovanni by constructing a wooden frame for one part of the
bronze of exactly the right size, without borders but with
decorative heads in the corners of the spaces for the scenes
and friezes surrounding them. Then with the greatest care,
he made and dried the mould in a room he had purchased
opposite Santa Maria Novella (where today, the Hospital of
the Weavers called the Threshing-Floor is located), and he
built an enormous furnace which I remember having seen,
casting the above-mentioned frame in metal. But, as luck
would have it, the casting did not turn out well, and so
without losing his courage or becoming alarmed, he dis-
covered the error and quickly constructed another mould
without anyone else knowing about it; he recast the frame,

and it came out extremely well. He continued in this way
with the rest of the work, casting each scene separately and
putting it in its place when it was polished. And the division of
the scenes was similar to that already employed by Andrea
Pisano in the first set of doors which Giotto designed, contain-
ing twenty stories from the New Testament. At the bottom,
in eight spaces of a similar size following these stories, he
placed the Four Evangelists, two for each door, and then in the
same fashion, the Four Doctors of the Church; these figures
differ in their poses and garments: one is writing, another is
reading, a third thinking, and so forth, while their liveliness
demonstrates how well they were executed. Besides this, in
the frame of the decorations around the scenes, Lorenzo placed
a frieze of ivy and other kinds of foliage which separates them
from each other, while in each corner he placed the head of a
man or a woman in full relief representing the prophets and
sibyls, which are very beautiful and reflect, in their variety, the
genuine quality of Lorenzo's talent. Above the Doctors of the
Church and the Evangelists already mentioned, beginning
from below on the side closest to Santa Maria del Fiore, there
are four pictures: the first contains the Annunciation of Our
Lady, where Lorenzo depicted in the pose of the Virgin a ter-
ror and a sudden fear, as She gracefully turns at the coming of
the angel. And next to this he created the Nativity of Christ
where Our Lady, having given birth, is lying down to rest,
while Joseph contemplates the shepherds and the singing
angels. On the other side of the door, across from this scene
and on the same level follows the scene of the coming of the
Wise Men, their adoration of Christ, and their presentation
of gifts to Him, where their retinue is following them with
horses and other equipment, all of which is executed with
great skill. And next to this scene is Christ's disputation in the
temple with the learned priests, in which the admiration and
attention given to Christ by the priests are no less well
expressed than the joy of Mary and Joseph at finding Him
again. Above these four scenes, beginning over the Annun-
ciation, follows the story of the baptism of Christ by John in
the River Jordan, where, in their actions, the reverence of the
one and the faith of the other can be recognized. Next to this

scene follows the Temptation of Christ by the devil, who is
terrified by Christ's words and strikes a frightened pose, show-
ing in this way that he recognizes Christ to be the Son of God.
On the other side in a corresponding space there is the scene of
Christ driving the moneychangers from the temple, overturn-
ing their money, victims, doves, and other merchandise; in
this scene the figures are falling upon one another in a graceful
sequence that is very beautiful and well thought out. Next to
this Lorenzo continued with the shipwreck of the Apostles,
where Saint Peter begins to sink into the water as he leaves the
boat while Christ holds him up; this scene is filled with the
different gestures of the Apostles working in the boat, while
Saint Peter's faith is made evident by his movement towards
Christ. Beginning again on the other side above the scene of
the Baptism, there is the Transfiguration of Christ on Mount
Tabor, where Lorenzo expressed in the poses of three Apostles
the way in which heavenly visions bedazzle mortal eyes; and
here Christ is recognized in His divinity between Elijah and
Moses with His head held high and His arms outstretched.
And next to this scene is the Raising of Lazarus, who comes
out of the tomb with his hands and feet bound, standing
upright to the astonishment of the onlookers; here Martha and
Mary Magdalene kiss the feet of Our Lord with humility and
great reverence. On the other side of the door across from this
scene follows the one of Christ entering Jerusalem upon an ass,
while the children of the Jews, in various poses, are casting
their clothing upon the ground along with olive branches and
palms, and the Apostles follow the Saviour. And next to this is
the very beautiful and well-composed Last Supper with the
Apostles, depicted at a long table with half of them on one
side and half on the other. Above the scene of the Trans-
figuration begins the Agony in the Garden, with the three
Apostles sleeping in different poses. And next to this follows
the scene in which Christ is arrested and Judas gives him the
kiss, and in which there are many details to consider, such as
the Apostles in flight, or the Jews whose actions and efforts in
capturing Christ are extremely bold. On the other side across
from this scene, Christ is shown bound to the column; His face
is somewhat contorted with the pain of the whipping but His

expression is compassionate, while the Jews who scourge Him display, through their gestures, a rage and a thirst for revenge that are terrible to behold. Next follows the scene in which they lead Christ before Pilate, who washes his hands and condemns Him to the cross. Above the Agony in the Garden and on the other side in the last row of stories is Christ carrying the cross and going to His death, led by a tumultuous band of soldiers in strange poses who are dragging Him along as if by force; besides this, the painful sorrow that the two Maries express in their gestures is so real that eyewitnesses could not have seen it better. Next to this scene, Lorenzo did the Crucifixion of Christ, showing Our Lady and Saint John the Evangelist sitting upon the ground with sorrowful expressions and full of indignation. Then, beside this but on the other side of the door, there is the Resurrection, where the guards have been stunned by the thunder and stand as if they were dead men, while Christ ascends into Heaven in a pose which glorifies Him in the perfection of His beautiful body, all created by Lorenzo's ingenuity. In the last space Lorenzo placed the coming of the Holy Spirit, where the rapt attention and the sweet gestures of those who receive it are evident.

And Lorenzo brought this work to its conclusion and per-fection without sparing any of the time or labour that can be devoted to a work in metal, considering that the bodies of his nude figures are very beautiful, and the garments, while still retaining a little of the old style of Giotto, nevertheless contain something which moves towards the style of modern artists and brings a certain very pleasing grace to figures of that size. And to tell the truth, the composition of each scene is so well ordered and so well arranged that Lorenzo deserved to win the praise—and even more—which Filippo [Brunelleschi] had lavished upon him from the beginning. And as a result, he was recognized by his fellow citizens with great honour, and he was praised highly not only by them but by other artisans, both natives and foreigners alike. This work, with its border decorations ingraved with festoons of fruit and animals all cast in metal, cost twenty-two thousand florins, while the bronze doors themselves weighed thirty-four thousand pounds.

When the doors were completed, the consuls of the

Merchants' Guild felt that they had been very well served, and because of the praise everyone bestowed upon Lorenzo, they decided that Lorenzo should do a bronze statue of some four-and-a-half armslengths in memory of Saint John the Baptist for one of the niches on a pillar outside Orsanmichele which faced the cloth finishers. Lorenzo began this work and never left it until he had brought it to completion; and it was highly praised then and still is today. Upon the saint's mantle, Lorenzo made a frieze for lettering, where he wrote his own name.* In this statue, which was erected in the year 1414, the beginning of good modern style can be seen in the head, in an arm which seems as if it is made of flesh, in the hands, and in the entire pose of the figure. Thus, Lorenzo was the first sculptor who began to imitate the works of the ancient Romans, whom he studied very thoroughly as must anyone who desires to do good work. On the frontispiece of the tabernacle, he attempted to work in mosaic, placing within it the half-length figure of a prophet.

Lorenzo's fame as the most skilled master in casting was already on the rise throughout Italy and abroad, and as a result, after Jacopo della Fonte [della Quercia], Vecchietta from Siena, and Donatello had created for the Signoria of Siena in their own Baptistery of San Giovanni some scenes and figures in bronze which were to decorate the Baptistery of that church,* and the Sienese had seen Lorenzo's works in Florence, they met together and decided to have Lorenzo do two scenes from the life of Saint John the Baptist. In one of them Lorenzo depicted the Baptism of Christ, adding to it many figures, some nude and some very richly clothed, and in the other scene he depicted Saint John who is seized and brought before Herod. In both of these scenes he outdid and surpassed all those who had sculpted the other scenes, and as a result he was highly praised by the Sienese and others who saw them.

In Florence the masters of the Mint had to erect a statue in one of the niches around Orsanmichele, facing the palace of the Wool Guild, and it had to be a Saint Matthew of the same height as that of the Saint John mentioned earlier. Hence, they commissioned Lorenzo to do it, who completed it perfectly,

and it was praised even more highly than his Saint John, since it was done more in the modern style. This statue was the reason why the consuls of the Wool Guild decided that he should cast another statue, also of metal, for another niche next to the one with his Saint John that would be just as tall as the other two statues and would represent Saint Stephen, their patron. Lorenzo completed this work, giving the bronze an extremely beautiful polish. This statue gave no less satisfaction than the other works which he had already completed....*

The excellent works of this most skilful artisan had brought Florence so much renown that the consuls of the Merchants' Guild decided to commission Lorenzo to do the third set of doors, also in metal, for the Baptistery of San Giovanni. And although Lorenzo had followed their directions in executing the first set of doors and had completed this work with decorations surrounding the figures and binding together the frame in a design similar to that of Andrea Pisano, when they saw how far Lorenzo had surpassed Andrea Pisano, the consuls decided to move Andrea's doors, which were in the centre, to the side facing the Misericordia. Lorenzo would then make the new doors for the centre, and they thought he would put all of his great skill and energy into the project because he excelled in that craft. And so they put themselves back in his hands, saying that he had permission to do anything he wished or preferred so that the doors would turn out even more elegant, rich, perfect, and beautiful than he could ever imagine. Nor should he worry about the time or the expenses, so that just as he had surpassed all the other statuary up to that time, he could now outdo and surpass all of his own works.

Lorenzo began this project, putting into it all of the great knowledge at his disposal;* hence, he divided the doors into ten panels, five on each side, so that the spaces containing the scenes would be one-and-one-third armslengths in size, and in the ornamentation of the framework that encloses the scenes, there are vertical niches containing figures almost in full relief, numbering twenty in all, and all very beautiful, such as a nude Samson, who is embracing a column and holding a jaw-bone in his hand, which is just as perfect as any of the Hercules in either bronze or marble done in classical antiquity. Another

witness to Lorenzo's talent is a figure of Joshua, portrayed in the act of speaking as if he were addressing his army. Apart from this, there are many prophets and sibyls dressed in various styles of clothing and with different hair-styles, head-dresses, and other adornments, and he also placed twelve recumbent figures in the niches of the traverse borders framing the decorations of the scenes, executing in the corners circles containing the heads of women, young boys, and old men, thirty-four in number.* Among these, in the middle of the same door where Lorenzo inscribed his name, is the portrait of his father Bartoluccio, who is the older man, while the younger man is Lorenzo himself, the master of the entire project. Besides the heads, there are countless varieties of foliage, many mouldings, and other decorations executed with the greatest skill.

The scenes on the door are from the Old Testament. The first contains the creation of Adam and Eve his wife, which is executed perfectly. It is clear that Lorenzo tried to render their members as beautifully as he could. Since he wished to show that they were the loveliest forms of life ever created, as they issued forth from the hand of God, his own figures were intended to surpass everything he had ever created in his other work, and he certainly took the greatest care. And so, in the same scene, he showed them eating the apple and then together being driven out of Paradise; the actions of the figures are responding first to the effects of sin, as they recognize their shame and cover themselves with their hands, and then to the effects of repentance, as they are driven out of Paradise by the angel. In the second panel, Lorenzo placed Adam and Eve with their little children, Cain and Abel; it also depicts Abel's sacrifice of the first fruits of his harvest and Cain's less acceptable offering, in which Cain's gestures reflect his envy for his brother, while Abel's reveal his love for God. And a scene of singular beauty is the one showing Cain as he ploughs the earth with a pair of oxen whose labour under the yoke to draw the plough seems real and natural. Equally beautiful is Abel, who is murdered by Cain while tending his flock; Cain's absolutely pitiless and cruel expression is evident as he murders his brother Abel with a club, a scene executed in

such a way that the bronze itself reflects the limpness of the dead limbs of Abel's beautiful body. In the distance in low relief is the figure of God, who is asking Cain what he has done to Abel. Each panel contains the details of four scenes.

In the third panel Lorenzo represented Noah leaving the ark with his wife, sons, daughters, and daughters-in-law, together with all the animals, both the birds and the beasts, each of which in its kind is carved with the greatest perfection that art allows in the imitation of Nature. The open ark and other details are seen in perspective and in very low relief, and it is impossible to describe their grace. Besides this, the figures of Noah and his family could not be more lifelike and lively, for while he performs the sacrifice, the rainbow can be seen, the sign of peace between God and Noah. But even more excellent than all the other figures are the ones showing Noah planting the vines and then, inebriated from the wine, exposing himself while his son Ham sneers at him. It would truly be impossible to imitate any more precisely a sleeping man, with his sprawling limbs abandoned to intoxication, or the respect and love of his other two sons, who cover him up with the most beautiful gestures. In addition, the cask, the vines, and the other tools for the wine-harvest are all executed here with care and placed appropriately so that they do not hinder the narrative but embellish it.

In the fourth panel, Lorenzo chose the appearance of the three angels in the Valley of Mambre, making them all alike and showing that holy old man adoring them with a gesture of the hands and face that is very appropriate and lively. With great power, Lorenzo also depicted the servants waiting with an ass at the foot of the mountain for Abraham, who had gone to sacrifice his son. The boy stands naked upon the altar, while the father, with his arm held high, seeks to obey, but is prevented from doing so by the Angel, who with one hand holds him back while, with the other, indicates where he can find the ram that should be sacrificed, saving Isaac from death. This is a truly beautiful scene, for among other details, there is a very marked difference between Isaac's delicate limbs and those of the servants, which are more robust, and there is not a single stroke in the scene that does not reflect the greatest skill.

Lorenzo outdid even himself in this particular work as he faced the difficult problems of designing the buildings, or the birth of Isaac, Jacob, and Esau, or of showing Esau hunting in order to fulfil his father's will and Jacob, upon Rebecca's instructions, offering the roast kid to his father Isaac, while wearing its skin around his neck, which Isaac is feeling as he gives Jacob his blessing. In this scene are some most handsome and realistic dogs in addition to the figures of Jacob, Isaac, and Rebecca, whose actions produce the same effect they must have produced when alive.

Encouraged by his study of this art, which continuously rendered it easier for him, Lorenzo tested his ingenuity with even more difficult, technical details. Hence, in the sixth panel he pictured the moment when Joseph is thrown by his brothers into the well and when they sell him to the merchants who then give him to Pharaoh,* for whom he interprets the dream of the famine; he also shows Joseph's remedy for the famine and the honours paid to him by Pharaoh. Similarly, Lorenzo depicts the occasion when Jacob sends his sons to buy grain in Egypt and how, once Joseph recognizes them, he sends them home for his father. In this scene, Lorenzo overcame a difficult problem in executing a round temple drawn in perspective, containing figures in various poses that are carrying grain and flour, as well as some extraordinary asses. Likewise, there is also the banquet Joseph offers for them, the hiding of the golden cup in Benjamin's sack, and the finding of the cup, as Joseph embraces and recognizes his brothers. Because of this scene's many expressions of emotion and the variety of details it contains, it is considered, among all Lorenzo's works, the most worthy of his skill as well as the most difficult and most beautiful.

Since Lorenzo possessed such fine talent and true grace in this type of sculpture, he could not have failed to make the most handsome figures when he thought out compositions for his beautiful scenes, just as he did in the seventh panel, where he depicts Mount Sinai and on its summit Moses, reverently kneeling, as he receives the laws from God. Half-way up the mountain is Joshua, who is waiting for him while all the people at the foot, terrified by the thunder, lightning, and

earthquakes, are shown in various poses executed with great facility. Then Lorenzo displayed diligence and loving care in the eighth panel, where he showed the moment when Joshua went to Jericho, crossed the River Jordan, and set up the twelve tents filled with the twelve tribes; these figures are very lively, but even more beautiful are some in bas-relief, picturing the moment when the Hebrews circle around the walls of Jericho with the Ark, destroy the walls to the sound of trumpets, and capture the city. In this scene, the relief of the landscape is seen to decrease and diminish from the figures in the foreground to the mountains and from the mountains to the city, and then from the city to the very low relief of the landscape in the distance; and it is all executed with complete perfection. And since Lorenzo day by day became more experienced in this art, he then presented in the ninth panel the slaying of the giant Goliath, whose head David cuts off with a proud and childish attitude, and the rout of the Philistine army by the army of God, which contains a number of horses, chariots, and other implements of warfare. After that, he depicted David who, returning with the head of Goliath in his hand, is greeted by the Hebrew people who are playing and singing. Their expressions are all appropriate and lively. It remained for Lorenzo to use all his talents in the tenth and last panel, which shows the visit paid by the Queen of Sheba to Solomon along with her enormous court, where Lorenzo created a building drawn in perspective, which is very handsome, and all the other figures are similar to those in the above-mentioned scenes, including the decoration of the architraves which surround the door, with fruits and garlands created with Lorenzo's usual skill.

Both in its details and as a whole, this work demonstrates what the talent and energy of an artisan in statuary could achieve in casting figures, some of which are in something close to full relief, and others in half relief, bas-relief, or extreme bas-relief; in elaborating with great imagination the compositions for his figures and the striking poses for both female and male figures; in lending variety to his buildings and to his use of perspective; and in expressing the graceful bearing of both sexes. Lorenzo also observed a sense of

decorum in the whole work, solemnity in the old men and both lightness and grace in the young. And it can truthfully be said that this work is perfect in every detail and is the most beautiful the world had ever seen among the ancients and the moderns. And Lorenzo should quite rightly have received high praise, for one day Michelangelo Buonarroti stopped to look at this work, and when he was asked what he thought of it and if the doors were beautiful, he replied: 'They are so beautiful that they would be do nicely at the entrance to Paradise.' This was a truly appropriate tribute, pronounced by someone capable of judging such a work. Lorenzo certainly deserved to execute these doors, since he had begun them at the age of twenty and had worked on them for forty years with the most painstaking efforts.*

In cleaning and polishing this work after it was cast, Lorenzo was assisted by many young men who later became most excellent masters: that is, by Filippo Brunelleschi, Masolino da Panicale, and Niccolò Lamberti (all goldsmiths); and by Parri Spinelli, Antonio Filarete, Paolo Uccello, and Antonio del Pollaiuolo, who was quite young at the time, as well as by many others. By working together on this project and conferring among themselves, as is customary when working as a group, they all profited no less from this co-operation than Lorenzo did. In addition to the payment Lorenzo received from the consuls, the Signoria gave him a fine farm near the abbey of Settimo. And very little time passed before Lorenzo was admitted to the Signoria and was given the honour of serving in the principal magistracy of the city. The Florentines should be as highly praised for their gratitude towards Lorenzo as they should be soundly condemned for their ingratitude towards other distinguished men of their city. . . .*

But to return to Lorenzo. During his lifetime, he showed an interest in many things and took delight in painting and in working with glass. For Santa Maria del Fiore he created the circular windows placed around the dome, except for the one that is from the hand of Donatello (the scene where Christ crowns Our Lady). He also made the three windows over the main door of Santa Maria del Fiore and all those in the chapels

and the tribunes; likewise he did the one in the front facade of Santa Croce. In Arezzo he did a window for the main chapel of the parish church, placing within it the Coronation of Our Lady, along with two other figures, for a very wealthy merchant, Lazzero di Feo di Baccio. But since all these windows were made of highly coloured Venetian glass, they made the places where they were installed darker rather than lighter. Lorenzo was assigned to Brunelleschi as his collaborator when Brunelleschi was commissioned to do the dome of Santa Maria del Fiore, but he was later removed from this position, as will be described in the life of Filippo.

Lorenzo himself wrote a work in the vernacular in which he treated many different topics but arranged them in such a fashion that little can be gained from reading it. In my opinion, the only good feature of the book is that after having discussed many ancient painters, especially those cited by Pliny, he makes brief mention of Cimabue, Giotto, and many others from those times. But this was done with far greater brevity than he should have employed, especially since Lorenzo did so for no other reason than to lapse into a fancy discourse about himself and to narrate in great detail, as he did, all of his own works one by one. Nor shall I remain silent about the fact that he presents the book as if it were written by others, for in the process of writing and as a person who knew how to design, chisel, and cast bronze better than how to spin stories, in speaking of himself he says in the first person: 'I did, I said, I used to do and say. . . .'

Finally, having reached the sixty-fourth year* of his life, he was attacked by a violent and persistent fever and died, leaving behind him the immortal fame he earned through the works he created and through the pens of writers, and he was honourably buried in Santa Croce. His portrait is on the main door of the Baptistery of San Giovanni in the middle border when the door is closed, showing him to be a bald man, while next to it his father Bartoluccio is depicted. Nearby the following words can be read: 'Laurentii Cionis De Ghibertis Mira Arte Fabricatum.'*

Lorenzo's drawings were truly splendid and executed in high relief, as can be seen in our book of drawings which

GHIBERTI

contains a sketch of one of the Evangelists by his hand, as well
as some others in chiaroscuro which are very beautiful. His
father Bartoluccio also drew rather well, as is shown in
another Evangelist by his hand in the same book, but it is of
a lesser quality than the one by Lorenzo. I obtained these
drawings, along with those by Giotto and others, from Vettorio
Ghiberti in the year 1528 when I was still a young man. I have
always held and still hold them in veneration, since they are
beautiful and serve as a memorial for so many men. And if,
when I was close friends with Vettorio and had dealings with
him, I had known then what I know now, I could easily have
obtained many other drawings by Lorenzo which were truly
beautiful. Among the many verses, both in Latin and in
Italian, which were composed at various times in praise of
Lorenzo, I shall avoid boring the reader and shall cite here
below only the following: 'When Michelangelo saw the
panels/ shining upon the church in gilded bronze/ he stood
amazed; and after long wonder, he broke the solemn silence in
this way:/ "Oh divine work! Oh door worthy of heaven!"'

THE END OF THE LIFE OF LORENZO GHIBERTI,
SCULPTOR

The Life of Masaccio from San Giovanni di Valdarno, Painter

[1401–1428]

It is Nature's custom, when she creates a person of great excellence in any profession, to create not just one man alone but another as well, at the same time and in the same part of the world as his competitor, so that both of them may profit from each other's talent and from the rivalry. Besides the singular advantage this brings to the two rivals themselves, this phenomenon also kindles beyond all measure the desire of the artisans who follow after them to strive as hard as they can, with continual study and effort, to attain the same honour and glorious reputation for which they hear their predecessors given high praise every day. And how true this is we can observe from the fact that Florence produced in the same period Filippo Brunelleschi, Donatello, Lorenzo Ghiberti, Paolo Uccello, and Masaccio, all most excellent artisans in their areas, who not only rid themselves of the crude and awkward styles which had prevailed up to their time, but also stimulated and excited with their beautiful works the minds of those who succeeded them to such an extent that the work in these arts was brought back to the greatness and perfection we witness in our own times. Thus, we are, in truth, greatly indebted to those first artisans who through their labours showed us the true path to follow to reach the highest level of excellence. And as far as good style in painting is concerned, we are primarily indebted to Masaccio, for it was Masaccio who, in desiring to acquire fame, realized that painting is nothing other than the art of imitating all the living things of Nature with their simple colours and design just as Nature produced them, so that anyone who fully follows Nature should be considered a splendid artisan.

Let me say, then, that when Masaccio realized this fact, it caused him to learn so much from his endless studies that he can be numbered among the first who in large measure purged the art of painting of its harshness, imperfections, and difficulties, and who paved the way towards more beautiful expressions, gestures, boldness, and vitality, achieving a certain relief in his figures which was truly appropriate and natural. This was something no painter before him had ever done. And because he possessed very sound judgement, he realized that all figures which are not standing with their feet placed firmly upon the ground, or which are not foreshortened while standing on tiptoe, are lacking in every good quality of style in their essential features. And those painters who create such figures reveal that they do not understand foreshortening. And although Paolo Uccello had worked on this problem and had actually done something to solve it in part, nevertheless Masaccio changed his methods in many ways, employing every kind of viewpoint to make his foreshortenings much better than any other artisan who had existed before him. He painted his works with exquisite harmony and softness, matching the flesh colours of the heads and the nudes with the colours of their garments, taking great delight in doing so with a few simple folds, as they naturally occur in life. This method has proved extremely useful to artisans, and Masaccio deserves to be commended for it, just as if he had invented it; to tell the truth, the works created before Masaccio can be described merely as paintings, while his creations compared to those executed by others are lifelike, true, and natural.

Masaccio's origins are to be found in Castello San Giovanni di Valdarno where, people claim, some figures painted by him in his early childhood are still to be seen. He was very absent-minded and unpredictable, like a man who has devoted his whole life and will only to the details of art, caring very little about himself and even less about others. And because he never wanted to think in any way about worldly affairs or concerns, not even about how he dressed himself, he was unaccustomed to collecting anything from his debtors unless he was in dire straits. Instead of Tommaso, which was his real name, everyone called him Masaccio.* This was not because

he was a bad man, for he embodied goodness itself, but rather because of his complete lack of concern. In spite of this, however, he was so kindly in doing favours or kindnesses for others that no more could be expected.

Masaccio began painting during the time when Masolino da Panicale* was working on the Brancacci Chapel in the Carmine Church of Florence, following as closely as possible in the footsteps of Brunelleschi and Donatello, even though the art of painting was different from theirs. And in his work Masaccio constantly tried to create the most lifelike figures with a fine animation and a similarity to the real. His outlines and his painting were done in such a modern style, and so different were they from those of other painters, that his works can surely stand comparison with any kind of modern design or colouring. That he studied his work diligently and was most amazingly skilful in resolving problems of perspective is made apparent in one of his scenes with small figures which today hangs in the home of Ridolfo del Ghirlandaio. In this work, besides Christ liberating a man possessed by demons, there are some very beautiful buildings drawn in perspective in a way which reveals simultaneously both the exterior and the interior, for Masaccio chose to show them not from the front but from the corners to achieve the most difficult point of view. More than other masters, he tried to employ nudes and foreshortenings in his figures, something done infrequently before him. He worked with extreme facility, and, as I mentioned, he did his draperies very simply. There is a panel done in tempera by Masaccio showing Our Lady in the lap of Saint Anne, with Her son in Her arms; today this panel is at the Church of Sant'Ambrogio in Florence in the chapel next to the door leading to the nuns' reception parlour. On the choir screen in the church of San Niccolò di là d'Arno, there is a panel in tempera by the hand of Masaccio in which, along with Our Lady, he painted the Angel of the Annunciation and a building full of columns drawn in perspective, which is very beautiful, for besides the perfect design of its lines, Masaccio did it in such a way that the colours shade off and little by little fade away from view, demonstrating quite well that he understood perspective.

In the Badia of Florence on a pillar opposite one of those which holds up the arch of the main altar, he painted a fresco of Saint Ives of Brittany, placing him inside a niche with his feet foreshortened, as seen from the point of view below. Since no one else had used this method before, Masaccio won no little praise, and under the same saint above another cornice, he painted the widows, orphans, and poor people who were assisted by Saint Ives in their need. In Santa Maria Novella, he also painted a fresco of the Trinity below the choir screen of the church and above the altar of Saint Ignatius, placed between Our Lady and Saint John the Evangelist as they contemplate the Crucified Christ. At the sides are two kneeling figures who are, as far as can be determined, portraits of those who had him paint the work, but they are hardly visible, since they are covered by a gold decoration. None the less, what is most beautiful, besides the figures, is the barrel vault drawn in perspective and divided in squares full of rosettes which are so well diminished and foreshortened that the wall appears to have holes in it.* Then in Santa Maria Maggiore, in a chapel near the side door which leads towards San Giovanni, Masaccio painted a panel of Our Lady, Saint Catherine, and Saint Julian. And in the predella, he did a number of small figures from the lives of Saint Catherine and Saint Julian, showing the latter killing his father and mother;* and in the middle he did a Nativity of Jesus Christ with that simplicity and liveliness characteristic of his work.

In the Carmine Church in Pisa, upon a panel which was inside a chapel on the choir screen, there is a Virgin with Child, with some little angels at Her feet who are playing instruments, while the one strumming a lute turns his ear attentively to the harmony of his playing. Our Lady is in the middle, along with Saint Peter, Saint John the Baptist, Saint Julian, and Saint Nicholas, all of which are very lively and brightly coloured figures. Below in the predella are some small figures in scenes from the lives of these saints, and in the middle the three Magi offer their gifts to Christ; and in this part of the panel there are a number of horses drawn from life so beautifully that one could not ask for more; and the

courtiers of these three kings are clothed in a variety of garments that were in fashion in those days. And above the panel, as the finishing touches, there are also many saints placed in frames around a crucifix. It is believed that the figure of the saint dressed as a bishop done in fresco beside the door in this church leading to the convent is by Masaccio, but I am convinced that it is by Fra Filippo, his student.* After he returned from Pisa, he worked in Florence on a panel, painting on it two life-size nudes (a man and a woman), a work located today in the Palla Rucellai home.

Later, not feeling at home in Florence and encouraged by his affection and love for his craft, Masaccio decided to go to Rome in order to learn and then to surpass other artisans, as he did. There, he acquired great fame, and for the cardinal of San Clemente, he worked in the church of San Clemente on a chapel in which he painted the Passion of Christ in fresco with the thieves on the cross and scenes from the life of Saint Catherine the Martyr.* He also painted many panels in tempera which were all either lost or misplaced during the troubles in Rome.* One of these was in the church of Santa Maria Maggiore inside a small chapel near the sacristy and contained four well-executed saints, painted as if they are in relief, with Our Lady of the Snows in the middle; and there is an actual portrait of Pope Martin who, with a hoe, marks out the foundations of that church, with Emperor Sigismund II at his side.* One day, while Michelangelo and I were looking at this work, he praised it very highly and then added that these people had been alive during Masaccio's lifetime. While Masaccio was in Rome, Pisanello and Gentile da Fabriano were working upon the walls of the church of San Giovanni for Pope Martin and gave him part of the commission, but when he received the news that Cosimo de' Medici, who had helped him a great deal and always shown him his favour, had been recalled from exile, Masaccio returned to Florence.* There, after the death of Masolino da Panicale, who had begun the Brancacci Chapel in the Carmine Church, Masaccio was given the commission. Before he put his hand to this project, Masaccio painted the figure of Saint Paul which is near the bell-ropes as a proof of his skill and to demonstrate

the improvement he had achieved in his craft. And he truly
demonstrated infinite skill in this picture, where the saint's
head (which is a living portrait of Bartolo di Angiolino
Angiolini) is so full of awe that it seems as if only the power of
speech were lacking in this figure. And anyone who did not
know Saint Paul when he gazed at this painting would see in
this figure that honourable quality of Roman citizenship
together with the invincible power of that most divine spirit
completely devoted to the problems of the faith. In this same
work, Masaccio also demonstrated his skill in foreshortening
figures from below and in completely solving a problem on
his own, a talent which is truly marvellous, as can be seen even
today in the feet of this same apostle when compared to that
clumsy old style which, as I said earlier, rendered all the
figures as if they were standing on tiptoe. This style had
endured until Masaccio's time without anyone correcting it,
but alone and before anyone else, Masaccio brought art back
to the good style of today.

While Masaccio was working on this project, it happened
that the Carmine Church was consecrated, and to commem-
orate this event, Masaccio painted a picture of the entire
ceremony just as it had taken place, in *terra verde* and chiaro-
scuro, over the door inside the cloister leading towards the
convent. And in it he portrayed countless citizens in their
cloaks and hoods taking part in the procession, among whom
are Filippo di Ser Brunellesco in wooden clogs, Donatello,
Masolino da Panicale (who was Masaccio's teacher), Antonio
Brancacci (who had the chapel decorated), Niccolò da Uzzano,
Giovanni di Bicci de' Medici, Bartolomeo Valori (all of whom
are also depicted in Masaccio's own hand inside the home of
the Florentine nobleman Simon Corsi). Likewise, he drew the
portrait of Lorenzo Ridolfi, who in those days was the
ambassador for the Florentine Republic in Venice. And he not
only drew living portraits of these noblemen but also painted
the convent door and the doorman holding the keys in his
hand. This work truly possesses great perfection and is a real
marvel, for Masaccio knew how to place five or six people in
a row upon the plane of the piazza and to arrange them with
such proportion and judgement that they recede into the

distance, following the vantage point of the eye. It is especially remarkable, since we can sense Masaccio's good judgement in painting these people as if they were really alive and not all of one size, distinguishing with a certain power of observation those who are small and fat from those who are tall and thin, while leaving all of them standing up with their feet upon a single plane and so well foreshortened that they appear as they would in real life.

After this, when Masaccio had returned to work on the Brancacci Chapel, continuing the scenes from the life of Saint Peter begun by Masolino, he completed some of them—that is, the story of Saint Peter's chair, his delivering of the sick, the raising of the dead, and the healing of the cripples with the passing of his shadow as he walks to the temple with Saint John.* But clearly the most notable of the scenes is the one in which Saint Peter pays the tribute money and, following Christ's command, takes the money from the belly of the fish, for here, besides the fact that we can see in one of the Apostles, the last in the group, the portrait of Masaccio himself, executed with the use of a mirror and done so well that he appears to be alive, we can also sense the fervour of Saint Peter in his questions and the attentiveness of the Apostles standing in various poses around Christ, as they await His decision with gestures so natural they truly appear to be alive. And Saint Peter is especially lifelike, for his head is flushed from the effort of bending over to take the money out of the fish's belly. And much more admirable still is the payment of the tribute money, where we can see the emotion he feels while counting the money, as well as the greed of the man who receives it, as he stares at the money in his hand with the greatest pleasure.

Masaccio also painted the resurrection of the King's son by Saint Peter and Saint Paul, but because of Masaccio's death, the work remained unfinished and was later completed by Filippino.* In the scene showing Saint Peter performing baptisms, a very fine nude figure, shown shivering among those being baptized, numb with cold, is executed with the most beautiful relief and the sweetest style. This is a figure which both older and modern artisans have always held in the greatest reverence and admiration, and as a result, this chapel

has been visited by countless masters and those who were practising their drawing from those times to our own. In it some heads are still so lifelike and beautiful that it could easily be said no master of that period so clearly resembles the moderns as Masaccio. Thus, his labours deserve endless praise, above all because he gave shape in his masterful painting to the beautiful style of our own times.

How true this is may be seen from the fact that all the most celebrated sculptors and painters who have worked or studied in this chapel have become distinguished and renowned: that is, Giovanni da Fiesole; Fra Filippo; Filippino (who completed the chapel); Alesso Baldovinetti; Andrea del Castagno; Andrea del Verrocchio; Domenico Ghirlandaio; Sandro Botticelli; Leonardo da Vinci; Pietro Perugino; Fra Bartolommeo di San Marco; Mariotto Albertinelli; and the most divine Michelangelo Buonarroti. Raphael of Urbino also developed in the chapel the beginnings of his beautiful style; also Granacci; Lorenzo di Credi; Ridolfo Ghirlandaio; Andrea del Sarto; Rosso Fiorentino; Franciabigio; Baccio Bandinelli; Alonso Spagnuolo; Jacopo da Pontormo; Pierino del Vaga; and Toto del Nunziata.* In short, all those artisans who have sought to study the craft of painting have always gone for instruction to this chapel to learn from Masaccio the precepts and the rules of executing figures properly. And if I have not listed many of the foreigners or Florentines who have gone to study there in the chapel, let it suffice to say that whatever great artists pursue, so do the lesser ones.*

Although Masaccio's works have always been held in high esteem, there is nevertheless an opinion or, rather, a firm conviction among many people that he would have achieved even greater results in his craft if death, which carried him off at the age of twenty-six, had not cut his life so short. But, either because of the envy of Fortune, or because good things normally do not endure, he died in the flower of his youth and so suddenly that there were many people who suspected poison rather than some other cause.

It is said that when he heard of Masaccio's death, Filippo di Ser Brunellesco said: 'We have suffered a very great loss with Masaccio's death', and it pained him a great deal, for he had

worked very hard for a long time to teach Masaccio many of
the techniques of perspective and architecture. He was buried
in the same Carmine Church in the year 1443.* And since he
had not been very highly esteemed when he was alive,
no memorial was placed over his tomb, but there were those
who honoured him after his death with the following
epitaphs:

By Annibale Caro

I painted, and my painting was equal to truth;
I gave my figures poses, animation, motion,
And emotion. Buonarroti taught all the others
And learned from me alone.

By Fabio Segni

Oh jealous Lachesis, why does your finger lay low
And pluck the threads of youth's first bloom?
This one slaying slays countless Apelles:
All painting's charm dies with this single death.
With the quenching of this sun, all stars are extinguished.
Alas! Beside this fall, all beauty is laid low.

THE END OF THE LIFE OF MASACCIO

The Life of Filippo Brunelleschi, Sculptor and Architect

[1377–1446]

Nature has created many men who are small and insignificant in appearance but who are endowed with spirits so full of greatness and hearts of such boundless courage that they have no peace until they undertake difficult and almost impossible tasks and bring them to completion, to the astonishment of those who witness them. No matter how vile or base these projects may be, when opportunity puts them into the hands of such men, they become valuable and lofty enterprises.

Thus, we should never turn up our noses when we meet people who in their physical appearance do not possess the initial grace and beauty that Nature should bestow upon skilful artisans when they come into the world, for without a doubt veins of gold are hidden beneath the sod. And many times those with poor features develop such great generosity of spirit and sincerity of heart that when nobility of soul is joined to these qualities, the greatest miracles may be expected of them, for they work to embellish ugliness of body with strength of intellect. This can be clearly seen in Filippo di Ser Brunellesco, who was no less ill-favoured in appearance than Forese da Rabatta and Giotto,* but whose genius was so lofty that it might well be said he had been sent to us by Heaven to give a new form to architecture which had been going astray for hundreds of years; the men of those times had spent many fortunes badly, constructing buildings with no sense of order, bad methods, poor design, bizarre inventions, a shameful lack of grace, and the worst kinds of decoration. And since the world had existed for so many years without such a remarkable mind and such a divine spirit, Heaven willed that Filippo should leave behind him the

greatest, tallest, and most beautiful structure of all those
built in modern times as well as in antiquity, demonstrating
that the genius of Tuscan artisans, although it had been
lost, was not completely dead.* Heaven also endowed Filippo
with the highest virtues, among which was that of friend-
ship, so that there never existed a man more kind or loving
than he. In his judgement he was dispassionate, and when-
ever he considered the measure of another man's merits,
he set aside his own interest or that of his friends. He knew
himself and communicated the degree of his own talent to
others, and he was always ready to help a neighbour in need,
declaring himself a confirmed enemy of vice and an admirer
of those who practised virtue. He never wasted his time but
was always striving to assist his friends, either by himself or
with the help of others, and he went about visiting his friends
and always supporting them.

It is said that in Florence there lived a man of excellent
reputation, with many praiseworthy habits and industrious in
his affairs, whose name was Ser Brunellesco di Lippo Lapi,
whose grandfather, called Cambio, was an educated person
and the son of a physician, Master Ventura Bacherini, who
was very famous in those days.* Brunellesco married a very
well-bred woman from the noble Spini family, and as part of
her dowry she brought him a house, where he and his sons
lived until their death, which is situated just opposite San
Michele Berteldi on the side in a corner past the Piazza degli
Agli. There he worked and lived happily until the year 1377,*
when a son was born to him, whose birth made him as happy
as could be imagined and to whom he gave the name of
Filippo, after his dead father. In his early years, the father
diligently taught his son the rudiments of letters, in which the
boy showed himself to be so clever and of such a lofty intellect
that he often kept his mind detached, as if he did not intend
to perfect himself in such matters. On the contrary, it seemed
as if his mind were turned to matters of greater utility, with
the result that Ser Brunellesco—who wanted his son to fol-
low his own profession, that of notary, or that of his great-
great-grandfather—was very displeased. Nevertheless, since
his father observed his son to be continuously attracted to

ingenious matters of art and mechanics, he had him learn to
use the abacus and to write; and then he apprenticed him in
the goldsmith's craft so that he might learn the art of design
with a friend of his. And this greatly satisfied Filippo, who
began to learn and to practise the various aspects of this craft,
and not many years had passed before he could mount
precious stones better than the older artisans in the trade. He
tried his hand at niello* and worked upon larger pieces, such
as some half-length silver figures of prophets placed at the
head of the altar of the church of San Jacopo in Pistoia, which
he executed for the trustees of the Works Department of that
city's cathedral and which are considered most beautiful. He
also worked on objects in bas-relief, demonstrating such a pro-
found understanding of this craft that it was inevitable his
mind would surpass the boundaries of this profession. Thus,
after taking some training with certain learned men, he began
to speculate over matters of time and motion, weights and
wheels, how they could be made to turn and how they
moved, and as a result, he created with his own hands a num-
ber of very fine and very beautiful clocks.

Not satisfied with this, there arose in his heart the desire to
do sculpture on the largest scale. And this occurred later, for
since the young Donatello was reputed to be talented in this
art and to show great promise, Filippo began to keep his
company constantly, and such great affection grew up be-
tween them due to the talent each possessed that it seemed as if
they could not live without each other. And so Filippo, who
was very skilled in many things, worked at many professions,
and he did not work in them long before he was considered
by people with some understanding of these matters to be a
most excellent architect, as he demonstrated in his techniques
for decorating and restoring houses: for instance, on the corner
of the Ciai family facing towards the Old Market, he did a
great deal of work at the home of Apollonio Lapi, one of his
relatives, where he worked while it was being built. And he
did much the same thing outside of Florence for the tower and
house of the Petraia at Castello. In the Palazzo della Signoria,
he arranged and partitioned all those rooms where the office of
the officials of the Monte* was located, and he constructed the

doors and windows in a style derived from that of antiquity
but which was then not widely used, since architecture was in
a very crude state in Tuscany.*

Then, the friars of Santo Spirito wanted him to carve a
lime-wood statue of the penitent Saint Mary Magdalene to
place in a chapel, and since Filippo had done a number of
small things in sculpture, he was anxious to demonstrate that
he could succeed in works of a larger scale and agreed to do
the figure. When it was completed and put in place, it was
considered very beautiful, but in the subsequent fire in that
church during the year 1471, it was burned along with many
other important objects.

Filippo paid great attention to perspective, then very badly
employed as a result of the many errors made in using it. He
wasted a great deal of time in this but finally discovered by
himself a means by which it could be done correctly and per-
fectly—that is, by tracing it with a ground-plan and profile
with intersecting lines, a discovery truly very ingenious and
useful to the art of design. He took such delight in perspective
that he drew a sketch of Piazza San Giovanni,* which shows
all the divisions of the black-and-white marble inlay diminish-
ing with a singular gracefulness, and in a similar way he drew
the house of the Misericordia with the shops of the *cialdone*
makers* and the arch of the Pecori, with the column of Saint
Zenobius on the other side. Since this work was praised by the
artisans and those who possessed good judgement in this craft,
it encouraged him so much that before long he began another,
and he drew the Palace, Piazza, and Loggia of the Signoria
along with the roof of the Pisani and all the surrounding
buildings. These works kindled the spirits of other artisans
who studied them afterwards with careful attention.

In particular, Filippo taught perspective to Masaccio, a
young painter and his very close friend at the time, who then
honoured his teacher by what he displayed in the buildings he
painted in his works. It only remained for him to teach his
method to those who worked in tarsia, which is the craft of
inlaying coloured pieces of wood, and he stimulated these
artisans so much that they developed excellent procedures
and useful techniques from his teaching, for both then and

afterwards many excellent works brought fame and profit to Florence for many years.

One evening Messer Paolo dal Pozzo Toscanelli* returned from his work and happened to be in his garden having supper with some of his friends, and he invited Filippo to join them. Having listened to him discussing the mathematical sciences, Filippo struck up such a friendship with Paolo that he learned geometry from him. And although Filippo was not a learned man, he was able to argue everything so well from his own practice and experience that he confounded Paolo on many occasions. And thus, Filippo continued to study, working on matters of Christian scripture, not hesitating to intervene in the disputations and sermons of learned men and profiting so much from his remarkable memory that Messer Paolo, in praising him, used to say that when he heard Filippo argue, he thought he was listening to a new Saint Paul. He also spent a great deal of this period working on matters relating to Dante, coming to understand the places Dante mentioned and their dimensions so well that he would often use Dante to make comparisons and cite the poem in his arguments. His mind was constantly grinding out and thinking up ingenious and difficult problems. Nor could he have found anyone whose intelligence satisfied him more than Donatello, with whom he held friendly conversations, both men taking pleasure in each other's company, as they conferred together on the problems of their trade.

Now, in those days Donatello had finished a wooden crucifix which was placed in Florence's church of Santa Croce under the scene of the young boy resurrected by Saint Francis painted in fresco by Taddeo Gaddi, and Donatello wanted to hear Filippo's opinion of it. But he regretted having asked, for Filippo replied that he had placed a peasant on the cross, which gave birth to the popular saying that is discussed at length in the life of Donatello: 'Take some wood and make one yourself.' As a result, even though Filippo never lost his temper over things that were said to him, no matter what the provocation, he remained silent for many months while he executed a wooden crucifix of the same dimensions and excellence and worked with great artistry, design and care.

And so he sent Donatello to his home ahead of him almost as a joke (since Donatello did not know that Filippo had executed such a work), and while he gazed at it, Donatello dropped the apron he was wearing filled with eggs and things they had intended to eat together, carried away by his astonishment and by the ingenious and artistic style Filippo had employed in the legs, torso, and arms of the figure, all arranged and combined in such a fashion that besides declaring himself beaten, Donatello proclaimed the work to be a miracle. Today this crucifix is in Santa Maria Novella between the Strozzi Chapel and the Bardi da Vernia Chapel and is still praised to the skies by modern artists. The talents of these truly distinguished masters were so apparent that they were commissioned by the Butchers' Guild and the Linen-Drapers' Guild to sculpt two marble figures to be placed in their niches on the sides of Orsanmichele. Filippo left the statues for Donatello to do alone, since he had taken on other responsibilities, and Donatello executed them perfectly.*

After this, in 1401, it was decided, since sculpture had reached such heights, to redo the two bronze doors of the Church and the Baptistery of San Giovanni, since from Andrea Pisano's death until that time no masters existed who knew how to execute them. As a result, these intentions were made known to the sculptors then living in Tuscany, and they were summoned and given an allowance and a year's time to complete a single scene. Among those summoned were Filippo and Donatello in competition with Lorenzo Ghiberti, Jacopo della Fonte [Quercia], Simone da Colle, Francesco di Valdambrino, and Niccolò d'Arezzo, each of whom was to execute a scene on his own. The scenes were completed in the same year and put on display for comparison, and they were all very beautiful, each one different from the others. Donatello's scene was well designed but poorly executed; the one by Jacopo was well designed and carefully executed but lacked the diminishing of the figures which properly divides the scenes; Francesco di Valdambrino's scene, given the manner in which he had executed it, reflected a poverty of invention and figures; and the worst of all were those by Niccolò d'Arezzo and Simone da Colle. The best was that by Lorenzo

di Cione Ghiberti. It possessed design, care, inventiveness, skill, and figures which were well worked out. Nor was Filippo's scene much inferior to it, for in it he had represented Abraham sacrificing Isaac, along with a servant who, while waiting for Abraham near an ass grazing, pulls a thorn from his foot, a detail which deserves considerable praise. When the scenes were placed on display, Filippo and Donatello were satisfied only with the one by Lorenzo, and they judged him to be more suitable for this project than either they or the artisans who had created the other scenes. And so they persuaded the consuls with sound arguments to commission the project to Lorenzo, demonstrating in this fashion how the public and private interests might best be served, and this was certainly the true fruit of friendship, talent without envy, and sound judgement of their own abilities, for which they deserved more praise than if they had brought the project to perfection themselves. What happy spirits are those who, while helping one another, also take pleasure in praising the labour of others! How unhappy are the artisans of our own times who, while doing harm to others, are eaten up by envy in attacking them when they cannot vent their malice!

The consuls begged Filippo to work on the project along with Lorenzo, but he did not wish to do so, intending instead to be first in a single craft rather than equal or second in this work. And so he gave the scene, which he had executed in bronze, to Cosimo de' Medici, who, with the passing of time, had it set up in the Old Sacristy of San Lorenzo on the back of the altar, where it is today, and Donatello's scene was given to the Money-Changers' Guild.*

After the commission had been given to Lorenzo Ghiberti, Filippo and Donatello met and decided to leave Florence together and to stay in Rome for several years, Filippo studying architecture and Donatello sculpture. Filippo did so because he wished to surpass both Lorenzo and Donatello, believing that architecture was more necessary for man's needs than sculpture or painting. He sold a small farm that he possessed in Settignano and left Florence to go to Rome.* Upon seeing the grandeur of the buildings and the perfection of the remains of the temples, he stood there so engrossed

in thought that he seemed beside himself with amazement.

And so, Filippo and Donatello arranged to take the measurements of the cornices and to sketch out the ground-plans of these buildings, constantly working without sparing either time or expense. They left no spot unvisited, either within Rome or out in the countryside, and, in so far as they could, they took the measurements of everything of any worth. And since Filippo was free from domestic concerns, he abandoned himself to his studies and did not worry about eating or sleeping; his only concern was the architecture, which was already in ruins, that is, the good ancient orders and not the barbarous German style which was frequently employed in his times.* And Filippo conceived two grandiose ideas: the first was to bring good architecture back to light, since he believed that if he did this, he would leave behind him no less a reputation than Cimabue or Giotto; the other was to find a means, if he could, to raise the dome of Santa Maria del Fiore in Florence. The difficulties of accomplishing this were such that no one after the death of Arnolfo Lapi* had enough courage to attempt the feat without expending an enormous sum for a wooden frame. Filippo, however, never confided his thoughts to Donatello or to any living soul, nor did he cease working in Rome until he had pondered all the problems related to the Pantheon and how it might have been vaulted. He had examined and sketched all the vaultings of antiquity and studied them continually. And if by chance he and Donatello found buried fragments of capitals, columns, cornices, and supports for buildings, they would set to work and have them excavated to reach the foundations. As a result, rumours spread around Rome, and as they passed through the streets carelessly dressed, the people called them the 'treasure-hunters', because they believed they were practising geomancy* in order to locate buried treasure. The reason for this was that one day they uncovered an ancient earthenware pot full of medals.

Filippo was short of money and went about meeting his expenses by setting very precious gems for his goldsmith friends, and since Donatello had returned to Florence, he thus remained alone in Rome, and with even greater study and toil than before he continued training himself by observing the

ruins of these buildings. He did not rest until there was no sort
of building he had not sketched: round, square, and octagonal
temples, basilicas, aqueducts, baths, arches, coliseums, amphi-
theatres, and every kind of brick temple, extracting from all
this the methods employed in girding and securing the walls
and in constructing the arches of the vaults, as well as all the
means of joining stones by hinging and dovetailing. When he
investigated the fact that all the huge stones had acute-angled
holes underneath in the middle, he discovered that it was for
the iron instrument we call the *ulivella*, with which the stones
were hoisted, and he reintroduced this technique and brought
it back into use once again. Then he classified the various
architectural orders one by one: Doric, Ionic, and Corinthian.
And his studies were so intense that his mind was capable of
imagining how Rome once appeared even before the city fell
into ruins.

The air of the city caused Filippo a slight problem in the
year 1407, and, advised by his friends to seek a change of
climate, he returned to Florence. There, in his absence, many
building projects had suffered, and upon his arrival he pro-
vided many plans and much advice. During the same year,*
the trustees of the Works Department of Santa Maria del Fiore
and the consuls of the Wool Guild called together local
architects and engineers to discuss the method of vaulting the
dome. The group included Filippo, and he advised them that
it was necessary to remove the roof from the building and to
avoid following Arnolfo's plan. He suggested that they should
instead construct a frieze fifteen armslengths in height and
make a large eye in the middle of each side, since besides
taking off the supports of the dome it could thus be vaulted
more easily. Models were accordingly planned and built.

One morning, a few months after recovering from his
illness, Filippo was standing in the piazza of Santa Maria del
Fiore with Donatello and some other artisans, discussing
matters relating to ancient sculpture. Donatello was telling
how, as he returned from Rome, he had taken the road
through Orvieto to see the famous marble façade of the
Duomo which was constructed by several different masters
and in those times considered a remarkable work. And he

added that while passing through Cortona, he entered a parish church and saw an extremely beautiful ancient tombstone upon which there was a scene carved in marble, a very rare thing in those days, since the abundance of antiquities we enjoy today had not yet been unearthed. Donatello continued, describing the method the ancient master had employed in creating that work, and the finesse which it displayed along with the perfection and excellence of its workmanship. This aroused in Filippo such a burning desire to see it that dressed just as he was, in his cloak, hood, and wooden clogs, without telling anyone where he was going, he went off on foot and willingly allowed himself to be carried off to Cortona by his love for the art of sculpture. And when he had seen and enjoyed the tombstone, he sketched it with his pen, and then, taking his drawing, he returned to Florence, without Donatello or anyone else realizing that he had even left, since they thought he must be drawing plans or dreaming up some project.

When he returned to Florence, he showed them the sketch of the tombstone he had drawn with such great care. Donatello was greatly amazed by it, since he could see how much love Filippo had for the art of sculpture. Filippo then remained for many months in Florence, where he secretly executed models and mechanisms for work on the dome but still spent time joking with the other artisans. It was then that he played the practical joke of the Fat Man and Matteo,* and often amused himself by going to help Lorenzo Ghiberti polish something on his doors. But Filippo had heard that there was some discussion of making provisions for engineers to vault the dome [of Santa Maria del Fiore], and one morning his fantasy moved him to return to Rome because he thought his reputation would increase if he had to be sought after in a place other than Florence. Therefore, while Filippo was in Rome, the project was studied, and his exceptionally sharp mind was recalled, since he had demonstrated in his arguments a certainty and courage which had not been found in the other masters, who were standing around with the masons, bewildered, having lost their confidence, and believing they could never discover a method of vaulting the dome,

nor beams to construct a framework strong enough to support
the reinforcement and weight of such a gigantic structure.
Determined to see the project through to its conclusion, they
wrote to Filippo in Rome and begged him to return to
Florence. And since he wished for nothing else, Filippo very
graciously returned.

Upon his arrival, the trustees of the Works Department of
Santa Maria del Fiore and the consuls of the Wool-Makers'
Guild assembled and explained to Filippo all of the diffi-
culties—from the largest down to the smallest—which their
workmen were encountering, and since the artisans were pres-
ent at the meeting along with the others, Filippo spoke these
words:

Honourable Trustees, there is no doubt that difficulties always arise in
the execution of great projects, and if ever an undertaking presented
problems, this plan of yours presents more perplexing ones than
perhaps even you imagine. For I do not know if the ancients ever put
up a vault as awesome as this one, and I have thought many times
about the reinforcements required both outside and inside, so that
we can work safely on the project, but I have never been able to
make up my mind: the width of the structure discourages me no less
than the height. If the dome could be rounded, we might employ the
technique employed by the Romans when they vaulted the Pantheon
in Rome—that is, the Rotunda—but here we must pursue the eight
sides, using iron ties and toothing in the stones, which will be an even
more difficult feat. But when I remember that this is a church
consecrated to God and the Virgin, I am confident that since it is
being built in Her honour, She will not fail to instil knowledge
where there is none and to provide to whoever may be the architect
of such an enterprise the necessary strength, wisdom, and talent. But
how can I assist you here, when the project is not mine? Let me
tell you, however, that if I were commissioned to do it, I would
courageously and quite resolutely discover a way to vault the dome
without so many difficulties. But until now I have not thought about
this at all, and you would like me to explain my method to you? But
when Your Lordships really decide that the dome must be vaulted,
you will be obliged not only to test my opinion (which will be
insufficient advice for such a grandiose undertaking) but to take
the trouble and expense of arranging for Tuscans and Italians, as well
as Germans, Frenchmen, and architects of every nation, to gather
in Florence within a year's time on a specific day, and you should

propose your project to them so that after it has been argued and
resolved among so many masters, it may be initiated and given over
to the man who most clearly gives some indication of possessing the
best technique and judgement for completing such a work. And I
know of no better advice or procedures to give you than these.

The consuls and trustees liked Filippo's advice and proced-
ures, but in the meantime they would have liked him to con-
struct a model to which he had given some thought. But he
pretended not to be concerned with the project; indeed, after
he took his leave of them, he declared he had been asked
by letter to return to Rome. Once the consuls realized that
their prayers and those of the trustees were not enough to stop
him, they had many of his friends entreat him, but when he
did not yield to their request, one morning—it was the
twenty-sixth day of May in 1417*—the trustees allocated
him a sum of money, which can be found credited to
Filippo in the account books of the Office of the Works
Department, all this being done to mollify him. But, firm
in his purpose, Filippo left Florence and returned to Rome,
where he continuously studied this project, organizing and
preparing for the completion of such a work and believing (as
was true) that he was the only man capable of carrying out
such a plan.
Filippo's advice about engaging other architects was given
for no other reason than the fact that they might bear witness
to his exceptional talent, rather than because he thought they
might discover a means of vaulting the dome and take on a
burden that was too great for them. And thus a great deal of
time was wasted before these architects arrived from their
various cities and countries, since they had been summoned
from afar by orders given to Florentine merchants who lived
in France, Germany, England, and Spain, and who had been
commissioned to spend whatever was necessary to secure from
the rulers of these countries the services of the most experi-
enced and distinguished talents who lived in those regions.
When the year 1420 arrived, all of these foreign masters,
along with those from Tuscany, as well as all of the most
skilful Florentine architects, were finally assembled in Florence,

and Filippo returned from Rome. They all then met in the
Office of the Works Department of Santa Maria del Fiore in
the presence of the consuls and the trustees, along with a
selected group of the most worthy citizens, in order to choose a
method for vaulting the dome after the opinion of each artisan
had been heard. Thus, they summoned all the artists to the
hearing and listened to their opinions one by one, as each artist
explained the plans he had developed for the project. It was a
marvellous thing to hear the strange and varied views on this
subject, for some declared that they would construct brick
pillars from ground level to support the arches and hold up the
framework that would bear the weight; others maintained
that it would be well to vault the dome with pumice stone
so that it would weigh less; and many of them agreed on
constructing a pillar in the middle and vaulting the dome with
a pavilion-shape, like the one over San Giovanni in Florence.
And there were even some who said that it would be a good
idea to fill up the church with a mixture of earth and coins,
so that when the space was vaulted anyone who wanted
to do so would be permitted to carry away the earth, and in
this fashion the people would rapidly clear it away without
expense. Filippo alone declared that the dome could be
vaulted without using too many beams and without pillars or
mounds of earth at a much lower cost than the many arches
would incur, and he said it could be done quite easily without
any reinforcements.

To the trustees, as well as to the workmen and all the
assembled citizens, who had expected some fine scheme, it
seemed that Filippo was talking nonsense, and they mocked
him and laughed at him, turning away and declaring that he
should speak of something else—that his method was that of a
madman—which he was. As a result, Filippo, taking offence,
declared:

Sirs, you must realize that it is not possible to vault the dome in any
way other than this one. Although you may laugh at me, you must
understand (unless you wish to be obstinate) that it neither should nor
could be done otherwise. If you want to execute it according to the
scheme I have developed, it will be necessary to turn the cupola with

the curvature of a pointed arch and to make two vaults with one inside and one outside, so that a man can walk between them. And over the corners of the angles of the eight sides, the structure must be bound together through its thickness by dovetailing the stones and, similarly, the sides of the dome must be bound together with ties of oak. And attention must be paid to the lighting, the stairways, and the conduits for draining off the rain-water. And none of you has remembered to point out that internal scaffolding can be constructed to do the mosaics and a countless number of other difficult tasks. But I, who envision the dome already vaulted, recognize that there is no other method nor any other way to vault it than the one that I have set forth.

And the more heated Filippo grew in his discussion, as he sought to explain his idea so that they could understand it and believe in it, the more questions they raised, so that they believed him even less and considered him even more of a fool and a chatterbox. As a result, they dismissed him several times, but, in the end, he refused to leave and was carried out bodily from the hearing by several young men, with everyone considering him to be completely crazy. This disgraceful experience was the reason why Filippo later had to declare that he did not have the courage to pass through the streets of the city for fear of hearing people say: 'Look! There goes the madman!'

After this meeting, the trustees remained confused over the difficult methods proposed by the first masters as well as by the one suggested at last by Filippo, which seemed foolish to them, since they believed he was mistaken about the project in two ways: the first was the idea of erecting a double vault, which would be very large and dangerously heavy; and the second was the idea of constructing it without framework. On the other hand, Filippo, who had spent so many years of study in order to obtain the commission, did not know what to do and was tempted on many occasions to leave Florence. Yet, since he wanted to succeed, he had to arm himself with patience, and he was clever enough to realize that the opinions of the citizens in his home town never held firm for very long. Filippo could have shown them a small model that he had constructed, but he did not want to do so, having recognized

the lack of understanding on the part of the consuls, the envy
of the artisans, and the fickle favour of the citizens, each of
whom preferred first one thing and then another according to
whatever struck his fancy. I am not at all surprised by this,
since everyone in this town professes to understand as much in
these matters as skilled masters do, although there are very
few, in fact, who do so; and I say this hoping those who truly
understand will excuse me.

Thus, what Filippo was unable to achieve among the
assembled officials he tried to achieve by drawing different
individuals aside, speaking now with this consul and now with
that trustee, and in like manner with many townspeople,
showing them some part of his plan, so that he led them to the
decision to give the commission for this project either to him
or to one of the foreigners. As a result, the consuls, trustees,
and citizens, encouraged in this fashion, all met together and
discussed the project with the architects. But with his strong
arguments, they were all beaten and won over by Filippo. It is
said that the argument over the egg arose during the meeting
in the following way. They wanted Filippo to explain his
intentions in detail and to show his model, as they had shown
theirs, something he did not want to do, and he in turn
proposed to both foreign and Florentine masters that whoever
could stand an egg upright upon a marble slab should execute
the dome, since in this way their intelligence would be
revealed. Therefore, when Filippo produced an egg, all those
masters tried to make it stand upright, but none of them found
the way to do it. Then they asked Filippo to do it, and he
graciously took the egg, cracked its bottom on the marble and
made it stand upright. The artisans loudly complained that
they could have done the same thing, and, laughing, Filippo
answered that they would also have learned how to vault the
dome if they had seen his model and his plans. And so they
decided that Filippo should have the responsibility of ex-
ecuting this project, and he was told to give more details to
the consuls and trustees.

After he had returned home, Filippo wrote down what he
had in mind as clearly as he could upon a sheet of paper in
order to give it to the assembled officials in this fashion:

Honourable Trustees, considering the difficulties involved in building
this structure, I find that there is no possible means of forming the
vaults in a perfect circle, since the plane of the lantern is so great that
any weight placed upon it would immediately cause it to collapse.
Thus, it seems to me that those architects who have not kept their eye
on the longevity of such a structure show little passion for memorials
and do not understand why they are built. I decided, therefore, to
construct inner vaulting in sections matching the outer sides, giving
them the proportions and curvature of the pointed arch, for the
curvature of this type of arch always thrusts upwards to form the top
of the dome, and when the lantern is loaded on to the dome, they
will combine to make it durable. At its base, the vaulting must be
three-and-three-quarter armslengths thick, and it must rise like a
pyramid, narrowing outside where it closes up and where the lantern
is to be placed. And the vault must be one-and-one-quarter arms-
lengths thick. Then another vault must be made over this one which
will be two-and-a-half armslengths thick from the base, in order
to protect the one inside from the rain. This one must also diminish
proportionally like a pyramid and join the lantern like the other
vault, so that at its apex, it will be two-thirds of an armslength thick.
For every angle, there will be a ribbed buttress, making eight in all;
and there will be two buttresses for the middle of every side, which
makes a total of sixteen; two buttresses, each one four armslengths
thick at the base, must be built in the middle of these angles on the
interior and exterior of each face of the dome. The two vaults,
erected in the shape of pyramids, must rise together in equal
proportions up to the summit of the eye, which is closed up by the
lantern. Then twenty-four buttresses will be erected with the vaults
built around them as well as six arches of blue-grey sandstone, which
will be strong, long, and well-braced with iron; the iron ties will be
covered with tin, and iron chains will be placed over the blocks of
blue-grey sandstone to bind the vaulting to the buttresses. The
foundation must be built of solid blocks up to a height of five-and-
one-quarter armslengths, and from there the buttresses must continue
and the vaults must be separated. The first and second circles must be
completely reinforced at the base with long blocks of blue-grey
sandstone laid lengthwise, so that both of the dome's vaults may rest
upon them. And at the height of every nine armslengths, the vaults
should possess smaller arches between the buttresses linked together
with thick oaken ties to bind the buttresses that hold up the inner
vaulting. These oaken ties will then be covered with iron plates
because of the stairways. All of the buttresses must be constructed
with blue-grey sandstone and hard stone, and, in like manner, the

sides of the dome must be made of thick stone bound to the
buttresses up to a height of twenty-four armslengths, and from that
point on must be built with bricks or pumice stone, according to
whatever the builder may decide, to make them as light as possible.
Outside a passage-way must be constructed above the round win-
dows and a terrace below with perforated parapets two armslengths
high, corresponding to those of the little tribunes below; or rather
there should be two passage-ways, one above the other, resting upon
a well-decorated cornice, with the one above left uncovered. The
rain-water will be carried off the dome by a marble gutter, one-third
of an armslength wide, which will throw the water into a section of
hard stone constructed under the gutter; at the angles on the outside
surfaces of the dome there will be eight marble ribs of an appropriate
size and rising an armslength high above the dome, corniced at the
head and two armslengths wide, so that there may be peaks and eaves
everywhere. They must rise like a pyramid from their base up to the
summit. The two vaults must be constructed in this manner without
a framework up to a height of thirty armslengths, and from there
on in whatever way the master builders who are charged with its
construction advise, since practical experience will show how the
work should be carried out.

When Filippo had finishing writing this, he went in the
morning to the assembled officials, and after he gave them this
sheet of paper they considered the whole proposal. And
although they were incapable of understanding it, they saw
the liveliness of Filippo's mind and the fact that none of the
other architects was on firmer ground, in contrast to Filippo,
who displayed an obvious confidence in his explanations,
repeating the same thing in such a way that it seemed as if he
had already constructed ten such vaults. The consuls drew to
one side and decided to give him the project, but they did
want to see some proof of how the vault could be constructed
without any framework, while approving all the rest of his
details. Fortune was favourable to their desire, for Bartolomeo
Barbadori* had previously wanted to build a chapel in the
church of Santa Felicita and had discussed it with Filippo, who
had set to work and without a framework had vaulted this
chapel, which is at the entrance of the church on the right by
the holy-water stoup, also by his hand. And similarly, Filippo
had, at that time, vaulted another chapel in the church of San

Jacopo sopr'Arno for Stiatta Ridolfi next to the chapel of the high altar. These works inspired more confidence in Filippo's project than had his explanations.

And so, after the consuls and the trustees of the Works Department were convinced by Filippo's written explanation and by the projects they had examined, they commissioned the dome to him, naming him the principal master builder by a vote taken with beans. But they contracted with him to build no higher up than twelve armslengths, telling him that they wanted to see how the project was turning out; if it succeeded, as he claimed, they would not fail to commission him to do the rest of the work. Filippo thought it was strange to see such obstinacy and mistrust on the part of the consuls and trustees; and if he had not been convinced he was the only man capable of completing such a project, he would not have set to doing it. Yet, since he was anxious to pursue the fame it would bring, he took it on and pledged himself to bring the project to a perfect conclusion. His sheet of paper and his pledge were copied into a book used by the superintendent for keeping accounts for the wood and marble; Filippo was granted the same allowance for his work that they had given up to that time to other master builders. When the artisans and the townspeople learned that the commission had been granted to Filippo, some approved but others were resentful, as is always true of popular opinion, as well as the opinions of those who are thoughtless or envious. While preparations for beginning the construction were under way, there arose a faction among the artisans and townspeople who went to face the consuls and trustees and declared that the decision had been made in haste, that a project such as this one should not be undertaken on the advice of a single man, and that they could be excused for doing so only if there were a lack of excellent artisans, but there was, instead, an abundance of them. The decision, they claimed, brought no honour to the city, since if any mishap occurred, as sometimes happens with buildings, they might be blamed for having given too onerous a task to a single individual without considering the damage and public shame which might result from this; and so, in order to curb Filippo's enthusiasm, it

would be well, they claimed, to provide him with a partner.

Lorenzo Ghiberti had earned a fine reputation for the demonstration of his genius in the doors of San Giovanni, and the fact that he was admired by certain men who were very influential in the government was shown very clearly when these men observed Filippo's fame growing, and, under the pretext of their love and affection for this building, these men worked on the consuls and trustees in such a way that they imposed an associate on Filippo for this project. The degree of Filippo's despair and bitterness over what the trustees had done may be measured by the fact that he was about to leave Florence, and if it had not been for Donatello and Luca della Robbia, who comforted him, he might well have lost control. Truly wicked and cruel is the anger of those who, blinded by envy, endanger honour and beautiful works through ambitious rivalry! It was certainly not to their credit that Filippo did not destroy his models, burn his plans, and in less than half an hour discard the results of all the work he had done for so many years. The trustees first begged Filippo's pardon and urged him to proceed, assuring him that he, and no one else, was the inventor and creator of this structure, but they gave Lorenzo the same salary as they gave to Filippo. Filippo carried on the project with very little enthusiasm, realizing that he would have to endure all the hard work that it would require and that he would then have to share the honour and fame with Lorenzo. Still, he determined that he would find some way of ensuring that Lorenzo would not last too long on the project, and he went ahead together with Lorenzo according to his contract with the trustees.

Meanwhile, it occurred to Filippo to make a model, since no one had yet done so, and having thus set to work, he had it done by a carpenter named Bartolomeo* who lived near the studio. And in this model, which was made exactly to scale, he characteristically included all the difficult details, such as the illuminated and dark stairways, all sorts of windows, doors, tie irons, and buttresses, as well as a section of the gallery. Having heard about this model, Lorenzo tried to see it, but when Filippo prevented him from doing so, he flew into a rage and ordered a model of his own to be made so that it would

appear he was actually earning his salary and that he was about to do something. Filippo was paid fifty lire and fifteen soldi for these models, as we can see in an allocation recorded in the account book kept by Migliori di Tommaso on the third of October in 1419, and Lorenzo Ghiberti received three hundred lire for the labour and expenses incurred in making his model, more because of the friendship and favour that he enjoyed than because of its usefulness or benefit to the building project.*

This situation, which lasted until 1426, was an aggravation in Filippo's eyes because both Lorenzo and Filippo were considered equally to be the originators of the project, and the mental anguish Filippo suffered over this was so strong that he lived in great pain. Meanwhile, he had developed various new concepts and finally decided to rid himself of Lorenzo, who he realized would be of little use in this undertaking. Filippo had already raised the two vaults all around the dome to a height of twelve armslengths, and now had to install the stone and wooden ties. This was a difficult task, and he wanted to discuss it with Lorenzo to discover whether or not Lorenzo had considered these problems. And he found out that Lorenzo had not even thought about these matters and that his only response was to say that he relied upon Filippo, since Filippo was the designer. Lorenzo's reply delighted Filippo, since he felt this provided him with a way to remove Lorenzo from the project and to reveal that Lorenzo lacked the knowledge his friends thought he possessed and that it was their favouritism which had put him in the position he occupied.

Now the workmen on the project were at a standstill and were awaiting orders to begin the section above the twelve armslengths, to build the vaults and to bind them with the chains, since the dome had begun to close up towards the top. To do this, they had to build scaffolding so that the workmen and masons could work without danger, since the height was so great that merely looking down from above brought fear and dismay to even the most confident soul. Therefore, the masons and the other master builders were awaiting the plans for building the chains and scaffolding, and when neither Lorenzo nor Filippo made any decisions, the masons and the

other masters began to mutter among themselves when they saw that the initial sense of urgency was now lacking. And since these men were poor individuals who lived by their labour and were afraid that neither architect had the courage to go ahead with the project, as best they could and knew how, they remained at work on the structure, replastering and retouching everything that had been built up to that moment.

One morning or another, Filippo did not turn up at work but went to bed with a bandage around his head, and, constantly crying out, he had hot plates and cloths prepared with the greatest solicitude, pretending to have a pain in his side. When they heard this, the masters awaiting orders about how to proceed asked Lorenzo what should be done next. He replied that the schedule was Filippo's responsibility and that they would have to wait for him. Somebody asked him: 'But don't you know what he has in mind?' 'Yes,' Lorenzo answered, 'but I wouldn't do anything without him.' Lorenzo said this to excuse himself, for he had never seen Filippo's model and had never asked him what kind of schedule he wanted to keep to, and, in order not to appear ignorant, he was very vague and answered only in ambiguous terms in speaking about the matter, especially since he knew that he was taking part in the project against Filippo's will.

Filippo's illness had already lasted more than two days, and the supervisor of the project and a good number of the master builders went to see him and continuously begged him to tell them what they should do. But Filippo declared: 'You have Lorenzo; let him do a little something.' Nor could they get any other answer out of him. Upon hearing this, discussions and serious criticism arose over the entire project: some people were saying that Filippo had taken to bed out of grief because he lacked the courage to vault the dome, or that he regretted having become involved in the project. And his friends defended him, saying that if he were upset, it was a result of the disgrace of having been given Lorenzo as a partner, but that he was actually ill from the pain in his side, caused by his strenuous work on the project.

Thus, while the arguments continued, the project was stalled, and almost all of the work by the masons and the

stone-cutters came to a standstill. And these men, muttering against Lorenzo, began to say: 'He's good enough to draw his salary but not to give orders so that we can do the work. Oh, if Filippo were not here, or if his illness were to last for long, how would Lorenzo manage? Is it Filippo's fault that he is sick?' Seeing themselves put to shame by this state of affairs, the trustees of the Works Department resolved to go and see Filippo, and upon arriving, they first consoled him for his illness and then explained to him the state of disorder into which the building project had fallen and how many difficulties his illness had caused. At this, with speech impassioned both by his love for the project and by his feigned illness, Filippo declared: 'Isn't he there—Lorenzo? What is he doing? I'm amazed at you.' When the trustees responded, 'He won't do anything without you!', Filippo retorted to them: 'I would do quite well without him.'

His very pointed and double-edged reply was enough for them, and after they had left him, they knew he was ill because he wanted to work alone. Therefore, they sent his friends to remove him from his bed, intending to take Lorenzo off the project. And so Filippo returned to the building, but when he saw the degree of favouritism shown to Lorenzo and realized that he would still receive his salary without doing any work, Filippo devised another means of holding him up to ridicule and making public how little understanding Lorenzo had of this profession. And in Lorenzo's presence, he presented this proposal to the trustees:

My Lords the Trustees, if we were as sure about the length of time we have to live as we are about the probability of our death, there is no doubt whatsoever that many projects which are begun would be completed rather than left unfinished. The misfortune of the illness I suffered could have taken my life and brought this project to a halt. Therefore, in case I ever fall ill again, or—God forbid!—Lorenzo should, in order for one or the other of us to go on with his part of the work, I thought that just as you, My Lords, have divided the salary between us, so you should also divide the work, so that spurred on by the desire to demonstrate what each of us knows, each may securely acquire honour and profit in the presence of this republic. Now, there are two difficult matters which at present have to be dealt

with: the first is the scaffolding so that the masons can lay their bricks, which is to be used both inside and outside the structure and which must hold up workers, stones, and lime, as well as the winch for pulling up heavy loads and other similar devices; the other is the chain which has to be placed above the level of twelve-armslengths in order to bind the eight sides of the dome and to support the structure, so that all the weight superimposed upon it will tighten and hold it in such a way that the weight will not stretch or widen the dome but will, on the contrary, be evenly distributed throughout the entire edifice. Let Lorenzo, therefore, take up one of these tasks, whichever he feels he can most easily carry out, and I shall work without any disagreement to execute the other so that no more time is lost.

When he heard this, Lorenzo was forced for the sake of his own honour to accept one of these tasks, and even though he did so quite unwillingly, he decided to pick the chain as the easiest of the two, since he could trust the advice of the masons and remembered that in the vault of San Giovanni in Florence, there was a chain of stone ties from which he could take part, if not all, of the plan. And so one set to work on the scaffolding while the other worked on the chain, and both completed their work. Filippo's scaffoldings were built with so much ingenuity and skill that they were truly considered to be the contrary of what many had imagined them to be before, since the masons could work upon them just as safely and could pull up heavy loads and stand upon them just as securely as if they were standing upon solid ground. And the models for this scaffolding are preserved in the Works Department of the Duomo. Upon one of the eight sides, Lorenzo built his chain with the greatest difficulty, and when it was completed Filippo was called by the trustees to see it; he said nothing to them, but with certain of his friends he discussed the matter, declaring that another kind of binding was required, that it should have been put up in a different way, that it was not sufficient to support the weight that was to be placed on it, since it did not bind the structure as tightly as it should, and, finally, that the allowance which was given to Lorenzo, along with the cost of the chain he had built, was money thrown away. Filippo's opinion became known, and he was charged with showing how he would have constructed the chain if he

had undertaken that task. Since he had already prepared plans
and models, he immediately showed them, and when they
were examined by the trustees and the other master builders,
they recognized the error they had fallen into by favouring
Lorenzo, and wishing to rectify this mistake and to demon-
strate that they understood the proper procedures, they named
Filippo administrator and head for life of the entire structure*
and ordered that nothing should be done on the project
without his approval. And in order to acknowledge their
approval, they presented Filippo with the gift of one hundred
florins appropriated by the consuls and trustees on 13 August
1423, and signed by Lorenzo Paoli, notary of the Works
Department, and charged to Messer Gherardo di Filippo
Corsini; and they came to a decision to provide Filippo with
an allowance for life of one hundred florins a year.*

And so, having given orders for the construction to
proceed, Filippo pursued it so closely and carefully that not a
stone could be placed without his wanting to inspect it. On
the other hand Lorenzo, finding himself beaten and nearly
disgraced, was favoured and assisted to such an extent by his
friends that he still drew his salary, claiming he could not
be dismissed for another three years. For every little detail,
Filippo continuously drew sketches and made models of
frames to be built and structures for pulling up heavy loads.
But this did not prevent spiteful people, friends of Lorenzo,
from driving him to desperation, having different models built
every day to compete with his, to the extent that Master
Antonio da Verzelli* executed one of them, while other mas-
ters, shown favouritism and preference now by this citizen
and now by that one, demonstrated their fickle nature, their
inadequate knowledge, and their lack of understanding, for
although they had perfect models in hand, they kept pro-
moting imperfect and useless ones.

The chains around the eight sides of the dome were already
completed, and the masons, gaining heart, worked boldly, but
Filippo then asked of them more than the usual, and because
of some criticism that he directed at their work as well as some
other things which happened daily, they got sick and tired of
him. And so, moved by this and by envy, the leaders joined

together in a conspiracy and said that the work was strenuous and dangerous, and that they did not want to vault the dome without a huge raise (even though their salary had already been increased more than usual), thinking in this way to take revenge upon Filippo and to make a profit for themselves. This development displeased the trustees and Filippo as well, and, having thought about it, one Saturday evening he made up his mind to fire them all. Finding themselves fired and not knowing how matters might end, the men were in a very bad humour, and on the following Monday Filippo set ten Lombards to work, and by staying right there on the spot, ordering 'Do this here and that there', he taught them so much in a single day that they worked on the project for many weeks. On the other hand, the masons who saw themselves fired, their work taken away from them, and this disgrace heaped on them, did not have any other work that was more profitable than this, and they sent messengers to tell Filippo that they would willingly return to work, begging his pardon as vigorously as they could. In this way, Filippo kept them dangling for many days in the fear that he would not hire them back; then he took them back at a lower salary than they had initially received; and so, where they had thought to make a profit, they suffered a loss, and with their vendetta against Filippo they only caused damage and loss for themselves.

The grumbling thus stopped, and the genius of Filippo prevailed, once it was seen how smoothly the structure was being vaulted, and anyone who was not blinded by passion held that he had already shown a courage never seen in the works of any other architects, either ancient or modern, and this came about because he brought out his model. In it everyone could see for himself the extremely careful plans he had conceived for the stairs, the lighting both inside and out (so that no one might injure himself in the darkness out of fear), and all the various iron guard-rails for the ascent which were set up and carefully arranged where the climb was steep. Besides this, he had even thought of putting iron bars inside to support the scaffolding if ever mosaics or paintings were to be added; and he likewise placed in the least dangerous positions

the various sections of the guttering from which the water could run off, showing some covered, others uncovered; and he followed this up by organizing various holes and openings so that the force of the winds would be broken and to ensure that exhalations or earthquakes could not damage the structure. In all of this he demonstrated how much he had profited from his studies during his many years in Rome. Considering what he achieved in the dovetailing, fitting, joining, and binding the stones makes one tremble and stand in awe and shrink with fear at the thought that a single mind was capable of as much as that of Filippo. And it continued to grow at such a pace that there was nothing, no matter how difficult and challenging, it could not render simple and easy. And he showed this in using counterweights and wheels for hauling heavy loads, which enabled a single ox to draw a load as heavy as six pairs could barely have drawn before.

The structure had grown so high by this time that it was extremely disruptive to go down to the ground after having climbed up, and not only was a great deal of time lost by the masters in going to eat and drink, but they suffered great discomfort from the heat of the day. Filippo therefore found a way to open eating places with kitchens on the dome, where he sold wine as well, and in this fashion no one left the work until the evening. This was convenient for the workmen and exceedingly advantageous to the project. Filippo's spirits rose so high as he observed the project moving steadily ahead and turning out so successfully that he worked constantly; he himself went to the kilns where the bricks were being formed, since he wanted to see the clay and knead it himself, and when the bricks were baked, he wanted to pick them out as carefully as possible with his own hands. He would examine the stones being used by the stone-cutters to see if they were hard or contained any thin cracks, and he provided them with models for the joints and the fittings made from wood, from wax, and even from turnips, and similarly, he designed iron tools for the blacksmiths. He discovered a means of producing hinges with heads and hooks which greatly simplified architecture, which through him was raised to a level of perfection probably never before achieved among the Tuscans.

In 1423, Florence could not have been happier or more joy-
ful when Filippo was elected to the Signoria for the months
of May and June by the San Giovanni district,* while Lapo
Niccolini was chosen as Gonfaloniere of Justice by the Santa
Croce district. And if he is found listed in the register of priors
as Filippo di Ser Brunellesco Lippi, as he ought to be, no one
should be surprised by this, since his grandfather was named
da Lippi and not de' Lapi—an error which is seen in this same
register and repeated in countless other lists, as anyone well
knows who has seen it or is familiar with the customs of those
times. Filippo performed the duties of this office and the other
judicial positions he held in his native city and always
demonstrated good judgement in all his actions.

They had already begun to close the two vaults towards the
eye where the lantern was to begin, and although Filippo had
constructed in both Rome and Florence several models in clay
and in wood of each one, which had not been seen, he still had
to make the final decision about which one he wanted to
execute. Deciding to complete the gallery, he drew several
designs for it which remained, after his death, in the Office
of the Works Department but which have been misplaced
because of the carelessness of those officials. In our own day, in
order to complete the project, one section of one of the eight
sides was built, but because it did not match Filippo's design,
it was abandoned and left unfinished upon the advice of
Michelangelo Buonarroti.

With his own hands, Filippo also made a model for the
lantern with eight sides based upon the proportions of the
dome, which, to tell the truth, turned out very well because of
its inventiveness, variety, and decoration. He included in the
model a stairway for climbing up to the ball [on the lantern],
which was a marvellous thing indeed, but because he had
plugged up the entrance with a piece of wood inserted from
underneath, no one but Filippo knew it existed. Although he
was now highly praised and had already triumphed over the
envy and the arrogance of many, he was not able to prevent
all the masters in Florence from setting out to produce various
models of their own, once they had seen what he had done,
and even a woman from the Gaddi family dared to enter

the competition with Filippo's design! However, he merely
laughed at their presumption, and many of his friends advised
him not to show his model to any other artisans, so that they
would not learn from it. To them he replied that there existed
only one good model, and that the rest were worthless. Some
of the other masters had put details from Filippo's model into
their own, but when he saw them, Filippo would always say:
'The next model this man makes will be just like mine.'

Filippo's model was lavishly praised by everyone, but they
supposed it to be defective, since they could not see the
stairway leading to the ball. Nevertheless, the trustees decided
to commission Filippo to do the project, provided, however,
that he showed him where to place the stairway. So Filippo
removed the piece of wood from the model, which was in
the lower part, revealing in a pillar the stairway as we see it
today—in the form of a hollow tube; on one side, there was a
channel with bronze rungs by which, placing one foot after
the other, one might climb up to the top. Because Filippo was
old and would not live long enough to see the lantern com-
pleted, he stipulated in his will that it should be built follow-
ing the model and his written instructions. Done otherwise,
he declared, the structure would collapse, because it was
vaulted in a pointed arch, and the weight would have to press
downward to strengthen it. Filippo was not able to see the
completion of the edifice before his death, but he raised it up
quite well to a height of several armslengths. He also had
almost all the marble that was to be used cut and carefully
prepared, and when the people saw all the marble delivered,
they were amazed that it was possible he wished to place such
a weight upon that vaulting. It was also the opinion of many
clever people that the vaulting would not bear the weight, and
it seemed to them quite fortunate that he had brought the
project to where it then stood and that it was tempting God to
load the vaults too heavily. Filippo always laughed about this
to himself, and after preparing all the machinery and gear that
would be used to build it, he spent all his time and thought in
anticipating, preparing, and providing for every little detail,
even to the point of making sure that the corners of the
finished marble would not be chipped when it was being

hauled up by protecting all the arches of the tabernacles with wooden frames, and as for the rest, as I have said, there were written instructions and models.

As for how beautiful the project is, the structure itself provides the most eloquent testimony. From ground-level to the lantern, the height measures one hundred and fifty-four armslengths; the body of the lantern thirty-six armslengths; the copper ball four armslengths;* the cross eight armslengths; or two hundred and two armslengths in all.* And it can quite rightly be declared that the ancients never constructed their buildings so high, nor did they run so great a risk as that of wishing to challenge the heavens, as this work of Filippo's surely seems to do: seeing it soaring up to such a height, it appears equal to the mountains around Florence. And, to tell the truth, it appears that the heavens are envious of it, for it is continuously struck by lightning bolts every day.

While this project was under construction, Filippo worked upon many other buildings which we shall now describe in order. With his own hand, he constructed a model for the chapter house of Santa Croce in Florence for the Pazzi family,* a work of great variety and beauty.* ... Around that time work was begun on the church of San Lorenzo in Florence by order of the parishioners, who had named the prior as master builder of the structure, a man who professed to understand architecture and who took great delight in it as a pastime. He had already begun the construction of brick pillars when Giovanni di Bicci de' Medici, who had promised the parishioners and the prior to erect the sacristy and a chapel at his expense, had Filippo over for lunch one morning, and after discussing a number of things, he asked Filippo about the initial work on San Lorenzo and what he thought of it. Filippo was forced by Giovanni's entreaties to reveal his honest opinion, and in order to tell the truth, he found fault with many details of the project, such as the fact that it was organized by a person who perhaps possessed more book learning than experience with buildings of that kind. Whereupon, Giovanni asked Filippo if he could produce something better and more beautiful, and to this Filippo replied:

Without a doubt! And I am amazed that, as the leader of this project, you do not pledge several thousand *scudi* and construct the body of a church with dimensions worthy of such a site and of the burial places of so many noblemen, for once the nobility see such a beginning, they will follow suit with their chapels and all their resources— especially since no other memory of us remains behind except the walls which bear witness for hundreds and thousands of years to those who constructed them.*

Inspired by Filippo's words, Giovanni decided to construct the sacristy and the major chapel along with the entire body of the church, although only seven other families agreed to join him because the others lacked the resources. And these families were: the Rondinelli, the Ginori, the Dalla Stufa, the Neroni, the Ciai, the Marignolli, the Martelli, and the Marco di Luca, and their chapels were to be built in the cross of the building. The sacristy was the first part to be erected, while the church was built a section at a time. The other chapels constructed along the length of the church were then granted one by one to parishioners who were not of the nobility. The sacristy had not yet been covered when Giovanni de' Medici passed to a better life, leaving behind his son Cosimo. Cosimo possessed a bolder spirit than his father, and, taking delight in such memorials, he arranged for the construction to continue as his first building project, which brought him so much pleasure that from then on until the time of his death, Cosimo was always building. Cosimo took a warmer interest in this project, and while one part was being planned, another was being completed. And since Cosimo had taken on the project as a pastime, he was constantly occupied with it. His concern was the reason why Filippo completed the sacristy and Donatello made the stuccoes, the stone ornaments for the porticoes, and the bronze doors. Cosimo also had his father's tomb constructed under a large slab of marble supported by four small columns in the middle of the sacristy where the priests don their vestments, and in the same place, he had tombs built for his own family, separating the women from the men. In one of the two little rooms on either side of the sacristy, he built a well and a wash-basin in one corner. And all in all, everything built in this structure reflects his excellent judgement.

Giovanni and the others had planned to place the choir under the tribune in the middle; Cosimo changed this plan at Filippo's suggestion. Filippo enlarged the main chapel (which was originally a smaller space) so that the choir could be constructed where it stands today, and when it was completed, the tribune in the middle and the rest of the church remained to be built. This tribune and the remainder [of the church] was not vaulted until after Filippo's death. The church is one hundred and forty-four armslengths long, and a great many mistakes can be seen in its construction; one among the others is that of placing the columns on the ground without mounting them on dados of the same height as the bases supporting the pillars on the steps. Thus, the pillars appear shorter than the columns, making the entire work look lopsided. All this was the result of following the advice of the men who remained after Filippo died and were envious of his renown, and who, during his lifetime, having constructed opposing models, had been, nevertheless, humiliated by some of his sonnets. And after Filippo's death, these individuals took their revenge not only upon this project but upon all those which remained for them to complete. Filippo left behind his model, and completed part of the presbytery for the priests of San Lorenzo, making the cloister one hundred and forty armslengths long.

While this building was being constructed, Cosimo de' Medici decided to build his own palace, and he therefore explained his intentions to Filippo, who put everything else aside and made for Cosimo a very beautiful and large model of this palace, which Filippo wanted to place in the piazza facing San Lorenzo, isolated on every side. Filippo's virtuosity was so clearly displayed in this model that it seemed too luxurious and grand to Cosimo, and, more to avoid envy than the expense, he gave up the idea of using Filippo's plan. While Filippo was working on the model, he used to thank fate for the opportunity of building such a home—something he had desired to do for many years—and for having come upon someone who wanted and was able to build it. But then when he learned of Cosimo's decision not to go on with the project, he angrily broke his model into a thousand pieces. And

Cosimo was very sorry not to have followed Filippo's plan, for he later constructed the other palace,* and he used to say that he had never conversed with a man of greater courage and intelligence than Filippo.... *

It is also said that Filippo invented the machinery for the Paradise of San Felice in Piazza (located in the same city) in order to stage the mystery play or, rather, the feast of the Annunciation as was customary in the old days at that place in Florence. The machinery was truly marvellous and demonstrated the talent and skill of the man who invented it, for on high a Heaven full of living and moving figures could be seen, as well as countless lights, flashing on and off like lightning. I do not want my description to appear laboured in recounting precisely how the mechanisms of this machinery functioned, since every bit of it has been ruined and the men who knew how to discuss its workings from experience are now dead. There is no hope of reconstructing it, for the Camaldolite monks who once inhabited the place are gone and have been replaced by the nuns of Saint Peter Martyr, primarily because the monastery of the Carmine was damaged by the machinery which pulled down the timbers supporting its roof.

In order to create these effects, Filippo had placed a half-globe shaped like an empty bowl, or a barber's basin turned upside-down, between two of the beams which supported the roof of the church. This half-globe was made from thin and light laths fastened to an iron star which turned around its circumference; the laths narrowed towards a large iron ring in the centre, which was balanced in the middle and around which revolved the iron star which supported the framework of laths. This entire mechanism was held up by a strong beam of fir-wood well reinforced with iron, which was lying across the timbers of the roof, and to this beam was attached the ring which held the half-globe suspended and balanced. From the ground it truly looked like Heaven. At its base on the inside edge, certain wooden brackets were placed, just large enough for a person to stand upon, and also inside but at the height of an armslength, there were iron clasps. On each of the brackets stood a child of about twelve years of age, secured with an iron clasp one-and-one-half armslengths high in

such a way that he could not have fallen even if he tried.

These young cherubs, twelve in all, were arranged upon the brackets, as I have explained, and were dressed as angels with golden wings and golden skeins of hair. When it was time, they joined hands, and as they moved their arms about, they seemed to be dancing—especially since the half-globe was constantly turning and moving. Inside the globe and above the angels' heads were three circles or garlands of lights set up with some tiny little torches that could not be overturned. These lights looked like stars from the ground, while the supports covered with raw cotton resembled clouds.

From the above-mentioned ring hung a thick iron bar with another ring on its side, to which was attached a thin cord which fell to the ground, as I shall describe. This thick iron bar had eight arms which revolved in an arc large enough to cross the entire space of the empty half-globe, and at the end of each arm was a flat stand as large as a wooden platter; placed on each stand was a young boy of about nine years of age who was held tightly in place by an iron clasp soldered to the upper portion of the branch, but in such a fashion that he could turn slowly in every direction. Supported by this iron bar, these eight little angels were lowered, by means of a small winch which was let out very slowly, from the empty space in the half-globe to a distance of eight armslengths below the level of the flat timbers supporting the roof, in such a fashion that they could be seen without obstructing the view of the other angels who were standing around the inside of the half-globe. Inside this 'bouquet' of eight angels (as it was appropriately called) was a copper mandorla which was hollow inside and contained many little torches set in small holes upon an iron tube shaped like a pipe: when a spring was held down, all of the lights were concealed in the empty space within the copper mandorla; and when the same spring was released, all of the lights could be seen shining through the little holes.

Once the 'bouquet' reached its appointed place, the mandorla, which was attached to that thin cord, was lowered very, very slowly by another little winch and reached the platform where the performance took place. On the stage, exactly where the mandorla came to rest was a raised throne with four

steps in the middle with an opening through which the iron point of the mandorla passed. A man hidden below the throne bolted the mandorla down when it reached its place, and it thus stood securely upright. Inside the mandorla, playing the role of an angel, was a young boy of about fifteen years of age who was fastened by an iron clasp to the middle of the mandorla and also to its base to prevent him from falling, and so that he could kneel, the iron clasp was made in three pieces—as he kneeled down, one piece slid smoothly into the other.

And so, when the 'bouquet' was lowered down and the mandorla rested upon the throne, the man who bolted down the mandorla unfastened the iron clasp which held in the angel, whereupon he came out, walked along the stage, and reached the place where he hailed the Virgin and made the Annunciation. Then, after he returned to the mandorla, while the lights—which had been extinguished upon his arrival—were relit, the iron clasp supporting him was fastened once again by the man hidden underneath; and once the bolt holding the mandorla down was released, it was drawn upwards once again, while the angels in the 'bouquet' sang and those in the Heaven turned about, making it seem a real Paradise, especially since, besides the chorus of angels and the 'bouquet', there was a figure of God the Father near the shell of the half-globe surrounded by angels similar to the ones described above and secured with iron clasps. In this fashion, the Heaven, the 'bouquet', the figure of God the Father, and the mandorla with its countless lights and sweet music truly represented Paradise. In addition, to make it possible to open and close this Heaven, Filippo had two huge doors built on either side, each five armslengths high, with iron rollers, or actually copper ones, set in grooves, and the grooves were so well oiled that when a thin rope was pulled on either side with a small winch, the doors opened and closed, according to what was desired, by drawing together the two parts of the doors or drawing them slowly apart by means of the grooves. And, thus constructed, these doors produced two effects: first, since they were heavy, they created a noise sounding like thunder when they were pulled; second, when closed they served as

a stage for arranging the angels and for accommodating the other items that were needed inside. Thus, these ingenious devices, as well as many others, were invented by Filippo, even if some people maintain that they were invented long before him. Whatever the case may be, it is appropriate to have discussed them, since they have completely fallen into disuse.

But let us return to Filippo. His fame and reputation had grown to such an extent that anyone who needed to construct a building sent for him from great distances to obtain drawings and models prepared by the hand of such a great man, and people would employ the influence of his friends and the most lavish means to do so.... *

One year during Lent, the sermons at the church of Santo Spirito were delivered by Master Francesco Zoppo, then very popular with the congregation, who spoke strongly in favour of the convent, the school for young men, and especially the church which had burned down in those days.* As a result, the leaders of the district—Lorenzo Ridolfi, Bartolomeo Corbinelli, Neri di Gino Capponi, Gogo di Stagio Dati, and countless other citizens—obtained permission from the Signoria to rebuild the church of Santo Spirito, and they named Stoldo Frescobaldi the supervisor. Because of the interest Stoldo had in the old church (the main chapel and the high altar of which belonged to his family), he toiled long hours on this project. In fact, at the very beginning, before the funds were received from taxing those who owned tombs and chapels there, he provided thousands of *scudi* out of his own pocket, for which he was later reimbursed.

After the project had been discussed, Filippo was sent for, and he made a model complete with all the useful and honourable details he could devise suitable for a Christian church. Filippo urged that the ground-plan of this edifice be turned completely around, since above all he wanted the piazza to reach the bank of the Arno so that everyone passing by there from Genoa, the Riviera, the Lunigiana district, and from the areas of Pisa and Lucca could observe the magnificence of the structure. But because certain citizens who did not wish to tear down their homes refused this change, Filippo's desires had no impact.

Filippo then constructed a model for the church along with that of the monks' quarters as it is today. The length of the church was one hundred and sixty-one armslengths, while its width was fifty-four armslengths, and it was so well planned in the arrangement of its columns and its other decorations, that no other building could have been constructed which would have been richer, more delightful, or more graceful. And, to tell the truth, if it had not been for the curse of those who spoil the lovely beginnings of things by always pretending to understand more than others, this church would today be the most perfect church in all Christendom. As it stands, it is therefore more charming and better proportioned than any other, even though its model was not followed in every respect, as we see in certain external details which do not reflect the arrangement of its interior: it seems, for example, that this is the case with the doors and the frames of the windows, which do not correspond to those in the model. I shall pass over some errors attributed to Filippo, which, one has to believe, would not have been tolerated if he had carried out the building's construction, for everything he created he brought to perfection with his great judgement, discretion, ingenuity, and skill. And this work proved him to possess a truly divine genius.

Filippo was humorous in his conversation and very witty in his retorts. For example, on one occasion he wished to make a biting remark about Lorenzo Ghiberti who had bought a farm at Monte Morello, called Lepriano. Spending two times more on this farm than he earned from it, Lorenzo became so disgusted with it that he sold it. When someone asked Filippo what was the best thing Lorenzo had ever done, perhaps thinking that he should vex Lorenzo because of the enmity between them, Filippo replied: 'Selling Lepriano.'

Finally, having grown very old—that is, having reached the age of sixty-nine—Filippo passed to a better life in the year 1446 on the sixteenth of April, after labouring strenuously to create those works which earned him an honourable name on earth and a resting place in Heaven. His death caused indescribable grief in his native city, which recognized and esteemed him more after death than it had done while he was alive, and he

was buried with elaborate ceremony and the greatest honour in Santa Maria del Fiore (although his family tomb was in San Marco) under the pulpit near the door, where there is a coat of arms with two fig leaves and some green waves in a field of gold, indicating that his ancestors came from the region of Ferrara, namely, from Ficaruolo, a walled town on the River Po, as is suggested by the leaves which signify the place and the waves the river. His artisan friends grieved most deeply— especially the poorer ones whom he constantly assisted. Thus, living like a Christian, he left to the world the memory of his kindness and his remarkable talents. In my opinion, it can be said of Filippo that from the time of the ancient Greeks and Romans to the present day, there never existed a man more rare or excellent than he, and Filippo deserves even greater praise, for in his lifetime the German style was venerated throughout Italy and practised by older artisans, as is seen in countless buildings. Filippo rediscovered the use of the ancient cornices and restored the Tuscan, Corinthian, Doric, and Ionic orders to their original forms.* . . . Filippo was most unfortunate in some respects, because besides always having to contend with some opposition, several of his buildings were not completed during his lifetime, and they were left unfinished afterwards. And among the other unfinished projects, it was a great tragedy that the monks of the Angeli could not (as I mentioned) complete the church he began,* since after they had spent more than three thousand *scudi* on what we can see today—the funds coming in part from the Merchants' Guild and in part from the Monte where the moneys were deposited —the capital was squandered, and the structure was left and remains incomplete. Thus, as was mentioned in the life of Niccolò da Uzzano,* whoever wishes to leave behind a memorial of this kind should complete it himself while he is still alive, without relying upon anyone else. And what I have said about this church could also be said of a great many other buildings planned by Filippo Brunelleschi.

THE END OF THE LIFE OF FILIPPO BRUNELLESCHI

The Life of Donatello, Florentine Sculptor
[1386–1466]

Donato, who was called Donatello by his relatives and thus signed some of his works this way, was born in Florence in the year 1303.* And devoting himself to the art of design, he became not only an unusually fine sculptor and a marvellous statue-maker, but also grew experienced in stucco, quite skilled in perspective, and highly esteemed in architecture. His works possessed so much grace and excellence and such a fine sense of design that they were considered to be more like the distinguished works of the ancient Greeks and Romans than those of any other artist who has ever existed, and he is therefore quite rightly recognized as the first artisan who properly used the device of scenes in bas-relief. He worked out these scenes with such careful thought, true facility, and expert skill that it was obvious he possessed a true understanding of them and executed them with extraordinary beauty. Thus, no other artisan surpassed him in this field, and even in our own times, there is no one who is his equal.

Donatello was raised from childhood in the home of Ruberto Martelli, and with his fine qualities and the diligence with which he refined his skill, he not only earned Martelli's affection but that of this entire noble family. In his youth, he worked upon so many things that they were not very highly regarded because there were so many of them. But the thing which earned him a name and brought him recognition was an Annunciation in blue-grey stone which was placed in the church of Santa Croce in Florence at the altar in the chapel of the Cavalcanti family, for which he made a decoration in the grotesque style.* Its base was varied and twisted, completed by a quarter-circle to which were added six putti carrying several garlands who seem to be steadying themselves by embracing

each other as if they were afraid of the height. But Donatello demonstrated above all his great ingenuity and artistry in the figure of the Virgin, who, frightened by the sudden appearance of the angel, timidly but gently moves Her body in a very chaste bow, turning towards the angel greeting Her with the most beautiful grace, so that Her face reflects the humility and gratitude one owes to the giver of an unexpected gift, and even more so when the gift is so great. Besides this, Donatello proved his ability to carve masterful folds and turns in the robes of this Madonna and the angel, and in suggesting the nude forms of his figures, he showed just how he was attempting to rediscover the beauty of the ancients which had already remained hidden for so many years. And he exhibited so much facility and skill in this work that no one could really expect more from him in design and judgement, or from the way he carved and executed the work.

In the same church below the choir screen beside the scenes frescoed by Taddeo Gaddi, Donatello took extraordinary pains in carving a wooden crucifix which, upon completing it and believing that he had produced a very rare object, he showed to Filippo di Ser Brunellesco, his very dear friend, in order to have his opinion of it. Filippo, who expected to see something much better from Donatello's description of it, smiled a bit when he saw it. When Donatello saw this, he begged Filippo for the sake of their friendship to give him his honest opinion of it, and so, Filippo, who was very candid, replied that it seemed to him as if Donatello had placed a peasant upon the cross and not a body like that of Jesus Christ, which was most delicate and represented, in all its parts, the most perfect human being born. Hearing himself criticized— and even more sharply than he had imagined—rather than receiving the praise he had hoped for, Donatello answered: 'If it were as simple to create something as to criticize, my Christ would look like Christ to you and not like a peasant; take some wood and try to make one yourself.' Without saying another word, Filippo returned home, and without anyone knowing, he set his hand to making a crucifix, seeking to surpass Donatello in order to vindicate his own judgement, and after many months he brought it to the highest degree of

perfection. And once this was finished, he invited Donatello one morning to have lunch with him, and Donatello accepted the invitation. And so, they went together towards Filippo's home, and when they reached the Old Market, Filippo bought a few things and gave them to Donatello, saying: 'Go on home with these things and wait for me there, and I'll be along shortly.' Donatello therefore entered the house and, on the ground-floor, saw Filippo's crucifix in a perfect light, and stopping to examine it, he found it so perfectly finished that, realizing Filippo had outdone him, and completely stupefied, as if he had lost his wits, he relaxed his grip on his apron; whereupon, the eggs, the cheese, and everything else fell out, breaking into pieces and spilling all over, and as he stood there stunned and amazed, Filippo caught up with him, and said with a laugh: 'What's your plan, Donatello? How can we have lunch if you have spilled everything?' Donatello replied: 'Personally, I've had enough for this morning, but if you want your share, take it. But no more, thank you: it's for you to make Christs and for me to make peasants.'*

In the Baptistery of San Giovanni in the same city, Donatello created the tomb of Pope Giovanni Coscia who had been deposed from his pontificate by the Council of Constance; he was commissioned to do this by Cosimo de' Medici, a very close friend of this same Coscia.* For this tomb Donatello made the figure of the dead man in gilded bronze with his own hands, as well as the marble figures of Hope and Charity, and Michelozzo, his pupil, carved the figure of Faith. In the same baptistery, opposite this tomb, a statue from Donatello's own hand can be seen, a wooden Saint Mary Magdalene in Penitence* which is very beautiful and well executed, for she has wasted away by fasting and abstinence to such an extent that every part of her body reflects a perfect and complete understanding of human anatomy. In the Old Market upon a granite column, there is by Donatello's hand a figure of Abundance made of hard grey stone which stands completely by itself and is so well made that it has been highly praised by artisans and all people of understanding. The column upon which this statue stands was once in the Baptistery of San Giovanni along with the other granite

columns holding up the inner gallery, but it was taken away and replaced by another fluted column upon which the statue of Mars formerly stood in the middle of that temple, before being removed when the Florentines were converted to the faith of Jesus Christ. While still a young man, Donatello made a marble statue of the prophet Daniel for the facade of Santa Maria del Fiore, and he afterwards executed one of Saint John the Evangelist, seated, four armslengths tall, and clad in a simple habit, which received high praise.* In the same location on the corner of the facade that faces towards Via del Cocomero is the statue of an old man standing between two columns with more similarities to the ancient style than anything else of Donatello's to be seen; in his head are reflected the cares and concerns that the years bring to those who are wasted by time and toil.* Inside the same church, Donatello also did the decoration for the organ over the door of the old sacristy with figures roughed out, as we have already mentioned, in such a fashion that they truly seem to be living and moving.* About this work, it can be said that Donatello worked as much with his judgement as with his hands, when we consider that many works appear beautiful while they are being executed and in the place where they are created, but that later when they are removed and put in another location and in a different light or up higher, they take on a different appearance and turn out to be quite the opposite of what they seemed. But Donatello created his figures in such a way that in the room where he worked on them, they never seemed to be half as fine as they turned out to be in the location for which they were destined.

In the new sacristy of the same church, Donatello created the design for those little boys who are holding up the garlands that go around the frieze;* and he also made the design for the figures placed in the glass of the round window below the dome—that is, the one with the Coronation of Our Lady, a design very much better than those in the other windows, as can clearly be seen.* For San Michele in Orto [Orsanmichele] in the same city, Donatello carved a marble statue of Saint Peter for the Butchers' Guild, which is an obviously sophisticated and admirable figure, and for

the Linen-Drapers' Guild he did a statue of Saint Mark the
Evangelist which he was at first supposed to do with Filippo
Brunelleschi but later completed by himself with Filippo's
consent.* This figure was worked by Donatello with such
good judgement that, while on the ground, its excellence was
not recognized by people lacking in understanding, and the
consuls of the guild were unwilling to have it erected, but
Donatello asked them to put it up, saying he wanted to show
them that after he worked on it further, it would turn out
differently. Once they agreed, he covered it up for fifteen
days and then, without retouching it in any other way, he
uncovered it, filling everyone with amazement.

For the Armourers' Guild Donatello executed a very lifelike
figure of Saint George in armour. In the head of this figure,
its youthful beauty, courage and skill in arms are reflected, as
well as a fiercely awesome vitality and a marvellous sense
of movement inside the stone itself. And such vitality and
spirit in marble had never been expressed in modern statues
to the extent that Nature and art worked through Donatello's
hands in this statue. On the base supporting the tabernacle,
Donatello executed a bas-relief in marble—the moment when
Saint George kills the dragon—with a horse that is highly
esteemed and highly praised. On the frontispiece he carved in
bas-relief a half-figure of God the Father, and opposite the ora-
tory of this church he made for the Merchants' Guild a marble
tabernacle using the ancient architectural order known as
Corinthian and avoiding any hint of the German style to hold
two statues he later decided not to execute, since they could
not agree on a price. After Donatello's death, these figures were
cast in bronze (as will be explained) by Andrea del Verrocchio.

On the front of the bell tower of Santa Maria del Fiore,
Donatello did four statues in marble five armslengths high,
two of which were sculpted from life and placed in the
middle; one is Francesco Soderini as a young man, while the
other is Giovanni di Barduccio Cherichini, known today as
'Il Zuccone'.* The latter was considered a most unusual work
and more beautiful than anything Donatello had ever done,
and whenever Donatello wanted to swear an oath that would
be credible, he used to swear 'by the faith I have in my

Zuccone'. And while he was working on it, he would stare at it, and kept saying to it: 'Speak, speak or be damned!'

Over the door of the bell tower on the side facing towards the canonry, Donatello made an Abraham in the act of sacrificing Isaac* and another prophet, which were placed between the two other statues. For the Signoria of Florence, Donatello cast a statue in metal, placed in the piazza under one arch of their Loggia, which represented Judith cutting off the head of Holofernes.* This is a work of great excellence and mastery which clearly reveals, to anyone who considers the simplicity of Judith's appearance in her dress and her expression, the great inner courage of this woman and the assistance of God, just as in the expression of Holofernes one can see the effects of wine, sleep, and death in his limbs, which look cold and limp after his bodily spirits have fled. This work was executed so well by Donatello that the casting turned out very fine and beautiful, and, afterwards, he polished it so well that the statue was a great marvel to behold. In like manner, the base, which is a granite baluster of simple design, proved to be full of grace and pleasing in appearance to the eye. Donatello was so satisfied with this work that he wanted to put his name on it (something he had not done before), and we can see the inscription: 'Donatelli opus.'

In the courtyard of the palace of these *signori*,* there stands a life-size nude David in bronze, who has severed the head of Goliath, and, raising his foot, places it upon his enemy, and he holds a sword in his right hand. This statue is so natural in its vitality and delicacy that other artisans find it impossible to believe that the work is not moulded around a living body.* It once stood in the courtyard of the Medici home and was moved to this new location when Cosimo was sent into exile. In our day, Duke Cosimo moved it again, after having constructed a fountain where it stood, and he is saving it for another very large courtyard which he is planning to build behind the palace—that is, where the lions used to be. On the left-hand side where the clock of Lorenzo della Volpaia sits, there still stands a very beautiful David in marble, who holds the dead head of Goliath between his legs under his feet, and the sling with which he struck Goliath down is in his hand.*

In the first courtyard of the Medici home are eight marble medallions containing copies of ancient cameo portraits and the reverse sides of medals as well as several very beautiful scenes executed by Donatello; they are built into the frieze between the windows and the architrave above the arches of the loggias. Donatello was responsible for the restoration of an ancient statue of Marsyas in white marble erected at the entrance to the garden as well as countless ancient heads arranged over the doors, which he adorned with ornamental wings and diamonds—Cosimo's emblem—carefully executed in stucco. He also created a very handsome granite basin which spouted water, and in the garden of the Pazzi family in Florence he worked upon a similar basin which also spouted water. In the same Medici home are marble and bronze Madonnas in bas-relief, as well as other scenes in marble with the most beautiful figures and marvellous flat relief. Cosimo's love for Donatello's talents was so great that he wanted to keep him working constantly, and in return, Donatello felt such affection for Cosimo that he could guess exactly what Cosimo wanted from the slightest indication, and he always responded to his wishes.

It was said that a Genoese merchant had Donatello execute a very handsome life-size bronze head which was thin and light, so that it could be carried over a long distance, and it was through Cosimo that Donatello received the commission for such a work. When it was finished and the merchant wanted to pay Donatello, he thought that the sculptor was asking too high a price. So the deal was referred to Cosimo, who had the bust carried to a courtyard above his palace and had it placed between the battlements overlooking the street so that it could be better seen. Wishing to settle the matter, Cosimo, who found the merchant far from the price asked by Donatello, turned to the merchant and declared that Donatello's price was too low. At this, the merchant, who thought it too high, declared that Donatello had worked upon it for only a month or a little more, and that this added up to more than half a florin per day. Donatello then turned angrily away, thinking himself too greatly offended, and told the merchant that in one hundredth of an hour he could spoil the labour and value

of an entire year, and he gave the bust a shove, immediately breaking it upon the street below into many pieces and telling the merchant he proved himself more accustomed to bargaining for beans than for statues. The merchant regretted what he had done and wanted to give Donatello more than double his price if he would only recast the bust, but neither the merchant's promises nor Cosimo's entreaties could ever convince Donatello to redo it.

In the homes belonging to the Martelli family are many scenes in marble and bronze, and among other things a David three armslengths high* and many other works, given quite generously by him to attest to the sense of duty and love he bore that family and, in particular, he finished a free-standing Saint John in marble that is three armslengths high—a most unusual work found today in the home of the heirs of Ruberto Martelli. Ruberto bequeathed it to them in trust so that it could never be pawned, sold, or given away, without incurring heavy penalties, as evidence and proof of the affection his family felt for Donatello, who had given it to them because, having recognized his talent, they had protected and encouraged it.*

Then Donatello executed and sent to Naples a marble tomb for an archbishop, which stands in the church of Sant'Angelo di Seggio di Nido; it contains three free-standing figures supporting the coffin of the dead man, while upon the casket itself there is a scene in bas-relief so beautiful that it deserves endless praise.* And in the same city in the home of the Count of Matalone is the head of a horse by Donatello's hand which is so handsome that many believe it to be an ancient work.* In the town of Prato, Donatello executed a marble pulpit where the Girdle is displayed; in the panels of the pulpit he carved a scene of young children dancing so miraculously beautiful it can be said that the perfection of his skill is exhibited no less in this work than in his other sculptures. In addition, as the support for this work, he made two bronze capitals, only one of which still stands there, because the Spaniards carried off the other one when they sacked the town.*

At the same time, it came about that the Signoria of Venice, hearing of his fame, sent for Donatello to erect a memorial

to Gattamelata in the city of Padua, where he went quite
willingly and created the bronze horse which now stands
in the piazza of the church of Sant'Antonio.* In this work
Donatello displayed the snorting and whinnying of the horse
as well as the great courage and ferocity vividly expressed in
the artfulness of the figure riding it. And Donatello showed
truly admirable skills in casting a large statue of such fine
proportions and quality that it can be favourably compared
to the work of any ancient artisan in terms of its movement,
design, art, proportion, and painstaking care. For not only did
it amaze everyone who saw it, but it continues to amaze
everyone who sees it today. Because of this, the Paduans
sought with every means to make him a citizen and tried to
keep him there with every kind of affectionate gesture. And in
order to keep him employed, they commissioned him to do
the scenes from the life of Saint Anthony of Padua on the
predella of the high altar in the church of the Minor Friars,
which are done in bas-relief and executed with such good
judgement that men distinguished in this art remain amazed
and astonished by them, having considered their beautiful and
varied compositions and such an abundance of extravagant
figures and diminished perspectives.* Likewise, on the altar
frontal, Donatello made some very beautiful Maries weeping
over the dead Christ. And in the home of one of the Counts of
Capo di Lista, he executed the skeleton of a horse in wood
which can still be seen today without its head, in which the
joints are so well constructed that anyone considering its de-
sign must appreciate the charm and originality of Donatello's
intelligence and his great mind.*

In a convent, he made a Saint Sebastian in wood at the
request of a chaplain, a Florentine who was a friend of the
nuns and one of Donatello's acquaintances. The chaplain
brought Donatello an old, awkward statue which the nuns
owned and begged him to create another one like it. Thus, he
made every effort to imitate it to satisfy the chaplain and the
nuns, but he was unable to make his as awkward as the
original or to avoid executing it with his habitual good skill
and quality. Together with this statue he made many other
figures in clay and stucco, and from a corner of a piece of old

marble which these nuns had in their garden, he created a very beautiful Madonna. Countless works by Donatello are likewise scattered throughout the entire city of Padua. Although he was considered something of a marvel and praised by every intelligent person, he decided that he really wanted to return to Florence, declaring that if he remained there any longer, he would forget everything he knew, since he was so highly praised by everyone. And so he gladly returned to his native city, where he would receive the constant criticism which would cause him to study and consequently to achieve even greater glory. For this reason, he left Padua and, returning through Venice, as a token of his kindness, he left behind as a gift to the Florentine community a Saint John the Baptist in wood for their chapel in the church of the Minor Friars, which he executed with the greatest care and diligence.*

In the city of Faenza, Donatello carved a Saint John and a Saint Jerome in wood, no less esteemed than his other works. Then, after returning to Tuscany, he made a marble tomb with a most beautiful scene in the parish church of Montepulciano, and in Florence for the sacristy of San Lorenzo, a marble wash-basin on which he worked with Andrea Verrocchio.* And in the home of Lorenzo della Stuffa, he made heads and figures which are very lively and animated. He then left Florence to move to Rome, seeking to imitate the works of the ancients as best he could, and, while studying them, he executed in stone a tabernacle for the sacrament which today is in Saint Peter's.* Returning to Florence and passing through Siena, he stopped to make a bronze door for the Baptistery of San Giovanni; after making the wooden model, finishing the wax moulds, and bringing the shell for casting the metal nearly to completion, Bernardetto di Mona Papero, a Florentine goldsmith and a friend and acquaintance of Donatello, who was on his way home from Rome, acted and spoke so persuasively that either for his own purposes or for some other reason, he was able to bring Donatello back with him to Florence. Thus, this work remained incomplete or, rather, not even begun. All that remained by Donatello's hand in the Works Department of the Cathedral in that city was a Saint John the Baptist in metal, which lacked its right

arm below the elbow; and this, it is said, Donatello left unfinished because he had not been satisfied with the full payment.*

Having thus returned to Florence, he worked for Cosimo de' Medici on stuccoes for the sacristy of San Lorenzo—namely on four medallions on the corbels of the vault with their fields of perspective, some painted and others in bas-relief with scenes from the lives of the Evangelists. And in the same place he created two bronze doors in the most beautiful bas-relief showing Apostles, Martyrs, and Confessors; and above them he made some shallow niches, one containing the figures of Saint Laurence and Saint Stephen and the other Saint Cosmas and Saint Damian. In the transept of the church, he created four saints in stucco each five armslengths high which are skilfully done. Donatello then designed the bronze pulpits containing scenes from the Passion of Christ, a work which displays a fine sense of design, power, inventiveness, and an abundance of figures and buildings, but since he could not complete the work on them because of his age, his pupil Bertoldo finished the pulpits and brought them to perfection.* At Santa Maria del Fiore, he made two gigantic figures in brick and stucco which stood outside the church, placed above the corners of the chapels as decoration.* Over the door of Santa Croce, one can still see a bronze Saint Louis five armslengths high finished by Donatello: when someone told him he had blundered in making a statue so awkward that it was quite possibly the worst work he had ever done, Donatello replied that he had done it that way only after careful study, since Saint Louis was a blunderer to have abandoned his kingdom to become a monk.* He also made a bronze head of the wife of Cosimo de' Medici, kept in the wardrobe of Duke Cosimo where there are many other works in bronze and marble from the hand of Donatello; among them is a marble Madonna and Child, a very low relief carved in marble; it would be impossible to find anything more beautiful, especially since it is decorated all around with scenes done in miniature by Fra Bartolomeo which are most admirable, as will be discussed in the proper place.*

The same Lord Duke also has, from the hand of Donatello, a very beautiful—no, miraculous—bronze crucifix

in his study where there are countless rare antiquities and
beautiful medals. In the same wardrobe is a bronze panel in
bas-relief of the Passion of Our Lord with a large number of
figures, and in another panel, also of metal, there is another
Crucifixion. Likewise, in the home of the heirs of Jacopo
Caponi, who was a fine citizen and a true gentleman, is a
marble panel of the Madonna carved in half relief which is
held to be a most rare thing indeed. Also, Messer Antonio de'
Nobili, who was His Excellency the Duke's treasurer, had in
his home a marble panel from Donatello's hand in which there
is a Madonna in half relief so beautiful that this Messer
Antonio considered it worth more than everything else he
owned. Nor does Giulio his son—a young man of singular
qualities and good judgement, and an admirer of all talented
and distinguished men—value it any less. In the home of
Giovambatista d'Agnol Doni, a Florentine nobleman, is a
metal statue of Mercury by Donatello one-and-a-half arms-
lengths high, free standing and clothed in a certain odd fashion
which is truly most handsome and no less rare than the other
works which adorn his very lovely home. Bartolomeo Gondi,
who we discussed in the life of Giotto, owns a Madonna in
half relief executed by Donatello with so much love and care
that it is impossible either to find a better one or to imagine
how Donatello managed to create with such a light touch the
expression of Her head or the gracefulness of the garments She
is wearing. Also, Messer Lelio Torelli, the Lord Duke's chief
Justice and Secretary, and no less an admirer of all the sciences,
talents, and honoured professions than an eminent jurist, owns
a marble panel of Our Lady by Donatello.

Whoever wished to give a complete account of Donatello's
life and works would have a longer story to tell than the one I
intend to write about the lives of our artists, for he not only
set his hand to accomplishing the great works about which we
have said enough, but he also did the most insignificant things
in his craft, making coats of arms for fireplaces or façades
for the homes of townspeople, as can be seen from a very
handsome one on the home of the Sommai family which
stands opposite the Vacca bakery. For the Martelli family,
Donatello also made a wicker chest in the shape of a cradle to

serve as a burial urn, but this is placed below the church of San
Lorenzo, because no tombs of any sort appear above it except
the epitaph on the tomb of Cosimo de' Medici, the opening of
which is, nevertheless, below like the others. It is said that after
Donatello's brother Simone* had worked up the model for
the tomb of Pope Martin V, he sent for Donatello to examine
the model before it was cast. And so, going to Rome,
Donatello arrived just at the time when Emperor Sigismund
was there to receive his crown from Pope Eugenius IV;* and so,
along with Simone, he was obliged to work in preparing the
most stately decorations for that festival, from which he
acquired fame and the highest honours. In the wardrobe of
Lord Guidobaldo, Duke of Urbino, there is a head of the most
beautiful marble by Donatello, which, it is believed, was given
to the duke's ancestors by the Magnificent Giuliano de'
Medici, when he stayed at that court full of the most worthy
noblemen.

In short, Donatello was such an artist and so admirable in
his every deed that he can be said to have been one of the first
among the moderns to render illustrious the art of sculpture
and good design by his practice, good judgement, and
knowledge. And he deserves even more praise, since in his
times the remains of antiquities had not yet been unearthed
and seen, except for columns, short pillars marking tombs,
and triumphal arches. And it was primarily Donatello who
awakened in Cosimo de' Medici the desire to bring such
antiquities to Florence, which were and still are in the Medici
palace, all of which were restored by Donatello. Donatello
was very generous, kind, and gracious, and more attentive to
his friends than he was to himself. He never placed much
importance on money and kept his in a basket suspended on a
cord attached to the ceiling from which all his workers and
friends could take what they needed without saying anything
to him. He passed his old age very contentedly, and when he
became decrepit he had to be assisted by Cosimo and his other
friends, since he could no longer work.

It is said that when Cosimo was about to die, he com-
mended Donatello to the care of his son Piero who, as a most
conscientious executor of his father's will, gave Donatello a

farm in Cafaggiuolo with enough income for him to live comfortably. Donatello was delighted by this, for he felt that with this more than secure income he would not risk dying from hunger. But he had only held it for a year when he returned to Piero and gave it back to him by means of a written contract, declaring that he did not wish to lose his peace of mind having to dwell upon domestic concerns or the troubles of his peasant tenant, who was underfoot every third day—first, because the wind blew the roof off his doves' hatch; next, because the Commune seized his livestock for taxes; and then, because the storm deprived him of wine and fruit. He was so fed up and disgusted with all these things that he preferred to die from hunger rather than to think about them.

Piero laughed at Donatello's simple ways, but in order to free Donatello from this worry he accepted the farm at Donatello's insistence, and he assigned him from his own bank an allowance of the same amount or more but in cash, which was paid to Donatello every week in appropriate instalments. This made Donatello exceedingly content. And as the servant and friend of the Medici family, he lived happily and without care for the rest of his life, although upon reaching the age of eighty-three, he became so paralysed that he could no longer work in any way and became bedridden in a poor little house he owned in the Via del Cocomero near the Convent of San Niccolò. There he grew worse day by day, and, wasting away little by little, he died on 13 December 1466.* He was buried in the Church of San Lorenzo near the tomb of Cosimo, as he himself had ordered, and just as in life he had always been close to Cosimo in spirit, so, too, now in death, his body could rest near that of Cosimo.

The citizens and the artisans and anyone who knew Donatello while he was alive mourned his death intensely. And in order to pay him more honour in death than they had in life, they celebrated the most stately funeral in San Lorenzo: all the painters, architects, sculptors, goldsmiths, and almost the entire populace of the city accompanied him to his grave. And for some time afterwards, they kept on composing in different languages various kinds of verses in his praise; of

these, it is sufficient to cite only those which can be read below.

But before I come to the epitaphs, it would be well for me to recount at least one more thing about him. While he was sick and shortly before he died, some of his relatives came to visit him, and after they had greeted and comforted him, as was customary, they informed him it was his obligation to bequeath to them a farm he owned near Prato; although it was tiny and yielded a very small income, they begged him for it very insistently. When Donatello, who was kind in everything he did, heard this, he replied: 'I cannot oblige you, my relatives, because I wish to leave it to the peasant who has always worked it and who has endured so many hardships there; it seems reasonable for me to do this rather than to leave it to you, since you have never ever done anything useful on the farm but have thought only of owning it, just as you wish to convince me to leave it to you by visiting me. Go now, and may God bless you.' And to tell the truth, this is the way you should treat such relatives whose love depends only upon what they can gain or upon their hope for profit. Therefore, Donatello summoned the notary, and he left the said farm to the peasant who had always worked it and who was probably more attentive to his master's needs than his relatives were.

Donatello left his artistic materials to his pupils, who were: Bertoldo the Florentine sculptor, who imitated him rather closely, as one can see in a very beautiful bronze battle scene depicting men on horseback which is now in the wardrobe of the Lord Duke Cosimo; Nanni d'Anton di Banco, who died before his master; Rossellino, Disiderio; and Vellano da Padua.* In fact, after Donatello's death, it could be said that anyone who ever wanted to do good work in relief was his pupil. In design, Donatello was resolute, and he executed his plans so skilfully and boldly that they had no equals, as can be seen in our book of drawings where I have from his hand sketches with both clad and naked figures and animals which would astonish anyone who saw them, as well as other similarly fashioned things of rare beauty. His portrait was done by Paolo Uccello, as was mentioned in Paolo's life. . . . *

The world is so full of the works of this man that it can

quite truthfully be claimed no other artisan ever produced any more than he did. Because he took delight in all things, he set his hand to doing everything, without considering whether it was insignificant or prestigious. Nevertheless, Donatello's vast productivity in any kind of figure whatever—whether free-standing, half-figure, low, or extremely low relief—was wholly indispensable to the art of sculpture. For, whereas in the good periods, many of the sculptors of ancient Rome and Greece raised this art to perfection, Donatello by himself brought sculpture back to a level of perfection and magnificence in our century with the abundance of his works. And thus, artists should recognize the greatness of his art more than that of anyone else born in the modern period, since Donatello rendered the problems of sculpture less complex by the sheer number of his works, joined together with his inventiveness, sense of design, skill, and good judgement, and every other quality that a divine genius could or should possess. Donatello was extremely determined and quick, and he executed all his works with the greatest skill, always accomplishing much more than he promised.

All his work was left behind to Bertoldo, his pupil, especially the bronze pulpits for San Lorenzo, which for the most part were polished by Bernardo and brought to the state of completion in which they presently can be seen in this church....*

THE END OF THE LIFE OF DONATELLO,
FLORENTINE SCULPTOR

The Life of Piero della Francesca, Painter from Borgo San Sepolcro

[c.1420–1492]

———

Truly unhappy are those who, after labouring over their studies to give pleasure to others and to leave behind a name for themselves, are not permitted either by sickness or death to bring to perfection the works they have begun. And it often happens that when such a person leaves behind him works which are not quite finished or that are at a good stage of development, they are usurped by the presumption of those who seek to cover their own ass's hide with the noble skin of the lion. And if Time, which is said to be the father of Truth, sooner or later reveals what is true, it is none the less possible that for some period of time the man who has done the work can be cheated of the honour due his labours; this is what happened to Piero della Francesca from Borgo San Sepolcro.

He was regarded as an uncommon master of the problems of regular bodies in both arithmetic and geometry, but the blindness which overtook him in old age and finally his death kept him from completing his brilliant efforts and the many books he wrote which are still preserved in Borgo, his native town.* The man who should have tried his best to increase Piero's glory and reputation (since he learned everything he knew from him), instead wickedly and maliciously sought to remove his teacher Piero's name and to usurp for himself the honour due to Piero alone by publishing under his own name—that is, Fra Luca del Borgo—all the efforts of that good old man who, besides excelling in the sciences mentioned above, also excelled in painting.*

Piero was born in Borgo San Sepolcro, which was not then a city as it has come to be; he was named after his mother, Della Francesca, because she was pregnant with him when his

father, her husband, died, and because she raised him and helped him acquire the high repute his good fortune granted him. In his youth, Piero applied himself to the study of mathematics, and even though by the age of fifteen he was on the way to becoming a painter, he never abandoned his studies. On the contrary, producing amazing results both in his studies and in painting, he was employed by Guidobaldo da Montefeltro,* the old Duke of Urbino, for whom he executed many paintings with extremely beautiful small figures which for the most part have come to grief during the many times that state has been troubled by war. Nevertheless, some of his writings on geometry and perspective have been preserved there, and they show him to be inferior to no one in his own times, or perhaps in any other time as well, as do all his works which are full of perspectives, most especially a vase drawn in squares and facets so that the front, back, sides, bottom, and mouth are visible; it is certainly a stupendous work, for he drew every small detail with subtlety and foreshortened all the curves of its circles with infinite grace.

Once he had gained a good reputation and made a name for himself in this court, Piero wanted to make himself known in other places, and so he went to Pesaro and Ancona and was right at a crucial point in his work when he was summoned to Ferrara by Duke Borso, who was painting a large number of rooms in his palace, later demolished by the old Duke Ercole when he remodelled the palace in the modern style.* Thus, there was nothing left by Piero in that city except a chapel in the church of Sant'Agostino done in fresco, and even that has been badly damaged by the humidity. Then, after being brought to Rome, Piero painted two scenes for Pope Nicholas V in competition with Bramante of Milan in the upper chambers of the palace, which were likewise torn down by Pope Julius II so that Raphael of Urbino could paint the Imprisonment of Saint Peter, the Miracle of the Mass at Bolsena, along with several other scenes which Bramantino, an excellent painter for his times, had executed there....*

Having completed his work in Rome, Piero returned to Borgo upon his mother's death, and in the parish church there he painted a fresco of two saints on the inside of the middle

door which was considered extremely beautiful. In the convent of the Friars of Saint Augustine, Piero painted a panel for the main altar which was widely praised;* and for a company or a confraternity, as they call it, he also painted a Madonna della Misericordia in fresco;* and in the Palazzo de' Conservatori he executed a Resurrection of Christ which is considered the best of all the works in that city and of all his other works.*

Together with Domenico Veneziano,* Piero painted the beginning of a work on the vault of the sacristy in Santa Maria di Loreto, but, fearing the plague, they left it unfinished and it was later completed by Luca da Cortona, Piero's pupil, as will be discussed in the proper place.* Piero left Loreto for Arezzo, and there for a citizen of Arezzo named Luigi Bacci he painted the chapel of the main altar of San Francesco, the vault of which had already been started by Lorenzo di Bicci.* In this work, there are scenes depicting the Legend of the True Cross, from the time when Adam's sons bury him and place under his tongue the seed which gives birth to the tree from which the wood [of the cross] derives, down to the Exaltation of the Cross by the Emperor Heraclius who, carrying the cross upon his shoulders, marches barefoot with it into Jerusalem.*

This work contains many beautiful ideas and expressions worthy of praise. For example, the garments of the women in the retinue of the Queen of Sheba, executed with a sweet and new style; many natural and very lifelike portraits of the ancients; a row of Corinthian columns with sublime proportions; and a peasant who, while the three crosses are being unearthed, is leaning upon his spade with his hands and waits to hear the words of Saint Helena, a scene which could not be improved. Also well depicted are the dead man, who is revived when the cross touches him, and the joy of Saint Helena, along with the amazement of the bystanders who are kneeling down in adoration. But over and above every other consideration of Piero's talent and technique is his depiction of Night, where he shows an angel in flight, fore-shortened with its head foremost on the plane, coming to bring the sign of victory to Constantine as he sleeps in a tent guarded by a servant and some armed men faintly visible in

the shadows of the night. With the greatest discretion, Piero
shows how the heavenly visitor illuminates the tent, the
soldiers, and all the surroundings with his own light, and, with
his depiction of the darkness, Piero makes us realize how
important it is to imitate real things and to draw them out,
deriving them from reality itself. He accomplished this admir-
ably well and caused modern painters to imitate him and to
reach the heights of perfection we see in such things in our
own times. This same fresco cycle contains a battle scene in
which Piero expresses quite effectively the fear, courage,
shrewdness, strength, and all the other emotions that must be
considered in men at war and, similarly, all the incidents
which occur, including an almost unbelievable slaughter of
wounded, fallen, and dead men. Piero deserves the greatest
praise for having reproduced in fresco the lustre on the
armour in this scene, but no less so than for having depicted
on the other wall, in the scene of the flight and submersion
of Maxentius, a group of foreshortened horses which are so
marvellously rendered that it could be said they are too
beautiful and too excellent for those times. And in the same
scene, he painted a man riding on a lean horse who is half-
naked and half-dressed in the Saracen fashion, which reflects
his profound knowledge of anatomy, something little under-
stood in his day. For this work he was justly and generously
rewarded by Luigi Bacci, whose portrait he placed, along with
those of Carlo, his other brothers, and many other Aretines
who were then distinguishing themselves in letters, in the
scene of the decapitation of a king, and he deserved the love
and respect he received then and ever afterwards in that city
which he had rendered so illustrious with his works.

 In the same city, for the bishop's palace, Piero also painted
a fresco of Saint Mary Magdalene beside the door to the
sacristy, and for the Confraternity of the Annunciation, he
made a banner for carrying in their processions; in Santa
Maria delle Grazie outside town, at the front of a cloister, he
painted a Saint Donatus in perspective seated in his bishop's
robes surrounded by several putti; and in San Bernardo for the
monks of Monte Oliveto he completed a Saint Vincent in a
niche high up on the wall which is greatly valued by artisans.

At Sargiano outside Arezzo, in a place belonging to the Barefoot Franciscans, Piero painted in a chapel there a very beautiful Christ praying in the Garden at night. He also worked on many things which can be seen in Perugia: for instance, in the church of the Nuns of Saint Anthony of Padua, he did a panel in tempera of the Madonna and Child with Saint Francis, Saint Elizabeth, Saint John the Baptist, and Saint Anthony of Padua, with a very beautiful Annunciation above it containing an angel who seems as if he has truly descended from Heaven, and, what is more, a truly beautiful row of columns which diminish in perspective. The predella, which is composed of scenes made up of tiny figures, shows Saint Anthony raising a little boy from the dead; Saint Elizabeth saving a boy who has fallen into a well; and Saint Francis receiving the stigmata. In the church of San Ciriaco d'Ancona, on the altar of Saint Joseph, Piero painted a very beautiful scene of the Marriage of the Virgin.

As I mentioned earlier, Piero was a most diligent student of his art and frequently practised drawing in perspective; he possessed a remarkable knowledge of Euclid, to the extent that he comprehended better than any other geometrician all of the curves in regular bodies, and thus he shed the clearest light yet upon these matters with his pen. Master Luca del Borgo, the Franciscan monk who wrote about regular bodies in geometry, was his student. And when Piero reached old age and died after having written many books, the said Master Luca usurped them for his own purposes and had them printed as his own work once they had fallen into his hands after his master's death.

Piero frequently made clay models, which he draped with wet cloths arranged in countless folds in order to sketch them and use them in various ways....* Piero from Borgo, whose paintings were done around the year 1458, was blinded at the age of sixty by an attack of catarrh and lived on in this state until he was eighty-six years old. He left behind him in Borgo some fine properties and several houses, which he himself had built, and which were burned and ruined in the civil uprisings of 1536. He was buried honourably by his fellow citizens in the main church,* which then belonged to the Camaldolite

Order but has now become the bishop's cathedral. Piero's books are, for the most part, to be found in the library of Duke Federigo II of Urbino, and their quality is so excellent that they have quite deservedly acquired for Piero the reputation of the greatest geometrician who lived in his times.

THE END OF THE LIFE OF PIERO DELLA
FRANCESCA

The Life of Fra Giovanni of Fiesole
[Fra Angelico] of the Order of
Preaching Friars, Painter

[c.1387–1455]

Brother Giovanni Angelico of Fiesole (known in the world as Guido),* was no less an excellent painter and illuminator than a worthy priest, and he deserves for both of these reasons to be greatly honoured by posterity. Although he could have lived most comfortably in the secular world, and in addition to what he already owned, could have earned whatever he wanted from the arts in which, even as a young man, he was already quite proficient, he nevertheless desired, for his own satisfaction and tranquillity (being by nature calm and gentle) and, principally, for the salvation of his soul, to join the Order of the Preaching Friars. For although people in all sorts of conditions may serve God, nevertheless some feel that they can best achieve their salvation inside monasteries rather than by living in the world. And although this is a happy choice for good men, it leads to a truly miserable and wretched existence for anyone who becomes a religious person for any other reason.

In Fra Angelico's monastery at San Marco in Florence, there are several choir books he illuminated that are so beautiful it is impossible to describe them further, and he left several other similar books at San Domenico da Fiesole which he designed with incredible diligence. It is quite true that in doing these he was assisted by his older brother who was likewise an illuminator and most experienced in painting.* One of the first works of this good priestly painter was a panel placed in Cardinal degli Acciaiuoli's main chapel in the Certosa of Florence which contained a very beautiful Madonna and

Child with some angels at Their feet playing and singing, and, on the sides, Saint Laurence, Saint Mary Magdalene, Saint Zenobius, and Saint Benedict. In the predella are little scenes from the lives of those saints drawn with tiny figures and infinite care. On the intersection of the vaults in the same chapel are two other panels by his hand: one of them shows the Coronation of Our Lady, while in the other the Virgin and two saints are handsomely executed in shades of ultramarine blue. Afterwards, on the choir screen of Santa Maria Novella beside the door facing the choir, he frescoed the figures of Saint Dominic, Saint Catherine of Siena, and Saint Peter Martyr along with some little scenes in the Chapel of the Coronation of the Virgin on the same choir screen. And for the doors which close the old organ, he painted an Annunciation on canvas, which is now in the monastery facing the door of the lower dormitory between one cloister and the other.

This friar was loved and admired by Cosimo de' Medici because of his special merits, and after Cosimo had built the church and monastery of San Marco, he had Fra Angelico paint the entire Passion of Jesus Christ upon one wall of the chapter house: on one side were all of the saints who had been the leaders and founders of religious orders, grieving and weeping at the foot of the Cross, while on the other side was a Saint Mark the Evangelist, along with the Mother of the Son of God, who has fainted upon seeing the Saviour of the World crucified, surrounded by the Maries, who support Her in their sorrow, and Saints Cosmas and Damian. It is said that in the figure of Saint Cosmas, Fra Angelico drew an actual portrait of Nanni d'Antonio di Banco, a sculptor friend of his. Below this work, in a frieze over the wall panel, he painted Saint Dominic at the foot of a tree, and some medallions which surround the branches contain all the popes, cardinals, bishops, saints, and masters of theology that his order of Preaching Friars had produced up to that time. In this work, he was assisted in painting many true-to-life portraits by the monks who sent around to various places for them, and they included the following: Saint Dominic in the middle holding the branches of the tree; the French Pope Innocent V; the Blessed Ugo, the first cardinal of the order; the Blessed

Paolo, Patriarch of Florence; Saint Antonino, Archbishop of Florence; the Blessed Giordano the German, the second general of the order; the Blessed Niccolò; the Blessed Remigio, the Florentine; the Florentine martyr Boninsegno; and all these are on the right hand; then, on the left are: Benedict II of Treviso; Giandomenico, the Florentine cardinal; Pietro da Palude, patriarch of Jerusalem; Albertus Magnus the German; the Blessed Raymond of Catalonia, third general of the order; the Blessed Chiaro of Florence, provincial of Rome; Saint Vincent of Valencia; and Blessed Bernard of Florence; and all of their heads are truly graceful and most beautiful. Then in the first cloister over some half tondos he frescoed many beautiful figures, as well as a crucifix with Saint Dominic at the foot of the cross which was highly praised, and in the dormitory, besides many other things in the cells and on the surface of the walls, he did a scene from the New Testament too beautiful to describe. But astonishingly beautiful is the panel on the high altar of the church, for, besides the Madonna whose simplicity inspires devotion in anyone who gazes at Her, as do the saints who resemble and surround Her, there are scenes in the predella from the martyrdoms of Saints Cosmas, Damian, and others which are so well done that it is impossible to imagine seeing anything created with more care, or figures executed with greater delicacy than these.*

Fra Angelico also painted the panel on the high altar at San Domenico in Fiesole, which seemed to be deteriorating and was made worse when it was retouched by other masters. But the predella and the ciborium of the Sacrament are better preserved, and their countless little figures displayed in a Celestial Glory are so beautiful that they seem truly to be in Paradise, and no one who approaches them can have his fill of them. In a chapel of the same church there is a panel by Fra Angelico of the Annunciation to Our Lady by the angel Gabriel painted in profile which is so devout, delicate, and well executed that it truly seems to have been created in Paradise rather than by a human hand. Standing in a field in the landscape are Adam and Eve, who were the cause of the Redeemer's birth by the Virgin, and in the predella there are also several very beautiful little scenes.

But above all the works he created, Fra Angelico surpassed himself and displayed the height of his skill and understanding of his craft in a panel located in the same church* beside the door as one enters from the left: in it, Jesus Christ crowns Our Lady standing in the midst of a choir of angels and among a countless multitude of saints that are so numerous, so well done, and with such variety in their poses and various facial expressions that incredible pleasure and joy is felt by anyone who gazes upon it. In fact, it appears that those blessed spirits in Paradise could not be any different from these, or, to put it better, they could not be any different if they possessed bodies, for all the saints in this painting are so lifelike and have such sweet and delicate expressions that the entire colouring of this work seems to have come from the hand of such a saint or angel as these. Thus, this good friar was always called Brother Giovanni 'Angelico' [the Angelic Brother John] with very good reason. Then, in the predella, the scenes from the lives of Our Lady and Saint Dominic are, of this type, most divine, and as for me, I can truthfully affirm that I never view this work without seeing something new, nor do I ever have my fill of seeing it.

In the Chapel of the Annunciation in Florence, which Piero di Cosimo de' Medici had built, Fra Angelico also painted the doors of the cupboard where the silver is kept with small figures executed with great care.* This friar did so many things for the homes of Florentine citizens that sometimes I am amazed by how a single man, even over so many years, could have executed so much work that is perfect. The Most Reverend Don Vincenzio Borghini, Prior of the Innocenti, owns a small Madonna by this friar which is most beautiful, and Bartolomeo Gondi, whose love for the arts is equal to that of any other gentleman, owns a large painting, a small painting, and a crucifix by Fra Angelico. The paintings in the arch under the door of San Domenico are also by him. And in the sacristy of Santa Trìnita is a panel of the Deposition* which he painted with such care that it may be counted among the best things he ever did. In San Francesco outside the San Miniato gate, there is an Annunciation by him, and in Santa Maria Novella, besides the other works already

mentioned, he painted the Paschal candle with small scenes as
well as some reliquaries which are placed upon the altar on the
most solemn occasions. In the Badia of Florence, Fra Angelico
painted over the door of the cloister a Saint Benedict com-
manding silence. For the Linen-Drapers' Guild, he executed
a panel painting which is located in the guild office;* in
Cortona, he painted a little arch over the door of the church
belonging to his order, as well as the panel painting for the
main altar. In Orvieto, on the vaulting of the Chapel of Our
Lady in the Duomo, he began some prophets which were later
completed by Luca da Cortona.* For the Confraternity of the
Temple in Florence, Fra Angelico did a panel painting of the
dead Christ. And for the church of the monks of Santa Maria
degl'Angeli, he finished a painting of Paradise and Hell
containing tiny figures which reflect keen observation; they
depict the Blessed as most handsome and filled with joy and
celestial bliss, while they show the Damned, who are being
prepared for the pains of Hell, in various mournful poses, with
the mark of their sins and shortcomings imprinted on their
faces; the Blessed can be seen dancing through the Gates of
Paradise with celestial movements, while the Damned are
dragged off by demons to the eternal punishments of Hell.*

This work is in the same church on the right as one goes
towards the main altar, where the priest goes to stand as the
Mass is sung. For the nuns of Saint Peter Martyr (who now
live in the Monastery of San Felice in the square, which used to
belong to the Camaldolite Order), Fra Angelico did a panel
painting of Our Lady, Saint John the Baptist, Saint Dominic,
Saint Thomas Aquinas, and Saint Peter Martyr along with a
number of smaller figures. Another panel by his hand can be
seen in the choir screen of Santa Maria Nuova.

By means of these many works, Fra Angelico's fame spread
throughout Italy, and Pope Nicholas sent for him, and for
him, Fra Angelico decorated the chapel of the Vatican palace
where the pope hears Mass with a Deposition from the Cross
and some most beautiful scenes from the life of Saint
Laurence, and he illuminated some extremely beautiful
books.* In the church of Santa Maria sopra Minerva, he
painted a panel on the high altar and an Annunciation

which is now beside the main chapel hanging on a wall.
For the same pope he also decorated the Chapel of the
Sacrament in the Vatican which was later torn down by
Paul III to build his staircase; in this work, which was an
excellent example of his particular style, Fra Angelico painted
in fresco some scenes from the life of Christ, and he painted
many real portraits of prominent people of those times which
would probably have been lost if Giovio* had not procured
them for his museum. They included: Pope Nicholas V; the
Emperor Frederick, who had come to Italy at that time;
Brother Antonino, who later became archbishop of Florence;
Flavio Biondo of Forlì; and Ferrante of Aragon. And because
Fra Angelico seemed to the pope to be a person who led a
most holy life, quiet, and modest (as he actually was), when
the archbishopric of Florence fell vacant at that time, he
judged him worthy of such a rank. When the friar realized the
pope's intentions, he begged His Holiness to find another man,
since he did not feel himself capable of governing other
people, declaring that there was another friar in his order most
skilled in government who loved the poor and was a God-
fearing man, and that it would be much more appropriate to
confer such a dignified rank upon this man than upon himself.
When the pope heard this and realized that what Fra Angelico
said was true, he granted the request; thus Friar Antonino
of the Order of Preaching Friars was made archbishop of
Florence—a man rightly renowned for his holiness and
knowledge of doctrine and, in brief, such a fine individual that
he deserved to be canonized by Adrian VI in our own day.
The inherent goodness of Fra Angelico was very great, for in
truth it was a most unusual thing to concede a dignified rank
and an honour along with the great responsibility offered
by the supreme pontiff to someone whom Fra Angelico—
employing a keen eye and heartfelt sincerity—judged to be
much more worthy than himself.

The priests of our own times should learn from this holy
man not to take on responsibilities that they cannot properly
handle and to leave them to others who are most worthy of
them. And returning to Fra Angelico and meaning no offence
to good priests, would to God that all priests spent their time

as did this truly angelic man, since he lived his entire life
serving God and benefiting the world and his neighbour. And
what more can or should a man desire than to gain the
heavenly kingdom by living a holy life and earning eternal
fame in this world by working with skill? And in truth, a
sublime and exceptional talent such as that Fra Angelico
possessed could and should not be bestowed upon anyone
but a man leading the most holy of lives; for this reason,
those who engage in ecclesiastical and holy works should be
ecclesiastics and holy men themselves, for we see that when
such things are executed by people who have little faith and
hold religion in low esteem, they often fill the mind with
impure appetites and lascivious desires, with the result that
the work is censured for its impurity but praised for its
craftsmanship and skill. But I would not wish anyone to be
mistaken and to construe that clumsy and inept works are
pious, while beautiful and well-done ones are corrupt, as some
people do when they see figures either of women or young
boys that are a bit more pleasing, beautiful, and ornate than
usual and who immediately seize upon them and judge them
as lustful, without realizing that they are very much in the
wrong to condemn the good judgement of the painter, who
holds that the beauty of the saints, both male and female, who
are celestial beings, surpasses that of mortal beings just as
heavenly beauty surpasses our earthly beauty and our mortal
works. But worse than this, they reveal their own infected and
corrupted souls when they dig out evil and impure desires
from these works, for if they were truly lovers of virtue, as
they wish to prove by their foolish zeal, they would discern
the painter's yearning for Heaven and his attempt to make
himself acceptable to the Creator of all things, from Whose
most perfect and beautiful nature all perfection and beauty
are born. What should such men do—or what can we believe
they might do—if they found themselves in the presence of
beautiful living things with lascivious ways, sweet words,
movements full of grace, and eyes which enrapture their not-
so-resolute hearts, since they are moved so passionately by the
mere image and only the shadow of beauty? But I would not
want people to believe I approve of such figures, which are

little less than completely naked, and painted in the churches, for such figures show that the painter has not shown the proper consideration for the location. Whenever a painter wishes to display all that he knows, he should do so according to the circumstances and show the proper respect for the people, the time, and the place.

Fra Angelico was a simple and most holy man in his habits; and it was a sign of his goodness that one morning when Pope Nicholas V wished to dine with him, he excused himself from eating meat because he lacked his prior's permission—without a thought for the pope's authority. He shunned all the things of the world; living a pure and saintly life, he befriended the poor just as his soul is, I believe, now befriended by Heaven. He applied himself continuously to his painting and never wanted to work on anything but holy subjects. He could have been rich but cared little about wealth; on the contrary, he used to say that true wealth was nothing but being content with little. He could have wielded power over many others but did not wish to do so, saying there was less hardship and error in obeying others. It was indeed within his power to attain high rank among his friars and in the secular world, but he did not place any value on such things, affirming that he sought no other rank but the one to be gained from trying to avoid Hell and to draw near to Paradise. And to tell the truth, what rank could be compared to that one, the one to which all religious persons, not to mention all human beings, should aspire—a rank which resides solely in God and in living virtuously? Fra Angelico was most humane and temperate; living chastely, he freed himself from earthly ties and was in the habit of repeating that anyone who practised this craft of his needed peace and a life free from care, and that anyone who created works involving Christ ought always to reside with Christ. No one ever saw him lose his temper among the friars—an amazing fact, it seems to me, and almost impossible to believe—and it was his practice to admonish his friends with a simple derisive smile. To those who requested a work from him, he would declare with incredible friendliness that if his prior would consent, he would not fail them.

In short, this friar who could never be sufficiently praised

was in all he did or said most humble and modest, and in his paintings articulate and devout; the saints he painted possess more of the expression and the appearance of saints than those by any other artist. It was his habit never to retouch or to redo any of his paintings but, rather, always to leave them just as they had turned out the first time, since he believed (according to what he said) that this was God's will. Some people claim that Fra Angelico never set his hand to a brush without first saying a prayer. He never painted a crucifix without the tears streaming down his cheeks, and the goodness of his sincere and noble nature inspired by the Christian religion can be recognized in the faces and poses of his figures. He died at the age of sixty-eight in 1455, and he left behind as his pupils Benozzo of Florence, who always imitated his style, and Zanobi Strozzi, who did paintings and panels throughout Florence in the homes of its citizens... Gentile da Fabriano and Domenico di Michelino were also his students....* Fra Angelico was buried by his fellow friars in Santa Maria sopra Minerva in Rome along the side entry near the sacristy in a round marble tomb, upon which his likeness is sculpted from life....*

THE END OF THE LIFE OF FRA GIOVANNI
OF FIESOLE

The Life of Leon Battista Alberti, Florentine Architect

[1404–1472]

Letters bring the greatest benefits to all those artisans who take
delight in them, and most especially to sculptors, painters, or
architects, by opening the way to creativity in all of their
endeavours. Anyone who is deprived of the experience of
life's contingencies, that is, of the companionship of good
books, cannot possess perfect judgement (even if this judge-
ment is a natural gift). For who does not realize that in
choosing a site for buildings, one must use natural philosophy
to avoid the severity of pestilential winds, unhealthy air, and
the smells or vapours of impure and unhealthy waters? Who
does not recognize that one must know what to avoid and
what to accept in one's own work after careful consideration,
without having to rely upon the theories of others, which, in
most cases, are found to be of little value when separated from
practice? But when by chance theory and practice meet and
join together, there is nothing more useful to our lives, for
through the means of science, art is perfected and enriched,
and the advice and writings of learned artisans are more useful
and trustworthy than the words or works of those artisans
who do nothing more than practise their craft, whether they
do so well or badly. The truth of these statements is clearly
demonstrated by Leon Battista Alberti, who, having studied
the Latin language and having practised architecture, per-
spective, and painting, left behind him books written so
well that although countless modern artisans have proved
more excellent than him in practice,* they have been unable to
equal him in writing about their craft. Accordingly, his
writings have exercised so much influence upon the works and
conversations of learned men that it is commonly believed he

far surpassed those artisans who actually surpassed him in the practice of their craft. Thus, experience shows us that as far as fame and reputation are concerned, the written word is far more influential and long-lasting than anything else; and provided that books are truthful and do not lie, they easily travel everywhere, and everywhere are trusted.

Thus, it is not surprising that the famous Leon Battista Alberti is better known for his writings than for the works he did with his hands. He was born in Florence* into the most noble family of the Alberti (which I discussed elsewhere),* and he spent his time not only investigating the world and measuring the ancient ruins but also, since he was very much inclined in this direction, devoting more energy to writing than to producing actual works. He was a very fine arithmetician and geometrician, and in Latin he composed a treatise on architecture in ten books which he published in 1481 and which can be read today in a translation in the Florentine language by the Reverend Messer Cosimo Bartoli, provost of San Giovanni in Florence.* He also wrote a treatise on painting in three books, now translated into Tuscan by Messer Ludovico Domenichi;* he did a treatise on pulling weights and the rules for measuring heights, as well as a book on the civic life and some erotic works in both prose and verse.* And he was the first to try to adapt vernacular poetry to Latin prosody, as in this letter of his:

> I send this most wretched letter
> To you, who so wretchedly scorn us.*

Leon Battista happened to arrive in Rome during the reign of Pope Nicholas V, who had turned Rome upside-down with his methods of building, and through the intercession of Flavio Biondo from Forlì, his close friend, he came to be on close terms with the pope, who had earlier taken advice on architectural matters from Bernardo Rossellino, the Florentine sculptor and architect (as will be discussed later in the life of Antonio, his brother).* After Bernardo had begun to remodel the papal palace and to do several things in Santa Maria Maggiore following the pope's wishes, from that time on he always sought Leon Battista's advice. As a result, by depending

upon the judgement of the one and the ability of the other to execute a project, the pontiff constructed many things which were useful and worthy of praise; among them were the refitting of the water pipes to the Acqua Vergine fountain, which had fallen into disrepair, and the construction of the fountain in the Piazza de' Trevi with the marble decorations that can be seen there today, upon which are found the coat of arms of that pontiff and of the Roman people.*

Afterwards, Leon Battista went to serve Lord Sigismondo Malatesta of Rimini, where he constructed the model for the church of San Francesco and especially for the facade, which was built of marble, as well as the vaulting on the side facing south which contained large arches and tombs for the illustrious men of that city.* In short, his fine workmanship so changed the edifice that it became one of the most famous churches in Italy. Inside the church, there are six of the most beautiful chapels; one of these, a most ornate chapel dedicated to Saint Jerome, is used to hold the many relics brought back from Jerusalem. In the same church stand the tombs of the same Lord Sigismondo and his wife, most richly carved from marble in 1450; over one of them is the portrait of this ruler, and in another part of the work that of Leon Battista. Then, in the year 1457, when the German Johann Gutenberg discovered his extremely useful method of printing books, Leon Battista likewise discovered a means of tracing natural perspectives and diminishing figures by means of an instrument, as well as the way to enlarge smaller figures by adapting them to larger proportions—these were all charming and helpful inventions, both useful to art and quite beautiful.

It was during Leon Battista's lifetime that Giovanni di Paolo Rucellai wished to build, at his own expense and entirely in marble, the main façade for Santa Maria Novella, and he spoke with his close friend Leon Battista about this project, and receiving not only his advice but also the design, Rucellai resolved to execute this work, whatever the cost, in order to leave behind some monument to his own memory. And so, the project was begun and completed in the year 1477 to the great satisfaction of all, who found the entire work pleasing but most especially the door, where it is evident that Leon

Battista expended more than ordinary effort.* He likewise
created for Cosimo Rucellai the design for the palace which
he built in the street called La Vigna, as well as for the loggia
opposite the palace, in which he constructed arches over the
narrow columns in the façade and upper parts; and because he
wished to continue them and not merely form a single arch,
he left space between each part; and thus he was forced to
make some projections on the inside corners. When later he
wanted to construct the arch of the interior vault, he observed
that he could not give it the curvature of a semicircle, since
it would turn out flattened and awkward, and he decided to
build small arches in the corners from one projection to
another. Here he lacked the good judgement and the sense of
design that demonstrate quite clearly the necessity of practical
experience in addition to learning. For judgement can never
become perfect until knowledge, taking concrete form, is put
into practice.

It is said that Leon Battista also designed the home and
garden of this same Rucellai family in the Via della Scala, a
project executed with excellent judgement which turned out
to be exceptionally comfortable, for besides its other many
conveniences, it has two loggias—one facing south and the
other towards the west—both very handsome and constructed
without arches over the columns. This method is the true and
proper one which the ancients practised, for the architraves
laid across the capitals of the columns stand level, whereas
something with square edges—such as curving arches—cannot
rest upon a round column without appearing faulty. Thus, the
proper method of construction requires that architraves be
placed upon columns, and when arches must be built, pillars
and not columns should be used.

For the same Rucellai family Leon Battista built a chapel in
San Brancazio in this same style of his which is supported
by large architraves resting upon two columns and two pillars
that go through the wall of the church, a difficult but most
secure method. As a result, this work is one of the best
completed by this architect. In the middle of this chapel, there
is a very well-made marble tomb of an elongated oval shape
which, an inscription reveals, is similar to the tomb of Jesus

Christ in Jerusalem. At the same time, Lodovico Gonzaga, Marquis of Mantua, wanted to build the tribune and principal chapel in the Servite Church of the Annunziata in Florence using Leon Battista's plans and his model;* and he tore down a square chapel in the same church which was old, not very large, and painted in the old style, and built the new tribune in a refreshingly original and difficult manner, in the shape of a round temple surrounded by nine chapels, all of which form a semicircular arch and which can be used like a niche. For this reason, since the arches of this chapel are supported by the pillars in the front, the stone ornaments on the arch while moving towards the wall always turn backwards to meet the wall, thus turning away from the curve of the tribune. As a result, when the arches of these little chapels are viewed from the sides, they seem to be falling backwards and look as awkward as they are in fact, even though their measurements are correct and their method of construction difficult. And to tell the truth, if Leon Battista had avoided this method, it would have come out much better, for besides being difficult to execute, this method is awkward in its details, both large and small, and cannot really be successful. And that this is the case in its larger particulars may be seen from the very large arch in front which forms the entrance to the tribune, for while from outside it is very beautiful, yet from the inside, since it must turn around following the chapel, which is round, it appears to be falling backwards and is extremely awkward. Perhaps Leon Battista would not have done this if, along with his knowledge and theory, he had possessed practical knowledge and experience in building, for another architect would have avoided this difficulty by attempting, instead, to render the grace and greater beauty of the edifice. Otherwise, all of this work is in itself most beautiful, strikingly original, and exact. And Leon Battista had nothing less than a great deal of courage to have vaulted the tribune in the manner he chose during those times.

This same Marquis Lodovico then brought Leon Battista to Mantua, to have him make the model of the church of Sant'Andrea, as well as a number of other things, and on the road leading from Mantua to Padua, several churches can

be seen which are built in Leon Battista's style.* Salvestro
Fancelli of Florence, a rather good architect and sculptor,
executed Leon Battista's designs and models, and followed his
wishes with good judgement and extraordinary care in all
the works Leon Battista undertook in Florence. The buildings
he constructed in Mantua were done by a Florentine named
Luca, who continued to live in Mantua, where after his death,
according to Filarete, he left his name to the Luchi family,
which still lives there today. Alberti was therefore very for-
tunate to have friends who understood him and who were
willing and able to work for him, for since architects cannot
always watch over their building projects, it is a great help to
them to have someone who will faithfully and lovingly carry
them out, and if no one else ever realized this, I certainly have
done so through long experience.

In painting, Leon Battista never produced any great or
unusually beautiful works, since those that can be still seen
(which are very few in number) are less than perfect; nor is
this surprising, since he spent more time on his studies than on
the art of design. Nevertheless, he could demonstrate his ideas
quite well with his drawings, as can be seen in some sheets in
his hand included in our book; in these sheets are the plans for
the Sant'Angelo bridge and the covering which he designed
like a loggia to protect it from the sun in the summers and
from the rains and the winds in the winters. This he was
commissioned to do by Pope Nicholas V, who had intended
to build many other similar projects throughout Rome before
death interrupted his plans. There is a work by Alberti in a
little chapel dedicated to Our Lady on the side of the Ponte
alla Carraia in Florence—that is, a predella—containing three
small scenes with some perspectives which he described much
better with his pen than he painted with his brush. Likewise
in Florence, in the home of Palla Rucellai, there is Alberti's
self-portrait which he executed with the help of a hand-
mirror, as well as a panel containing very large figures done
in chiaroscuro. He also painted a picture of Venice and San
Marco in perspective, but the figures which it contains were
executed by other masters, and this is one of the best examples
of his painting to be seen. Leon Battista was a person of the

most civilized and praiseworthy habits, a friend of talented men, generous and completely courteous with everyone, and he lived honourably, as the gentleman he was, during his entire life. And when he finally reached a ripe old age, he passed away to a better life contented and tranquil, leaving behind him a most honourable reputation.

THE END OF THE LIFE OF LEON BATTISTA ALBERTI

The Life of Antonello da Messina, Painter
[c.1430–1479]

When I myself consider the various kinds of benefits and advantages conferred upon the art of painting by many masters who have followed this second style, I cannot but call them truly industrious and excellent through their works, since their principal concern was to bring painting to a higher level of perfection without giving a thought to any hardship, expense, or other personal interest. Thus, they persisted in using no other kind of colouring than tempera on their panels and canvases, a method which was begun by Cimabue in the year 1250 when he was working with the Greeks and was later continued by Giotto and the other painters we have discussed up to this point. These artisans kept on painting in this way although they recognized full well that in tempera painting their works lacked a certain softness and vitality which would have produced, had it been found, more grace in design, more beauty in the colours, and greater facility in blending colours together, and they had always been in the habit of executing their works with nothing but the points of their brushes.

But although many had tried to find such a method, raising questions along the way, no one had ever discovered a good method—either by using liquid varnish or by using other kinds of colours mixed with the tempera. Among the many who experimented with such methods or other similar ones but failed were Alesso Baldovinetti, Pesello, and many others, none of whom succeeded in executing works of the beauty and excellence they had imagined.* And even if they had discovered the method they were seeking, they lacked the means of making the figures in their panels pose like those they painted upon walls; the method of washing them without the colours running; and that of creating works

which could tolerate any kind of abuse in the process of being handled. A good number of artisans, gathering together, had often discussed these problems without ever finding any solutions.

Outside of Italy, many gifted minds dedicated to painting —that is, all the painters of France, Spain, Germany, and other countries—possessed this same desire. It therefore happened, as matters stood, that while Giovanni da Bruggia,* a painter greatly esteemed in those parts for the excellent practical skill he had acquired in his craft, was working in Flanders, he began to try out various kinds of colours and, as a man who took delight in alchemy, to make a number of oils for use in varnishes and other purposes, following the ideas of learned men such as himself. And on one occasion or other, after having expended a good deal of effort on painting a panel, he brought his work to completion with great care, gave it a coat of varnish, and set it out in the sun to dry as was the custom. But, either because the heat was extreme, or because the wood had been badly joined or poorly seasoned, his panel unfortunately split along the joints. As a result, when Giovanni saw the damage the sun's heat had caused his panel, he decided to find a way to prevent the sun from ever again causing such great damage to his works. And so, rejecting both varnish and working in tempera, he began to ponder a means of producing a kind of varnish which would dry in the shade without putting his paintings in the sun. And after he had experimented with many materials, both pure substances and mixtures, he finally discovered that linseed and walnut oil dried faster than all the other oils he had tested. Thus, by boiling these oils with some other mixtures he made, he produced the varnish that he—or rather, all of the painters in the world—had long desired. After testing many other materials, he realized that mixing his colours with these kinds of oils gave them a very strong consistency, and that when they dried, not only were they waterproof, but the colours gleamed so brightly that they possessed lustre by themselves without the need for varnish, and, what seemed even more amazing to him, they could be blended infinitely better than tempera.

As one might reasonably expect, Giovanni was extremely delighted with this invention, which gave birth to many works, filling the whole region with them to the incredible delight of the public and the greatest profit to himself, and Giovanni, assisted from day to day by his experience, went on to produce ever greater and better works. Before long, the fame of Giovanni's discovery spread not only throughout Flanders but throughout Italy and other parts of the world, and artisans were extremely anxious to know how he rendered his works with so much perfection. Those artists who saw his works without understanding the methods he employed were forced to admire them and to bestow lavish praise upon them, but, at the same time, they were envious of his skills, especially since for a time he did not want anyone to see him working or to learn his secret. But when he became old he finally bestowed the favour upon Ruggieri da Bruggia, his pupil, and Ruggieri told Ausse his student and others who are mentioned in works treating the subject of oil painting.* But in spite of this and the fact that merchants purchased these works and sent them all over the world to princes and important personages, making huge profits, the method did not travel beyond Flanders. And although such works, especially when they were fresh and when it seemed possible to recognize the secret, possessed the sharp odour that the colours and the oils mixed together gave them, this secret was still never discovered over the course of many years.

But then, when some Florentines who were engaged in business in Flanders and Naples sent a panel by Giovanni containing many figures and painted in oil to King Alfonso I of Naples, who valued it very highly both for the beauty of its figures and for the new invention of its colouring, all the painters in that kingdom gathered around to see it, and it was highly praised by them all. Now, one of them was a man named Antonello da Messina, a person with a good and lively mind, who was very clever and experienced in his trade, and who had studied the art of design in Rome for many years; he had first gone off to Palermo, where he worked for many years, and then finally moved to his native Messina, where he had confirmed with the works he finished there the good

opinion his native city held of his talent as a painter of great
style. Thus, travelling for business on one occasion from Sicily
to Naples, this man heard that the above-mentioned panel,
painted in oil by Giovanni da Bruggia, had reached King
Alfonso from Flanders, and that it was done in such a manner
that it could be washed, would withstand every kind of abuse,
and was completely perfect. And after he made the effort to
see the painting, the vitality of its colours as well as its beauty
and harmony made such an impression upon him that, setting
aside every other business matter and concern, he went off to
Flanders.*

When Antonello reached Bruges, he struck up a close
friendship with Giovanni, showing him many drawings done
in the Italian style and other things. Because of this friendship,
Antonello's observations, and the fact that Giovanni was
already very old, he allowed Antonello to see how he made oil
paints, and Antonello therefore did not leave Bruges until he
had mastered this method of painting he had so intensely
desired to learn. Not long afterwards, following Giovanni's
death, Antonello returned from Flanders to his native country
to acquaint all of Italy with this practical, beautiful, and useful
secret. After passing a few months in Messina, he moved to
Venice, where, as a man greatly given over to all the carnal
pleasures, he resolved to live forever and to end his life in a
place where he had found a way of living exactly to his
liking.* Thus, he set to work, and, following the method he
had learned in Flanders, he executed many oil paintings there
which are scattered throughout the homes of that city's
nobility, who held them in high esteem for their innovations
in workmanship. He also did a great many more which were
sent to various places, and when he had finally acquired fame
and a great reputation in Venice, he was commissioned to do
the panel painting which was to go in San Cassiano, a parish
church of that city, and the panel was executed by Antonello
with all his knowledge and without sparing any of his time.*
When it was completed, it was greatly praised and held in the
highest esteem for its new method of painting in oil as well
as for the beauty of its figures, which were executed with a
good sense of design, and later on, once this new secret that

Antonello had brought from Flanders into the city of Milan
had been understood, Antonello was admired and cherished
by those magnificent noblemen for as long as he lived.
Among painters of some repute at that time in Venice was a
Master Domenico who was considered a very good painter.*
Upon Antonello's arrival in Venice, this painter paid
Antonello all those kindnesses and courtesies that one might
pay to a most dear and intimate friend; for this reason,
Antonello, who did not wish to be surpassed in kindness by
Messer Domenico, taught him not many months later his
secret and his method of painting in oil. No other act of
courtesy or kindliness could have been more precious to him,
since by means of this secret Domenico became, as one might
imagine, greatly honoured in his native city. And clearly
people are grossly mistaken in thinking that by being as stingy
as possible with things that cost them nothing they will be well
served by everyone for the sake of their beautiful eyes, as the
saying goes. The kindnesses of Master Domenico Veneziano
extracted from Antonello's hands what he had acquired with
so much labour and toil and what he would probably never
have conceded to anyone else for an enormous sum of money.
But because the life of Messer Domenico, his work in Florence,
and his generosity with the gift he had received with such
courtesy from others, will be discussed when it is appropriate
to do so, let me say now that, following the San Cassiano
painting, Antonello completed many paintings and portraits
for a great number of Venetian noblemen, and that Messer
Bernardo Vecchietti of Florence owns a painting by Antonello
of Saint Francis and Saint Dominic who are both very
handsome. When the Signoria later commissioned Antonello
to do some scenes in the palace (which they refused to
commission to Francesco di Monsignore of Verona,* although
he was very much a favourite of the Duke of Mantua),
Antonello became ill from tuberculosis and died at the age of
forty-nine without even putting his hand to the work....*

Such was the end of Antonello, to whom our artists are
certainly no less indebted for having brought the method of
oil painting into Italy than they are to Giovanni da Bruggia
for having discovered it in Flanders, since both of them

benefited and enriched this art. Because of this invention,
excellent artisans have subsequently arrived on the scene and
have been able to paint figures that seem almost alive. This
invention should be even more esteemed, because no writer
whatsoever can be found who attributes this method of
painting to the ancients. And if we could know that it had
never truly been employed by them, this century would truly
be considered superior to the ancients in the perfection of this
method. But since nothing can be said which has not already
been uttered before, perhaps nothing can also be done which
has not already been done before, and so I shall pass over the
question without saying any more. And praising lavishly those
men who have always added something to their art beyond
their designs, I shall turn to write about others.

THE END OF THE LIFE OF ANTONELLO DA MESSINA

The Life of Fra Filippo Lippi, Florentine Painter

[c. 1406–1469]

Fra Filippo di Tommaso Lippi, a Carmelite, was born in Florence in a main street called Ardiglione below the Canto alla Cuculia and behind the monastery of the Carmelite friars, and, after the death of his father Tommaso, at the age of two he was left in poverty without anyone to care for him, since his mother had also died not long after giving birth to him. Thus, he was raised by his aunt, Mona Lapaccia, the sister of his father Tommaso, who experienced great hardship in providing for him, and when she could no longer sustain the costs, and since he had already reached the age of eight, she made him a friar in the above-mentioned monastery at the Carmine Church.* There he showed himself as skilful and resourceful in manual labour as he was slow in his studies and ill-suited for letters; as a result, he never really tried to apply his mind to them and never felt any enthusiasm for them. This boy, who was called by his secular name, Filippo, was placed with the other novices under the guidance of the master who taught grammar in order to see what he might learn to do, and, rather than studying, he never did anything but mark up his books and those of his fellow novitiates with crudely drawn figures. Thus, the prior decided to give Filippo every opportunity and encouragement to learn how to paint.

At that time, Masaccio's chapel had just been painted in the Carmine Church, and because of its great beauty it pleased Fra Filippo very much, and so, as a pastime, he visited it every day; and he practised continuously in the company of many other young men who were always sketching there, so far surpassing the others in skill and knowledge that it was taken for granted he would certainly in time create marvellous

things. But both in his youth and in his maturity, Fra Filippo produced so many praiseworthy works that it was a miracle. And before very long, he executed a painting in *terra verde* in the cloister near Masaccio's Consecration of a pope confirming the rule of the Carmelites;* on many of the walls of the church, Fra Filippo painted frescos in various places, in particular a Saint John the Baptist and some scenes from his life. And thus, his work grew better each day, and he had acquired Masaccio's touch to such an extent that his own works greatly resembled those of Masaccio himself, and caused many people to say that Masaccio's spirit had entered Fra Filippo's body. On a pillar in the church near the organ, he painted the figure of Saint Martial, which brought him boundless fame, since it could be compared with the works that Masaccio had painted. Hearing himself highly praised by everyone, he boldly threw off his monk's habit at the age of seventeen.*

One day when he was in the March of Ancona amusing himself with some of his friends in a small boat on the ocean, they were all captured by the Moorish galleys that prowled in those waters, seized, and carried off to Barbary, where each one was placed in chains and held as a slave—and there Fra Filippo remained in great discomfort for eighteen months. But one day Filippo, who was familiar with his owner, decided to take the opportunity to draw his portrait, and so he took a burnt coal from the fire and sketched him full length in his Moorish clothing upon a white wall. The other slaves told their owner about this, for since neither design nor painting was employed in those parts they all thought it was a miracle, and this was the cause of his liberation from the chains which held him captive for so long. Truly, it is a glorious tribute to the great skill of painting that it caused someone with the legal authority to condemn and punish to do exactly the opposite and, instead of torture and death, he was led to bestow compassion and freedom.

Later, after he had done some works in colour for his owner, he was brought safely to Naples, where for King Alfonso, then Duke of Calabria, he painted a tempera panel in the chapel of the castle where the guard is now posted.*

Afterwards, he had the desire to return to Florence, where he stayed for several months, and he worked for the nuns of Sant'Ambrogio on a most beautiful panel for the main altar, which won him the gratitude of Cosimo de' Medici, who became his very close friend.* He also did a panel painting in the chapter house of Santa Croce,* and another in which he depicted the Nativity of Christ was placed in the chapel in the Medici palace;* he also worked for Cosimo's wife on a panel with the same Nativity scene, along with the figures of Christ and Saint John the Baptist, which were to be placed in the hermitage of Camaldoli in one of the hermit's cells dedicated to Saint John the Baptist which she had decorated as an act of piety;* and finally, he did some scenes which Cosimo sent as a gift to Pope Eugenius IV of Venice,* a work which earned for Fra Filippo great favour with the pontiff.

It is said Filippo was so lustful that whenever he saw women who pleased him, he would give them all his possessions just to have them, and if he could not, as a middle course, he cooled the flames of his amorous passion by talking to himself while painting their portraits. He was so obsessed by this appetite that when he was in such a libidinous humour he paid little or no attention to the projects he had undertaken. On one such occasion, Cosimo de' Medici, having commissioned him to do a work in his home, locked him inside so that he would not leave the house and waste time, but one evening after Filippo had remained there for two days, he was driven by his amorous—or rather, his bestial desires—to cut up some sheets from his bed into strips with a pair of scissors, and, once he had lowered himself out of a window, he pursued his pleasures for many days. And when he did not find him, Cosimo conducted a search for him and finally brought him back to work, and from that time on, he gave Filippo the freedom to come and go as he pleased, very much regretting having shut him up inside, considering Filippo's madness and the dangers he might encounter. Thus, in the future Cosimo always tried to restrain Filippo with acts of kindness, and he was accordingly served by Filippo with even greater readiness. And Cosimo always used to declare that rare geniuses are celestial forms and not beasts of burden.

Fra Filippo did a panel painting in the church of Santa
Maria Primerana on the piazza in Fiesole, in which he depicted
the Annunciation of Our Lady with the greatest care and in
which the figure of the angel is so beautiful that it truly seems
to be a celestial being. For the nuns of the Murate, he did two
panels: one of the Annunciation, placed on the main altar, and
the other on an altar in the same church, which contained
scenes from the lives of Saint Benedict and Saint Bernard;
and in the Palazzo della Signoria, he painted a panel of the
Annunciation over a door as well as a panel of Saint Bernard
over another door of the same palace; and in the Sacristy of
Santo Spirito in Florence, he painted a panel depicting Our
Lady surrounded by angels with saints on the sides—a rare
work and one which has always been held in the highest
veneration by our own masters today.*

In the chapel of the trustees of the Works Department of
San Lorenzo, Fra Filippo did a panel with another Annuncia-
tion,* and in the Della Stufa Chapel, he left another which is
incomplete. In a chapel in the Santi Apostoli Church of the
same city, Fra Filippo painted a panel containing some figures
grouped around a Madonna, and in Arezzo, for Messer Carlo
Marsuppini, he did the panel in the Chapel of Saint Bernard at
the monastery of Monte Oliveto depicting the Coronation of
Our Lady with many saints surrounding Her, a work which
has retained its freshness and seems only just now to have been
finished by Fra Filippo.* When he was working on this panel,
Messer Carlo warned him to take care when he painted the
hands, since many of his works had been criticized for this
reason. Thus, when Fra Filippo painted hands from that time
on, he covered them up with draperies or some other in-
vention in order to avoid such criticism. In this work, he did
an actual portrait of Messer Carlo. For the nuns of the
Annalena in Florence, he painted a panel of the Nativity,* and
also in Padua some of his works can still be seen.* He sent to
Rome two small scenes which he painted with tiny figures
for Cardinal Barbo, both splendidly painted and carefully
executed. Fra Filippo certainly painted with marvellous grace,
giving his works the most exquisite finish and harmony, and,
for this reason, he has always been celebrated with the highest

praise by artisans of quality and by modern masters, and as long as the exquisite works to which his many labours gave birth survive the ravages of Time, he will be held in the highest esteem in every century.

In Prato near Florence, where he had some relatives, he remained for many months, working throughout the entire district on a number of projects along with Fra Diamante of the Carmine* who had been his companion when they were novices together. Then, the nuns of Santa Margherita gave him the project of painting the panel for the main altar, and one day while he was at work on it, he caught sight of the younger daughter of Francesco Buti, a Florentine citizen, who was living there either as a ward or as a nun. Once Fra Filippo cast his eye on Lucrezia (for that was the girl's name), who had the most beautiful grace and bearing, he was so persistent with the nuns that they allowed him to paint her portrait in order to use it in a figure of the Madonna for the work he was completing for them. This opportunity caused him to fall even more deeply in love, and he then made arrangements, using various means, to steal Lucrezia away from the nuns, leading her away from the convent the very day that she was going to see the showing of the Girdle of Our Lady, a relic greatly venerated in that town. As a result, the nuns fell into disgrace over the affair, and her father Francesco was never happy again and did everything he could to have her back. But either out of fear or some other reason, she never wanted to return, and, instead, she stayed with Filippo, for whom she bore a male child who was also called Filippo and later became, like his father, a most excellent and famous painter.*

There are two of Fra Filippo's panel paintings in the church of San Domenico in Prato, as well as a Madonna in the choir screen of the church of San Francesco, which was removed from where it originally stood, and, so as not to ruin it, they cut it out of the wall upon which it had been painted, and then, bound to a wooden framework, it was transferred to an inner wall of the church, where it can still be seen today. And over a well in the courtyard of the Ceppo of Francesco di Marco, there is a little panel by Fra Filippo which contains a portrait of Francesco di Marco, who was the creator and founder of that

pious institution.* In the parish church of the same town, he painted a small panel over the side door, on the way up the stairs, depicting the death of Saint Bernard, who is restoring to health a great many cripples as they touch his coffin; there are also friars who mourn their dead master, and it is a marvellous thing to see the skill and naturalness with which he rendered the beautiful expressions on their faces in their sad lamentation. Some of the monks' cowls display the most beautiful folds and deserve endless praise for their fine design, colouring, composition, grace, and proportion, which are obviously the work of Fra Filippo's extremely delicate hand. In order to have a memorial of him, the trustees of the Works Department of the same parish church commissioned Fra Filippo to paint the chapel of the main altar; he exhibited so much of his talent in this work that besides its excellence and craftsmanship, there are garments and heads which are wholly admirable. In these frescos, he painted his figures larger than life, thus introducing modern artisans to the method of working on a large scale typical of the style of our own day. By clothing some of the figures in garments which were not customary in that period, he began to encourage others to abandon a simplicity that can more readily be termed old-fashioned in keeping with the style of antiquity. In this work are scenes from the life of Saint Stephen, the titular saint of the parish church, painted in sections upon the wall on the right side, that is, the Disputation, the Stoning, and the Death of this first martyr. Fra Filippo showed such zeal and fervour in Saint Stephen's face as he disputes with the Jews that it is difficult to imagine it, much less express it, along with the hatred, contempt, and anger in the faces and poses of these Jews who see themselves vanquished by him; he made the bestiality and rage of those who murder him with stones even more obvious, showing some seizing large stones while others pick up smaller ones, with a horrible gnashing of teeth and gestures that are all cruel and violent. And none the less, during this terrible attack, Saint Stephen, confidently turning his face towards Heaven, is seen praying to the Eternal Father with the greatest charity and fervour for the very men who are killing him. These are certainly beautiful ideas which should make

other painters realize the importance of invention and know-
ing how to express emotions in painting. Fra Filippo observed
these things so well that the figures of the men who are
burying Saint Stephen are depicted in such sorrowful poses
and their faces so tormented by unrestrained weeping that it is
hardly possible to gaze upon them without being moved.*

On the other side of the chapel, Fra Filippo painted scenes
from the life of Saint John the Baptist: the Birth, the
Preaching in the Wilderness, the Baptism, the Feast of Herod,
and the Beheading; the divine spirit is evident in Saint John's
face as he preaches, while the various movements of the crowd
listening to him—both men and women—express the joy and
sorrow of all those caught up and absorbed by his teachings.
Beauty and kindness can be seen in the Baptism, and in the
Feast of Herod, the sumptuousness of the meal, the agility of
Herodias, the amazement of the guests, and their immeas-
urable sorrow as the severed head is presented in a bowl are all
apparent. Around the banquet table, countless figures can be
seen in very beautiful poses with garments and facial expres-
sions that are well executed, including a portrait of the artist
clad in black in a priest's habit, done with the aid of
a mirror, while in the scene where Saint Stephen is being
mourned, Fra Filippo depicted his pupil Fra Diamante. And in
truth, this painting is the most excellent of all his works, not
only for the reasons mentioned above but also because he
executed his figures somewhat larger than life. This encour-
aged those who came after him to paint on a larger scale. Fra
Filippo was so highly esteemed for his good qualities that the
many other blameworthy things he did were compensated for
by his rare talent. In this same work, he also did a portrait of
Messer Carlo, Cosimo de' Medici's natural son, who was at
that time provost of the church, which received many gifts
from him and his family.

After Fra Filippo had completed this work in the year
1463, he painted a tempera panel containing a most beautiful
Annunciation in the church of San Jacopo of Pistoia for
Messer Jacopo Bellucci, who is seen in this work in a very
lively portrait. In the home of Pulidoro Bracciolini, there is a
painting of the Nativity of the Madonna by his hand; in the

Offices of the Eight in Florence, there is a lunette painted in tempera containing a Madonna with Child; in the home of Lodovico Caponi, in another painting, there is a very beautiful Madonna; and in the home of Bernardo Vecchietto—a Florentine gentleman whose virtue and goodness are so great that I hardly know how to describe them—there is a beautiful little portrait of Saint Augustine in his study by Fra Filippo. But even better than this is the Saint Jerome in Penitence of the same size in Duke Cosimo's wardrobe.* And if Fra Filippo's paintings exhibit rare beauty, he surpassed even himself in his small pictures, for he painted them so gracefully and beautifully that they could not be better, as we can see in the predellas of all his panel paintings. In short, he was such a great painter that in his own day no one surpassed him and only a few have done so in our own times, and not only has Michelangelo always praised him, but he has even imitated him in many ways. He also did a panel for the church of San Domenico Vecchio in Perugia, portraying the Madonna, Saint Peter, Saint Paul, Saint Louis, and Saint Anthony Abbot, which was later placed on the main altar.* Messer Alessandro degli Alessandri, then a knight and a friend of his, had him paint a panel for the church in his villa at Vincigliata on the hillside near Fiesole which depicts Saint Laurence and other saints and includes portraits of Alessandro and two of his sons.*

Fra Filippo always liked to befriend cheerful people and he always lived a happy life. He taught the art of painting to Fra Diamante, who did many pictures for the Carmine Church of Prato; by imitating Fra Filippo's style, Fra Diamante did himself great honour, for he reached the height of perfection. Those who studied with Fra Filippo in their youth include Sandro Botticelli; Pesello; Jacopo del Sellaio, the Florentine, who painted two panels in tempera for the church of San Frediano and one for the Carmine Church; and countless other masters to whom Fra Filippo lovingly taught this art.*

Fra Filippo lived honourably from his labours and spent exceptional amounts on his love affairs, which he continued to enjoy throughout his life up to the time of his death. Because

of Cosimo de' Medici, he was asked by the community of
Spoleto to do the chapel in the main church dedicated to Our
Lady, on which he made good progress, working together
with Fra Diamante, but before he could finish it, he was
overtaken by death. It is said that as he was pursuing one of
those blessed love affairs to which he was so inclined, some of
the relatives of the woman with whom he was involved had
him poisoned. Fra Filippo met his end in 1438,* and in his will
he left his son Filippo in the care of Fra Diamante. His son, a
boy of ten, learned the art of painting from Fra Diamante,
with whom he returned to Florence. Fra Diamante took along
with him the 300 ducats that the community still owed them,
using it to purchase a number of things for himself but giving
only a small portion to the young boy. Filippo was placed
with Sandro Botticelli, at that time considered to be a very
fine master. And the old painter was buried in a tomb of red
and white marble erected by the people of Spoleto in the
church where he had painted.

Fra Filippo's death grieved his many friends but most
particularly Cosimo de' Medici and Pope Eugenius, who had
hoped to give Fra Filippo a dispensation while he was still
alive so that he could take Lucrezia di Francesco Buti as his
legitimate wife.* But since Fra Filippo preferred to live and to
pursue his appetites as he pleased, he did not accept the offer.
While Pope Sixtus IV was living, Lorenzo de' Medici, who
had been made an ambassador of Florence, went to Spoleto to
ask the community for the body of Fra Filippo in order to
bury it at Santa Maria del Fiore in Florence. But they told him
that Spoleto lacked any monuments of note, especially those
to distinguished men, and asked Lorenzo as a favour to leave
his body there in order to honour their town, adding that
Florence had such an infinity of distinguished men, almost a
superfluity, that they could manage to live without this one;
and so Lorenzo did not obtain what he wanted. However,
later on, since Lorenzo had resolved to honour Fra Filippo in
the best way he could, he sent his son Filippino to Rome to
paint a chapel for the Cardinal of Naples. On his way through
Spoleto, Filippino, who had been commissioned by Lorenzo,
erected a marble tomb for him under the organ over the

sacristy, on which he spent one hundred gold ducats disbursed by Nofri Tornabuoni, director of the Medici bank....*

That Fra Filippo was a very fine draughtsman is evident in our book containing the drawings of the most famous painters, most especially in some sheets containing the design for the panel painting in Santo Spirito, as well as others for the chapel in Prato.

THE END OF THE LIFE OF FRA FILIPPO, FLORENTINE PAINTER

The Life of Andrea del Castagno of Mugello
[c.1423–1457]

and Domenico Veneziano
[d. c.1461],

Painters

How blameworthy it is to find the vice of envy in a dis-
tinguished person, a vice no one should possess! And what a
wicked and horrible thing it is to seek, under the guise of false
friendship, to extinguish in others not only their fame and
glory but their very lives as well! I certainly do not believe it
possible to express this in words, since the villainous nature of
the act would overcome every gift and power of the tongue,
no matter how eloquent it might be. Thus, without discussing
the matter any further, I shall only say that within a person
who does such things lodges a spirit which is not only savage
and inhuman but utterly cruel and diabolical as well, and such
persons are so far removed from every virtue that they are no
longer human beings or even animals, nor do they deserve to
live. And one may conclude that just as imitation and com-
petition, which, working virtuously and seeking to overcome
and to surpass all that is superior in pursuit of glory and fame,
represent praiseworthy qualities and should be valued as useful
and necessary in the world, so, too, on the contrary, the most
villainous envy deserves even more reproach and condem-
nation, for envy, unable to tolerate honour and esteem in
others, is prepared to take the life of anyone whom it cannot
strip of glory, as did the spiteful Andrea del Castagno. In
painting and the art of design, he was truly excellent and
great, but far greater still were the rancour and envy he bore

for other painters, so great, in fact, that the shadow of his sins buried and obscured the splendour of his talents.

Because he was born in a small village called Il Castagno in the Florentine territory of the Mugello, this man took the name of the town as his surname when he came to live in Florence, and this came about in the following manner. Since he had been left fatherless in early childhood, Andrea was taken in by one of his uncles, who for many years kept him guarding his herds, because he found the boy to be alert and quick-witted and so exceptional that he could not only guard his animals but also the pastures and everything else that touched upon his interests. And thus continuing to practise this trade, it happened one day while he was trying to avoid the rain that he came upon a spot where one of those country painters who work for low wages was painting a tabernacle for a peasant. Andrea, who had never before seen such a thing, was suddenly struck with wonder, and began most attentively to examine and to contemplate the style of such work. And he was suddenly seized by so strong a desire and so passionate a yearning to practise this art that, without wasting any time, he began to draw and sketch animals and figures on walls or on rocks with charcoal or the point of his knife, which were done so well that they aroused no little surprise in those who saw them. And so, the fame of this new study of Andrea's began to spread among the peasants, and, as fortune would have it, reached the ears of a Florentine nobleman named Bernardetto de' Medici,* who owned property in that area, and he wanted to meet the young man. When he finally saw him and heard him talk with such ease, he asked Andrea if he was willing to take up the painter's trade. Andrea answered that he would like nothing better, nor would anything ever please him more, and so that he might perfect his craft, Bernardetto took Andrea back with him to Florence and arranged for him to work with one of those masters who at the time was considered to be among the best.

And so, Andrea pursued the craft of painting, devoting all his time to studying it, and he demonstrated the sharpest intelligence in confronting the problems of that trade, especially in the art of design. He did not do as well in the

colouring of his works; by executing them in a somewhat
crude and harsh fashion, he greatly diminished their excellence
and grace, especially the kind of charm which is absent from
his use of colours. He was very bold in painting the move-
ments of his figures and exceptional in his execution of the
heads of both men and women, giving them serious ex-
pressions and executing them with a good sense of design. The
works he painted in coloured frescos when he was quite
young are in the cloister of San Miniato al Monte as you
descend from the church to go to the convent: there is a scene
depicting Saint Minias and Saint Crescentius as they leave
their father and mother. In San Benedetto, a very pretty
monastery outside the Pinti gate, there were many paintings
by Andrea in a cloister and inside the church which require
no mention, since they were destroyed during the siege of
Florence.* Inside the city, at the monastery of the monks
of the Angeli, in the first cloister facing the main door, he
painted the Crucifixion with Our Lady, Saint John, Saint
Benedict, and Saint Romuald which is still there today.* And
at the end of the cloister, which is above the garden, he did a
similar Crucifixion, varying only the heads and a few other
small details.* In Santa Trinita, beside the chapel of Master
Luca,* he painted Saint Andrew. In Legnaia, for Pandolfo
Pandolfini, he painted a number of illustrious men in a hall.*
And for the Confraternity of the Evangelist, he made a stand-
ard to be carried in processions which was considered most
beautiful. In the church of the Santissima Annunziata in the
same city, he painted frescos on three flat niches in various
chapels. One devoted to Saint Julian* contains scenes from the
life of this saint with a large number of figures and a fore-
shortened dog that was highly praised; above this work, in the
chapel dedicated to Saint Jerome,* he depicted this saint gaunt
and shaven with a fine sense of design and with enormous
care, and above this he painted a Holy Trinity with a fore-
shortened Cross so well executed that Andrea deserves to be
highly praised for it, since he completed the foreshortening
with a much better and more modern style than others before
him had ever achieved. But this painting is no longer visible,
since a panel painting belonging to the Montaguti family

was placed over it. In the third chapel, which is beside the one below the organ and which was constructed by Messer Orlando de' Medici, Andrea painted Lazarus, Martha, and Mary Magdalene. For the nuns of San Giuliano, he did a Crucifixion in fresco above the door with the Madonna, Saint Dominic, Saint Julian, and Saint John—one of the best paintings Andrea ever did and generally praised by all artisans.

He also worked at Santa Croce in the Cavalcanti Chapel, painting a Saint John the Baptist and a Saint Francis, both considered very good figures.* But the work which astonished other artisans was an extremely beautiful Christ tied to a column being scourged which he painted in fresco in the new cloister of that convent—that is, at the end and opposite the door; in this work he created a loggia containing columns in perspective, vaults with pointed arches and diminishing bands, and the almond-shaped walls with so much skill and care that he showed himself to understand the problems of perspective no less than he did those of design in painting. In the same scene the poses of the men who flagellate Christ are beautiful and violent, their faces displaying hatred and rage, while that of Christ expresses patience and humility; in Christ's body, beaten and bound tightly by ropes to the column, it appears that Andrea attempted to express the suffering of the flesh, and that the divinity concealed within His body preserves a certain noble splendour which moves Pilate, who is seated among his counsellors and seems to be trying to find a way to set Him free. In short, this painting is so well done that if, as a result of the neglect it has suffered, it had not been scratched and ruined by children and other simple people, who erased all the heads, arms, and almost every other trace of the Jews—as if they had taken revenge against them for the abuse they inflicted upon Our Lord— this would certainly be among the most beautiful of all of Andrea's works. If Nature had only given him a delicacy in his use of colours as she granted him great powers of invention and design, he would truly have been considered marvellous.

In Santa Maria del Fiore, Andrea painted the image of Niccolò da Tolentino on horseback,* and while Andrea was at work, a young boy passing by shook the ladder, and Andrea

flew into such a rage that, like the bestial man he was, he climbed down and ran after the boy all the way to the corner of the Pazzi palace. In the ossuary of the cemetery at Santa Maria Novella, he painted a Saint Andrew which was so delightful that he was subsequently asked to paint a Last Supper* with the Apostles in the refectory where the servants and other altar attendants eat, a work which earned him favour with the Portinari family and a brother Hospitaller who had him paint a part of the main altar*—commissioning another part to Alesso Baldovinetti and the third to the painter Domenico Veneziano, who was more celebrated at that time and was brought to Florence because of his new technique of painting in oil.

Each painter, therefore, attended to his own work, but Andrea was terribly envious of Domenico, for even though Andrea realized he was superior to Domenico in design, he nevertheless took it badly that a foreigner such as Domenico was treated affectionately and entertained by the townspeople, and since anger and resentment were such strong forces in his personality, Andrea began to consider how, by one means or another, he might get him out of the way.* Because Andrea was no less a clever hypocrite than a remarkable painter, he could wear a happy expression on his face whenever he wished, possessed a quick tongue and remarkable courage, and showed himself to be as resolute in all his actions as he was in his intentions; he showed as much rancour towards other painters as he did towards Domenico, habitually scratching up the works of others with his nails in secret whenever he discovered a defect in them. In his youth, when his paintings were criticized in some way, he made it clear to his critics with blows and other types of abuse that he was able and willing to take revenge for such injurious attacks.

But before we come to the work in the chapel, let me say something about Domenico. Even before he came to Florence, Domenico had joined Piero della Francesca in painting some extremely graceful things in the sacristy of Santa Maria di Loreto that—along with the work he had executed in other places, such as the room he decorated in the home of the Baglioni, which has since been destroyed—had already made

him well known in Florence.* Then after being summoned to Florence and before doing anything else, he painted in fresco a Madonna surrounded by some saints for a tabernacle on the Carnesecchi side of the street at the corner of the two streets which run, respectively, towards the new square and the old square of Santa Maria Novella.* And the fact that the work was very pleasing and was greatly praised by the citizens and artisans of those times kindled even greater resentment and envy against poor Domenico in Andrea's mind. And so, after some thought, he decided to achieve with deceit and treachery what he could not achieve openly without obvious danger to himself, and he pretended to be Domenico's friend. Since Domenico was a good, kind person who enjoyed singing and playing the lute, he willingly became friends with Andrea, taking him to be a person of intelligence and a delightful companion. This friendship, real on one side but feigned on the other, continued on, and the two men were together every night, amusing and serenading their sweethearts, much to Domenico's great delight. He genuinely liked Andrea and taught him his method of painting in oil which was not yet known in Tuscany.

But, to proceed in an orderly way, Andrea then executed on his side of the chapel at Santa Maria Novella an Annunciation which is considered very beautiful because he had painted the angel in the air, which was not the custom at that time. But considered an even finer work is the Madonna he painted in the act of climbing the temple stairs, upon which Andrea represented many poor people—among them a man who is striking another with a jug. And not only this figure but all the others are truly beautiful, since in his competition with Domenico, Andrea had worked upon them with a great deal of study and loving care. Also, in the middle of a square, an octagonal temple drawn in perspective is seen standing alone and full of pillars and niches, its façade most beautifully adorned with figures that look as if they were made of marble. Around the piazza, there is a variety of the most beautiful buildings upon which falls the shadow of the temple cast by the light of the sun in a most beautiful, ingenious, and artistic fashion. On the other side, Maestro Domenico painted in oil a

scene of Joachim meeting Saint Anne, his wife, with a scene of the Birth of the Madonna below, in which he depicts with exquisite grace a highly decorated imaginary chamber where a *putto* is knocking at the door with a hammer. Below this Domenico painted the Betrothal of the Virgin along with a good number of portraits drawn from life, including those of Messer Bernardetto de' Medici, the Florentine Constable, wearing a red cap; Bernardo Guadagni, who was the Gonfaloniere; Folco Portinari, and other members of that family. He also painted a very lively dwarf breaking a club, as well as some women wearing extremely lovely and graceful garments, following the fashion of those times. But this work remained unfinished for reasons that will be explained below.

Meanwhile, on his wall Andrea had painted in oil the Death of the Madonna in which, because of the competition with Domenico and because he wished to be recognized for the skill he actually possessed, he employed incredible care in foreshortening the bier upon which the dead Virgin lies; although it measures no more than one-and-a-half armslengths, it appears to be three. Around the Virgin are the Apostles painted in such a way that their faces express their sorrow at remaining upon earth without Her and, at the same time, reveal their joy in seeing Her being transported into Heaven by Jesus Christ. Among the Apostles are some angels holding lighted candles with expressions so beautiful and so finely executed that it is obvious Andrea knew how to use oil colours as well as Domenico, his rival. In these paintings, Andrea drew actual portraits of Messer Rinaldo degli Albizi, Puccio Pucci, Il Falgavaccio (who brought about the liberation of Cosimo de' Medici) along with Federico Malavolti, who kept the keys of the Alberghetto; and in like manner, he drew the portrait of Messer Bernardo di Domenico della Volta, director of the hospital there, who seems to be alive; and in a medallion at the beginning of the work he drew himself as Judas Iscariot—whom he resembled both in appearance and in his actions.* After Andrea had successfully brought this work to completion, blinded by envy for the praise he heard bestowed upon Domenico's skill, he decided to

get rid of him, and after considering many ways of doing so, he put one of the plans into action in this fashion.

One summer night, as he usually did, Domenico took his lute, and left Santa Maria Novella, where Andrea was still drawing in his room, having declined Domenico's invitation to go out for a stroll on the pretext he had certain important drawings to complete. After Domenico had gone out by himself to pursue his pleasures, Andrea secretly went to wait for him around a corner, and when Domenico was returning home and reached the spot, Andrea smashed both his lute and his stomach in the same blow with some pieces of lead, and still not feeling that he had settled the matter as he would have liked, he struck Domenico forcefully on the head with the same pieces of lead and then, leaving him lying upon the ground, he went back to his room in Santa Maria Novella and closed the door, returning to his drawing just as he had done when Domenico left him. In the meanwhile, the noise had been overheard, and the servants, having discovered the murder, ran to call Andrea and to give him (both murderer and traitor) the news; he ran to where the others were standing around Domenico and refused to be comforted, continuing to exclaim: 'Alas, my brother; alas, my brother!' Finally, Domenico expired in his arms, and in spite of every effort to find out, no one ever discovered who had murdered him. And if Andrea had not revealed the fact in his confession as he lay dying, we would still not know.*

Andrea painted a panel of the Assumption of Our Lady with two figures in San Miniato between the towers of Florence, and a Madonna in a tabernacle at the Lanchetta nave outside the Croce gate. In the Carducci home (now belonging to the Pandolfini), he also did portraits of a number of famous men—some imagined and others painted from life, including Filippo Spano degli Scolari, Dante, Petrarch, Boccaccio, and others. Over the door of the vicar's palace at Scarperia in the Mugello, he painted a very beautiful nude figure of Charity which was later ruined. During the year 1478, when the Pazzi family and their followers and co-conspirators killed Giuliano de' Medici in Santa Maria del Fiore and wounded his brother Lorenzo, the Signoria decided that all those who took part in

the conspiracy would be painted as traitors upon the wall of the Palace of the Podestà. This project was offered to Andrea, who, as a servant of the Medici household and obligated to it, accepted the task most willingly, and he executed the work in such a beautiful fashion that it was amazing, for it would be impossible to describe how much skill and good judgement can be discerned in the portraits of those figures drawn, for the most part, from life and strung up by their feet in strange positions—all of them quite different and very admirable. And because this work pleased the entire city and especially those who understood the details of painting, from then on they called him not Andrea del Castagno but Andrea degli Impiccati ['Andrea of the Hanged Men'].*

Andrea lived in an honourable manner, and because he spent a great deal, most especially on dressing himself and on living most respectably at home, he left very little behind him when he passed to another life at the age of seventy-one.* But because his wicked murder of Domenico, who loved him so well, was revealed shortly after his death, he was buried in an ignominious ceremony in Santa Maria Novella, where the unfortunate Domenico had also been buried at the age of fifty-six. And the project Domenico had begun in Santa Maria Novella remained incomplete and totally unfinished. But Domenico did complete the panel for the main altar of Santa Lucia de' Bardi, in which he executed with the greatest care a Madonna with Child, Saint John the Baptist, Saint Nicholas, Saint Francis, and Saint Lucy.* He had brought this panel to perfect completion just before his death. Andrea's followers were Jacopo del Corso, who was a reasonably good master, Pisanello, Il Marchino, Piero del Pollaiuolo, and Giovanni da Rovezzano, etc.*

THE END OF THE LIFE OF ANDREA DEL CASTAGNO
AND DOMENICO VENEZIANO

The Life of Domenico Ghirlandaio, Florentine Painter

[1449–1494]

Domenico di Tommaso del Ghirlandaio, who can be called one of the principal artists and one of the most excellent masters of his age because of the merits, grandeur, and multitude of his works, was created by Nature herself to become a painter, and thus, notwithstanding the contrary wishes of his guardian (for on many occasions, the best fruits of our finest minds are spoiled by employing them in matters for which they are unsuited, thus diverting them from enterprises in which they are naturally gifted), he followed his natural instincts, achieving great honour and profit both for art and for his family, and he was beloved in his own time. His father apprenticed him in his own profession with a goldsmith, a craft in which he was more than an adequate master, and he executed most of the silver *ex-votos* once kept in the wardrobe of the Annunziata, as well as the silver lamps in the chapel, all of which were melted down during the siege of the city in 1529. Tommaso was the first artist to discover and make use of the head ornaments of young Florentine girls called garlands [*ghirlande*]; from this practice he acquired the name of Ghirlandaio—not only because he was the first inventor of this decoration, but also because he executed a countless number of such rare beauty that only those produced in his shop seemed sufficiently charming.

Thus, he was apprenticed to a goldsmith, but he did not find that profession to his liking and did nothing but draw continuously. He was gifted by Nature with a perfect wit and a marvellous and judicious taste in painting, and even though he had been a goldsmith in his youth, he had always worked at the art of design, and had come to have great quickness and

facility in it; this caused many people to claim that even while he stayed with the goldsmith, he would sketch everyone who passed by the shop, and that in his drawings he immediately produced their likenesses. Among his works are countless portraits which still bear witness to this talent, for they are the living images of their models. His first paintings were in the Vespucci Chapel in Ognissanti, where he depicted a dead Christ and a number of saints, with a Madonna della Misericordia over an arch containing the portrait of Amerigo Vespucci who navigated the Indies.* And in the refectory of the same church, he painted a Last Supper in fresco.* In Santa Croce over the right-hand entrance of the church, Ghirlandaio painted stories from the life of Saint Paulinus.* Having thus earned great fame and a fine reputation, he painted for Francesco Sassetti a chapel in Santa Trinita containing scenes from the life of Saint Francis, a work which he executed in an admirable fashion, completing it with grace, exquisite finish, and loving care.* In this fresco, he painted with great accuracy the Santa Trinita Bridge along with the Spini Palace, depicting in the first panel the appearance of Saint Francis as he came through the air to resuscitate a young child. In this scene, the women who observe the saint reviving the boy are seen to be expressing their grief over his death as they carry him to the grave, and their joy and wonder at his resurrection. Then he represented the monks leaving the church, with the grave-diggers following behind the cross, to bury the child, executing all this in a most realistic fashion, along with some other figures amazed by the miracle, which provide no small delight to the onlooker. Among them are portraits of Maso degli Albizi, Messer Agnolo Acciaiuoli, and Messer Palla Strozzi, all important citizens who were very prominent in the history of the city. In another scene he depicted the moment when Saint Francis, in the presence of the vicar, renounces the inheritance of Pietro Bernardone, his father, and dons the habit of sackcloth tied with its rope belt. In the middle panel, Ghirlandaio portrayed the occasion when Saint Francis goes to Rome to the court of Pope Honorius and has his rule confirmed, presenting roses to that pontiff in January. In this scene, Domenico represented the Hall of the

Consistory with cardinals seated all around, as well as a flight of stairs rising up from below, calling attention to a number of half-length figures drawn from life and arranged in order along the banister as they climb up. Among these figures, he drew a portrait of Lorenzo de' Medici, 'Il Magnifico' (the Elder). In the same chapel, he also painted Saint Francis receiving the stigmata. And in the final scene, he depicted the death of Saint Francis and the monks who mourn him, where we see one of the monks kissing his hands; the effect of this scene could not be any better expressed in painting, not to mention the figure of a bishop wearing spectacles upon his nose and singing the vigil, who is so real that only the absence of sound proves him to be a painted image. In two pictures separated by the altar, he drew kneeling portraits of Francesco Sassetti on one side, and Madonna Nera, his wife, on the other, and he depicted their children in the scene above where the young boy is revived, along with a number of very beautiful young ladies of the same family whose names I have been unable to discover. They are all wearing the clothes and costumes of that day, a detail which provides no small delight. Besides this, he painted four sibyls on the vaulting, while outside the chapel he decorated the arch of the front wall with a scene which shows the Tiburtine Sibyl moving the Emperor Octavius to adore Christ, which, for a fresco, is executed in a very knowledgeable way and reflects a selection of the most vivid and delightful colours. And finally, as a companion to these frescos, he painted with his own hand a panel in tempera: it contains a Nativity of Christ that will astonish every intelligent person, in which he drew a portrait of himself and painted several heads for the shepherds which are considered truly sublime works. The drawings for the Sibyl and other details of this project, especially the perspective of Santa Trìnita Bridge, which are beautifully done in chiaroscuro, are contained in our book of drawings.

For the main altar of the Jesuate friars,* he did a panel painting containing several saints kneeling—that is: Saint Giusto, bishop of Volterra who was the patron saint of the church; Saint Zenobius, bishop of Florence; the Angel Raphael; a Saint Michael armed and clad in the most magnificent

armour; and other saints. In truth, Domenico deserves praise
for this, since he was the first to begin imitating the colours of
various kinds of gold trimmings and ornaments, which was
not customary until that time, and, for the most part, did
away with the type of ornamentation which used gold over
mordant or clay and which is more suitable for bolts of cloth
than for good masters. But the most beautiful figure is that of
the Madonna with Her child in Her arms and four small
angels surrounding Her; this panel, which could not have been
better executed for a tempera painting, was then set up outside
the Pinti gate in the church of these friars, but since it was then
damaged, as will be discussed later, it is now to be found in the
church of San Giovannino inside the San Pier Gattolini gate,
where the convent of these same Jesuates is located.

In the church of Cestello, he did a panel, completed by his
brothers David and Benedetto, which contained the Visitation
of Our Lady along with a number of female heads which were
most delightful and beautiful.* In the church of the Innocenti,
he painted a highly praised tempera panel of the Magi in
which there are some heads with beautiful expressions and
different physiognomies, both of the young and of the old;
most especially in the head of the Madonna, the honest beauty
and grace that art can bestow may be discerned in the Mother
of the Son of God.* And in San Marco he did another panel
for the choir screen of the church, while in the guest quar-
ters he executed a Last Supper—completing both works with
care.* In the home of Giovanni Tornabuoni, there is a round
painting containing the story of the Magi, which he executed
with care.* At Villa dello Spedaletto, Domenico executed the
story of Vulcan for Lorenzo de' Medici the Elder, in which he
depicted a great number of nudes at work hammering out
Jove's thunderbolts. And in the church of Ognissanti in
Florence, in competition with Sandro Botticelli, he painted in
fresco a picture of Saint Jerome surrounded by a countless
number of instruments and books by learned scholars, which
is now by the door leading into the choir.*

Since the friars had to remove the choir from the site where
it was located, this fresco, together with the one by Sandro
Botticelli, was bound with iron chains and transported to

the middle of the church without cracking at the very time
that these lives were being reprinted for the second time.
Domenico also painted an arch above the door of Santa Maria
Ughi and a small tabernacle for the Linen-Drapers' Guild,
while he did a very handsome Saint George killing the dragon
in the same Ognissanti church. To tell the truth, he under-
stood quite well the method of painting upon walls and
worked in this medium with great facility; nevertheless, his
compositions were carefully finished.

Then he was called to Rome by Pope Sixtus IV along with
other masters to paint in his chapel,* and there he painted the
scene when Christ summons Peter and Andrew from their
fishing nets, and that of the Resurrection of Jesus Christ, the
greater part of which is ruined today, since it was located
above a door where a rotten architrave had to be replaced. At
that time, Francesco Tornabuoni, a respected and rich mer-
chant and a great friend of Domenico's, was in Rome. Since
his wife had died in childbirth (as will be discussed in the life
of Andrea del Verrocchio),* he wished to honour her memory
in a manner appropriate to their noble status and had a tomb
for her constructed in Santa Maria sopra Minerva. He wanted
Domenico to paint the entire façade of the tomb and, in
addition, to execute a small panel in tempera. Therefore, on
that wall Domenico painted four scenes, two from the life of
Saint John the Baptist and two from the life of the Madonna,
which truly were highly praised at the time. And Francesco
saw such delicacy in Domenico's work that when Domenico
returned to Florence from Rome with honours and money,
Francesco sent letters of recommendation for him to his rel-
ative Giovanni, describing how diligently and well he had
served him in this project and how completely the pope had
been satisfied by his paintings. When Giovanni heard these
things, he began to plan how to put Domenico to work on
some magnificent project to honour his own memory that
would also bring fame and profit to Domenico.

Now it happened that in Santa Maria Novella, the convent
of the Preaching Friars, the main altar had already been
painted by Andrea Orcagna, but since the roof of the vault
had been badly covered, it had been ruined in several places by

the water, and as a result many citizens had already decided that it should be patched up or painted afresh. But the patrons, who were from the Ricci family, had never allowed anything to be done, since they could not afford such an expense themselves but would not cede the chapel so that others could repair it, since they did not want to lose their rights of patronage or the symbol of the coat of arms left to them by their ancestors. Therefore, since he was anxious for Domenico to execute this memorial, Giovanni set to work on the problem, trying out various strategies. Ultimately, he promised the Ricci family that he would bear the entire expense himself and would compensate them in some manner, and that he would furthermore place their coat of arms in the most prominent and honourable place in the chapel. And so, once an agreement was struck and a contract drawn up, a strictly worded legal document following the terms described above, Giovanni commissioned Domenico to execute the project, employing the same scenes that had been represented before, and they fixed the price at one thousand, two hundred gold ducats, with an additional payment of two hundred ducats in the event that the work was satisfactory. And so Domenico set to work, and in four years he had completed it, that is, in 1485,* to Giovanni's greatest satisfaction and delight. Giovanni declared he had been well served, and ingenuously admitted that Domenico had earned his extra two hundred ducats but declared that he would rather Domenico content himself with the original figure, and Domenico, who valued glory and honour more than wealth, immediately freed him from the remaining payment, declaring he would much rather satisfy Giovanni than receive the payment.

Then Giovanni had two large coats of arms carved in stone, one for the Tornaquinci family and the other for the Tornabuoni family, and he had them mounted upon pillars outside the chapel, while upon the arch he placed the other coats of arms of this same family, arranged according to name and heraldic devices—that is, in addition to the Tornaquinci and the Tornabuoni, there were the Giachinotti, Popoleschi, Marabotini, and the Cardinali. And when Domenico painted the panel for the altarpiece, he had a very beautiful tabernacle

of the Sacrament placed under an arch in the golden ornamentation to serve as a finishing touch; and upon the frontispiece, of the tabernacle, he painted upon a small shield a quarter of an armslength high the arms of the patrons—that is, of the Ricci family. And the best thing happened during the unveiling of the chapel, for, making a great commotion, the Ricci looked everywhere for their coat of arms and finally, when they could not find it, they went to the Eight carrying their contract. But the Tornabuoni demonstrated that they had placed the Ricci coat of arms in the most prominent and honourable place in the work, and although the Ricci objected that it could not be seen, they were told that they were in the wrong and that since the coat of arms had been put in a place as honourable as that one, and that since it was close to the Holy Sacrament, they should be satisfied with it. And so it was decided by this magistracy that the painting should remain unchanged, just as it stands today. If anyone thinks all this goes beyond the details of the life I have to write, he should not become annoyed, for it fell from the tip of my pen and will serve, if for no other reason, to demonstrate how poverty is easy prey to wealth and how wealth accompanied by prudence will accomplish anything it desires without censure.

But, returning to the beautiful paintings of Domenico, first, the Four Evangelists are painted larger than life-size on the vaulting in this chapel; scenes from the lives of Saint Dominic, Saint Peter Martyr, and Saint John the Baptist going into the desert are on the walls near the windows; an Annunciation by the angel, with many of the patron saints of Florence kneeling, is above the windows; and below, an actual portrait of Giovanni Tornabuoni is on the right side and one of his wife on the left, both of which people say are very realistic. The right wall contains seven scenes, divided into six below done in frames occupying the width of the wall with a seventh scene above, twice the size of the others and filling the arch of the vaulting. The left wall contains an equal number of scenes, all from the life of Saint John the Baptist. The first scene on the right wall portrays Joachim as he was driven from the temple; in it, his face reflects his patience, while the expressions

of the Jews show their contempt and hatred for those who came to the temple without offspring. On the part of the wall near the window, this scene contains four men, one of whom—that is, the old man who is shaven and wearing a red cap—is the actual portrait of Alesso Baldovinetti, Domenico's teacher in painting and mosaics. Another man, with a bare head, holding his hand to his side and wearing a red cloak with a blue garment underneath, is Domenico himself, the master of the project, who painted his own portrait with the assistance of a mirror. The man with a head of long black hair and fat lips is Bastiano da San Gimignano, his pupil and brother-in-law, while the other man who is turning his shoulders away and wearing a little cap on his head is David Ghirlandaio, his brother the painter. All these portraits are described as truly lifelike and natural by those who knew these men.

The second scene contains the Nativity of the Madonna executed with great care, and among the other noteworthy details Domenico painted here, there is a window set into the building in perspective which lights the chamber and deceives the onlooker. Besides this, while Saint Anne is in bed receiving a visit from several women, Domenico introduced several other women who are carefully washing the Virgin—one pours water, another prepares the swaddling clothes, yet another does one chore or another, and while one attends to her own task, there is another woman who holds the little Child in her arms and makes Her laugh with a smile, expressing a feminine grace that is truly worthy of a painting like this one—not to mention many other expressions worn on the faces of all the other figures.

The third scene, which is above the first, depicts the Virgin as she climbs the steps of the Temple, where there is a building which recedes quite correctly from the eye. Besides this, there is a nude figure which was praised at the time, since nudes were not common then, although it lacks the complete perfection of the more excellent ones done today. Next to this is the Betrothal of the Virgin, in which Domenico displayed the anger of the young men who vent their rage by breaking the rods which did not blossom forth as Joseph's did, and the scene

is copiously filled with figures in a well-designed building. The fifth scene shows the arrival of the Magi in Bethlehem, with a large retinue of men, horses and camels, and various other things, a scene which is certainly well composed.

And next to this is the sixth scene, which portrays Herod's cruel and wicked Massacre of the Innocents, in which there is a beautifully arranged confusion of women, who are being shoved and beaten by soldiers and horses. And to tell the truth, of all the scenes which can be seen here by Domenico, this one is the best, because it was executed with good judgement, ingenuity, and great skill. In it we recognize the wicked will of those men who, at Herod's command and without regard for the mothers, murder those poor little children. Among the children one is seen still clinging to his mother's breast and dying from throat wounds, with the result that the child is sucking, or, rather, drinking, as much blood as milk from the breast—this scene is true to life, and because it is executed in its particular style it could revive compassion even where it had truly died.* Here as well is a soldier who has seized a little boy by force, and while he holds the child against his breast to kill him as he runs away, the child's mother can be seen hanging on to the soldier's hair with the fiercest rage. And while she forces his back into an arch, her action makes the onlooker aware of three extremely beautiful effects: the first is the death of the little boy whose body is ripped open; the second is the wickedness of the soldier who takes his vengeance upon the young child when he feels how painfully he is being twisted; and the third is the furious, indignant, and grief-stricken mother who, upon witnessing the death of her son, attempts to prevent that traitor from escaping without paying any penalty for his crime—truly a scene that exhibits marvellous judgement, more worthy of a philosopher than of a painter. Many other emotions are expressed in this painting, and anyone who looks at it will no doubt recognize that, in his day, this master was truly excellent. Above this is the seventh scene which occupies the space of two scenes and fills the arch of the vaulting; it contains the Dormition of the Virgin and Her Assumption along with an infinite number of angels and countless figures, landscapes, and other decorations in which

Domenico's paintings usually abounded, all being done in that flowing and practised style of his.

On the other wall, where scenes from the life of Saint John the Baptist are represented, the first scene depicts the moment when the angel appears to Zacharias, who is making a sacrifice in the Temple, and strikes him dumb because of his lack of faith. In this scene, Domenico demonstrates how the most important people always attended such sacrifices in the temples, by painting the portraits of a large number of Florentine citizens who were at that time governing the state, and especially all those from the Tornabuoni family (both young and old) in order to render the scene more illustrious. Besides this, to show how every kind of talent, but most particularly that of letters, flourished in that period, Domenico created four half-figures in a circle who are arguing with each other at the bottom of the scene; these figures represented the most learned men that could be found in Florence in those days, and they are as follows: the first is Messer Marsilio Ficino, who is dressed in canonical attire; the second, wearing a red cloak and a black scarf around his neck, is Cristoforo Landino; Demetrius the Greek stands in their midst and is turning around, while the man who has slightly raised his hand is Messer Angelo Poliziano; and all of these figures are quite lifelike and lively.*

Next to this, the second scene follows with the Visitation of Our Lady and Saint Elizabeth, which also contains many other women in their company who are wearing the hair-styles of that period, and among them, Domenico painted the portrait of Ginevra de' Benci, a most beautiful young girl living at the time. Above the first is the third scene which depicts the birth of Saint John and contains a most beautiful announcement of this event: for while Saint Elizabeth is lying in bed, certain neighbours come to visit her; the wet-nurse is seated, suckling the baby, while a young woman cheerfully calls out to the visitors to show them the unusual event which has befallen her mistress in her old age. And finally, there is a woman who, following Florentine custom, brings fruit and flasks of wine from the country—a very beautiful detail.* Next to this one is the fourth scene in which Zacharias, whose spirit is undaunted

although he is still mute, expresses amazement that a son has been born to him, and while they ask him what name to give his son, he writes on his knees—all the while staring at his son, who is held by a woman kneeling reverently before him—forming with a pen on paper the words 'His name will be John', to the astonishment of many of the other figures, who seem to be wondering whether this could be true or not.

The fifth scene follows, portraying the moment when John preaches to the multitude. In this scene one is aware of the attention people pay when they hear new and unusual things, especially in the heads of the scribes who are listening to John and with a certain kind of expression seem to be mocking—rather, detesting—this new law, and the picture contains a number of men and women standing and seated who are dressed in various costumes. The sixth scene shows the Baptism of Christ by Saint John, and its sense of reverence reveals precisely the kind of faith one must have in such a sacrament. And because this baptism was to bear such great fruit, Domenico also represented a multitude of naked and barefoot people waiting to be baptized, whose faith and desire are chiselled into their faces. Among them, there is one who removes a shoe—the very image of readiness itself. The last scene, the one in the arch next to the vaulting, presents the sumptuous Banquet of Herod and the Dance of Herodias, along with countless servants performing various chores in the scene; the picture also contains a large building drawn in perspective which, together with the painted figures, clearly reveals Domenico's skill. He also executed the altarpiece in tempera which stands alone, as well as the other figures in the six pictures: besides the Madonna, seated in the air with the Child in Her arms, and the other saints surrounding Her, are Saint Laurence, Saint Stephen, both extremely lifelike, as well as Saint Vincent and Saint Peter Martyr, who lack nothing but the power of speech. It is true that a part of this panel was left unfinished when Domenico died, but he had brought it so far along that nothing remained to be done but to finish certain figures in the border on the back depicting the Resurrection of Christ, and three figures in the square spaces; it was later

completely finished by Benedetto and David Ghirlandaio, his brothers.*

This chapel was considered extremely beautiful, grand, elegant, and delightful for the vivacity of its colours, the skill and finish in the handling of the frescos on the walls, and for the very few instances of retouching in *fresco secco*, not to mention its invention and composition. Domenico certainly deserves great praise on every account but especially for the lifelike qualities of his heads, which, drawn from life, display to the onlooker the most lively images of a great many prominent people. For the same Giovanni Tornabuoni, Domenico painted a chapel at Casso Maccherelli,* his villa not far from the city near the Terzolle River, but today these paintings are half ruined because of their proximity to the river, and although they remained uncovered, continuously soaked by the rain and baked by the sun for many years, they have been preserved in such a state that they appear to have been covered. This is the value of work in fresco when it is applied with care and good judgement and not retouched *a secco*. In the hall of the Palazzo della Signoria containing the marvellous clock of Lorenzo della Volpaia, Domenico also painted the portraits of many Florentine saints with the most beautiful costumes.*

Domenico liked to work so much and was so anxious to please everyone that he ordered his apprentices to accept whatever work came to the shop, even if it was only to make rims for the women's baskets, and if they did not want to paint them, he would do them personally, since he wanted no one to leave his shop dissatisfied. He complained loudly when he had family problems, and, as a result, entrusted all his purchases to his brother David, telling him: 'Let me work and you do the shopping, for now that I have begun to understand the methods of this art, I am sorry I was not commissioned to paint scenes around the entire circumference of the city walls of Florence', thus displaying his indomitable and resolute spirit in every enterprise....*

It is said that when Domenico sketched antiquities in Rome—arches, baths, columns, coliseums, eagles, amphitheatres, and aqueducts—he was so precise in these drawings

that he was able to work with only his naked eye and without
rulers, compasses, or measurements, and when they were later
examined after he had drawn them, they were found to be
as accurate as if he had actually measured them. When
Domenico sketched the Colosseum with his naked eye, he
placed a standing figure at its base which was perfectly in scale
with the entire edifice, and after his death, when other masters
studied the drawing, it was found to be flawless. Over a door
in the cemetery of Santa Maria Novella, he did a fresco
of Saint Michael in armour which was most handsome
and contained reflections of light upon armour infrequently
painted before him, and at the Badia in Passignano, a church
belonging to the monks of Vallombrosa, he worked along
with his brother David and Bastiano da San Gimignano on
a number of projects. Before Domenico's arrival there, the
monks gave the other artisans very poor food, and they
lodged a complaint with the abbot, begging him to do some-
thing about obtaining better service for them, since it was not
proper to treat them like workmen. The abbot promised them
he would do so and begged their pardon on the grounds that
it was due to their ignorance of outsiders rather than to any ill
will. Domenico then arrived, and still matters continued in the
same fashion, and so David once again went to the abbot,
excusing himself by saying that he was not complaining on his
own account but because of the merit and the talent of his
brother. But the abbot, ignorant as he was, made no other
reply. That evening, after they had sat down to supper, the
man in charge of visitors came in with a tray full of soup
plates and poorly prepared pies—still insisting upon the same
kind of cooking he had done on other occasions. As a result,
David rose up in a rage and spilled the soup all over the monk,
and when he grabbed the bread on the table and hurled it at
him, it struck him in such a way that he was carried away to
his cell more dead than alive. The abbot, who was already in
bed, arose and ran to see what the noise was all about, think-
ing that the monastery was collapsing, and, finding the monk
in a bad way, he began to argue with David. Infuriated by
this, David told him he must put a stop to it, since Domenico's
talents were worth more than all the swinish abbots like him

that had ever been lodged in that monastery. At this, the abbot reconsidered the matter, and, from that time on, did his best to treat them as the worthy men they really were.... *

Domenico lived forty-four years, and, accompanied by many tears and pious laments on the part of his brothers David and Benedetto and his son Ridolfo, he was buried with a beautiful funeral ceremony in Santa Maria Novella; his loss brought great sorrow to his friends, and when his death became known, many distinguished painters outside of Florence wrote to his relatives, lamenting its untimeliness. He left behind as his followers David and Benedetto Ghirlandaio, Bastiano Mainardi da San Gimignano, the Florentine Michelangelo Buonarroti, Francesco Granacci, Niccolò Cieco, Jacopo del Tedesco, Jacopo dell'Indaco, Baldino Baldinelli, and other masters—all Florentines. He died in 1493.* Domenico enriched the art of painting with mosaics that were done in a more modern style than those of any other Tuscan, among countless artists who tried, as his works demonstrate, although few in number.* Because of the richness of this record, he deserves high rank and honour in his profession as well as extraordinary praise and celebration in death.

THE END OF THE LIFE OF DOMENICO GHIRLANDAIO

The Life of Sandro Botticelli, Florentine Painter

[1445–1510]

In the time of Lorenzo de' Medici, 'Il Magnifico' (the Elder), truly a golden age for men of talent, there flourished an artist named Alessandro, shortened to Sandro according to our custom, with the second name of Botticelli, for reasons we shall soon discover. He was the son of Mariano Filipepi, a Florentine citizen, who raised him very conscientiously and had him instructed in all those things usually taught to young boys during the years before they were placed in the shops. And although the boy learned everything he wanted to quite easily, he was nevertheless restless; he was never satisfied in school with reading, writing, and arithmetic. Disturbed by the boy's whimsical mind, his father in desperation placed him with a goldsmith, a friend of his named Botticello, a quite competent master of that trade in those days.*

In that period, very close relations and almost a constant intercourse existed between goldsmiths and painters, and because of this, Sandro, who was a clever boy and had taken a fancy to painting, turned completely to the art of design and decided to devote himself to it. Thus, he confided in his father, who recognized the boy's aptitude and took him to Fra Filippo, an illustrious painter of the period, at the Carmine, and arranged for him to teach Sandro, just as the boy himself desired. Sandro therefore put all of his energies into learning this craft; he followed and imitated his master in such a way that Fra Filippo grew fond of him and taught him so thoroughly that he soon reached a level no one would have expected. When he was still a young man, Sandro painted a figure symbolizing Fortitude in the palace of the Merchants' Guild of Florence which was included among the paintings of the virtues done by Antonio and Piero Pollaiuolo.* In the

church of Santo Spirito in Florence, he did a panel painting for
the Bardi Chapel, which was done most conscientiously and
beautifully finished, and which includes some olive and palm
trees executed with loving care.* Then Sandro did a panel for
the nuns of the Convertite Convent,* and another similar one
for the nuns of Saint Barnabas.* In Ognissanti on the choir-
screen by the door leading to the choir, he painted a fresco
of Saint Augustine for the Vespucci family,* on which he
worked very hard in his effort to surpass all those who painted
in his day, but most especially Domenico Ghirlandaio, who
had done a Saint Jerome on the other side. The work turned
out very well, for Sandro had shown in the head of the saint
that profundity of thought and sharpness of mind typical of
people who constantly reason and reflect upon complex and
elevated questions. As we mentioned in the life of Ghirlandaio,
the painting was removed, safe and sound, from its location,
during this very year of 1564.

Because of the credit and reputation he acquired from this
painting, he was asked by the Guild of Por Santa Maria to
execute in the church of San Marco a panel painting of the
Coronation of the Virgin with a chorus of angels, which he
designed very well and also completed.* Sandro worked on
a number of projects in the Medici home for Lorenzo, 'Il
Magnifico' (the Elder), the most important of which were a
figure of Pallas painted life-size upon a coat of arms contain-
ing a large bough with many flaming branches, and a Saint
Sebastian.* In Santa Maria Maggiore in Florence, there is a
very beautiful *Pietà* with tiny figures beside the Panciatichi
Chapel.

In various homes throughout the city, he himself painted
tondi and numerous female nudes. Two of these paintings are
still at Castello, Duke Cosimo's villa: one depicts the Birth of
Venus, and those breezes and winds which blew her and her
Cupids to land;* and the second is another Venus, the symbol
of Spring, being adorned with flowers by the Graces.* In both
paintings Sandro expressed himself with grace. Around a
room in Giovanni Vespucci's home on Via dei Servi (which
today belongs to Piero Salviati), he did a number of paintings
on the walls and bedframes enclosed in decorated walnut

panels, which contained many beautiful and lifelike figures.*
Likewise, for the Pucci home, he illustrated Boccaccio's
novella of Nastagio degli Onesti, in four paintings with tiny
figures, which are most lovely and delightful,* along with a
tondo depicting the Epiphany.*

For the monks of Cestello, he painted a panel of the Annun-
ciation in one of their chapels.* In the church of San Pietro
Maggiore, at the side door, he painted a panel for Matteo
Palmieri with a vast number of figures depicting the Assump-
tion of the Virgin and including the heavenly spheres as they
are represented, the Patriarchs, Prophets, Apostles, Evangelists,
Martyrs, Confessors, Doctors of the Church, Holy Virgins,
and the Hierarchies of Angels, all taken from a drawing given
to him by Matteo, who was a learned and worthy man.*
Sandro painted this work with masterful skill and minute
attention. At the foot of the work, he included portraits of
Matteo and his wife kneeling. But in spite of the fact that this
painting was so beautiful it should have overcome all envy,
there were nevertheless some slanderers and detractors who,
unable to condemn the work in any other way, accused
Matteo and Sandro of having committed the grievous sin of
heresy.* Whether this is true or not, I am not the person to
pass judgement, but it is enough for me that the figures
Sandro painted here are truly to be praised, both for the effort
he expended in drawing the heavenly spheres, and for the
different ways in which he used foreshortenings and spaces
between the figures and angels, all of which he executed with
a fine sense of design. During this period, Sandro was com-
missioned to do a small panel with figures three-quarters of an
armslength high which was placed in Santa Maria Novella
between the two doors in the main façade of the church on
the left as one enters through the middle door.* It depicts the
Adoration of the Magi, and in it the first old man, overcome
by tenderness as he kisses the foot of Our Lord, expresses so
much emotion that it is clear he has reached the end of his
long journey. The figure of this king is the actual portrait of
Cosimo de' Medici, 'Il Vecchio', and is the most lifelike and
natural of all such portraits that have survived to our day. The
second king, actually a portrait of Giuliano de' Medici, the

father of Pope Clement VII, is shown paying reverence to
the Child with the most willing and attentive devotion as he
offers Him his gift. The third man, who is also kneeling and
appears, as he adores Him, to be giving thanks and to be
proclaiming Him the true Messiah, portrays Cosimo's son
Giovanni. Nor can the beauty Sandro revealed through the
heads in this painting be described: they are turned in various
poses—some full-face, some in profile, some in three-quarter
profile, and some gazing downward—with a wide variety of
attitudes and expressions on the faces of young and old alike,
including all those imaginative details that reveal the artist's
perfect mastery of his craft. He distinguished between the
three retinues of each king so that it is clear which servants
belong to each king. This is truly a marvellous painting: every
artisan of our day is still amazed by the beauty of its colouring,
design, and composition.

At that time, this work brought Sandro so much renown
both in Florence and elsewhere that after completing the con-
struction of the chapel in his palace in Rome and wishing
to paint it, Pope Sixtus IV summoned Sandro to head the
project. There Sandro himself did the following scenes: the
Temptation of Christ, and Moses slaying the Egyptian and
accepting a drink from the daughters of Jethro the Midianite.
He also painted the fire falling from heaven during the sacri-
fice of the sons of Aron, and a number of canonized popes in
the niches above.* Acquiring from this work even greater
fame and reputation among the many competitors who
painted there with him, both Florentine artists and those from
other cities, Sandro received from the pope a good sum of
money, all of which he immediately squandered and wasted
during his stay in Rome, in living his customarily haphazard
existence, and when he had completed and unveiled the part
of the project for which he had been commissioned, he
immediately returned to Florence. There, since Sandro was
also a learned man, he wrote a commentary on part of Dante's
poem, and after illustrating the *Inferno*, he printed the work.
He wasted a great deal of time on the project, and while
completing it he was not painting, which caused countless
disruptions in his life.*

Sandro also printed many of his other designs, but they were poorly printed because the engravings were poorly done; the best drawing we have by Botticelli is the Triumph of the Faith of Fra Girolamo Savonarola of Ferrara. He was apparently a follower of Savonarola's faction, which led him to abandon painting; unable to make enough to live on, he fell into the direst of straits. Nevertheless, he obstinately remained a member of this faction and became a *piagnone* (as they were called in those days), which kept him away from his work.* Thus, he eventually found himself both old and poor, and if Lorenzo de' Medici (for whom Sandro, among many other projects, had done a great deal of work at the Villa dello Spedaletto in Volterra), along with his friends and other prominent men who were admirers of his talent, had not assisted him financially during the rest of his life, he would almost have starved to death.* In the church of San Francesco, outside the San Miniato gate, there is a Virgin painted by Sandro in a tondo with a number of angels as large as life, which was considered a most beautiful painting.*

Sandro was a very pleasant person who played many practical jokes on his pupils and friends, and the story goes that one of his dependants named Biagio* painted a tondo for sale similar to the one mentioned above, and that after Sandro sold it for six gold florins to one of the citizens of Florence, he found Biagio and said to him:

'I finally sold that picture of yours, but this evening it would be good to hang it up high so that it can be seen better, and then, tomorrow morning, you should go to the buyer's house and bring him here—this way, he can see it displayed in the right light and the right place; then he'll count out your money for you.'

'Oh,' exclaimed Biagio, 'how well you've done, Master.' And then, going to the shop, he placed the tondo in a spot which was rather high up and left. Meanwhile, Sandro and Jacopo,* another one of his pupils, made eight paper hoods (like those worn by the townspeople), and with white wax they fastened them on to the heads of the eight angels surrounding the Virgin in this tondo. When the next morning came, there was Biagio along with the citizen who had

bought the painting and was aware of the joke, and after they had entered the shop, Biagio raised his eyes and saw his Virgin surrounded not by angels but by the Signoria of Florence, all seated and wearing those paper hoods. He wanted to cry out and to beg the pardon of the man who had struck the bargain with him, but Biagio noticed that the man said nothing; on the contrary, he began to praise the painting, and so Biagio, too, remained silent. Finally, after Biagio had accompanied the man home, he received his payment of six florins according to the agreement Sandro had struck when he had sold the painting.

Then, returning to the shop, just as Sandro and Jacopo had removed the paper hoods, he saw that his angels had become angels again and were no longer citizens in hoods. So completely dumbfounded he hardly knew what to say, Biagio finally turned to Sandro and exclaimed: 'Master, I don't know if I'm dreaming or if this is real; when I came here those angels had red hoods on their heads and now they don't—what does this mean?'

'You're losing your mind, Biagio,' Sandro answered. 'That money has gone to your head: if what you say were true, do you think the man would have bought the painting?'

'That's true,' Biagio remarked, 'He didn't say anything to me, and yet it seemed very strange.'

Finally, all the other boys in the shop, gathering around Biagio, talked to him and convinced him that he had suffered from a dizzy spell.

On another occasion, a cloth-weaver once came to live near Sandro and set up no less than eight looms which, when they were in operation, not only deafened poor Sandro with the noise of treadles and the clanging of the spindle boxes, but also rattled the entire house, whose walls were not as sturdy as they should have been, and between one thing and another, Sandro was unable to work or to remain at home. He begged his neighbour any number of times to do something about this source of irritation, but after the neighbour declared that in his own home he could and would do as he pleased, Sandro was very annoyed, and he balanced an enormous stone—larger than a cart could carry—upon one of his walls which was higher than his neighbour's wall and not very sturdy, and it

seemed that every time the wall moved, it was about to drop
and to crush the roofs, joists, fabrics, and looms of his neigh-
bour. Terrified by this danger, the neighbour ran to Sandro,
but was answered with his own words—Sandro told him that
in his own home, he could and would do as he pleased—and
unable to come to any other conclusion, the weaver was
obliged to reach a reasonable agreement with Sandro and be a
good neighbour to him.

People also tell the story that, for a joke, Sandro went to the
Vicar and denounced a friend of his for heresy. When the man
appeared and demanded to know who had accused him and
on what charge, he was told that it had been Sandro, who
claimed that he held the opinion of the Epicureans—that the
soul died with the body. The man asked to see his accuser
before the judge, and after Sandro appeared, the accused man
declared: 'It's true that I hold *this* opinion in so far as *this* man's
soul is concerned, since he's an animal, but aside from this,
don't you think that *he* is a heretic, since without having any
learning and scarcely knowing how to read, he did a com-
mentary on Dante and took his name in vain?'*

It is also said that Sandro was extraordinarily fond of people
who were serious students of painting, and that he earned a
great deal of money but wasted all of it badly through poor
management and carelessness. Finally, after he had grown old
and useless and had to walk with two canes (since he could
no longer stand upright), he died, sick and decrepit, at the
age of seventy-eight, and he was buried in the year 1515 in
Ognissanti.*

In the Lord Duke Cosimo's wardrobe, there are two female
heads in profile drawn by Sandro's hand which are very
beautiful: one is said to represent the mistress of Lorenzo's
brother, Giuliano de' Medici, while the other is Madonna
Lucrezia de' Tornabuoni, Lorenzo's own wife.* In the same
place, there is also a Bacchus he did, an extremely graceful
figure raising a barrel with both his hands and lifting it to his
lips, and in the Duomo of Pisa in the Impagliata Chapel, he
began an Assumption with a choir of angels, but when it
dissatisfied him he left it unfinished.* In San Francesco di
Monte Varchi, he painted the panel on the high altar, and in

the parish church of Empoli, he painted two angels on the same side as Rossellino's Saint Sebastian.*

Sandro was one of the first painters to discover how to work on pennants and other draperies by piecing the material together, as they say, so that the colours do not run and show on either side of the material. Employing this method, he himself created the *baldacchino* for Orsanmichele which is filled with images of Our Lady, all different and beautiful. This work clearly shows how his method conserves the material better than dyes, for they damage the fabric and shorten its life—even if the use of dyes today is more common due to its lesser expense. Sandro drew far better than was usually the case, so that after his death, artisans used to go to a great deal of trouble to obtain his sketches. And in our book we have some of them, all executed with great skill and good judgement. He decorated his scenes with plenty of figures, as can be seen in the inlay on the frieze of the processional cross done for the friars of Santa Maria Novella, which was based completely on his design. Sandro therefore deserved high praise for all his paintings, because he put all of his energy into his works and did them with loving care, just as he had the previously mentioned panel of the Magi for Santa Maria Novella, which is truly wondrous. A small tondo he painted that can be seen in the Chamber of the Priors in the Angeli of Florence is also most beautiful, with tiny but very gracious figures rendered with admirable care. A Florentine gentleman, Messer Fabio Segni, owns another panel by Sandro of the same size as the panel of the Magi, upon which he depicted the Calumny of Apelles—which is as beautiful as anything can possibly be. Sandro himself gave this work to his very close friend Antonio Segni, and underneath the painting, these verses by Messer Fabio can be read:

> This little picture warns rulers of the earth
> To avoid the tyranny of false judgement.
> Apelles gave a similar one to the king of Egypt;
> That ruler was worthy of the gift, and it of him.*

THE END OF THE LIFE OF SANDRO BOTTICELLI

The Life of Andrea del Verrocchio, Painter, Sculptor, and Architect

[1435–1488]

Andrea del Verrocchio, a Florentine, was in his time a gold-smith, master of perspective, sculptor, woodcarver, painter, and musician. To tell the truth, he had a rather hard and crude style in both sculpture and painting, as if he had acquired it after endless study rather than because of any natural gift or aptitude. But even if he had completely lacked such an aptitude, his deliberate study and his diligence would have brought him to prominence anyway, and he would have excelled in both these arts. Study and natural talent need to be joined to reach the height of perfection in painting and sculpture, and whenever one of the two qualities is missing, the artist rarely reaches the summit, although study may well carry him most of the way. This occurred in Andrea's case, for since he applied himself more than others, he earned a place among the most rare and excellent artisans in our profession.

In his youth, he applied himself to the sciences and particularly to geometry. While he was working as a goldsmith, among the many things he created were some clasps for copes which are located in Santa Maria del Fiore in Florence. Among his larger works, especially important is a cup richly decorated with animals, foliage, and other imaginative details, the mould for which still survives and is widely known among all goldsmiths today, as well as another similar cup decorated with a very lovely group of dancing children. After he had shown some proof of his skill in these works, he was given the task of executing two scenes in silver relief for the ends of the altar of San Giovanni by the Merchants' Guild which, when completed, earned him great praise and a fine reputation.*

At that time in Rome, some of those large statues of the apostles which customarily stand upon the altar of the pope's chapel were missing, as well as some other silver pieces which had been destroyed, and, as a result, Pope Sixtus sent for Andrea, who with the pope's favour was given the task of executing everything that was needed, and he completed all of this with great care and perfect judgement. In the meanwhile, Andrea noted the great value placed upon the many ancient statues and other works being discovered in Rome, as well as the fact that the pope had that bronze horse set up in San Giovanni in Laterano,* and he saw the attention that was given to fragments, not to mention the complete works, of sculpture that were being found every day. Thus, he decided to devote himself to sculpture.

And having completely abandoned the art of goldsmithing, he began to cast some little figures in bronze which were highly praised. Gaining greater confidence from this, he began to work in marble. When the wife of Francesco Tornabuoni died in childbirth, her husband, who had loved her very much and wanted to honour her memory as best as he could, gave Andrea the task of making her tomb. Andrea carved the lady's effigy in stone upon a marble sarcophagus, depicting the birth of her child and her passing to another life, and he then executed the figures of three Virtues, which were considered very beautiful, considering this was the first work he had completed in marble, and the tomb was placed in Santa Maria sopra Minerva.*

Returning afterwards to Florence with money, fame, and honour, Andrea was asked to cast a bronze David, two-and-a-half armslengths high, which, when finished, was placed in the Palazzo [Vecchio] at the head of the staircase where the chain used to be, and earned him great praise.* While he was working on this statue, he also did the Madonna in marble which is in Santa Croce over the tomb of Leonardo Bruni of Arezzo, a statue which he made while still very young for Bernardo Rossellino, the architect and sculptor, who, as was mentioned earlier, carried out the entire work in marble.* He also did a half-length Madonna and Child in half relief on a marble panel which used to be in the home of the Medici and today is

kept as a most beautiful object in the chamber of the Duchess of Florence, hanging over a door.* He also cast two metal heads, one of Alexander the Great in profile, and the other an imaginative portrait of Darius, likewise in half relief, varying the crests of the helmets, the armour, and all the other details in each one.* Both of these works were sent by Lorenzo de' Medici, 'Il Magnifico' (the Elder) to King Matthias Corvinus in Hungary with many other presents, as will be explained in the proper place. Having gained from these works the reputation of being an excellent master, above all in works cast in metal, which he very much enjoyed doing, Andrea then cast a bronze tomb in San Lorenzo, completely in the round, for Giovanni and Piero di Cosimo de' Medici with a sarcophagus of porphyry supported by four bronze corner-pieces and decorated with twisting foliage that was very well executed and polished with the greatest care.* This tomb is located between the Chapel of the Sacrament and the Sacristy, and no work, either in bronze or in any other metal, could be cast any better, especially since he demonstrated at the same time his skill in architecture by arranging the tomb in the opening of a window five armslengths wide and about ten armslengths high, and placing it upon a base that separates the Chapel of the Sacrament from the Old Sacristy. In order to fill up the gap between the sarcophagus and the vaulting above the tomb, he did a grating of bronze ropes in an almond-shaped pattern, all quite natural in appearance, along with decorations in various places in the form of garlands and other beautiful and fanciful details, all of them noteworthy and executed with great skill, good judgement, and invention.

Meanwhile, Donatello had made the marble tabernacle for the Tribunal of Six of the Merchants' Guild which today is opposite the Saint Michael in the oratory of Orsanmichele, but nothing was done about the bronze statue of Saint Thomas feeling the wounds of Christ, since some of the men in charge wanted to give the commission to Donatello, while others preferred Lorenzo Ghiberti. And matters stood this way as long as Donatello and Lorenzo lived, but the two statues were finally commissioned to Andrea, who created the models and moulds and cast them so beautifully that they came out

solid, whole, and well fashioned.* Then Andrea set himself to
polishing and finishing them, bringing them to the perfection
we see today, which could not be surpassed, for the figure of
Saint Thomas expresses the saint's incredulity and impatience
in learning the truth and, at the same time, the love which
moves him, in a most beautiful gesture, to place his hand upon
Christ's side; and the figure of Christ Himself, who raises one
arm in a gesture of great generosity and opens His garments,
dispelling the doubt of His incredulous disciple, expresses all
the grace and divinity, so to speak, that art can bestow upon a
statue. The fact that Andrea has created both these figures
with the most lovely and suitable garments reveals that he was
no less knowledgeable in this art than Donatello, Lorenzo, and
others who came before him. As a result, this statue truly
deserved to be placed in a tabernacle created by Donatello,
and ever afterwards to be held in the highest esteem and
greatest respect.*

As a result, Andrea's fame could not have grown nor could
his reputation rise any higher in this profession, and as a person
to whom excellence in a single field was insufficient, he
decided, through study, to achieve the same distinction in
others as well, and he turned his attention to painting. Thus,
he made cartoons for a battle scene with nude figures,
sketching them out carefully in pen in order to paint them in
colour upon a wall.* Andrea also made cartoons for a number
of scenes and later began to execute them in colour, but for
some reason they remained unfinished. There are some of his
drawings in our book, all done with great patience and the
best possible judgement. Among these are a number of female
heads done with such skill and such beautiful hair that
Leonardo da Vinci used to imitate them because of their love-
liness; there are also two horses with the dimensions and centre
points required to enlarge them so that they come out in the
proper proportions without errors. I also have a very rare
terracotta relief of a horse's head drawn in the ancient fashion,
while the Very Reverend Don Vincenzio Borghini has still
yet other paper drawings in his book which was mentioned
earlier. Among them is a design for a tomb which Andrea did
in Venice for a doge, a sketch for a scene of the Magi adoring

Christ, and the head of a woman as delicate as could be, painted on paper. He also did a bronze boy strangling a fish for the fountain in Lorenzo de' Medici's villa at Careggi; as we can see today, Lord Duke Cosimo has had it placed on the fountain in the courtyard of his palace, and the figure of the boy is truly marvellous.*

Then, once the construction of the dome of Santa Maria del Fiore had been completed, it was decided, after much discussion, that the copper ball which was to be placed upon the top of the structure should be made according to the plans Filippo Brunelleschi had left behind him, and after Andrea was put in charge of this project, he made the ball four armslengths high, balanced it upon a button-shaped disc, and chained it so that the cross could then be firmly mounted on top. When this work was completed, it was erected with the greatest festivities and to the delight of the populace.* It is a fact that this work required skill and care, so that it could be entered from below (as can be done), and so that it could be reinforced with firm foundations, and the winds could not damage it.

Andrea never rested and was always working on something, either painting or sculpture, and he would sometimes work on several projects at the same time in order to avoid the boredom which many artists feel at doing the same thing all the time. Although he did not execute the cartoons mentioned earlier, he nevertheless painted a number of things. Among them was a panel for the nuns of San Domenico in Florence, which he thought had turned out very well;* so, shortly afterwards, he painted another one in San Salvi for the monks of Vallombrosa, which depicts the Baptism of Christ by Saint John the Baptist.* And Leonardo da Vinci, then a young boy and Andrea's pupil, assisted him in this work, painting an angel by himself, which was much better than the other details. This was the reason why Andrea resolved never to touch a brush again, for Leonardo had surpassed him in this craft at such a young age.

At that time, Cosimo de' Medici had received many antiquities from Rome, and he set up a very handsome statue in white marble of Marsyas,* bound to a tree-trunk and ready

to be flayed, inside his garden gate, or rather his courtyard which opens on to the Via de' Ginori. As a result, his grandson Lorenzo, who had come into possession of a torso with the head of another figure of Marsyas sculpted in red marble, that was very ancient and much more beautiful than the other one, wanted to set them up together, but was unable to do so because the second figure was so damaged. Therefore, he gave it to Andrea to restore and refinish, and Andrea made the legs, thighs, and arms missing from this figure out of some pieces of red marble; it all came out so well that Lorenzo was very satisfied and had it placed opposite the other statue on the other side of the door. This ancient torso, made for the figure of a flayed Marsyas, was worked with such care and good judgement that some thin, white veins inside the red stone were carved by the artisan in the exact place where tiny tendons would appear, which can be observed in real bodies when they are flayed. This must have made the statue seem remarkably lifelike when it received its first polishing.

Meanwhile, the Venetians had decided to honour the great ability of Bartolomeo da Bergamo,* the driving force behind many of their victories, in order to encourage their other commanders, and when they heard of Andrea's fame, they brought him to Venice, where he was presented with the request to execute an equestrian statue of this commander in bronze to be placed in the Piazza di SS Giovanni and Paolo.* Andrea therefore fashioned the model for the horse, and he had begun to fit it out so that it could be cast in bronze when, through the influence of some Venetian noblemen, it was decided that Vellano da Padova should make the figure and Andrea the horse. Hearing of this decision, Andrea smashed the legs and the head of his model, and he returned to Florence completely infuriated without saying a word. When the Signoria [of Venice] heard about this, they gave Andrea to understand that he was never again to take the liberty of returning to Venice, for they would chop his head off. To this Andrea replied in a letter that he would be careful not to do so, since it was not in their power to re-attach men's heads after having chopped them off—and certainly never one like his—whereas he would know how to re-attach his horse's

head and legs to something even more beautiful. After they received this reply (which did not displease the Signoria at all), Andrea was brought back with twice his salary to Venice, where he repaired his first model and cast it in bronze but did not completely finish it, for he became overheated during the casting, caught a chill, and died from it a few days later in that city, leaving unfinished not only this project (even though little polishing remained to be done, before it was set up in the designated place), but another one as well, which he was doing in Pistoia: that is, the tomb of Cardinal Forteguerri, with the three Theological Virtues and God the Father on its cover, a project later completed by Lorenzetto, the Florentine sculptor.*

When Andrea died, he was fifty-six years old. His death greatly sorrowed his friends and pupils, of whom there were not few, but above all the sculptor Nanni Grosso, a very eccentric person both as an artist and as a man. It is said that this Nanni would never work outside his shop, and most particularly not for monks or friars, unless as an added benefit he had access to the vault (or, rather, the cellar), so that he could go to drink whenever he wanted without having to ask permission. Another story also tells of an occasion when he had returned from Santa Maria Novella after having been cured from some illness or other there, and, when his friends came to visit and asked him how he was, he replied: 'I'm really doing badly.'

'But you're cured,' they exclaimed.

And Nanni remarked: 'That's why I'm doing badly, for I need a bit of a fever to keep me there in the hospital, all comfortable and well cared for.'

Later, when Nanni was dying in the hospital, a crude and very poorly made crucifix was placed before him; whereupon, he begged them to take it away and to bring him one made by Donatello, declaring that if they did not remove it he would die out of desperation, since he had such a strong dislike for poorly executed works from his own trade.

Piero Perugino and Leonardo da Vinci (who will be discussed in the proper place) were Andrea's pupils, as well as Francesco di Simone,* the Florentine, who worked in

Bologna in the church of San Domenico on a marble tomb containing many small figures which, because of their style, seem to have been done by Andrea and which was made for Messer Alessandro Tartaglia, the lawyer from Imola.* Francesco did a similar one in San Pancrazio in Florence near the sacristy and one of the chapels for Messer Pier Minerbetti, a knight.* Agnolo di Polo* was also Andrea's pupil, and he was very experienced in working in clay and filled the city with the things he made; if he had tried his best to understand his art, he would have created beautiful things.

But of all his pupils, Andrea most loved Lorenzo di Credi,* who brought Andrea's remains back from Venice and laid them to rest in the church of Sant'Ambruogio in the tomb of Ser Michele di Cione, over whose tombstone are carved these words:

Ser Michele di Cione and his relatives.

And then:

Here lie the bones of Andrea del Verrocchio, who died in Venice in 1488.

Andrea took great delight in making plaster casts—the kind made from a soft stone which is quarried around Volterra and Siena and in many other places in Italy. This stone, baked in the fire, crushed, and then made into a paste with tepid water, becomes pliable so that one can make anything one wishes with it; afterwards it dries and sets so hard that whole figures can be cast from it. Andrea used to make moulds of various parts of the body—hands, feet, knees, legs, arms, torsos—so that later, having them before him, he could imitate them with greater ease. Later during Andrea's lifetime, people began to fashion inexpensive death masks [from this material], and over the fireplaces, doors, windows, and cornices of every home in Florence, one can see countless portraits of this kind, which are so well made and lifelike that they seem alive. This extremely useful practice has continued from Andrea's time to our own day, providing us with the portraits of many individuals introduced into the scenes painted in Duke Cosimo's palace. Certainly we owe an enormous debt for this to

Andrea's ingenuity, since he was one of the first who began to make use of this technique.

Andrea also inspired the making of more perfect images, not only in Florence but also in all those devotional sites where people gather to place ex-votos, or 'miracles' as they are called, because they have been granted some divine favour. Whereas these objects had only been produced in small sizes in silver, on poorly painted wooden panels, or with crudely formed wax, in Andrea's day they began to be executed with a much better style, since Andrea, a close friend of Orsino the wax-worker, a man in Florence who possessed very good judgement in this craft, began to show Orsino how he could attain excellence. The death of Giuliano de' Medici and the danger which befell his brother Lorenzo, who was wounded in Santa Maria del Fiore, provided the opportunity for Lorenzo's friends and relatives to order that his image be placed in numerous places in order to give thanks to God for his escape. As a result, Orsino (among others) with Andrea's assistance and advice, executed three life-size images in wax, employing an inner framework made of wood (as I have described elsewhere) interwoven with split cane and then re-covered with waxed cloth, folded, and arranged in such a fashion that it would be difficult to find anything better or more lifelike. He made the heads and then the hands and feet from a thicker wax which was hollow inside, and then he did living portraits and painted them in oil, with the hair-style and other necessary features done so naturally and well that they seemed to be living men rather than wax figures, as we can see from each of the three he made, one of which stands in the church of the nuns of Chiarito in Via di San Gallo before the miraculous Crucifix. And this figure is dressed exactly as Lorenzo was when, wounded in the throat and bandaged, he stood at the windows of his home to be seen by the people, who had raced there to see if he were alive, as they hoped, or, instead, dead, so that they could avenge him. The second figure of Lorenzo is wearing the *lucco*, a citizen's ceremonial gown characteristic of the Florentines, and this one stands in the church of the Servites at the Nunziata above the small door which is near the table where the candles are sold. The

third figure was sent to Santa Maria degli Angeli in Assisi and placed in front of the Madonna. In the same place, as I have already noted, Lorenzo de' Medici paved with bricks the entire street running from Santa Maria to the gate of Assisi facing the Church of San Francesco, and likewise, he restored the fountains which Cosimo, his grandfather, had built there. But returning to the wax images—all those made by Orsino in the church of the Servites are marked at the base with a large O containing an R inside and a cross on top. And they are all so beautiful that few have since been produced that could compare to them. This craft, even though it has been kept alive right up to our own day, is now in true decline —either because of the lack of devotion or for some other reason.

But, to return to Verrocchio, besides all the works mentioned, he also executed wooden crucifixes and various other things in clay, in which he excelled, as we can see in the models of scenes he created for the altar of San Giovanni, in a number of extremely beautiful putti, and in a head of Saint Jerome, which is considered quite marvellous. Andrea also made the putto on the clock at the New Market with movable arms that, when raised, strike the hours with a hammer he holds in his hand. It was considered in those days to be a very beautiful and inventive work. And let this conclude the life of Andrea del Verrocchio, a most excellent sculptor.... *

THE END OF THE LIFE OF ANDREA DEL VERROCCHIO

The Life of Andrea Mantegna,
Painter of Mantua

[c.1431–1506]

What an inspiration it can be to have one's talent recognized is
known by anyone who works skilfully and has been, in some
measure, rewarded, for such a man feels no discomfort, in-
convenience, or fatigue when he can look forward to honour
and compensation. And what is more, each day such talent
becomes more evident and more illustrious. Of course, it is
true that one does not always find someone who recognizes,
values, and rewards such skill, as was the case with Andrea
Mantegna, who was born of the most humble stock in the ter-
ritory of Mantua. And although as a young boy he used to
lead the flocks to pasture, he was raised so high by fate and his
skill that he earned the rank of noble knight, as I shall relate in
the proper place. When he was older, he was brought into the
city, where he worked at painting under the tutelage of
Jacopo Squarcione, a Paduan painter; Jacopo took him into his
home and shortly afterwards, when he recognized his talent,
adopted him as his son, according to what Messer Girolamo
Campagnuola wrote to Messer Leonico Timeo, a Greek philo-
sopher, in a Latin letter in which he provides information
concerning older painters who served the Carrara, the Lords
of Padua.*

Squarcione realized he was not the most talented painter in
the world, and so that Andrea might learn more than he him-
self knew, he had him carefully study plaster casts taken from
ancient statues and paintings on canvas which he had brought
in from various places, but especially from Tuscany and
Rome. In these and other ways, Andrea learned a great deal
in his youth. Also, the competition with Marco Zoppo of
Bologna, Dario da Treviso, and Niccolò Pizzolo of Padua—

pupils of his adoptive father and master—also gave him no
small amount of assistance and incentive in learning.* When
he was no more than seventeen years old, Andrea executed the
panel painting for the main altar of Santa Sofia in Padua,* a
work which seemed done by an older and more experienced
man rather than a young boy; shortly afterwards Squarcione
was commissioned to do the Chapel of Saint Christopher
in the Eremitani Church of Sant'Agostino in Padua, and he
therefore entrusted the project to Niccolò Pizzolo and to
Andrea.* Niccolò depicted a God the Father sitting in majesty
among the Doctors of the Church, which was later considered
to be no less excellent than the paintings Andrea did there.
To tell the truth, Niccolò did few paintings, all of which were
very good, and if he had taken as much delight in painting as
he did in arms, he would have become an excellent painter
and, perhaps, he would also have lived much longer, but, since
he always went about armed and had a great many enemies,
he was attacked and treacherously murdered one day when he
was returning from work. As far as I know, he did not leave
any other works, except for another God the Father in the city
prefect's Chapel.

Left alone, Andrea then did the Four Evangelists in the same
chapel, which were considered very beautiful. Because of this
and other works, people began to have great expectations of
Andrea and to consider it highly probable that he would suc-
ceed, as he later did; Jacopo Bellini, the Venetian painter (the
father of Gentile and Giovanni Bellini, and Squarcione's rival),
arranged things so that Andrea would marry a daughter of his
who was Gentile's sister.* When Squarcione learned of this, he
was so infuriated with Andrea that they became enemies from
that time on. And whereas Squarcione had formerly always
praised Andrea's works, he criticized them after that in equal
measure and always in public. And above all else he merci-
lessly attacked the paintings Andrea had done in the Chapel of
Saint Christopher, declaring that they were poorly done
because Andrea had imitated ancient marbles; he claimed that
one cannot learn to paint perfectly by imitating sculpture,
since stone always possesses a hardness and never the tender
sweetness which flesh and other natural objects that bend and

move possess, adding that Andrea would have painted those figures better and more perfectly if he had given them the colour of marble rather than such a variety of colours, since his pictures resembled ancient marble statues rather than living creatures, and other like remarks.

Such reproaches stung Andrea to the quick, but on the other hand they were of great value to him, for he recognized that what Squarcione said was, in large measure, true, and, devoting himself to drawing portraits from life, he became so skilled in this that in one of the scenes in the chapel which remained to be completed, Andrea demonstrated that he was no less capable of learning from Nature and from living things than he was from those produced by art. But despite all that, Andrea always held the opinion that good ancient statues were more perfect and more beautiful in their particulars than anything in the natural world. He maintained that, according to what he judged and observed in such statues, those excellent masters had selected out from many living people all the perfection of Nature, which seldom brings together and joins all forms of beauty in a single body, making it necessary to select one element from one body and another element from yet another body; and besides this, he found ancient statues to be better finished and more exact in depicting muscles, veins, nerves, and other particulars than natural figures, in which certain defects are concealed and covered by soft, pliable flesh, except in the case of certain old or emaciated individuals whose bodies, however, are avoided by artisans for other reasons. His works make it obvious that Andrea was very convinced of this opinion, for in them one can truly discern a style which is just a little bit sharp and sometimes seems to suggest stone more than living flesh.

At any rate, in this last scene, which pleased everyone enormously, Andrea depicted Squarcione as an ugly, paunchy figure carrying a lance, with a sword in his hand. He also included portraits of Noferi, son of Messer Palla Strozzi, the Florentine; Messer Girolamo dalla Valle, an excellent doctor; Messer Bonifazio Frigimelica, a doctor of law; Niccolò, Pope Innocent VIII's goldsmith; and Baldassarre da Leccio—all good friends of his. He dressed all of them in white armour

which was polished and glistening as if real, executing every-thing in a beautiful style. He also painted portraits of Messer Borromeo, a knight, and a certain bishop from Hungary, a very foolish man who used to wander around Rome all day like a vagabond and then at night would go off to sleep in the stables like the animals. He portrayed Marsilio Pazzo in the figure of the executioner who is beheading Saint James, and drew a portrait of himself as well. In short, the excellence of this work acquired for Andrea a very great reputation.

While he was doing this chapel, Andrea also painted a panel which was placed on the altar of Saint Luke in Santa Justina.* And afterwards, he worked in fresco on the arch which is over the door of Sant'Antonino, where he signed his name.* In Verona he painted a panel for the altar of Saint Christopher and Saint Anthony, and at the corner of the Piazza della Paglia he did several figures. For the friars of Monte Oliveto, Andrea painted the very beautiful panel for the main altar in Santa Maria in Organo, and he also did the one in San Zeno.* And among the other works which Andrea worked on and sent to various places while he was in Verona was a painting owned by his friend and relative, an abbot of the Badia in Fiesole, which contained a half-length Madonna with Child and the heads of some singing angels that are executed with exquisite grace. Today, this painting is in the library of that monastery and was considered then, just as it is now, to be a work of rare beauty.

Because Andrea had served Ludovico Gonzaga, the mar-quis, extremely well when he lived in Mantua, that ruler always held Andrea in great esteem and favoured his talent; thus, he had him paint a little panel for his chapel inside the castle which contained scenes with some rather small but very beautiful figures.* In the same place, there are many figures which are foreshortened from the bottom up that have been widely praised, for although his method of arranging the draperies was a bit crude and overworked and his style some-what dry, it is nevertheless obvious that every detail was executed with great skill and care.*

For the same marquis Andrea painted the Triumph of Caesar in a hall of the Palazzo di San Sebastiano in Mantua,

which is the best work he ever did* In this elegantly organized
triumph, we see the beautiful and ornate chariot, the figure
of the man who vituperates the victor, the relatives, the
perfumes, the incenses, the sacrifices, the priests, the sacrificial
bulls with their crowns, the prisoners, the booty taken by the
soldiers, the ranks of the squadrons, the elephants, the spoils,
the victories, the cities and the fortresses represented in various
chariots with countless trophies on spears, as well as various
types of armour for the head and the body, headgear, orna-
ments, and countless vases, and among the multitude of
spectators there is a woman who holds the hand of a young
boy whose foot has been pierced by a thorn and who is crying
and showing it to his mother in a most graceful and natural
fashion. As I may have indicated elsewhere, Andrea had a
wonderful inspiration in this scene, for having situated the
plane upon which his figures stand above eye-level, he placed
the feet of the figures in the foreground upon the outer edge
of the plane, while making the others farther back gradually
recede, so that their legs and feet eventually disappear, as
demanded by the rules of point of view, and in like manner he
showed only the lower portions of the spoils, vases, and other
devices or decorations, allowing the upper portions to be lost
from view, as required by the rules of perspective. Andrea
degli Impiccati [del Castagno] observed these same rules with
great care in the Last Supper he painted for the refectory of
Santa Maria Novella. Thus, we observe that in this age, those
worthy men were closely investigating and zealously imitating
the true properties of natural objects. To express it in a word,
this entire project could not be more beautiful nor any better
executed.

As a result, if the marquis esteemed Andrea before, he after-
wards loved him even more and honoured him much more
highly, and in addition, Andrea's fame became so widespread
that Pope Innocent VIII, hearing of his excellence in painting
and the other good qualities with which he was marvellously
endowed, sent for him so that when he had completed build-
ing the walls of the Belvedere, Andrea would decorate them
with his paintings, just as many other artists had been com-
missioned to do.* Therefore, Andrea went to Rome with the

highest regard and the most favourable recommendation of the marquis who, in order to honour him even further, made him a knight, and he was lovingly received by that pontiff and was immediately asked to paint a small chapel in that place.* Andrea worked on every detail with such love and precision that the vault and walls seem more like illuminations in manuscripts than paintings, and the largest figures in the work are over the altar, which he did like the other parts in fresco; while Saint John the Baptist is baptizing Christ, people standing around him are removing their clothes and making signs that they wish to be baptized. Among the figures there is a man who wishes to pull off a stocking clinging to his leg with the sweat and who, crossing one leg over the other, pulls it off inside out with such a violent effort that both pain and discomfort clearly appear in the expression on his face: this ingenious detail amazed everyone who saw it in those days.

It is said that because of the many commitments he had, this pope did not give Mantegna the money he needed often enough, and that because of this, when he painted some Virtues in monochrome, Andrea included among them the figure of Prudence. When the pope came to see the work one day, he asked what that figure represented, and Andrea replied: 'That is Prudence.' Then the pontiff added: 'If you wish her to have a proper companion, paint Patience beside her.' The painter understood what the Holy Father wished to say, and never again uttered another word. When the project was completed, the pope sent him back to the duke with his favour and very honourable rewards.* While Andrea was working in Rome on this chapel, he also painted a small picture of the Madonna and Her Child sleeping in Her arms, while in the background on a mountain, he showed some stone-cutters quarrying stones in some caves for various kinds of work—a scene so subtle and done with such patience that it does not seem possible for such exquisite work to be done with the tip of a fine brush.* This painting is today owned by the Illustrious Lord Don Francesco Medici, the Prince of Florence, who counts it among his most cherished possessions. In our book there is half a folio sheet with a drawing by Andrea* finished in chiaroscuro which contains a Judith who

places the head of Holofernes in a sack held by one of her
Moorish slaves; it is done in a style of chiaroscuro no longer
used, for Andrea left the folio sheet white, which takes the
place of the light created with white lead so perfectly that the
dishevelled hair and other delicate details can be seen no less
well than if they had been very carefully executed with a
brush. Therefore, in a certain sense, one could call this piece a
work in colour rather than a paper drawing. Like Pollaiuolo,
Andrea liked to do copper engravings, and among other
things he reproduced his Triumphs, which were highly
esteemed since none better had ever been seen. Among the last
works he executed was a panel painting at Santa Maria della
Vittoria, a church built according to Andrea's plans and
designs by the Marquis Francesco to commemorate his victory
on the River Taro when he was the commander of the
Venetians against the French.* This painting, which was done
in tempera and placed upon the high altar, depicts the
Madonna and Child seated on a pedestal; below are Saint
Michael the Archangel, Saint Anne, and Saint Joachim, who
are presenting the marquis, whose portrait is painted so well
that he seems alive, to the Virgin, Who holds out Her hand to
him. This work, which gives pleasure to everyone who sees it,
so satisfied the marquis that he most generously rewarded
Andrea's talent and diligence, and since Andrea was recog-
nized by princes for all his works, he was able to retain most
honourably the rank of knight until his death....*

In Mantua, Andrea built and painted for his own use a very
lovely home in which he enjoyed living. Finally, in 1517, at
the age of sixty-six, he died.* He was buried in Sant'Andrea
with honour, and upon his tomb, where he is depicted in
bronze, there was placed this epitaph:

> Whoever beholds the bronze statue of Mantegna
> Will know that he is Apelles' peer, if not more.

Andrea was so kind and in all his actions so praiseworthy
that his memory will always endure, not only in his native city
but in the entire world, for he deserved to be celebrated
by Ariosto no less for his extremely kind habits than for
the excellence of his painting. Hence, in the beginning of

Canto XXXIII, Ariosto lists him among the most illustrious painters of his times:

Leonardo, Andrea Mantegna, Gian Bellino.*

Andrea discovered a better method for foreshortening figures in painting from the bottom up, which was certainly a difficult and ingenious invention, and, as we said, he enjoyed engraving the prints of figures in copper, which is truly a most singular convenience through which the world has been able to see not only the Bacchanals, the battle of the sea-monsters, the Deposition from the Cross, the Entombment of Christ and His Resurrection along with Longinus and Saint Andrew (all works by Mantegna himself), but also the individual styles of all the artisans who have ever lived.*

THE END OF THE LIFE OF ANDREA MANTEGNA

The Life of Bernardino Pinturicchio, Painter from Perugia

[c.1454–1513]

Just as there are many aided by Fortune who have not been endowed with much talent, so, on the contrary, there are countless talented men persecuted by adverse and hostile Fortune. Thus, it is common knowledge that Fortune adopts as her children those who depend upon her without the help of any talent, for she likes to raise up some with her own favour who would never have been recognized through their own worth. This is what happened with Pinturicchio from Perugia,* who, even though he executed many works and was assisted by various people, none the less enjoyed a much greater reputation than his works deserved. Just the same, he was a man with great experience in works of a large scale, and he kept many workers continuously employed upon his projects.

After working in his early youth upon many projects with Pietro da Perugia, his teacher,* earning a third of the profit that was made, he was summoned by Cardinal Francesco Piccolomini to Siena to paint the library constructed by Pope Pius II in the Duomo of that city.* But it is true that the sketches and the cartoons for all of the scenes that he executed there were done by Raphael of Urbino, then a young man, who had been his companion and a fellow pupil of the above-mentioned Pietro, whose style Raphael had learned very well; today one of these cartoons can be seen in Siena, as well as some of the sketches by Raphael, which are in our book. The scenes of this work, in which Pinturicchio was assisted by many apprentices and workers, all from Pietro's school, were divided into ten panels. The first depicts the birth of Pope Pius II to Silvio and Vittoria Piccolomini, who named

him Aeneas, in the year 1405 in Valdorcia in the township of Corsignano, which today is called Pienza from the pope's name, since it was he who later built it and made it into a city.* The painting contains actual portraits of both Silvio and Vittoria. The same painting also shows Aeneas passing over the Alps covered with ice and snow with Domenico, the Cardinal of Capranica, in order to go to the Council at Basle. In the second panel, Pinturicchio shows the council sending Aeneas on many missions—that is, three times to Strasbourg; to Trent; to Constance; to Frankfurt; and to Savoy.

The third panel shows Aeneas being sent as orator by the antipope Felix to the Emperor Frederick III, at whose court Aeneas's quick wit, eloquence, and grace were so meritorious that he was crowned by Frederick as poet laureate, made a protonotary, accepted among the emperor's friends, and appointed First Secretary.* The fourth panel shows when Aeneas was sent by Frederick to Pope Eugenius IV, by whom he was named Bishop of Trieste and later Archbishop of his native city of Siena. In the fifth scene, the emperor, wishing to come to Italy to take the imperial crown, sends Aeneas to Telamone, the Sienese port, to meet his wife Leonora, who is coming from Portugal. In the sixth panel, Aeneas is sent by the emperor to Pope Calixtus IV to persuade him to make war on the Turks, and in this section of the work we see this pontiff (while Siena is being harassed by the Count of Pitigliano and other soldiers at the instigation of King Alfonso of Naples) sending Aeneas to negotiate the peace. Once peace is achieved, a war against the Orientals is planned, and after Aeneas returns to Rome, he is made a cardinal by the pope.

In the seventh panel, after the death of Calixtus, Aeneas is elected supreme pontiff and takes the name of Pius II. In the eighth scene, the new pope goes to Mantua to a council organizing an expedition against the Turks, where Marquis Ludovico receives him with the most splendid display and incredible magnificence. In the ninth scene, Aeneas places in the catalogue of the saints (or canonizes, as is said) Catherine, the Sienese nun and holy woman of the order of Preaching

Friars.* In the tenth and last scene the pope, while preparing an enormous army against the Turks with the aid and support of all Christian princes, dies in Ancona, and a hermit from the hermitage at Camaldoli, a holy man, sees the soul of the pope at the instant of his death, as we can also read, just as it is being carried up into Heaven by angels. Then, in the same scene, his body is being transported from Ancona to Rome, with a distinguished company of countless lords and priests who are mourning the death of so great a man and so rare and holy a pontiff. The entire work is full of the portraits of actual people (so that recounting their names would be a long story); it is all painted with delicate and very lively colours and executed with various decorations in gold and very well thought out compartments in the ceiling. Under each scene is a Latin epitaph which describes what it contains.

The Three Graces in marble located there (which are ancient and extremely beautiful) were brought to this library by Cardinal Francesco Piccolomini, the pope's nephew, and were placed in the middle of the room; at the time, they were the first ancient monuments to be held in great esteem.* Before the library (which contains all the books that Pius II left behind) was even completed, Cardinal Francesco, nephew of the pontiff Pius II, was elected to the papacy, and in memory of his uncle he wished to be called Pius III. Over the door of the library which leads into the Duomo, Pinturicchio depicted in an enormous scene—so large that it covers the entire façade —the coronation of Pius III with many portraits of real people, and below the scene these words can be read:

Pius III of Siena, nephew of Pius II, was crowned on 8 October after having been elected on 21 September 1503.

Having worked in Rome in the time of Pope Sixtus when he was an assistant of Pietro Perugino, Pinturicchio had entered the service of Domenico della Rovere, Cardinal of San Clemente, who after constructing in Borgo Vecchio a very handsome palace, wanted Pinturicchio to paint it all and to erect the arms of Pope Sixtus on the façade held by two putti. Pinturicchio also did several things for Sciarra Colonna

in the Palazzo of Santi Apostoli. And not long afterwards—
that is, in the year 1484—Pope Innocent VIII of Genoa had
him paint several rooms and loggias in the Belvedere Palace,
where among other things, as the pope wished, he painted a
loggia entirely with landscapes, in which he depicted Rome,
Milan, Genoa, Florence, Venice, and Naples in the Flemish
style, something which was rarely employed until that time
and which was very pleasing. In the same place he painted a
Madonna in fresco at the entrance of the main door. At Saint
Peter's, in the chapel containing the lance that pierced Christ's
side, he painted a panel in tempera with a Madonna larger
than life-size for Pope Innocent VIII. And in the church of
Santa Maria del Popolo, he did two chapels, one for the same
Cardinal of San Clemente, Domenico della Rovere, in which
he was later buried, and the other for Cardinal Innocent
Cybo, in which the donor was also later buried, and in each of
the two chapels he painted the portraits of the cardinals who
had commissioned the work. In the pope's palace, he painted
several rooms overlooking the courtyard of Saint Peter's,
where a few years ago the ceilings and paintings were restored
by Pope Pius IV. In the same palace, Alexander VI com-
missioned him to paint all the rooms in which he lived as well
as the entire Borgia Tower, where in one room he executed
scenes of the Liberal Arts and decorated all the vaults with
stucco and gold. But since they lacked the method of
executing stucco in the way it is done today, these decorations
have been, for the most part, ruined. There, over the door of
one of the chambers, he also painted the portrait of Signora
Giulia Farnese in the face of a Madonna, while in the same
painting he drew the head of Pope Alexander who is adoring
her.*

In his paintings, Bernardino frequently employed golden
ornaments in relief to satisfy those who understood very little
about this craft, so that they would be more gaudy and lus-
trous, something which is an extremely crude device in paint-
ing. Then, after executing in these rooms a scene from the
life of Saint Catherine, he depicted the arches of Rome in
relief with the figures represented in such a way that while
the figures are in the foreground and the buildings in the

background, the receding objects seem nearer than those which should be larger to the eye—the most tremendous heresy in our craft.

He decorated countless rooms in the Castel Sant'Angelo with grotesques, while inside the large tower in the garden below he painted scenes from the life of Pope Alexander VI, and there he painted portraits of the Catholic Queen Isabella, Niccolò Orsini, Count of Pitigliano; Giangiacomo Trivulzio, along with other relatives and friends of the same pope—in particular, Cesare Borgia, his brother and sisters, and many talented men of those times.* In the chapel of Paolo Tolosa at Monte Oliveto in Naples, there is a panel painting of the Assumption by Pinturicchio.* He painted countless other works, all over Italy, and since they are skilful but not very remarkable, I shall pass over them in silence.

Pinturicchio used to say that to give the highest relief possible to his figures, a painter should himself stand out without owing anything to princes or to others. He also worked in Perugia, but on few projects. In Araceli he painted the chapel of Saint Bernardino, while in Santa Maria del Popolo (where we have already said that he decorated two chapels), he did the Four Doctors of the Church on the vault of the main chapel.* When he reached the age of fifty-nine, he was commissioned to paint a panel of the Birth of the Virgin for San Francesco in Siena, where, after he had begun, the friars assigned him a room to live in which was, as he requested, empty and cleared of everything, except for an enormous old chest which seemed to them too bothersome to take somewhere else. But Pinturicchio, like the strange and eccentric man that he was, made such a fuss about this and on so many occasions that, in desperation, the friars finally decided to take it away. And their fortune was so great that, as they carried it away, they broke one of its planks and found five hundred golden ducats inside. Pinturicchio took such displeasure in this and was so heart-broken that, thinking of nothing else, he died as a result. . . . *

Let this be the end of the life of Pinturicchio, who, among other things, greatly satisfied many princes and lords, since he quickly delivered his finished works, as they desired, even

though such works perhaps lack the quality of those done slowly and with greater deliberation.

THE FND OF THE LIFE OF BERNARDINO PINTURICCHIO, PAINTER FROM PERUGIA

The Life of Pietro Perugino,* Painter

[c.1450–1523]

How beneficial poverty may sometimes be to those with talent, and how it may serve as a powerful goad to make them perfect or excellent in whatever occupation they might choose, can be seen very clearly in the actions of Pietro Perugino. Wishing by means of his ability to attain some respectable rank, after leaving disastrous calamities behind in Perugia and coming to Florence, he remained there many months in poverty, sleeping in a chest, since he had no other bed; he turned night into day, and with the greatest zeal continually applied himself to the study of his profession. After painting had become second nature to him, Pietro's only pleasure was always to be working in his craft and constantly to be painting. And because he always had the dread of poverty before his eyes, he did things to make money which he probably would not have bothered to do had he not been forced to support himself. Perhaps wealth would have closed to him and his talent the path to excellence just as poverty had opened it up to him, but need spurred him on since he desired to rise from such a miserable and lowly position—if not perhaps to the summit and supreme height of excellence, then at least to a point where he would have enough to live on. For this reason, he took no notice of cold, hunger, discomfort, inconvenience, toil, or shame if he could only live one day in ease and repose; and he would always say—and as if it were a proverb—that after bad weather, good weather must follow, and that during the good weather houses must be built for shelter in times of need.

But in order to make this artisan's progress better understood, let me begin from his origins and say that according to common knowledge, there was born in the city of Perugia to

a poor man from Castello della Pieve named Cristofano a son who, at his baptism, was given the name of Pietro. Raised in misery and privation, he was given by his father as an errand-boy to a painter from Perugia who was not very skilled in this trade but who held in great veneration this profession and the men who excelled in it. He never did anything with Pietro but talk about how profitable and honourable painting was to anyone who did it well. And by telling of the rewards already earned by ancient and modern painters, he encouraged Pietro to study it. Thus, he sparked the boy's imagination in such a way that he was inspired to become one of these men, if only Fortune would help him.

And so Pietro often used to ask anyone he knew who had travelled about the world where the best masters of this profession were produced; in particular, he asked this of his own teacher, who always replied in the same way, claiming that in Florence, more than anywhere else, men came to be perfect in all the arts, and especially in the art of painting, because the people of this city are spurred on by three things. For one thing, they were motivated by the constant criticism expressed by many people, since the air in Florence naturally produces free spirits who are generally discontent with mediocre works and who always judge them more on the basis of the good and the beautiful than with regard to their creator. Secondly, anyone wishing to live there must be industrious, which means nothing less than continually exerting one's mind and judgement, being sharp and ready in one's affairs, and, finally, knowing how to make money, since Florence lacks a large and fertile countryside which might easily support its inhabitants, as in places where good land is abundant. The third and perhaps no less powerful motivation is a thirst for glory and honour which that air generates in men of every profession and which will not permit men of bold spirit to remain equal, let alone lag behind those they judge to be men like themselves, even though they acknowledge them as their masters. Indeed, this thirst often compels them to desire their own greatness to such an extent that, if they are not kind or wise by nature, they turn out to be malicious, ungrateful, and unappreciative of the benefits they received. It is certainly true

that when a man has learned all he needs to learn in Florence and, wishing to do more than live from day to day, like the animals, he wants to make himself rich, he must leave, and sell the excellence of his works and the reputation of the city in other places, just as the learned scholars from the university do. For Florence does to her artisans what time does to its own creations: after creating them, it destroys them and consumes them little by little. Moved, therefore, by this advice and the convictions of many others, Pietro came to Florence with the desire to excel, and he had considerable success, since in his day works in his style were held in the greatest esteem.

Pietro studied under Andrea del Verrocchio, and his first figures were painted outside the Prato gate for the nuns of San Martino (now in ruins because of the wars), while in Camaldoli he did a Saint Jerome on a wall which was then highly valued by the Florentines and particularly praised for having depicted that saintly old man as a lean and wizened figure with his eyes fixed upon the cross and so emaciated that he looks like a skeleton, as we can see in a drawing based on the painting owned by the previously mentioned Bartolomeo Gondi. In a few years, therefore, Pietro's reputation had grown to such an extent that not only Florence and Italy were filled with his works but also France, Spain, and many other countries, where they were sent. Since his works were highly regarded and greatly prized, merchants began to corner the market in them and to send them abroad to various countries, to their own considerable profit and gain.

Pietro worked for the nuns of Santa Chiara on a panel of the dead Christ* with such delightful and novel colouring that he made all the artisans believe he had the ability to become marvellous and pre-eminent. In this work, some very handsome heads of old men are seen along with figures of the two Maries who, having ceased to weep, are contemplating the dead man with admiration and extraordinary love; besides this, he painted a landscape that was then considered extremely beautiful, since the true method of painting them had not yet been seen as it has been since that time. It is said that Francesco del Pugliese wanted to give the nuns three times the amount they had paid Pietro and to have Pietro himself paint them

another similar panel, but they did not agree to this, since Pietro said he did not believe he could equal that one. There were also many works by Pietro outside the Pinti gate in the convent of the Jesuate friars, but since this church and convent are now in ruins, I shall not find it tiresome to say something about them before going on with this *Life.* . . . *

But, returning to Pietro now, let me say that of the works he executed in this convent, only the panel paintings have been preserved, since those finished in fresco were, along with the entire structure, razed to the ground because of the siege of Florence, and the panels were transported to the San Pier Gattolini gate, where the friars were given lodging in the church and convent of San Giovannino. The two panels, then, which were on the choir screen mentioned above were by Pietro. In one of them, there is a Christ in the garden with the Apostles who are sleeping, a work in which Pietro demonstrated the power of sleep over trouble and sorrow by depicting them in very relaxed poses. In the other panel, he painted a *Pietà*, that is, the figure of Christ in the Madonna's lap, surrounded by four figures that are no less well done than all the others in his style, and, among other things, he depicted the dead Christ all stiffened, as if He had been hanging on the cross so long that time and cold had reduced Him to such a state; and so Pietro showed Him being supported by Saint John and Mary Magdalene, who are weeping and full of grief. On another panel, he did a Crucifixion with Mary Magdalene and, at the foot of the Cross, Saint Jerome, Saint John the Baptist, and the Blessed Giovanni Colombini, founder of that order, with infinite care. These three panels have deteriorated a great deal and are full of cracks in dark areas and areas of shadow; and this happens when the first coat of colour applied on the primer is not dried well, for there are three coats of colour applied on top of each other, and with the passage of time the different layers of paint contract as they dry and can eventually cause those cracks. Pietro could not have known this, since it was only in his own day that they had begun to paint well in oil.

Then, since Pietro's works were highly praised by the Florentines, a prior of the same convent of Jesuates who took

pleasure in this art had him do a Nativity with the Magi on
a wall of the first cloister showing exquisite detail, which
Pietro completed perfectly with charm and great elegance. It
contained a great number of different heads and not a few
actual portraits, including among them the head of Andrea del
Verrocchio, his teacher. In the same courtyard, he did a frieze
over the arches of the columns with life-size heads that was
very well executed; among these was the head of the prior,
which was so lifelike and painted in such a fine style that it was
judged by the most skilful artisans to be the best thing Pietro
ever did. And in the other cloister, above the door which led
into the refectory, he was asked to do a scene depicting the
moment Pope Boniface* confirmed the habit of his order for
the Blessed Giovanni Colombini, in which he portrayed eight
of the friars and executed a very beautiful scene receding in
perspective which was quite deservedly praised, since Pietro
made this technique a speciality of his. In another scene below
this, he began a Nativity of Christ with some angels and
shepherds, executed with the brightest colouring, and over the
door of the oratory he painted three half figures on an arch:
Our Lady, Saint Jerome, and the Blessed Giovanni, all in such
a beautiful style that it was considered to rank among the best
fresco paintings Pietro ever did on a wall.

As I have heard the story told, the prior was very good at
preparing ultramarine blues, and since he had a great abund-
ance of this, he wanted Pietro to employ it lavishly in all the
above-mentioned works, but he was none the less so miserly
and suspicious that he did not trust Pietro and always wanted
to be present when Pietro used this colour in his work. Thus
Pietro, who was by nature good and honest and never desired
anything from others except what he had earned by his own
labours, took the prior's distrust very badly and thought about
how he could put the prior to shame. And so he took a small
basin of water, and whenever he had to paint either draperies
or other details for which he wanted to use blue and white, he
kept coming back to the prior time after time, who, with
some distress, kept going back to his little bag and putting the
ultramarine into the pot containing the water for mixing. As
he began his work, Pietro rinsed off his brush in the basin after

every two brush-strokes, so that more ultramarine remained
in the water than was on the wall. And the prior, who saw his
sack being emptied and that the work was not taking shape,
constantly declared:

'Oh, what a large quantity of ultramarine this plaster is
absorbing!'

'You can see for yourself,' Pietro would reply. After the
prior had left, Pietro would remove the ultramarine that was
left on the bottom of the basin, and when the time seemed
right to him, he returned it to the prior and said to him:

'Father, this is yours: now learn to trust honest men who
never deceive those who trust them but who know how very
well, if they wish, to deceive suspicious men such as yourself.'

And so, for these and many other works, Pietro's fame
grew so widespread that he was almost forced to go to Siena,
where in San Francesco he painted a large panel which was
considered very handsome, while in Sant'Agostino he did
another one containing a Crucifixion with some saints.* And
shortly after this, in the church of San Gallo in Florence, he
executed a panel of Saint Jerome in Penitence which is found
today in San Jacopo tra Fossi, where the previously mentioned
friars live near the corner of the Alberti family. He was
commissioned to do a Dead Christ with Saint John and the
Madonna above the stairway of the side-door to San Pietro
Maggiore, and he did this in such a way that even though
exposed to rain and wind, it has been preserved with the same
freshness as if Pietro had just now completed it.* Pietro's mind
certainly knew how to use colours, both in fresco and in oil,
and as a result all skilled artisans are indebted to him, since
through him they have gained knowledge of the use of light,
which can be seen in all his works.

In the same city in Santa Croce, he executed a *Pietà* with
a Dead Christ in the Madonna's arms and two other figures
which are marvellous to behold, not just for their excellence
but, rather, for the way in which the colours painted in fresco
have remained so bright and new. He was commissioned
by Bernardino de' Rossi, a Florentine citizen, to do a Saint
Sebastian to send to France, and they agreed upon a price of
one hundred gold *scudi*; Bernardino then sold this painting

to the King of France for four hundred gold ducats. At Vallombrosa, he painted a panel for the main altar,* and in the Certosa of Pavia, he did a similar panel for those friars.* For Cardinal Caraffa of Naples, he painted an Assumption of Our Lady, with the Apostles standing in wonder around Her tomb, for the main altar of the bishop's palace.* And for Abbot Simone de' Graziani of Borgo San Sepolcro, he painted a large panel in Florence which was then at enormous expense carried to San Gilio in Borgo on the shoulders of porters.* He sent a panel with some standing figures and a Madonna in Glory to the church of San Giovanni in Bologna.*

Thus, Pietro's fame spread throughout Italy and abroad to such an extent that, to his great honour, he was brought to Rome by Pope Sixtus IV to work on the [Sistine] chapel along with other skilled artisans; there in the company of Don Bartolomeo della Gatta, the abbot of San Clemente in Arezzo,* he painted the scene showing Christ giving the keys to Saint Peter, as well as the Birth and Baptism of Christ* and the Birth of Moses, when he is discovered in the little basket by Pharaoh's daughter. And on the same wall where the altar is, he painted a mural painting depicting the Assumption of the Virgin with a portrait of Pope Sixtus kneeling. But these works were torn down* to execute the wall of the divine Michelangelo's Last Judgement in the time of Pope Paul III. In a vault in the Borgia Tower of the pope's palace, he painted several scenes from the life of Christ with some foliage in chiaroscuro which in his time gained extraordinary renown for its excellence.* Likewise, for the church of San Marco in Rome, he painted a scene of two martyrs next to the Sacrament, one of the better works he executed in that city.* For Sciarra Colonna he also painted a loggia and other rooms in the Palace of the Sant'Apostolo.

These works put an enormous amount of money into his hands; as a result, he decided to remain no longer in Rome, and, departing with the blessing of the entire court, he returned to his native city of Perugia. There, he completed panel paintings and frescos for many locations in the city, most particularly an oil painting for the chapel in the palace of the Signori containing Our Lady and other saints.* At San

Francesco del Monte, he painted two chapels in fresco: one contained the story of the Magi who are going to present gifts to Christ, and the other the martyrdom of some Franciscan friars who were murdered as they were going to visit the sultan of Babylon. In the convent of San Francesco, he also painted two panels in oil, one representing the Resurrection of Christ,* and the other Saint John the Baptist and other saints.* Likewise, in the Servite church, he completed two panels, one containing the Transfiguration of Our Lord and the other, which is next to the sacristy, the story of the Magi, but since these paintings are not 'of the same good quality as other works by Pietro, it is certain that they are among the first works he executed.* In San Lorenzo, the Duomo of Perugia, there are pictures by Pietro of Our Lady, Saint John, the other Maries, Saint Laurence, Saint James, and other saints in the Chapel of the Crucifixion. He also painted a Marriage of the Virgin for the Altar of the Holy Sacrament, where the ring with which the Virgin Mary was married is preserved.*

Afterwards, he frescoed the entire audience chamber of the Cambio—that is: in the compartments of the vaulting, the seven planets drawn upon chariots by various kinds of animals, according to the old style; on the wall facing the entrance, the Nativity and Resurrection of Christ; and in a panel painting, a Saint John the Baptist surrounded by other saints. Then on the side walls, he painted in his own style the figures of Fabius Maximus, Socrates, Numa Pompilius, Fulvius Camillus, Pythagoras, Trajan, L. Sicinius, Leonidas the Spartan, Horatius Cocles, Fabius Sempronius, Pericles the Athenian, and Cincinnatus. On the other wall, the portrayed the prophets Isaiah, Moses, Daniel, David, Jeremiah, and Solomon, as well as the Erythrean, Libyan, Tiburtine, Delphic, and other sibyls. And under each of these figures, in lieu of a motto, he painted in writing something they uttered which was appropriate to that place. On the decoration, he drew a self-portrait (which appears very lifelike), writing these lines under his name:

Even if the craft of painting had been lost, here by the distinguished Pietro of Perugia it was restored; had it been invented nowhere else, Pietro would have done so. In the year of Our Lord 1500.

This work, which was extremely beautiful and praised more lavishly than any other Pietro had completed in Perugia, is today held in esteem by the citizens of that town in memory of this praiseworthy artisan from their native city.*

Later, Pietro executed a large, free-standing panel surrounded by a rich decorative frame for the main chapel of the church of Sant'Agostino with Saint John baptizing Christ on the front, and, on the back, that is, on the side facing the choir, the Nativity of Christ with some saints in the upper parts; the predella contained many scenes with small figures painted with great care.* And in the same church, for Messer Benedetto Calera, he did a panel in the Chapel of San Niccolò.* After returning to Florence, he did a panel depicting Saint Bernard for the monks of Cestello, and in the chapter house he painted the Crucifixion, Our Lady, Saint Benedict, Saint Bernard, and Saint John.* And for San Domenico in Fiesole, in the second chapel on the right-hand side, he completed a panel containing Our Lady and three figures, among them a Saint Sebastian which has been very highly praised.*

Pietro had worked so hard and always had such an abundance of paintings to complete that he quite often placed the same details in his pictures. He thus reduced the theory of his craft to such a fixed style that he executed all his figures with the same expression. And since Michelangelo had already arisen in his day, Pietro had a strong desire to see his figures because of their fame among the other artisans. And seeing that the greatness of his own reputation, which he had acquired entirely because of his very promising beginnings, was being overshadowed, he constantly tried to use sarcastic remarks to insult those who were working [in this manner]. Because of this, he richly deserved it not only when the other artisans made ugly remarks to him, but also when Michelangelo said to him in public that he was clumsy in his trade. Since Pietro was unable to tolerate such slander, both men appeared before the Tribunal of Eight, where Pietro came away with very little honour left.

In the meanwhile, the Servite friars in Florence wished to have the panel of their main altar executed by some famous

person, and since Leonardo da Vinci had left for France, they
gave the project to Filippino [Lippi] who, after doing half of
one of the two panels for this altar, passed away to another
life. As a result, the friars commissioned the entire project to
Pietro because of their faith in him.* In the panel where he
had been painting the Deposition of Christ from the Cross,
Filippino had completed the figure of Nicodemus who is
taking Him down, and Pietro continued below with the
swooning of Our Lady and some other figures. Since this
work included two panels—one turned toward the friars'
choir and the other towards the body of the church—the
Deposition was supposed to face towards the choir and the
Assumption of Our Lady towards the front, but Pietro
painted it in such a commonplace fashion that the Deposition
was placed in front and the Assumption on the side facing the
choir. In order to erect the tabernacle of the Holy Sacrament,
both these two panels have now been taken away and placed
upon certain other altars in the church, and, from the entire
work, there remain only six pictures containing some saints
that Pietro painted inside certain niches. It is said that when
this work was uncovered, it was very harshly attacked by all
the young artisans, most especially because Pietro had re-used
figures which he had placed in his works on other occasions,
and even his own friends, questioning him, said that he had
not taken sufficient pains and had neglected the good method
of working, either out of avarice or out of a desire to save
time. To these remarks, Pietro responded:

'In this picture, I have put figures which on other occasions
were praised by all of you and which pleased you beyond
measure. If now you don't like them and don't praise them,
what can I do?'

But these harsh people kept on bombarding Pietro with
sonnets and public abuse. As a result, Pietro, already an old
man, left Florence and returned to Perugia where he executed
several works in fresco for the church of San Severo, a monas-
tery of the Camaldolite Order, where Raphael of Urbino (as I
shall discuss in his life), while still a young man and Pietro's
pupil, had executed some of the figures.* Pietro also worked
at Montone, at La Fratta, and in many other places in the

Perugian countryside, and especially in Assisi at Santa Maria degli Angeli where, on the wall at the back of the Chapel of the Madonna facing the monks' choir, he painted a Christ on the Cross with numerous figures. And in the church of San Piero, the abbey of the Black Friars in Perugia, he painted an Ascension with the Apostles below looking towards Heaven on a large panel for the main altar.* The predella of this panel contains three scenes worked with great care: that is, the story of the Magi, the Baptism of Christ, and the Resurrection.* The entire work is obviously filled with such fine efforts that it is the best of the paintings done in oil by Pietro in Perugia. He also began a work in fresco of no little importance at Castello della Pieve but did not finish it.

Since Pietro trusted no one, he used to come and go between Castello and Perugia, always carrying on his person all the money he possessed; and so some men waited for him at a pass and robbed him, but, after much pleading, they spared his life for the sake of God. Afterwards, employing various means and friends, of which he had a great many, he recovered a large part of the money which had been taken from him. But, he was, none the less, close to death out of grief.

Pietro was a person of very little religion, and no one could ever make him believe in the immortality of the soul. On the contrary, with words suitable to that rock-hard brain of his, he most obstinately rejected every good reason. He placed all his hopes in the gifts of Fortune, and he would have struck any evil bargain for money. He earned great wealth, and in Florence he built and bought houses, while in Perugia and Castello della Pieve, he acquired a great deal of real estate. He took as his wife a very beautiful young woman and had a number of children by her, and he took great delight in the fact that she wore, both inside and outside the home, charming head-dresses which, it is said, Pietro himself often arranged for her. Having finally reached old age, he finished his life's journey at the age of seventy-eight in Castello della Pieve, where he was honourably buried in the year 1524.*

Pietro trained many masters in his style, and one of them was truly most excellent, who, after devoting himself com-

pletely to the honourable study of painting, surpassed his master by far. This man was the miraculous Raphael Sanzio of Urbino, who worked with Pietro for many years in the company of Giovanni de' Santi, his father. Pinturicchio, the painter from Perugia, as is related in his life, was also his student and always adhered to Pietro's style. . . . *

But none of his many pupils ever equalled either Pietro's diligence or the grace with which he used colours in his own personal style, which was so pleasing during his day that many artisans from France, Spain, Germany, and other countries came to learn it. And, as we mentioned, many people traded in his works and sent them to various places before the appearance of the style of Michelangelo, who demonstrated the true and good path to these arts and has brought them to the perfection which will be observed in the following third part [of these lives]. In that section, we shall discuss the excellence and the perfection of art and shall prove to artisans that whoever works constantly, without indulging in fantasies or caprices, will leave behind works and acquire a good name, wealth, and friends.

THE END OF THE LIFE OF PIETRO PERUGINO, PAINTER

The Life of Luca Signorelli of Cortona, Painter
[c.1441–1523]

Luca Signorelli, an excellent painter about whom, following chronological order, we must now speak, was more famous in his day, and his works were held in higher esteem, than any other previous artist no matter the period, because in the pictures he painted, he demonstrated how to execute nude figures and how, although only with skill and great difficulty, they could be made to seem alive. He was the dependant and pupil of Piero della Francesca,* and in his youth he tried very hard to imitate his master and even to surpass him. While he worked in Arezzo with Piero, Luca went to live with his uncle Lazzaro Vasari* and, as was mentioned, he imitated the said Piero's manner in such a way that it was almost impossible to distinguish one from the other.

Luca's first works were in San Lorenzo d'Arezzo where, in the year 1472, he painted the Chapel of Saint Barbara in fresco, while for the Confraternity of Saint Catherine he painted in oil on canvas the sign carried in processions, along with a similar banner for the Confraternity of the Trinity, which seems more like a work by Piero than one by Luca. For Sant'Agostino, he did a panel depicting Saint Nicholas of Tolentino, containing beautiful little scenes, executed by him with good design and invention. And in the same town, for the Chapel of the Holy Sacrament, he painted two angels in fresco.

In the church of San Francesco for the Chapel of the Accolti, he executed a panel painting for Messer Francesco,* a doctor of law, in which he portrayed this Messer Francesco and some of his relatives; the work contains a remarkable Saint Michael who is weighing souls, and the splendour of the armour, the reflections of the light, and indeed the whole work, particu-

larly demonstrates Luca's understanding of his art. In Saint Michael's hands Luca placed a pair of scales with beautifully foreshortened nude figures, one of which goes up while the other goes down. Among the other ingenious details in this picture is a nude figure most cleverly transformed into a devil while a green lizard licks the blood flowing from his wound. Besides this, there is also a Madonna and Child, along with Saint Stephen, Saint Laurence, Saint Catherine, and two angels playing respectively a lute and a small rebec, and all these figures are so well dressed and adorned that it is amazing, but what is even more astonishing is the predella full of little figures treating the deeds of Saint Catherine.

Luca painted many works in Perugia, and among them he did a panel in the Duomo for Messer Jacopo Vannucci, a citizen of Cortona and bishop of that city; in it, he represented Our Lady, Saint Onuphrius, Saint Herculano, Saint John the Baptist, and Saint Stephen, as well as a very beautiful angel tuning a lute.* At Volterra, he painted a fresco over the altar of a confraternity in the church of San Francesco representing the Circumcision of Our Lord, which is considered beautiful and a marvel, although the child in the painting has suffered from the humidity and the restoration by Il Sodoma is much less beautiful than the original.* To tell the truth, it would sometimes be better to leave the works done by excellent men half ruined rather than to have them retouched by those who are less knowledgeable. In Sant'Agostino in the same city, Luca executed in tempera a panel painting along with a predella containing small figures and scenes from the Passion of Christ, a work that is considered extraordinarily beautiful.* For the rulers at Monte a Santa Maria, he painted a panel of a Dead Christ, while in Città di Castello in San Francesco, he did a Nativity;* and in San Domenico he did another panel with a Saint Sebastian.* For the Franciscans in his home town of Cortona, he completed a Dead Christ at Santa Margherita, one of his most unusual paintings.* And for the Confraternity of Jesus in the same city, he did three panels, including the marvellous one upon the main altar which shows Christ taking Communion with the Apostles while Judas places the Host in his purse.* And in the parish church, today the

bishop's palace, he painted in fresco several life-size prophets in the Chapel of the Holy Sacrament; around the tabernacle there are some angels who are opening a pavilion, with a Saint Jerome and a Saint Thomas Aquinas on each side. For the main altar of this same church, he painted a very beautiful panel of the Assumption;* he also designed its main window, which was later executed by Stagio Sassoli d'Arezzo.*

In Castiglione Aretino, Luca did a Dead Christ with the two Maries above the Chapel of the Holy Sacrament.* And in San Francesco di Lucignano, he painted the doors of a cabinet inside which there is a coral tree with a cross at its summit. For Sant'Agostino in Siena, he completed a panel in the Chapel of San Cristofano containing several saints which surround a figure of Saint Christopher in relief. Having gone to Florence from Siena to see works by masters then alive, as well as those of the past, he painted a number of nudes upon a canvas for Lorenzo de' Medici which were highly praised,* and a picture of Our Lady with two small prophets done in *terretta* which is now to be found at Duke Cosimo's villa in Castello;* and he gave both works to Lorenzo, who never wanted to be surpassed by anyone in generosity or magnificence. Then he painted a very beautiful tondo of Our Lady which is located in the audience chamber of the leaders of the Guelph party.* At Chiusuri in the Sienese countryside, the main location of the monks of Monte Oliveto, he painted eleven stories from the life and deeds of Saint Benedict around one side of the cloister.* And from Cortona he sent some of his works to Montepulciano, to Foiano (the panel on the main altar of the parish church*), and to other places in the Valdichiana. In the main church of the Madonna in Orvieto, he himself painted the chapel which Fra Giovanni da Fiesole had already begun; there he executed all the scenes of the end of the world with bizarre and fanciful inventions—angels, demons, ruins, earthquakes, fires, miracles of the Antichrist, and many other similar details besides these, including nudes, foreshortenings, and many beautiful figures—imagining to himself the terror which will exist on that last dreadful day.* With this work, Luca encouraged all those painters following him who came to find the difficulties of his style more manageable. And so, I

am not amazed that Luca's works were always highly praised by Michelangelo, who, in his own Last Judgement for the [Sistine] chapel, kindly borrowed some of Luca's inventions, such as angels, demons, the order of the heavens, and other details in which Michelangelo imitated Luca's approach, as everyone can see.* In this work, Luca drew his own portrait and those of many of his friends: Niccolò, Paolo, and Vitellozzo Vitelli; Giovan Paolo and Orazio Baglioni; and many others whose names are not known.*

In the sacristy of Santa Maria di Loreto, Luca painted in fresco figures of the Four Evangelists, the Four Doctors of the Church, and other saints, which are very beautiful, and he was very generously rewarded for this work by Pope Sixtus IV.* It is said that when his much beloved son, who was extremely handsome in face and figure, was killed in Cortona, even as he grieved, Luca had the body stripped, and with the greatest constancy of heart, without crying or shedding a tear, he drew his portrait so that he could always see whenever he desired, through the work of his own hands, what Nature had given him and inimical Fortune had taken away. Then Luca was summoned by the same Pope Sixtus to work in the [Sistine] chapel of his palace, and in competition with many other painters, he painted two scenes there which were considered the best among many. One represents the testament of Moses to the Hebrew people after seeing the Promised Land, and the other his death.* Finally, after having completed paintings for almost all the rulers of Italy and having already grown old, Luca returned to Cortona, where during his last years he worked more for pleasure than for any other reason like a man who, accustomed to toil, is unable or unwilling to remain idle. Thus, in his old age he executed a panel for the nuns of Santa Margherita d'Arezzo and another for the Confraternity of Saint Jerome, part of which was paid for by Messer Niccolò Gamurrini—doctor of law and judge in the Rota.* An actual portrait of Messer Gamurrini is drawn in this latter panel and shows him kneeling before the Madonna, to Whom he is presented by a figure of Saint Nicholas who appears in this panel. Also included are figures of Saints Donatus and Stephen, with a nude Saint Jerome below them, and a David

singing from a Psalter. There are also two prophets who, judging by the papal letters they hold in their hands, are discussing the Conception. This work was carried from Cortona to Arezzo on the shoulders of the members of this confraternity, and Luca, old as he was, wanted to come to set it up as well as to see his friends and relatives again. He stayed in the Vasari home, and since I was a child of eight years of age, I still remember this good old man, who was gracious and refined in every way. When he learned from the master who taught me my first letters that in school I applied myself to nothing but drawing figures, I remember, let me say, that Luca turned to my father Antonio and said to him:

'Antonio, have little Giorgio learn to draw at any rate so that he will not get even worse, since this art, even if he applied himself to his literary studies, cannot fail to provide him with the same profit, honour, and delight it has provided to all worthy men.'

Then, turning to me as I stood before him, he said: 'Learn, little cousin, learn.'

He said many other things about me which I shall not mention, since I recognize that I have not fully confirmed the opinion this good old man had of me. Since he understood (which was the case) that I lost a great deal of blood at that age from nosebleeds, which sometimes left me half dead, he himself placed a jasper on my neck with the greatest tenderness. This memory of Luca will be forever fixed in my mind.

After he had set up this panel painting, he returned to Cortona, accompanied much of the way by many citizens, friends, and relatives, since, as his talent deserved, he always lived more like a lord or an honoured gentleman than as a painter. During the same period, Benedetto Caporali, the painter from Perugia, had built a palace half a mile outside the city for Silvio Passerini, the Cardinal of Cortona; the cardinal wanted Caporali, who took great pleasure in architecture and had just written a commentary on Vitruvius, to decorate almost the entire palace. Thus Benedetto set to work with the help of Maso Papacello of Cortona, a pupil of his who had also learned a great deal from Giulio Romano (as will be discussed later) and from Tommaso and other pupils and appren-

tices, and Benedetto never stopped until he had decorated practically the entire palace in fresco. But since the cardinal also wanted to have some paintings by Luca there, Luca—so old and hindered by paralysis—painted in fresco upon the wall of the altar in the chapel of this palace the occasion when Saint John the Baptist baptizes the Saviour, but he was unable to finish it completely, for while he was working he died at the advanced age of eighty-two.*

Luca was a person of the most admirable habits, sincere and loving with his friends, amiable and pleasant in conversation with everyone, and, above all, courteous to anyone who needed his work and kind in teaching his pupils. He lived splendidly and enjoyed dressing well. Because of these good qualities, he was always greatly revered in his native town and abroad.

Thus, with the end of this man's life, which came in 1521,* we bring to an end the second part of these lives, concluding with Luca as the man who, by means of the fundamentals of design, especially those of his nudes, and by means of his graceful invention and the composition of his scenes, opened the way to the ultimate perfection of art for the majority of the artisans whom we shall discuss from here on, and who, in following, were able to give it the finishing touches.*

THE END OF THE LIFE OF LUCA SIGNORELLI, PAINTER

THE END OF THE SECOND PART OF THE WORK

PART THREE

PART THREE

possible, and using it as a model for all the figures in each of one's work, and on account of this, it is said to be beautiful style.

Giotto, Ghiberti, ... [faint bleed-through text, illegible] they had improved the principles their dilig-culties and had resolved them superficially, as in the case of drawing, which became more lifelike than it had been before

Preface to Part Three

Those excellent masters we have described up to this point in the Second Part of these *Lives* truly made great advances in the arts of architecture, painting, and sculpture, adding to the accomplishments of the early artists rule, order, proportion, design, and style, and if they were not perfect in every way, they drew so near to the truth that artists in the third group, whom we shall now discuss, were able, through that illumination, to rise up and reach complete perfection, the proof of which we have in the finest and most celebrated modern works. But to clarify the quality of the improvements that these artists made, it will not be out of place to explain briefly the five qualities I mentioned above and to discuss succinctly the origins of that true goodness which has surpassed that of the ancient world and rendered the modern age so glorious.

In architecture, rule is, then, the method of measuring ancient monuments and following the plans of ancient structures in modern buildings. Order is the distinction between one type and another, so that each body has the appropriate parts and there is no confusion between Doric, Ionic, Corinthian, and Tuscan orders. Proportion in architecture as well as sculpture is universally considered to be the making of bodies with straight, properly aligned figures, and similarly arranged parts, and the same is true in painting. Design is the imitation of the most beautiful things in Nature in all forms, both in sculpture and in painting, and this quality depends upon having the hand and the skill to transfer with great accuracy and precision everything the eye sees to a plan or drawing or to a sheet of paper, a panel, or another flat surface, and the same is true for relief in sculpture. And then the most beautiful style comes from constantly copying the most beautiful things, combining the most beautiful hands, heads, bodies, or legs together to create from all these beautiful qualities the most perfect figure

possible, and using it as a model for all the figures in each of one's works; and on account of this, it is said to be beautiful style.

Neither Giotto nor those early artisans did this, even though they had discovered the principles underlying all such difficulties and had resolved them superficially, as in the case of drawing, which became more lifelike than it had been before and more true to Nature, and in the blending of colours and the composition of the figures in scenes, and in many other things, about which enough has already been said. And although the artists of the second period made extraordinary efforts in these crafts in all the areas mentioned above, they were not, however, sufficient to achieve complete perfection. They still lacked, within the boundaries of the rules, a freedom which—not being part of the rules—was nevertheless ordained by the rules and which could coexist with order without causing confusion or spoiling it; and this freedom required copious invention in every particular and a certain beauty even in the smallest details which could demonstrate all of this order with more decoration. In proportion, they lacked good judgement which, without measuring the figures, would bestow upon them, no matter what their dimensions, a grace that goes beyond proportion. In design they did not reach the ultimate goal, for even when they made a rounded arm or a straight leg, they had not fully examined how to depict the muscles with that soft and graceful facility which is partially seen and partially concealed in the flesh of living things, and their figures were crude and clumsy, offensive to the eye and harsh in style. Moreover, they lacked a lightness in touch in making all their figures slender and graceful, especially those of women and children, whose bodies should be as natural as those of men but yet possess a volume and softness which are produced by design and good judgement rather than by the awkward example of real bodies. They also lacked an abundance of beautiful costumes, variety in imaginative details, charm in their colours, diversity in their buildings, and distance and variety in their landscapes.

And although many of these men, like Andrea Verrocchio, Antonio del Pollaiuolo, and many other more recent artists,

began by seeking to make their figures more studied and to display in them a greater sense of design along with the kind of imitation that would achieve a greater similarity to natural objects, they did not attain that level of perfection which displays even greater confidence. However, they were moving in the right direction, and their works might well have been praised in comparison with the works of the ancients. This was evident in Verrocchio's efforts to repair the legs and arms of the marble Marsyas at the home of the Medici in Florence, which still lacks a refined and absolute perfection in its feet, hands, hair, and beard, even if everything was done according to antique style and possessed a certain proper proportion in its measurements. If these artisans had mastered the details of refinement which constitute the perfection and the flower of art, they would have created a robust boldness in their works and would have achieved the delicacy, polish, and extreme grace they do not possess, despite the diligent efforts which endow beautiful figures, either in relief or in painting, with the essential elements of art. They could not quickly achieve the finish and certainty they lacked, since study produces a dryness of style when it is pursued in this way as an end in itself.

The artisans who followed them succeeded after seeing the excavation of some of the most famous antiquities mentioned by Pliny: the Laocoon, the Hercules, the great torso of Belvedere, the Venus, the Cleopatra, the Apollo, and countless others, which exhibit in their softness and harshness the expressions of real flesh copied from the most beautiful details of living models and endowed with certain movements which do not distort them but lend them motion and the utmost grace. And these statues caused the disappearance of a certain dry, crude, and clear-cut style which was bequeathed to this craft through excessive study by Piero della Francesca, Lazzaro Vasari, Alesso Baldovinetti, Andrea del Castagno, Pesello, Ercole Ferrarese, Giovanni Bellini, Cosimo Rosselli, the Abbot of San Clemente, Domenico Ghirlandaio, Sandro Botticelli, Andrea Mantegna, Filippino Lippi, and Luca Signorelli. All these artisans made every effort, seeking to achieve the impossible in art with their labours, and especially

in their displeasing foreshortenings and perspectives, which were as difficult to execute as they are unpleasant to look at. And while the majority of them were well drawn and free from error, they were nevertheless completely lacking in any hint of the liveliness and softness of the harmonious colours that Francia of Bologna and Pietro Perugino first began to display in their works. And the people ran like madmen to see this new and more realistic beauty, absolutely convinced that it could never be improved upon.

But their mistakes were later clearly demonstrated by the works of Leonardo de Vinci, who initiated the third style which we call modern; besides his bold and powerful design and his extremely subtle imitation of all the details of Nature, exactly as they are, his work displayed a good understanding of rule, better order, correct proportion, perfect design, and divine grace. Abounding in resources and most knowledge-able in the arts, Leonardo truly made his figures move and breathe. Following after him somewhat later was Giorgione of Castelfranco, whose pictures possessed a delicacy of shading and a formidable sense of motion through his use of the depth of shadows, which he well understood. Fra Bartolomeo of San Marco was by no means less skilful in giving to his own paintings a strength, relief, softness, and grace in colour. But the most graceful of all was Raphael of Urbino, who studied the efforts of both ancient and modern masters, taking the best elements from them all; and, by assimilating them, he enriched the art of painting with the kind of complete perfec-tion reflected in the ancient works of Apelles and Zeuxis and perhaps even surpassed them, if it were possible to claim that his work equalled theirs. His colours triumphed over those of Nature herself, and anyone who looks at his works can see that invention was effortless and natural to him, because his scenes, which resemble stories in writing, show us similar sites and buildings, and the faces and clothing of our own peoples as well as those of foreigners, just as Raphael wished to depict them. Besides the graceful quality of the heads in his young men, old men, and women, he carefully represented the mod-est with modesty, the wanton with lustfulness, and his chil-dren now with mischief in their eyes and now in playful poses.

And in the same way, the folds of his draperies were neither too simple nor too elaborate but had a very realistic appearance.

Andrea del Sarto followed his use of this style, but with a softer and less bold colouring; it can be said of him that he was a rare artisan, since his works were without mistakes. It is impossible to describe the extremely delicate vitality that Antonio da Correggio achieved in his works, for he painted hair in a new style which, unlike the refined one used by the artisans before him, was exacting, well-defined, and unadorned rather than soft and downy; the ease with which he painted enabled him to distinguish the strands of hair so that they seemed like gold and even more beautiful than natural hair, which was surpassed by his use of colour.

Francesco Mazzola Parmigiano created similar effects and in many details the grace, decoration, and beauty of his style surpassed even Correggio, as is evident in many of his paintings, which are full of smiling faces, the most expressive eyes, and even the beatings of the pulse, all depicted in whatever way it suited him. But anyone who will examine the wall paintings of Polidoro [da Caravaggio] and Muturino will see figures performing incredible exploits and will be amazed by their ability to create with the brush rather than the tongue (which is easy) formidably inventive scenes in their works which reveal their great knowledge and skill and represent the deeds of the Romans as they actually were. And how many artisans, now dead, were there who brought their figures to life with their colours? Like Rosso [Fiorentino], Fra Sebastiano [del Piombo], Giulio Romano, Perin del Vaga, not to mention numerous living artisans who are themselves well known.

But what matters most* is that the artisans of today have made their craft so perfect and so easy for anyone who possesses a proper sense of design, invention, and colouring that whereas previously our older masters could produce one panel in six years, the masters of today can produce six of them in a year. And I bear witness to this both from personal observation and from practice; and these works are obviously much more finished and perfect than those of the other reputable masters who worked before them.

But the man who wins the palm among artists both living

and dead, who transcends and surpasses them all, is the divine
Michelangelo Buonarroti, who reigns supreme not merely in
one of these arts but in all three at once. This man surpasses
and triumphs over not only all those artists who have almost
surpassed Nature but even those most celebrated ancient artists
themselves, who beyond all doubt surpassed Nature: and alone
he has triumphed over ancient artists, modern artists, and even
Nature herself, without ever imagining anything so strange or
so difficult that he could not surpass it by far with the power
of his most divine genius through his diligence, sense of
design, artistry, judgement, and grace. And not only in paint-
ing and colouring, categories which include all the shapes and
bodies, straight and curved, tangible and intangible, visible
and invisible, but also in bodies completely in the round; and
through the point of his chisel and his untiring labour, this
beautiful and fruitful plant has already spread so many hon-
ourable branches that they have not only filled the entire
world in such an unaccustomed fashion with the most luscious
fruits possible, but they have also brought these three most
noble arts to their final stage of development with such won-
drous perfection that one might well and safely declare that his
statues are, in every respect, much more beautiful than those
of the ancients. When the heads, hands, arms, and feet they
created are compared to those he fashioned, it is obvious his
works contain a more solid foundation, a more complete
grace, and a much more absolute perfection, executed at a cer-
tain level of difficulty rendered so easily in his style that it
would never be possible to see anything better. The same
things can be said of his paintings. If it were possible to place
any of them beside the most famous Greek or Roman paint-
ings, they would be held in even greater esteem and more
highly honoured than his sculptures, which appear superior to
all those of the ancients.

But if we have admired those most celebrated artists who,
inspired by excessive rewards and great happiness, have given
life to their works, how much more should we admire and
praise to the skies those even rarer geniuses who, living not
only without rewards but in a miserable state of poverty,
produced such precious fruits? It may be believed and there-

fore affirmed that, if just remuneration existed in our century,
even greater and better works than the ancients ever executed
would, without a doubt, he created. But being forced to
struggle more with Hunger than with Fame, impoverished
geniuses are buried and unable to earn a reputation (which is a
shame and a disgrace for those who might be able to help
them but take no care to do so). And that is enough said on
this subject, since it is now time to return to the *Lives* and to
treat separately all those who have executed celebrated works
in this third style: the first of these was Leonardo da Vinci,
with whom we shall now begin.

THE END OF THE PREFACE

The Life of Leonardo da Vinci, Florentine Painter and Sculptor

[1452–1519]

The greatest gifts often rain down upon human bodies through celestial influences as a natural process, and sometimes in a supernatural fashion a single body is lavishly supplied with such beauty, grace, and ability that wherever the individual turns, each of his actions is so divine that he leaves behind all other men and clearly makes himself known as a genius endowed by God (which he is) rather than created by human artifice. Men saw this in Leonardo da Vinci, who displayed great physical beauty (which has never been sufficiently praised), a more than infinite grace in every action, and an ability so fit and so vast that wherever his mind turned to difficult tasks, he resolved them completely with ease. His great personal strength was joined to dexterity, and his spirit and courage were always regal and magnanimous. And the fame of his name spread so widely that not only was he held in high esteem in his own times, but his fame increased even more after his death.*

Truly wondrous and divine was Leonardo, the son of Piero da Vinci,* and he would have made great progress in his early studies of literature if he had not been so unpredictable and unstable. For he set about learning many things and, once begun, he would then abandon them. Thus, in the few months he applied himself to arithmetic, Leonardo made such progress that he raised continuous doubts and difficulties for the master who taught him and often confounded him. He turned to music for a while, and soon he decided to learn to play the lyre, like one to whom nature had given a naturally elevated and highly refined spirit, and accompanying himself on this instrument, he sang divinely without any preparation.

Nevertheless, in spite of the fact that he worked at so many different things, he never gave up drawing and working in relief, pursuits which appealed to him more than any others. When Ser Piero saw this and considered the level of his son's intelligence, he one day took some of Leonardo's drawings and brought them to Andrea del Verrocchio, who was a very good friend of his, and urgently begged him to say whether Leonardo would profit from studying design.*

Andrea was amazed when he saw Leonardo's extraordinary beginnings, and he urged Ser Piero to make Leonardo study this subject; and so Piero arranged for Leonardo to go to Andrea's workshop, something Leonardo did very willingly. And Leonardo practised not only this profession but all those in which design played a role.

Possessing so divine and wondrous an intelligence, and being a very fine geometrician, Leonardo not only worked in sculpture but in architecture. In his youth, he made in clay the heads of some women laughing, created through the craft of plaster-casting, as well as the heads of some children, which seemed to have issued forth from the hand of a master; in architecture, he made many drawings of both ground-plans and other structures, and he was the first, even though a young man, to discuss making the River Arno a canal from Pisa to Florence.* He drew plans for mills, fulling machines, and implements that could be driven by water-power; and since painting was to be his profession, he carefully studied his craft by drawing from life, and sometimes by fashioning models or clay figures, which he covered with soft rags dipped in plaster and then patiently sketched upon very thin canvases of Rheims linen or used linen, working in black and white with the tip of his brush—marvellous things indeed, as is demonstrated by some of the examples I have from his own hand in our book of drawings. Besides this, he drew so carefully and so well on paper that no one has ever matched the delicacy of his style, and I have a head from these sketches in chiaroscuro which is divine. There was infused in this genius so much divine grace, so formidable and harmonious a combination of intellect and memory to serve it, as well as so great an ability to express his ideas through the designs of his hands,

that he won over with arguments and confounded with reasonings the boldest minds.

And every day he constructed models and designs showing how to excavate and bore through mountains with ease in order to pass from one level to the next, and with the use of levers, winches, and hoists, he showed how to lift and pull heavy weights, as well as methods for emptying out harbours and pumps for removing water from great depths; his brain never stopped imagining such things, and many sketches for these ideas and projects can be found scattered about among our profession, a good number of which I myself have seen.* Besides this, he wasted time in designing a series of knots in a cord which can be followed from one end to the other, with the entire cord forming a circular field containing a very difficult and beautiful engraving with these words in the middle: *Leonardus Vinci Accademia.** Among all these models and designs there was one which on numerous occasions he showed to the many intelligent citizens then ruling Florence to demonstrate how he wanted to raise and place steps under the church of San Giovanni without destroying it, and he persuaded them with such sound arguments that they thought it possible, even though when each one of them left Leonardo's company, each would realize by himself the impossibility of such an enterprise.

Leonardo was so pleasing in his conversation that he won everyone's heart. And although we might say that he owned nothing and worked very little, he always kept servants and horses; he took special pleasure in horses as he did in all other animals, which he treated with the greatest love and patience. For example, when passing by places where birds were being sold, he would often take them out of their cages with his own hands, and after paying the seller the price that was asked of him, he would set them free in the air, restoring to them the liberty they had lost. As a result, Nature so favoured him that, wherever he turned his thought, his mind, and his heart, he demonstrated such divine inspiration that no one else was ever equal to him in the perfection, liveliness, vitality, excellence, and grace of his works.

It is clearly evident that because of Leonardo's understand-

ing of art, he began many projects but never finished any of them, feeling that his hand could not reach artistic perfection in the works he conceived, since he envisioned such subtle, marvellous, and difficult problems that his hands, while extremely skilful, were incapable of ever realizing them. And his special interests were so numerous that his enquiries into natural phenomena led him to understand the properties of herbs and to continue his observations of the motions of the heavens, the course of the moon, and the movements of the sun.*

As mentioned earlier, Leonardo was placed in this profession by Ser Piero during his youth in the shop of Andrea del Verrocchio. At the time, Andrea was completing a panel showing Saint John baptizing Christ in which Leonardo worked on an angel holding some garments, and although he was a young boy, he completed the angel in such a way that Leonardo's angel was much better than the figures by Andrea.* This was the reason why Andrea would never touch colours again, angered that a young boy understood them better than he did. Leonardo was then commissioned to do a cartoon of Adam and Eve as they sinned in the Earthly Paradise for a door-curtain that was to be made in Flanders of gold and silken fabric and sent to the King of Portugal; for this he drew with his brush in chiaroscuro illuminated with white lead a lush meadow with a number of animals, and it can truthfully be said that genius could not create anything in the divine realm equal in precision and naturalness. There is a fig tree, which besides the foreshortening of its leaves and the appearance of its branches, is drawn with such love that the mind is dazzled by the thought that a man could possess such patience. And there is a date palm the circular crown of which is worked with a great and marvellous artistry that would be impossible to achieve without Leonardo's patience and genius. The work was carried no further and so, today, the cartoon is in Florence in the fortunate house of the Magnificent Ottaviano de' Medici, to whom it was presented not long ago by Leonardo's uncle.*

It is said that when Ser Piero da Vinci was at his country villa, he was sought out at home by one of his peasants, who had with his own hand made a small round shield from the

wood of a fig tree on the farm which he had cut down, and
who wanted Ser Piero to have it painted in Florence; he was
delighted to do this, since the peasant was very experienced in
catching birds and fish and Ser Piero made great use of him in
these activities. And so he had it taken to Florence, and with-
out saying anything else to Leonardo about whose it was, he
asked him to paint something on it. One day when Leonardo
picked up the shield and saw that it was crooked, badly
worked, and crude, he straightened it over the fire and gave
it—as rough and crude as it was—to a turner who made it
smoother and even. And after he had covered it with gesso
and prepared it in his own manner, he began to think about
what he could paint on it that would terrify anyone who
encountered it and produce the same effect as the head of the
Medusa. Thus, for this purpose, Leonardo carried into a room
of his own, which no one but he himself entered, crawling
reptiles, green lizards, crickets, snakes, butterflies, locusts, bats,
and other strange species of this kind, and by adapting vari-
ous parts of this multitude, he created a most horrible and
frightening monster with poisonous breath that set the air on
fire. And he depicted the monster emerging from a dark and
broken rock, spewing forth poison from its open mouth, fire
from its eyes, and smoke from its nostrils so strangely that it
seemed a monstrous and dreadful thing indeed. And Leonardo
took such pains in creating it that out of the great love he felt
for his profession, he did not smell the overpowering stench
that arose from the dead animals. When the work was finally
completed, it was no longer sought after by either the peasant
or his father, to whom Leonardo announced that as far as he
was concerned, the work was complete, and he could come
to pick it up at his convenience. Therefore, one morning Ser
Piero went to his room for the shield, and when he knocked at
the door, Leonardo opened it to him, asking him to wait for
a moment; and returning inside the room, he arranged the
shield on his easel in the light and shaded the window to dim
the light, and then he had Ser Piero come inside to see it. At
first glance Ser Piero, who was not thinking about it, was
immediately shaken, not realizing that this was the shield, nor
that what he saw drawn there was a painting. And as he

turned and stepped back, Leonardo stopped him and said:
'This work has served the purpose for which it was made.
Take it away, then, and carry it home with you, for this was
the intended effect.' Ser Piero thought the work was more
than miraculous, and he lavishly praised Leonardo's fanciful
invention; later, after quietly purchasing from a pedlar another
shield with a heart pierced by a arrow, he gave that one to the
peasant, who remained grateful to Ser Piero for the rest of his
life. Ser Piero then secretly sold Leonardo's shield to some
merchants in Florence for one hundred ducats. And in a short
time the shield fell into the hands of the Duke of Milan, sold
to him by those same merchants for three hundred ducats....*

When Giovan Galeazzo, Duke of Milan, happened to die
and Lodovico Sforza assumed that title, all in the year 1494,*
Leonardo was brought with great ceremony to Milan to play
the lyre for the duke who was very fond of the sound of that
instrument. Leonardo brought with him an instrument he had
made with his own hands largely from silver and shaped in the
form of a horse's head (a strange and unusual thing) so that the
sound would be more full and resonant, and he thus surpassed
all the other musicians who had gathered there to play.
Besides this, he was the best declaimer of improvised poetry in
his day. When the duke had listened to the admirable argu-
ments of Leonardo, he became so enamoured of his abilities
that it was incredible to behold. And he begged Leonardo to
paint for him an altarpiece containing a Nativity, which was
sent by the duke to the emperor.*

Leonardo then did a Last Supper in Milan for the
Dominican friars at Santa Maria delle Grazie, a most beautiful
and wondrous work in which he depicted the heads of the
Apostles with such majesty and beauty that he left the head of
Christ unfinished, believing that he was incapable of achieving
the celestial divinity the image of Christ required. This work,
left as it was, has always been held in the greatest veneration
by the Milanese and by foreigners as well, for Leonardo had
imagined and succeeded in expressing the suspicion the Apostles
experienced when they sought to discover who would betray
their master. As a result, all their faces show their love, fear,
and indignation, or, rather, sorrow, over being unable to

grasp Christ's meaning. And this is no less a source of wonder than the recognition of the contrasting stubbornness, hatred, and treachery in Judas, without even mentioning the fact that every small detail in the work reflects incredible care and diligence. Even the fabric of the tablecloth is reproduced so well that Rheims linen itself would not appear more real.

It is said that the prior of the church entreated Leonardo with tiresome persistence to complete the work, since it seemed strange to him to see how Leonardo sometimes passed half a day at a time lost in thought, and he would have preferred Leonardo, just like the labourers hoeing in the garden, never to have laid down his brush.* And as if this was not enough, he complained to the duke and made such a disturbance that the duke was forced to send for Leonardo and to question him skilfully about his work, showing with great civility that he was doing so because of the prior's insistence. Leonardo, who knew that the prince possessed a sharp and discerning intellect, was willing to discuss his work at length with the duke (something he had never done with the prior); he talked to him extensively about art and persuaded him that the greatest geniuses sometimes accomplish more when they work less, since they are searching for inventions in their minds, and forming those perfect ideas which their hands then express and reproduce from what they previously conceived with their intellect. And he added that he still had two heads to complete: that of Christ, for which he was unwilling to seek a model on earth and unable to presume that his imagination could conceive of the beauty and celestial grace required of divinity incarnate. The head of Judas, which caused him much thought, was also missing, for he did not believe himself capable of imagining a form to depict the face of a man who, after receiving so many favours, could have possessed a mind so wicked that he could have resolved to betray his Lord and the Creator of the World. None the less, he would search for a model for this second face, but if in the end he could not find anything better, there was always the head of the prior, who was so insistent and indiscreet. This moved the duke to laughter, and the duke declared that Leonardo was quite right. And so, the poor confused prior returned to press

on with the work in the garden and left Leonardo in peace. He
skilfully completed the head of Judas, who seemed the very
image of treachery and inhumanity. That of Christ remained,
as was said, unfinished.

The nobility of this painting, both for its composition and
for the incomparable care with which it was completed,
caused the King of France* to wish to take it back to his king-
dom. As a result, he tried every method to find architects who
might be able to protect it with beams of wood and iron so
that it could safely be carried away, never considering the
expense he might incur, so intensely did he wish to have it.
But since the painting was done on a wall, His Majesty had
to endure his longing for the work, and it was left to the
Milanese. While working on the Last Supper, Leonardo drew
the portrait of Lodovico with his first-born son Massimiliano
on an end wall in the same refectory where there is a Passion
done in the older style, and on the other side, he drew the
Duchess Beatrice with Francesco, his other son (both later
becoming dukes of Milan), and all these portraits are sublime.
While he was attending to this work, Leonardo proposed to
the duke that he should make a bronze horse of astonishing
size to commemorate the image of the duke, his father.* And
Leonardo began the work and carried it out on such a scale
that he could never complete it. There are those who hold
the opinion (human judgements being so various and, often
enough, enviously malicious) that Leonardo (as with some of
his other works) began this project without any intention of
completing it, because its size was so great that casting it all
in one piece obviously involved incredible difficulties, and it
is possible to believe that many people have formed such a
judgement based on the results, since so many of his other
works remained unfinished. But the truth is that Leonardo's
splendid and exceptional mind was hindered by the fact that
he was too eager and that his constant search to add excellence
to excellence and perfection to perfection was the reason why
his work was slowed by his desire, as our Petrarch declares.*
And to tell the truth, those who saw the large model that
Leonardo fashioned in clay thought they had never seen any-
thing more beautiful or superb, and it lasted until the French,

who smashed it to pieces, came to Milan with King Louis of France. Also lost was a small wax model of it which was held to be perfect, along with a book on the anatomy of horses drawn by Leonardo for his preparations.* Leonardo then applied himself, but with even greater care, to the study of human anatomy, working together with Messer Marc'Antonio della Torre,* an excellent philosopher, who was then lecturing in Pavia and writing on the subject; he was one of the first (as I have heard it said) who, with Galen's teachings, began to bring honour to medical studies and to shed real light upon anatomy, which had until that time been shrouded in the deepest shadows of ignorance. In this work, he was marvellously served by the genius, labour, and hand of Leonardo, who created a book with red crayon drawings outlined in pen in which he sketched cadavers he had dissected with his own hand, depicting them with the greatest care. He drew all the bony structures, joining them in order to all the nerves and covering them with the muscles: the first group is attached to the skeleton, the second holds it firm, and the third makes it move, and in these drawings he wrote notes in various places in ugly characters written with the left hand from right to left, which cannot be understood by anyone who is not used to reading them, since they cannot be read without a mirror.*

Many of these papers on human anatomy are in the possession of Messer Francesco Melzi, a Milanese gentleman who in Leonardo's day was a very handsome boy and much beloved by him, just as today he is a handsome and courteous old man who treasures these papers and conserves them along with a portrait of Leonardo to honour his happy memory.* And anyone who reads these writings will be amazed by how clearly this divine spirit discussed art, muscles, nerves, and veins, taking the greatest pains with every detail. There are also other writings by Leonardo in the possession of a Milanese painter,* also written with the left hand from right to left, which treat painting and methods of drawing and using colour. Not long ago this man, wishing to print this work, came to Florence to see me, and he then took it on to Rome to do so, but I do not know what happened afterwards.

But to return to Leonardo's works. During his lifetime the

king of France came to Milan, and he begged Leonardo to
make something unusual, and so Leonardo made a lion which
walked a few steps before its chest opened, revealing it to be
filled with lilies. In Milan, Leonardo took on as his servant
Salaí,* a pleasingly graceful and handsome boy from that
city with beautiful, thick, curly hair which greatly pleased
Leonardo, who taught him many things about painting, and
some of the works attributed to Salaí in Milan were retouched
by Leonardo.

After returning to Florence, Leonardo discovered that the
Servite friars had commissioned Filippino to paint the altar-
piece for the high altar in the Nunziata; this caused Leonardo
to declare that he would have gladly painted a similar work.
Upon hearing this, Filippino, like the gentle-hearted person he
was, withdrew, and so that Leonardo might paint it, the friars
took him into their household, paying the expenses for him
and all his family. And as was his custom, Leonardo kept them
waiting for a long time without ever beginning anything.
Finally he did a cartoon showing Our Lady and Saint Anne
with the figure of Christ, which not only amazed all the
artisans but, once completed and set up in a room, brought
men, women, young and old to see it for two days as if they
were going to a solemn festival in order to gaze upon the
marvels of Leonardo which stupefied the entire populace. For
in the face of this Madonna all the simplicity and beauty
which can properly shed grace upon Christ's mother can
be seen, since Leonardo wished to show the modesty and
humility of a virgin delighted to witness the beauty of Her
child, who holds Him tenderly in Her lap, while with a
modest glance downward She notices Saint John as a little
boy who is playing with a lamb, not without a smile from
Saint Anne, overjoyed to see Her earthly progeny become
divine.* Such considerations had their origin in Leonardo's
intellect and genius. This cartoon, as will be explained, was
subsequently taken to France.

Leonardo made a portrait of Ginevra, the wife of Amerigo
Benci, an extremely beautiful painting, and he abandoned the
work he was doing for the friars, who went back to Filippino,
but Filippino, overcome by death, was unable to complete it.

For Francesco del Giocondo, Leonardo undertook the por-
trait of Mona Lisa, his wife, and after working on it for four
years, he left the work unfinished, and it may be found at
Fontainebleau today in the possession of King Francis.* Any-
one wishing to see the degree to which art can imitate Nature
can easily understand this from the head, for here Leonardo
reproduced all the details that can be painted with subtlety.
The eyes have the lustre and moisture always seen in living
people, while around them are the lashes and all the reddish
tones which cannot be produced without the greatest care.
The eyebrows could not be more natural, for they represent
the way the hair grows in the skin—thicker in some places and
thinner in others, following the pores of the skin. The nose
seems lifelike with its beautiful pink and tender nostrils. The
mouth, with its opening joining the red of the lips to the flesh
of the face, seemed to be real flesh rather than paint. Anyone
who looked very attentively at the hollow of her throat
would see her pulse beating: to tell the truth, it can be said that
portrait was painted in a way that would cause every brave
artist to tremble and fear, whoever he might be. Since Mona
Lisa was very beautiful, Leonardo employed this technique:
while he was painting her portrait, he had musicians who
played or sang and clowns who would always make her
merry in order to drive away her melancholy, which painting
often brings to portraits. And in this portrait by Leonardo,
there is a smile so pleasing that it seems more divine than
human, and it was considered a wondrous thing that it was as
lively as the smile of the living original.

Because of the excellence of his works, the fame of this
divine artisan grew so great that everyone who loved art,
indeed the entire city, wanted him to leave behind some mem-
orial, and they all discussed how to have him do some notable
and great work which would decorate and honour the public
with all the genius, grace, and judgement recognized in
Leonardo's works. The Gonfaloniere and the most important
citizens carried out the plan, while the Grand Hall of the
Council was being renovated, and its architecture was being
planned with the advice and counsel of Giuliano San Gallo,
Simone Pollaiuolo (called Cronaca), Michelangelo Buonarroti,

and Baccio d'Agnolo (as will be related in detail in the proper place).* When this was completed, it was quickly decided by public decree that Leonardo would be given some beautiful work to paint, and Leonardo was thus commissioned to do the hall by Piero Soderini, then Gonfaloniere of Justice.*

Wishing to carry out this task, Leonardo began work on a cartoon in the Hall of the Pope, a place in Santa Maria Novella, treating the story of Niccolò Piccinino, a commander of Duke Filippo of Milan, in which he drew a group of horsemen fighting for a standard, a drawing held to be most excellent and masterful for its marvellous treatment of figures in flight. In it, anger, disdain, and vindictiveness are displayed no less by the horsemen than by their horses, two of which with forelegs intertwined are battling with their teeth no less fiercely than their riders are fighting for the standard, which one of the soldiers has seized. While urging his horse to flight, using the power of his shoulders, he has turned around and grasped the staff of the standard, trying to wrench it by brute force from the hands of four men, while two soldiers defend it with one hand and try with the other to cut off the staff with their swords in the air; at the same time, an old soldier with a red beret, crying out, holds on to the staff with one hand, and brandishing a curved sword high with the other, delivers a furious blow to cut off the hands of the two men who are forcefully gnashing their teeth, attempting to defend their standard with the most ferocious expressions; besides all this, there are two foreshortened figures fighting each other on the ground between the horses' legs, while a man lying prone upon the ground has another soldier on top of him who is raising his arm as high as he can, so that with even greater force he can plunge his dagger into the throat of his opponent and end his life, while the man on the ground, his legs and arms helpless, does everything he can to avoid death. It would be impossible to express the inventiveness of Leonardo's design for the soldiers' uniforms, which he sketched in all their variety, or the crests of the helmets and other ornaments, not to mention the incredible skill he demonstrated in the shapes and features of the horses, which Leonardo, better than any other master, created with their

boldness, muscles, and graceful beauty. It is said that to draw the cartoon Leonardo created a most ingenious scaffolding which rose higher when drawn together and lower when extended. And imagining that he could paint the walls in oil, he created a composition so thick for the coating of the walls that while he continued to paint in the hall, it began to run, so that he soon abandoned the work, seeing that it was ruined.

Leonardo possessed great courage and was most generous in every deed. It is said that when he went to the bank for his salary, which he used to receive every month from Piero Soderini, the cashier wanted to give him certain rolls of pennies, and, being unwilling to take them, he remarked: 'I am no penny painter!' When he was accused of cheating Piero Soderini, there arose murmurs about him, and so, with the assistance of his friends, Leonardo collected the money and carried it to Piero to pay him back, but Piero did not wish to accept it.

Leonardo went to Rome with Duke Giuliano de' Medici upon the election of Pope Leo X,* who was a great student of philosophy and most especially of alchemy. In Rome, he developed a paste out of a certain type of wax and, while he walked, he made inflatable animals which he blew air into, making them fly through the air; but when the air ran out, they fell to the ground. To a very strange lizard, found by the gardener of the Belvedere, he fastened some wings with a mixture of quicksilver made from scales scraped from other lizards, which quivered as it moved by crawling about. After he had fashioned eyes, a horn, and a beard for it, he tamed the lizard and kept it in a box, and all the friends to whom he showed it fled in terror. Often he had the guts of a steer purged of fat, and they came out so small that they could be held in the palm of one hand. And he had placed in another room a pair of smith's bellows to which he attached one end of these guts so that by blowing them up he filled the entire room, which was enormous, so that anyone standing there would have to move to one corner. Pointing to these trans- parent forms full of air, Leonardo compared them to talent, since at first they occupy little space but later come to occupy a great deal. He created an infinite number of these mad

inventions and also experiments with mirrors, and he tried out
the strangest methods of discovering oils for painting and
varnishes for preserving the finished works.

At this time, for Messer Baldassarri Turini da Pescia, Leo's
datary, he painted a small picture of the Madonna with Her
child in Her arms that was done with infinite care and skill.
But either because of a mistake made by whoever prepared
the panel with gesso or because of his many capricious
mixtures of paints and colours, it is now in very bad con-
dition. In another small painting, he did the portrait of a little
boy who is wonderfully beautiful and graceful. And both of
these paintings are now in the hands of Messer Giulio Turini.
It is said of Leonardo that when the pope commissioned a
work from him, he would immediately begin to distil oils and
herbs for the varnish; as a result, the pope exclaimed: 'Alas,
this man is never going to do anything, for he starts to think
about finishing the work before it is even begun!' There was
great animosity between Leonardo and Michelangelo, and as a
result, Michelangelo left Florence on account of this rivalry,
with Duke Giuliano giving him leave when he was sum-
moned by the pope to discuss the façade of San Lorenzo.
Hearing of this, Leonardo left Rome and went to France,
where the king, who owned several of his works, was very
fond of him and wanted Leonardo to paint the cartoon of
Saint Anne, but, in his habitual manner, Leonardo put the
king off with promises.*

When Leonardo finally became old, he lay ill for many
months; and seeing himself near death, he wished to be care-
fully informed about the Catholic faith and about the path of
goodness and the holy Christian religion, and then, with much
lamenting, having confessed and repented, he devoutly desired
to take the most Holy Sacrament out of bed, even though he
could not stand upon his feet and had to be supported by his
friends and servants. The king, who was in the habit of paying
him frequent and affectionate visits, arrived, and, out of re-
spect, Leonardo sat up in bed to tell him about his illness and
its symptoms, declaring, all the same, how much he had
offended God and the men of the world by not having
worked at his art as he should have.* He was then seized by a

paroxysm, the harbinger of death. Because of this, the king arose and held his head to help him and to show him favour, so as to ease his pain, and Leonardo's most divine spirit, aware that he could receive no greater honour, expired in the arms of that king at the age of seventy-five.

The loss of Leonardo saddened beyond all measure every-one who had known him, for no one ever lived who had brought such honour to painting. His splendidly handsome appearance could bring calm to every troubled soul, and his words could sway the most hardened mind to either side of a question. His great physical strength could check any violent outburst; with his right hand he could bend the iron ring of a door-knocker or a horseshoe as if it were made of lead. His generosity was so great that he sheltered and fed all his friends, rich and poor alike, provided they possessed talent and ability.

By his every action Leonardo adorned and honoured the meanest and humblest dwelling-place; and with his birth, Florence truly received the greatest of all gifts, and at his death, the loss was incalculable. To the art of painting, he added a kind of shadowing to the method of colouring with oils which has enabled the moderns to endow their figures with great energy and relief. He proved himself in sculpture with the three bronze figures over the north door of San Giovanni which were executed by Giovan Francesco Rustici but finished with Leonardo's advice; they are the most beauti-ful casts both for their design and for their perfection that have yet been seen in the modern age. From Leonardo we have a more perfect understanding of the anatomy of horses and of men. And because of his many divine qualities, even though he accomplished more by words than by deeds, his name and fame will never be extinguished. For this reason, Messer Giovanbatista Strozzi wrote the following words in his praise:

> Alone he vanquished
> All others; he vanquished Phidias and Apelles,
> And all their victorious band.*

THE END OF THE LIFE OF LEONARDO DA VINCI,
FLORENTINE PAINTER AND SCULPTOR

The Life of Giorgione da Castelfranco, Venetian Painter

[c.1478–1510]

In the same period that Florence was acquiring so much fame through the works of Leonardo, no small embellishment was bestowed upon Venice by the talent and excellence of one of its citizens who surpassed by far the Bellinis,* whom the Venetians held in such high esteem, as well as every other artist who had painted in that city up to that time. This was Giorgio, born in Castelfranco in the province of Treviso in the year 1478 while the doge was Giovan Mozenigo, the brother of Doge Piero, and because of his physical features and his greatness of spirit, he was in time called Giorgione.* Although Giorgione was a man of the most humble origins, he was, however, nothing but gentle and well-mannered all his life. He was brought up in Venice, continuously took delight in affairs of the heart, and was so greatly pleased by the sound of the lute that, in his time, he played and sang divinely; he was for that reason often engaged for various musical events and gatherings of the nobility.

He studied design and enjoyed it enormously, and in this study nature favoured him so strongly that he developed a passion for beautiful things and did not want to include anything in his work that was not drawn from life. He was so under nature's domination and imitated it so well that not only did he acquire a reputation for having surpassed Gentile and Giovanni Bellini, but also for rivalling those artists working in Tuscany who were the authors of the modern style. Giorgione had seen some of the things done by Leonardo that, as has been mentioned, were very subtly shaded off and darkened, as has been said, through the use of deep shadows.

And this style pleased him so much that, while he lived, he always went back to it, imitating it most especially in his oil paintings. Since he appreciated the good qualities of craftsmanship, Giorgione always used to pick out the most beautiful and varied subjects he could find to put in his works. And nature gave him such a gracious spirit that, in either oil or fresco, he created living forms and other images so soft, so harmonious, and so carefully shaded off into the shadows that many of the most skilful artists of those times agreed he had been born to infuse life into his figures and to reproduce the freshness of living flesh more than any other artist who had ever painted, not only in Venice but anywhere.

In the beginning Giorgione worked in Venice, where he painted many Madonnas as well as other living portraits, which are both very lifelike and beautiful, as can still be seen in three very beautiful heads he did in oil which are in the study of the Most Reverend Grimani, the Patriarch of Aquileia. One represents David with his hair falling down to his shoulders, as was customary in those days (and is said to be Giorgione's self-portrait), which is so animated and full of colour that it seems to be made of real flesh; the arm in which David is holding the severed head of Goliath, and his chest, are covered in armour. The second contains a much larger portrait, drawn from life, the portrait of a man who is holding in his hand the red beret of a commander and wearing a leather collar, with one of those cloaks in the antique style below; this picture is thought to have been painted for an army general. The third portrait is that of a child, as beautifully executed as it could be, with hair as soft as fleece, which bears witness to Giorgione's pre-eminence no less than to the admiration which the Patriarch, who quite rightly cherished these works, always felt for his talent.

In Florence, in the home of the sons of Giovanni Borgherini is a portrait by Giorgione's own hand of Giovanni as a young man in Venice, and the painting also includes his tutor; one could not see two heads with better flesh tones or more beautiful hues in the shadows. In Anton de' Nobili's home is another head of a captain in armour which is very animated and lively and is said to be one of the captains that Gonsalvo Ferrante

brought with him to Venice when he visited Doge Agostino
Barberigo; it is said that Giorgione painted the great Gonsalvo
in armour at that time, creating a truly exceptional painting
of incomparable beauty, and that Gonsalvo carried it off with
him.* Giorgione painted many other extremely fine portraits
which are scattered throughout Italy in many places, for
example, the portrait of Lionardo Loredano, which Giorgione
painted when he was doge and which made me think I was
seeing that most serene prince alive when I saw it displayed
during a Feast of the Assumption. Besides this, there is one
in Faenza, in the home of Giovanni da Castel Bolognese (an
engraver of cameos and crystal and so forth) that was done for
his father-in-law, a work truly sublime, for its harmonious
and delicate shading of colours seems to be done in relief
rather than painted.

Giorgione enjoyed painting in fresco, and among the many
works he did he frescoed the entire façade of the Ca' Soranzo
on the Piazza di San Polo. On it, besides many pictures, scenes,
and other fanciful inventions of his, a picture worked in oil on
the plaster can be seen which has withstood water, sun, and
wind to remain intact up to our own time. Also, there is a pic-
ture of spring, which I find to be one of the most beautiful
things he ever painted in fresco, and it is a great pity that time
has so cruelly damaged it. In my opinion, nothing harms a
fresco more than the sirocco winds, especially near the ocean
where they always carry a salty moisture with them.

In the year 1504, a terrible fire broke out in Venice in the
Fondaco dei Tedeschi near the Rialto Bridge which destroyed
everything, including the merchandise, and inflicted great
losses on the merchants. The Signoria of Venice ordered it to
be rebuilt, and it was done very quickly with more comfort-
able accommodations, as well as greater magnificence, decora-
tion, and beauty, and, since Giorgione's fame had grown,
those in charge of the project deliberated and arranged for
Giorgione to colour it in fresco according to his own wishes,
provided that he demonstrate his talent by producing an
exemplary work, since it would have the most beautiful
position and location in that city. And so, setting to work,
Giorgione thought of nothing other than to paint figures after

his own fantasy in order to demonstrate his talent; and in truth, there are no historical scenes which have any special order or which represent the deeds of any distinguished person, either ancient or modern; and, as for me, I have never understood his figures, nor have I ever, with my questioning, found anyone who did, for here is a woman, there a man in different poses; one figure stands near the head of a lion, another with an angel in the guise of Cupid, and you cannot tell what it means.* Directly over the main door opening into the Merzeria is a woman seated who, like a figure of Judith, has the head of a dead giant at her feet, and who is lifting the head with her sword and speaking to a German below her. I have been unable to explain why Giorgione created this figure, unless he wanted her to represent Germania. None the less, one can clearly see that his figures are well grouped and that he always continued to improve his work, for there are heads and parts of figures that are extremely well executed and coloured in a most lively fashion. And everything that he did there, Giorgione took pains to copy only from living things rather than imitating another style. This building is celebrated in Venice and famous no less for what Giorgione painted there than for its convenience to businesses and its usefulness to the public.

Giorgione worked on a picture of Christ carrying the cross and a Jew pulling Him along which, with the passage of time, was placed in the Church of San Rocco, and today, because of the devotion in which it is held by many people, it performs miracles, as we can see. Giorgione worked in different places, such as Castelfranco and in the province of Treviso; he painted many portraits for various Italian rulers and many of his works were sent abroad as objects of true worth to bear witness to the fact that, if Tuscany had an overabundance of artisans in every period, the region beyond Tuscany near the mountains had not always been abandoned and forgotten by heaven.

It is said that during the time Andrea Verrocchio was creating his bronze horse,* Giorgione got into an argument with some sculptors who insisted that sculpture was superior to painting, since sculpture showed in a single figure various

attitudes and aspects to anyone walking around it, whereas painting showed only one side of a figure; Giorgione was of the opinion that in a painted scene one could see at a single glance, without having to walk about, all the types of attitudes that a man can express in a number of gestures (something sculpture is incapable of doing unless the observer changes his location and point of view so that he sees several different aspects of a piece); and he proposed something further, for he wanted to represent the front, back, and two profiles with a single painted figure, a proposal which made them see reason. And Giorgione accomplished this in the following manner: he painted a male nude with his back turned; on the ground there was an extremely limpid fountain of water in which Giorgione painted the reflection of a front view; on one side was a burnished breastplate that the man had removed in which his left profile was reflected, since the polished surface of that armour revealed everything; on the other side there was a mirror which contained the other profile of the nude figure; this was a most beautiful, clever, and fanciful work, by which he hoped to demonstrate that painting actually requires more skill and effort and can show more of nature in a single scene than sculpture. The painting was highly praised and admired for its ingenuity and beauty.

Giorgione also did a living portrait of Catherine, Queen of Cyprus, which I once saw in the possession of the renowned Messer Giovanni Cornaro. And in our sketch-book along with other sketches and drawings which he did in pen and ink, there is a head painted in oil, the portrait of a German from the Fugger family who was then one of the most important merchants in the Fondaco dei Tedeschi, which is an admirable work.

While Giorgione was writing diligently to bring honour to himself and his native city, in the many conversations he had while entertaining his many friends with his music, he fell in love with a lady, and they both took great pleasure from their love affair. It happened that in the year 1511 she was infected with plague, but without knowing this Giorgione kept on visiting her as usual and caught the plague himself, so that before long, at the age of thirty-four, he passed on to another

life,* to the enormous sorrow of his many friends, who loved him for his talents, and to the detriment of the world, who lost them. However, the damage and loss was made more bearable by the two excellent pupils he left behind: Sebastiano Viniziano (who later became the friar at the Piombo in Rome) and Titian of Cadore, whose work not only equalled but far surpassed that of Giorgione, and the honour and the benefits they brought to the art of painting will be discussed in full in its proper place.*

THE END OF THE LIFE OF GIORGIONE DA CASTELFRANCO, VENETIAN PAINTER

The Life of Raphael of Urbino,
Painter and Architect
[1483–1520]

How generous and kind Heaven sometimes proves to be when it brings together in a single person the boundless riches of its treasures and all those graces and rare gifts that over a period of time are usually divided among many individuals can clearly be seen in the no less excellent than gracious Raphael Sanzio of Urbino.

He was by nature endowed with all the modesty and kindness that is usually seen in those who, more than others, possess an innately gentle humanity joined to a beautifully graceful affability that always showed itself sweet and pleasing with every kind of person and in every kind of circumstance. Nature created him as a gift to the world: after having been vanquished by art in the work of Michelangelo Buonarroti, it wished to be vanquished through Raphael by both art and moral habits as well.

And truthfully, most of the artisans up to that time had received from Nature a certain trace of madness and wildness which, besides making them unmindful and eccentric, had also caused them, on many occasions, to reveal inside themselves the shadow and darkness of vices rather than the clarity and splendour of those virtues which make men immortal. Hence, Nature had ample cause, on the other hand, to make clearly resplendent in Raphael all those rare virtues of mind, accompanied by as much grace, study, beauty, modesty, and fine manners as would have sufficed to cover up any flaw, no matter how ugly, or any blemish, no matter how large. As a result, it is safe to say that those who possess as many rare gifts as were seen in Raphael from Urbino are not simple mortals

but (if it is permitted to speak in this way) mortal gods, and that those who by their endeavours leave behind in this world an honoured name in the annals of fame can also hope to enjoy a worthy reward in Heaven for their hard work and merit.

Now Raphael was born in Urbino, a most famous city in Italy, in the year 1483, on Good Friday at three o'clock in the morning, of Giovanni de' Santi, a painter of no great talent but truly a man of good intellect, capable of directing his children towards the proper path which, through bad fortune, had not been shown to him in his youth. And Giovanni knew how important it was for children to be brought up on their mother's milk rather than on a nursemaid's; and so when Raphael (whom he baptized with this name as a sign of good luck) was born, Giovanni insisted that, since he had no other children before or afterwards, Raphael's own mother should nurse him, and that during his tender years he would be taught how to behave by his parents rather than by the peasants and common folk with their rude and unrefined habits and beliefs. Once he had grown, Giovanni began to train him in painting, since he saw that he had a great predilection and a real talent for this art. As a result, not many years had passed before Raphael, still a young boy, was of great assistance to Giovanni in many works that he executed in the state of Urbino.

Finally, when this good and loving father realized that his son could learn very little from him, he resolved to take him to Pietro Perugino who, as he was told, ranked first among the painters of that time; and so he went to Perugia, but failing to find Pietro there, he began to work in San Francesco on several paintings in order to await him with greater ease. But once Pietro returned from Rome, Giovanni, who was a well-mannered and courteous man, became his friend, and, when the time seemed right, he explained his wish to Pietro in the most suitable way he knew how. And thus Pietro, who was very gracious and an admirer of fine talents, accepted Raphael, whereupon Giovanni joyfully returned to Urbino, and, taking the young lad, despite many tears from the boy's mother who loved him tenderly, he brought him to Perugia

where Pietro, seeing Raphael's style of drawing and his beau-
tiful manners and moral habits, formed a judgement about
him which time and his works later proved to be perfectly
accurate. It is remarkable that while Raphael studied Pietro's
style, he imitated it so exactly and in all its details that his
portraits could not be distinguished from his master's ori-
ginals, nor could his own paintings be distinguished with
any certainty from those of Pietro, as is still demonstrated at
San Francesco in Perugia by some figures that Raphael
worked on in an oil panel for Madonna Madalena degli Oddi,
and these include: the Assumption of Our Lady into heaven;
Her Coronation by Jesus Christ; and, below, the Twelve
Apostles around the tomb contemplating the celestial splen-
dour. At the foot of the panel in a predella with small figures,
which is divided into three scenes, there is the figure of Our
Lady receiving the Annunciation from the angel; the Ador-
ation of Christ by the Wise Men; and the Presentation in the
Temple with Christ in Simeon's arms. This work is certainly
done with extreme care, and anyone unfamiliar with the style
would absolutely believe it to be by Pietro, whereas it is
undoubtedly by Raphael.*

After completing this painting, Pietro went to Florence to
attend to some business of his own, and, after leaving Perugia,
Raphael went off with some friends to Città del Castello,
where he painted a panel in Pietro's style for Sant'Agostino
and another of a Crucifixion in a similar style for San
Domenico, which everyone would have believed to be a work
by Pietro rather than by Raphael, had the young painter's
name not been written on it. Also in San Francesco in the
same city he did a small panel painting of the Marriage of the
Virgin, which clearly reveals the growth of Raphael's skill as
he refined Pietro's style and then surpassed it.* In this work, a
temple is drawn in perspective with so much love and atten-
tion that it is amazing to see the difficult problems Raphael
sought to confront in such an exercise.

While Raphael acquired great fame by painting in this
style, Pinturicchio was commissioned by Pope Pius II* to
decorate the Library of the Duomo in Siena, and since
Pinturicchio was a friend of Raphael and knew him to be

a very fine draughtsman, he brought him to Siena, where
Raphael executed some of the designs and cartoons for that
project; and the reason Raphael did not continue was that
while in Siena he heard several painters extol with the greatest
praise the cartoon that Leonardo da Vinci had executed for the
Hall of the Pope in Florence containing a group of extremely
fine horses projected for the Great Hall of the Palazzo
Vecchio, as well as some nudes Michelangelo did in com-
petition with Leonardo which were much better.* Because of
the love he always bore for excellence in painting, Raphael
became so eager to see these cartoons that he set aside his work
and every personal advantage and convenience and went to
Florence.*

Upon his arrival, he was as delighted by the city as by the
works of Leonardo and Michelangelo, which he considered
divine, and he decided to live there for a while; and so, having
become friends with some of the young painters (including
Ridolfo Ghirlandaio, Aristotele San Gallo, and others),*
Raphael was greatly honoured in the city, especially by
Taddeo Taddei, who always wanted him in his home and at
his table, since he was a man who loved all men of talent. And
in order not to be outdone in kindness, Raphael, who was
courtesy itself, painted two pictures for him which reflect both
the initial style of Pietro and the other and much better style
which he learned later through study, as will be recounted.
These pictures are still in the home of Taddeo's heirs.*

Raphael also became a close friend of Lorenzo Nasi, who
had recently taken a wife, and he did a painting for him in
which he showed a young boy between the knees of Our
Lady to whom a youthful Saint John joyfully offers a bird,* to
the great delight and pleasure of both children. In the poses of
both, there is a certain childish simplicity which is wholly
charming, and, in addition, they are so carefully coloured,
and carried out with such diligence that they seem more to
be made of living flesh than of painted colours. Likewise,
Raphael's Madonna possesses an expression that is truly full of
grace and divinity, and, to sum up, the plain, the landscape,
and all the rest of the work are extremely beautiful. This
painting was held by Lorenzo Nasi in the greatest veneration

while he was alive, as much in memory of Raphael, who had been his close friend, as for the dignity and excellence of the work. But in the year 1548 on the seventeenth of August, the painting met an unfortunate fate when Lorenzo's house, along with the extremely ornate and beautiful houses of the heirs of Marco del Nero and other nearby houses, collapsed during a landslide on Monte San Giorgio. Nevertheless, after the fragments of the work were recovered from beneath the rubble of ruined masonry, they were put back together again in the best way possible by Battista, son of the aforesaid Lorenzo, who was a great lover of art.*

After having completed these works, Raphael was forced to leave Florence and to go to Urbino where, following the death of his mother and his father Giovanni, all his affairs were going to ruin.* Thus, while staying there, for Guidobaldo da Montefeltro, then commander of the Florentine armies, he painted two small Madonnas in his later style which were extremely beautiful. Today they are in the possession of the Most Illustrious and Excellent Guidobaldo, Duke of Urbino. He also painted for Guidobaldo a small picture of Christ praying in the garden while, somewhat off in the distance, the three Apostles sleep. This painting is so delicately finished that a miniature could not be any better done. After having remained for a long time in the possession of Francesco Maria, Duke of Urbino, it was later given by the Most Illustrious Lady Leonora, his consort, to Don Paolo Justiniano and Don Pietro Quirini, both Venetians and monks in the holy hermitage at Camaldoli, and like a relic and a most rare work, both because it came from the hand of Raphael of Urbino and because they wished to honour the memory of this most illustrious lady, they placed it in the chamber of the Superior of this hermitage, where it is held in the veneration it deserves. After completing these works and arranging his affairs, Raphael returned to Perugia, where in the church of the Servite Friars he did a panel for the Ansidei Chapel containing the Madonna, Saint John the Baptist, and Saint Nicholas.* And in the same city for the Chapel of Our Lady in San Severo (a small monastery of the Camaldolite Order), he did a fresco of Christ in glory and a God the Father surrounded by

some angels and six saints seated, three on either side: Saint
Benedict, Saint Romuald, Saint Laurence, Saint Jerome, Saint
Maur, and Saint Placidus; and on this work, which at the time
was considered very beautiful for a fresco, he wrote his name
in large and very visible letters.* In the same city, the sisters of
Sant'Antonio of Padua had him paint a panel of the Madonna
holding a clothed Jesus Christ on Her lap (as those simple and
venerable sisters wished), with Saint Peter, Saint Paul, Saint
Cecilia and Saint Catherine on either side of the Madonna.*
For these two holy virgins, Raphael created the most beautiful
and sweet expressions and the most distinctive hair-styles one
might see, which was a rare thing in those days. And over the
panel in a half-tondo he painted a God the Father of unusual
beauty, while the predella of the altarpiece contained three
scenes with tiny figures: Christ praying in the garden; Christ
carrying the cross (where the movements of the soldiers
dragging Him along are most beautiful); and the dead Christ
lying in His mother's lap. This was certainly a marvellous
and devout work, and it was held by those sisters in great ven-
eration and highly praised by all artists. I should also mention
the widespread opinion that, after having seen so many works
by the great masters while he was in Florence, Raphael
changed and enhanced his style so much that it had nothing
whatsoever to do with his early style, which looks like the
work of a different and less proficient painter. Before he left
Perugia, Madonna Atalanta Baglioni begged him to agree to
paint a panel for her chapel in the church of San Francesco,
but as he could not fulfil her request at that time, he promised
that when he had returned from Florence, where he was then
forced to go to attend to his own business, he would not fail
her. And so, having arrived in Florence, where he applied
himself with incredible effort to the study of the arts, he drew
the cartoon for this chapel with the intention of completing
the work, as he did as soon as he was able to do so.

Agnolo Doni was then living in Florence, and although
thrifty in other things, Doni gladly spent a good deal (while
economizing as much as he could) on paintings and sculpture
which gave him great pleasure, and he had Raphael paint his
portrait and that of his wife in this second style, which can be

seen in the home of Giovanbatista, his son, a fine and com-
modious structure built by Agnolo in the Corso de' Tintori
near the corner of the Albertis.* For Domenico Canigiani he
also did a picture of Our Lady with the baby Jesus who is
joyfully greeting a young Saint John held out to Him by
Saint Elizabeth, who, while carrying the child, gazes with the
greatest animation at a Saint Joseph who, leaning with both
hands on a staff, inclines his head towards the old woman,
almost marvelling and praising the greatness of God that a
woman so old could have so tiny a son.* And all of the figures
appear to be astonished to see the wisdom and reverence with
which the two cousins, despite their tender age, greet each
other, not to mention the fact that every touch of colour in
the heads, the hands, and the feet is more like the brush-
strokes of living flesh than the painted tints of the masters
of this craft. Today this splendid painting is the property of
Domenico Canigiani's heirs, who hold it in the esteem that a
work by Raphael of Urbino deserves.

This exceptional painter studied the old works of Masaccio
in the city of Florence, while the things he saw in the works
of Leonardo and Michelangelo made him apply himself
with great intensity to his studies, and, as a result, make
extraordinary improvements in his art and style. While
Raphael stayed in Florence, he was very close friends with Fra
Bartolomeo di San Marco,* among others, whose use of
colour he found extremely pleasing and diligently tried to
imitate, and, in exchange, Raphael taught that good father
the methods of perspective, which the friar had not studied
until that time. But at the height of their relationship Raphael
was recalled to Perugia, where first he completed the painting
in San Francesco for the previously mentioned Madonna
Atalanta Baglioni for whom (as I mentioned) he had drawn
the cartoon in Florence. This sublime painting* contains the
figure of a dead Christ being carried to His burial, executed
with such freshness and mature love that it appears only just
now to have been painted. In composing this painting,
Raphael imagined the pain felt by the closest and dearest
relatives as they lay to rest the body of some loved one on
whom the happiness, honour, and profit of the entire family

depend; in it, Our Lady can be seen fainting, and the heads of all the other figures are most graceful in their weeping, particularly that of Saint John, who, with his hands clasped, bows his head in a way that would move the hardest heart to pity. And to tell the truth, anyone who considers the care, love, skill, and grace in this painting, has good reason to be amazed, for it would astonish anyone looking at it because of the expression of its figures, the beauty of its garments, and, in short, the utmost excellence of all its elements.

When he completed this work and returned to Florence, the Dei family, Florentine citizens, commissioned him to do a panel to go in the chapel of their altar in Santo Spirito; he began this and brought the outline to an excellent state of completion, and at the same time he painted a picture that he sent to Siena, which he entrusted to Ridolfo del Ghirlandaio upon his departure to finish a blue drapery that was incomplete.* And this departure occurred because Bramante from Urbino, who was in the service of Julius II, both because of the distant kinship he had with Raphael and because he was from the same town, had written to Raphael, telling him that he had convinced the pope, who had some rooms built, to allow Raphael to demonstrate his worth in decorating them. This proposal pleased Raphael, for he abandoned the works in Florence and the unfinished panel for the Dei (but complete enough so that, later, Messer Baldassarre da Pescia placed it in the parish church of his city after Raphael's death) and moved to Rome,* where, upon his arrival, he discovered that a large number of the rooms in the palace had already been painted and were still being painted by various masters; and so it happened, as we have seen, that there was one room with a scene completed by Piero della Francesca; in another, Luca da Cortona had brought one wall to a good state of completion; and Don Pietro della Gatta, abbot of San Clemente in Arezzo, had begun a number of works there. Likewise, Bramantino from Milan had painted numerous figures, which for the most part were living portraits and considered exceptionally beautiful.*

Having been greeted very affectionately by Pope Julius upon his arrival, Raphael began a scene in the Room of the

Segnatura depicting the theologians reconciling philosophy and astrology with theology in which he portrayed all the wise men of the world presenting different arguments.* There are some astrologers to one side who have drawn geomantic and astrological figures and characters in various forms on some tablets, and they send them by means of certain beautiful angels to the Evangelists, who explain them. Among them is a figure of Diogenes with his cup lying upon the stairs, a most preoccupied and thoughtful figure, which for its beauty and the disorderliness of its garments deserves praise. Likewise, there are Aristotle and Plato, the latter with the *Timaeus* in his hand, the former with the *Ethics*, while around them a large school of philosophers form a circle. The beauty of these astrologers and geometricians drawing numerous figures and characters on tablets with their compasses cannot be described. Among them, in the figure of a young man with a beautiful form who is throwing open his arms in amazement and bowing his head, is the portrait of Federigo II, Duke of Mantua, who was in Rome at that time. Likewise, there is a figure who is bending towards the ground with a pair of compasses in hand and turning them on a tablet, which is said to be the architect Bramante, whose portrait is so well done that he seems no less himself than if he were alive. Next to a figure who turns his back and holds a globe of the heavens in his hand is the portrait of Zoroaster, and next to him is the portrait of Raphael, the master of this work, who painted himself by looking in a mirror. He has a youthful head and a very modest appearance coupled with a pleasant and gentle grace, and he is wearing a black beret. Nor could one describe the beauty and goodness that can be seen in the heads and figures of the Evangelists, in whose faces Raphael has created a certain caution and attentiveness which is very natural, especially in those who are writing. And behind Saint Matthew, who is copying characters out of the engraved tablets held by an angel and writing them down in a book, an old man who has placed a sheet of paper on his knee copies all the words Saint Matthew is writing down. And while he remains intent in that uncomfortable position, it seems as if he is moving his mouth and his head, following the movements of his pen.

Besides the small details of the artist's plan, which are quite
numerous, the composition of the entire scene is arranged
with such order and measure that it truly proved his self-
worth and made it known that, among those who employ the
brush, he wanted to hold his ground without opposition.

Raphael also adorned this painting with perspective and
many figures completed with such a delicate and soft style
that it caused Pope Julius to destroy all the scenes painted by
other masters from the past and present, so that Raphael alone
would be honoured above all those who had laboured on the
paintings which had been done up to that time. Although the
work of Giovan Antonio Sodoma da Vercelli, which was
above Raphael's scene, was to have been torn down by the
pope's order, Raphael nevertheless wanted to use its arrange-
ment and grotesques, and in each of the four tondos which
were there he created a figure expressing the meaning of the
scene below, towards which it turns. For the first, where he
had depicted Philosophy and Astrology, Geometry and Poetry
being reconciled with Theology, he painted a female figure
representing Knowledge who is seated upon a chair supported
on each side by a figure of the goddess Cybele, with the
numerous breasts by which the ancients represented Diana
Polymastes; her garment is composed of four colours repres-
enting the elements—from her head down the colour of fire;
below her waist the colour of air; from her thighs to her knees
the colour of earth; and from there to her feet the colour of
water. And she is accompanied by some extremely beautiful
putti.

In a tondo turned towards the window looking out on
the Belvedere, Raphael depicted Poetry, in the person of
Polyhymnia crowned with laurel, who, with her legs crossed,
is holding an ancient musical instrument in one hand and
a book in the other. With the expression and beauty of a
heavenly face, she is raising her eyes towards heaven, accom-
panied by two lively and animated putti who, with her and the
other figures, form various compositions, and on this side over
the same window he later painted Mount Parnassus. In
another tondo which is painted above the scene in which the
Doctors of the Church are organizing the liturgy of the Mass,

there is a figure of Theology surrounded by books and other objects and accompanied by the same putti, no less beautiful than the others. And above the other window overlooking the courtyard, in yet another tondo, Raphael painted a figure of Justice with her scales and raised sword, and with the same putti of the utmost beauty accompanying the other figures, since in the scene on the wall below he painted the giving of Civil and Canon Law, as we shall discuss in the proper place.

Likewise, on the same ceiling in the corners of the pendentives, he painted four scenes that are drawn and painted with great care, although the figures are not very large. In one of them, near the figure of Theology, he depicted Adam's sin, the eating of the apple, which is finished in the most light and graceful style, and in the second corner, near the figure of Astrology, it is Astrology herself who settles the fixed and wandering stars.* Then in a third corner near the scene of Mount Parnassus, Marsyas is bound to a tree and being flayed alive by Apollo, and near the scene where the Decretals are being given, he painted the Judgement of Solomon, who has decided that the child will be cut in two. These four scenes are all full of meaning and emotion and executed with excellent draughtsmanship and charming, graceful colours. But now, having finished with the vaulting (that is, the representation of heaven on the ceiling in that room), it remains for me to relate what Raphael painted on each of the walls below the works mentioned above.

Now, on the wall facing the Belvedere, where he painted Mount Parnassus and the fountain of Helicon, Raphael surrounded the mountain with a deep and shadowy laurel wood, where the trembling of the leaves in the sweet winds can almost be seen in the greenery, while in the air countless naked cupids with the most beautiful expressions on their faces are gathering laurel branches and making garlands of them, throwing and scattering them about the mountain. With the beauty of its figures and the nobility of its painting, the work seems to breathe the breath of divinity, which astonishes anyone who examines it intently, causing them to wonder how the human mind working with the imperfect medium of simple colours could, with the excellence of design, make objects in

a painting seem alive. Accordingly, those poets we can see
scattered about the mountain are very lifelike—some are
standing, some sitting, and some writing, while others are
arguing, singing or telling tales among themselves, in groups
of four or six, according to how Raphael decided to divide
them. In this picture, there are true portraits of all the most
famous ancient and modern poets who ever lived or were still
alive in Raphael's day, and some were taken partly from
statues or medals, a good many others from old paintings, and
still others were drawn from life by Raphael himself while
they were still alive. Beginning from one side, there are Ovid,
Virgil, Ennius, Tibullus, Catullus, Propertius, and the blind
Homer, who with his head raised up is reciting verses, while
there is someone at his feet who is writing them down; then
there are the nine Muses in a group with Apollo, with such
beautiful expressions and divine figures that they breathe forth
grace and life. There is the learned Sappho and the sublime
Dante, the graceful Petrarch and the amorous Boccaccio, all
full of life, as well as Tibaldeo and countless other modern
poets. This scene is executed with much grace and finished
with care.

On another wall Raphael painted a heaven with Christ
and Our Lady, Saint John the Baptist, the Apostles, the
Evangelists, and the Martyrs, all in the clouds with God the
Father, who from above them all sends down the Holy Spirit,
most particularly to a countless number of saints who are
below, writing out the form of the Mass and arguing about
the nature of the Host which is on the altar.* Among these
figures are the Four Doctors of the Church, who are sur-
rounded by countless saints. Included are Dominic, Francis,
Thomas of Aquinas, Bonaventure, Scotus, Nicholas of Lyra,
Dante, Fra Girolamo Savonarola from Ferrara, and all the
Christian theologians, countless numbers of which are de-
picted from life; and in the sky there are four children who are
holding open the Gospels. No painter could create figures
with more grace or greater perfection. The saints, who happen
to appear seated in a circle in the air, not only seem truly alive
with colour, but are foreshortened in the usual manner and
recede in just the way they would if they were depicted in

relief. Moreover, they are dressed differently, with clothing that falls in the most beautiful folds and with facial expressions that are more celestial than human, as can be seen in the expression of Christ, Who shows all the mercy and compassion that divinity depicted in paint can display towards mortal men. Indeed, Nature bestowed upon Raphael the gift of painting the sweetest and most gracious expressions on faces, as is clearly shown in the figure of Our Lady Who, placing Her hands upon Her breast, while looking at and contemplating Her Son, seems unable to withhold any favour; without sparing his truly fine sense of decorum, he shows old age in the expressions of the Holy Patriarchs, simplicity in the Apostles, and faith in the Martyrs. But he demonstrated even more skill and ingenuity in depicting the Holy Doctors of the Church, who are debating in groups of six, three, and two, and whose faces show a certain curiosity and the difficulty of trying to find out what is true in all that is in doubt; they are giving some indication of their efforts by gesturing with their hands during their discussions, making certain movements with their bodies, bending their ears, and knitting their brows, expressing astonishment in many different ways, all certainly different and appropriate. Separately, a group of four Doctors of the Church enlightened by the Holy Spirit untangle and resolve by means of the Holy Scriptures all the problems of the Gospels, which are being held up by putti hovering in the air. On one side of the other wall, where there is another window, Raphael painted Justinian giving the laws and the learned men who are correcting them, with the figures of Temperance, Fortitude, and Prudence above. On the other side, he painted the pope issuing the canonical decretals, and for this pope he drew Pope Julius from life, attended by Cardinal Giovanni de' Medici (who later became Pope Leo), Cardinal Antonio di Monte, and Cardinal Alessandro Farnese (who later became Pope Paul III), as well as other portraits. . . . *

But, to return to Raphael, his skills improved so greatly that he was commissioned by the pope to continue with the second room near the great hall. And since he had made an illustrious name for himself, he painted a portrait in oil of Pope Julius during this time, which was so lifelike and real that it

made the onlooker shrink from it in fear, as if the pope were truly alive. Today this work is in Santa Maria del Popolo,* along with a very beautiful painting of the Madonna, done at the same time, which contains the Nativity of Jesus Christ with the Virgin using a veil to cover Her son, whose figure is of such beauty that the expression on His face and every part of His body prove that He is the true Son of God. And no less beautiful are the head and face of the Madonna, displaying both joy and compassion in addition to the greatest beauty. There is also a figure of Joseph, who remains leaning with both hands upon a staff in pensive contemplation of the King and Queen of Heaven with the wonder of a very holy old man. Both of these paintings are displayed on important feast days.

During this period, Raphael gained great fame in Rome, and although his soft and delicate style was considered extremely beautiful by everyone, and he had studied continuously, examining the many antiquities in the city, he still had not endowed his figures with the grandeur and majesty that he gave them from this time on. It was at this same time that Michelangelo terrified the pope with his outburst in the Sistine Chapel, which we shall discuss in his *Life*, and which forced him to flee to Florence, and, since Bramante held the keys to the chapel, he showed it to his friend Raphael so that he would be able to understand Michelangelo's techniques. And this spectacle was the reason why after he had already finished it, Raphael immediately repainted the figure of the prophet Isaiah* in Rome's Sant'Agostino above the Saint Anne by Andrea Sansovino. As a result of having seen the painting by Michelangelo, Raphael greatly improved and magnified his style in this work and gave it more noble proportions. When Michelangelo later saw Raphael's work, he thought (and rightly so) that Bramante had done him this bad turn in order to benefit Raphael and to increase his reputation.

Not long after this, Agostino Chigi, a very rich merchant from Siena and a true friend of all talented men, commissioned Raphael to decorate a chapel; he did so because, shortly before, Raphael had painted in a loggia of his palace (today called the Chigi Palace in Trastevere) with the sweetest

style a Galatea in a chariot on the sea drawn by two dolphins
and surrounded by Tritons and many sea-gods.* After Raph-
ael had completed the cartoon for this chapel (which is near
the entrance of the church of Santa Maria della Pace on the
right-hand side as you go inside the main door), he completed
it in fresco in the new style, which was considerably grander
and more magnificent than the earlier one.* In the painting,
Raphael, who had himself seen Michelangelo's chapel before
it was opened to the public, depicted a number of prophets
and sibyls which, in truth, are considered to be the best of his
works and, among his many beautiful paintings, the most
beautiful, for the women and children present display the
greatest liveliness as well as perfect colouring. Since it was the
most exceptional and exquisite work Raphael ever completed,
it brought him great esteem in his lifetime and after his death.

 Then, encouraged by the entreaties of one of Pope Julius's
chamberlains, Raphael painted the panel for the high altar of
the Aracoeli Church, in which he depicted a Madonna in
the heavens, an extremely beautiful landscape, and Saint John,
Saint Francis, and Saint Jerome portrayed as a cardinal; the
Madonna expresses a humility and modesty truly worthy of
the Mother of Christ; and, besides the Child, who is playing
with His mother's cloak in a lovely pose, the figure of Saint
John exhibits the air of penitence usually brought on by fast-
ing, while his head reflects the sincerity of heart and the ready
confidence typical of people who, having withdrawn from the
world, despise it, and who, in their associations, hate lies and
speak only the truth. Similarly, the head of Saint Jerome is
raised with his eyes turned, completely in contemplation,
towards Our Lady, and in them we find signs of all the doc-
trine and learning he displayed in writing his works, as he
holds out his hands to present the chamberlain, and, in this
portrait, the chamberlain is no less lifelike for being painted.
Raphael succeeded in much the same way with the figure of
Saint Francis, who is kneeling upon the ground with one arm
extended and his head raised, gazing above at the Madonna
and burning with love in the emotion of the painting, while
his features and colouring show him consumed with emotion
and drawing comfort and life from the gentle sight of the

Madonna's beauty and from the beauty and liveliness of Her son. Raphael painted a putto standing in the middle of the panel under Our Lady raising his head towards Her and holding an epitaph, whose beauty of face and well-proportioned body could not be finer or more graceful; and there is besides a landscape which in its complete perfection is singular and extremely beautiful.

Afterwards, continuing to work on the rooms in the pope's palace, he painted the story of the sacramental miracle of the corporal at Orvieto (or Bolsena, as it is called*). In this scene, we see in the flushed face of the priest the shame he feels upon seeing the Host liquefy into blood on his corporal because of his own lack of faith; with terror in his eyes, he is beside himself and lost in the presence of his congregation, seeming as if he knows not what to do; the trembling and fright typical of such events can almost be seen in the position of his hands. All around, Raphael painted many varied and different figures, some assisting at the Mass, others kneeling upon a flight of stairs, and all of them, perturbed by the unusual nature of the event, assume the most handsome poses with different gestures, expressing in their many faces a single emotion of guilt as much in the men as in the women, among whom there is one at the very bottom of the scene seated upon the ground holding a child in her arms; she is listening to the explanations another woman is giving her about what has happened to the priest, and while she does so, she twists around in a marvellous manner with a womanly grace that is very animated and appropriate. On the other side Raphael represented Pope Julius hearing the same Mass, a very astonishing thing to behold, in which he has portrayed the Cardinal of San Giorgio* and countless others, while inside the opening in the window he placed a flight of stairs that the scene shows in its entirety; in fact, it appears that if the space for the window were not present, the painting itself would not have been properly finished.

Thus, it can truly be claimed that in creating compositions for the scenes he painted, no one ever surpassed him in aptness, clarity, and skill, as he demonstrated once again at this same location in a scene opposite this one showing Saint Peter in

Herod's hands, imprisoned and guarded by armed soldiers. In this painting, his understanding of architectural drawing and his discretion in depicting the prison building are such that, in comparison, the works of other painters are truly as confused as his are beautiful. Raphael always sought to represent his scenes as if they were written out and to create within them elegant and excellent details, as he demonstrates in this work with the horror of the prison, the sight of that old man in iron chains between the two armed soldiers, the heavy sleep of the guards, and the shining splendour of the angel in the dark shadows of the night that brightly lights up every particular in the prison and causes the armour of the soldiers to shine so resplendently that the lustre seems more burnished than if they had been real rather than painted. He displays no less skill and genius in representing the point in the action when, freed from his chains, Saint Peter comes out of the prison accompanied by the angel, and his face reflects his feeling of being in a dream rather than alive, just as the faces of the other armed guards standing outside the prison still reveal their terror and fright as they hear the noise of the iron door; a sentry with a torch in his hand arouses the other guards, and while he gives them light with his torch, its flame is reflected in all their armour, and where its light fails to strike, its place is taken by the light of the moon. Raphael painted this imaginative composition over the window, making this wall even darker, and when you look at this painting it reflects the light into your face, and the natural light contends so well with what is painted of the various lights of the night that you seem to see the smoke of the torch and the splendour of the angel along with the dark shadows of the night, which are so natural and lifelike that you could never tell they had been painted, so perfectly had Raphael expressed such a difficult act of the imagination. Here in the armour we discern the shadows, flickerings, reflections, and smoky heat of the lights that are defined in such dark shadows that it could truthfully be declared that Raphael is the master of all other painters. And as a work which reproduces night with greater similitude than painting had achieved before, this work is absolutely sublime and considered by everyone to be the most exceptional of all.

Then, on one of the bare walls, Raphael also depicted the holy worship, the ark, and the candelabrum of the Hebrews, with Pope Julius driving Avarice from the Church,* a scene similar in beauty and excellence to that of the night described above. In this scene are the portraits of several papal footmen then still living, who are carrying a truly lifelike Pope Julius in his litter. While some of the crowd make way so that he may pass, the fury of an armed man on horseback, accompanied by two men on foot, can be seen in his ferocious pose as he strikes and attacks the arrogant Heliodorus, who, on the orders of Antiochus, intends to despoil the temple of all the wealth left there by widows and orphans; and we see the removal of the goods and treasures which are being carried away, but because of the fear caused by the misfortune of Heliodorus, who is struck down and violently beaten by the three soldiers who are part of a vision he alone sees and hears, we see everything being overturned and spilled on the ground, while those who were carrying these treasures away are falling to the ground with a sudden feeling of horror and fright that has sprung up in all of Heliodorus's men.

Set apart from these men, the most holy Onias, the high priest, can be seen dressed in his robes, with his hands and eyes turned towards heaven and praying fervently, moved by his compassion for the poor creatures who are about to lose their possessions and rejoicing at the aid he feels has come from heaven. Besides this, with a beautiful stroke of the imagination, Raphael shows a great number of people who have climbed up on the socles at the base of the columns, where they are clinging to them in extremely uncomfortable positions as they wait and see, as well as a dumbfounded crowd, depicted in many and different ways, which awaits the outcome of the event. This work was so stupendous in all respects that even its cartoons are held in the greatest veneration....*

But, to return to Raphael. On the ceiling above he painted four scenes: the appearance of God to Abraham as He promises him the multiplication of his seed; the sacrifice of Isaac; Jacob's ladder; and the burning bush of Moses, which exhibit no less skill, invention, draughtsmanship, and grace than the other paintings he executed.

While the happy existence of this artisan was bringing so many great marvels into the world, envious Fortune took the life of Julius II, who nurtured such talent and took pleasure in every good thing. Thus, Leo X, who wanted such good work to be continued, was then made pope,* and having encountered such a great prince who had inherited from his family the capacity to appreciate painting, Raphael earned the pope's highest praise with his skill and enjoyed countless favours from him. And so, Raphael resolved to complete the work, and on the other wall represented the arrival of Attila in Rome and his encounter at the foot of Monte Mario with Pope Leo III, who drove him away with nothing more than his blessings. In this scene Raphael depicted Saint Peter and Saint Paul in the heavens with their swords in hand as they arrive to defend the Church. And even if this is not in the history of Leo III, Raphael nevertheless may have wanted to depict it in this manner as an invention of his, for paintings, like poems, stray from their subjects in order to embellish the work without departing in an inappropriate way from the original idea.

In the two Apostles can be seen the fierce pride and celestial courage that divine judgement often puts in the faces of its servants in order to defend our most holy religion. Attila, mounted on a black horse with white fetlocks and a white star on its forehead, as handsome an animal as could be, gives an indication of this, and, in a fearful posture, he raises his head and turns away in flight. There are other extremely beautiful horses, especially a dappled Spanish horse ridden by a figure whose naked body is covered with fish-like scales, which was copied from Trajan's Column, where there are men armed in this fashion. It is thought that this armour was made from crocodile skins. And then there is Monte Mario ablaze, showing that once soldiers have completed their detail their camp-grounds are always put to the torch. He also drew the living portraits of some mace-bearers who are accompanying the pope and who along with the horses are extremely lifelike, and equally so are all those in the cardinals' retinue as well as the grooms holding the white horse upon which Leo X, in a living portrait like the others and dressed in his pontifical

robes, is riding along with numerous courtiers—a most charming thing to see, appropriate to such a work, and most useful to our craft, especially for those who are in need of such ideas.

During this same time, Raphael painted a panel in Naples, which was placed in the church of San Domenico in the chapel where the crucifix that spoke to Saint Thomas Aquinas is located; it contains the figure of the Madonna, Saint Jerome dressed as a cardinal, and the Angel Raphael accompanying Tobias.* For Signor Leonello da Carpi, the lord of Meldola, who is still alive today at an age of over ninety, Raphael executed a painting which was quite marvellous in its colour-ing and singular beauty. It was done with such energy and charming grace that I cannot imagine it is possible to do any-thing better; a certain divinity can be seen in Our Lady's face, and in her pose a modesty which could not be improved. Raphael depicted her with joined hands, adoring Her Son who is seated upon Her lap and caressing a youthful Saint John, who worships Him along with Saint Elizabeth and Joseph. This painting was once in the possession of the Most Reverend Cardinal of Carpi, the son of this Signor Leonello, who was a great admirer of our arts, and it must now be in the possession of his heirs.*

After Lorenzo Pucci, Cardinal of Santi Quattro, was named Grand Penitentiary, he asked of Raphael the favour of paint-ing a panel in Bologna for San Giovanni in Monte, which is now located in the chapel containing the body of the Blessed Elena dall'Olio, a work which demonstrated how much the grace of Raphael's extremely delicate hands could achieve when joined with his skill.* It contains the figure of Saint Cecilia, who, dazzled by a chorus of angels in heaven, stands listening to the sound, completely carried away by its har-mony, and one can see in her head the sense of total absorption that can be detected in the living flesh of those who are in ecstasy; besides this, there are musical instruments scattered on the ground which seem to be real and true to life rather than painted, like some of Cecilia's veils and garments made of gold and silken cloth, under which there is a marvellous hairshirt. And there is a Saint Paul, who has placed his right

arm on his naked sword and rested his head on his hand, in whom we can see the thoughtfulness of his learning no less than a look of fierce pride which has been transformed into weighty dignity; he is barefooted and dressed like an apostle with a simple piece of red cloth for a cloak and a green tunic underneath; then there is Saint Mary Magdalene who is holding in her hands a vase of the finest stone, and who seems joyful about her conversion as she turns her head in a delightful pose, a figure which for its genre could not, I think, be done any better; and the heads of Saint Augustine and Saint John the Baptist are also extremely beautiful.

And in truth, although other paintings may be called paintings, those of Raphael are living things: for the flesh in his figures seems palpable, they breathe, their pulses beat, and their lifelike animation is conspicuous; and besides the praise they had already received, they earned for Raphael even greater renown.... *

While Raphael was working on these paintings, which he could not fail to complete since he had to serve great and distinguished persons (not to mention the fact that his own private interests prevented him from refusing), he still never ceased pursuing the plan he had begun in the papal apartments and halls, where he continuously kept people working who, with his own designs, carried the work forward, while he oversaw everything, providing the best assistance he could to such a weighty undertaking. Not much time passed before he unveiled the apartment in the Borgia Tower, in which on every wall he had painted a scene—two above the windows and two others on the walls that were empty. One of them depicted a fire in the Borgo Vecchio of Rome, which no one could put out until Saint Leo IV went to the loggia of the palace and completely extinguished it with his blessing.* In this scene, various dangers are depicted. On one side are women whose hair and garments are blown about by the windstorm with a tremendous fury while they are carrying water to put out the fire. Others trying their best to throw water are blinded by the smoke and confused. On the other side, depicted in the same way Virgil described Anchises being carried by Aeneas, is the figure of a sick old man, beside

himself from the effects of his infirmity and the flames of the fire. In the figure of the younger man, we see courage and strength, as well as the suffering in all his limbs from the weight of the abandoned old man on his back. He is followed by a dishevelled, barefooted old woman who is running from the fire, and a naked young boy in front of them. On the top of the ruins we can see a naked and frantic woman holding her son in her arms about to throw him to one of her relatives who has escaped from the flames and is standing on his tiptoes in the street with his arms extended to receive the infant boy. The emotion she feels in trying to save her son from danger can be seen no less clearly than her own suffering in the dangerously raging flames which are burning her; nor is the distress any less conspicuous in the man who takes the child, who fears for the child's safety as well as for his own life; it would be impossible to express the imaginative power of this most resourceful and admirable artisan in the figure of a barefooted, dishevelled mother, her clothes unbuttoned and undone and her hair in disarray, who is holding her children in front of her and part of her dress in her hands, beating them so that they will flee from the ruins and the fire's blaze. Besides these figures, there are also a few women, kneeling before the pope, who seem to be begging His Holiness to put an end to the fire.

The other scene depicts the same Saint Leo IV on the occasion when the port of Ostia ended up being occupied by an army of Turks who had come to take him prisoner.* We can see the Christians fighting the fleet at sea, while the countless prisoners who have already come back to port in a boat are disembarking, dragged by their beards by a number of soldiers with the most beautiful bearing and boldest poses, and in their different galley-slave costumes, they are brought before Saint Leo, who is depicted by a portrait of Pope Leo X. There Raphael painted His Holiness in his pontifical robes between the Cardinal of Santa Maria in Portico, that is, Bernardo Dovizio da Bibbiena, and Cardinal Giulio de' Medici, who later became Pope Clement VII. It would be impossible to count in exact detail the admirable devices that this most ingenious artisan employed in the expressions of the prisoners

who, without the power of speech, convey the emotions of sorrow, terror, and fear of death.

There are two other scenes: one represents Pope Leo X consecrating the Most Christian King Francis I of France, singing Mass in his pontifical robes and blessing the holy oils to anoint him along with the royal crown.* Besides a number of cardinals and bishops in their vestments who are assisting the pope, Raphael depicted many ambassadors and other people from life, including certain figures with French-style clothing according to the fashion of that period. In the other scene he painted the coronation of this same king,* in which the pope and Francis are portrayed from life, one in armour and the other in pontifical garments. Besides this, all the cardinals, bishops, chamberlains, squires, and papal servants are dressed in their pontifical vestments and seated in order in the chapel, as was the custom; all were painted from life—such as Giannozo Pandolfini, the Bishop of Troyes, a very close friend of Raphael, and many other prelates who were prominent at that time. And near the king is a young boy kneeling and holding the royal crown, the portrait of Ippolito de' Medici, who later was a cardinal and vice-chancellor, a man held in great esteem who admired not only this talent but all others as well. I know myself to be greatly indebted to his blessed person, since I owe my own beginnings as an artist, such as they were, to him.

It would be impossible to describe the minute details of this artisan's work, for in truth, his very silence seems to speak; the bases beneath these scenes are decorated with figures of the defenders and benefactors of the Church, each surrounded by a different border and all executed in a single style, so that every detail reflects wit, emotion, and thought, with such a harmony and blending of colours that no one could imagine anything better. And since the vaulting of this room was painted by his master Pietro Perugino, Raphael did not wish to destroy it out of respect for his memory and the affection he bore him, for Perugino had been the prime mover behind the first step that Raphael took in developing his talent. . . .*

Raphael was a very amorous man who was fond of women, and he was always quick to serve them. This was the

reason why, as he continued to pursue his carnal delights, he was treated with too much consideration and acquiescence by his friends. When his dear friend Agostino Chigi commissioned him to paint the first loggia in his palace,* Raphael could not really put his mind to his work because of his love for one of his mistresses; Agostino became so desperate over this that, through his own efforts and with the assistance of others, he worked things out in such a way that he finally managed to bring this woman of Raphael's to come and stay with him on a constant basis in the section of the house where Raphael was working, and that was the reason why the work came to be finished. In this work, Raphael executed all the cartoons and coloured many of the figures in fresco with his own hand. And on the vault, he painted the council of the gods in heaven, where we can see on their bodies many costumes and features copied from classical antiquity and expressed with the most beautiful grace and draughtsmanship; and in the same manner he painted the marriage of Psyche, with Jove's ministers and the Graces scattering flowers around the banquet table; and in the pendentives of the vaults he executed many scenes, including one in which Mercury in flight with a flute seems to be descending from heaven, while in another Jove is kissing Ganymede with celestial dignity; and below this is the chariot of Venus and the Graces who, with Mercury, are taking Psyche to heaven, as well as many other poetic scenes in the other pendentives. And in the sections of the vaults above the arches between the pendentives, there are many putti beautifully foreshortened, carrying in flight all the instruments of the gods: the thunderbolts and arrows of Jove; the helmets, swords, and shields of Mars; Vulcan's hammers; the club and lion's skin of Hercules; Mercury's wand; Pan's pipes; and the agricultural rakes of Vertumnus. And all are accompanied by animals appropriate to their natures—a truly beautiful painting and poem. Raphael had Giovanni da Udine paint a border for the scenes with all kinds of flowers and foliage and garlands of fruit that could not be more beautiful. He also organized the architectural design of the Chigi stables and Agostino's chapel in the church of Santa Maria del Popolo. Besides painting this chapel, Raphael ordered a marvellous

tomb to be built for it, and he had Lorenzetto, a Florentine sculptor, carve two figures which are still in his home in the Macello de' Corbi in Rome. But Raphael's death and then Agostino's caused the project to be given to Sebastiano del Piombo.

Raphael had risen to such heights that Leo X ordered him to begin the great upper hall, containing the Victories of Constantine, and he started it. Likewise, the pope also decided to have some rich tapestries woven with gold and floss-silk; so Raphael with his own hand designed and coloured all the cartoons in their proper form and size, and they were sent to be woven in Flanders, and once they were completed, they came back to Rome.* This project was so miraculously executed that it makes anyone who sees it marvel to think that it was possible to have woven the hair and beards and to have given such softness to the flesh with a thread; this was certainly more the result of a miracle than of human artifice, for in these tapestries there are bodies of water, animals, and buildings that are so well made they seem to be painted with the brush rather than woven. The work cost seventy thousand *scudi* and is still kept in the pope's chapel.

Raphael painted a Saint John on canvas for Cardinal Colonna, who bore a great love for the painting because of its beauty, and when he was struck down by an illness, the doctor who cured him, Messer Jacopo da Carpi, asked for the painting as a gift, and since Messer Jacopo wanted it, the cardinal, who felt he was under an endless obligation to him, gave it up, and it is now in Florence in the possession of Francesco Benintendi. For Giulio de' Medici, cardinal and vice-chancellor, he painted a panel of the Transfiguration of Christ to send to France which he himself worked on continuously and brought to the height of perfection.* In this scene he represented Christ's transfiguration on Mount Tabor with his eleven disciples waiting for him below; a young boy who is possessed is brought there so that when Christ has descended from the mountain he will set him free; while the boy's body is stretched out in contortions, he is screaming and rolling his eyes; his suffering is revealed by his flesh, his veins, and the beats of his pulse which are all corrupted by the evil spirit, and

his flesh is pale as he makes unnatural and terrifying gestures.
This figure is held up by an old man who, embracing him and
taking courage, with round eyes which reflect the light,
demonstrates both strength and fear by raising his eyebrows
and wrinkling his forehead. Yet he fixes his gaze upon the
Apostles and seems to draw strength from trusting in them.
There is also one woman among many others, the main figure
in the panel, who is kneeling before the Apostles and turning
her head towards them, and with a gesture of her arms
towards the possessed boy she points out his misery. In
addition, the Apostles—some standing, some seated, others
kneeling—reveal their profound compassion for so great a
misfortune. And in this scene Raphael truly created figures
and heads which were not only extraordinarily beautiful but
were so novel, varied, and striking that it is the common
opinion of artisans that this work, among all the paintings he
completed, is the most famous, the most beautiful, and the
most inspired. Whoever wishes to understand and then rep-
resent in painting the divinely transfigured Christ should
examine Him in this work, where Raphael depicted Him
foreshortened and floating in the shimmering air above the
mountain in the company of Moses and Elijah, who, illumin-
ated by a brilliant splendour, come alive in His light; Peter,
James, and John are prostrate upon the ground in various
beautiful poses—one has his head on the ground, another
protects himself from the rays and the tremendous light from
Christ's splendour by shading his eyes with his hands. Clothed
in snow-white garments, Christ seems, as he opens his arms
and raises his head, to display the essence and godly nature of
all three Persons of the Trinity, closely united in the perfection
of Raphael's art, which the artist seemingly brought together
with all his skill to demonstrate the power and the worth of
his art in the face of Christ, for after Raphael finished this
painting, which was the last thing he undertook, he never
touched another brush and was overtaken by death.

Now that I have recounted the works of this most excellent
artisan, I should like to take some pains in discussing Raphael's
different styles at some length for the benefit of our artisans
before I come to treat other details of his life and death. In

his youth, then, he imitated the style of his master, Pietro
Perugino, and made it much better in terms of design, colour-
ing, and invention, but when he was older, although he
thought he had accomplished a great deal, he recognized that
this style was too far from the truth. For that reason, when he
saw the works of Leonardo da Vinci, who had no equal in
rendering expressions in the heads of men as well as women,
and who in giving grace to his figures and their movements
surpassed all other painters, Raphael was left wholly aston-
ished and amazed; in short, since the style of Leonardo pleased
him more than any other he had ever seen, he set himself to
studying it, and gradually leaving behind Pietro's style, albeit
with great effort, he sought to imitate the style of Leonardo
to the best of his knowledge and ability. But in spite of his
diligence and the studies he undertook, he was never able to
surpass Leonardo in his approach to certain problems: and
if it may seem to many people that Raphael had surpassed
Leonardo in his sweetness and in a certain natural facility,
nevertheless he was never superior to Leonardo in the funda-
mental majesty of his concepts or the grandeur of his art, in
which Leonardo had few equals. But Raphael came nearer to
Leonardo than any other painter, especially in the elegance of
his colours.

But to return to Raphael himself: with the passage of time
the style he had adopted from Pietro as a young boy, and
which he had easily taken on because of its precise, spare
nature and its inadequate sense of design, became a great
impediment and burden to him; nevertheless, his inability to
forget it was the reason he experienced great difficulties in
learning the beautiful details of nude figures and the means
of executing difficult foreshortenings from the cartoon that
Michelangelo Buonarroti created for the Council Hall in
Florence. Another man would have lost heart, and, thinking
that he had been wasting time until then, would never, no
matter how great his talent, have done what Raphael did, for
Raphael purified and rid himself of Pietro's style in order to
learn that of Michelangelo, which was fraught with difficulties
in all its details, and from a master he almost transformed him-
self into a new pupil; and he strove with incredible intensity to

achieve in a few months as a grown man what should have required the tender age of youth, when everything is more easily learned, and the space of many years. In truth, the artist who does not learn quite early on the good principles and the style he wishes to follow, and who does not gradually resolve the difficulties in the arts with experience, seeking to understand all their details and to put them into practice, will almost never attain perfection; and if he does, it will take more time and much greater effort. When Raphael began to want to change and improve his style, he had never worked upon nudes with the intensity that this requires but had merely drawn them from life in the style he had seen his master Pietro employ, adding to these drawings the grace given him by Nature. Therefore, he devoted himself to studying nudes and to comparing the muscles in anatomical studies and dead and dissected men with those of the living, since they do not appear as clearly defined under skin as when it is removed; and then, seeing how soft and fleshy parts are formed in the appropriate places, and how by changing the points of view certain contortions can be gracefully executed, as well as the effects of inflating, lowering, or raising either a limb or the entire body, and the connections of the bones, nerves, and veins, Raphael became a master of all the details required of the greatest painters. But he nevertheless realized that he could not reach the perfection of Michelangelo in these matters, and, as a man of the soundest judgement, he considered the fact that painting does not consist entirely in creating naked men, since it has a wide range; that among painters who have reached perfection can be numbered those who know how to express the imaginative composition of their scenes with skill and facility and their fantasies with sound judgement, and who in composing their scenes know how to avoid confusing them with too many details or impoverishing them with too few, and how to organize them in a creative and orderly way; and that this kind of painter can be called a talented and judicious artist. To this conclusion, as he continued to think about the problem, Raphael added the idea of enriching his works with the variety and inventiveness of his perspectives, buildings, and landscapes; a graceful way of dressing his figures, so that some-

times they disappear in the shadows and sometimes stand out in the light; a way of creating lively and beautiful heads for women, children, young men and old alike, and to give these, as necessary, a sense of movement and vigour. He also considered the importance of a painter's skill in representing the flight of horses in battle, and the ferocity of soldiers; the knowledge of how to depict all sorts of animals; and, above all else, the method of painting portraits which resemble men who seem so alive that one may recognize the person for whom they have been painted as well as countless other details, such as the style of garments, footwear, helmets, armour, women's head-dresses, hair, beards, vases, trees, grottoes, rocks, fires, overcast or clear skies, clouds, rains, lightning-bolts, calm weather, night, moonlight, brilliant sunshine, and numerous other things which are still essential elements in the art of painting.

Let me say, then, that after having considered all these things, Raphael decided that since he was unable to match Michelangelo in the kind of painting to which his rival had put his hand, he would equal Michelangelo in other respects and perhaps even surpass him, and thus instead of imitating Michelangelo's style, which would have been a vain waste of time, he began to attain great versatility in all those other aspects of painting that have been described. If other artisans of our time had done the same thing instead of studying nothing but work by Michelangelo, without either imitating him or being able to reach such a high level of perfection, they would not have laboured in vain, nor would they have produced a style which is very harsh, full of problems, lacking proper charm and colour, and impoverished in inventiveness, but they would have been able, in seeking to achieve versatility and to imitate other kinds of painting, to benefit themselves and the world as well.

After Raphael had made this decision, he realized that Fra Bartolomeo di San Marco possessed a very good method of painting, with sound design and a pleasing style of colouring, although he sometimes used too much shadow to give his works greater relief, and he took from Fra Bartolomeo what he thought appropriate according to his needs and fancy—that

is, a middle way both in design and in colours; and mixing this style with some other details chosen from the best works of other masters, he created a single style out of many that was later always considered his own, for which he was and always will be endlessly admired by artisans. This style can be seen perfectly later on in the sibyls and prophets he painted, as we have already mentioned, in Santa Maria della Pace. Having seen the work of Michelangelo in the Sistine Chapel was a great help to him in executing this work. And if Raphael had stopped here with his style and had not sought to enrich it and vary it, in order to prove that he understood the painting of nudes as well as Michelangelo, he would not have lost some part of the reputation he had already acquired, for the nudes he painted in the chamber of the Borgia Tower, where he did the Fire in the Borgo Nuovo, while good, are not excellent in every respect. Likewise, the ones that were executed by him in a similar style on the ceiling of Agostino Chigi's palace in Trastevere are not at all satisfactory, because they lack the grace and sweetness typical of Raphael; and this was in large part caused by his having had them painted by others following his designs. Once he realized his error, like the judicious man he was, he then preferred to work by himself and without the assistance of others on the panel for San Pietro a Montorio showing the Transfiguration of Christ; and this work contains those elements which, as I have already mentioned, a good painting should seek and must possess. And if Raphael had not almost as a whim made use of printers' lampblack, which by nature, as I have said more than once, always becomes darker with the passage of time and damages the other colours with which it is mixed, I believe that this work would still be as fresh as when Raphael painted it, whereas today it seems rather more stained than otherwise.

I wanted to treat this subject near the end of this *Life* in order to demonstrate the great energy, study, and care with which this honourable artist always guided himself, especially for the benefit of other painters, so that they may know how to defend themselves from those obstacles that Raphael's prudence and skill knew how to avoid. I shall also add this remark: every artist should be content to do willingly those

things towards which he feels a natural inclination and should never wish to undertake, in a spirit of competition, those tasks for which he lacks a natural gift, if he is not to work in vain and often to his shame and loss. Besides this, when his work is sufficient, he must not seek to carry it too far in order to surpass those who, through the assistance of Nature and the special grace granted to them by God, have created or are creating miracles in the art of painting. For any artist who is not fit for a task will never, strive though he may, reach the level to which another artist may easily progress with the help of Nature.

And an example of this among the older painters is Paolo Uccello, who, striving against what he was capable of achieving in order to move ahead, always slipped backwards. In our times, and only a brief while ago, Jacopo da Pontormo did the same thing. And experience has shown the same thing occurring in many other artists, as has already been explained and will be explained again. Perhaps this happens because Heaven goes about distributing its favours in such a way that each artist should be content with whatever falls to him.

But now that I have already discussed these artistic matters, perhaps more than was required, let me return to the life and death of Raphael to say that, since Raphael was a close friend of Bernardo Dovizio, Cardinal of Bibbiena, the cardinal for many years had begged him to take a wife, and Raphael had not explicitly refused to follow the cardinal's wishes but had delayed the matter by saying that he wanted to wait three or four years. Once this period passed, and Raphael was least expecting it, the cardinal reminded him of his promise, and, feeling himself obliged, Raphael, as the courteous man he was, did not want to break his promise, and so he accepted as his wife a niece of this cardinal. And because he was always very discontented with this noose, he tried to gain time in such a way that many months passed before the marriage took place. And Raphael did this for a respectable reason. Since he had served at the papal court for many years and since Pope Leo owed him a tidy sum of money, Raphael had been given some indication that at the end of the work on the hall he was painting for the pope, the latter, in recognition of his labours

and his talents, would give him a cardinal's red hat, having already decided to name a good number of cardinals, among whom were men of less merit than Raphael.

Meanwhile, Raphael secretly attended to his love affairs and pursued his amorous pleasures beyond all moderation, and on one occasion he happened to be even more immoderate than usual; having returned home, for that reason, with a very high fever, his doctors thought he had become overheated, and since he did not admit to them the excesses he had committed, his doctors imprudently bled him in such a way that he grew weak and felt faint, just when he needed a restorative. So he made his will and first, as a good Christian, sent his mistress away after giving her the means to live honestly; afterwards he divided his possessions among his pupils Giulio Romano (whom he had always loved a great deal), Giovanfrancesco Fiorentino called Il Fattore, and some priest from Urbino who was a relative of his. He then gave instructions that some of his wealth should be used to restore a tabernacle in Santa Maria Rotonda by replacing old stones with new ones, and to build an altar with a marble statue of Our Lady, which he selected as his tomb and place of repose after his death, and he left all his property to Giulio and Giovanfrancesco, making Messer Baldassarre da Pescia, then datary of the pope, his executor. Then, having confessed and repented, Raphael came to the end of his life's journey on the same day that he was born, which was Good Friday of his thirty-seventh year, and we can believe that just as his talents embellished this world, so he himself will adorn heaven.

As Raphael lay dead in the hall where he had been working, the painting of the Transfiguration he had done for Cardinal de' Medici was placed at his head, and the sight of his dead body and this living painting filled the soul of everyone looking on with grief. Because of Raphael's death, this painting was placed by the cardinal on the high altar of San Pietro a Montorio, and afterwards it was always held in great esteem for the unusual quality of its every gesture. Raphael's body was given the honourable burial that such a noble spirit deserved, for there was no artisan who did not weep in sorrow and accompany him to his tomb. His death also deeply grieved the

entire papal court, first since he had held the office of Groom
of the Chamber while he was alive, and then because he was
so well loved by the pope, who wept bitterly at his death. Oh
happy and blessed soul, for every man gladly speaks of you,
celebrates your deeds, and admires every design you left
behind! When this noble artisan died, painting too might as
well have died, for when he closed his eyes, painting was left
almost blind.

Now for those who have survived him, it remains for us to
imitate the good, or rather the truly excellent style left behind
by him as an example, and, as his talent deserves and our duty
requires, to preserve the most graceful memory of his talent
and always to pay homage to it.

For in truth, because of Raphael, the arts of painting,
colouring, and invention were harmoniously brought to a
stage of completion and perfection that could hardly be hoped
for, nor is it likely that any other soul will ever think of sur-
passing him. And besides the benefits he conferred upon the
art of painting, as a true friend of art, Raphael while alive
never ceased showing us how to deal with great men, men of
middle station, and those of the lowest rank. And among his
singular gifts I detect one of such great value that it fills me
with astonishment: heaven gave him the power to achieve
in our profession a result quite contrary to the disposition of
our painters; and what happened quite naturally is that our
artists—and I am speaking not only of the less talented ones
but also of those who felt themselves to be great (as the art of
painting produces many men of this humour)—working on
projects in the company of Raphael remained so united and
harmonious that all their evil humours diminished when they
saw him, and every vile and vulgar thought vanished from
their minds. Such harmony never ever existed in any other
time than his. And this came about because these artists were
won over by his courtesy and his skill, but even more by the
genius of his good nature, which was so full of nobility and
kindness that even animals loved him, not to mention other
men. It is said that when other painters who knew him (and
even some who did not) asked Raphael for some drawing that
they required, he would leave his own work to assist them.

And he always kept a great number of artisans at work, help-
ing them and teaching them with the kind of love that is more
appropriately given to one's own children than to other
artisans. For this reason, he was never seen leaving home to go
to court without fifty painters, all worthy and good men,
accompanying him to pay him honour. In short, Raphael
lived more like a prince than a painter: Oh Art of Painting,
You may well consider Yourself most fortunate in having one
of Your artisans elevate You, by his talent and manners, above
the heavens! And You may truly call Yourself blessed, inas-
much as Your disciples have seen, from following in the
footsteps of such a man, how one ought to live and how
important it is to couple together skill and virtue. Combined
in Raphael, these qualities were capable of compelling the
great Julius II and the generous Leo X, in their exalted rank
and dignity, to treat Raphael as their intimate friend and to
show him every kind of generosity, so that with their favour
and the resources with which they provided him, he was able
to honour greatly both himself and the art of painting. All
those who remained in his service and worked under him may
also be called blessed, for anyone who imitated him discovered
that he had taken refuge in a secure port, and likewise, those
painters who in the future will imitate his efforts in the art
of painting will be honoured in the world, while those who
follow the example of his holy behaviour will be rewarded
in heaven. . . . *

THE END OF THE LIFE OF RAPHAEL OF URBINO

The Life of Madonna Properzia de' Rossi, Sculptress from Bologna

[c.1490–1530]

It is extraordinary that in all the skills and pursuits in which women in any period whatever have with some preparation become involved, they have always succeeded most admirably and have become more than famous, as countless examples could easily demonstrate. And everyone certainly knows how valuable all women are in economic matters, as well as in warfare, where we recognize Camilla, Harpalice, Valasca, Thomyris, Penthesilea, Malpadia, Orithyia, Antiope, Hippolyta, Semiramis, Zenobia, and also Fulvia, Mark Antony's wife, who (as the historian Dione relates) took up arms on many occasions to defend her husband and herself. But in poetry women have been even more marvellous: as Pausanias tells us, Corinna was greatly celebrated as a writer of verse, while Eustathius mentions the very distinguished young woman Sappho in the catalogue of Homer's ships, as does Eusebius in his chronicle, and if Sappho really was a woman, she was a woman who surpassed by far all the distinguished writers of her time. And Varro also praises excessively but deservedly Erinna, who with three hundred verses contended with the glorious renown of the first light of Greece, and whose one small volume called *Elicate* equalled the great Homer's lengthy *Iliad*. Aristophanes celebrates Carissenna, likewise a poetess, as a most learned and distinguished woman; and also Theano, Merone, Polla, Elpis, Cornificia, and Telesilla, to whom a very beautiful statue was erected in the temple of Venus because of her many wondrous talents. And leaving aside many other women who wrote verse, do we not read that Areta instructed the learned Aristippus in the problems of philosophy? And Lasthenia and Assiotea were pupils of the

most divine Plato? And in the art of oratory, Sempronia and
Hortensia, Roman women, were very famous. In grammar,
Agalla (as Athenaeus remarks) was truly exceptional, while in
predicting future events by astrology or magic, it is sufficient
to recall that Themis, Cassandra, and Manto enjoyed great
renown in their day, just as Isis and Ceres did in the laws of
agriculture and the daughters of Thespis in all fields of know-
ledge generally.

But certainly in no other age could this be better recognized
than in our own, an age in which women have acquired the
greatest fame, not only in the study of letters, as have Signora
Vittoria del Vasta, Signora Veronica Gambara, Signora
Caterina Anguisola, Schioppa, Nugarola, Madonna Laura
Battiferra, and a hundred other extremely learned women,
both in the vernacular and in Latin and Greek, but even in all
the other branches of learning.* They have not been ashamed,
as if to wrest us away from boasting of our superiority, to
place themselves, with their tender and lily-white hands, in
the mechanical arts between the roughness of marble and the
harshness of iron in order to attain their desire and to earn
renown, just as Properzia de' Rossi has done in our day;
a young girl from Bologna, she was not only skilful in
household duties like other women, but in countless fields
of knowledge, so that not only the women but all the men
were envious of her. This woman was very beautiful and
played and sang better than any other woman of the city in
her day. And because she had a ready and inventive wit, she
began to carve peach-stones, which she did so well and with
such patience that they were most unusual and marvellous to
see, not only for the precision of her work but for the slender
figures she carved on them and for her most truly delicate
style of arranging them. It was certainly a marvel to see the
entire Passion of Christ carved upon such a small peach-stone
in the most beautiful intaglio, with countless characters besides
the crucifiers and the Apostles.* And since it had been decided
to decorate the three doors of the façade of San Petronio with
marble figures, this carving of hers gave her the courage to ask
the trustees, through her husband as intermediary, for a part
of the project, to which they were happy to agree, as soon

as she showed them some work in marble carved with her own hand. Accordingly, she immediately carved for Count Alessandro de' Pepoli a living portrait in the finest marble of Count Guido, his father. This work was extremely pleasing, not only to the count but to the entire city, and as a result the trustees did not fail to commission her for part of that project. She completed a most graceful panel, to the greatest amazement of all Bologna—since at the time the poor woman was very much in love with a handsome young man who, it seemed, cared little for her—in which she carved Potiphar's wife who, having fallen in love with Joseph and almost desperate after so many entreaties to him, finally takes off her clothes before him with a womanly grace that is more than admirable.* This sculpture was deemed most beautiful by everyone, and it gave her great satisfaction, since with this figure from the Old Testament she felt she had expressed in part her own most burning passion.* Nor did she wish to do anything else for this building, even though everyone asked her to go on, except Maestro Amico,* who always discouraged her out of envy and always spoke badly of her to the trustees and was so malicious that she was paid a very wretched price for her work. She also did two angels in high relief with beautiful proportions, though against her will, which can be seen today in the same cathedral. Eventually, she took up copper engraving, which she did faultlessly and with the greatest praise. In the end, the poor enamoured girl succeeded perfectly at everything except her most unhappy love.

The renown of such a noble and elevated talent spread through all of Italy and finally reached the ears of Pope Clement VII who, soon after he had crowned the emperor in Bologna,* asked about her and discovered that the unhappy woman had died that same week and had been buried in the Ospedale della Morte, as she had requested in her last testament. The pope, who was anxious to see her, was extremely distressed by her death, but her fellow citizens were even more so, for while she lived they had regarded her as one of the greatest miracles of nature in our times. In our sketch-book, there are several drawings done by her in pen and ink and

copied from works by Raphael of Urbino, which are very good, and her own portrait was obtained from some painters who were her close friends.

But even though Properzia was very skilful in design, there have been other women who have not only equalled her in design but who have done as well in painting as she did in sculpture. The first of these is Sister Plautilla,* a nun and now the prioress of the convent of Santa Caterina of Siena in Florence on Piazza San Marco. Beginning little by little by sketching and imitating with her colours the pictures and paintings of excellent masters, she has with great diligence completed a number of works which have amazed our artisans. Two panels in the church of the same Convent of Santa Caterina are by her hand.* But most praised is the one in which the Wise Men are worshipping Christ. In the Monastery of Santa Lucia in Pistoia, there is a large panel in the choir which contains the Madonna with Her child in Her arms, Saint Thomas, Saint Augustine, Saint Mary Magdalene, Saint Catherine of Siena, Saint Agnes, Saint Catherine the Martyr, and Saint Lucy. And another large panel done by her was sent to the hospital of Lemo. In the refectory of the same Convent of Santa Caterina, there is a large Last Supper,* while another of her panels is in the work-room. For the homes of Florentine noblemen, she did so many paintings that it would take too long to discuss them all. The wife of Signor Mondragone the Spaniard owns a large Annunciation, and another similar painting of it is owned by Madonna Marietta de Fedini. A small Madonna is in San Giovannino in Florence. And a predella for the altar is in Santa Maria del Fiore, in which there are some very handsome scenes from the life of Saint Zenobius. And since this venerable and talented nun studied the art of miniature before she began to work on panels and important works, there are many lovely little works done by her hand now owned by a number of people which need not be mentioned. But best among her works are those she imitated from others, which demonstrates that she would have created marvellous works if, like men, she had been able to study and to work on design and to draw natural objects from life. The truth of this can be seen in her painting

of Christ's Nativity, copied from one done by Bronzino for Filippo Salviati. The truth of this is also demonstrated in this fact: that in her works, the faces and features of the women, whom she could see whenever she liked, are much better than the heads of men and are closer to reality. In one of her works, among the women's faces, she portrayed Madonna Gostanza de' Doni, who, in our day, was an example of incredible beauty and honesty, and she did it so well that for a woman (since she had little experience for the reasons given above), one could not wish for more.

Likewise, Madonna Lucrezia, the daughter of Messer Alfonso Quistelli dalla Mirandola and now wife of Count Clemente Pietra, has to her great praise studied design and painting and is still doing so, having learned from Alessandro Allori,* the pupil of Bronzino, as we can see in her many paintings and portraits, which are worthy of being praised by everyone. But Sophonisba of Cremona,* the daughter of Amilcaro Angusciuola, has worked with deeper study and greater grace than any woman of our times at problems of design, for not only has she learned to draw, paint, and copy from nature, and reproduce most skilfully works by other artists, but she has on her own painted some most rare and beautiful paintings. Thus, it was well deserved when Philip, King of Spain, having heard about her talents and merits from the Duke of Alba, sent for her and had her brought with the greatest honour to Spain, where he supports her in the queen's company with a huge provision, to the amazement of all his court which admires as a wondrous thing Sophonisba's excellence. Not long ago Messer Tommaso Cavalieri, a Roman gentleman, sent to Lord Duke Cosimo, in addition to a drawing by the divine Michelangelo which contains a Cleopatra, another drawing by Sophonisba, in which a young girl is laughing at a small boy crying, because after she had placed a basket full of lobsters in front of him, one of them bit his finger. One could not see a more graceful or realistic drawing than this one. Since she lives in Spain and Italy does not possess copies of her works, I have placed it in our sketch-book in memory of Sophonisba's talent. We can therefore truthfully say along with the divine Ariosto:

And truly women have excelled indeed
In every art to which they set their hand.*

And let this be the end of the life of Properzia, sculptress from
Bologna.

The Life of Rosso, Florentine Painter

[1494–1540]

Men of reputation who devote themselves to their talents and embrace them with all their might are sometimes, when least expected, exalted and honoured to excess in the presence of the whole world; this can clearly be seen from the efforts that Rosso, a Florentine painter,* put into the art of painting. And if in Rome or in Florence his efforts were not sufficiently rewarded by those who had the means to do so, he nevertheless found someone in France who recognized them, with the result that the glory he acquired could have quenched the desire for success that may dwell in the heart of any artisan whatsoever. Nor could he in this life have obtained greater dignity, honour, or rank, since he was highly regarded and esteemed above everyone else in his craft by such a great monarch as the king of France. And in truth, the merits of Rosso were such that if Fortune had brought him any less, she would have done him a grave wrong. For all that, besides his skill in painting, Rosso was gifted with a most handsome appearance; his manner of speaking was very gracious and serious; he was a fine musician and possessed a sound grasp of philosophy; and what mattered more than all his other very fine qualities was the fact that he was consistently very poetic in the composition of his figures, bold and well-grounded in his design, with a charming style and breathtaking fantasy, as well as very skilful in composing figures. In architecture he was most talented and extraordinary, and no matter how poor, he was always rich in spirit and grandeur. For this reason, those who gain the same rank as Rosso in the labours of painting will be as continuously celebrated as his works, which, having no equal for their boldness, were executed without strenuous effort, stripped of a certain feeble and tedious quality that

many artists allow in order to make their nothings seem to be something.

In Rosso's youth, he drew from Michelangelo's cartoon,* and he wished to work at his art with very few masters, since he held certain opinions in opposition to their styles, as we can see at Marignolle outside the San Pier Gattolini gate in Florence from a tabernacle worked in fresco for Piero Bartoli which contains a dead Christ, where he began to show how much he wanted to develop a bold style with more grandeur, grace, and surprise than other painters. While still a beardless youth and when Lorenzo Pucci was made cardinal by Pope Leo, he worked over the gate of San Sebastiano de' Servi on the Pucci coat of arms, executing two figures that in those days amazed other artisans, since they did not expect him to succeed. And this encouraged him so much that after Rosso had done a half-length painting of Our Lady with the head of Saint John the Baptist for Maestro Jacopo, a Servite friar who studied poetry, he was persuaded by Jacopo to paint in the courtyard of these same Servites, beside the scene of the Visitation done by Jacopo da Pontormo, the Assumption of Our Lady, in which he painted a heaven filled with angels in the form of naked children who are dancing around Our Lady in a circle, foreshortened with the most beautiful contours and swirling through the air, so that if the colouring he used had been executed with the artistic maturity he acquired with time, he would have surpassed the other scenes by far, since he already equalled them in grandeur and design. He weighed the Apostles down with overly luxurious garments, but their poses and some of the heads are more than beautiful.

The head of the hospital of Santa Maria Novella had him do a panel,* but he was a man who had little understanding of the art of painting, and when he saw the work sketched out, all the saints seemed to him to be devils, since Rosso was accustomed in his oil sketches to create certain cruel and desperate expressions and later, while finishing them, he would soften the expressions and bring them back into the good style. Because of this, the man ran out from the house and refused the panel, declaring that Rosso had tricked him. Likewise, Rosso painted the arms of Pope Leo with two children

(now destroyed) over another door going into the cloister of
the convent of the Servites. And in the homes of private
citizens other paintings and many portraits may be seen. For
the arrival of Pope Leo in Florence, he built a most beauti-
ful arch at the Canto de' Bischeri.* Then, for the ruler of
Piombino, Rosso executed a panel with a very beautiful dead
Christ, and he also completed a little chapel. Similarly, in
Volterra, he painted a very beautiful Deposition from the
Cross.

And since he had grown in fame and merit, he executed the
panel for the Dei family in Santo Spirito in Florence,* which
they had earlier commissioned to Raphael of Urbino, who
abandoned it to attend to the work he had undertaken in
Rome. Rosso painted it with the most lovely grace, as well
as a strong sense of design and liveliness of colour. No one
should imagine that any work ever possessed greater power or
looked so beautiful from a distance as this one, which for the
boldness of its figures and the abstract quality of these poses,
still uncommon among other painters, was considered a most
extraordinary work. And if he was not much praised for it
at the time, people subsequently recognized its good qualities
little by little, and they have given Rosso marvellous praise,
for it would be impossible to surpass its harmony of colours,
since the clear lights at the top, where the greatest light falls,
gradually move with the less bright lights to merge so softly
and harmoniously with the dark parts, through the artifice of
casting shadows, that the figures stand close up against one
another, each setting the other into relief by means of
chiaroscuro. And this work contains such boldness that it may
be said to have been conceived and executed with more judge-
ment and mastery than any other work ever painted by how-
ever judicious a master. In San Lorenzo, he did a panel for
Carlo Ginori of the marriage of Our Lady, which was con-
sidered extremely beautiful. And in truth, there has never
existed anyone who in practice or dexterity could surpass him,
or approach him, in his facility of painting, for Rosso made
his colouring so soft, varied his garments with such grace, and
took such delight in his craft that he was always, as a result,
highly praised and admired, and anyone who looks at such a

work will understand that all I have written is absolutely true, considering his nudes, which are very well conceived on the basis of a thorough knowledge of anatomy. His female figures are extremely graceful and the arrangements of their garments curious and charmingly original. Similarly, Rosso considered carefully, as one should, both the heads of his old men with their curious looks and those of his women and children, with their sweet and pleasing expressions. He was so rich in invention that he never left any space unused in his paintings, and he carried out everything with such facility and grace that it was astonishing. For Giovanni Bandini, he also painted a picture of some very beautiful nudes in a scene of Moses killing the Egyptian, which contains some very praiseworthy details, and I believe it was sent to France.* He did another similar work for Giovanni Cavalcanti, who went to England, depicting the scene of Joseph taking water from the women at the fountain, which was held to be divine, since it contained male nudes and women executed with consummate grace, for whom Rosso continuously delighted in creating delicate garments, hair-styles with braids, and other clothing.

When he was executing this painting, Rosso lived in Borgo de' Tintori, where his rooms overlooked the gardens of the friars of Santa Croce, and he took great delight in a large male Barbary ape that possessed a spirit more human than animal; because of this he held the animal most dear and loved it as he did himself, and since the beast possessed an astonishing intellect, Rosso made the ape perform many services for him. Now it happened that this animal fell in love with one of his assistants called Batistino, who was very handsome, and he could figure out everything that Batistino wanted to tell him from the gestures the young man made to him. And so, since there was a vine-trellis full of plump San Colombano grapes belonging to the prior against the wall at the back of the rooms overlooking the friars' gardens, Rosso's assistants used to send the ape down to the trellis, which was some distance away from the window, and then, with a rope they would pull the animal back with his hands filled with grapes. When the prior discovered his vine picked clean, not knowing who might have done it, he suspected rats and lay in wait, and

when he saw Rosso's ape climb down, he became furious and seized a rod to beat the animal, going towards it with both hands raised. When the ape saw that he would take some hard knocks no matter whether he climbed back up or remained where he was, he began jumping around and ruining the trellis, and then, gaining the courage to throw himself upon the friar, he grabbed with both hands the outside cross-piece girding the trellis; while the friar was wielding his rod, the ape shook the trellis in terror and with such force that he pulled all of the poles and cross-pieces out of their holes, whereupon both the trellis and the ape came crashing down upon the friar, and, as he called for mercy, Batistino and the others pulled the rope up and put the ape safely back in his room, with the result that the prior withdrew to one of his terraces, muttering things that are not in the Mass; and full of rage and animosity, he went off to the Office of the Eight, the greatly feared magistracy of Florence.

After his complaint had been filed and they had sent for Rosso, the ape was condemned for this joke to have a weight attached to his rear end, so that he could not jump around as he had done before on the trellis. And so Rosso fashioned a roller that turned on a chain which he fastened on to the ape so that he could go about the house but could not jump on other people as he had done before. When the ape saw himself condemned to such a punishment, he seemed to guess that the friar was the cause of it, and so every day he practised jumping step by step with his legs, holding the weight in his hands, and, pausing often, he would, in this fashion, reach his destination. One day when he was loose in the house, the ape gradually jumped from roof to roof during the hour the prior was singing vespers, and he reached the roof of the prior's room. And there he dropped the weight and for half an hour enjoyed a nice romp, leaving not a single tile or gutter unbroken. Then he returned home, and in three days, after a rainfall, the prior's complaints were heard.

Having completed his work, Rosso set out for Rome with Batistino and his ape, where his works were enthusiastically anticipated and in demand beyond all expectation, because some of his drawings had been seen and were considered

marvellous, for Rosso drew in a most inspired fashion and
with great polish. In Rome, Rosso painted a work in Santa
Maria della Pace above the frescos of Raphael, the worst he
ever did, and I cannot imagine how this occurred unless it came
from something which can be seen not only in Rosso but in
many others.* And this phenomenon—something which seems
astonishing and secret by nature—comes down to this: anyone
who changes his country or location seems also to change his
nature, talents, customs, and personal habits to the degree that
he sometimes seems to be another person, completely dazed
and stupefied. This could have happened to Rosso in the air of
Rome both because of the stupendous works of architecture
and sculpture he saw there and because of the paintings and
statues of Michelangelo, which may have overwhelmed him.
Works such as these also caused Fra Bartolomeo of San Marco
and Andrea del Sarto to flee from Rome without allowing
any of their work to be completed there. All the same, for
whatever reason, Rosso never did poorer work, and in
addition, the work stands in comparison with the painting by
Raphael of Urbino.

During this time, Rosso painted for his friend Bishop
Tornabuoni a picture of the dead Christ held up by two
angels, which today belongs to the heirs of Monsignor Della
Casa and was a most beautiful undertaking. For Il Baviera he
did drawings for prints of all the gods, which were then
engraved by Giacopo Caraglio:* they included one of Saturn
changing himself into a horse and, in particular, the scene of
the rape of Proserpina by Pluto. He also worked up a sketch of
the Beheading of Saint John the Baptist, which is located
today in a little church on the Piazza de' Salviati in Rome.
Meanwhile, the Sack of Rome followed, and poor Rosso was
taken prisoner by the Germans and very badly treated.*
Besides stripping him of his clothes and leaving him barefoot
and without anything on his head, they made him carry heavy
loads on his back and empty almost an entire grocery shop.
After this poor treatment, he barely made his way to Perugia,
where he was given a warm welcome and new clothes by the
painter Domenico di Paris,* for whom he drew a cartoon for
a panel painting of the Magi, a most beautiful work which can

be seen at Domenico's home. But Rosso did not remain there
for long, since he heard that Bishop Tornabuoni, who had also
fled from the Sack of Rome, had come to Borgo San Sepolcro,
and so he went there himself, since he was close friends with
the bishop.

At that time, there was a painter in Borgo San Sepolcro
named Raffaello dal Colle,* the pupil of Giulio Romano, who
had undertaken a very inexpensive panel painting in his native
city for Santa Croce, the seat of the confraternity of
Flagellants, and he very kindly gave up the commission and
gave it to Rosso so that some memorial of him might remain
in that town. And although the confraternity was offended,
the bishop offered Rosso many conveniences. Once the panel,
which brought him renown, was completed, it was placed in
Santa Croce: and this Deposition from the Cross* is a very
rare and beautiful work, for in his colouring Rosso respected
the special quality of darkness from the eclipse that occurred
when Christ died, and he also executed the work with the
greatest care. Afterwards, Rosso was commissioned to do a
panel in Città di Castello,* which he had begun work on, and
was priming with gesso, when the roof collapsed and crushed
everything, and he caught such a bestial fever that he was
on the verge of death and was carried from Castello back
to Borgo San Sepolcro. Since this illness was followed by
quartan malaria, Rosso then moved to Pieve a Santo Stefano
to take the air and finally to Arezzo, where he was nursed in
the home of Benedetto Spadari, who with the support of
Giovanni Antonio Lappoli of Arezzo and as many friends and
relatives as they both had together, worked things out in such
a way that Rosso was asked to fresco a vault for the Madonna
delle Lagrime, a work already assigned to the painter Niccolò
Soggi. And so that Rosso would leave behind some memorial
of himself in the city, he was commissioned to do this work
at a price of three hundred gold *scudi*. Thus, Rosso began
drawing the cartoons in a room they had assigned him in a
place called Murello, and he finished four of them there.

In one of them, he drew our first parents bound to the tree
of sin, along with Our Lady who removes sin from their
mouths in the form of that apple, while under their feet he

depicted the serpent, and in the air (wishing to symbolize that She was clothed by the sun and the moon) he depicted Phoebus Apollo and Diana in the nude. In another cartoon, where Moses is carrying the Ark of the Covenant, he depicts Our Lady surrounded by five Virtues. In another, he drew the throne of Solomon, again depicting Our Lady to whom votive offerings are presented to symbolize those who can turn to Her for grace, with other curious ideas that were invented by the fine mind of Messer Giovanni Polastra, a canon from Arezzo and Rosso's friend, for whose satisfaction Rosso executed a very beautiful model of the entire project, which is now in our home in Arezzo. Rosso also drew a study of nudes for this painting, which is a very unusual work: it was thus a pity he did not complete it, since if he had begun it and executed it in oils rather than fresco it would truly have been a miracle. But Rosso was always opposed to working in fresco, and so he continued to procrastinate drawing his cartoons, intending to have them finished by Raffaello dal Borgo and others, and he never completed the project.

At that same time, since he was a courteous person, he did many drawings in Arezzo and the surrounding countryside for paintings and buildings, such as the one for the rectors of the fraternity of the chapel located at the foot of the piazza which now contains the Holy Face of Christ, for whom Rosso had sketched a panel which he was to execute in his own hand in the same place, depicting Our Lady with a crowd of people under Her mantle.* This sketch which Rosso never executed, is in our book of drawings, along with many other very beautiful ones from his own hand.

But to return to the painting that Rosso was supposed to do for the Madonna delle Lagrime Church. Giovanni Antonio Lappoli of Arezzo, Rosso's trusted friend, had acted as guarantor for this project and with every kind of service had shown Rosso his affection. But in the year 1530, while Florence was under siege and because of Papo Altoviti's lack of prudence, the Aretines, who remained free, attacked the citadel and pulled it to the ground. And since the Aretines bore ill will towards the Florentines, Rosso refused to trust them and went to Borgo San Sepolcro, leaving his cartoons and the drawings

for the project locked up in the citadel: the people of Città
di Castello who had commissioned him to do the panel
wanted him to complete it, but because of the illness he had
experienced there, Rosso did not wish to return, and so he
completed their panel in Borgo San Sepolcro. He did not even
want to give them the pleasure of being able to see the paint-
ing, in which he depicted a crowd of people with Christ in the
air, held in adoration by four figures, and he also painted
Moors, gypsies, and the strangest things in the world; and,
apart from the figures, which are perfect in their excellence,
the composition follows everything but the intentions of those
who had requested the picture. At the same time, while he was
working on this, he exhumed dead bodies in the bishop's pal-
ace where he was staying, and drew very beautiful anatomical
studies. In truth, Rosso was a great student of the details of the
art of painting, and few days passed without his sketching
some nude figure from life.

Now, having always imagined finishing his life in France
and getting away from a certain kind of wretchedness and
poverty in which, as he used to say, those who work in
Tuscany and in the towns where they were born are trapped,
Rosso decided to leave. And he had recently learned the Latin
language, in order to appear more experienced in all things
and to have a universal background, when something hap-
pened to him which greatly hastened his departure; for one
Holy Thursday when Matins are said in the evening, a young
Aretine who was his pupil was in church, and while they were
singing what are called the *Tenebrae*, he ignited some flames
of fire with a lighted candlewick and some hard resin, and
the boy was reprimanded and beaten by some priests. When
Rosso, beside whom the young man was sitting, saw this, he
bristled with animosity towards the priest. An uproar arose,
without anyone knowing how the affair had begun, and they
pursued poor Rosso, who was fighting with the priests, with
drawn swords. He escaped and managed to take shelter in his
quarters without being injured or overtaken by anyone. But
considering himself dishonoured by this, he completed the
panel for Castello, and without worrying about the work for
Arezzo or the damage he was doing to Giovanni Antonio, his

guarantor, since he had received more than one hundred and
fifty *scudi*, he left during the night and, taking the Pesaro road,
went to Venice.*

In Venice, Rosso was entertained by Messer Pietro Aretino,
for whom he drew, on a sheet of paper which was later
engraved, the figure of Mars sleeping with Venus while her
Cupids and the Graces are undressing him and dragging his
cuirass about. After leaving Venice, he went to France, where
he was received with great affection by the Florentine com-
munity. He did several paintings here, later hung in the
gallery at Fontainebleau, which he gave to King Francis,
who liked them immensely but enjoyed even more Rosso's
company, his conversation, and his style of living, for Rosso
was a large man with red hair corresponding to his name,
and in all his actions he was serious, considerate, and very
judicious. The king, therefore, immediately ordered that he
receive a salary of four hundred *scudi* and gave him a home in
Paris, where he seldom stayed so that he could spend most of
his time at Fontainebleau, where he had quarters and lived like
a lord, and Francis made Rosso the superintendent of all the
buildings, paintings, and other decorations in that place.

Rosso first began to build a gallery over the lower court,
creating overhead not a vault but a flat ceiling, or, rather, a
ceiling of woodwork with very beautiful partitions; he had
the walls on every side covered in stucco with bizarre and
extravagant panels, and he employed various kinds of carved
cornices, with life-sized figures on the supports, decorating the
parts beneath the cornices, between one support and another,
with garlands of the richest stucco or with paintings of the
most beautiful fruit and greenery of every type. And then, in a
large room (if what I have heard is true), following his own
design, he had some twenty-four scenes painted in fresco
depicting, I believe, the deeds of Alexander the Great; as I said,
he executed all the drawings, which were in water-colours and
chiaroscuro.

At the two ends of this gallery are two oil paintings he him-
self designed and executed with such perfection that little
better could be seen in painting. In one of them, there are the
figures of Bacchus and Venus, executed with marvellous skill

and judgement. Bacchus is a naked young man, so tender, delicate, and sweet that he seems to be living, palpable flesh and alive rather than painted. And around him are some imaginary vases in gold, silver, crystal, and various precious stones, so extravagant and covered with such curious decorations that whoever sees this work with its many inventions will remain full of amazement. Among the other details, there is also a satyr raising part of a pavilion, whose head is of astonishing beauty with its strange goat-like face, and especially because it seems to laugh and to be filled with mirth at the sight of such a handsome young man. There is also a putto riding a bear which is very beautiful, and many other graceful and beautiful ornaments scattered about. The other painting contains Cupid and Venus along with other beautiful figures. But the one with which Rosso took the greatest pains is that of Cupid, for he imagined a twelve-year-old putto but one who had grown up and possessed greater strength than is common at that age, most beautiful in every respect.

When the king saw these works and was exceedingly pleased by them, he regarded Rosso with incredible affection, and not long afterwards the king gave Rosso the canonry in the Holy Chapel of Our Lady in Paris, as well as many other revenues and benefices, so that, with a goodly number of servants and horses, Rosso lived like a lord and gave banquets and performed extraordinary acts of courtesy for all his acquaintances and friends, and especially for foreigners from Italy who happened to be in those parts. He then built another hall, called the Pavilion, because it is above the first-floor rooms and is thus above all the other rooms in the form of a pavilion: he decorated it from the floor up to the ceiling with various beautiful stucco decorations and figures in full relief at regular intervals, and with putti, garlands, and various kinds of animals. And in the compartments in the walls, he painted seated figures in fresco in such great number that they represent all the gods and goddesses of the ancient pagan world. And at the end over the windows there is a frieze completely decorated with stuccoes and extremely rich, but without paintings. Then in many of the chambers, bathrooms, and other rooms, he created countless stuccoes and paintings, some

of which were drawn and can be seen in circulation as engravings that are very beautiful and graceful, as are the countless drawings that Rosso made for salt-cellars, vases, large bowls, and other curious items, all of which the king later had cast in silver, and which were so numerous that it would be impossible to mention all of them. It will suffice, however, to say that Rosso executed the designs for all the vessels in the king's credenza, and all those items for the trappings of horses, masquerades, triumphs, and all the other things you could imagine; and with such strange and unusual objects, it is impossible to do better than Rosso.

In the year 1540, when the Emperor Charles V came to France under the safe-conduct of King Francis with no more than twelve of his men, Rosso created half of the decorations that the king had ordered to honour such an emperor at Fontainebleau. The other half were created by Francesco Primaticcio of Bologna.* But the things that Rosso created for arches, colossal structures, and other similar buildings were, according to what was said at the time, the most stupendous that had ever been constructed by anyone until then. But most of the rooms Rosso built at Fontainebleau were torn down after his death by this Francesco Primaticcio, who built a newer and larger building in that location. . . . *

Besides the works already mentioned, Rosso did a figure of Saint Michael which is an exceptional work. And for the High Constable he painted a panel of the Dead Christ, an exceptional work located at one of the Constable's properties in Écouen,* and he also produced wonderful miniatures for the king. He then did a book of anatomical figures to be published in France, from which there are some examples by his own hand in our book of drawings; and, after his death, two extremely beautiful cartoons were found among his personal effects: in one of them is a figure of Leda, which is a most singular work, while in the other is the Tiburtine Sibyl, who is showing to the Emperor Augustus the glorious Virgin with Christ in Her arms. In this cartoon, he drew King Francis, the queen, the guards, and the people with such a great number of figures so well executed that one can truthfully say this work was one of the most beautiful things Rosso ever created.

Because of these works and of many others we know nothing about, Rosso so pleased the king that shortly before his death he found himself with an income of more than a thousand *scudi*, not counting the provisions for his work, which were huge. As a result, he lived more like a prince than a painter, keeping numerous servants and riding-horses, and he had his house furnished with tapestries and silver, and other furnishings and household goods; then Fortune, who rarely or never allows anyone who places too much trust in her to retain high rank for long, brought Rosso to an unfortunate end in the strangest possible manner in the world. For while Francesco di Pellegrino, a Florentine, who took pleasure in painting and was a great friend of Rosso, was associating with Rosso on close and intimate terms, Rosso was robbed of some hundreds of ducats. And Rosso, suspecting nobody else but this Francesco, had him taken away from court and tormented him greatly with rigorous questioning. But Francesco, who was innocent, confessed nothing but the truth and was finally released, and then, moved by righteous indignation, he was forced to show his resentment towards Rosso for the shameful charges Rosso had falsely filed against him. Thus, Francesco swore out a complaint of libel against Rosso, and he pressed him so closely that, being unable to help or to defend himself, Rosso saw he was in a sorry predicament, since he thought that he had not only falsely accused his friend but had also stained his own honour, and that denying his charges or adopting other shameful means would likewise prove him to be a disloyal and evil man. And so he decided to kill himself rather than be punished by others, and he chose this alternative.

One day when the king was at Fontainebleau, Rosso sent a peasant to Paris for a certain extremely poisonous liquor, pretending he wanted to use it to make his colours or varnishes, but intending, as he did so, to poison himself with it. The peasant thus returned with the liquor, and such was the evil power of this poison that, by merely holding his thumb over the mouth of the phial that had been carefully plugged with wax, he almost lost that finger, which was consumed and almost eaten up by the deadly power of this poison, which

shortly afterwards killed Rosso, who, though a very healthy man, had taken it so that it might, as it did, take his life in a few hours. When this news was brought to the king, he was displeased beyond all measure, for he believed that with Rosso's death he had lost the most excellent artist of his day. And so that his work would not perish, the king had it continued by Francesco Primaticcio of Bologna, who had already completed many works for him, as we have said, giving Francesco a fine abbey just as he had conferred a canonry upon Rosso.

Rosso died in the year 1541* and was greatly missed by his friends and fellow artists, who through his work had understood how much may be acquired from a prince by a man with universal talents, who is well-mannered and gentle in all his actions, as Rosso was, and who for many reasons has deserved and still deserves to be admired as a truly most excellent artist.

THE END OF THE LIFE OF ROSSO, FLORENTINE PAINTER

The Life of Giulio Romano, Painter
[1492 or 1499–1546]

Among the many, or rather countless, pupils of Raphael of
Urbino, most of whom turned out to be talented artists, there
was no one who imitated Raphael more closely in style,
invention, design, and colouring than Giulio Romano,* nor
was there anyone among them better grounded, bolder, more
confident, inventive, versatile, prolific, and well-rounded, not
to mention for the present that he was extremely gentle in
conversation, jovial, affable, gracious, and absolutely abound-
ing in the finest manners. These attributes caused him to be
well loved by Raphael, who could not have loved him more
had he been his son. And so it came about that Raphael always
used Giulio in his most important works, and especially in
painting the papal loggias for Leo X. For after Raphael had
completed the plans for the architecture, the decorations, and
the scenes, he had Giulio execute many of these paintings,
including, among others, the creation of Adam and Eve, the
creation of the animals, the construction of Noah's ark, the
sacrifice, and many other works which can be recognized by
the style, such as the one in which Pharaoh's daughter and her
maidservants find Moses in the basket cast into the river by the
Hebrews, a work which is marvellous for its extremely well-
executed landscape.

Giulio also assisted Raphael* in painting many of the works
in the rooms of the Borgia Tower, which contains the burn-
ing of the Borgo, and particularly the bronze-coloured base,
Countess Matilda, King Pepin, Charlemagne, Godfrey of
Bouillon (King of Jerusalem), and other benefactors of the
Church, all of which are extremely good figures. Recently
part of this scene was published in prints, taken from a draw-
ing in Giulio's own hand; he also worked on most of the

scenes done in fresco for Agostino Chigi's loggia, and in oil he worked on a very beautiful painting of Saint Elizabeth which Raphael did and sent to King Francis of France along with another picture of Saint Margaret, almost entirely painted by Giulio following a drawing by Raphael, who sent the same king the portrait of the viceroy of Naples' wife, in which he did only the head from life while Giulio finished the rest. These works, which pleased the king greatly, are still in France at Fontainebleau in the king's chapel.

And since Giulio exerted himself in this fashion in the service of Raphael, his master, and learned about the greatest difficulties in the art of painting which Raphael taught him with incredible loving-kindness, it was not long before he was perfectly able to draw in perspective, to measure buildings, and to work up plans. And sometimes when Raphael was making drawings and sketching out his inventions in his own fashion, he would later have them measured out and enlarged by Giulio to use them in his own architectural works. In this way, Giulio began to take delight in architecture, and studied it so thoroughly that when he later began to practise it he became a most distinguished master.

Once Raphael died and Giulio and Giovanfrancesco, called Il Fattore,* were named his heirs with the charge of finishing the works that Raphael had begun, they honourably brought most of them to completion. After Cardinal Giulio de' Medici, who later became Clement VII, had acquired a site in Rome under Monte Mario where, besides a beautiful view, there were springs of fresh water, some gently sloping woodlands, and a beautiful plain that ran alongside the Tiber as far as Ponte Molle and formed on one side and the other a stretch of meadows that extended almost up to the gates of Saint Peter's, he planned to erect a palace at the top of the slope on the level ground there, with all the comforts and conveniences of rooms, loggias, gardens, fountains, woods, and the like, as beautiful and excellent as could be wished for, and he gave the whole task to Giulio,* who took it on willingly and set his hand to it, eventually bringing that palace, which then was called the Vigna de' Medici and today the Villa Madama, to the level of perfection that will be described below. Accom-

modating himself to the qualities of the site and the cardinal's
wishes, Giulio designed a semicircular façade for the front, like
a theatre, dividing it into niches and windows of the Ionic
order, which was so highly praised that many people believed
Raphael executed the first sketch for it and that the work was
then continued and brought to completion by Giulio. Giulio
painted many pictures in the rooms and elsewhere, and
especially beyond the first vestibule, in a very beautiful loggia
he decorated with large and small niches on every side in
which there are a great many antique statues; among them
there was the statue of Jove, a rare work, which was later sent
by the Farnese family to King Francis of France, along with
many other extremely beautiful statues. Besides these niches,
he adorned this loggia with stuccoes, while Giovanni da
Udine covered the walls and vaults with many grotesques.
At the head of the loggia, Giulio painted an enormous
Polyphemus in fresco, along with countless young children
and little satyrs who are at play around him, for which Giulio
received great praise, as he did as well for all the works and
designs he executed for that site, which he adorned with
fishponds, pavements, rustic fountains, woods, and other sim-
ilar things, all extremely beautiful and constructed with fine
order and judgement. It is, of course, true that with the advent
of Leo's death the project was not continued at that time,
for when Adrian was named pope and Cardinal de' Medici
returned to Florence, all the public works begun by the pope's
predecessor remained at a standstill, along with this one.

Meanwhile, Giulio and Giovanfrancesco completed many
of the works of Raphael that had been left unfinished, and
they were preparing to execute some of the cartoons Raphael
had drawn for the painting of the great hall of the palace,
where Raphael had begun to paint four scenes from the life
and deeds of the Emperor Constantine and had, at the time of
his death, covered one wall with the undercoating for painting
in oils, when they perceived that Adrian, who was a man who
took no delight in painting or sculpture or in any other good
thing, did not care whether or not the hall was finished. Giulio
and Gianfrancesco were desperate, and along with them
Perino del Vaga, Giovanni da Udine, Bastiano Viniziano, and

other excellent artists who, while Adrian was alive, came close
to dying from hunger.* But as God willed, while the papal
court, accustomed to the grandeur of Leo, was completely
demoralized and all the best artists were thinking about where
they should take refuge, seeing that no skill was any longer
held in esteem, Adrian died, and Cardinal Giulio de' Medici
was elected supreme pontiff, taking the name of Clement VII,
who revived in a single day all the arts of design, along with
other skills. Both Giulio and Gianfrancesco, at the pope's
order, immediately began with great joy to complete the
above-mentioned Hall of Constantine, and they tore down the
façade which had been covered with the undercoating so that
it could be done in oil, leaving, however, as they were, two
figures they had previously painted in oil to serve as decora-
tion for the figures of certain popes, and these included the
figure of Justice and another similar to it.

The arrangement of the hall, which was low, had been
designed with good judgement by Raphael, who had placed
at its corners above all the doors some large niches, decorated
with putti holding various devices of Leo, such as lilies,
diamonds, plumes, and other devices of the House of Medici.
And in the niches, several popes in full pontifical dress were
seated, each one under a shade within the niche. And around
these same popes were several putti in the form of little angels
who were holding books and other appropriate objects in
their hands. Each pope stood between figures of two Virtues,
according to his principal merits, and just as the Apostle Peter
had Religion on one side and Charity or, rather, Piety, on the
other, in like manner all the others were accompanied by
other similar Virtues, and the popes represented were Damasus I,
Alexander I, Leo III, Gregory, Sylvester, and some others.
They were all very well situated and executed by Giulio, who
did the best-known parts of this work in fresco, for he toiled
on them and took great pains with them, as can be seen from a
paper drawing of Saint Sylvester that was very well designed
by Giulio himself and is perhaps more graceful than the paint-
ing done from it. Although it can be said that Giulio always
expressed his ideas better in his drawings than in his works or
paintings, since there is, in the former, more vitality, boldness,

and emotion. And this perhaps occurred because, filled with the boldness and passion of working, he could complete a drawing in an hour, while painting consumed months or even years. Thus, finding them tiresome and lacking that fervent and burning love that an artist has when he begins something, it is not surprising if he failed to bring his paintings to that complete perfection visible in his drawings.

But to return to the scenes. On one of the walls Giulio depicted Constantine making a speech to his troops, while in the air a cross appears in a radiant light, along with a number of putti and letters which read: IN HOC SIGNO VINCES. A dwarf at Constantine's feet donning a helmet is executed with great skill. Then on the main wall is the cavalry battle which took place near the Ponte Molle where Constantine defeated Maxentius. Because of the figures of the wounded and dead that can be seen in it, as well as the strange and varied poses of the groups of infantrymen and horsemen, all done boldly, this is a most commendable work, not to mention the fact that it contains many portraits from life. And if this scene had not been too shaded and tinted with blacks, which Giulio always liked in his colouring, it would have been completely perfect; but this takes away much of its grace and beauty. In the same scene, Giulio painted the entire landscape of Monte Mario, with Maxentius who is drowning in the Tiber on a horse, all proud and awesome. In short, Giulio acquitted himself in this work in such a way that for this kind of battle scene this painting has been a source of great inspiration for anyone after him who has done something similar; he learned so much from the ancient columns of Trajan and Antoninus in Rome that he made use of what he had seen in the uniforms of the soldiers, their armour, banners, ramparts, stockades, battering-rams, and all the other implements of war painted throughout this hall. And under these scenes all around the room he painted many objects in the colour of bronze, which are all beautiful and praiseworthy. On the other wall, he depicted Saint Sylvester the pope baptizing Constantine, and he represents the very baptismal font made by Constantine found today in Saint John Lateran; he also drew a portrait of Pope Clement from life for the figure of Saint Sylvester, who is carrying on

the baptism with some assistants in vestments and many other people. Among the many members of the pope's household that he likewise painted from life, he depicted Cavalierino, who then advised His Holiness, and Messer Niccolò Vespucci, a knight of Rhodes. And below this on the base he painted in bronze-coloured figures Constantine having the church of Saint Peter's built in Rome (an allusion to Pope Clement), as well as the architect Bramante and Giuliano Leno, who holds in his hand the drawing of the ground-plan for this church, which is a very beautiful scene.

On the fourth wall, above the fireplace in this hall, he depicted the church of Saint Peter's in perspective with the papal residence as it is when the pope sings the pontifical Mass, with the order of cardinals, other prelates from the entire court, and the chapel of the singers and musicians, and the pope is seated, representing Saint Sylvester with Constantine kneeling at his feet and offering him a symbol of Rome made of gold similar to those on ancient medals, by which Constantine meant to symbolize the gift the emperor gave to the Roman Church. In this scene, Giulio painted many women watching this ceremony on their knees, all of whom are very beautiful, as well as a poor man begging for alms, a putto riding a dog and playing, and the lancers of the papal guard who are forcing the crowd to make way and move back, as is customary. And among the many portraits this work contains are those of Giulio, the painter himself, done from life, and Count Baldassare Castiglione, the author of *The Courtier* and Giulio's close friend, along with those of Pontano, Marullo, and other courtiers and men of letters. Around and between the windows, Giulio painted numerous devices and mythological scenes that were charming and fanciful; as a result, every detail delighted the pope, who rewarded Giulio generously for his labours.

While this room was being decorated, Giulio and Giovanfrancesco, though unable to satisfy their friends even in part, executed a panel of the Assumption of Our Lady which was very beautiful and which was sent to Perugia and placed in the convent of the nuns of Monteluce.* Afterwards Giulio withdrew into seclusion and painted a picture of Our Lady

containing a cat so realistic it seemed to be alive: it was thus called the Picture of the Cat.* In another large painting, he did the figure of Christ being scourged on the column that was placed on the altar of the church of Santa Prassede in Rome.* Not long afterwards, Messer Giovanmatteo Giberti, later bishop of Verona but at that time the datary of Pope Clement, had Giulio, who was his very intimate friend, design some rooms to be built with bricks near the gate of the papal palace overlooking the piazza of Saint Peter's where the trumpeters stand when the cardinals go into the consistory, along with a very commodious flight of steps that can be ascended on horseback or on foot. For this same Messer Giovanmatteo, Giulio did a panel painting of the Stoning of Saint Stephen, which Giovanmatteo sent to a benefice of his in Genoa of the same name [as that of the saint]. In this panel, which is most beautiful for its invention, grace, and composition, the young Paul can be seen sitting upon the garments of Saint Stephen while the Jews are stoning him. In short, Giulio never produced a work more beautiful than this one on account of the bold poses of the stone-throwers and the well-expressed patience of Stephen, who truly seems to be seeing Jesus Christ seated on the right hand of God the Father in a divinely painted heaven. Messer Giovanmatteo presented this painting, along with his benefice, to the monks of Monte Olivetto, who have turned the site into a monastery.

Giulio also painted for the German Jacob Fugger a beautiful panel painting in oil for a chapel in Santa Maria dell'Anima in Rome, which contains Our Lady, Saint Anne, Saint Joseph, Saint James, Saint John as a young child crawling on his knees, and Saint Mark the Evangelist with a lion lying at his feet* with a book, whose coat turns according to the position in which he lies. This was a difficult and beautiful detail, not to mention the fact that this same lion has short wings on its shoulders whose feathers are so soft and downy that it seems impossible to believe that the hand of an artist could imitate Nature so closely. Besides that, he also painted a building that curves around like an amphitheatre and contains statues of such beauty and composition that none better could be seen. And among other figures, there is one of a woman spinning

who is watching her hen and its chicks which could not be more natural. And above Our Lady are some very well executed and graceful putti holding up a pavilion. And if this painting were not so tinted with black, as a result of which it has become extremely dark, it certainly would have been much better. But this black colour causes the greater part of Giulio's labours in the painting to be lost or obscured, since black, even when varnished, causes good parts of a painting to be lost, for black always has an acid effect, whether it contains charcoal, burnt ivory, smoke-black, or burned paper. . . . *

Because of his excellent qualities, Giulio was celebrated as the best artist in Italy after the death of Raphael, and Count Baldassare Castiglione, in Rome at that time as the ambassador of Federigo Gonzaga, Marquis of Mantua, and, as was previously mentioned, a close friend to Giulio, was ordered by the marquis, his lord, to procure an architect whom he could use to meet the needs of his palace and the city, and he stated that he would particularly like to have his dear Giulio, and the count worked at this so diligently with entreaties and promises that Giulio declared he would go at any time provided it was by the leave of Pope Clement. Once this permission had been obtained, and the count left for Mantua and then went from there as papal envoy to meet the emperor, he took Giulio with him,* and when they arrived, Castiglione presented Giulio to the marquis who, after many acts of kindness, gave Giulio an honourably furnished home and provided a salary and food for him, Benedetto Pagni, his pupil, and another young man who served Giulio. Moreover, the marquis sent Giulio several lengths of velvet and satin, as well as other kinds of cloth and fabric for his clothing. And afterwards, learning that Giulio had no horse, he had one of his own favourite horses, called Luggieri, brought out and gave it to Giulio, and when Giulio had mounted the horse, they went off outside the gate of San Sebastiano the distance of a shot from a crossbow to where His Excellency had a place and some stables called the Te,* in the middle of a meadow, where he kept the stud of his horses and his mares. And after they had arrived there, the marquis declared that, without destroying the old wall-work, he would like to prepare a small place where he could go and take

refuge on occasion to have lunch or amuse himself at dinner.

Having heard the marquis's wishes, Giulio surveyed everything, took the ground-plan for the site, and set to work; using the old walls, he constructed the first hall in a larger section (as one sees it today upon entering) with a suite of rooms on either side. And because the location possessed no living rock or convenient quarries that could provide stone for cutting and carving as used in buildings by those who can find them, he employed bricks and tiles, subsequently covered with stucco. And from these materials he constructed columns, bases, capitals, cornices, doors, windows, and other works with the most beautiful proportions, and with a new and extravagant style he created the decorations of the vaults with extremely beautiful partitions and richly adorned alcoves. This was the reason why the marquis later decided, after such a humble beginning, to make the entire edifice into a grand palace, for Giulio executed a very beautiful model, its courtyard rusticated inside and out, which pleased that ruler so much that he ordered an ample provision of money, while Giulio brought in many master craftsmen, and the work was rapidly brought to a conclusion.

The form of the palace is as follows: the edifice is square, and, in the middle, there is an open courtyard like a meadow or, really, a piazza, with four entrances opening into it across from each other. The first of these in view runs through, or rather passes, into an enormous loggia which opens through another entrance into the garden, while two others lead into various apartments, and all these are decorated with stuccoes and paintings. The vault of the hall into which the first entrance leads is divided into various compartments and painted in fresco, and on the walls are life-size portraits of all the most beautiful and most favoured horses from the marquis's stock, accompanied by dogs of the same coat or markings as the horses, along with their names; they were all drawn by Giulio and painted on the plaster in fresco by the painters Benedetto Pagni and Rinaldo Mantovano, who were Giulio's pupils, and to tell the truth they were done so well that they appear to be alive. From there, one proceeds into a room at one corner of the palace, which has a vault with very

beautiful compartments done in stucco and varied cornices,
enriched in some places with gold. And these cornices form a
compartment with four octagonals which rise at the highest
part of the vault to a picture of Cupid who is marrying Psyche
in the presence of Jove (who appears on high in a dazzling and
heavenly light) and all the other gods. It is impossible to see a
work done with greater grace or a better sense of design than
this scene; Giulio foreshortened the figures so well with the
view from below upwards that although some of these figures
measure barely an armslength, they appear to be three arms-
lengths in height when seen from the ground. And to tell the
truth, they are executed with admirable skill and ingenuity,
since besides making his figures seem alive (for they are done
in such relief), Giulio knew how to fool the human eye with
their pleasant appearance. Then, in the octagonals are all the
early stories of Psyche and the adversities that befell her
because of the wrath of Venus, executed with the same beauty
and perfection. In other angles, as well as in the windows,
there are many cupids that produce different effects according
to the spaces they occupy, and this entire vault is painted in oil
by the previously mentioned Benedetto and Rinaldo. The rest
of the stories of Psyche are on the walls below (and these are
the largest): that is, one fresco depicts the moment when
Psyche is at her bath and the cupids are washing her and then
drying her with the most beautiful gestures. In another sec-
tion, Mercury prepares a banquet while Psyche is bathing,
with the Bacchantes playing their instruments, and the Graces
showering the table with flowers in the most beautiful man-
ner. And there is Silenus, held up by satyrs on his ass, just
above a goat sitting on the ground which has two putti
sucking its teats, while nearby is Bacchus with two tigers at his
feet, standing with one arm resting on a sideboard, on one side
of which is a camel and on the other an elephant. This side-
board, semicircular and shaped like a barrel, is covered with
garlands of greenery and flowers and completely full of vines
loaded with clusters of grapes and grape-leaves, under which
are three rows of unusual vases, basins, jugs, cups, goblets, and
other similar containers with various and fanciful forms that
are so lustrous they seem to be made of real silver or gold,

being counterfeited with a simple yellow colour or another colour so well that they demonstrate the genius, ability, and skill of Giulio, who in this section showed himself to be versatile, rich, and copiously endowed with powers of invention and craftsmanship. A short distance away is Psyche who, while the many women around her serve and present her, sees in distant hills Phoebus Apollo arising with his sun chariot, driven by four horses, while Zephyr, lying completely naked upon some clouds, blows through a horn in his mouth the gentlest breezes, creating a calm and cheerful atmosphere all around Psyche. Not many years ago, these scenes were printed from drawings by Batista Franco, the Venetian, who copied them exactly as they were painted from Giulio's large cartoons by Benedetto da Pescia and Rinaldo Mantovano, who executed all these scenes except for Bacchus, Silenus, and the two putti suckled by the goat. It is true, however, that the work was subsequently almost completely retouched by Giulio, and thus it is as if it had been completely painted by him. This technique, which Giulio learned from his teacher Raphael, is very useful for the young men who train themselves through it, for in this way they may succeed in becoming most excellent masters. And although some of them persuade themselves that they are greater painters than the master who puts them to work, when these young painters lose their guide before they reach the end or misplace the designs and working plans, they realize that by losing time or leaving their guide they are like blind men in a sea of countless errors.

But, to return to the apartments in the Te, one passes from the room of Psyche into another room completely full of double friezes with figures in low relief done in stucco according to Giulio's design by Francesco Primaticcio of Bologna, then still a young man, and Giovambatista Mantovano. On these friezes all the ranks of the soldiers on Trajan's column in Rome are depicted in a beautiful style. And on a ceiling, or rather a soffit of an antechamber, there is an oil painting of Icarus, who, after being taught by his father Daedalus, tries to rise up too high as he flies, and after having seen the sign of Cancer and a foreshortened chariot of the sun drawn by four horses near the sign of Leo, loses his wings when the wax is

destroyed by the heat of the sun. And then Icarus can be seen hurtling headlong through the air, almost as if he is going to fall on the spectator, his face pale with the colour of death. This invention was carefully conceived and thought out by Giulio, for it truly appears real: in it, one sees the burning heat of the sun scorch the wings of the wretched young man, as the blazing fire smokes, and one can almost hear the crackling of the burning feathers, while death can be seen sculpted on the face of Icarus, and on that of Daedalus his emotion and sharp pain. In our book of drawings by various painters, there is the actual drawing of this very beautiful scene by Giulio himself, who also executed in the same place the scenes of the twelve months of the year and the crafts most commonly practised by men in each one of them; this painting is no less full of fancy, beautiful inventions, and charm than reflective of the judgement and care with which it was finished.

Passing through this great loggia decorated with stuccoes, as well as many arms and various other unusual ornaments, one arrives in certain rooms so full of different imaginative creations that the mind is dazzled there; and in order to prove his worth, Giulio, who was extremely inventive and resourceful, made plans to build a corner-room similar to the previously mentioned room of Psyche in another angle of the palace in which the walls would correspond with the paintings, in order to deceive the people who would see it as much as he could.* Therefore, after laying deep, double foundations in that corner, which was in a swampy spot, Giulio had built over that angle a large, round room with extremely thick walls, so that the four corners of the outside walls would be stronger and could support a double vault rounded like an oven. And having done this, since the room had corners, he built here and there all the way around it the doors, windows, and a fireplace of rusticated stones with worn-away edges, which were disjointed and crooked almost to the extent that they even seemed to lean over on one side and actually to collapse. And after building this room in such a strange fashion, Giulio began to paint there the most fanciful composition that one could encounter, that is, Jove annihilating the giants with his thunderbolts. And so, after depicting heaven, Giulio painted

Jove's throne on the highest part of the vault, foreshortening it from below upwards and from the front, inside a round temple above columns adorned in the Ionic style, with his canopy in the middle above his throne and his eagle, and all of this placed above the clouds.

Then, lower down, Giulio depicted Jove enraged, striking down the arrogant giants with his thunderbolts, while still lower Juno helps him, and around them the winds, with certain strange expressions, are blowing towards the earth, while the goddess Ops turns with her lions at the terrible noise of the thunderbolts, as do the other gods and goddesses, especially Venus, who is standing next to Mars and Momus with outstretched arms, and seems to fear that the heavens will come crashing down, yet stands motionless. Likewise, the Graces are standing there full of fear, and nearby the Hours are in the same condition. In short, all the deities are starting to flee with their chariots. The Moon as well as Saturn and Janus are heading towards a clearing of daylight in the clouds to move away from that dreadful terror and fury, and Neptune is doing the same, for it seems as if he is trying to rest with his dolphins upon his trident. Pallas and the nine Muses are staring and wondering what horrible thing this may be. And Pan, embracing a nymph trembling in terror, apparently wishes to save her from that conflagration and the flashes of lightning that fill the heavens. Apollo stands in the chariot of the sun, while some of the Hours seemingly wish to hold his horses from their course. Bacchus and Silenus, with their satyrs and nymphs, show their great fear. And Vulcan, with his heavy hammer over one shoulder, looks towards Hercules, who is speaking about the situation with Mercury, standing alongside Pomona, who is completely terrified, as is Vertumnus along with all the other gods scattered throughout that heaven where all the effects of fear are carefully scattered about, both in those who remain as well as in those who are fleeing, so that it would be impossible to imagine, let alone see, a fantasy in painting more beautiful than this one.

In the parts below, that is, on the walls standing below under the curve of the vault, are the giants, some of whom, underneath Jove, have mountains and enormous rocks on their

backs, supported by their strong shoulders, in order to pile them up for their ascent towards heaven, where their ruin is being prepared, for with Jove hurling his thunderbolts and all of heaven enraged against them, it appears not only that the gods are frightened by the reckless daring of the giants, destroying them with the mountains on their backs, but that the entire world is upside-down and almost at its final end. In this part, Giulio painted Briareus in a dark cavern, almost completely buried by huge segments of rock from the mountains, with all the other giants crushed or dead under landslides from the mountains. Besides this, through a cleft in the darkness of a grotto, which reveals a scene in the distance executed with fine judgement, many giants can be seen in flight, all struck down by Jove's thunderbolts and on the verge of being overwhelmed by the landslides from the mountains just like the others. In another part, Giulio represented other giants upon whom are crashing down temples, columns, and other parts of buildings, creating among these arrogant creatures great havoc and loss of life. And in this spot among the buildings crashing down was placed the fireplace for the room which, when a fire is lit, makes it seem as if the giants are burning, for Pluto is painted there fleeing towards the centre with his chariot driven by wizened horses and accompanied by the hellish Furies. And so, without any deviation, Giulio used this invention of the fire to make an extremely beautiful decoration for the fireplace. Moreover, to make this work more terrifying and awful, Giulio depicted the giants as huge and deformed, being struck down in various ways by lightning and thunderbolts, and crashing to the earth: some in the foreground, others in the background, some dead, others wounded, some completely buried by mountains, others by buildings.

Therefore, let no one ever imagine seeing a work from the brush that is more horrible or frightening or more realistic than this one. And anyone who enters that room and sees the windows, doors, and other such details all distorted and almost on the verge of crashing down, as well as the mountains and buildings collapsing, can only fear that everything is toppling down upon him, especially when he sees all the gods in that

heaven running this way and that in flight. And what is marvellous about the work is that the entire painting has neither beginning nor end, and that it is all tied together and runs on continuously without boundary or decoration so that the details near the buildings seem very large, while those in the landscapes recede into infinity. As a result this room, which is no longer than fifteen armslengths, seems like a place in the countryside; in addition, since the pavement is made of small, round stones set in with a knife, and the lower parts of the walls are painted with the same stones, no sharp angle appears there, and the entire room comes to look as if it were one vast plane. This was accomplished by Giulio with good judgement and admirable skill, and to him our artisans owe a great debt for such inventions.

The Rinaldo Mantovano mentioned above became a perfect colourist in this work, for while working with Giulio's cartoons he brought the entire project to perfection, along with the other rooms as well. And if he had not been taken from this world while still a young man, just as he brought honour to Giulio while alive, he would have done so after Giulio's death. Besides this palace, where Giulio completed many things worthy of praise about which I shall say nothing in order to avoid too lengthy a discussion, he rebuilt many of the rooms in the castle at Mantua where the duke lives,* and constructed two large spiral staircases with very magnificent apartments, all decorated with stucco. And in one room he had the entire history of the Trojan war painted, and likewise, in an antechamber, twelve scenes in oil under the busts of the twelve emperors previously painted by Titian Vecelli and considered most rare.... *

After the death of Duke Federigo,* by whom Giulio was loved beyond all belief, Giulio was so distressed that he would have left Mantua if the cardinal, the duke's brother, to whom it was left to govern the state because Federigo's sons were too young, had not kept him in that city where he had a wife, children, homes, country properties, and all the other conveniences necessary for a gentleman of means. And the cardinal did this, besides the reasons already mentioned, because he needed Giulio's advice and assistance in renovating

and practically building anew the entire Duomo of the city.* Setting his hand to this, Giulio carried the work quite far forward in a beautiful fashion.

During this time, Giorgio Vasari, who was an intimate friend of Giulio even though they knew each other only by reputation and through corresponding, took the road through Mantua to see Giulio and his works on the way to Venice.* And when he reached Mantua, he went to find the friend he had never met, and when they ran into each other they recognized each other as if they had been together in person a thousand times before. This made Giulio so content and happy that for four days he never left Giorgio's side, showing him all his works and especially all the ground-plans for the ancient monuments of Rome, Naples, Pozzuoli, and the Campagna, and all the other best antiquities of which there is a record, drawn partly by him and partly by others. Then, having opened an enormous cupboard, Giulio showed him the ground-plans for all the buildings that had been constructed following his designs and instructions, not only in Mantua and Rome but throughout Lombardy, and they were so beautiful that I do not believe it possible to see more original or beautiful ideas for buildings, or any so well laid out. Afterwards, the cardinal asked Giorgio what he thought of Giulio's works, and Giorgio replied (in Giulio's presence) that they were of such a quality that he deserved to have his statue erected in every corner of the city, and that for his renovations, one half of that state would not be enough to repay Giulio's labours and talents. To this the cardinal replied that Giulio was more the master of the state than he was himself. And because Giulio was very affectionate, especially with his friends, there was no mark of love and kindness that Giorgio did not receive from him.

When Vasari left Mantua and went to Venice and then returned to Rome, at exactly the time Michelangelo had uncovered his Last Judgement in the Sistine Chapel,* he sent to Giulio, by way of Messer Nino Nini of Cortona, secretary to the same cardinal of Mantua, three sheets of drawings depicting the seven deadly sins, sketched from Michelangelo's Last Judgement, which Giulio treasured beyond all measure

for their intrinsic value and also because at that time he had to decorate a chapel in the palace for the cardinal, and the drawings served to awaken his thoughts to greater things than he previously had in mind. And so he took the utmost care to create a very beautiful cartoon, and in it he depicted with fine fancy the moment when Peter and Andrew, called by Christ, leave their nets to follow Him, and from fishermen become fishers of men. This cartoon, which came out more beautifully than any Giulio had ever done, was later executed by the painter Fermo Guisoni, one of Giulio's students, who is today an excellent master.*

Not long afterwards, the superintendents of the Works Department of San Petronio in Bologna wanted to begin the façade for that church, and took the greatest pains in bringing Giulio there in the company of a Milanese architect named Tofano Lombardino,* a man then highly esteemed in Lombardy for the many buildings that can be seen there by his hand. So the two men then made a number of designs, and after those by Baldassare Peruzzi of Siena were lost, one of the drawings Giulio executed was so beautiful and well organized that he deserved to receive lavish praise from the people of Bologna and to be rewarded with generous gifts upon his return to Mantua. Meanwhile, since Antonio San Gallo had died about that time in Rome,* the deputies of the Works Department at Saint Peter's remained in great distress, not knowing to whom they could turn and entrust the task of completing such an enormous project according to the initial plans, and they thought that no one would be more capable of doing the job than Giulio Romano, of whose excellence and worth they all knew; and believing that he would more than willingly accept such a task in order to return to his native city honourably and with a huge salary, they had some of his friends sound him out, but it was in vain, for however willingly he might have gone, two things held him back: the cardinal, who did not want him to leave on any account, and his wife, friends, and relatives, who discouraged him in every way. But perhaps neither of these two considerations could have dissuaded him, had he not found himself unwell at the time. For considering how much honour and profit he and his

children could have gained by accepting such an honourable opportunity, he was completely determined to use every bit of his strength to avoid being prevented from doing this by the cardinal, when his illness began to worsen. But because it was ordained on high that he would go no more to Rome and that this would be the end of his life, what with disappointment and illness, he died within a few days in Mantua, which could easily have allowed him to have adorned and honoured his native city of Rome as he had embellished Mantua.

Giulio died at the age of fifty-four, leaving a single male child, to whom, in memory of his master, he had given the name Raphael. This boy had barely learned the first principles of the art of painting, with the promise of becoming a worthy man, when he died not many years later, along with his mother, Giulio's wife. And so, there remained of Giulio's family only a daughter named Virginia, who is still living in Mantua and married to Ercole Malatesta.

Giulio, whose death brought endless grief to everyone who knew him, was buried in San Barnaba with the idea of erecting some honourable monument for him. But his children and wife kept putting the matter off from one day to the next, and, for the most part, they have died without doing anything else about it. And indeed, it is a shame that there has never existed anyone to recognize this man, who did so much to honour that city, except those whom he served and who often remembered him in their moments of need. But his own talent, which brought him so much honour while he was alive, has after his death created for him through his works an eternal burial-place which neither time nor the years will ever destroy.

Giulio was neither large nor small in stature, compact rather than thin, with black hair, a handsome face, dark and sparkling eyes, full of loving-kindness, well-mannered in all his actions, frugal in eating, but fond of dressing and living honourably....*

THE END OF THE LIFE OF GIULIO ROMANO,

PAINTER

and, taking his leave from Lorenzo Beccafumi (from whom he assumed the family surname), he went off to Rome, where he arranged to live with a painter who kept him in his
... on many private Michelangelo, ancient statues and colou... ... so, nor much time passed before he became a high daught... ... man, prolific in his inventions, and a beautiful colourist ... During this period, which did not exceed two years, he did

The Life of Domenico Beccafumi, the Sienese Painter and Master Caster

[1486–1551]

That same talent which could be seen solely as a gift of Nature in Giotto and several of the other painters we have discussed to this point was most recently seen in Domenico Beccafumi, the Sienese painter, for while he was guarding some sheep belonging to his father, a man named Pacio who was a labourer for Lorenzo Beccafumi, a Sienese citizen, he was seen, child though he was, practising drawing all by himself on the rocks or in other ways; and it happened that one day this Lorenzo saw him sketching some things with a pointed stick in the sand of a small stream where he was tending his flock, and Lorenzo asked for the boy from his father, intending to employ him as a servant and at the same time to have him taught. Thus the boy, who was then called Mecherino, was given by his father Pacio to Lorenzo, who brought him to Siena, where, for a time, he made him spend the hours left over from household duties in the shop of a nearby painter of little worth. Nevertheless, what the man did not know he taught to Mecherino from the drawings he possessed by excellent painters which he used for his own purposes, as some masters do when they have few skills in design. And so by practising in this fashion, Mecherino showed promise of becoming a fine painter.

At this time Pietro Perugino, then a famous painter, happened to be in Siena, where he painted, as we have said, two panels, and Domenico liked his style so much that he began to study it and to sketch these panels, and not much time passed before he mastered this style. Later, after Michelangelo's chapel and the works of Raphael from Urbino were unveiled in Rome, Domenico, who had no greater desire than to learn, realized that he was wasting time in Siena,

DOMENICO BECCAFUMI

378

and, taking his leave from Lorenzo Beccafumi (from whom he assumed the family surname), he went off to Rome,* where he arranged to live with a painter who kept him in his home at his own expense and with whom Domenico worked on many projects, all the while studying the paintings of Michelangelo, Raphael, and other excellent masters, as well as ancient statues and columns of astonishing workmanship. And so, not much time passed before he became a bold draughtsman, prolific in his inventions, and a beautiful colourist. During this period, which did not exceed two years, he did nothing else worthy of note except a façade in the Borgo with the coat of arms of Pope Julius II in colour.

At this time, Giovan Antonio da Verzelli, the painter,* a young man of considerable skill, was brought to Siena (as will be explained in due course) by a merchant of the Spanocchi family, and he was frequently employed by the gentlemen of that city (which has always been a friend and supporter of all talented men), especially in the painting of portraits from life. And when Domenico, who very much wanted to return to his native city, heard this, he then went back to Siena, and seeing that Giovan Antonio had a very sound foundation in design (in which he knew the excellence of artists to consist), Domenico made every effort to follow him, feeling that what he had done in Rome was insufficient and practising hard at drawing anatomical figures and nudes. This helped him a great deal, and in a short time he began to be highly esteemed in that most noble city. Nor was he any less admired for his kindness and manners than for his painting: whereas Giovan Antonio was brutish, licentious, and eccentric and was called Il Sodoma because he always associated with and lived with young, beardless boys, a name to which he quite willingly responded, Domenico, on the other hand, who was well-mannered and decent, lived alone most of the time as a good Christian. And since in many cases those most esteemed by other men are those who can be called good and amusing companions rather than virtuous and well-mannered ones, most of the Sienese youth followed Il Sodoma and celebrated him as a singular individual. Il Sodoma, a capricious man, always kept parrots, apes, dwarf asses, small horses from Elba,

a talking crow, Barbary horses for racing in the Palio,* and other such things in his home to satisfy the rabble, and he had acquired a reputation among the vulgar, who talked of nothing but his follies.

And so, since Il Sodoma had painted the façade of Messer Agostino Bardi's house in fresco, Domenico, at the same time and in competition with him, frescoed the façade of one of the Borghesi homes by the column of the postern near the Duomo, a job in which he took great pains. In a frieze under the roof, he painted a number of small figures in chiaroscuro which were highly praised, and in the spaces between the three rows of travertine windows in this palatial home, he painted a great number of the ancient gods and other figures in a chiaroscuro the colour of bronze and other colours, all of which were more than reasonably well done, although those by Sodoma were more highly praised; and both of these façades were done in the year 1512. Afterwards, in San Benedetto, the property of the monks of Monte Oliveto outside the Tufi gate, Domenico did a panel painting of Saint Catherine of Siena receiving the stigmata under an apartment house, with Saint Benedict standing on her right side and Saint Jerome dressed as a cardinal on her left, a panel which for its extremely soft colouring and its great relief was and is still highly praised.* Likewise, on the predella of this panel, he painted some little scenes in tempera with boldness and incredible vitality, and with such facility of design that they could not be more graceful, and yet they seem to have been executed without a trace of effort. One of the little scenes depicts the moment when the angel places part of the host consecrated by the priest into Saint Catherine's mouth; another depicts her marriage with Jesus Christ and later the moment when she receives Saint Dominic's habit, along with other stories.

In a large panel inside the church of San Martino, Domenico painted the Nativity and Adoration of Christ by the Virgin, Joseph, and the shepherds, with a most beautiful group of angels dancing on high in the manger. In this work, which is widely praised by artisans, Domenico began to make those who knew something understand that his works were

executed on foundations very different from those by Il
Sodoma. Then, in the Spedale della Scala, he painted a fresco
of the Madonna's visit to Saint Elizabeth in a charming and
very natural style,* while in the church of Santo Spirito he
painted a panel of Our Lady with Her Child in Her arms Who
is marrying Saint Catherine of Siena, with figures of Saint
Bernardino, Saint Francis, Saint Jerome, and Saint Catherine
Virgin and Martyr on the sides.* And in front, standing upon
some steps, are the figures of Saint Peter and Saint Paul, in
which he depicts most skilfully some reflections of colour
from the clothing upon the polish of the marble staircase. This
painting, which was executed with great judgement and a fine
sense of design, won great honour for Domenico, as did a
number of small figures painted on the predella of the panel
which show Saint John baptizing Christ, a king throwing
the wife and children of Saint Sigismund into a well, Saint
Dominic having the books of the heretics burned, Christ
presenting to Saint Catherine of Siena two crowns, one of
roses and another of thorns, and Saint Bernardino of Siena
preaching to an enormous crowd in the main square of Siena.

Later, as a result of the fame of these works, Domenico was
commissioned to execute a panel which was to be placed in
the Carmine, in which he was to depict Saint Michael killing
Lucifer, and, as the inventive man he was, Domenico thought
of a new device to display the power and beautiful concepts
of his mind. And so, in order to represent Lucifer with his
followers being driven out of heaven because of their pride
into the profoundest depths of hell, he began with a shower
of nudes that is very beautiful, although because of the great
effort he put into them they appear somewhat confused. Since
this panel remained unfinished, it was taken after Domenico's
death to the Spedale della Scala near the high altar at the top
of the stairs, where it still may be seen* with great admiration
for certain of its foreshortened and extremely beautiful nudes,
and in the Carmine, where it was supposed to have been
located, another panel was substituted, in which the figure of
God the Father is depicted with the most charming grace
above the clouds in the heavens, surrounded by many angels,
while in the middle of the panel is the Angel Michael in

armour, pointing as he flies to show that he has placed Lucifer
at the centre of the earth, where there are burning walls, cave-
ins, and a lake of fire, with angels in various poses and naked
souls swimming around with different gestures that are suf-
fering torments in that conflagration. All this is rendered with
such lovely grace and style that the dark shadows in this
miraculous work seem to be illuminated by the fire, and for
that reason it has been considered a rare painting.* Baldassare
Peruzzi, the fine Sienese painter, never tired of praising it, and
one day, when I saw the painting with him as I was passing
through Siena, I remained amazed by it and by how Do-
menico also painted five small scenes for the predella in tem-
pera with beautiful and judicious style.*

Domenico did another panel for the nuns of Ognissanti
in the same city in which he painted the figure of Christ on
high in heaven crowning the Virgin in Her glory, while Saint
Gregory, Saint Anthony, Saint Mary Magdalene, and Saint
Catherine Virgin and Martyr stand below. In the predella
there are likewise some very beautiful small figures done
in tempera.* In the home of Signor Marcello Agostini,
Domenico painted some extremely beautiful works in fresco
on the vault of a room containing three lunettes on each wall
and two lunettes at each end, with a row of friezes running all
around the room.* In the middle of the ceiling the compart-
ment forms two pictures: in the first, with a decoration of
feigned silk cloth, it seems that we can see woven upon it
Scipio Africanus returning the young bride intact to her hus-
band, and in the other Zeuxis, a most famous painter, is draw-
ing the portraits of several female nudes in order to create the
painting that must be placed in the temple of Juno. In one of
the lunettes are small but very beautiful figures about half an
armslength high which depict the two Roman brothers who
were enemies but became friends for the public good and the
benefit of their homeland. In another that follows there is the
figure of Torquatus* who, in order to obey the laws, must put
out his son's eyes, and who puts out one of his son's and one of
his own. In the one that follows there is the petition ... when,
after having been read a list of the crimes he has committed
against his homeland and the Roman people, he [Spurius

Cassius] is put to death.* And after this one the Roman people
is depicted as it decides in favour of Scipio's expedition to
Africa. Next to this one in another lunette is the picture of an
ancient sacrifice filled with different and very beautiful figures
containing a temple drawn in perspective which stands in very
high relief, for in this technique Domenico was truly a splen-
did master. The last contains Cato committing suicide as he
is overtaken by several horsemen, which are painted most
beautifully. Similarly, the spaces of the lunettes contain some
small scenes which are very well done, and the fine quality of
this work was the reason that those who were in the Sienese
government recognized Domenico to be an excellent painter
and engaged him to paint the vault of a hall in the Palazzo dei
Signori, in which he used all the care, pains, and effort he
could muster in order to prove his worth and to decorate that
celebrated place belonging to his homeland which paid him so
much honour.*

This hall, two compartments in length and one in width,
has a ceiling shaped like a ship's hull rather than composed of
lunettes. Thinking that it would turn out better in this fash-
ion, Domenico divided his paintings with gilded friezes and
cornices designed so well that, without any stuccoes or other
ornaments, it was so well finished and had such lovely grace
that it truly seems to have been done in relief. Then, at each
end of the hall, there is a large painting with a scene, and on
each wall there are two of them, separated by an octagonal
form. And so, there are six square paintings and two octagonal
ones, with each containing a scene. In the corners of the ceiling
at the angles, there is a tondo half of which is on one wall and
half on the other, and since these tondi are broken by the
angles of the ceiling, they form eight spaces. Inside each of
these are the large seated figures representing famous men
who have defended the republic and respected its laws. The
plane of the ceiling at its highest point is divided into three
parts, which form a circle in the middle directly above the
octagonals and two squares above the squares on the walls.
In one of the octagonals, then, there is a woman surrounded
by several children who is holding a heart in her hand to
symbolize the love one owes to one's homeland, while in the

other there is another woman with as many putti symbolizing Concord among the citizens. Between them is a figure of Justice, which is in the tondo with a sword and scales in her hands and foreshortened with a view from below upwards which is so boldly executed that it is a marvel, for the design and colouring is dark at the bottom near the feet and becomes clearer moving towards the figure's knees, and in this fashion continues gradually towards the torso, shoulders, and arms until the head is surrounded by a celestial brightness that makes it seem the figure will, little by little, go up in smoke. As a result, it is impossible to imagine, let alone see, a figure more beautiful than this one, or another executed with better judgement and skill among the many that have ever been painted and foreshortened from below upwards.

As for the scenes, in the first one at the end, where one enters the hall from the left, are the figures of the censors Marcus Emilius Lepidus and Fulvius Flaccus, who were enemies but immediately upon becoming colleagues in the magistracy of the censorship set aside their personal hatred for the good of the homeland and behaved in that office as close friends. Domenico painted these figures kneeling and embracing, with many figures around them and a very handsome arrangement of buildings and temples drawn so well and so ingeniously in perspective that they reveal the extent to which Domenico understood perspective. On the other wall in a square frame is the story of the dictator Postumius Tubertus, who, after having left in his place his only son in charge of the army, commanding him to do nothing but guard the camp, put his son to death for having been disobedient, when, taking a splendid opportunity, he assaulted the enemy and achieved victory. In this scene Domenico represented Postumius as an old, clean-shaven man, with his right hand resting upon the axe and with his left pointing out to his army his son dead upon the ground, a nicely foreshortened figure. Under this painting, which is very beautiful, is a most appropriate inscription. In the middle of the following octagonal is Spurius Cassius, who the Roman Senate feared would make himself king, and so they had him decapitated and destroyed his houses. In this scene, the head lying beside the executioner and

the body, foreshortened upon the ground, are very beautiful.
In the other square is the tribune Publius Mucius who burned
all his fellow tribunes who aspired, with Spurius, to tyrannize
the homeland; in this scene, the blaze burning their bodies is
well and skilfully done.

At the other end of the hall in another square painting is
Codrus the Athenian, who, after the oracle prophesied that
victory would belong to the side whose king was killed by his
enemies, removed his robes, entered the ranks of the enemy
unrecognized, and was killed, giving, with his own death, the
victory to his men. Domenico painted him seated with his
captains around him while he is undressing near a very beauti-
ful round temple. And in the distant background of the scene,
one can see the moment of his death and his name written
underneath in an epitaph. Turning then to the other long wall
facing the two square paintings that place the octagonal paint-
ing in the middle, one sees in the first scene Prince Seleucus,
who had one of his own eyes and one of his son's put out in
order to avoid violating the laws, while many people stand
around him, begging him in turn not to be so cruel against
himself and his son; in the distance, his son can be seen
violating a young girl, and below is his name in an epitaph. In
the octagonal beside this painting is the story of Marcus
Manilius, who was hurled from the Capitoline. The figure of
Marcus is that of a young man thrown from some circular
balconies, and done in a foreshortening with the head upside-
down so well that he seems alive, as do a number of figures
below. In the other square is Spurius Melius from the order of
knights, who was executed by the tribune Servilius because
the people suspected he would make himself tyrant of the city.
Servilius is seated with many people around him, while one of
the people in their midst points to Spurius lying dead on the
ground, a figure done with great skill.

Then, in the tondi paintings on the corners where the eight
figures are placed are many men who have been most un-
usual in their defence of their homeland. In the main section is
depicted the extremely famous Fabius Maximus, seated and in
armour. On the other side there is Speusippus, duke of the
Tegeates, who, when a friend tried to persuade him to rise up

against one of his rival adversaries, replied that, driven by personal interest, he did not wish to deprive the homeland of so worthy a citizen. In the tondo that follows in the other corner, there is on one side the praetor Caelius, who was punished by the senate for having offered battle against the advice and wishes of the soothsayers, even though he conquered the enemy and won the victory; at his side sits Thrasybulus, who, accompanied by some friends, valiantly kills thirty tyrants to liberate his homeland. He is an old, clean-shaven man with white hair, whose name is written beneath him, as are those of all the others. On the other side, in a corner below in a tondo, is the praetor Genutius Cippus, upon whose head a bird miraculously lighted with its wings in the shape of a horn, and who, when the oracle explained that he was to become king of his country, therefore decided, since he was already an old man, to go into exile in order to avoid this. And for that reason, Domenico paints a bird on his head. Next to him is sitting Charondas, who having returned from his country house immediately went to the Senate without disarming himself, violating a law which stated that anyone entering the Senate armed must be put to death, and who killed himself when he realized his error. In the last tondo on the other side are Damon and Pythias, whose singular friendship is widely noted, and with them is Dionysius, tyrant of Sicily. And next to these figures sits Brutus, who through his zeal for his homeland condemned his two sons to death because they sought to bring the Tarquins back into the country. This truly remarkable work, therefore, made the Sienese aware of the skill and worth of Domenico, who demonstrated in all his actions his skill, judgement, and great talent.

The first time the Emperor Charles V came to Italy, he was expected to go to Siena, as he had made his intentions known to the ambassadors of that republic, and among the other magnificent and grandiose preparations for the reception of such a great emperor, Domenico fashioned a horse in full relief eight armslengths high, made wholly of papier mâché and hollow inside. The weight of the horse was sustained by an iron framework, while upon the horse sat the statue of the emperor armed in the ancient style with his sword in his hand,

while beneath him were three large figures as if they had been conquered by him which also sustained some of the weight, since the horse was in the act of jumping with its front legs high in the air, and these three figures were to represent three provinces that the emperor had overcome and conquered. In this work Domenico showed that he understood sculpture no less than painting. In addition, the entire work was placed upon a wooden castle another four armslengths high with a set of wheels underneath which, when set in motion by men inside, were made to move along. Domenico's plan was that on His Majesty's entrance, the horse, being made to move in the way described above, would accompany him from the gate all the way to the Palazzo de' Signori and then would stop in the middle of the piazza. This horse, which had been executed completely by Domenico, who had nothing left to do but to gild it, remained in this state, because His Majesty did not go to Siena at that time but left Italy after having been crowned in Bologna, and the work remained unfinished. But Domenico's talent and ingenuity were nevertheless recognized, and the excellence and size of this machine was greatly praised by everyone; it remained in the Works Department of the Duomo from that time until the victorious return from the African campaign of His Majesty, who passed over to Messina and then to Naples, Rome, and finally Siena, and this time Domenico's work was set up in the piazza of the Duomo and won him great praise.*

Thus, the fame of Domenico's talent spread, and Prince Doria, who was with his court and had seen all the works in Siena by Domenico, sought to bring him to work in Genoa on his palace, where Perino del Vaga, Giovan Antonio da Pordenone, and Girolamo da Treviso had worked.* But Domenico could not promise that ruler he would go to work for him then, although he was willing to go another time, since at that moment he had started to complete part of the marble floor in the Duomo that the Sienese painter Duccio had begun earlier with a new style of workmanship.* And because the figures and a large number of the scenes had already been drawn on the marble, with outlines cut by the chisel and filled with a black mixture, surrounded by decora-

tions of coloured marble which also filled the backgrounds of the figures, Domenico's good judgement made him see that this work could be greatly improved, for with grey marble that would darken the middle portions, set alongside the clear colour of the white marble and outlined with the chisel, he discovered that one could thus produce works in stone with a perfect chiaroscuro effect using grey and white marble. Therefore, after he had done a test, the work turned out so well, because of its invention, its basic design, and the quantity of figures, that with this approach Domenico initiated the most beautiful, grandiose, and magnificent pavement that had ever been constructed, and, while he was alive, he gradually completed a large part of it. Around the high altar he created a frieze of pictures in which, following the order of the scenes begun by Duccio, he depicted stories from Genesis: that is, Adam and Eve, who are driven out of Paradise and work the land, as well as the sacrifice of Abel and that of Melchizedek. In front of the altar in a large scene is Abraham who wants to sacrifice Isaac, and this scene is surrounded by a border of half-length figures who seem to be leading various animals to sacrifice. Descending the steps, another large picture to accompany the one above can be found. In it Domenico represented Moses who is receiving the laws from God on Mount Sinai. And below, there is the scene where Moses, having discovered the people worshipping the golden calf, becomes enraged, and breaks the tablets upon which the law was written.

Across the church and opposite the pulpit is a frieze with numerous figures under this scene composed with such grace and design that it is difficult to describe. It contains the figure of Moses who strikes the rock in the desert, making the water gush forth and giving his thirsty people a drink; here Domenico made the water from the stream flow the entire length of the extended frieze, and the people are drinking from it in various ways with such animation and grace that it is almost impossible to imagine figures in more charming, lovely, beautiful, and graceful poses than in this scene: some lean down to the ground to drink; others kneel before the rock pouring forth the water; still others draw water with vases or cups; and there are some, finally, who drink with

their hands. Besides this, there are some who are leading
animals to the water amid the rejoicing of the crowd. But
among the other details, there is a marvellous little boy who
has seized a dog by the head and collar and plunges its muzzle
into the water so that it can drink. Then, after the animal has
drunk and no longer wants to drink, it shakes its head so con-
vincingly that it seems alive. In short, this frieze is so beautiful
that nothing of this type could be executed with more skill,
considering that the shadows and shading of these figures
are more astonishing than beautiful. And although this whole
work is extremely beautiful due to the extravagance of the
craftsmanship, this part is considered the best and most beau-
tiful. Under the cupola is a hexagon divided into seven
hexagons and six rhombuses. Domenico finished four of the
hexagons before he died, doing scenes from the life and
sacrifices of Elijah, all at his own pace, since this project was a
subject for study and Domenico's pastime, and he never aban-
doned it entirely for his other works. Therefore, while he was
working sometimes here and sometimes elsewhere, he painted
a large panel in oil in San Francesco on the right side as one
enters the church, which contains Christ's glorious descent
into Limbo to release the Patriarchs, where among the many
nudes is an extremely beautiful one of Eve; a thief behind
Christ with a cross is an extremely well-executed figure; and
the grotto of Limbo, the demons, and the fires in that place are
quite unusual.*

And because Domenico held the opinion that paintings
coloured in tempera lasted better than those coloured in oil,
declaring that he thought the works by Luca of Cortona, the
Pollaiuoli, and other masters who worked in oil in those days
had aged more than those painted in tempera before that
time by Fra Giovanni, Fra Filippo, Benozzo, and others, he
decided, on account of this, I would say, to do the panel he
was to paint for the Company of San Bernardino on the
piazza of San Francesco in tempera, and so he finished it in a
splendid way, depicting on it Our Lady in the company of
many saints. In the predella, which he likewise did in tempera
and which is very beautiful, he depicted Saint Francis who is
receiving the stigmata; Saint Anthony of Padua who, in order

to convert some heretics, is performing the miracle of the ass, which bows down before the Most Sacred Host; and San Bernardino of Siena who is preaching to the people of his city in the Piazza de' Signori.* He also did two scenes of the Madonna in fresco for the walls of this company in competition with some other paintings that Il Sodoma had done in the same place. In one he painted the Visitation of Saint Elizabeth, and in the other the Assumption of the Madonna surrounded by the Apostles.* Both paintings are widely praised.

Finally after Prince Doria had awaited his arrival in Genoa for some time, Domenico was brought there, but with great difficulty, for he was a man accustomed to a quiet life and was content with whatever met his needs and no more, besides which, he was not used to travelling; he had also just built a little house in Siena, and since he owned a vineyard a mile outside the Comollia gate, he tended it personally as a pastime and went there often, and for some time he had not gone far from Siena. Thus, when he reached Genoa, he painted a scene next to the one by Pordenone, with which he acquitted himself very well but not so well that it can be numbered among his best works. But since the ways of the court did not please him and he was used to living as a free man, he did not remain happy there for very long, but rather seemed, in a certain way, a little bewildered. And so, when he brought this work to a conclusion, he asked his leave of the prince and departed to return home, passing through Pisa to see the city, where, guided by Batista del Cervelliera, he was shown all its most noble works, especially the panels by Sogliani* and the paintings in the niche in the Duomo behind the high altar. Meanwhile Sebastiano della Seta, head of the Works Department of the Duomo, had learned of Domenico's merits and talents from Cervelliera and, anxious to complete the work on which Giovanni Antonio Sogliani had taken so long, he commissioned two paintings for the same niche to Domenico so that he could work on them in Siena and send them to him in Pisa; and so it was done.

One of them contains Moses who, after discovering the people have made sacrifices to the golden calf, breaks the

tablets. In this work Domenico painted some nudes that are extremely beautiful figures, while in the other painting is the same Moses at the moment the earth opens up and swallows a part of the people, and here, too, are some nude figures killed by lightning bolts which are admirable. The arrival of these paintings in Pisa was the reason Domenico did the Four Evangelists in four other paintings placed in front of this niche—two on each side—all four of which are very beautiful figures.* As a result, Sebastiano della Seta, who saw that Domenico served him quickly and well, commissioned Domenico afterwards to do a panel for one of the Duomo's chapels, while up to that time Sogliani had completed four of them. Domenico therefore stayed in Pisa and in this panel painted Our Lady in the heavens with a child in Her arms above some clouds held up by other putti, while below many male and female saints are standing, which are very well executed but not, however, with the perfection that marks the previously mentioned works. But Domenico made apologies for this with many of his friends, and in particular on one occasion with Giorgio Vasari, declaring that when he was outside the air of Siena without certain of his conveniences, he did not seem to know how to do anything. And so, after he returned home, having resolved never to leave in order to work somewhere else, he painted a panel in oil for the nuns of San Paolo, near San Marco, depicting the Nativity of Our Lady with several wet-nurses and Saint Anne on a fore-shortened bed, imagined to be inside a door, while a woman in the shadows who is washing clothes has no other light than that which shines upon her from the fire. In the predella, which is extremely lovely, there are three scenes in tempera: the Presentation of the Virgin, her Marriage, and the Adoration of the Magi.*

In the Mercanzia, a tribunal in that city, the officials have a small panel which they declare was painted by Domenico when he was a young man, which is very beautiful. It contains the half-length figure of Saint Paul seated, with scenes of his conversion on one side in small figures and, on the other, of his decapitation.* Finally, Domenico was commissioned to paint the large niche in the Duomo behind the high altar,

where he first executed entirely in his own hand a decoration of stucco with foliage and figures and two victories in the semicircular spaces, which was in truth a very rich and beautiful work. Then, in the middle he painted the Ascension of Christ in fresco, while from the cornice down he did three paintings divided by columns in relief and painted in perspective. In the middle painting, which contains an arch above in perspective, are Our Lady, Saint Peter, and Saint John, and on the sides in the two spaces are ten Apostles, five on each side in different poses, who are watching Christ as he ascends into the heaven, and over each one of these two paintings of the Apostles is a foreshortened angel, representing the two angels that announced, after the Ascension, that He had risen into heaven. This work is certainly marvellous, but it would have been even more so if Domenico had painted beautiful expressions for the heads, but, instead, they have a certain look that is not very pleasing, since in his old age Domenico seemingly employed the ugly expression of frightened, not very beautiful, faces. If the heads in this work had been more pleasing, it would have been, in my opinion, so beautiful that none better could be seen. In the judgement of the Sienese, Il Sodoma prevailed over Domenico in facial expressions, for Il Sodoma made them much more beautiful, even if those done by Domenico possessed more inventiveness and power. And in truth, the style of painting heads in these arts of ours is very important, and creating them with beautiful expressions and admirable grace has saved many masters from the censure that they would have received for the rest of their work.

This was the last painting Domenico did, for having at last taken a fancy to working in relief, he began work on casting bronzes, and he spent so much time at it that he completed, but only with the greatest effort, for six columns in the Duomo, those nearest the high altar, six free-standing bronze angels, a little less than life-size, which are holding up a candlestick with a lantern, as well as some cups, or little bowls, which are very beautiful. And in these last works, Domenico acquitted himself in such a manner that he was most highly praised; as a result, with increased courage, he began to cast the Twelve Apostles to place them on the columns below,

where there are now some carved in old marble in a bad style, but he did not continue this, since he did not live much longer.

Because Domenico was extremely inventive and succeeded in everything he did, he made woodcuts by himself to do prints in chiaroscuro, and two splendidly executed Apostles resulted from this effort, one of which we have in our book of drawings, along with some other sheets in his hand, divinely drawn. In like manner, he did copper engravings with the burin and etched with nitric acid some very fanciful scenes of alchemy, showing how Jove and the other gods, who wanted to congeal Mercury, put him in a crucible bound with straps, while Vulcan and Pluto stir up the fire around him, and just when they think that they might stop, Mercury flies off and away in a puff of smoke. Besides the above-mentioned works, Domenico created many others of less importance, such as paintings of Our Lady and other similar things for the bedroom, such as a Madonna in the home of the Cavalier Donati, and a painting in tempera which shows Jove changing himself into a shower of gold and raining upon Danaë's lap. Piero Catanei also has a tondo in oil of the Virgin from his hand which is extremely beautiful. Domenico also painted a beautiful bier for the Confraternity of Saint Lucy, and another similar one for the Confraternity of Saint Anthony. Nor should anyone be amazed if I mention such works, for they are amazingly beautiful, as anyone who has seen them knows.

Finally, after reaching the age of sixty-five, Domenico hastened the end of his life by toiling alone day and night, casting metal and refinishing it by himself, without asking anyone for assistance. Thus, he died on 18 May 1549* and was buried by his dear friend, Giuliano the goldsmith,* in the Duomo, where he had worked on so many rare works. Domenico was carried to his tomb by all the artisans of his city, which then recognized the enormous loss it had suffered with his death, and today the city recognizes it even more than ever, admiring his works. Domenico was a well-mannered and honest person, God-fearing and studious in his craft, but unusually solitary; as a result he deserved to be honourably celebrated in verse both in the vernacular and in Latin by

his fellow-citizens of Siena, who have always, to their great credit, applied themselves to *belles-lettres* and poetry.

THE END OF THE LIFE OF DOMENICO BECCAFUMI, THE SIENESE PAINTER AND MASTER CASTER

his fellow-citizens of Siena who have always to their great credit applied themselves to lyric rimes and poetry.

THE END OF THE LIFE OF DOMENICO BECCAFUMI, THE SIENESE PAINTER AND MASTER CASTER

The Life of Jacopo da Pontormo, Florentine Painter
[1494–1556]

According to what some people say, the ancestors or fore-fathers of Bartolomeo di Jacopo di Martino, the father of Jacopo da Pontormo, whose *Life* we are presently writing, were originally from Ancisa, a castle in the upper Valdarno, which is also very famous as the place in which the ancestors of Messer Francis Petrarch had their early origins. But whether his forefathers were from there or elsewhere, the pre-viously mentioned Bartolomeo, a Florentine and, according to what I have heard, one of the Carrucci family, was said to have been a disciple of Domenico del Ghirlandaio; it is also said that, having executed many works in the Valdarno, as a painter of moderate talent for those times, he eventually came to Empoli to do some paintings, and living there and in places nearby, he took as his wife in the town of Pontormo a very virtuous and honest young girl named Alessandra, daughter of Pasquale di Zanobi and his wife Mona Brigida. And so, in the year 1493, Bartolomeo's son Jacopo was born,* but since his father died in the year 1499, his mother in 1504, and his grand-father in 1506, Jacopo remained in the care of his grandmother Mona Brigida, who kept him in Pontormo for several years and had him taught reading and writing as well as the first principles of Latin grammar; he was finally taken to Florence at the age of thirteen and was made a ward of the court so that, following the custom, his few possessions might be protected and preserved; and after placing him in the home of a certain shoemaker named Battista, a distant relative, Mona Brigida returned to Pontormo and took with her one of Jacopo's sisters. But not long afterwards, since Mona Brigida also died, Jacopo was forced to take his sister back to Florence

and to place her in the home of one his relatives named Nicolaio who lived in Via de' Servi. But even this girl, following his other relatives and even before she had been married, died in the year 1512.* But to return to Jacopo. He had not lived in Florence for many months when he was placed by Bernardo Vettori with Leonardo da Vinci, and shortly after with Mariotto Albertinelli, with Piero di Cosimo, and finally, in 1512, with Andrea del Sarto, with whom Jacopo did not stay for very long, since after Jacopo had executed the cartoons for the small arch of the Servites, which will be discussed later, it seemed that Andrea never again regarded him favourably, whatever the reason might have been.

The first work, then, that Jacopo completed during this time was a tiny Annunciation for a tailor friend of his, but since the tailor died before the work was finished, it remained in the hands of Jacopo, then living with Mariotto, who was very proud of it and showed it off as something unusual to anyone who happened to enter his shop. Thus, when Raphael of Urbino came to Florence at that time, he saw the painting and the young man who had executed it, and, completely astonished, he predicted for Jacopo the success he was later seen to achieve. Not long after this, Mariotto left Florence and went to work in Viterbo on the panel that Fra Bartolomeo had begun there, and Jacopo, who was a melancholy and solitary young man, left without a master, went of his own accord to be with Andrea del Sarto just when Andrea had completed the scenes from the life of Saint Philip in the cloister of the Servites, which pleased Jacopo beyond measure, as did all of Andrea's other paintings, his style, and his drawing. Therefore, Jacopo began to do everything he could to imitate Andrea, and not much time passed before he was seen to have made such astonishing progress in drawing and painting that, in terms of his skill, it seemed as if he had been painting for many years. Now since Andrea had at that time completed a panel of the Annunciation for the church of the Friars of San Gallo, now in ruins, he gave the task, as was mentioned in his *Life*,* of painting the predella for the panel in oil to Jacopo, who depicted on it a Dead Christ and two little angels illuminating Him with two torches as they weep over Him,

while on the sides, in two tondos, he painted two prophets so
skilfully that they seemed to have been the work of a skilled
master rather than a young boy. But it could also be, as
Bronzino says, that he remembers Jacopo da Pontormo him-
self declaring that Rosso also worked on the predella. But just
as Jacopo was assisted by Andrea in painting this predella, so in
like manner Jacopo helped Andrea in completing the many
pictures and works he was constantly doing.

In the meanwhile, Cardinal Giovanni de' Medici had been
elected Supreme Pontiff and had taken the name of Leo X,*
and throughout Florence the friends and supporters of that
family were having many of the pontiff's coats of arms made
in stone, marble, canvas, and fresco. For this reason, the
Servite friars also wanted to produce some sign of their
devotion and indebtedness towards this same family and pope,
and they had Leo's arms done in stone and placed in the
middle of the arch of the first portico of the Annunziata,
which is on the piazza, and, shortly afterwards, they gave
orders for the painter Andrea di Cosimo* to gild and decorate
it with grotesques, of which he was an excellent master, and
with emblems of the House of Medici, and besides this, to
place it in the middle of figures representing Faith and Char-
ity. But, realizing he could not complete so many things by
himself, Andrea di Cosimo decided to commission the two
figures to others; and so he called Jacopo, who at that time was
no older than nineteen, and engaged him to complete the pre-
viously mentioned two figures, although it took more than a
little effort to convince Jacopo to accept, for, since he was a
young man, he did not want to put himself at such great risk
for his first painting or to work in such an important place;
yet, after taking heart, Jacopo took on the task of doing the
two figures even though he was not as experienced at working
in fresco as in oil. And going off (for he was still with Andrea
del Sarto) to do the cartoons at Sant'Antonio near the Faenza
gate where he lived, Jacopo completed them in a short time.
After this was done, he brought his master Andrea del Sarto
one day to see them, and when Andrea had looked at them
with immense astonishment and wonder, his praise for Jacopo
knew no bounds, but later, as I mentioned, whether out of

envy or for some other reason, he never again looked upon Jacopo favourably. On the contrary, when Jacopo would on occasion go to his shop, either it was not opened for him or he was made fun of by the apprentices in such a way that Jacopo finally went away for good, and, because he was rather poor, he began to reduce his expenses and to study with great assiduousness.

When, therefore, Andrea di Cosimo had finished gilding the coat of arms and all the tiles, Jacopo set out alone to finish the rest, and carried away by the desire to make a name for himself, by the wish to create, and by Nature which had endowed him with an enormously graceful and fertile genius, Jacopo carried out this work with incredible speed and so much perfection that a splendid old and experienced master could not have done better; and so, through this experience, his courage grew, and, thinking about the possibility of creating a much better work, he had determined, without saying anything to anyone, to pull down this work and redo it according to another design he had in mind. But in the meanwhile, the friars had seen that the work was done and that Jacopo no longer came to work, and after finding Andrea [di Cosimo] they goaded him so much that he decided to unveil the work. As a result, after looking for Jacopo to ask if he wanted to do anything more on it without finding him, since he was shut up with his new design and responded to no one, Andrea had the screen and scaffolding removed and unveiled the work, and that same evening, when Jacopo left home to go to the Servites and, since night had fallen, to pull down the work he had done and begin his new design, he found the scaffolding had been removed and that everything was on display, with an enormous crowd standing around and looking on. Completely enraged by this, Jacopo found Andrea and complained that he had unveiled the work without him, adding a description of what he had in mind to do. To this, Andrea replied with a laugh: 'You're wrong to complain, because the work that you have done is so good that, if you had to redo it, I'm firmly convinced you could not do it any better, and since you won't be lacking for work, save these drawings for other occasions.'

This painting, as can be seen, was of such great beauty, because of both its new style and the sweetness of the faces of the two female figures, and because of the beauty of the lively and graceful putti, that it was the most beautiful work in fresco that had ever been seen up to that time,* for besides the putti around the figure of Charity, there are two others in the air draping a cloth over the pope's coat of arms that are so beautiful they could not be improved, not to mention the fact that all the figures are in high relief and executed with such colouring and detail they could not be sufficiently praised. One day when Michelangelo Buonarroti saw the painting and noted that it was done by a young man of nineteen, he declared: 'This young man will be such an artist, based on what can be seen, that if he lives and continues on, he will exalt this art to the heavens.' When the people of Pontormo heard of Jacopo's reputation and fame, they sent for him and had him paint the arms of Pope Leo inside the castle above a gate on the main road, along with two putti that were very beautiful, although this has already been almost completely ruined by the water.

For the carnival of that same year,* since all of Florence was celebrating with great joy the election of Pope Leo X, many festivities were organized, including two extremely beautiful and expensive ones by two companies of lords and gentlemen of the city: one of these was called the Diamond and was headed by Giuliano de' Medici, the brother of the pope,* who had named the company in this fashion because the diamond was the emblem of his father, Lorenzo the Elder;* the other company took as its name and insignia the Branch and was headed by Signor Lorenzo, the son of Piero de' Medici,* who, I should mention, had for his emblem a branch, that is, a dry laurel bough with its leaves growing green once again, as if to demonstrate that he was restoring and resurrecting the reputation of his grandfather.

The Diamond Company therefore gave to Messer Andrea Dazzi,* who was then teaching Greek and Latin literature at the University of Florence, the task of thinking up an idea for a triumph. And so he organized one similar to those which the victorious Romans celebrated, with three very beautiful

chariots carved in wood and painted with rich and refined artifice. In the first chariot was Boyhood with a very fine arrangement of young boys; in the second was Manhood with many people who in their prime had done great deeds; and in the third was Old Age, with many illustrious men who in their later years had accomplished great things; and all these characters were so sumptuously decked out that no one could imagine being able to do better. The architects of these chariots were Raffaello delle Vivuole,* Carota the engraver,* and the painters Andrea di Cosimo and Andrea del Sarto, while those who made and designed the clothes for the figures were Ser Piero da Vinci, Leonardo's father,* and Bernardino di Giordano,* all men of great talents. But to Jacopo da Pontormo alone fell the task of painting all three of the chariots, upon which he executed a number of scenes in chiaroscuro of the many transformations of the gods into various forms, which are now in the possession of Pietro Paolo Galeotti, a worthy goldsmith.* The first chariot bore the inscription *Erimus* in bold letters, the second *Sumus*, and the third *Fuimus*: that is, 'We Shall be', 'We Are', and 'We Were'. The [accompanying carnival] song began: 'The years fly....*

After Signor Lorenzo, the head of the Branch Company, had seen these triumphs, wishing to surpass them, he entrusted the whole task to Jacopo Nardi, a noble gentleman of great learning,* to whom for what he did subsequently his native city of Florence is greatly indebted, and this Jacopo organized six triumphs in order to double those created by the Diamond Company. The first, drawn by a pair of oxen decked out in green leaves, represented the age of Saturn and Janus, called the golden age; at the top of the chariot were Saturn with his scythe and two-headed Janus holding the key to the Temple of Peace in his hand with the figure of Fury tied at his feet, and countless objects pertaining to Saturn, all splendidly made in various colours by Pontormo's genius. Six pairs of naked shepherds accompanied this triumph, partially covered with the skins of martens and sables and wearing little boots of various kinds in the ancient style, and goat-skin pouches, along with garlands made of many kinds of different foliage on their heads. The horses upon which the shepherds were mounted

were without saddles but were covered with the skins of lions, tigers, and lynxes, whose paws, gilded with gold, hung from the sides most gracefully. The decorations for the horses' hindquarters and their grooms were made from golden cords; the stirrups took the form of the heads of rams, dogs, and other similar animals, while the bridles and reins were made from various kinds of foliage and silver cords. Each shepherd was accompanied by four grooms dressed as shepherd-boys, clad more simply in other skins and carrying torches made to look like dry branches and pine boughs, which made a very beautiful sight.

On the second chariot, drawn by two pairs of oxen covered by sumptuous fabrics, with garlands on their heads and enormous rosaries hanging from their gilded horns, stood Numa Pompilius, the second king of the Romans, with his books of religion and all the priestly orders and rules pertaining to sacrifices, for, among the Romans, he was the founder of their religion and the first to institutionalize it and their sacrifices. This chariot was accompanied by six priests astride very handsome mules, their heads covered with linen hoods embroidered in gold and silver masterfully fashioned in the form of ivy leaves, and they wore priestly garments in the ancient style, with extremely rich gold borders and trim, with one carrying a censer, another a golden vase, and still another something similar. At their stirrups they had attendants dressed in priestly fashion, who held torches in their hands shaped like ancient candlesticks and executed with beautiful craftsmanship.

The third chariot represented the consulate of Titus Manlius Torquatus, who was consul after the end of the first Punic War and governed in such a way that in his time all virtues flourished and prosperity increased in Rome. This chariot, upon which this same Titus stood, was covered with many decorations made by Pontormo and was drawn by eight extremely beautiful horses, and in front of them were six pairs of senators in togas riding upon horses covered with golden cloth, accompanied by a large number of footmen representing lictors with their fasces, axes, and other objects pertinent to the administration of justice.

The fourth chariot, drawn by four buffaloes decked out to look like elephants, represented the triumphant Julius Caesar after his victory over Cleopatra, and all over the entire chariot Pontormo had painted the most famous deeds of Caesar; this chariot was accompanied by six pairs of soldiers clad in the most magnificent and brightly shining armour, all trimmed with gold, who held their lances by their sides; and the torches that the lightly armed grooms were carrying were made in the form of trophies arranged in different ways.

The fifth chariot was drawn by winged horses that had the appearance of griffins, and on it stood Caesar Augustus, ruler of the universe, accompanied by six pairs of poets on horseback, all crowned like Caesar himself with laurel and clad in various costumes, according to the provinces from which they came; these poets were present, since they were always greatly favoured by Caesar Augustus, and with their works they exalted his name to the heavens. And so that they would be recognized, each poet bore an inscription in the form of a band worn across the chest upon which his name was written.

On the sixth chariot drawn by four pairs of richly adorned heifers stood Trajan, the most just of all the emperors, before whom, as he sat on the chariot most ably painted by Pontormo, rode six pairs of doctors of law upon handsome horses with generous trappings, who were wearing togas down to their feet and robes of squirrel fur, which these doctors customarily wore in ancient times; the footmen, who were carrying a great number of torches, were scribes, copyists, and notaries with books and documents in their hands.

After these six came the chariot, or, rather, the Triumph of the Age and World of Gold, which was executed with the most beautiful and rich craftsmanship, with numerous figures in relief done by Baccio Bandinelli,* and with the most beautiful pictures by the hand of Pontormo, among which the figures in relief of the four Cardinal Virtues were greatly praised. In the middle of the chariot arose a huge sphere in the form of a globe of the world, upon which lay prostrate on his face, as if he were dead, a man wearing rusty armour which was opened and cleft in the back, from which emerged a

young boy, completely naked and gilded, who represented the
resurgence of the Age of Gold and the end of the Age of Iron,
from which he emerged and was reborn through the election
of this pope. And the dry branch putting forth new leaves
signified the same thing, although some declared it alluded to
Lorenzo de' Medici, who was Duke of Urbino. I should not
fail to mention that the gilded boy, the son of a baker, died
shortly thereafter from the pain he endured to earn ten *scudi*.
The song which, following the custom, was sung at this mas-
querade, was the composition of the same Jacopo Nardi, and
the first stanza went like this:

> He who gives laws to Nature
> And orders various states and ages
> Is the cause of every good;
> And when He permits, evil reigns in the world.
> Therefore, in contemplating
> This figure, you may see
> How with a sure step
> One age follows another in the world
> And transforms good into evil and evil into good.

From the works he executed for this celebration, over and
above his profit, Pontormo earned the kind of praise that per-
haps few young men of his age had ever earned in that city,
and when subsequently Pope Leo came to Florence,* Pontormo
was frequently engaged to prepare the trappings. . . . *

Jacopo also worked on the decoration of the wooden fur-
nishings that had already been magnificently fashioned, as
we mentioned previously, for some rooms of Pierfrancesco
Borgherini in competition with other masters, and, in particu-
lar, he himself painted on two chests some stories from the
deeds of Joseph in small figures which are truly beautiful.* But
anyone who wishes to see the best work Jacopo did in his life,
in order to take the measure of his genius and skill in the
vitality of his faces, the composition of his figures, the variety
of their poses, and the beauty of his ideas, should examine
a rather large scene, inside this bedchamber belonging to
Borgherini, a Florentine gentleman, at the entrance of the
door on the left, which, though filled with small figures,

depicts the occasion when Joseph, who in Egypt is almost a
king and a ruler, receives with incredible kindness his father
Jacob as well as all of Jacob's sons and brothers; among these
figures, at the bottom of the scene sitting upon some steps,
Jacopo portrayed Bronzino, then a young boy and his pupil,*
holding a basket—a wondrously lifelike and beautiful figure.
And if this scene had been done life-size (as it is small) either
on a large panel or a wall, I should venture to say that it
would be impossible to see another painting executed with
as much grace, perfection, and good craftsmanship as that em-
ployed by Jacopo in this one, and it is, as a result, deservedly
regarded by all the artisans as the most beautiful painting
Pontormo ever did. Nor is it any wonder that Borgherini held
it in such high esteem, nor that prominent men sought him
out to ask that he sell it so that they might bestow it as a gift
upon the most powerful lords or princes.

On account of the siege of Florence,* Pierfrancesco had
withdrawn to Lucca, and Giovambattista della Palla, who
wished to possess the decorations from this room and to pre-
sent them to King Francis in the name of the Signoria of
Florence along with other objects he was taking to France, had
such important connections and was so clever in word and
deed, that the standard-bearers and the Signori gave per-
mission to take the work away from Pierfrancesco's wife and
to pay her for it. And so, when Giovambattista went with
some men to execute the will of the Signori, they reached
Pierfrancesco's house, and his wife, who was still at home,
directed the worst insults towards Giovambattista that were
ever uttered to another man:

So, Giovambattista—she said—you miserable rag-picker, you two-
bit little merchant, you'd be daring enough to rip the decorations out
of the bedrooms of gentlemen and despoil this city of its richest and
most honourable treasures, as you have done and are still doing, in
order to embellish foreign countries and our enemies? I am not sur-
prised by you, a plebeian and enemy of your native city, but I am
amazed at the magistrates of this city, who are tolerating these abom-
inable atrocities. The bed you are looking for, out of your own self-
interest and greed for money, even though you are covering up your
malevolence with feigned piety, is my marriage bed, and it was in

honour of my marriage that my father-in-law Salvi made all these
magnificent and regal furnishings, which I revere in memory of him
and for the love of my husband, and which I intend with my own
blood and life to defend. Leave this house with these brigands of
yours, Giovambattista, and go and tell the people who sent you with
orders to take these things away from their proper places, that it is I
who don't want anything inside my house moved; and if those who
believed in a worthless and vile little man like you want to present
something to King Francis of France, let them go and plunder their
own homes to send him their furnishings and the beds from their
own bedrooms; and if you are ever so bold as to return to plunder
this house again, I'll make you understand, and to your very great
harm, how much respect should be paid to the houses of gentlemen
by people like you.

These words of Madonna Margherita, wife of Pierfrancesco
Borgherini and daughter of the most noble and prudent cit-
izen Robert Acciaiuoli, a truly valiant woman and a daughter
worthy of such a father, with her noble daring and intelli-
gence, were therefore the reason why these treasures are still
conserved in the home for which they were made....*

Then in the year 1522, while there was a mild plague in
Florence and many people left the city to flee from this
extremely contagious disease and to save themselves, Jacopo
had the opportunity of going some distance away and leaving
the city, because a prior of the Certosa,* a place built by the
Acciaiuoli family three miles outside Florence, had to have
some pictures in fresco painted in the corners of a very large
and beautiful cloister enclosing a meadow, and he heard about
Jacopo; the prior had him sought out, and having at that
time most willingly accepted the project, he went off to the
Certosa, taking only Bronzino with him. Enjoying this kind
of life, this calm, silence, and solitude (all things favourable to
Jacopo's genius and nature), Jacopo decided that this was the
occasion to make a strong effort to study the art of painting
and to demonstrate to the world that he had acquired greater
perfection and a style different from what he had done in the
beginning. And, before very long, a large number of sheets
printed from engravings most subtly executed with the burin
by Albrecht Dürer, the splendid German painter and an

exceptional engraver of wooden and copper plates, had reached Florence from Germany, including, among others, many large and small scenes of the Passion of Jesus Christ, which reflected all the perfection and skill of engraving done with the burin that could ever be possible through their beauty, variety of costumes, and originality of invention; Jacopo thought, since he had to paint scenes from the Passion of Our Saviour in the corners of this cloister, that he might be able to use the ideas of the previously mentioned Albrecht Dürer, firmly believing that in this way he would be able to satisfy not only himself but the majority of the artisans of Florence, all of whom, with one voice and a common judgement and consent, proclaimed the beauty of these prints and Albrecht's pre-eminence. Thus, Jacopo set himself to imitating that style, seeking to give his figures that animation and variety in their facial expressions that Albrecht had given them, and he captured it so boldly that the beauty of his early style, which was given to him by Nature full of softness and grace, was altered by this new zeal and effort and so harmed by the unforeseen encounter with this German style that, in all these works, even though they are lovely, barely anything can be recognized but the smallest part of the skill and grace that Jacopo had up to that time given all his figures.

And so, at the entrance to the cloister in one corner, Jacopo painted the figure of Christ in the garden, simulating so skilfully the obscurity of night illuminated by the moonlight that it almost seems like day, and while Christ is praying, not far away Peter, James, and John are sleeping, painted in a style so similar to that of Dürer that it is astonishing; nearby is Judas leading the Jews, with a face as strange as the looks on the faces of all the soldiers drawn in the German style, with expressions so odd that they move anyone who sees them to feel compassion for the simplicity of the man who tried with so much patience and effort to learn what others avoid and attempt to lose, in order to leave behind the style which, in its skill, surpassed all the others and gave endless pleasure to everyone. Now did Pontormo not know that the Germans and the Flemish come to these parts to learn the Italian style that he, with such toil tried, as if it were bad, to abandon?

Next to this painting, which contains Christ being led before
Pontius Pilate by the Jews, he painted in Our Saviour all the
humility that can truly be imagined in the very personification
of innocence betrayed by wicked men, and in Pilate's wife,
the compassion and fear felt for themselves by those who fear
divine punishment; while this woman commends Christ's
case to her husband, she looks into his face with compassionate
wonder. Around Pilate there are some soldiers so properly
German in their facial expressions and clothes that anyone not
knowing whose hand did this work would truly believe it was
executed by people from beyond the mountains. It is never-
theless true that in the background of this scene a cupbearer of
Pilate is descending some stairs with a bowl and a jug in his
hands, bringing them so that his master may wash his hands,
which is very beautiful and lifelike, possessing something of
Jacopo's old style.

Next, having to paint the Resurrection of Christ in one of
the other corners, Jacopo, who was a man without a firm and
steady mind and who always went about indulging in fanci-
ful ideas, took a notion to change his colouring, and so he
executed this work in fresco with colours so soft and pleasing
that if he had completed the painting with any other style but
that German one it would certainly have been extremely
beautiful, for such skill can be seen in the faces of those
soldiers, almost dead on their feet and full of sleep in their
various poses, that it seems impossible to do better. Then, con-
tinuing the scenes from the Passion in one of the other corners,
he painted Christ bearing the cross upon His shoulders to
Mount Calvary, while behind Him are the people of
Jerusalem who are accompanying Him, with the two naked
thieves in front surrounded by the ministers of justice, some
on foot and others on horseback, with the ladders, the inscrip-
tion for the cross, hammers, nails, ropes, and other such
instruments; and at the summit behind a little hill is Our Lady
with the Maries who are weeping as they wait for Christ,
Who has fallen to the ground in the middle of the scene, sur-
rounded by many Jews who are whipping Him while Veron-
ica offers Him the Veil, accompanied by women young and
old who weep at the sight of Our Saviour's torment. This

scene, either because he was admonished by his friends, or because Jacopo finally realized, though rather late, the damage caused to his own soft style by studying the German, came out much better than the others painted in the same location. As a result, certain naked Jews and some of the old men's faces are so well executed in fresco that one could not do better, although he obviously maintained the above-mentioned German style throughout the composition.

After these scenes, he was to have followed them in the other corners with the Crucifixion and the Deposition from the Cross, but he abandoned them for the time being with the intention of completing them last, and in their place he painted Christ taken down from the cross, employing the same style but with great harmony in his colours. And in this work, besides the figure of Mary Magdalene kissing the feet of Christ, which is extremely beautiful, there are two old men done to represent Joseph of Arimathaea and Nicodemus, who, though done in the German style, have the most beautiful faces and expressions that could be seen in old men, with their downy beards and marvellously soft colouring. Besides the fact that Jacopo usually spent a long time on his works, he also liked the solitude of the Certosa, and he therefore spent a number of years on these paintings, and so when the plague was over and he had returned to Florence, he did not stop his frequent visits to the place, constantly coming and going between the Certosa and the city. Continuing in this fashion, he satisfied the monks in many particulars, and, among other things, over one of the doors leading into the chapels inside the church, he painted in a half-length figure the portrait of a lay brother of the monastery still alive at that time who was one hundred and twenty years old, a figure so well and smoothly finished, with such vitality and liveliness, that it deserves by itself to excuse Pontormo for the strangeness and the new capricious style imposed upon him by remaining in solitude far away from commerce with other men. In addition, for the room of the prior of that monastery, he painted a picture of the Nativity of Christ, imagining that Joseph in the darkness of that night illuminated Jesus Christ with a lantern, and this work too he did with the same ideas

and fancies that the German prints put into his mind. No one should believe Jacopo is to be blamed because he imitated Albrecht Dürer in his compositions, since this is no error and many painters have done it and continue to do it, but rather because he employed the unadorned German style in everything—in garments, in expressions on the faces, and in poses—which he should have avoided and employed only in his inventions, since he possessed the modern style completely in all its grace and beauty.....*

Not long afterwards, when Lodovico di Gino Capponi returned from Rome, he had purchased the chapel in Santa Felicita on the right of the entrance into the church, which the Barbadori family had already commissioned to Filippo di Ser Brunelleschi, and Capponi decided to have the entire vault painted and then to have a richly decorated altarpiece made for it. And so he conferred with Messer Niccolò Vespucci, a knight of Rhodes and a very close friend; the knight, who was also a friend of Jacopo's and, what is more, recognized this good man's talent and worth, acted and spoke in such a fashion that Lodovico commissioned the work to Pontormo.* And so, after constructing a screen which closed off the chapel for three years, Jacopo set to work. On the ceiling of the vault, he painted a God the Father surrounded by the Four Patriarchs which were very beautiful, while in the four tondi at the angles he painted the Four Evangelists, that is, he did three of them and Bronzino did one all by himself. Nor shall I fail to mention on this occasion that Pontormo hardly ever had his young apprentices assist him, nor did he allow them to touch anything he intended to work on with his own hands, and when he did wish to use some of them, mainly in order to teach them, he allowed them to do everything by themselves, as he did here with Bronzino. In the paintings Jacopo completed up to this time in the chapel, it almost seems as if he had returned to his early style, but he did not do so in painting the altarpiece,* for as he was thinking over new ideas, he completed it without shadows and with such a clear and harmonious colouring that one can hardly distinguish the light from what is partially shaded and what is partially shaded from the shadows. This panel painting contains a Dead Christ

deposed from the cross Who is being carried to the tomb; there, too, Our Lady is fainting, along with the two Maries, who are done in a manner so different from the first ones he painted that one can clearly see how this genius always went about investigating new conceits and extravagant ways of working, never resting content with any of them. In short, the composition of this panel painting is completely different from the figures on the vault, and likewise the colouring, and the Four Evangelists in the tondi on the corbels of the vaults are much better and in another style. On the wall with the window are two figures in fresco, that is, on one side the Virgin and on the other the angel who makes the annunciation, but both are twisted around in such a fashion that, as I mentioned above, the bizarre fancy of this genius who was never content with anything can be recognized. And so that he could do things his own way without being bothered by anyone, he never wanted even the patron himself to see this work while he was painting it. And so, having painted it in his own way without any of his friends being able to point anything out to him, it was finally uncovered and seen with astonishment by all of Florence. . . . *

And since His Excellency,* following in the footsteps of his ancestors, had always sought to embellish and adorn his city, he decided, when the matter came up for consideration, to have painted the entire main chapel of the magnificent church of San Lorenzo, previously constructed by the great Cosimo de' Medici the Elder. And so he gave the task to Jacopo Pontormo, either by his own decision or, as has been said, through the influence of Messer Pier Francesco Ricci, the major-domo, and Jacopo was very pleased by this favour, for although the size of the project* gave him second thoughts, since he was well on in years, and perhaps even frightened him, on the other hand he took into consideration the fact that in a work of such dimensions he would have a great opportunity to demonstrate his worth and his talent. Others assert that when Jacopo saw the project being commissioned to him, notwithstanding the fact that Francesco Salviati, a painter of great reputation,* was in Florence and had successfully brought to a conclusion the decoration of the hall of the palace

which was formerly the audience chamber of the Signoria, he declared he would demonstrate how to draw and paint and how to work in fresco, and besides this, that other painters were only a penny a dozen, along with other similar arrogant and excessively insolent remarks. But since I always knew Jacopo as a modest person who spoke of everyone honourably and in the way a well-mannered and talented artist (as he was) ought to do, I believe that these remarks were attributed to him and that he would never utter such boasts, which are, for the most part, the remarks of vain men who are too presumptuous. In such a person there can be no room for talent or good manners. And although I might have kept silent about such matters, I did not wish to do so, for the procedure I have followed seems to me to be the duty of a faithful and truthful writer. It is enough to say that although these remarks circulated, especially among our artists, I nevertheless hold the firm opinion that they were the words of malicious men, for Jacopo had always been, as he appeared to be, modest and well-mannered in his actions.

Therefore, after having closed off the chapel with walls, partitions, and blinds, and having given himself over to total solitude, Jacopo kept the place locked up so tight for the space of eleven years that, with the exception of himself, not a living soul ever went inside, neither a friend nor anyone else. It is true that while some young men were sketching in Michelangelo's sacristy, as young men will do, they climbed up the spiral staircase to the roof of the church, and after lifting off the tiles and the board from one of the gilded rosettes there, they saw everything. When Jacopo realized this, he took it very badly, but his only reaction was to close everything off even more carefully, although some say that he persecuted those young men a great deal and tried to do something little to their liking.

Imagining, therefore, that in this work he had to surpass all painters and, perhaps, according to what was said, even Michelangelo, Jacopo painted in the upper part several scenes depicting the Creation of Adam and Eve, their eating of the forbidden fruit and their expulsion from Paradise, the tilling of the earth, the sacrifice of Abel, the death of Cain, the bless-

ing of the seed of Noah, and the moment when Noah drew the plan and measurements for the Ark. Then, on one of the walls below, each of which measures fifteen armslengths on either side, he did the inundation of the Flood, in which there is a mass of dead and drowned bodies, and Noah who is speaking with God. On the other wall, he painted the universal Resurrection of the Dead, which is to take place on the very last day, with so much confusion that fortunately it will probably be no greater or as lifelike, in a manner of speaking, than Pontormo has depicted it. In front of the altar between the windows, that is, on the middle wall, there is a row of nude men on either side who, grasping each other by the hand and clinging to each other by the legs and bodies, form a ladder to ascend to Paradise, leaving the earth, where there are many dead bodies following them; two dead men mark the end of each row, clothed except for their legs and arms, with which they are holding two lighted torches. At the top of this middle wall, over the windows, he painted Christ in His majesty in the middle, Who, surrounded by many angels who are all nude, raises the dead in order to judge them. But I have never understood the doctrine of this scene (although I know Jacopo had a fine mind and associated with learned and literate people): that is, what he wished to signify in the part of the painting where Christ on high is raising the dead while at His feet God the Father is creating Adam and Eve. Besides this, in one of the angles where the Four Evangelists stand naked with books in their hands, Jacopo, it seems to me, has not observed in any single place the organization of scenes, measure, time, variety in the faces, or changes in the tones of the flesh, nor, in brief, any rules at all either of proportion or perspective, but the work is so full of nude figures with an order, design, invention, composition, colouring, and painting done in Jacopo's own way, with so much melancholy and so little pleasure for anyone who looks at the work, that I have decided, since even I do not understand it although I am a painter myself, to leave the judgement of the work to those who see it. For I think I would go mad and become entangled in this painting, just as I believe that in the eleven years of time Jacopo spent on it, he tried to entangle himself and anyone else who saw this

painting with figures done in this fashion. And although one can see in this work torsos with shoulders turned from the front, and with details of the side of the body, executed with astonishing care and much effort by Jacopo, who for almost everything made finished models of clay in full relief; all of this is none the less foreign to his style, and, as it seems to almost everyone, without proper measure, because, for the most part, the torsos are large, while the legs and arms are small, to say nothing of the heads in which there can be seen absolutely nothing of that skill and singular grace that he used to give them, to the fullest satisfaction of anyone looking at his other paintings. Thus it appears that, in this painting, he only thought about certain details, while he took no account whatsoever of the other more important aspects of it. And in short, whereas he had thought to surpass in this work all the paintings in this craft, he scarcely reached the level of his own works executed in times past.

From this one can see that anyone who wishes to do too much and almost force Nature ruins the good with which Nature has generously endowed him. But what can or should one do except feel compassion for him, since men in our crafts are as subject to error as any other men? As it is said, even the good Homer on occasion nods off to sleep. Nor will it ever happen that in every one of Jacopo's works (no matter how hard he tried to force Nature) there will not be something good and praiseworthy. And because he died shortly before completing this work, some have claimed that he died from grief, remaining during his last moments very much dissatisfied with himself. But the truth is that, being old and wholly exhausted from painting portraits, making clay models, and working so much in fresco, he fell sick with the dropsy, which finally killed him at the age of sixty-five.* After his death, many very fine designs, cartoons, and clay models were found in his home, as well as a painting of Our Lady in a beautiful style, which he had ably executed, from what one can see, many years earlier, and was subsequently sold by his heirs to Piero Salviati.

Jacopo was buried in the first cloister of the church of the Servite friars under the scene he had previously painted there

of the Visitation, and he was honourably accompanied to the tomb by all of the painters, sculptors, and architects. Jacopo was a very frugal and well-mannered man, and in his style of living and dressing he was rather more miserly than thrifty, and he always stayed by himself, without wanting anyone to wait on him or cook for him. Yet during his last years he took in Battista Naldini, a young man of good spirit, to raise, and Battista took the modicum of care of Jacopo's life that Jacopo wished him to do, and under Jacopo's instruction he attained no small success in drawing but, rather, such success that excellent results are expected.* Pontormo's friends, most particularly during the last days of his life, were Pierfrancesco Vernacci and Don Vincenzio Borghini, with whom he sometimes relaxed on rare occasions, eating with them. But above anyone else, Jacopo was exceedingly fond of Bronzino, who loved Jacopo equally in return, since he was grateful and cognizant of the benefits he received from Jacopo.

Pontormo had some curious traits, and was so afraid of death that he did not even want to hear it discussed, and he fled from having any contact with dead bodies. He never went to festivals or to other places where people gathered together in order to avoid being caught in the crowd, and he was solitary beyond belief. On occasion when he went to work, he began to think so deeply about what he wanted to do that he would leave without having done anything else all that day except stand deep in thought. And that this occurred on countless occasions during the work in San Lorenzo can easily be believed, because when he was resolute, as an experienced and worthy man, he had no difficulty in doing what he wanted or had decided to carry out.

THE END OF THE LIFE OF JACOPO DA PONTORMO, FLORENTINE PAINTER

The Life of Michelangelo Buonarroti, Florentine Painter, Sculptor, and Architect

[1475–1564]

While industrious and distinguished spirits, illuminated by the widely renowned Giotto and his followers, were striving to give the world proof of the talent which the benevolence of the stars and the proportionate mixture of their humours had bestowed upon their genius, all toiling anxiously, though in vain, in their eagerness to imitate the grandeur of Nature with the skills of art, in order to come as close as they could to that ultimate knowledge many people call intelligence, the most benevolent Ruler of Heaven mercifully turned His eyes towards earth, and, witnessing the hopeless quantity of such labours, the most fervid but fruitless studies, and the presumptuous opinion of men who were further from the truth than shadows from the light, He decided, in order to rid us of so many errors, to send to earth a spirit who, working alone, was able to demonstrate in every art and every profession the meaning of perfection in the art of design, how to give relief to the details in paintings by means of proper drawing, tracing, shading, and casting light, how to work with good judgement in sculpture, and how to make buildings comfortable and secure, healthy, cheerful, well proportioned, and richly adorned with various decorations in architecture.* Moreover, He wanted to join to this spirit true moral philosophy and the gift of sweet poetry, so that the world would admire and prefer him for the wholly singular example of his life, his work, the holiness of his habits, and all his human undertakings, and so that we would call him something divine rather than mortal. And because He saw that in the practice of these professions and in these most singular crafts—that is, painting, sculpture, and architecture—Tuscan minds were

always among the greatest and most elevated, and because they were more scrupulous in their efforts to study these arts than any other people of Italy, He wanted to bequeath to this spirit, as his native city, Florence, the most worthy among all the other cities, so that the perfection Florence justly achieved with all her talents might finally reach its culmination in one of her own citizens.

Thus, in the year 1474 under a fateful and fortunate star, a son was born in the Casentino district of an honest and noble lady to Lodovico di Lionardo Buonarroti Simoni who, according to what people say, was a descendant of the most noble and ancient family of the Counts of Canossa.* To this Lodovico, who, in that year, was *podestà** of the castle of Chiusi and Caprese, near Sasso della Vernia in the diocese of Arezzo, where Saint Francis received the stigmata, was born a son, let me say, on the sixth day of March on Sunday, around eight o'clock at night, to whom he gave the name of Michelangelo, for without thinking any further about the matter, he was inspired by One from above and wished to make him into something celestial and divine, beyond the usual human scope, as was seen in the horoscope of his birth, which had Mercury ascendant and Venus entering the house of Jupiter in a favourable position, showing that one could expect to see among his accomplishments miraculous and magnificent works created through his hands and his genius. After Lodovico's term as *podestà* ended, he returned to Florence and to his villa in Settignano, three miles from the city, where he owned a farm inherited from his ancestors (a place abundant in stone and everywhere filled with quarries of blue-grey sandstone continuously mined by stone-cutters and sculptors, most of whom are born in this area), and Michelangelo was given by Lodovico to a wet-nurse in the villa who was the wife of one of the stone-cutters. Thus, conversing with Vasari on one occasion, Michelangelo jokingly declared: 'Giorgio, if I have any intelligence at all, it has come from being born in the pure air of your native Arezzo, and also because I took the hammer and chisels with which I carve my figures from my wet-nurse's milk.'

In time the number of Lodovico's children grew, and since

he was not well off and had little income, he placed his children in service with the Wool and Silk Guilds while Michelangelo, who was already grown, was placed with Master Francesco da Urbino in his grammar school, and because Michelangelo's genius attracted him to the pleasures of drawing, he spent all the time he could drawing in secret, for which he was scolded and sometimes beaten by his father and his elders, since they probably thought applying oneself to a craft they did not recognize was a base and unworthy undertaking for their ancient house. During this time Michelangelo struck up a friendship with Francesco Granacci, also a young man, who had been placed with Domenico Ghirlandaio to learn the art of painting, and since Granacci, who was fond of Michelangelo, saw he was skilful in drawing, he assisted him every day by giving him sketches by Ghirlandaio, known at that time not only in Florence but throughout all of Italy as one of the best masters alive.* And so Michelangelo's desire to draw increased day by day, and since Lodovico could not prevent the young man from studying design and saw no remedy for it, he decided, in order to derive some benefit from it and upon the advice of friends, to place him with Domenico Ghirlandaio.

When Michelangelo was apprenticed into the craft with Domenico, he was fourteen years of age, and because the man who wrote his biography after 1550, when I wrote these *Lives* the first time, declares that some people who never associated with Michelangelo have said things which never happened and left out many details worthy of note, I cite in particular the passage where he accuses Domenico of jealousy and of never having offered Michelangelo any kind of assistance; this was obviously false, as can be seen from a document written in the hand of Lodovico, Michelangelo's father, and inscribed in Domenico's record books now in the possession of his heirs, which states as follows:

1488. On this day, the first of April, I record that I, Lodovico di Lionardo di Buonarroti, place my son Michelangelo with Domenico and David di Tommaso di Currado for the next three years to come with these covenants and agreements: that the said Michelangelo must remain with the above-mentioned for the stipulated period to

learn to paint and to practise this trade, and to do whatever the above-mentioned may order him to do, and, during these three years, the aforesaid Domenico and David must give him twenty-four newly minted florins—six in the first year, eight the second, and ten the third, in all, a total of ninety-six lire.

And below this statement is this record or entry written in Lodovico's hand: 'The above-mentioned Michelangelo on this day of 16 April received two florins in gold. I, Lodovico di Lionardo, his father, received twelve lire and twelve *scudi*.' I have copied these entries from this book to demonstrate that everything written earlier and everything that is now to be written is the truth; nor do I know anyone who was more familiar with Michelangelo than I, or anyone who has ever been a better friend or more faithful servant to him, as anyone can testify; nor do I believe that anyone can display a greater number of letters written by Michelangelo himself or letters which contain more affection than he has shown for me. I have made this digression to bear witness to the truth, and this must suffice for the remainder of his *Life*. Now, let us return to the story.*

Michelangelo's skill and character grew in such a way that it amazed Domenico, who saw him executing works beyond a young man's ability, for it seemed to him that Michelangelo not only surpassed his other students (of whom he had a large number) but on many occasions equalled works he himself had completed. It happened that one of the young men studying with Domenico had copied some clothed female figures in ink from Ghirlandaio's works, and Michelangelo took the paper and went over the outlines with a thicker pen in the way it should have been done (that is, perfectly), and it is a marvellous thing to see the difference between the two styles and the excellence and judgement of a young man who was so spirited and bold that he had enough courage to correct the work of his master. Today, I keep this drawing near me as a relic, for I obtained it from Granacci to put in my book of drawings with others I received from Michelangelo; in the year 1550, when he was in Rome, Giorgio [Vasari] showed it to Michelangelo, who recognized it and loved seeing it again,

saying modestly that he knew more of that art as a child than
he did now as an old man.

Now while Domenico was working on the main chapel of
Santa Maria Novella, it happened one day while he was away
that Michelangelo began to sketch the scaffolding with some
stools and the implements of the craft, along with some of the
young men who were working there. When Domenico
returned and saw Michelangelo's sketch, he declared: 'This
boy knows more about it than I do.' And he was astonished
by the new style and the new kind of imitation that derived
from the judgement given by heaven to a youth of such a
tender age, for to tell the truth, it was as much as one might
expect in the practice of an artisan who had worked for many
years. This was because all the knowledge and ability of true
grace was, in his nature, enhanced by study and practice, for in
Michelangelo it produced more sublime works every day, as
he clearly began to demonstrate in the portrait he did from an
engraving by Martin the German,* which gained him a fine
reputation. Since a scene by this same Martin, which was
engraved in copper and showed Saint Anthony being beaten
by devils, had reached Florence, Michelangelo drew it with his
pen in such a way that it was not recognized as his, and he
painted it with colours; in order to copy the strange forms
of some of the devils, he went to buy fish that had scales of
unusual colours and showed so much talent in this work that
he acquired from it both credit and renown. He also copied
drawings done by various old masters so closely that they
were not recognized as copies, for by staining and ageing
them with smoke and various materials, he soiled them so that
they seemed old and could not be distinguished from the
originals; he did this for no other reason than to have the ori-
ginals, giving away his copies, because he admired the
originals for the excellence of their skill, which he sought to
surpass in his copies, thereby acquiring a very great reputation.

In those days Lorenzo de' Medici the Magnificent kept
Bertoldo the sculptor* in his garden near Piazza San Marco,
not so much as the custodian or guardian of the many beauti-
ful antiquities he had collected and assembled there at great
expense, but rather because he wished above all else to create a

school for excellent painters and sculptors and wanted them
to have the above-mentioned Bertoldo, who was a pupil of
Donatello, as their teacher and guide. And although he was so
old that he could no longer work, he was nevertheless a very
experienced and famous master, not only because he had most
carefully polished the pulpits cast by his master Donatello, but
also because he had cast many other works in bronze of battle
scenes as well as some other small objects, and his skill was
such that no one in Florence at that time could surpass him.
Thus, Lorenzo, who bore a great love for the arts of painting
and sculpture, lamenting the fact that in his day no renowned
and noble sculptors could be found as compared with painters
of the greatest merit and fame, decided, as I said, to found a
school, and accordingly he told Domenico Ghirlandaio that if
he had any young men in his shop who were inclined to this
art, he should send them to his garden, where he wished to
train and form them in a way that would honour himself,
Domenico, and his city. Thus, Domenico gave him some of
his best young men, including among others Michelangelo
and Francesco Granacci; and when they went to the garden,
they found that Torrigiani, a young man of the Torrigiani
family, was there working on some clay figures in the round
that Bertoldo had given him to do.*

After Michelangelo saw these figures, he made some himself
to rival those of Torrigiani, so that Lorenzo, seeing his high
spirit, always had great expectations for him, and, encouraged
after only a few days, Michelangelo began copying with
a piece of marble the antique head of an old and wrinkled
faun with a damaged nose and a laughing mouth, which
he found there. Although Michelangelo had never before
touched marble or chisels, the imitation turned out so well
that Lorenzo was astonished, and when Lorenzo saw that
Michelangelo, following his own fantasy rather than the
antique head, had carved its mouth open to give it a tongue
and to make all its teeth visible, this lord, laughing with
pleasure as was his custom, said to him: 'But you should have
known that old men never have all their teeth and that some
of them are always missing.' In that simplicity of his, it seemed
to Michelangelo, who loved and feared this lord, that Lorenzo

was correct; and as soon as Lorenzo left, he immediately broke
a tooth on the head and dug out the gum in such a way that it
seemed the tooth had fallen out, and anxiously awaited
Lorenzo's return, who, after coming back and seeing Michel-
angelo's simplicity and excellence, laughed about it on more
than one occasion, recounting it to his friends as if it were
miraculous; and having resolved to assist Michelangelo and to
show him favour, he sent for his father Lodovico and asked if
he could have the boy, telling him that he wanted to raise him
as one of his own sons, and Lodovico most willingly granted
his request; and then Lorenzo prepared a room for Michel-
angelo in his home and had him cared for, so that he always
ate at the table with his sons and other worthy and noble
people who stayed with Lorenzo and by whom he was treated
with honour. This occurred the year following Michelangelo's
apprenticeship to Domenico when Michelangelo was either
fifteen or sixteen years old, and he remained in that house for
four years until the death of Lorenzo the Magnificent in 1492.

During this time, as his salary and in order to assist his
father, Michelangelo received five ducats a month from
Lorenzo, and to make him happy Lorenzo gave him a purple
robe and his father a job in the Customs Department; indeed,
all the young men in the garden were being paid a salary,
some more and others less, because of the generosity of this
most noble and magnificent citizen, and while he lived they
were rewarded. Around this time, on the advice of a singular
man of letters named Poliziano,* Michelangelo created in a
single piece of marble given to him by Lorenzo the Battle of
Hercules with the Centaurs, which was so beautiful that those
who examine it today sometimes cannot believe it is by the
hand of a young man rather than by an esteemed master who
has been steeped in the study and practice of this art. Today
the work is in Michelangelo's home, kept as an except.)nal
treasure in his memory by Lionardo, his nephew; it is not
many years ago that Lionardo also owned, in memory of
his uncle, a bas-relief in marble of Our Lady executed by
Michelangelo a little more than an armslength high; in this
work Michelangelo, as a young man at this same time who
wanted to imitate Donatello's style, acquitted himself so well

that it seems to have been done by Donatello himself, except that it contains more grace and a better sense of design.* Lionardo later gave the second work to Duke Cosimo de' Medici, who considers it especially unique, since it is the only sculpture in bas-relief by Michelangelo.

Returning to Lorenzo the Magnificent's garden, it was completely filled with antiquities and lavishly decorated with excellent paintings, all of which had been collected there for their beauty as well as for study and pleasure, and Michelangelo always had the keys to the place, for he was far more eager than the other young men in all his actions and with great boldness always proved himself to be very quick. He sketched the paintings of Masaccio for many months in the Carmine, and he copied those works with such judgement that he amazed the artisans and others in such a way that along with his fame, envy began to grow up against him. It is said that Torrigiani, who struck up a friendship with him, was fooling around when, prompted by envy at seeing Michelangelo more honoured and more talented as an artist, he struck Michelangelo upon the nose with such force that he broke and flattened it, unfortunately marking Michelangelo for life; and this was the reason why he was banished from Florence, as was mentioned elsewhere.*

After the death of Lorenzo the Magnificent, Michelangelo returned to his father's home with endless sorrow over the death of such a great man, a friend to all with talent, and there he purchased a large block of marble from which he carved a Hercules that was four armslengths high, which stood for many years in the Strozzi palace and was considered a marvellous work; afterwards, during the year of the siege, it was sent by Giovambattista della Palla to France to King Francis.* It is said that Piero de' Medici, who was the heir of his father Lorenzo, often used to send for Michelangelo, with whom he had long been friends, when he wanted to purchase ancient cameos and other engraved stones; and one winter when it snowed heavily in Florence, Piero had him make a very beautiful statue out of the snow in his courtyard, and he honoured Michelangelo for his talents in such a fashion that the artist's father, who was beginning to see that his son was

esteemed by important people, dressed Michelangelo much more honourably than he usually did.

For the church of Santo Spirito in Florence, Michelangelo carved a wooden crucifix which was placed above the lunette of the main altar, where it remains, to the satisfaction of the prior who provided him with spacious quarters, where on many occasions Michelangelo dissected dead bodies in order to study the details of anatomy, and began to perfect the great skill in design that he subsequently possessed.* It happened that the Medici were driven out of Florence, and that, a few weeks before, Michelangelo had already left for Bologna and then for Venice, because, having seen the insolent actions and bad government of Piero de' Medici, he feared some sinister accident might befall him as a friend of the family; and finding nothing to keep him in Venice, he returned to Bologna, where he foolishly neglected to take the countersign for leaving the city when he came through the city gates, as had been decreed at that time as a precaution by Messer Giovanni Bentivogli, who ordered foreigners without the countersign to pay a fine of fifty Bolognese lire; and when Michelangelo found himself in this predicament without the means of paying the fine, he was fortunately spotted by Messer Giovanfrancesco Aldovrandi, one of the Sixteen in the government, who, after having Michelangelo recount the story, freed him out of compassion and kept him in his home for more than a year. One day Aldovrandi took him to see the tomb of Saint Dominic carved, as was mentioned, by the older sculptors Giovanni Pisano and, later, Niccolò dell'Arca, but which lacked an angel holding a candlestick and a figure of Saint Petronius about one armslength high, and Aldovrandi asked Michelangelo if he had the courage to complete the tomb; Michelangelo replied that he did. And so he had the marble delivered to Michelangelo, who executed the works, which are the best figures on the tomb, and Messer Francesco Aldovrandi paid him thirty ducats for them.*

Michelangelo remained in Bologna for a little more than a year, and he would have remained longer to repay the kindness of Aldovrandi, who loved him both for his skill in design and also because he liked Michelangelo's Tuscan pro-

nunciation and gladly listened to him read the works of
Dante, Petrarch, Boccaccio, and other Tuscan poets. But since
Michelangelo realized he was wasting time, he willingly re-
turned to Florence and carved a little figure of Saint John in
marble for Lorenzo di Pierfrancesco de' Medici, and then with
another piece of marble he immediately began to carve a life-
size figure of a sleeping Cupid. When this was completed,
Baldassare del Milanese showed it as a beautiful piece of work
to Pierfrancesco, who agreed with Baldassare's judgement and
declared to Michelangelo: 'If you buried it, I am convinced it
would pass as an ancient work, and if you sent it to Rome
treated so that it appeared old, you would earn much more
than by selling it here.' It is said that Michelangelo treated it in
such a way that it appeared to be ancient, nor is this astonish-
ing, since he had the genius to do this and more. Others main-
tain that Milanese took it to Rome and buried it in a vineyard
he owned and then sold it as an antique statue to Cardinal San
Giorgio for two hundred ducats. Still others say that Milanese
sold a copy Michelangelo made for him to the cardinal, then
wrote to Pierfrancesco, telling him to give Michelangelo
thirty *scudi*, declaring he received no more than that from
the cupid, thus deceiving the cardinal, Pierfrancesco, and
Michelangelo; but later the cardinal heard from someone who
had seen the cupid being carved in Florence, and, using every
means to discover the truth through one of his messengers, he
then forced Milanese's agent to return his money and take
back the cupid, which then fell into the hands of Duke
Valentino, who gave it to the Marchioness of Mantua, and she
took it to her own city where it can still be seen today.* This
affair did not come about without damage to Cardinal San
Giorgio, who did not recognize the value of the work, which
consists in its perfection, for modern works are just as good as
ancient ones when they are excellent, and it is greater vanity to
pursue things more for their reputation than for what they
really are, but these kinds of men can be found in any age,
men who pay more attention to appearances than to realities.*

Nevertheless, this affair gave Michelangelo such a reputa-
tion that he was immediately brought to Rome and taken in
by Cardinal San Giorgio, with whom he stayed almost a year,

and the cardinal, who had little understanding of the arts, did not give Michelangelo anything to do. During that time, the cardinal's barber, a painter who worked with diligence in tempera but lacked all sense of design, befriended Michelangelo, who drew him a cartoon with the figure of Saint Francis receiving the stigmata, which was painted very carefully by the barber on a small panel in colour; this painting today is located in one of the first chapels on the left as you enter the church of San Piero a Montorio.* Afterwards, Messer Jacopo Galli, a Roman gentleman and a man of some intelligence, clearly recognized Michelangelo's talent and had him carve a life-size Cupid in marble and then a Bacchus ten palms high, holding a cup in his right hand and in the left a tiger's skin along with a cluster of grapes, which a little satyr is trying to eat; in this figure it is clear that Michelangelo wanted to attain a marvellous combination of various parts of the body and, most particularly, to give it both the slenderness of the young male figure and the fleshiness and roundness of the female: it was such an astonishing work that it showed Michelangelo to be more skilled than any other modern sculptor who had ever worked up to that time.*

While staying in Rome, Michelangelo acquired so much skill in his study of art that it was incredible to see his lofty concepts and his difficult style, which he put into practice with such great facility that it terrified people unaccustomed to seeing such works as well as those accustomed to good ones, for the works that others were showing seemed nothing in comparison with his. All these things aroused the desire of the Cardinal of Saint-Denis, a Frenchman called Cardinal Rouen, to leave behind some worthy memorial of himself in such a renowned city through the talents of such an unusual artist, and he commissioned Michelangelo to do a marble *Pietà* in the round, which, when completed, was placed in Saint Peter's in the Chapel of the Madonna della Febbre in the temple of Mars.*

No sculptor, not even the most rare artist, could ever reach this level of design and grace, nor could he, even with hard work, ever finish, polish, and cut the marble as skilfully as Michelangelo did here, for in this statue all of the worth and

power of sculpture is revealed. Among the beautiful details it contains, besides its inspired draperies, the figure of the dead Christ stands out, and no one could ever imagine—given the beauty of its limbs and the skill with which the body is carved—seeing a nude so well endowed with muscles, veins, and nerves stretched over the framework of the bones, or the figure of a dead man which more closely resembled a dead body than this one. The expression on the face is so very gentle, and there is such harmony in the joints and the articulations of the arms, torso, and legs, with their finely wrought pulses and veins, that, in truth, it is absolutely astonishing that the hand of an artist could have properly executed something so sublime and admirable in a brief time, and clearly it is a miracle that a stone, formless in the beginning, could ever have been brought to the state of perfection which Nature habitually struggles to create in the flesh. Michelangelo placed so much love and labour in this work that on it (something he did in no other work) he left his name written across a sash which girds Our Lady's breast. This came about because one day when Michelangelo was entering the church where the statue was placed, he found a large number of foreigners from Lombardy who were praising the statue very highly; one of them asked another who had sculpted it, and he replied: 'Our Gobbo from Milan.'* Michelangelo stood there silently, and it seemed somewhat strange to him that his labours were being attributed to someone else; one night he locked himself inside the church with a little light, and, having brought his chisels, he carved his name upon the statue. And it has such qualities that a very fine mind has described it as a true and lifelike figure:

> Beauty and goodness,
> And grief and pity, alive in dead marble,
> Do not, as you do,
> Weep so loudly,
> Lest too early He should reawaken from death
> In spite of Himself,
> Our Lord and Thy
> Spouse, Son and Father,
> Only bride, His Daughter and Mother.*

Because of this statue, Michelangelo gained very great fame. And some people, more stupid than anything else, say that he made Our Lady too young, but have they failed to realize or to discover that spotless virgins keep themselves young and their faces remain well preserved for a long time without any blemish whatsoever, while whose who are afflicted, as was Christ, do the opposite? And so this work added more glory and distinction to Michelangelo's talent than all the others he had done before.

Some of Michelangelo's friends wrote from Florence to tell him to return, since it was not beyond the realm of possibility that he might be given the block of spoiled marble in the Works Department, which Piero Soderini, recently elected Gonfaloniere of the city for life* had many times talked about giving to Leonardo da Vinci, and which he was then arranging to give to Master Andrea Contucci dal Monte San Sovino, an excellent sculptor, who was trying to obtain it; although it would be difficult to carve an entire figure out of it without adding additional pieces, no other man except Michelangelo had the courage to complete it without other pieces, and since many years previously he had wanted it, Michelangelo attempted to obtain it when he returned to Florence.

This marble was nine armslengths high, and unfortunately a certain master named Simone da Fiesole* had begun to carve out the figure of a giant, and the stone was so poorly hewn that he had bored a hole between its legs, and had botched and bungled everything; and so the trustees of the Works Department of Santa Maria del Fiore, who were in charge of the project, had abandoned the block without thinking about completing it, and it had already lain there for many years and was lying there still. Michelangelo once again examined it closely and, calculating that one could carve a reasonable figure from the stone by adapting its pose to the rock which had been mutilated by Master Simone, he decided to request the block from the trustees and from Soderini, who gave it to him as something of no use, believing that whatever he made of it would be better than the condition in which it then happened to be, for whether broken up in pieces or left in that poorly hewn state, it was of no use whatsoever to the Works Department.

Thus, Michelangelo did a wax model depicting a young David with a sling in hand, as the symbol of the palace, for just as David had defended his people and governed them with justice, so, too, those who governed this city should courageously defend it and govern it with justice:* he began the statue in the Works Department of Santa Maria del Fiore, where he erected a scaffolding between the wall and the tables surrounding the marble, and, working continuously without letting anyone see it, he brought the statue to perfect completion. The marble had been mutilated and spoiled by Master Simone, and in some places even Michelangelo's will-power did not suffice to achieve what he wished; so he allowed some of Master Simone's original chisel marks to remain on the extremities of the marble, a few of which can still be seen. And Michelangelo certainly performed a miracle in restoring to life a block of marble left for dead.

When the statue was completed, various disputes arose over how, given its size, it should be transported to the Piazza della Signoria. For that reason, Giuliano da San Gallo and his brother Antonio built a very strong wooden frame and suspended the statue from it with ropes so that when it was shaken it would not break or, rather, just come tumbling down, and they pulled it with winches over flat planks laid upon the ground and set it in place. They tied a slip-knot in the rope that held the statue suspended which moved very easily and tightened as the weight increased, a very fine and ingenious device that I have in my book drawn up by Michelangelo himself, a secure and strong knot for holding weights, which is remarkable. Around this time it happened that Piero Soderini saw the statue, and it pleased him greatly, but while Michelangelo was giving it the finishing touches, he told Michelangelo that he thought the nose of the figure was too large. Michelangelo, realizing that the Gonfaloniere was standing under the giant and that his viewpoint did not allow him to see it properly, climbed up the scaffolding to satisfy Soderini (who was behind him nearby), and having quickly grabbed his chisel in his left hand along with a little marble dust that he found on the planks in the scaffolding, Michelangelo began to tap lightly with the chisel, allowing

the dust to fall little by little without retouching the nose from the way it was. Then, looking down at the Gonfaloniere who stood there watching, he ordered:

'Look at it now.'

'I like it better,' replied the Gonfaloniere: 'you've made it come alive.'

Thus Michelangelo climbed down, and, having contented this lord, he laughed to himself, feeling compassion for those who, in order to make it appear that they understand, do not realize what they are saying; and when the statue was finished and set in its foundation, he uncovered it, and to tell the truth, this work eclipsed all other statues, both modern and ancient, whether Greek or Roman; and it can be said that neither the Marforio in Rome, nor the Tiber and the Nile of the Belvedere, nor the colossal statues of Monte Cavallo can be compared to this David, which Michelangelo completed with so much measure and beauty, and so much skill. For the contours of its legs are extremely beautiful, along with the splendid articulations and grace of its flanks; a sweeter and more graceful pose has never been seen that could equal it, nor have feet, hands, and a head ever been produced which so well match all the other parts of the body in skill of workmanship or design. To be sure, anyone who sees this statue need not be concerned with seeing any other piece of sculpture done in our times or in any other period by any other artist.

Michelangelo received four hundred *scudi* in payment from Piero Soderini, and the David was erected in the year 1504; this statue brought great fame to Michelangelo in the art of sculpture, and, as a result, he cast an extremely beautiful David in bronze for the above-mentioned Gonfaloniere which Soderini then sent to France;* at the same time he roughed out but left unfinished two marble tondos, one for Taddeo Taddei, which today hangs in his home, and another, only just begun, for Bartolomeo Pitti, which was given by Fra Miniato Pitti of Monte Oliveto, an unusually knowledgeable expert in cosmography and many areas of study, especially the art of painting, to his close friend Luigi Guicciardini; both works were considered most worthy and admirable.* And at the

same time, he also roughed out a marble statue of Saint Matthew in the Works Department of Santa Maria del Fiore, a statue which even in an unfinished state reveals its perfection and teaches other sculptors how to carve figures from marble without mutilating them, so that they may always be carefully improved by carving away some of the marble while leaving enough for redesigning or altering the piece as is sometimes necessary. He also did a bronze tondo of Our Lady which he cast at the request of some Flemish merchants of the Moscheroni family, extremely noble men in their own country, who paid him one hundred *scudi* and sent the work to Flanders.*

Angelo Doni, a Florentine citizen and friend of Michelangelo, as a man who took great delight in owning beautiful objects by both ancient and modern artists, decided that he wanted something done by Michelangelo; hence, Michelangelo began painting a tondo for him,* containing the figure of Our Lady kneeling down with a young child in Her arms whom She holds out towards Joseph, who receives Him; in the way Christ's mother turns Her head and fixes Her eyes upon the supreme beauty of Her Child, Michelangelo makes us understand Her marvellous sense of contentment and the emotion She feels in sharing it with that most holy old man, who takes the child with equal love, tenderness, and reverence, which can easily be discerned in his face at a glance. Since these details were not enough for Michelangelo to prove that his skill was immense, he painted in the background of this work many nudes, some leaning, others standing or seated, and he completed this painting with such diligence and polish that of all his paintings on panels, although they are few, this one is surely considered the most perfect and the most beautiful painting in existence. After it was completed, he sent it by messenger to Angelo's home, covered, along with a bill asking seventy ducats in payment. Since Angelo was a thrifty person, he thought it strange to pay so much for a painting, even though he knew it to be worth even more, and he told the messenger that forty ducats were enough and gave them to him; at this Michelangelo sent the messenger back again, telling him to say that either one hundred ducats

or the painting should be returned to him. At this, Angelo,
who liked the painting, declared: 'I'll give him those seventy.'
But Michelangelo was not satisfied, and, indeed, because of
Angelo's lack of good faith, he wanted double the payment he
had requested the first time; since Angelo wanted the painting,
he was forced to send Michelangelo one hundred and forty
ducats.

It happened that while that exceptional painter, Leonardo
da Vinci, was working in the Grand Hall of the Council, as is
recounted in his *Life*, Piero Soderini, the Gonfaloniere of that
time, because of the great talent he observed in Michelangelo,
commissioned him to do part of the hall, and this was why he
came to compete with Leonardo on the other wall, taking as
his subject the Pisan war.* For this reason, Michelangelo had
access to a room in the Dyers' Hospital at Sant'Onofrio, and
there he began an enormous cartoon, which he never wanted
anyone else to see. He filled it with nudes bathing during the
heat in the river Arno, imagining the moment when the alarm
is sounded in the camp at the assault of the enemy, and while
the soldiers emerge from the water to dress, the divinely
inspired hands of Michelangelo depicted some hurrying to
take up their arms to help their comrades, while others buckle
on their cuirasses, and many put on other kinds of armour,
with countless men fighting on horseback to start the scuffle.
Among the other figures is an old man wearing a garland of
ivy to shade his head; he has sat himself down to put on his
stockings but is unable to do so because his legs are wet from
the water, and hearing the tumult of the soldiers and the cries
and the rolls of the drums, he hurriedly forces his foot into a
stocking; besides the fact that all the muscles and nerves in this
figure can be seen, Michelangelo gave him a contorted mouth,
using it to show that he was suffering and exerting himself
down to the very tips of his toes.

Drummers and naked figures with their clothes wrapped in
a bundle are also racing towards the fight, and men in extravag-
ant poses can be seen, some standing upright, others kneeling
or bent over or lying down, all in positions drawn with the
most difficult foreshortenings. There are also many figures
grouped together and sketched out in various ways, some

outlined with charcoal, others drawn in with a few strokes, some shaded and illumined with white lead, since Michelangelo wished to demonstrate how much he knew about this craft. Thus, the artisans remained astonished and amazed when they saw the limits of the art of painting demonstrated to them in this cartoon by Michelangelo. Once they had examined these sublime figures, some of the people who saw them declared that no other genius, neither Michelangelo nor any other artist, could ever produce anything to equal the sublime qualities of this work of art. And this can certainly be believed, for as soon as it was finished and, to the great glory of Michelangelo, carried to the Pope's Chamber with a great clamour among the craftsmen, all those who studied the cartoon and sketched from it, which both foreigners and local artisans continued to do in Florence for many years afterwards, became distinguished individuals in this profession, as we have seen; those who later studied the cartoon included Aristotle da San Gallo, Michelangelo's friend; Ridolfo Ghirlandaio, Raphael Sanzio of Urbino, Francesco Granacci, Baccio Bandinelli, and the Spaniard Alonso Beruguete; following them were Andrea del Sarto, Franciabigio, Jacopo Sansovino, Rosso, Maturino, Lorenzetto, Tribolo as a young boy, Jacopo da Pontormo, and Perin del Vaga, all of whom were excellent Florentine masters; and since the cartoon had become a subject of study for artisans, it was taken to the large upper hall in the Medici's home, and this was the reason why it was placed too freely in the hands of the artists. Thus, during the illness of Duke Giuliano and while no one was looking after such a thing, it was, as we said elsewhere, torn apart and divided into many pieces so that it was scattered around in a number of places, as is substantiated by some pieces that can still be seen in Mantua in the home of Uberto Strozzi, a Mantuan gentleman who conserves them with great reverence.* And certainly anyone who sees them considers them something divine rather than human.

The *Pietà*, the giant of Florence, and the cartoon had made Michelangelo so famous that in the year 1503, when Pope Alexander VI died and Julius II was named pope, at a time when Michelangelo was about twenty-nine years of age, he

was summoned with great courtesy by Julius II to build his tomb, and for his travelling expenses he was paid one hundred *scudi* by the pope's agents.* After he had been brought to Rome, many months passed before he was put to work on anything. Finally the pope decided upon a design that Michelangelo had done for the tomb, which provided admirable proof of his talent and which in beauty, splendour, magnificent decoration, and the richness of its statuary surpassed every ancient and imperial tomb. And as Pope Julius's courage increased, it caused him to decide to begin rebuilding the church of Saint Peter in Rome in order to place the tomb inside it, as was mentioned elsewhere.*

Thus, Michelangelo boldly set to work: to begin the project, he went to Carrara to excavate all of the marble with two of his apprentices, and from Alamanno Salviati in Florence he received a thousand *scudi* on this account; he spent eight months in those mountains without any other salary or provisions, where, challenged by those massive blocks, he conceived many fantastic ideas for carving giant statues in those quarries in order to leave a memorial of himself as the ancients had already done. After having chosen the appropriate pieces of marble, he had them loaded at the dock and then brought to Rome, where they filled half the square of Saint Peter's near Santa Caterina and the space between the church and the corridor that runs towards Castel Sant'Angelo, where Michelangelo had set up a room to work on the figures and the rest of the tomb; and so that he could conveniently come to see Michelangelo work, the pope had a drawbridge built from the corridor to the room, and, because of this, he came to be on very intimate terms with Michelangelo, though in time these favours brought Michelangelo great annoyance and even persecution, and also stirred up a great deal of envy among his fellow artisans.

While Julius was alive and after his death, Michelangelo executed for this project four finished statues and eight others only roughed out, as I shall describe in the proper place, and since the project was conceived with the greatest powers of invention, we shall describe below the plan he followed. In order to give it a greater sense of grandeur, Michelangelo

wanted the tomb to be isolated so that it could be seen from all four sides, each of which measured twenty-four feet in one direction and thirty-six feet in the other, so that the proportions were a square and a half. The outside of the tomb had a series of niches all around it divided by terminal figures clothed from the middle upwards which supported the first cornice with their heads, and to each of these terminal figures was bound a nude prisoner standing on a projection of the base in a strange and unusual pose. These prisoners represented all the provinces subjugated by the pontiff and made obedient to the Apostolic Church; and other different statues, also bound, represented all the Virtues and the Liberal Arts and Sciences to show that they, too, were no less subject to death than the pontiff who so honourably employed them. Four large figures were to go on the corners of the first cornice: the Active and Contemplative Life, Saint Paul, and Moses. Above the cornice the work rose in diminishing steps, with a decorated bronze frieze and other figures, putti, and decorations all around, and at the top, completing the monument, there were two figures, one of which was Heaven, who was smiling and bearing a coffin on her shoulders, and the other Cybele, the goddess of earth, who seemed unhappy to remain in a world deprived of every virtue at the death of such a man, while Heaven seemed to be rejoicing that his soul had passed to celestial glory. The tomb was arranged so that one could enter and leave through the space at the ends of the square panels between the niches, while the inside had the configuration of a temple in an oval form, in the middle of which was the sarcophagus where the dead body of that pontiff was to be placed, and, finally, forty marble statues—not counting the other scenes, putti, decorations, and all the carved cornices and other architectural details—were to adorn the entire work.

To facilitate the work, Michelangelo ordered part of the marble to be brought to Florence, where he planned on occasion to pass the summer to avoid the unhealthy air of Rome, and where he executed one side of the work in several pieces down to the last detail; and in Rome, with his own hand, he completed two of the prisoners in a truly sublime

fashion as well as some other statues that have never been surpassed. Since they were not placed upon the tomb, the two prisoners were given to Signor Roberto Strozzi by Michelangelo, because Michelangelo had been in Strozzi's home during an illness; later they were sent as a gift to King Francis and are today in Écouen in France.* In Rome he also roughed out eight statues, and another five in Florence,* and he completed a Victory standing over the figure of a prisoner which is now in the possession of Duke Cosimo, to whom the work was given by Michelangelo's nephew Lionardo; His Excellency has placed the statue of Victory in the Great Hall of his palace, which was painted by Vasari.*

Michelangelo finished the figure of Moses, a statue in marble five armslengths high, which no modern statue could ever rival in beauty (and one could say the same of ancient statues as well), for seated with a most serious expression, Moses rests one arm upon the tablets he is holding in one hand, and with the other he grasps his long and flowing beard, which is executed so well in the marble that the hairs, so difficult to render in sculpture, are delicately carved, downy, and soft, and drawn out in such a way that it seems as if the chisel has become a brush;* and besides the beauty of the face, which wears the expression typical of a true saint and a most formidable prince, it seems that while you gaze at the statue, you feel the desire to ask for a veil to cover his face, so splendid and radiant does it appear to onlookers. And in the marble, Michelangelo has perfectly depicted the divinity God has endowed upon his most holy face, not to mention the fact that his garments are carved and finished with the most beautiful folds in the hems, while the muscles of the arms and the bones and sinews of the hands are brought to the height of beauty and perfection along with the legs and knees, and the feet below are fitted with such well-fashioned sandals, and every aspect of the work is finished so skilfully, that, today more than ever, Moses can call himself the friend of God, since through the hands of Michelangelo He wished to restore and prepare Moses' body for the Resurrection long before that of anyone else. May the Jews continue to go there, as they do in crowds, both men and women, every Saturday, like flocks

of starlings, to visit and adore the statue, for they will be worshipping something that is not human but divine.

Finally, when an agreement was reached for the completion of this work, one of the smaller of the four sides was built in San Pietro in Vincoli. It is said that while Michelangelo was carrying out this work, the rest of the marble for the tomb that had been left in Carrara arrived at Ripa, and was brought to Saint Peter's square along with the rest, and because he had to pay the men who had delivered it, Michelangelo went as usual to see the pope, but since that day His Holiness had to attend to some matters which were of interest to him concerning the Bologna affair,* Michelangelo returned home and paid for the marble himself, assuming he would immediately receive the order of reimbursement from His Holiness. He returned on another day to speak to the pope about it and found it difficult to gain entrance, because a footman told him to be patient and that he had orders not to admit him: when a bishop told the footman 'Perhaps you don't know this man!', the footman declared: 'I know him only too well, but I am here to carry out the orders of my superiors and the pope.'

This attitude displeased Michelangelo, who thought it stood in contrast to the treatment he had received up to then, and he indignantly told the footman to tell the pope that from now on when he looked for Michelangelo he would find that he had gone somewhere else, and having returned to his quarters at two o'clock in the morning, he mounted a post horse, leaving behind him two servants to sell all his household goods to the Jews with orders to follow him to Florence where he was headed. When he reached Poggibonsi, a city in the Florentine territory, he felt safe enough to stop, even though it was not long before five couriers arrived there with written instructions from the pope to bring Michelangelo back, and neither their entreaties nor the letter ordering him to return to Rome on pain of disgrace could make Michelangelo listen to anything, but the prayers of the couriers finally convinced him to write two words in reply to His Holiness, asking his pardon for not returning again to His Presence, after he had been driven away like a poor wretch, and explaining that his

faithful service did not deserve such treatment, and that the pope should look elsewhere for someone to serve him.

Having arrived in Florence, Michelangelo set about finishing, in the three months he stayed there, the cartoon for the Great Hall, which Piero Soderini the Gonfaloniere wanted him to execute. However, during this time three papal briefs reached the Signoria, ordering the government to return Michelangelo to Rome, and since Michelangelo had witnessed the pope's wrath and distrusted him, according to what people say, he wanted to go to Constantinople through the agency of some Franciscan friars to work for the Turk, who wished to have him there to construct a bridge from Constantinople to Pera. However, Piero Soderini persuaded him against his wishes to go and meet the pope as a public official with the title of ambassador of the city to safeguard his life, and he finally commended Michelangelo to the care of Cardinal Soderini, his brother, who would present him to the pope, and sent him to Bologna, where His Holiness had already arrived from Rome.

There is still another version of the story about Michelangelo's departure from Rome: namely, that the pope became angry with Michelangelo, who did not want to let him see any of his works; and that Michelangelo distrusted his own workers, believing that on more than one occasion the pope, in disguise, had seen what he was doing at certain times when Michelangelo was either not in the house or at work; and that the pope had once bribed his apprentices to allow him to enter and see the chapel of Sixtus, his uncle, which he was having Michelangelo paint (as will be described shortly); and that Michelangelo once concealed himself, since he suspected the treachery of his assistants, and dropped some planks when the pope entered the chapel, not thinking about who it was and forcing the pope to leave in anger. Let it suffice to say that in one way or another, Michelangelo was angry with the pope, and then afraid of him, and had to run away.

Thus, Michelangelo arrived in Bologna, and no sooner had he pulled off his boots than he was brought by the pope's servants before His Holiness, who was in the Palace of the Sixteen; he was accompanied by one of Cardinal Soderini's

bishops, since the cardinal was ill and could not go with him; and when they came before the pope and Michelangelo knelt down, His Holiness looked at him askance and, as if he were angry, he said: 'Rather than coming to meet Us, you have waited for Us to come to meet you?', meaning to infer that Bologna was closer to Florence than to Rome. With courteous gestures and a loud voice, Michelangelo humbly begged the pope's pardon, excusing himself, since he had acted in anger, having been unable to bear being chased away in such a fashion, and he begged the pope once again to forgive him for having done wrong. The bishop who had presented Michelangelo to the pope tried to excuse him, declaring to His Holiness that such men were ignorant and worthless in anything outside of their art, and that he should willingly forgive him. This enraged the pope, who thrashed the bishop with a mace he was holding, telling him: 'You are the ignorant one, speaking insults We would never utter!' And so the bishop was driven out by the footmen with sticks and left, and after the pope vented his anger on him he blessed Michelangelo, who was kept waiting with gifts and promises in Bologna until His Holiness ordered him to do a bronze statue in his own likeness five armslengths high; in this work Michelangelo employed the most beautiful artistry in the pose of the statue, for it reflected majesty and grandeur in every detail, its garments displayed wealth and magnificence, and its face embodied courage, strength, quickness, and magnificence. This statue was placed in a niche above the door of San Petronio.

It is said that while Michelangelo was working on the statue, Il Francia,* a goldsmith and most excellent painter, came to see it, since he knew Michelangelo's reputation and the praise given his works but had never seen any of them. He sent messages asking to see the statue, and gained permission to do so. Upon seeing Michelangelo's skill, he was amazed and when he was asked what he thought of the figure, Il Francia replied that it was a very fine casting and beautiful material. Since Michelangelo felt he had praised the bronze more than the craftsmanship, he said: 'I have the same obligation to Pope Julius who gave me the bronze as you have to the apothecaries who give you the colours for your paint', and in the

presence of some gentlemen he angrily declared that Il Francia was a fool. And on this same subject, when Michelangelo encountered Il Francia's son, who was a very handsome boy, Michelangelo said to him: 'Your father makes more handsome figures in life than he does in painting.' Among the same gentlemen, there was one whose name I do not know who asked Michelangelo which was larger, the statue of Julius or a pair of oxen, and Michelangelo answered: 'That depends on the oxen, for these Bolognese oxen are no doubt larger than our Florentine ones.'

Michelangelo completed the statue in clay before the pope left Bologna for Rome; and when His Holiness went to see it, he did not know what was to be placed in the statue's left hand, while the right hand was raised in a proud gesture, and the pope asked if it was giving a blessing or a curse. Michelangelo answered that it was advising the people of Bologna to behave wisely; and when he asked His Holiness if he thought he should place a book in the left hand, the pope said: 'Put a sword there, I know nothing about literature!' The pope left one thousand *scudi* in the bank of Messer Antonmaria da Lignano to complete the statue, which was later, at the end of the sixteen months it took to complete it, placed on the front of the main facade of the church of San Petronio, as was previously mentioned, just as its size has already been described. The statue was destroyed by the Bentivogli and its bronze sold to Duke Alfonso of Ferrara, who had an artillery piece made from it called *La Giulia*, except for the head, which is in the duke's wardrobe.*

While the pope had returned to Rome and Michelangelo completed the statue in Bologna, Bramante, the friend and relative of Raphael of Urbino, and therefore no real friend of Michelangelo, realized, in Michelangelo's absence, that the pope favoured and encouraged Michelangelo's works in sculpture, and, along with Raphael, began thinking of a way to change his mind, so that upon Michelangelo's return His Holiness would not try to complete his tomb, by telling him that this would seem to hasten his death and that it was bad luck to build one's tomb while alive; and Bramante and Raphael persuaded the pope that upon Michelangelo's return, in mem-

ory of his uncle Sixtus, the pope should have Michelangelo
paint the vault of the chapel that Sixtus had built in the
[Vatican] palace, and in this way Bramante and other rivals of
Michelangelo hoped to take Michelangelo away from sculp-
ture, in which they saw he had reached perfection, and to
drive him to desperation, assuming that by having him paint
he would produce a less praiseworthy work and would be less
likely to succeed than Raphael, since he had no experience in
doing frescos in colour; and even if the work turned out well,
doing it would make him angry with the pope at any rate, so
that in one way or another their intention of getting rid of
him would succeed.*

And so Michelangelo returned to Rome, and the pope
decided not to complete his tomb for the time being and asked
him to paint the vault of the chapel. Michelangelo, who
wished to finish the tomb and saw that painting the vault
would be an enormous and difficult task, considering his lack
of experience with colours, tried in every way possible to
remove this burden from his shoulders, recommending above
all Raphael for the job. But the more he refused, the more
persistent he made the pope, who was an impetuous man in
his undertakings and was once again urged on by Michelan-
gelo's rivals, especially by Bramante, so that the pope, who
was quick to anger, almost flew into a rage with Michelan-
gelo. But having seen that his Holiness persisted in this idea, he
decided to do what he was asked, and the pope ordered
Bramante to build the scaffolding in order to paint it;
Bramante did so by piercing the ceiling and hanging every-
thing from ropes; upon seeing this, Michelangelo asked
Bramante how, once the painting had been completed, he
would be able to fill the holes; and Bramante replied, 'We'll
worry about that later', and added that there was no other
way to do it. Michelangelo then realized that either Bramante
knew little about it or he was not much of a friend, and he
went to the pope and told him that this scaffolding was unsat-
isfactory and that Bramante had not understood how to build
it; in Bramante's presence, the pope replied that he should
build one in his own way. And so Michelangelo ordered
scaffolding built on poles which did not touch the wall, the

method for fitting out vaults he later taught to Bramante and
others, and with which many fine works were executed. For
this project, Michelangelo had the poor carpenter who rebuilt
the scaffolding paid in advance for so much rope that, by sell-
ing what was left over, which Michelangelo gave him as a
gift, he paid the dowry for one of his daughters.

He then began work on the cartoons for the vault, and the
pope also wanted him to destroy the walls that had already
been painted in the time of Sixtus by masters who came before
him,* and decided that Michelangelo should receive fifteen
thousand ducats for the cost of the entire project, the price
being set by Giuliano da San Gallo. Obliged by the size of the
undertaking to seek assistance, Michelangelo sent to Florence
for men, and having decided to demonstrate in this project
that those who had painted there before him were unequal to
his labours, he also wished to show modern artisans how to
design and paint. Thus, the theme of the work compelled
Michelangelo to aim high for the sake of both his reputation
and the well-being of the art of painting, and he began and
completed the cartoons; then wishing to colour them in fresco
but lacking the necessary experience, he brought some painters
who were friends of his to Rome from Florence to assist him
in the project and also to see their method of working in
fresco, in which some were skilled; these included Granacci,
Giuliano Bugiardini, Jacopo di Sandro, the elder Indaco,
Angelo di Domenico, and Aristotle; and after starting the
project, he had them begin a few things as a sample of their
work. But when he saw that their labours were far from what
he wished to achieve and failed to satisfy him, he decided one
morning to pull down everything they had done. And closing
himself inside the chapel, he would not open it to them or
even see them at his home. And when they thought this joke
had been carried far enough, they made up their minds and
returned to Florence in disgrace. Then Michelangelo made
arrangements to do the whole work by himself, and he readily
brought it to a very fine conclusion with diligent effort and
study; nor would he ever see anyone, to avoid having to
reveal his work, and, as a result, everyone's desire to see it
grew greater every day.

Pope Julius was very anxious to see the work Michelangelo was doing, and the fact that it was hidden from him made his desire grow tremendously; so one day he wanted to go to see it but was not admitted, for Michelangelo would never agree to show his work. This gave rise to the disagreement which, as was discussed, caused Michelangelo to leave Rome, since he did not wish to show his work to the pope, and according to what I learned from Michelangelo to clarify this matter, when a third of the chapel had been completed, certain spots of mould started to appear one winter as the north wind was blowing. This was caused by the fact that Roman lime, which is white and made from travertine, does not dry very quickly, and when mixed with *pozzolana*,* which is tan in colour, it makes a dark mixture that is watery when it is in a liquid state, and when the wall is well moistened, it often develops a powdery crust while drying; here, in this case, the salty secretion popped up in many places but was worn away by the air with the passage of time. Michelangelo was in despair over this and did not want to continue, and when he apologized to the pope for the work that did not turn out well, His Holiness sent Giuliano da San Gallo there, who explained to Michelangelo the origin of the defect, encouraged him to continue, and showed him how to remove the mould. When he had finished half of the chapel, the pope, who had then climbed up to see it on several occasions on certain step-ladders assisted by Michelangelo, wanted him to uncover the painting, for he was by nature impetuous and impatient and could not wait until the work was complete and had received, as we say, the final touches.

As soon as it was uncovered, it drew all of Rome to see it, and the pope was the first, since he did not have the patience to wait until the dust settled from the dismantling of the scaffolding. Once Raphael of Urbino, who was a very excellent imitator, saw it, he quickly changed his style, and in order to show his skill he immediately painted the prophets and the sibyls in Santa Maria della Pace, while Bramante still tried to convince the pope to give the other half of the chapel to Raphael. When Michelangelo learned of this, he complained about Bramante and openly told the pope of Bramante's

many defects, both in his life and in his architectural works, and, as it later turned out, Michelangelo became the one to correct his mistakes in the Works Department of Saint Peter's. But the pope, recognizing Michelangelo's skill more each day, wanted him to continue, and when he saw the chapel uncovered, he judged that Michelangelo could do the other half much better. And so, Michelangelo brought the project to perfect completion in twenty months, wholly by himself alone without even the assistance of someone to grind his colours. Michelangelo sometimes complained that because of the pope's haste he was not able to complete it in his own way as he would have wished, since the pope importunately demanded to know when he would finish; on one occasion among others, Michelangelo replied that the work would be finished 'when it satisfies me in its artistic details'. 'And We', remarked the pope, 'want you to satisfy Us in Our desire to see it done quickly.' Finally, the pope threatened that if Michelangelo did not finish quickly, he would have him thrown down from the scaffolding. And so Michelangelo, who feared and had reason to fear the pope's temper, immediately finished what was left without wasting any time, and after he had dismantled the rest of the scaffolding, he unveiled it on the morning of All Saints' Day when the pope came to the chapel to sing Mass, to the satisfaction of the whole city.

Michelangelo wanted to retouch some details *a secco*, as those older masters had done on the scenes below, painting certain fields, draperies, and skies in ultramarine blue and golden decorations in some places to give the painting greater richness of detail and a finer appearance; when the pope understood that this decoration was still missing, having heard the work so highly praised by everyone who had seen it, he wanted this to be provided, but because it would have taken too long for Michelangelo to rebuild the scaffolding, the painting remained as it was. Since the pope saw Michelangelo often, he used to say to him: 'Let the chapel be embellished with colours and gold, for it looks too plain.' And Michelangelo replied in a familiar tone: 'Holy Father, in those days men did not wear gold, and those who are painted there never were rich, for they were holy men who despised wealth.'

Michelangelo was paid on account for this work in several instalments, a total of three thousand *scudi*,* of which he had to spend twenty-five on colours. These frescos were done with the greatest discomfort, for he had to stand there working with his head tilted backwards, and it damaged his eyesight so much that he could no longer read or look at drawings if his head was not tilted backwards; his condition lasted for several months afterwards, and I can testify to this fact, for after working on the vaults of five rooms in the great chambers of the palace of Duke Cosimo, if I had not built a chair upon which to rest my head and to stretch out while I was working, I would have never completed the work, for it ruined my sight and weakened my head to such an extent that I can still feel it, and I am amazed that Michelangelo tolerated such discomfort. But every day kindled even more his desire to work, and with the progress and improvement he made, he neither felt fatigue nor worried about all the discomfort.

The compartments in the work were organized into six pendentives on either side and one in the centre of the walls at the foot and one at the head, in which Michelangelo painted sibyls and prophets six armslengths in height, and in the middle of the ceiling he depicted scenes from the Creation of the World up to the Flood and the Drunkenness of Noah, and in the lunettes he painted all the ancestors of Jesus Christ. In the compartments he did not employ any rules of perspective for foreshortening, nor any fixed vantage point, but he went about accommodating the compartments to the figures rather than the figures to the compartments, since it was sufficient to execute the nude and clothed figures with a perfection of design that no work has ever equalled or will ever equal, and it is scarcely possible, even with hard work, to imitate what he did. This work has been and truly is the beacon of our art, and it has brought such benefit and enlightenment to the art of painting that it was sufficient to illuminate a world which for so many hundreds of years had remained in the state of darkness. And, to tell the truth, anyone who is a painter no longer needs to concern himself about seeing innovations and inventions, new ways of painting poses, clothing on figures, and various awe-inspiring details, for Michelangelo

gave to this work all the perfection that can be given to such details.

But any man will be astonished by this work who knows how to discern the excellence of the figures, the perfection of the foreshortenings, the truly stupendous round contours, all of which possess grace and delicacy, and the beautiful proportions seen especially in those beautiful nudes, in which he demonstrates the extremes and perfection of his craft, by creating nudes of all ages, all different in their expressions and forms, both in their faces and in their features, some with slimmer bodies and others with larger ones. Likewise, his artistic skill can be recognized in their beautiful and varied poses, for some are sitting, others are turning around, and still others are holding up garlands of oak and acorn leaves representing the coat of arms and insignia of Pope Julius and signifying the fact that the period during his rule was an age of gold, since Italy had not yet entered into the hardships and miseries that she later encountered.

Thus, in the middle of the ceiling the nudes are holding some medals containing roughed-out scenes painted in bronze and gold and taken from the Book of Kings. Furthermore, to demonstrate the perfection of his art and the greatness of God, Michelangelo depicted God dividing the light from the darkness in these scenes, where He is seen in all His majesty as He sustains Himself alone with open arms in a demonstration of love and creative energy. In the second scene, with the most admirable judgement and ingenuity, Michelangelo depicted the moment when God creates the sun and moon, where He is supported by many putti and shown to be awesome by means of the foreshortening of His arms and legs. Michelangelo did the same thing in this same scene when God blesses the earth and creates the animals, while He is seen flying on the vault, a foreshortened figure which continually turns and changes direction as you walk through the chapel; likewise the next scene depicts the moment when God divides the waters from the earth, with extremely beautiful figures revealing true insight and worthy of being created only by the most divinely inspired hands of Michelangelo.

And then below* this scene, he continued with the Creation

of Adam, in which he has represented God carried by a group of nude angels of a tender age who seem to sustain not only one figure but the entire weight of the world, an effect made visible in the most venerable majesty of God and His manner of movement, for He embraces some putti with one arm almost as if to support Himself, while with the other he stretches out his right hand to Adam, a figure whose beauty, pose, and contours are of such a quality that he seems newly created by his Supreme and First Creator rather than by the brush and design of a mere mortal. Just below this in another scene Michelangelo depicted God creating Our Mother Eve from Adam's rib, in which two nudes are seen, one almost dead from being imprisoned by sleep, while the other comes alive completely awakened by the benediction of God. The brush of this most ingenious artisan reveals the true difference between sleep and awakening, as well as how stable and firm His Divine Majesty may appear when speaking in human terms.

Following this below is the scene when Adam, at the instigation of a figure half woman and half serpent, partakes of his death and our own in the apple, and Adam and Eve are seen as they are banished from Paradise. There, in the figure of the angel, the execution of the order of a wrathful Lord is made visible with grandeur and nobility, while Adam's pose displays the sorrow he feels over his sin along with his fear of death; likewise, in the figure of the woman, shame, cowardice, and the desire for pardon are revealed through her contracting arms, her hands joined at the palms, and the lowering of her head upon her bosom; and when she turns her head towards the angel, she appears more fearful of justice than hopeful of divine forgiveness. No less beautiful is the scene of the Sacrifice of Cain and Abel, where some people are carrying wood, while others are leaning over to blow on the fire, and still others cut the throat of their sacrificial victim; this scene is certainly done with no less consideration and care than the others. Michelangelo employed the same skill and good judgement in the scene of the Flood, where various dying men appear, frightened by the horror of those days, and search as best they can for different ways to escape with their lives. Accordingly,

the heads of these figures reveal that life falls prey to death, no less than fear, terror, and scorn for all things. Michelangelo shows the compassion of many others, helping one another climb up to the summit of a rock seeking safety. Among the figures is one who has embraced a half-dead man and is trying as best he can to save him, a figure Nature herself could not have depicted any better. And no one can describe how well the story of Noah has been expressed in the scene where Noah, inebriated from the wine, sleeps naked in the presence of one son who is laughing at him while two others are covering him up, a scene and the incomparable talent of an artisan that could not be surpassed except by Michelangelo himself. And then, as if he had gained courage from the things he had painted up to that point, Michelangelo's talent was reinvigorated and proved itself greater in the figures of the five sibyls and the seven prophets he painted here, each five armslengths high or more; all of them are in different poses, with beautiful garments and variety in their dress, and all, in short, are executed with invention and miraculous judgement, appearing divinely inspired to anyone who can distinguish the emotions they express.

Jeremiah can be seen with his legs crossed, holding on to his beard with one hand and resting his elbow on his knee; the other hand rests on his lap, with his head bent in a manner which clearly displays his melancholy, his worry, his thinking, and the bitterness he feels over his people, and two putti behind him express similar emotions; likewise, in the figure of the first sibyl below him in the direction of the door, Michelangelo wanted to express the nature of old age, and besides enveloping her in draperies, he wished to show that her blood was already frozen with the passing of time, and, since her eyesight is failing, Michelangelo has her draw the book she is reading very close to her eyes. Below this figure is the old prophet Ezekiel, who is depicted with a very beautiful sense of grace and movement and dressed in ample garments, carrying a scroll of prophecies in one hand while he raises the other and, turning his head, shows that he means to speak of lofty and important matters, and behind him are two putti holding his books. Below these scenes follows a sibyl who, in

contrast to the Erythraean sibyl mentioned above, is holding a
book some distance away and is trying to turn a page, while,
with one knee over the other, she is absorbed in thought, con-
sidering seriously what she must write, while a putto behind
her is blowing on a burning brand to light her lamp. This
figure is extraordinarily beautiful owing to the expression of
its face, the arrangement of its hair, and the style of its
garments, not to mention its bare arms, which are as beautiful
as the rest of the body. And below this sibyl he painted the
prophet Joel, who, deep in his own thoughts, has taken a scroll
and is reading it with great attention and emotion. From his
appearance, it is obvious that he is so pleased by what he has
found written there that he appears to be a living person who
has most vigorously applied his mind to some question. Like-
wise, over the door of the chapel, he placed old Zachariah,
who is searching through a book for something he cannot
find, with one leg raised high and the other down low, and
while his haste in searching for what he cannot find makes him
sit this way, he is oblivious to the discomfort he endures in
such a posture. This figure is most admirable owing to its
depiction of old age; it is rather stout in stature dressed in a
garment with few folds that is very handsome, and, beyond it,
there is another sibyl turning in the direction of the altar on
the other side and displaying certain writings who, with her
putti, is no less praiseworthy than the other figures.

Above her, the prophet Isaiah, transfixed by his own
thoughts, has his legs crossed, and, keeping one hand inside his
book to mark the place where he is reading, he rests his other
elbow on the book and his chin in his hand; he is called by one
of the putti behind him and turns only his head, without
twisting the rest of his body; and anyone who examines this
figure will see details taken from Nature herself, the true
mother of the art of painting, and will see a figure that with
close study can in broad terms teach all the precepts of good
painting. Above this prophet is a very beautiful old sibyl with
extraordinary grace who, while seated, is studying a book, and
the poses of the two putti by her side are no less beautiful. Nor
could one even imagine making any improvements in the
beauty of the figure of a young man representing Daniel, who

is writing in a large book and copying some things he has found in certain other writings with an incredible eagerness. As a support for that weight, Michelangelo painted a putto between his legs who is supporting him while he writes, and this figure could never be equalled by a brush in the hand of any other artist; the same is true of the extremely beautiful figure of the Libyan sibyl, who, after having written a huge volume drawn from many books, is about to rise to her feet in a feminine pose, and, at the same moment, she shows her wish to arise and her desire to close the book—a difficult, not to say impossible, detail for any other master but Michelangelo.

What can be said of the four scenes at the corners in the pendentives of the vault? In one of them there is a David, expressing that boyish strength which can be especially effective in defeating a giant by cutting off his head and which brings astonishment to the faces of several soldiers shown around the camp; equally amazing are the extremely beautiful poses of the figures in the story of Judith in the opposite corner, where the headless, quivering body of Holofernes appears, while Judith places the severed head in a basket that one of her elderly maids carries on her head, and since the maid is tall in stature, she leans over so that Judith can reach it and arrange it properly; keeping her hands on this burden, she tries to cover it up, and, turning her face towards the body which, although dead, lifts an arm and a leg, making a noise inside the tent, the woman reflects in her expression her fear of the armed camp and her dread of the dead man: this is truly a very highly thought-of painting.

But more beautiful and divinely inspired than this and all the others is the scene depicting Moses' serpents over the left corner of the altar, for in it the slaughter of the dead can be seen as the serpents rain down, biting and stinging, as well as the bronze serpent itself that Moses placed upon the pole; this scene vividly portrays the diversity among the deaths suffered by those deprived of all hope by the serpents' bites. The deadly poison is seen to cause the deaths of countless people by convulsions and terror, not to mention the twisted legs and intertwined arms of those who remain in the position they were in when struck down, unable to move, or the extremely

beautiful heads shown screaming and turned up in despair. No less beautiful than all these are the figures of the people who, while examining the serpent, feel themselves restored to life with the lessening of their pain; they gaze at it with tremendous emotion, and among them a woman can be seen supported by another figure in a way that reveals not only the assistance offered by the person holding her up but also her need, as she is bitten in this sudden moment of terror.

Similarly, the scene which depicts Ahasuerus lying in bed and reading his chronicles contains very beautiful figures, and among others to be seen are three men eating at a table, who represent the council held to liberate the Hebrew people and to hang Haman; the figure of Haman himself is foreshortened in an extraordinary manner, since Michelangelo depicted the trunk holding up his body and his arm coming forward so that they seem alive and in relief rather than painted, just like the leg that he pushes out and other parts of his body that turn inward: a figure that is certainly the most beautiful and difficult among many difficult and beautiful figures.

It would take too long to explain the many beautiful and different poses and gestures Michelangelo imagined to represent the genealogy of the Fathers, beginning with the children of Noah, and to display the ancestry of Jesus Christ. It is impossible to recount the diversity of details in these figures, such as their garments, their facial expressions, and countless extraordinary and original inventions, all most beautifully conceived. In them there is no single detail that was not brought into being by Michelangelo's genius, and all the figures are most beautifully and skilfully foreshortened, while everything that is to be admired is worthy of the highest praise and splendid. But who will not admire and remain astonished upon seeing the magnificence of Jonah, the last figure in the chapel? There, through the power of art, the vault that by nature moves forward curving along the wall, is pushed up by the appearance of this figure turning in the opposite direction so that it seems straight, and then, conquered by the art of design, along with light and shadow, it truly seems to turn backwards.

Oh, truly happy age of ours! Oh, blessed artists! For you

must call yourselves fortunate, since in your own lifetime you
have been able to rekindle the dim lights of your eyes from a
source of such clarity, and to see everything that was difficult
made simple by such a marvellous and singular artist! Cer-
tainly the glory of his labours has made you recognize and
honour them, for he has removed the blinders from the eyes
of your minds, so full of shadows, and has shown you how to
distinguish the true from the false that clouded your intel-
lects. Therefore, thank Heaven for this and strive to imitate
Michelangelo in all things.

When the chapel was uncovered, people from everywhere
wanted to rush to see it, and the sight of it alone was sufficient
to leave them amazed and speechless; and so the pope, exalted
by this project and encouraged to undertake even greater
enterprises, rewarded Michelangelo greatly with money and
rich gifts, and Michelangelo used to say that the favours he
received from this pope proved that he fully recognized his
talents; and if on some occasions, because of their intimate
relationship, the pope abused him, he would heal his wounds
with gifts and extraordinary favours. For instance, this oc-
curred when Michelangelo, seeking the pope's permission to
go to spend the feast day of Saint John in Florence, asked him
for some money for this purpose, and the pope said:

'Well, what about this chapel? When will it be finished?'

'When I can, Holy Father,' replied Michelangelo.

The pope, who had a staff in his hand, struck Michelangelo
with it as he declared: 'When I can, when I can: I'll make you
finish it myself!'

But when Michelangelo returned home to make his pre-
parations for going to Florence, the pope immediately sent
Cursio, his chamberlain, to Michelangelo with five hundred
scudi, and Cursio tried to excuse the pope, declaring that such
acts were all signs of his favour and affection, fearing that if he
did not do something to placate Michelangelo, he would react
in his usual manner. And because Michelangelo understood
the pope's character and, in the end, loved him dearly, he
laughed about it, and then finally saw everything redound to
his favour and profit, since the pope would do anything to
keep Michelangelo's friendship.

When the chapel was completed and before the pope died, His Holiness ordered Cardinal Santiquattro and Cardinal Aginense,* his nephew, that in the event of his death they should finish his tomb on a smaller scale than first planned. And Michelangelo set to work once more, and thus willingly began again working on this tomb to finish it once and for all, without any further obstacles, but from then on it always caused him more displeasure, bother, and distress than anything else he ever did in his life, and also for some time and in some respects it earned him the reputation of being ungrateful towards the pope who had loved and favoured him so greatly. And so he returned to the tomb, working on it continuously, while also spending part of his time putting into order the plans to be executed for the façades of the chapel, but envious Fortune decreed that this memorial, which had such a perfect beginning, would never be brought to completion, since Pope Julius died at this time, and the project was abandoned with the creation of Pope Leo X, whose courage and bravery were no less splendid than Julius's and who, as the first pope elected from Florence, wished to leave behind himself in his native city, in his own memory and in that of a divinely inspired artisan who was his fellow citizen, those marvels that only a very great prince such as he was could create. And so he gave orders that the façade of San Lorenzo in Florence, the church built by the House of the Medici, should be completed for him, and this was why the work on the tomb of Julius remained incomplete, for Leo asked Michelangelo to advise him as well as to draw up plans and to take charge of the project. Michelangelo resisted as best as he could, claiming he was under an obligation to Cardinals Santiquattro and Aginense to finish the tomb; the pope replied that he should not worry about that, since he had already taken care of it and had arranged for them to release him, promising that Michelangelo could work in Florence, just as he had already begun to do, on the figures for the tomb; all this was done to the great displeasure of the cardinals and of Michelangelo, who left in tears.

The discussions that followed about the façade were various and endless, since such a project should have been divided

among several people, and many artisans flocked to Rome to
compete for the architectural commission before the pope:
Baccio d'Agnolo, Antonio da San Gallo, Andrea and Jacopo
Sansovino, and the gracious Raphael of Urbino, who was
later brought to Florence during the pope's visit for this pur-
pose. Michelangelo therefore decided to construct a model and
wanted no one else as his superior or guide in the architec-
ture.* But his refusal of all assistance was the reason why
neither he nor any others went to work, and in desperation the
other masters returned to their usual jobs. And Michelangelo
passed through Florence on his way to Carrara with an order
for Jacopo Salviati to pay him one thousand *scudi*, but since
Jacopo was shut up in his room in a business meeting with
some other citizens, Michelangelo did not wish to wait for
an interview and left without a word, going immediately to
Carrara. When Jacopo heard of Michelangelo's arrival, and
did not find him in Florence, he sent him the thousand *scudi* in
Carrara. The messenger wanted Michelangelo to give him a
receipt, to which Michelangelo replied that they were for the
pope's expenses and not for his own purposes, and that he
should report to Salviati that he was not accustomed to giving
vouchers or receipts to anyone; and so, out of fear, the messen-
ger returned to Jacopo without a receipt. . . . *

Michelangelo spent many years quarrying marble; it is true
that while he was doing this he made wax models and other
things for the façade. But this undertaking was drawn out for
so long that the money the pope set aside for the project
was spent on the wars in Lombardy, and on the death of
Leo the project remained incomplete,* and nothing had been
accomplished on it except the foundations to support it, and
the shipment of a huge marble column from Carrara to the
Piazza of San Lorenzo. The death of Leo paralysed the artisans
and the arts both in Rome and in Florence to such an extent
that while Adrian VI lived, Michelangelo worked in Florence
on the tomb of Julius. But when Adrian died Clement VII
became pope,* a man no less anxious than Leo and his other
predecessors to acquire fame in the arts of architecture, sculp-
ture, and painting. At that time and in the year 1525,* Giorgio
Vasari was brought as a young boy to Florence by the Car-

dinal of Cortona and was placed with Michelangelo to learn the arts. But since Michelangelo had been summoned to Rome by Pope Clement VII, who had begun the Library of San Lorenzo and the New Sacristy in which to place the marble tombs he was having built for his ancestors, Michelangelo decided that Vasari should go to stay with Andrea del Sarto until he sent for him, and he himself went to Andrea's shop to introduce him.

Michelangelo left for Rome in a hurry, and once again he was harassed by Francesco Maria, duke of Urbino and the nephew of Pope Julius, who complained about Michelangelo, declaring that he had received sixteen thousand *scudi* for the tomb and that he had willingly remained in Florence, and he threatened him angrily that if he did not attend to the matter, he would make him regret it. When he arrived in Rome, Pope Clement, who wished to make use of him, advised Michelangelo to settle accounts with the duke's agents, for the pope thought that, considering what Michelangelo had done for him, he was more a creditor than a debtor; the matter was left at that. And, discussing together a number of projects, they decided to finish completely the sacristy and the new library of San Lorenzo in Florence. And so, after leaving Rome, Michelangelo vaulted the dome that can be seen there today, which he finished in a variety of styles, and for it he had Piloto the goldsmith make a very beautiful golden ball with seventy-two facets. It happened that while they were vaulting the dome, Michelangelo was asked by some of his friends:

'Michelangelo, you will have to make your lantern very different from that of Filippo Brunelleschi.'

And he replied to them: 'It can be made different but not better.'*

Inside the sacristy, Michelangelo executed four tombs as decorations for the walls to hold the bodies of the fathers of the two popes, the elder Lorenzo and his brother Giuliano, as well as those of Giuliano, brother of Leo, and Duke Lorenzo, his nephew.* And since Michelangelo wanted to execute the project in imitation of the Old Sacristy done by Filippo Brunelleschi but with a different order of decorations, he

created inside a composite decoration, more varied and original than ancient or modern masters had for some time been able to achieve, for in the originality of its beautiful cornices, capitals, bases, doors, tabernacles, and tombs, Michelangelo departed in a significant way from the measures, orders, and rules men usually employ, following Vitruvius and the ancients, because he did not wish to repeat them. His licence has greatly encouraged those who have seen his way of working in order to set about imitating it, and new fantasies were subsequently seen to exhibit more of the grotesque than reason or rules in their decorations. Thus artisans owe an immense and everlasting debt to Michelangelo, since he broke the bonds and chains that made them all continue to follow a common path.

But then he displayed this technique even more effectively and sought to make it known in the Library of San Lorenzo in the same location: that is, in the beautiful divisions of the windows and the ceiling, and the marvellous entrance hall. Never before had there been seen such resolute grace in the whole as well as in the parts, as in the corbels, tabernacles, and cornices, nor was there ever a more commodious staircase: in it, he executed so many unusual breaks in the steps and departed so far from the usual custom in other details that everyone was astonished by it.*

At that time, Michelangelo sent Pietro Urbano of Pistoia, his pupil, to Rome to prepare a painting of a naked Christ bearing the cross, a truly admirable figure which was placed in Santa Maria sopra Minerva near the main altar for Messer Antonio Metelli. Around this time the Sack of Rome and the expulsion of the Medici from Florence occurred, and during the change [of government], those governing the city made plans to refortify Florence, and they named Michelangelo commissioner general over all the fortifications.* Thus, he made plans for various parts of the city and had it fortified, and finally he surrounded the hill of San Miniato with ramparts, which he did not build with the commonly used clumps of earth, timbers, or bundles of brushwood, but rather with a framework underneath interwoven with chestnut, oak, and other good materials, and in place of the sod he used

rough bricks made from tow and manure, levelled with the greatest care; and because of this, he was sent by the Signoria of Florence to Ferrara to examine the fortifications of Duke Alfonso I, as well as his artillery pieces and munitions, where he received many courtesies from that lord, who begged Michelangelo to make something for him with his own hands, all of which Michelangelo promised to do. After returning to Florence, he continued fortifying the city, and despite these obstacles he nevertheless worked on a painting of Leda for the duke, which he coloured in tempera with his own hand (a splendid work, as will be explained in the proper place), while he was also secretly working upon the tombs for San Lorenzo. At the same time, Michelangelo remained some six months on San Miniato in order to hurry on the fortification of the hill, for if the enemy seized it the city would be lost, and so he pursued these undertakings with great care.

And during this time he continued to work on the previously mentioned sacristy; of this project there remained seven statues that were partially finished and partially not, in which, along with the architectural inventions of the tombs, it must be confessed that he had surpassed every man in all three crafts. These statues still bear witness to this fact, and he roughed them out and finished the marble in the place where they can be seen: one is Our Lady, Who is seated with Her right leg crossed over the left, resting one knee upon the other, while the Child, sitting astride Her highest leg, twists around towards His Mother with the most beautiful expression to ask for milk, and She holds Him with one hand, while with the other she supports Herself and bends down to give Him some. Although various parts of this statue were unfinished, what is left roughed out and full of chisel marks reveals, in its incomplete state, the perfection of the work. But those who examined the way Michelangelo fashioned the tombs of Duke Giuliano and Duke Lorenzo de' Medici were astonished even more by the artist's notion that the earth alone was insufficient to give them an honourable burial worthy of their greatness, and by his decision to include all the parts of the world here, and to cover and surround their tombs with four statues: on one tomb he placed Night and Day, and on the other Dawn

and Dusk; these statues are carved with the most beautifully formed poses and skilfully executed muscles and would be sufficient, if the art of sculpture were lost, to return it to its original splendour. Among the other statues, there are also the two captains in armour: one the pensive Duke Lorenzo, the image of wisdom, with the most handsome legs fashioned in such a way that the eye could not see better ones; and the other Duke Giuliano, so proud a figure with his head, throat, the setting of his eyes, the profile of his nose, the opening of his mouth, and his hair all made with splendid artistry, along with his hands, arms, knees, and feet; and, in short, everything that Michelangelo accomplished here is done in such a way that the eyes could never become bored or satiated. And truly, anyone who gazes at the beauty of the boots and cuirass will believe that this is a heavenly rather than a mortal work. But what can I say about the naked female figure of Dawn, a work that can arouse the melancholy in one's soul and confound the style of sculpture? Her posture reveals her concern as she arises sleepily, extricating herself from the downy cushions, for it seems as if, upon awakening, she has discovered the eyes of this great duke closed. And so she twists around with grief, lamenting in her everlasting beauty as a sign of her great sorrow. And what can I say about the figure of Night, a statue not only rare but unique? Is there anyone who, in the art of any century, has ever seen ancient or modern statues made like this one? For this work reveals not only the stillness of someone who is sleeping but the sorrow and melancholy of someone who is losing something great and honourable. It is possible that this figure may be the night that forever eclipses all those who for some time thought, I will not say to surpass but to equal, Michelangelo in sculpture or the art of design. The figure reveals the kind of drowsiness that can be seen in the living images of sleep; as a result, many verses in Latin and the vernacular were written in praise of his accomplishment by very learned people, such as these whose author is unknown:

Night, that you see in such sweet repose
Sleeping, was sculpted by an angel

> In this stone, and since she sleeps, she lives;
> Wake her, if you don't believe it, and she will speak to you.

To these verses, speaking in the person of Night, Michelangelo replied as follows:

> Sleep is dear to me and even more so being made of stone,
> As long as injury and shamefulness endure;
> Not to see, not to hear is my great good fortune;
> Therefore do not wake me, lower your voice.*

And certainly if the enmity that exists between Fortune and ability, between the skill of one and the envy of the other, had allowed this work to be finished, art could have demonstrated to Nature that it surpasses Nature by far in every thought. But while he was working with diligence and great love upon these works, the siege of Florence took place in the year 1529, which unfortunately prevented its completion; this was the reason why he did little or no more work on it, for the citizens of Florence had entrusted to his care not only the fortifications on the hill of San Miniato, but also those of the city itself, as has already been mentioned. . . . *

After the surrender agreement had been signed,* Baccio Valori, the pope's commissioner, had orders to arrest and imprison in the Bargello some of the citizens most involved in the opposing faction, and the court itself looked for Michelangelo in his home, but, suspecting this, Michelangelo had secretly fled to the home of one of his closest friends, where he remained hidden for many days until the uproar died down and Pope Clement remembered Michelangelo's talents and took great pains to find him with the order that nothing should be done to him but that his usual provisions should be returned to him and that he should attend to the project at San Lorenzo, naming Messer Giovanbatista Figiovanni, an old servant of the House of Medici and prior of San Lorenzo, as the supervisor.* Once Michelangelo had been reassured by this, he began, in order to ingratiate himself with Baccio Valori, a marble figure three armslengths high of Apollo drawing an arrow from his quiver which he almost brought to completion; it stands today in the apartment of the prince

of Florence, a most rare work even if it is not completely finished. . . . *

Michelangelo had to go to Rome to work for Pope Clement, who, although angry with him, forgave him completely as a lover of talent and ordered him to return to Florence and to finish the entire library and sacristy of San Lorenzo, and, in order to save time on this project, numerous statues that were to go there were assigned to other masters. Two were commissioned to Tribolo, one to Raffaello da Monte Lupo, and one to Fra Giovanni Angelo of the Servite friars, all three sculptors, and Michelangelo assisted them in this work, making models in rough clay for each of them, and they all worked boldly while Michelangelo was having the library attended to, where the ceiling was completed with carved woodwork based on his models, executed by Carota and Tasso, excellent Florentine woodcarvers and masters;* in like manner the bookshelves were then done from Michelangelo's designs by Batista del Cinque and his friend Ciapino, both skilful masters in this profession. To give the work the final touches, the splendid Giovanni da Udine was brought to Florence, who with some of his own workmen and still other Florentine masters worked on the stucco decorations for the tribune. And so with great diligence everyone sought to finish this enterprise.

While Michelangelo was intending to have the statues executed, the pope came up with the idea of having him nearby, since he was anxious to paint the walls of the Sistine Chapel, where Michelangelo had painted the vault for Julius II, the nephew of Sixtus; upon the main wall behind the altar, Clement wanted him to paint the Last Judgement* so that he could demonstrate in this scene all that the art of design was capable of achieving; and on the opposite wall over the main door he ordered Michelangelo to paint the moment when Lucifer was driven out of Heaven because of his pride and cast down to the centre of Hell along with all those angels who sinned with him. It was discovered that many years earlier Michelangelo had made studies and various drawings for these creations, one of which was later executed in the church of the Trinity in Rome by a Sicilian painter, who stayed with

Michelangelo for many months, assisting him and grinding his colours. This work is in the transept of the church in the chapel of Saint Gregory, painted in fresco, and even though it is badly executed, one can see a certain magnificent quality and variety in the poses and groups of the nudes raining down from heaven and the fallen at the centre of the earth, transformed into various kinds of very terrifying and unusual devils, and this is certainly an original flight of fantasy.*

While Michelangelo was preparing to do these sketches and the cartoons of the Last Judgement for the first wall, he could not avoid being disturbed every day by the agents of the Duke of Urbino, who alleged that he had received sixteen thousand *scudi* from Julius II for his tomb, and Michelangelo could not tolerate this accusation; he wanted to complete it one day even though he was already an old man, and he would gladly have remained in Rome, having unexpectedly been given a pretext for not returning again to Florence, since he was very much afraid of Duke Alessandro de' Medici, whom he considered to be no friend of his, for after the duke, through Signor Alessandro Vitegli, had given him to understand that he ought to determine the best site for constructing the castle and citadel of Florence, Michelangelo had replied that he did not wish to go there unless he was ordered to do so by Pope Clement.

Finally, an agreement was reached on the tomb, and it was to be finished in this way: Michelangelo would no longer make the tomb free-standing and four-sided but would do only one side in whatever way he liked, and he was obliged to include six statues by his own hand; and in the contract he made with the Duke of Urbino, His Excellency conceded that Michelangelo was legally bound to work for Pope Clement for four months during the year, either in Florence or wherever he wished to employ him. And while Michelangelo thought he was satisfied, it did not end like that, for Clement wished to see the ultimate proof of the power of his talents and forced him to work on the cartoon for the Last Judgement. But while Michelangelo showed the pope that he was engaged on that project, he never ceased working in secret, as hard as he could, on the statues that were to go on the

previously mentioned tomb. In the year 1533 came the death
of Pope Clement,* and in Florence the work on the sacristy
and the library, which Michelangelo had taken such great
pains trying to finish, stopped and the work remained
incomplete. Michelangelo then thought himself truly free to
attend to completing the tomb of Julius II, but after the
creation of the new pope, Paul III, not much time passed
before he, too, summoned Michelangelo, and after offering
him special signs of affection and proposals, he tried to
convince Michelangelo that he ought to serve him and that he
wanted him nearby. Michelangelo refused this request, de-
claring that he was unable to do so, since he was contractually
obligated to the Duke of Urbino until the tomb of Julius was
completed. At this, the pope became angry and said:

'I have had this desire for thirty years, and now that I am
Pope, am I not to satisfy it? I will tear up this contract, and, in
any case, I intend to have you serve me!'

When Michelangelo saw his determination, he was tempted
to leave Rome and find some means of completing the tomb.
Nevertheless, being a prudent man who feared the pope's
power, he decided to keep him waiting and to satisfy him
with words, given that he was a very old man, until some-
thing came up. . . . *

Since he could do nothing else, Michelangelo decided to
serve Pope Paul, who ordered him not to change in any way
the invention or concept he had been given by Clement;
indeed, the pope respected Michelangelo's talent and bore him
so much love and reverence that he sought only to please him,
as was evident when His Holiness wanted to place his coat of
arms under the figure of Jonah in the chapel where the coat
of arms of Pope Julius II had originally been placed; when
Michelangelo was asked about it, he did not wish to put it
there to avoid doing an injustice to either Julius or Clement,
declaring that it was not a good idea, and His Holiness
remained satisfied with this so that he would not offend
Michelangelo, for he very clearly recognized the goodness of
this man who always aimed for what was honest and right
without any show of respect and adulation, something princes
are rarely accustomed to experience.

Michelangelo therefore had a scarp built for the wall of this chapel from bricks which were properly baked, selected, and laid, and he wanted it to overhang the summit half an armslength to prevent dust or other dirt from settling on the wall. I shall not go into the particulars of the invention or the composition of this scene, for it has so often been copied and printed in sizes large and small that it does not seem necessary to lose time in describing it. It is sufficient to see that the intention of this singular man was never to paint anything other than the perfect and perfectly proportioned composition of the human body in its most unusual poses, as well as the effects of the soul's passions and joys, for Michelangelo was content to give satisfaction in the area in which he had proven himself superior to all his fellow artisans, and to display the method of his grand style and his nudes and the extent to which he understood the problems of design, and he finally revealed the way to achieve facility in the principal aim of the art of painting—that is, the depiction of the human figure—and, applying himself to this one goal, he left aside the charm of colours, the caprices and novel fantasies of certain small details and refinements, that many other painters, perhaps with some reason, have not entirely neglected. Thus some artists, lacking such a grounding in design, have sought with a variety of tints and shades of colour and various new and unusual inventions—that is, in brief, with this other method—to find a place among the ranks of the foremost masters. But Michelangelo, always standing firm in the profundity of his art, demonstrated to those artists who are most knowledgeable how to attain perfection.

Now, to return to the scene. Michelangelo had already completed more than three-quarters of the work when Pope Paul came to see it, and when Messer Biagio da Cesena, master of ceremonies and a scrupulous man who was in the chapel with the pope, was asked what he thought of the painting, he declared that it was a most unseemly thing in such a venerable place to have painted so many nudes that so indecently display their shame and that it was not a work for a pope's chapel but rather one for baths or taverns. This comment displeased Michelangelo, and, wishing to avenge himself, as soon as

Messer Biagio had left, he drew his actual portrait without
his being present, placing him in Hell in the person of Minos
with a large serpent wrapped around his legs in a heap of
devils. Nor did Messer Biagio's entreaties to the pope and
to Michelangelo that it be removed do any good, for
Michelangelo left it there in memory of the event, where it
can still be seen today.

During this time it happened that Michelangelo fell no
small distance from planks on the scaffolding of this work
and hurt his leg, but because of the pain and his anger he did
not wish to be treated by anyone. For this reason, Master
Baccio Rontini, a Florentine who was still alive at that time
and was Michelangelo's friend and admirer as well as a clever
physician, took pity on him, and went one day to knock
on his door, and when neither Michelangelo nor the neigh-
bours replied, he kept climbing up through certain secret
passages from room to room until he came upon Michel-
angelo, who was in desperate shape. And until Michelangelo
was cured, Master Baccio naturally refused to be away from
him or to leave his bedside. After he was cured of this
injury and had returned to the project, working on it con-
tinuously, Michelangelo brought it to a conclusion in a
few months, giving so much power to the paintings in the
work that he attested to the saying of Dante: 'The dead
seemed dead, and the living seemed alive.'* And this work
reveals the misery of the damned and the happiness of the
blessed.

When the Last Judgement was uncovered, Michelangelo
proved not only that he had triumphed over the first artisans
who had worked in the chapel but that he also wished to
triumph over himself in the vault he had made so famous,
and since the Last Judgement was by far superior to that,
Michelangelo surpassed even himself, having imagined the ter-
ror of those days, in which he depicted, for the greater punish-
ment of those who have not lived good lives, all of Christ's
Passion; he has various naked figures in the air carrying the
cross, the column, the lance, the sponge, the nails, and the
crown in different and varied poses with a grace that can
be executed only with great difficulty. There is the figure of

Christ Who, seated with a stern and terrible face, turns to the damned to curse them, while in great fear Our Lady, wrapping Herself in Her cloak, hears and sees great devastation. Countless figures of the prophets and apostles are there surrounding Christ, especially Adam and Saint Peter, who are thought to have been included because one was the first parent of those brought to judgement, while the other was the first foundation of the Christian religion. And at Christ's feet is the very beautiful figure of Saint Bartholomew displaying his flayed skin. There is also a nude figure of Saint Laurence, besides countless numbers of male and female saints and other male and female figures all around Christ, both nearby and far away, who are embracing each other and rejoicing because they have earned eternal blessedness through God's grace and as a reward for their good works. Under Christ's feet, the Seven Angels described by Saint John the Evangelist with their Seven Trumpets are sounding the call to judgement, and the awesomeness displayed in their faces causes the hair of those looking at them to stand on end, and, among others, there are two angels holding the Book of Life in their hands; nearby the Seven Deadly Sins can be seen depicted with the finest judgement in the form of devils in a band, fighting and pulling down to Hell the souls that are flying to Heaven with the most beautiful expressions and very admirable foreshortenings. Nor in the depiction of the resurrection of the dead did Michelangelo hesitate to demonstrate to the world how these bodies take on their bones and flesh anew from the very earth, or how, assisted by others who are alive, they go flying towards Heaven, where they are given assistance by some of the souls who are already beatified, along with all those details of good judgement considered appropriate to such a work as this one. In fact, Michelangelo executed studies and exercises of every kind for this painting, which is equally apparent throughout the work, and is also clearly shown in the detail depicting the boat of Charon who, with a frenzied expression, is beating with his oar the souls being dragged down into his boat by the devils in imitation of the description given by his very favourite poet, Dante, when he declared:

The devil Charon, with eyes of glowing coals,
 summons them all together with a signal,
 and with an oar he strikes the laggard sinner.*

Nor could anyone imagine the variety in the heads of these
devils, truly monsters from Hell. In the figures of the sinners
we can recognize their sins along with the fear of eternal dam-
nation. And besides every beautiful detail, it is extraordinary
to see such a work painted and executed so harmoniously that
it seems to have been done in a single day and with the type
of finish that no illuminator could ever have achieved; to tell
the truth, the multitude of figures and the magnificence and
grandeur of the work are indescribable, for it is full of all the
possible human emotions, all of which have been wonderfully
expressed: the proud, the envious, the avaricious, the lust-
ful, and all the other sinners can be easily distinguished from
every blessed spirit, since Michelangelo observed every rule
of decorum in portraying their expressions, poses, and every
other natural detail; although this was a marvellous and enorm-
ous undertaking, it was not impossible for this man, for he was
always shrewd, wise, and a great observer of men, who had
acquired the same understanding of the world from experi-
ence that philosophers acquire through speculation and books.
Thus, any person who has good judgement and an under-
standing of painting will see in this work the awesome power
of the art of painting, for Michelangelo's figures reveal
thoughts and emotions which were never depicted by anyone
else; such a person will also see how he varied with diverse and
strange gestures the many poses of the young and old, male
and female: to whom do these figures not display the awe-
some power of his art along with the sense of grace with
which Nature endowed him? For he moves the hearts of all
those who know nothing about painting, as well as the hearts
of those who understand this profession. The foreshortenings
that appear to be done in relief, the soft harmony of lights and
colours, and the refined details of the lovely things he painted
truly demonstrate that paintings have to be executed by good
and true painters, and one can see in the contours of the forms
he drew, using a method no other artist could ever have

followed, the true Judgement and the true Damnation and Resurrection. In our art, this painting is that example and that great picture sent by God to men on earth so that they could see how Fate operates when supreme intellects descend to earth and are infused with grace and the divinity of knowledge. This work leads like bound captives all those who are convinced they understand the art of painting, and in seeing the strokes he drew in the outlines of all his figures, every magnificent spirit is fearful and trembles, however knowledgeable he may be in the art of design. And in studying his labours, the senses are confused solely at the thought of how other paintings, both those that have been executed and those to come, would compare to this one. And how truly happy are those who have seen this truly stupendous wonder of our century, and how happy their memories must be! Most happy and fortunate Paul III, for God granted that under his patronage the glory that the writers' pens will accord to his memory and to your own would find shelter! How greatly will your merits enhance his own worth! Certainly his birth has brought a most happy fate to the artists of this century, for they have seen him tear away the veil from all the difficulties that can be encountered or imagined in the arts of painting, sculpture, and architecture.

Michelangelo laboured on this work for eight years and unveiled it (I believe) in the year 1541 on Christmas Day,* to the wonder and amazement of all of Rome, or rather, of the entire world, and that year, when I was living in Venice, I went to Rome to see it, and I was stupefied by it. . . . *

It happened that in the year 1546 Antonio da San Gallo died, and thus there was no one to guide the building of Saint Peter's, and the assistants on the project expressed different opinions to the pope about who should be given the position. Finally, inspired, I believe, by God, His Holiness decided to send for Michelangelo, and when the pope sought to put him in San Gallo's place, Michelangelo refused, declaring, in order to escape this burden, that architecture was not his true profession. Finally, after his entreaties were to no avail, the pope ordered Michelangelo to accept the job, and to his greatest displeasure and very much against his will he was

forced to join in this enterprise. And one day among others he headed to Saint Peter's to see the wooden model San Gallo had executed and the building itself in order to examine it, and there he came upon all of San Gallo's faction who had come forward and declared to Michelangelo in the best way they knew how that they were delighted the responsibility for the building had been entrusted to him, adding that San Gallo's model was a meadow where there would always be good grazing.

'That's certainly true,' Michelangelo answered, wishing to imply, as he later declared to a friend, that it was a pasture for sheep or oxen who understood nothing about art; and afterwards he used to declare publicly that San Gallo had constructed the building without proper lighting, that outside it had too many orders of columns one over another, and that with all its projections, spires, and excessive details and ornaments, it possessed much more of the German workmanship than the good ancient method or the pleasing and beautiful modern style; he added that he could save fifty years of time in completing the work and more than three hundred thousand *scudi* in expenses, and could finish it with more majesty, grandeur, and facility, as well as a superior design, greater beauty, and more convenience. And he then demonstrated this in a model he executed in order to convert the building to the style of the completed work as we see it today, and he made it understood that what he was saying was the simple truth. This model cost him twenty-five *scudi* and was completed in fifteen days; that of San Gallo, as was mentioned, cost more than four thousand *scudi* and took many years. And from this fact and other ways of doing things it became obvious that the building project was a shop and a business making a profit which was extended for the benefit of those who had cornered the market rather than for the purpose of finishing the church. These methods did not satisfy this righteous man, and to rid himself of these men while the pope was pressing him to accept the position of architect on the project, he told them one day openly that they should gain the assistance of their friends and do everything they could to prevent him from taking the post, for if he were given the

office, he did not want any of them involved in this building project; they took these words spoken in public very badly, as one might imagine, and this was the reason why they hated Michelangelo so deeply, a hatred which grew every day as they saw him changing the entire plan inside and out; why they could not allow him to go on living; and why every day they devised new and different stratagems to torment him, as will be explained in the proper place.

Finally, Pope Paul issued a *motu proprio* to Michelangelo, making him the head of the building project with full authority so that he could do and undo what was there, increase, decrease, or vary anything to his liking, and he decided that all the officials there should be under Michelangelo's authority. Thus, when Michelangelo saw the confidence and faith that the pope had in him, he insisted on proving his own goodness by having it declared in the papal decree that he was serving on the building project for the love of God and not for any other reward, although earlier the pope had given him the tolls over the river in Parma,* which earned him six hundred *scudi* that he lost upon the death of Duke Pier Luigi Farnese, when he was given in exchange a chancellery in Rimini of less value and interest to him. And though the pope also sent him money on numerous occasions as a salary, Michelangelo never wanted to accept this, as Messer Alessandro Ruffini, then chamberlain to the pope, and Messer Pier Giovanni Aliotti, Bishop of Forlì, can confirm.

Finally the model Michelangelo had executed which reduced Saint Peter's to a smaller size but also greater grandeur was approved by the pope, to the satisfaction of all those with good judgement, although certain people who profess to understand (but, in fact, do not) do not approve of it. Michelangelo discovered that the four main pillars made by Bramante and left in place by Antonio da San Gallo to support the weight of the tribune were weak, and he partly filled them up by building two spiral or winding staircases on the sides with flat steps up which pack animals could climb and carry all the materials to the summit, and likewise men could go there on horseback as far as the highest level. He executed the first cornice under the travertine arches; it curves around, and

is a marvellous thing, graceful and very different from the
others, and better than any other work of this kind. He began
the two large arms of the transept, and where, according to
the plans of Bramante, Baldassare [Peruzzi], and Raphael, as
we mentioned, eight tabernacles were being built facing the
Camposanto, a plan continued later by San Gallo, Michelan-
gelo reduced the number to three, with three chapels inside,
and above these he placed a travertine vault and an arrange-
ment of windows bright with light, which possess different
shapes and magnificent grandeur, but since these elements are
there and can also be seen in published prints (not only those
by Michelangelo but those by San Gallo), I shall not begin
describing them unnecessarily; let it suffice to say that, with
great thoroughness, he began to have work done in all those
places where the plan of the building was to change, so that
the building would be permanent and no one else could ever
change his design: this was the precaution of a wise and pru-
dent genius, for doing something well is not enough unless
one safeguards it in the future, since the presumption and
impudence of those who think they know something (if
words are believed more than deeds), along with the partiality
of those incapable of understanding, can cause many problems
to arise.

The Roman people with the consent of the pope wished to
give some beautiful, useful, and suitable form to the Capitol,
and to furnish it with architectural orders, ascents, ramps, and
staircases, and with decorations consisting of ancient statues
brought there to embellish the place; and Michelangelo,
sought as an advisor for this project, made for them a very
beautiful and rich drawing, in which on the side of the
Senators' Palace, which faces towards the east, he arranged a
façade of travertine and a flight of steps ascending from two
sides to reach a level space through which one enters into the
middle of the hall of this palace, along with rich volutes full of
varied balusters that serve as supports and parapets. Then, to
embellish the design further, he placed two ancient marble
statues of recumbent river gods on pedestals: one represented
the Tiber, the other the Nile, each nine armslengths long,
something most rare, while between them a statue of Jupiter

was to go in a large niche. On the south side, where the Palazzo de' Conservatori stands, to square off the shape he continued with a rich and varied façade with a gallery at the foot full of columns and niches for many ancient statues, and all around are various decorations, doors, and windows, some of which are already in place. And on the opposite side, towards the north, below the Aracoeli, there was to be another similar façade; and in front of this, to the west, an almost level ascent of bastons with an enclosure and a parapet of balusters where the principal entrance will be decorated with an order of columns and bases upon which will be placed all the noble statues with which the Capitol is today so richly endowed. In the middle of the piazza, on an oval-shaped base, stands the highly renowned bronze horse upon which rests the statue of Marcus Aurelius, the one the same Pope Paul had removed from the piazza of the Lateran where Pope Sixtus IV had placed it. Today this project is turning out to be so beautiful that it deserves being counted among the worthy things that Michelangelo created, and today it is being guided to its completion by Messer Tommaso de' Cavalieri, a Roman gentleman, who was and is one of the best friends that Michelangelo ever had, as will be explained below.... *

Michelangelo had spent seventeen years in the building of Saint Peter's, and on more than one occasion his deputies had tried to remove him from that post, and when they did not succeed, they then went around thinking about how they could oppose him in everything, now with some strange proposal, and now with another, so that he would resign out of weariness, since he was already too old to continue.... * Thus, we have seen that God, the protector of the good, has defended Michelangelo as long as he has lived, and has always worked for the benefit of this building and the protection of this man until his death. And it came about that Pius IV, living after Michelangelo, ordered the superintendents of the building not to change any of Michelangelo's plans, and his successor, Pius V, had them followed with even greater precision, for, in order to avoid confusion, he wanted Michelangelo's plans followed without deviations, and while the architects Pirro Ligorio and Jacopo Vignola were directing the

construction and Pirro presumptuously wanted to change and
alter this plan, he was removed from the project with little
honour to himself and Vignola was left in charge.* And
finally, in the year 1565, when Vasari went to kiss His
Holiness's feet, and again in the year 1566 when he was
recalled, this pope, no less zealous in defending the reputation
of the building of Saint Peter's than in defending the Christian
religion, spoke of nothing except ensuring that the designs
left behind by Michelangelo would be followed; and in order
to prevent any confusion, His Holiness commanded Vasari to
go with Messer Guglielmo Sangalletti, his private treasurer,
and, on his authority, to find Bishop Ferratino, the head of the
builders of Saint Peter's, and to tell him that he should pay
attention to all the notes and records Vasari would explain to
him, so that the words of malignant and presumptuous people
would never change a suggestion or an order left behind by
the superb talent and memory of Michelangelo. And Messer
Giovambatista Altoviti, a close friend of Vasari and these same
talents, was present at this event. Once Ferratino had heard
what Vasari had to tell him, he gladly accepted every record
and promised without fail to observe and to make everyone
else observe every order and plan for the building that
Michelangelo had left behind for it, and, besides this, to
protect, defend, and preserve the labours of such a great man.

And to return to Michelangelo, let me say that about a
year before his death, Vasari had secretly arranged for Duke
Cosimo de' Medici to persuade the pope, through the medi-
ation of Messer Averardo Serristori, his ambassador, that since
Michelangelo's condition had greatly deteriorated, special care
should be taken to watch those who looked after him or fre-
quented his home, for if some sudden misfortune befell him (as
often happens with old men), some provision should be made
for his belongings, drawings, cartoons, models, money, and all
his property to be inventoried after his death and to be set
aside and donated to the building of Saint Peter's, if there were
anything pertaining to the project, as well as to the sacristy,
the library, and the façade of San Lorenzo, so that they would
not be carried off, as often happens; eventually these precau-
tions proved useful and were finally all carried out.

Michelangelo's nephew Lionardo wanted to go to Rome on the following Lent, for he guessed that Michelangelo was already near the end of his life, and Michelangelo was very pleased about this, but when he fell ill with a slow fever he immediately had Daniel write for Lionardo to come, but his illness grew worse, even though his doctor Messer Federigo Donati and other physicians were in attendance, and, with the greatest lucidity, he pronounced his last testament in three sentences, leaving his soul in the hands of God, his body to the earth, and his property to his closest relatives, admonishing his closest friends to recall to him in his passing from this life the suffering of Jesus Christ; and so, on the seventeenth day of February in the year 1563 at the twenty-third hour according to the Florentine usage, or in 1564, according to the Roman, he expired to go to a better life.*

Michelangelo had a real propensity for the labours of art, given that he succeeded in everything, no matter how difficult it was, for he had received from Nature a very fit mind that was well adapted to his exceptional talents in the art of design; in order to become completely perfect in this art, he did anatomical studies on countless occasions, dissecting human beings in order to observe the principles and the ligatures of the bones, the muscles, nerves, veins, and their various movements, as well as all of the positions of the human figure. And he not only studied the parts of the human body but those of animals, and, most particularly, of horses, which he took great delight in keeping; and he wanted to see the principles and structure of all things in terms of his art and demonstrated this knowledge so thoroughly in the works he happened to produce that those who study nothing but anatomy achieve little more. Furthermore, he executed his works, which are inimitable, just as well with a brush as with a chisel, and he has given, as has already been said, so much skill, grace, and a certain vitality to his works that—and this may be said without disagreement—he surpassed and triumphed over the ancients, for he knew how to resolve the problems in his works so easily that they appear to be executed without effort even though, when others later try to sketch his works, they discover the difficulties in imitating them. Michelangelo's talent

was recognized during his lifetime and not, as happens to
so many, only after his death, for as we have seen, Julius II,
Leo X, Clement VII, Paul III, Julius III, Paul IV, and Pius IV,
all supreme pontiffs, wished to have him nearby at all times,
and, as is well known, Suleiman, Emperor of the Turks,
Francis Valois, King of France, Emperor Charles V, the
Signoria of Venice, and finally Duke Cosimo de' Medici, as
was mentioned, all provided him with generous salaries for
no other reason than to avail themselves of his great talent;
this happens only to men of great worth, as he was, for it was
recognized and understood that all three of these arts had
reached a true state of perfection in his works, and that God
had not granted such genius either to the artists of antiquity or
to those of the modern period as He had to Michelangelo, in
all the many years the sun had been revolving.* Michelangelo
had such a distinctive and perfect imagination and the works
he envisioned were of such a nature that he found it impossible
to express such grandiose and awesome conceptions with his
hands, and he often abandoned his works, or rather ruined
many of them, as I myself know, because just before his death
he burned a large number of his own drawings, sketches and
cartoons to prevent anyone from seeing the labours he
endured or the ways he tested his genius, for fear that he
might seem less than perfect; and I have a number of these
studies which I found in Florence and placed in our book of
drawings; and although they display the greatness of this
genius, they also reveal that when he wanted to bring forth
Minerva from the head of Jupiter he needed Vulcan's ham-
mer, for he used to make his figures with nine, ten, or twelve
heads, seeking only to create, by placing them all together, a
certain harmonious grace in the whole which Nature does not
produce, declaring that it was necessary to have a good eye for
measurement rather than a steady hand, because the hands
work while the eyes make judgements: he also held to this
same method in architecture. No one should think it strange
that Michelangelo took pleasure in solitude, as a man deeply
enamoured of his art, which wants a man to be alone and pen-
sive for its own purposes, since anyone who desires to apply
himself to the study of this art must avoid companions: it so

happens that those who attend to the considerations of art are never alone or without thoughts, and people who attribute their desire for solitude to daydreams and eccentricity are wrong, for anyone who wishes to work well must rid himself of cares and worries, since talent requires thought, solitude, comfort, and concentration of mind. All the same, Michelangelo cherished the friendships of many people, great men, learned scholars, and talented people, and he maintained these friendships whenever it was appropriate. . . . *

He loved and frequented the company of his fellow artisans, including Jacopo Sansovino, Rosso, Pontormo, Daniele da Volterra, as well as Giorgio Vasari of Arezzo, for whom he displayed countless signs of affection, and, with the intention of employing him some day, he caused Vasari to apply himself to architecture, and he gladly conferred with Vasari and discussed with him matters concerning art. And those who declare that he never wanted to teach are wrong, for he always taught his friends and anyone who asked his advice, and I myself was present on many such occasions which I shall not mention for modesty's sake, since I do not wish to reveal their shortcomings. It is quite obvious that he had bad luck with those who came to live with him in his home, for he came across students who were scarcely fit to imitate him: for example, his student Piero Urbano from Pistoia was a gifted person but he never wanted to exert himself; Antonio Mini would have liked to work, but he did not have a fit mind, and when wax is hard it does not take a good impression; Ascanio dalla Ripa Transone endured much hard work but never saw the fruits of his labours either in finished works or in drawings, and he spent a number of years on a panel for which Michelangelo had given him the cartoon, but in the end the high expectations everyone had for him all went up in smoke, and I remember that Michelangelo felt pity for him on account of his troubles and helped him with his own hands, but it did little good.* And as Michelangelo told me several times, if he had found a proper student, even as old as he was, he would often have done anatomical studies and would have written something on this subject for the benefit of his fellow artisans, who were often misguided by others, but he hesitated

because he was not capable of expressing with words what
he might have wished to say, since he was not practised in
rhetoric, although the prose in his letters explains his ideas
well and concisely, and he took particular delight in reading
the vernacular poets, especially Dante, whom he loved and
imitated in his conceits and inventions, as he did Petrarch,
enjoying the composition of madrigals and very serious
sonnets upon which commentaries have been written. Messer
Benedetto Varchi of the Florentine Academy read a very
distinguished lecture on the sonnet which begins as follows:

> Even the best of artists can conceive no idea
> That a single block of marble will not contain.*

He sent countless numbers of his poems, receiving replies in
verse and in prose, to the Most Illustrious Marchioness of
Pescara,* of whose talents Michelangelo was enamoured, as
she was of his, and on many occasions she came to Rome
from Viterbo to visit him, and for her Michelangelo drew a
Pietà showing Christ in Our Lady's lap, with two marvellous
little angels, as well as a splendid Christ nailed to the cross,
lifting His head and commending His spirit to God the
Father, and another Christ with the woman of Samaria at the
well.

As the admirable Christian he was, Michelangelo took great
pleasure from the Holy Scriptures, and he held in great ven-
eration the works written by Fra Girolamo Savonarola, whom
he had heard preaching in the pulpit. He dearly loved human
beauty which could be imitated in art, where the essence of
the beautiful could be separated from beautiful things, since
without this kind of imitation nothing perfect can be created,
but he did so without lustful or dishonest thoughts, which he
demonstrated in his personal life by being extremely frugal,
for as a young man he had been content while absorbed in his
work with a bit of bread and wine, and he had continued this
practice as he grew older up to the time he did the Last Judge-
ment in the chapel, by refreshing himself in the evening after
he had finished the day's work, even though very frugally.
Although he was wealthy, he lived like a poor man, and his
friends rarely or never ate with him, nor did he accept presents

from anyone, for he thought that when someone gave him
something he would always be obliged to him. His sobriety
made him very restless and he rarely slept, and very often dur-
ing the night he would arise, being unable to sleep, and would
work with his chisel, having fashioned a helmet made of paste-
board holding a burning candle over the middle of his head
which shed light where he was working without tying
up his hands. And Vasari, who saw the helmet on numerous
occasions, noticed that he did not use candles made of wax but
those made from pure goat's tallow (which are excellent), and
he sent Michelangelo four bundles of them which weighed
forty pounds. His courteous servant brought them to Michel-
angelo's door at two o'clock in the morning, and when
he presented them to Michelangelo, who protested that he did
not want them, the servant said:

'Sir, they have worn out my arms from the bridge to here,
and I don't want to take them back home. There's a solid
mound of mud in front of your door, and they would easily
stand upright. I'll light them all for you.'

And Michelangelo answered: 'By all means, put them
down. I don't want you playing any jokes at my doorstep.'

Michelangelo told me that in his youth he often slept with
his clothes on, just like a man who, exhausted by his work,
does not bother to undress, since later on he must get dressed
once again. There are some who have accused him of being
stingy; they are mistaken, for he always demonstrated the
contrary, both with his works of art and with his other
property. . . . *

Michelangelo possessed such a deep and retentive memory
that after seeing the works of others a single time, he recalled
them in such detail and used them in such a way that scarcely
anyone ever realized it; nor did he ever create any works
which resembled one another, because he remembered every-
thing that he had done. Once, in his youth, he was with his
painter friends, and they wagered a supper on whoever could
draw a figure which had no sense of design whatsoever and
was clumsy, like those stick figures drawn by people who do
not understand the art of design when they scribble on walls.
Here, Michelangelo's memory served him well, for he

remembered having seen one of these clumsy drawings on a
wall and reproduced it down to the slightest detail as if he had
it before his eyes, and he surpassed all his fellow painters, a
most difficult task for a man so knowledgeable in the art of de-
sign, accustomed to elegant work which turns out successfully.

He justly scorned those who injured him, but he was never
seen to take revenge, and he was a very patient man, modest
in all his behaviour and most prudent and wise in his speech;
his responses were at times most thoughtful and serious, while
on other occasions they were full of witty, pleasing, and sharp
retorts. He said many things that have been noted by us, and
we shall report only some of these, for it would take too long
to describe them all. Once a friend of his was speaking to
Michelangelo about death, and he declared that it must make
him grieve, since he was constantly at work on artistic projects
and never took a break, but Michelangelo replied that it was
of no real concern, because if life pleased him, death should
please him as well, since it came from the hand of the same
master. A fellow citizen found him near Orsanmichele in
Florence where he had stopped to look at Donatello's statue
of Saint Mark, and when he asked Michelangelo what he
thought of the statue, Michelangelo answered that he had
never seen a figure that possessed more of the appearance of a
good man than this one, and that if Saint Mark was like this,
he could believe what he had written. When he was shown a
drawing done by a young boy who had been recommended
to him and who was then learning to draw, and some people
tried to excuse him by saying that he had only begun to learn
this craft a short while ago, Michelangelo replied: 'That's
obvious.' He made a similar witty response to a painter who
had painted a *Pietà* and had not carried it off well, declaring
that it really was a pity to see it.*

When he learned that Sebastiano Veneziano was to paint a
friar in the chapel of San Piero a Montorio, he said that this
would ruin the chapel; when asked the reason for this, he
answered that since friars had ruined the world which is so
large, it would not be difficult for them to ruin such a small
chapel. A painter had completed a painting with enormous
effort and had struggled over it for a long time, and, after

unveiling it, he had earned a good deal of money from it; Michelangelo was asked what he thought of the painter of this work, and he answered:

'As long as he wants to be rich, he will continue to be poor.'

A friend of his who was already saying the Mass and had taken vows arrived in Rome dressed up in buckles and silk cloth, and he greeted Michelangelo, who pretended not to recognize him, so that the friend was obliged to tell him his name; Michelangelo pretended to be amazed that he was dressed in such a fashion, and then, almost congratulating him, he added:

'Oh, you do look fine! If you were as fine on the inside as I see you are on the outside, it would be good for your soul.'

This same person had recommended a friend of his to Michelangelo, who had given the man a statue to execute, and he then begged Michelangelo to give his friend more work, which Michelangelo kindly did, but the man who had made the request assumed Michelangelo would not fulfil it, and when he saw that he had done so, his envy caused him to complain, and Michelangelo was told about it; he replied that he disliked deceitful gutter-men, using a metaphor from architecture by which he meant to say that one can have only bad dealings with people who have two mouths. When a friend of his asked him what he thought of someone who had made marble copies of some of the most famous antique statues, boasting that in imitating them he had by far surpassed the ancients, Michelangelo answered:

'Anyone who follows others never passes them by, and anyone who does not know how to do good works on his own cannot make good use of works by others.'

Some painter or other had completed a work in which an ox was better rendered than anything else; Michelangelo was asked why the painter had made the animal more lifelike than the other details, and he declared: 'Every painter paints his own portrait well.'

Passing by San Giovanni in Florence, he was asked his opinion of [Ghiberti's bronze] doors, and he answered:

'They are so beautiful that they could easily be at the gates of Paradise.'

While he was working for a prince who changed his plans every day and could never make up his mind, Michelangelo told a friend of his: 'This lord has a brain like a weather vane, for every wind that blows behind it turns it around.'

He went to see a piece of sculpture that was to be placed outside because it was finished, and the sculptor was working hard to arrange the lights in the windows to show it off properly, and Michelangelo told him: 'Don't work so hard, the important thing will be the light in the square', meaning to imply that when works are displayed in public, the people judge whether they are good or bad.

In Rome there was a great prince who fancied himself an architect, and he had made certain niches in which to place statues, each of which was three squares high with a ring at the top, and inside these niches he tried to place various statues, none of which looked right. When he asked Michelangelo what he should place inside, the artist replied: 'Hang some eels from the ring.'

A gentleman who claimed to understand Vitruvius and to be a good critic was appointed to the administration overseeing the building of Saint Peter's. And Michelangelo was told: 'You now have someone on the building project who has a great mind'.

'That is true,' replied Michelangelo, 'but he has bad judgement.'

A painter had painted a scene and had copied many of the details from various drawings and pictures, and there was nothing original in the work, and it was shown to Michelangelo, who, after having examined it, was asked by one of the painter's close friends what he thought of it, and he replied:

'He has done very well, but when the Day of Judgement arrives and all the bodies take back their own parts, what will become of this scene when nothing is left?'

This was a warning that those who work in the arts should learn to do their own work.

As he was passing through Modena, he saw many beautiful terracotta figures coloured to look like marble by Master Antonio Bigarino, a sculptor from that city,* all of which

seemed to him to be excellent works, and, because the sculptor did not know how to work in marble, Michelangelo declared:

'If this clay were to become marble, woe to ancient statues.'

Michelangelo was told that he ought to resent Nanni di Baccio Bigio because he was always trying to compete with him, and he replied:

'Anyone who fights with a good-for-nothing wins very little.'

A priest, a friend of his, said: 'It's a pity you haven't taken a wife, for you would have had many children and bequeathed to them many honourable works.'

Michelangelo answered: 'I have too much of a wife in this art that has always afflicted me, and the works I shall leave behind will be my children, and even if they are nothing, they will live for a long while. And woe to Lorenzo di Bartoluccio Ghiberti if he had not created the doors of San Giovanni, for his sons and nephews sold and spoiled everything he left them, while the doors are still standing.'

When Julius III sent Vasari at one o'clock in the morning to Michelangelo's home for a design, he found him working on the marble *Pietà* that he broke into pieces. Having recognized him by his knock on the door, Michelangelo arose from his work and took a lantern by the handle; when Vasari had explained what he wanted, Michelangelo sent Urbino upstairs for the drawing, and they began to discuss something else; in the meanwhile Vasari turned his eyes to look at one of the legs of the figure of Christ on which Michelangelo was working and trying to make some changes, and to prevent Vasari from seeing this, Michelangelo let the lantern drop from his hand, leaving them in the dark; Michelangelo called to Urbino to bring a light, and coming out of the partition where he was, he declared:

'I am so old that death often tugs me by the cape to go along with him, and one day, just like this lantern, my body will fall and the light of life will be extinguished.'

Nevertheless, Michelangelo enjoyed the company of certain kinds of men who were to his liking, such as Menighella, the clumsy, second-rate painter from Valdarno,* who was an extremely agreeable person; he sometimes came to visit

Michelangelo, who made him a drawing of Saint Rocco and Saint Anthony to paint for the peasants. Michelangelo, whom kings found difficult to handle, would put everything aside and set to work, making Menighella simple sketches suited to his style and desires, just as he requested, and among others he did the model for a crucifix which was very beautiful, from which Menighella made a mould and made copies in pasteboard and other mixtures, selling them around the countryside, which made Michelangelo double up with laughter; Michelangelo was especially amused by his escapades, such as the story about a peasant who had him paint a picture of Saint Francis and was upset when Menighella painted the saint in grey robes, since he would have preferred a brighter colour; by adding a brocaded cope on the saint's back, Menighella made the peasant happy.

Michelangelo also liked equally well Topolino the stone-carver,* who imagined himself a fine sculptor although he was a very poor one. He spent many years in the mountains of Carrara sending blocks of marble to Michelangelo, and he never sent a boat-load without including on it three or four statues he had roughed out himself, which caused Michelangelo to die of laughter. Finally, he returned from Carrara and, after roughing out a figure of Mercury in marble, Topolino set about finishing it, and one day when he had almost done so, he wanted Michelangelo to look at it and absolutely insisted that he declare his opinion of it.

'Topolino, you're a crazy man', Michelangelo told him, 'to want to make statues; don't you see that this Mercury lacks more than a third of an armslength between the knees and the feet, and that you've made him a dwarf as well as crippled?'

'Oh, that's no problem! If it doesn't have any other defects, I will fix it. Leave it to me.'

Michelangelo laughed once again over Topolino's simplicity and left, while Topolino took a piece of marble, and, after cutting off a quarter of the statue of Mercury below the knees, he mounted it on this piece of marble and made a neat joint, carving a pair of boots for Mercury which covered the seam, lengthening it the required amount: when Michelangelo was later brought in and shown the work once again, he laughed

and marvelled that such clumsy artists, forced by necessity, may seize upon artistic solutions that the most worthy men cannot discover.

While Michelangelo was completing the tomb for Julius II, he had a stone-cutter execute a terminal figure to place on the tomb in San Pietro in Vincoli, with these words: 'Now, cut this away, smooth it out there, polish it here.' In this way and without the man's realizing it, Michelangelo made him carve a figure, and when it was finished the man stared at it in amazement, while Michelangelo asked: 'What do you think of it?'

The man answered: 'I like it a lot, and I am very much in your debt.'

'Why?' enquired Michelangelo.

'Because with your help I have rediscovered a talent that I never knew I had.'

But, to sum up, let me say that Michelangelo had a strong, healthy constitution, for he was lean and very sinewy, and although he had been a delicate child, as a man he only suffered two serious illnesses, and he always withstood every kind of hardship and had no ailments, except that in his old age he suffered from gravel in his urine which finally turned into kidney stones, and for many years he was in the hands of Master Realdo Colombo, his very close friend, who treated him with injections and looked after him carefully.* Michelangelo was of medium height, broad in the shoulders but well proportioned in the rest of his body. As he grew old, he constantly wore boots fashioned from dogs' skins on his bare feet for months at a time, so that when he later wanted to remove them his skin would often peel off as well. Over his stockings he wore boots of Cordovan leather fastened from the inside, for protection against the dampness. His face was round, the brow square and wide with seven straight furrows, and his temples jutted out some distance beyond his ears, which were rather large and stood out from his cheeks; his body in proportion to his face was rather large, his nose somewhat flattened, having been broken by a blow from Torrigiani, as was explained in his *Life*;* his eyes were rather small, the colour of horn marked with bluish-yellow flecks; his eyebrows had little hair; his lips were thin, and the lower lip

was larger and protruded somewhat; his chin was well shaped in proportion with the rest of his face; the hair of his beard was black, streaked with many white hairs and not too long; it was forked and not very thick.

Michelangelo was certainly, as I declared at the beginning, a man sent by God into the world as an example for men in our profession, so that they might learn from his life how to behave, and from his works how to become true and splendid artisans. And I myself, who must thank God for countless blessings that rarely befall men in our profession, count this among the greatest of them: that is, to have been born in the time Michelangelo was alive and to have been worthy of having him for a teacher, and for him to have been on such familiar and friendly terms with me, as everyone knows and as the letters he wrote to me prove; on account of my obligation to the truth and to his kindliness, I have been able to write many details about his life, all of which are true, which many other writers could not have known. The other blessing is one that Michelangelo once mentioned to me:

'Giorgio, thank God for having placed you in the service of Duke Cosimo, who spares no expense to allow you to build and paint and to realize his ideas and plans; you must consider that other artists, about whose lives you have written, had no such support.'

With a very dignified funeral attended by the entire artistic profession, as well as all his friends and the Florentine community, Michelangelo was buried in a tomb in the church of the Santi Apostoli in the presence of all of Rome, while His Holiness planned to erect a special memorial and a tomb in Saint Peter's itself.

Lionardo, his nephew, reached Rome after the funeral was over, even though he had travelled by coach; and, having learned of it, Duke Cosimo decided that since he had not been able to honour Michelangelo while he was alive, he would have him brought to Florence where he would not rest content until he had honoured him with every sort of pomp after his death, and Michelangelo's body was secretly shipped like merchandise in a bale, a method used so that in Rome there would be no chance of creating an uproar or of preventing

Michelangelo's body from being taken to Florence. But before the body arrived, word of his death reached Florence, and after the principal painters, sculptors, and architects gathered together at the request of the lieutenant of their Academy, who was at that time the Reverend Don Vincenzio Borghini, this man reminded them all that they were obliged, following the rules of the Academy, to honour the death of all their fellow artists, and having done so most lovingly and to the satisfaction of all in the funeral of Fra Giovan'Agnolo Montorsoli (the first to die after the creation of the Academy), they could clearly see what ought to be done in honour of Buonarroti, who had been unanimously elected by the entire company the first academician and head of them all. To this proposal they all replied that as men who loved and were indebted to the talents of such a man, they would do everything they could in their own way to honour him as lavishly and splendidly as possible. After agreeing on this, in order to avoid assembling so many people every day to their great inconvenience, and also in order to arrange things more quietly, four men were elected to organize the burial and the ceremonies: the painters Angelo Bronzino and Giorgio Vasari, and the sculptors Benvenuto Cellini and Bartolomeo Ammannati—all men of high standing and illustrious talent in their arts—so that, I should add, they might consult each other and decide among themselves and with the lieutenant about how and where everything should be done, with the authority to use all the resources of the Academy. They undertook this task all the more willingly, since all the members, young and old, each man from his own profession, eagerly volunteered to execute the paintings and statues required for the ceremonies. Later, it was decided that the lieutenant, because of his position, accompanied by the consuls, acting in the name of the confraternity and the Academy, should report everything to the Lord Duke and should request the assistance and support that were required, and most especially his permission to hold the funeral in San Lorenzo, the church of the most illustrious House of the Medici and where most of the works to be seen in Florence by Michelangelo are found. And besides this, they were to ask His Excellency to allow Messer Benedetto Varchi

to write and deliver the funeral oration, so that the matchless talents of Michelangelo would be praised by the exceptional eloquence of such a man as Varchi, who was also in His Excellency's service and who would not have undertaken such a task without the duke's permission, even though they were sure the duke would never have refused, since he was a most loving man by nature and extremely devoted to Michelangelo's memory....*

While these matters were being handled in Florence, Lionardo Buonarroti, nephew of Michelangelo, who, having heard of his uncle's illness, had gone to Rome by coach but had not found him alive, learned from Daniello da Volterra, a very close friend of Michelangelo, and from still others who had been close to that saintly old man, that Michelangelo had asked and begged for his body to be taken to Florence, his most noble native city which he had always tenderly loved; and so, with great determination, Lionardo had cautiously and quickly smuggled the body out of Rome and, as if it were merchandise, sent it to Florence in a bale. Here I shall not remain silent in declaring that, contrary to the opinion of some, Michelangelo's last wish proclaims the truth: that is, that he had for many years been absent from Florence for no other reason than the quality of the air in that city, since experience had taught him that the air in Florence, which is penetrating and thin, was very harmful to his constitution, whereas the sweeter and more temperate air in Rome kept him in fine health until he reached his ninetieth year, with all his senses as sharp and intact as they had ever been, and with such strength, relative to his age, that up to his last day he had never ceased working on something.

Then, since Michelangelo's body arrived so suddenly and unexpectedly in Florence, it was not possible at that moment to do everything that was to be done later, and on the day of its arrival in Florence—that is, the eleventh of March, a Saturday—his coffin was placed, as the deputies wished, in the Confraternity of the Assumption, which is under the steps behind the main altar of San Piero Maggiore, without ever being touched. The following day, which was the Sunday of the second week of Lent,* all the painters, sculptors, and

architects gathered in secret around San Piero, where they had brought only a velvet pall, all trimmed and embroidered with gold, to cover the casket, upon which lay a crucifix, and the entire bier. And then, about half an hour after dusk, they all drew close to the body, and the oldest and most distinguished artisans among them immediately took in their hands a large quantity of torches they had brought there, while the younger men picked up the bier so quickly that those who were able to draw near and get their shoulders under the bier could count themselves fortunate, as if they believed that in the future they could boast of having carried the remains of the greatest man who ever belonged to their professions.

Seeing this group gathered around San Piero caused a large number of people to stop there, as happens on similar occasions, and the crowd grew larger when it was rumoured that Michelangelo's body had arrived and that it was to be carried to Santa Croce. And as I said, everything had been done to keep the matter quiet, for fear that, as the news spread through the city, such a crowd of people would converge on the place that a certain uproar and confusion could not be avoided, and also because they wished at that time to carry out their little ceremony quietly and without pomp, reserving all the rest for a more suitable and convenient time, but everything turned out to the contrary, for the crowd, which (as I mentioned) gathered by word of mouth, filled the church in the blink of an eye, so that only with the greatest difficulty was the body finally carried from the church into the sacristy to be unpacked and put in its resting place. And as for the solemnity of the ceremony, although it cannot be denied that seeing a vast array of religious people in funeral processions with a large quantity of wax candles and a great number of mourners hastily prepared and dressed in black is a great and magnificent sight, it is also no less extraordinary to witness unexpectedly a group of those distinguished men who, today, are held in such esteem and will be held in even higher esteem in the future, gathered around Michelangelo's body to perform their duties with love and affection. And, to tell the truth, the number of these artisans in Florence (all of whom were present) has always been very great, since the arts have always truly

flourished there, and I believe it can be declared without
offence to other cities that Florence is the true and principal
home and dwelling place of the arts, just as Athens was once
home of the sciences. Besides this large number of artisans,
there were so many citizens following behind them, and so
many bands of people from the streets through which they
passed, that the place could hold no more of them. And what
is even more important, nothing was heard from anyone but
praise for Michelangelo's merits, with everyone declaring that
true talent possesses such great power that after all hope of
continuing to receive profit or honour from a talented man is
lost, it is, nevertheless, still loved and honoured for its own
nature and special merits. For this reason, the demonstration
appeared more lively and more precious than any display of
gold and silk could possibly have been. With this fine crowd,
the body had been brought into Santa Croce, and since the
friars had to perform the usual ceremonies for the deceased, it
was carried into the sacristy, but not without the greatest diffi-
culty, as was mentioned, because of the conflux of people; and
there the lieutenant, who was present because of his office,
thinking to do something that would please many others and
also (as he later confessed) wishing to see in death the man he
had never seen while he was living or had seen at such an early
age that he had lost all memory of it, decided at that moment
to have the casket opened. And after he had done so, although
he and all of us who were present thought we would find the
body already putrefied and decomposed since Michelangelo
had already been dead twenty-five days, twenty-two of them
in the casket,* we found him with all his bodily members
intact and without any foul odour, and we were tempted to
believe that he was only resting in a sweet and most tranquil
sleep. And besides the fact that his features were exactly as
they were when he was alive (except that his colour was a
little like that of a dead man), none of his limbs were
decomposed or showed any sign of decay, and his head and
cheeks were, to the touch, no different than if he had died only
a few hours earlier.

After the frenzy of the crowd had subsided, the order was
given to place the body in a tomb in the church near the altar

of the Cavalcanti family by means of the door leading towards the cloister of the chapter house. Meanwhile, the news spread through the city and a great multitude of young people ran to see him, so that the tomb was closed only with great effort. And if it had been day, instead of night, it would have had to have been left open for many hours in order to satisfy all the people. The following morning, while the painters and sculptors were beginning to organize the ceremonies, many of the gifted people who have always abounded in Florence began to attach verses in Latin and the vernacular over the tomb, and this continued for some time although these compositions, which were published later, formed only a small part of the many which were written.... *

And because it was not possible for the entire city to see the previously mentioned display in a single day, it was left standing by the Lord Duke's command for many weeks, to the satisfaction of his people and the foreign visitors who came to see it from nearby places.*

We shall not include here the great many epitaphs and verses in Latin or Tuscan composed by many worthy men in Michelangelo's honour, because these would require a separate book and also because they have already been written down and published by other writers. But I shall not forget to say in this last section that, after all the previously described ceremonies, the duke ordered that Michelangelo be given an honoured place in Santa Croce for his tomb, the church in which, when he was alive, he had decided to be buried, in order to be near the tombs of his ancestors. And to Lionardo, Michelangelo's nephew, His Excellency gave all the marble blocks and various stones for this tomb, which with the design by Giorgio Vasari was commissioned to Batista Lorenzi, a worthy sculptor, along with a bust of Michelangelo. And since there were to be three statues upon the tomb representing Painting, Sculpture, and Architecture, one of these was commissioned to this Batista, another to Giovanni dell'Opera, and the third to Valerio Cioli, all Florentine sculptors who are presently working upon the tomb, which will soon be completed and set in place. After receiving the marble from the duke, the expenses were borne by Lionardo Buonarroti,

but in order not to fail in any way to pay homage to such
a man, His Excellency will carry out his plans to place a
memorial inscribed with Michelangelo's name along with
his bust in the Duomo, where the names and images of other
excellent Florentines can be seen.

THE END OF THE LIFE OF MICHELANGELO BUONARROTI, FLORENTINE PAINTER, SCULPTOR, AND ARCHITECT

A Description of the Works of Titian of Cadore, Painter

[c.1487/90–1576]

In the year 1480,* Titian was born in Cadore, a small town on the River Piave, five miles from the pass through the Alps, to the Vecelli family, one of the noblest in those parts, and when, at the age of ten, he showed fine wit and a lively mind, he was sent to Venice to the home of an uncle of his, a respected citizen, who saw that the boy had a real propensity for the art of painting and who placed him with Giovanni Bellini, a skilful and very famous painter of those times, as we have said,* under whose instruction he applied himself to the art of design and very quickly proved that he had been gifted by Nature with all those qualities of intelligence and judgement which are necessary for the art of painting. And because at the time Giovanni Bellini and the other painters of that region had not studied ancient works, they frequently, or rather almost exclusively, copied everything from life, but with a dry, harsh, and laboured style, and for the time being Titian also learned this method. But then, around the year 1507, Giorgione of Castelfranco, being completely dissatisfied with this method of painting, began with a lovely style to give his works more softness and greater relief; he nevertheless still made use of live and natural objects and copied them as best he knew how with colours, tinting them with the crude and soft colours that Nature displays, without making preliminary drawings since he was firmly convinced that painting alone with its colours, and without any other preliminary study of designs on paper, was the truest and best method of working and the true art of design. But Giorgione did not realize that anyone who wishes to organize his compositions and to arrange his inventions must first produce them on paper in various different ways

in order to see how the entire composition will turn out. Indeed, the idea itself cannot perfectly envision or picture its inventions unless it opens up and displays its conceptions to the eyes, which assist it in producing sound judgement, not to mention the fact that the artisan must undertake a serious study of nudes if he wishes to understand them thoroughly, something that cannot be done without sketching them out on paper, for by always having naked or clothed models before him as he paints, a painter becomes a slave, whereas when he has tested his hand by drawing on paper, he can, in turn, set to work designing and painting with greater ease. And by gaining experience in his art in this way, a painter develops perfect judgement and style, avoiding the labour and effort with which the artisans we mentioned above executed their paintings, not to mention the fact that drawing on paper fills the mind with beautiful conceits and teaches the painter to imagine all the objects in Nature without always having to keep his subject in front of him, or to conceal under the charm of colours his poor knowledge of how to draw, in the way Venetian painters such as Giorgione, Palma, Pordenone, and others, who have not visited Rome or seen other completely perfect works, have done for years.

Therefore, when Titian observed the method and style of Giorgione, he abandoned the style of Giovanni Bellini, although he had not followed it for long, and drew closer to Giorgione's, imitating his works so well in such a short time that his paintings were sometimes mistaken and attributed to Giorgione, as we shall explain below. After Titian had grown older and had gained greater experience and developed good judgement, he executed many works in fresco which cannot be described in order, since they are scattered around many different locations; it is sufficient to note that they were so good that many knowledgeable people thought he would become a very fine painter, as was eventually the case. Therefore, in the beginning when he began to follow the style of Giorgione and was no more than eighteen years of age, he painted the portrait of a gentleman friend of his from the Barberigo family that was considered very beautiful, because the skin tones resembled those of real flesh and the hairs were

so well distinguished one from the other that they could be
counted, as could the stitches in a greatcoat of silver-sewn satin
that he painted in the portrait; in short, the painting was so
well considered and so carefully done that if Titian had not
written his name in the dark background, it would have been
taken for a painting by Giorgione.* Meanwhile, Giorgione
himself had completed the main façade of the Fondaco de'
Tedeschi, and through the influence of Barberigo Titian was
commissioned to do some scenes for the same building above
the Merceria.* After this work, he did a large painting with
life-size figures that is now in the hall of Andrea Loredano
who lives near San Marcuola; in this painting Titian depicted
Our Lady's Flight into Egypt,* in the midst of a great
wood with some well-executed landscapes, since he had spent
many months working on such details and had, for this pur-
pose, kept some German painters who excelled in landscapes
and foliage as guests in his home. In the woods he represented
a number of animals drawn from life, which are truly lifelike
and almost seem alive. Afterwards, in the home of Messer
Giovanni d'Anna, a gentleman and Flemish merchant who
was Titian's friend, he painted this man's portrait (which
seems alive) and an *Ecce Homo* with numerous figures, that
Titian himself and many others considered a very beautiful
painting.* In addition, he did a painting of Our Lady with
other life-size figures of men and children, all painted from life
by using members of the household as models. Then in the
year 1507, when the Emperor Maximilian was waging war on
the Venetians, Titian painted, according to his own account,
the angel Raphael, Tobias, and a dog in the church of San
Marziale along with a distant landscape, while in a grove Saint
John the Baptist is on his knees praying towards heaven, from
the direction of which comes a radiant light that illuminates
him.* And this work is thought to have been completed
before Titian began the façade at the Fondaco de' Tedeschi.
Since many gentlemen did not realize that Giorgione was no
longer working on this façade nor that Titian was doing
it, after Titian unveiled part of it these men congratulated
Giorgione as friends would when they ran into him, declaring
that he had acquitted himself better in the façade towards the

Merceria than in the one over the Grand Canal. Giorgione was so offended by this that until Titian had completely finished the work and it had become widely known that Titian had painted that part of it, Giorgione seldom allowed himself to be seen, and, from that time on, he never wanted to be in Titian's company or to be his friend.

During the following year, in 1508, Titian published a woodcut of his Triumph of the Faith with countless figures —our first parents, the patriarchs, prophets, sibyls, the Holy Innocents, the martyrs and apostles, and Jesus Christ, all borne in triumph by the four Evangelists and the four Doctors of the Church, with the Holy Confessors behind them.* In this work, Titian demonstrated boldness, a beautiful style, and the knowledge drawn from experience; and I remember that when Fra Sebastiano del Piombo was discussing this work, he told me that if Titian had been in Rome during this period and had seen the works of Michelangelo, those of Raphael, and ancient sculpture, and if he had studied the art of design, he would have created the most stupendous works, given his fine knowledge of colours; and he added that Titian deserved the reputation of being the finest and most able imitator of Nature in his use of colour in our time, and that with a foundation in the grand art of design, he would have reached the level of Raphael and Buonarroti.

After having gone to Vicenza, Titian painted a fresco of the Judgement of Solomon, a beautiful work, under the gallery where the public audiences are held; he then returned to Venice and painted the façade of the Grimani palace, while in the church of San Antonio in Padua he did some scenes, also in fresco, depicting some of the deeds of this saint.* And in the church of Santo Spirito, he painted a small panel of the figure of Saint Mark seated in the midst of various saints, whose faces include some portraits done from life and executed in oils with the greatest care; many people believed that this painting was by Giorgione.* When the death of Giovanni Bellini left incomplete a scene in the Hall of the Great Council, which depicted Frederick Barbarossa at the doors of the church of San Marco, kneeling before Pope Alessandro IV, who is placing his foot on Barbarossa's neck, Titian completed it,

changing many details and including the actual portraits of many of his friends as well as other individuals, and for this reason the Senate rewarded him with an office in the Fondaco de' Tedeschi, which is called the *senseria*, and which pays three hundred *scudi* a year; the senators customarily give this office to the most excellent painter of their city, with the understanding that from time to time he is obliged to do the portrait of their ruler or doge, when he is elected, for the price of only eight *scudi*, that is paid to him by that official himself; this portrait is then displayed in a public place in the Palazzo di San Marco to commemorate the doge.

During the year 1514, Duke Alfonso of Ferrara was having a small chamber decorated and had commissioned Dosso, a painter from Ferrara, to execute in several compartments scenes of Aeneas, of Mars and Venus, and of Vulcan in a cave with two blacksmiths at the forge, and in that room the Duke also wanted to have some paintings by Giovanni Bellini, who painted on another wall a vat of dark red wine surrounded by some Bacchantes, musicians, satyrs, and other drunken male and female figures, with a completely naked and very handsome Silenus riding nearby upon his ass in the midst of people who have their hands full of fruit and grapes; to tell the truth, this painting was coloured and finished with such great care that it is one of the most beautiful works Giovanni Bellini ever did, even though the style of the clothing has a certain sharpness, following the German manner, but this is not surprising, because Bellini had imitated a panel of the Flemish painter Albrecht Dürer, which at that time had been brought to Venice and placed in the church of San Bartolomeo; this painting is an unusual work, full of many beautiful figures executed in oil. Giovanni Bellini wrote these words on the vat mentioned above: IOANNES BELLINVS VENETVS P 1514.*

Because Bellini was an old man, he had not been able to complete the entire project, and, as the finest of all the other painters, Titian was sent for, so that he could finish it; since he was anxious to gain favour and make himself known, he executed with great care the two scenes this room was lacking. In the first is a river of dark red wine, surrounded by singers and musicians, both women and men, who are nearly

inebriated, and, along with other figures, a naked woman sleeping, who is so beautiful that she seems alive, and on this painting Titian signed his name.* In the other scene, which is next to this one and the first to be seen at the entrance, he painted many cupids and beautiful putti in a variety of poses, which greatly pleased this lord, as did the first painting, but among all these figures the most beautiful is one of the putti urinating into a river and looking at himself in the water, while the others are standing around the base of a pedestal shaped like an altar upon which stands a statue of Venus holding a sea-shell in her right hand, and near her are lovely figures of Grace and Beauty, both executed with incredible care. In addition, on the door of a wardrobe, Titian painted the figure of Christ from the waist up, to whom a Jewish peasant is displaying Caesar's coin.* This head and the other paintings in the room, our best artisans affirm, are the best and most skilfully executed paintings that Titian ever did, and in truth they are most unusual, and, for this reason, Titian deserved to be most generously recognized and rewarded by that ruler, whom he portrayed quite splendidly with his arm over a large artillery piece.* He also did a portrait of Signora Laura,* who later became the duke's wife, which is a stupendous work. And in truth, the gifts of those who toil as a result of their brilliance have great strength when they are nurtured by the generosity of princes.

At that time, Titian become friendly with the sublime poet Messer Ludovico Ariosto, who recognized him as a splendid painter and celebrated him in his *Orlando Furioso*:

> And Titian to whose mastery is due
> Such glory that Urbino shares no more,
> And Venice shines no brighter, than Cador,*

When Titian later returned to Venice, he painted for the father-in-law of Giovanni da Castel Bolognese a canvas in oils of a naked shepherd and a country girl who offers him some pipes to play, along with an extremely beautiful landscape. Today this painting is in Faenza in the home of this same Giovanni.* Next, in the church of the Minor Friars, called the

Ca' Grande, he did a panel for the main altar containing Our
Lady ascending into heaven, with the twelve Apostles stand-
ing below Her and watching Her ascent, but since this work
was painted on canvas and was perhaps poorly cared for, little
of it can be seen.* In the same church, in the chapel of the
Pesari family, Titian did a panel showing the Madonna with
Her Son in Her arms as well as Saint Peter and Saint George,
along with the patrons of the work kneeling all around,
painted from life, including the bishop of Paphos and his
brother, who had just returned from the victory the same
bishop had won against the Turks.* For the little church of
San Niccolò in the same convent, Titian painted a panel con-
taining Saint Nicholas, Saint Francis, Saint Catherine, and a
nude Saint Sebastian depicted from life without employing any
obvious artifice in revealing the beauty of his legs and torso;
nothing is shown except what Titian saw in nature, and, as a
result, everything seems imprinted from a living person, it is
so fleshy and real, and it is, for all these reasons, considered
very beautiful, as is a most charming picture of Our Lady
with Her Child in Her Arms, at whom all the previously
mentioned figures are staring. The work on this panel was
drawn on wood by Titian himself and then engraved and
printed by others.* For the church of San Rocco and after the
works mentioned above, Titian did a painting of Christ with
the Cross on His shoulders, being dragged along with a rope
around His neck by a Jew;* many have believed this figure to
be the work of Giorgione, and today it is held in the highest
reverence in Venice, having attracted more *scudi* in alms than
Titian and Giorgione earned in their entire lifetimes.

After being summoned to Rome by Bembo (who was then
secretary to Pope Leo X and whose portrait Titian had already
painted*) so that he could see Rome, Raphael of Urbino, and
other painters there, Titian kept putting the trip off from one
day to the next until, in 1520, Leo died and then Raphael too,
and, in the end, Titian never went. For the church of Santa
Maria Maggiore, Titian did a painting of Saint John the
Baptist in the desert among some rocks, with an angel that
seems alive, and there is a small section of landscape in the
distance with some extremely graceful trees on the bank of

a river.* He drew living portraits of the Doges Grimani and Loredan, which were considered marvellous works, and not long after that a portrait of King Francis at the moment of his departure from Italy to return to France; and Titian did an unusually fine portrait of Andrea Gritti in the year of his election as doge in a painting including Our Lady, Saint Mark, and Saint Andrew, who has the face of this doge; this painting, which is a most astonishing work, is in the Sala del Collegio.* And because, as was previously discussed, it was Titian's duty to do so, he painted the portraits of other doges, besides those already mentioned, who held office at different times: Pietro Lando, Francesco Donato, Marcantonio Trevisan, and Venier,* but because of his advanced age he was finally relieved of this task by the two doges who were brothers of the Priuli family.*

Before the Sack of Rome, the most celebrated poet of our times, Pietro Aretino, had come to live in Venice, and he became very close friends with both Titian and Sansovino, which brought Titian great honour as well as certain benefits, for Aretino made him known wherever his pen could reach and especially among important rulers, as will be explained in the proper place. Meanwhile, to return to Titian's works, he painted the panel for the altar of Saint Peter Martyr in the church of SS Giovanni e Paolo, making the figure of this holy martyr larger than life among enormous trees in a wood, where, having fallen to the ground, he is savagely assaulted by a soldier who has wounded him in the head in such a way that his face, as he lies there half alive, shows the horror of death, while in the figure of another friar who is in flight the terror and fear of death can be recognized. In the air are two nude angels coming from a light in heaven which illuminates this unusually beautiful landscape as well as the entire work; this is the most accomplished and celebrated, the greatest and best conceived and executed of the works that Titian completed during his whole lifetime.* Having seen this work, Doge Gritti, who was always a great friend of Titian (as he was of Sansovino), commissioned him to do a large scene of the rout of Ghiaradadda for the Sala del Gran Consiglio, in which he depicted a battle and the fury of soldiers fighting while a terrible rain falls from the sky; this work, taken entirely from

life, is considered the best of all the scenes in this hall, and the most beautiful.* In the same palace, at the foot of a staircase, Titian painted a Madonna in fresco.*

Not long afterwards, he painted a splendid picture of Christ sitting at the table with Cleopas and Luke* for a gentleman of the Contarini family, who thought the work worthy of public display (as it truly was), and as a man lovingly attached to his native city and the public good, he presented the painting as a gift to the Signoria, and it was kept for a long time in the doge's apartments, although today it is on public display and can be seen by anyone over the door in the Salotto d'Oro at the front of the hall of the Council of Ten. At almost the same time, he painted for the School of Santa Maria della Carità a picture of the Virgin climbing up the stairs of the Temple, with heads of all kinds drawn from life; likewise, in the School of San Fantino, he did a small panel of Saint Jerome in penitence, which was highly praised by other artisans, but it was destroyed by the fire two years later along with the entire church. It is said that in the year 1530, while the Emperor Charles V was in Bologna, Titian was summoned there by Cardinal Ippolito de' Medici, through the mediation of Pietro Aretino, where he painted a truly beautiful portrait of His Majesty in full armour that delighted the emperor so greatly that he made Titian a gift of one thousand *scudi*, half of which Titian later had to give to the sculptor Alfonso Lombardi, who had made a model for a marble statue of Charles, as will be described in Lombardi's life.*

Having returned to Venice, Titian discovered that many gentlemen had begun to promote Pordenone,* praising highly the works he did on the ceiling of the Sala de' Pregai and elsewhere, and they had commissioned him to paint a small panel in the church of San Giovanni Elemosinario so that he could compete with Titian, who in the same church a short time before had painted this same Saint John the Almoner in a bishop's robes.* But no matter how much care Pordenone took with his panel, he could not equal or even come close to Titian's painting. Titian then painted a very beautiful panel of the Annunciation for the church of Santa Maria degli Angeli on the island of Murano. But since those who commissioned it

did not want to spend the five hundred *scudi* Titian was asking for it, the painting was sent, upon Messer Pietro Aretino's suggestion, as a gift to the Emperor Charles V, who was so pleased with it that he gave Titian a present of two thousand *scudi*, and in the location where this picture was to have been hung, a painting by Pordenone was put up in its place.* Not much time passed before Charles V returned to Bologna with his army from Hungary in order to confer with Pope Clement VII, and he once again desired to have his portrait done by Titian,* and before leaving Bologna Titian also painted the portrait of the previously mentioned Cardinal Ippolito de' Medici in a Hungarian uniform,* as well as a smaller picture depicting the same individual in full armour; both of these portraits are now in Duke Cosimo's wardrobe. During the same period, he painted the portrait of the Marquis del Vasto, Alfonso Davalos, as well as that of the previously mentioned Pietro Aretino, who later convinced Titian to serve and to befriend Federigo Gonzaga, Duke of Mantua, and the portrait Titian made of this duke when he travelled to his state seemed to be alive; afterwards he did a portrait of his brother, the cardinal.* And when these were completed, Titian did twelve extremely beautiful portraits of the twelve Caesars from the waist upwards for the decoration of one of the rooms of Giulio Romano, and under each of them Giulio later painted a scene from their lives.*

In his native town of Cadore, Titian did a panel which contained Our Lady and Saint Titian the bishop, with a portrait of Titian himself kneeling.* The year that Pope Paul III went to Bologna and from there to Ferrara, Titian went to court and did the pope's portrait, which is a very beautiful work, and from that one he did another for Cardinal Santa Fiore; both of these portraits, for which Titian was very well paid by the pope, are in Rome, one in the wardrobe of Cardinal Farnese and the other in the possession of the heirs of Cardinal Santa Fiore. Many copies were later made from these and are scattered throughout Italy.* Almost at the same time, he also painted the portrait of Francesco Maria, Duke of Urbino, a marvellous work, which Messer Pietro Aretino celebrated in a sonnet that begins as follow:

When the great Apelles employed his art
To depict the face and breast of Alexander ... *

In this same duke's wardrobe, there are two very charming female heads by Titian along with a young recumbent Venus clothed in lovely fabrics and flowers, both beautiful and nicely finished, and, besides this, there is a very unusual half-length picture of Saint Mary Magdalene with her hair dishevelled.* Also by Titian, as I said, are portraits of Charles V, King Francis as a young man, Duke Guidobaldo II, Pope Sixtus IV, Pope Julius II, Paul III, the old cardinal of Lorraine, and Suleiman, emperor of the Turks, all very beautiful. In the same wardrobe, in addition to many other works, is a portrait of Hannibal of Carthage engraved in the hollow of an antique carnelian and a very beautiful marble head by Donatello.*

In the year 1541, Titian painted for the friars of Santo Spirito in Venice the panel for the main altar, in which he depicted the descent of the Holy Spirit upon the Apostles, representing God in the image of fire and the Holy Spirit as a dove. This panel was ruined not long afterwards, and Titian had to repaint it after lengthy litigation with the friars, and this second copy is the one which is presently over the altar.* In Brescia, for the church of San Nazaro, Titian did the panel painting for the main altar in five sections: the middle scene depicts Jesus Christ arising from the dead surrounded by some soldiers, with Saint Nazarius, Saint Sebastian, the Angel Gabriel, and the annunciation of the Virgin on the sides.* For the lower wall in the Duomo of Verona, he painted a panel representing the Assumption of Our Lady into Heaven with the Apostles on the ground below which is considered the best among the modern works in that city.* In the year 1541, Titian executed the full-length, standing portrait of Don Diego di Mendoza, then the ambassador of Charles V to Venice, a very beautiful figure, and with this work Titian began what later became the fashion, that is, painting some portraits in full length.* In the same style he did the portrait of the Cardinal of Trent as a young man,* and for Francesco Marcolini he painted a portrait of Messer Pietro Aretino, but this was not as beautiful as one, also by Titian, that Aretino

himself sent as a gift to Duke Cosimo de' Medici, to whom he
also sent a head of Lord Giovanni de' Medici, the duke's
father.* This head was painted from a mould belonging to
Aretino taken from that lord's face when he died in Mantua.
Both portraits are in the Lord Duke's wardrobe among many
other extremely noble paintings.

During the same year, while Vasari, as we have mentioned,*
lived in Venice for thirteen months to paint a ceiling for
Giovanni Cornaro and some other works for the Confratern-
ity of Hosiers, Sansovino, who was in charge of the building
of Santo Spirito, had Vasari draw some cartoons for three
large paintings for the ceiling so that they could be executed in
oil, but after Vasari left Venice, the three paintings were com-
missioned to Titian, who completed them very beautifully,
having applied himself with great skill to foreshortening the
figures from below upwards. One of them depicts Abraham
sacrificing Isaac, a second David beheading Goliath, and a
third Cain killing his brother Abel.* At the same time Titian
did a self-portrait in order to leave behind some remembrance
of himself to his sons. And when the year 1546 arrived, Titian
was summoned by Cardinal Farnese and went to Rome,
where he found Vasari back from Naples, working on the hall
of the cardinal's Chancellery, and after the Cardinal had
introduced Titian to Vasari, Vasari kindly kept his company
and took him around to see the sights of Rome. And after
Titian had rested for several days, he was given quarters in the
Belvedere so that he could set his hand once again to doing a
full-length portrait of Pope Paul along with those of Cardinal
Farnese and Duke Ottavio,* all admirably executed to the
great satisfaction of those lords, who persuaded Titian to
paint, as a gift for the pope, a half-length picture of Christ
in the form of an *Ecce Homo*, but this work, either because
it suffered in comparison to the works of Michelangelo,
Raphael, or Caravaggio or for some other reason, did not
seem to other painters (although it was certainly a good paint-
ing) to possess the excellence typical of many of his other
works, especially the portraits.

One day as Michelangelo and Vasari were going to see
Titian in the Belvedere, they saw in a painting he had just

completed a naked woman representing Danaë with Jupiter transformed into a golden shower on her lap, and, as is done in the artisan's presence, they gave it high praise. After leaving Titian, and discussing his method, Buonarroti strongly commended him, declaring that he liked his colouring and style very much but that it was a pity artisans in Venice did not learn to draw well from the beginning and that Venetian painters did not have a better method of study.

'If Titian', he said, 'had been assisted by art and design as greatly as he had been by Nature, especially in imitating live subjects, no artist could achieve more or paint better, for he possesses a splendid spirit and a most charming and lively style.'

And in fact this is true, for anyone who has not drawn a great deal and studied selected works, both ancient and modern, cannot succeed through his own experience or improve the things he copies from life by giving them the grace and perfection that derive from a skill that goes beyond Nature, some of whose parts are normally not beautiful.

Titian finally left Rome, taking many gifts given him by those lords and, in particular, a benefice with a good income for his son Pomponio, and he set out on the road to return to Venice, after his other son Orazio painted a very fine portrait of Messer Batista Ceciliano, an excellent player of the bass viol; Titian also did some other portraits for Duke Guidobaldo of Urbino. And when he reached Florence and saw the unusual works in that city, he remained no less amazed than he had been with the works in Rome, and, besides this, he paid a visit to Duke Cosimo, who was at Poggio a Caiano, offering to paint his portrait, which did not much interest His Excellency, perhaps because he did not wish to offend so many noble artisans in his city and domain.

When Titian arrived in Venice, he completed for the Marquis del Vasto an allocution (as they were called) of that lord to his soldiers,* and afterwards he painted the portrait of Charles V, that of the Catholic king, and many others. And having finished these works, he painted a small panel picture of the Annunciation* in the church of Santa Maria Nuova in Venice, and then with the assistance of his pupils he executed a Last Supper in the refectory of SS Giovanni e Paolo, while in

the church of San Salvadore he painted a panel for the main altar which contains a transfigured Christ on Mount Tabor, as well as a picture of Our Lady receiving the Annunciation from the Angel* for another altar in the same church. But these last works, although some good things can be seen in them, are not very highly regarded by him and do not possess the perfection of his other paintings. And because the works of Titian are countless, especially his portraits, it is almost impossible to recall all of them; therefore, I shall only speak of the most important, without putting them in chronological order, since it matters very little which was done first and which later.*

As has already been mentioned, Titian painted the portrait of Charles V several times, and, for that reason, he was finally summoned to the court, where he executed the portrait that depicted the emperor as he was in his last years; Titian's work pleased the invincible emperor so much that once he had met him he never wanted to be painted by other painters, and each time Titian painted him, he received a gift of one thousand gold *scudi*. He was made a knight by His Majesty with an allowance of two hundred *scudi*, drawn on the treasury of Naples. When Titian likewise did the portrait of Philip, King of Spain, Charles's own son, he received from him an additional fixed allowance of two hundred *scudi*, so that with the addition of these four hundred to the three hundred that Titian received from the Venetian Signoria through the Fondaco de' Tedeschi, Titian enjoys without too much effort a fixed provision of some seven hundred *scudi* every year.

Titian sent the portraits of Charles V and his son King Philip to Lord Duke Cosimo, who has them in his wardrobe. He then painted Ferdinando, King of the Romans who later became emperor, along with all of his sons: that is, Maximilian (now the emperor) and his brother; he painted Queen Mary, and, for the Emperor Charles, the Duke of Saxony, while the duke was in prison.* But what a waste of time all this is! There has scarcely been a lord of great renown, or a prince or great lady, who has not been painted by Titian, truly a most excellent painter in this regard. As we mentioned, he did the portrait of Francis I of France; Francesco Sforza, Duke of Milan; the Marquis of Pescara; Antonio da Leva; Massimiano

Stampa; Signor Giovanbatista Castaldo; and countless other lords. Also, besides those already mentioned, he painted many other works at different times: in Venice on the orders of Charles V he painted on a large altarpiece a God in the form of the Trinity; Our Lady is enthroned, the infant Christ has the Dove above Him, and a background made of fire represents love, while God the Father is surrounded by burning cherubim; Charles V on one side and the empress on the other are both enveloped in linen with their hands joined in an act of prayer amidst numerous saints, following instructions Titian received from Caesar [Charles], who at that moment was at the height of his victories but was beginning to reveal his intention to retire, as he later did, from the affairs of the world in order to die as a true Christian, fearing God and concerned for his own salvation. The emperor told Titian he wanted to place the picture in the monastery where he was later to end his life's journey. And because it is a very unusual work, there is every prospect that it will soon be published in an engraving.* For Queen Mary, Titian also painted a Prometheus bound to Mount Caucasus and being ripped apart by Jupiter's eagle, a Sisyphus in hell carrying a rock, and a Tityus torn apart by the vulture.* And, except for the Prometheus, Her Majesty received all of these, along with a picture of Tantalus of the same size—that is, life-size—and done in oil on canvas. He also did a marvellous painting of Venus and Adonis, showing Venus fainting while the young Adonis is about to leave her, surrounded by some very lifelike dogs.* In a panel of the same size, he painted Andromeda tied to a rock with Perseus who frees her from the sea monster, and no painting could be more charming than this one; equally lovely is another depicting Diana, who is standing in a fountain with her nymphs and transforms Actaeon into a stag.* He also painted a picture of Europa, crossing the ocean upon the bull.* These paintings are in the possession of the Catholic king, and they are held most dear because of the vitality Titian gave to his figures with colours that made them seem almost alive and very natural. But it is certainly true that his method of working in these last works is very different from the one he employed as a young man. While his early works are executed

with a certain finesse and incredible care, and are made to be seen both from close up and from a distance, his last works are executed with such large and bold brush-strokes and in such broad outlines that they cannot be seen from close up but appear perfect from a distance. And this technique explains why many, wishing to imitate Titian in this and to prove their expertise, have produced clumsy pictures, and this comes about because although many believe them to be executed without effort, the truth is very different and these artisans are very much mistaken, for it is obvious that his paintings are reworked and that he has gone back over them with colours many times, making his effort evident. And this technique, carried out in this way, is full of good judgement, beautiful, and stupendous, because it makes the pictures not only seem alive but to have been executed with great skill concealing the labour. Finally, Titian did a painting three armslengths high and four wide of Jesus Christ as a young child on Our Lady's lap being adored by the Magi, with a goodly number of figures, each one an armslength high, which is a very charming work, like yet another painting that he himself copied from this one and gave to the old cardinal of Ferrara.* Another very beautiful painting, in which he depicts Christ mocked by the Jews, was placed in the church of Santa Maria delle Grazie in Milan in a chapel.*

For the queen of Portugal, Titian painted a very beautiful picture of Christ, somewhat smaller than life-size, who is being scourged by the Jews at the column.* In Ancona, for the main altar in San Domenico, he did a panel of Christ on the cross, with Our Lady, Saint John, and Saint Dominic at His feet, all very beautiful and executed in this late style of his with large brush-strokes, as was previously mentioned. Also, in the church of the Crucicchieri in Venice is a panel painting by Titian on the altar of San Lorenzo which depicts the martyrdom of the saint and includes a building full of figures with a foreshortened Saint Laurence lying half on the grate over a huge fire, surrounded by some figures who are lighting it.* And because Titian has imagined a scene at night, he has two servants holding two torches in their hands which illuminate the places where the light of the fire, burning brightly and

intensely under the grate, does not reach. And besides these details, he has imagined a flash of lightning coming down from the heavens and cutting through the clouds to overcome the light from the fire and the torches, shining above the saint and the other main figures; and besides these three sources of light, the people that he has depicted in the distance in the windows of the apartment building are surrounded by the light from their lanterns and candles, and the whole picture is, in short, executed with admirable skill, ingenuity, and good judgement. In the church of San Sebastiano on the altar of San Niccolò is a small panel painting done by Titian of Saint Nicholas who seems to be alive, seated upon a chair made to look like stone with an angel holding his mitre, a work that the lawyer, Messer Niccolò Crasso, had him paint.* After this, Titian painted a work to be sent to the Catholic king, a dishevelled figure of Saint Mary Magdalene painted down to the middle of her thighs—that is, with her hair falling around her neck down on her shoulders and on her breast, while she raises her head with her eyes fixed towards the sky, showing remorse in the redness of her eyes and, in her tears, sorrow for her sins; this painting would move anyone gazing at it in the most profound manner, and, what is more, although she is extremely beautiful it does not move the viewer to lustful thoughts but, rather, to pity. When this painting was completed, it pleased Silvio Badoer, a Venetian gentleman, so much that he gave Titian one hundred *scudi* to have it, for he was a man who took the greatest delight in the art of painting; and so Titian was forced to paint another one, no less beautiful, to send to the Catholic king.*

Among the portraits Titian did from life is one of a Venetian citizen and a very close friend of his named Sinistri,* and another is of Messer Paolo da Ponte, whose beautiful young daughter and a confidante of Titian's, named Signora Giulia da Ponte, Titian also painted;* likewise he did a portrait of Signora Irene, a very beautiful girl, a woman of letters, a musician, and an initiate of the art of design who died about seven years ago and was celebrated by the pens of almost all the writers of Italy.* He did a portrait of Messer Francesco Filetto, the orator of happy memory, and in the same painting

he depicted one of his sons standing in front of him, who seems alive, and this portrait is in the home of Messer Matteo Giustiniano, a lover of the arts, who commissioned the painter Jacopo Bassano to do a painting which is as beautiful as many other works by this same Bassano scattered about Venice and held in high esteem,* especially for the details they contain and animals of all kinds.

On another occasion, Titian did portraits of Bembo, that is, after he was made a cardinal,* and of Fracastoro and Cardinal Accolti of Ravenna, which Duke Cosimo has in his wardrobe, and our own Danese, the sculptor, has in his home in Venice a portrait by Titian of a gentleman from the Delfini family.* Also by him are portraits of Messer Niccolò Zeno, Rossa, the wife of the Grand Turk, a girl of sixteen, and Cameria her daughter, both wearing very beautiful clothes and hair-styles. In the home of Messer Francesco Sonica, a lawyer and close friend of Titian's, there is a portrait of Messer Francesco himself by Titian, along with a large painting of Our Lady going down into Egypt; she has dismounted from the ass and is sitting upon a stone in the road with Saint Joseph nearby, and the little Saint John is offering the baby Christ some flowers gathered by the hand of an angel from the branches of a tree in the middle of this wood filled with animals, while in the distance the ass stands grazing. This painting, which is still most charming, has been placed by this same gentleman in one of the palaces he has built in Padua near Santa Justina.* In the home of a gentleman of the Pisani family near San Marco, there is a portrait by Titian of a lady which is an amazing work. For Monsignor Giovanni della Casa, the Florentine, a man distinguished in our times by birth and by learning, Titian painted a most beautiful portrait of a lady whom this nobleman loved when he lived in Venice, and for this work Titian deserved to be honoured with this splendid sonnet beginning:

> Titian, now I clearly see in new forms
> My idol, who opens her eyes and turns,

and so forth. Recently, this excellent painter sent to the Catholic king a picture of the Last Supper of Christ with the

Apostles in a frame seven armslengths long that was a work of extraordinary beauty.*

Besides all the previously mentioned works and many others of lesser value that this man completed and which have been omitted for the sake of brevity, Titian has in his house the following works, sketched out and begun: the martyrdom of Saint Laurence, similar to the one mentioned above, which he plans to send to the Catholic king;* a large canvas which contains Christ on the cross with the thieves and, below, the men who crucify them, which he is doing for Messer Giovanni d'Anna; and a painting which was begun for Doge Grimani, father of the patriarch of Aquilea.* And for the hall of the Palazzo Grande in Brescia, Titian has begun three large paintings that will go into the decoration of the ceiling, as was mentioned in discussing the lives of Cristofano and one of his brothers, both Brescian painters.* Many years ago, Titian began for Alfonso, the first Duke of Ferrara, the painting of a young woman in the nude who is bowing before Minerva, with another figure by her side, while in the distance Neptune is in the middle of the sea on his chariot, but because of the death of this ruler for whom Titian was painting the work according to his fantasy, it was not completed and remains in Titian's hands. He has also nearly completed but has not put the finishing touches on a painting in which an almost life-sized figure of Christ appears in the garden to Mary Magdalene as a gardener, as well as another work of similar size in which the dead Christ is placed in His tomb in the presence of the Madonna and the two Maries, and also among the fine works in Titian's home is a painting of Our Lady. In addition there is, as was mentioned, one of his self-portraits, a very beautiful and lifelike painting completed four years ago, and finally the half-length figure of Saint Paul reading, who seems very like the man himself, filled with the Holy Spirit. All these works, let me say, Titian has executed, along with many others that I will ignore in order to avoid being tedious, up to his present age of about seventy-six years.*

Titian was a very healthy man and was as fortunate as any other artisan of his kind has ever been, for he has received nothing from the heavens but favour and felicity. His home in

Venice has been visited by a great many princes, men of letters, and noblemen who, in his time, have gone to pass some time in Venice, because, besides being an excellent artisan, Titian was very kind and well-bred, being possessed of the gentlest habits and manners. He had many rivals in Venice, but none of great worth, and he easily surpassed them through the excellence of his art and his ability to deal with and to make himself pleasing to the nobility; he earned a great deal, because his works were always well paid for, but he would have done well in his last years not to have worked except as a pastime to avoid damaging with less skilful works the reputation he earned in his best years before his natural gifts had begun to decline.

When Vasari, the author of the present history, was in Venice in the year 1566, he went to visit Titian, as a close friend, and he found him, although extremely advanced in years, with his brushes in his hand painting, and he took great pleasure in seeing Titian's works and in discussing them with him; Titian introduced Vasari to Messer Gian Maria Verdezotti, a Venetian gentleman, a young man full of talent, a friend to Titian, and a reasonably good draughtsman and painter, as he has demonstrated in some very beautiful landscapes he has drawn. Verdezotti has two figures painted in oil in two niches—that is, an Apollo and a Diana—by Titian, whom he loves and respects as a father. Thus Titian, who has decorated Venice, or rather all of Italy and other parts of the world, with superb paintings, deserves to be loved and respected by all artisans and in many ways to be admired and imitated, like those other artisans who have produced and still are producing works worthy of boundless praise, which will endure as long as the memory of illustrious men.

Although a large number of artisans studied with Titian, not many of them can truly be called his followers, for he did not teach much, but each one of them learned more or less, according to what they knew how to take from the works Titian executed. . . . *

THE END OF THE LIFE OF TITIAN OF CADORE, PAINTER

The Author: To Artists of the Art of Design*

Most honourable and noble artisans, mainly for whose sake and benefit I undertook such a lengthy task a second time, I now see that, favoured and assisted by divine grace, I have completely fulfilled the promise I made at the beginning of this present labour. For this, I thank first of all God, and then my patrons, who have granted me everything required to do so comfortably, and so now there remains only to rest my pen and my weary mind, which I shall do as soon as I shall have briefly discussed several matters.

If, therefore, it has seemed to some of you that, on occasion, I have been rather long-winded and somewhat prolix in my writing, having desired as far as possible to be clear and to state matters for others so that things which are not understood or which I have not known how to say at first would at any rate be obvious, and if something said in one place is sometimes repeated in another, there are two reasons for this: first, because the material treated required it; and second, because during the time I rewrote this work and had it reprinted, I was interrupted on more than one occasion not simply for days but for months in my writing either by travel or by an excessive number of tasks, paintings, plans, and building projects, and, under such circumstances, it is, in my opinion—and I freely admit it—almost impossible to avoid errors.

To those who think I have excessively praised some artisans either old or modern, and that drawing comparisons between the older ones and those of this era would be a laughing matter, I do not know how else to reply except that I intended to give praise not simple-mindedly but, as they say, with respect for places, times, and other similar circumstances; in truth, taking the example of Giotto, no matter how highly praised he was in his own day, I do not know what would be said of

him and other older artisans if they had existed in Buonarroti's time; moreover, the men of this century, which has reached the peak of perfection, would not have attained the heights they have reached if those who came before had not been as they were, and it can be believed, in short, that what I have said in praise or in blame was not said maliciously but only to speak the truth, or what I believed to be the truth. But one cannot always have in hand the goldsmith's scales, and anyone who has experienced what writing entails, especially when comparisons have to be made (which are odious by nature), or who has had to pass judgements, will have to excuse me.

I know all too well the toil, troubles, and money I have spent over these many years pursuing this work. And the difficulties I have encountered have been so many and so great that I would have given up on many occasions out of desperation had it not been for the assistance of many good and true friends, to whom I shall always be extremely obligated, who encouraged me and persuaded me to continue with all the kindly assistance they were able to give me—information, advice, and verifications of various details about which, after I had seen them, I remained very perplexed and doubtful. Such assistance was truly given in such a way that I was able to discover the simple truth and give birth to this work in order to revive the memory of so many rare and pioneering geniuses who had almost been forgotten, for the benefit of those who will come after us.

In doing my work, as was mentioned elsewhere, the writings of Lorenzo Ghiberti, Domenico Ghirlandaio, and Raphael of Urbino have been of no small assistance.* And if I have trusted them, I have always, nevertheless, desired to compare what they say with an actual examination of the works themselves, since long experience teaches careful painters to recognize, as you well know, the various styles of the artisans in no other manner, just as a learned and experienced secretary recognizes the different and various handwritings of his colleagues, or as each one of us identifies the characteristics of his closest acquaintances, friends, and relations. Now if I have reached the goal I desired, that is, to be useful and to give pleasure, I shall be extremely grateful, and if I have failed

I shall rest content, or at least less troubled, having toiled in an honourable cause and one that should make me worthy, among men of talent, of at least their compassion, if not their forgiveness.

But now to come to the conclusion of such a long discussion, I have written as a painter in the order and manner I knew best, and as for the language I employ, whether it be Florentine or Tuscan, I have written in the manner I thought best, simply and fluently, wisely leaving ornate and lengthy periods, the choice of vocabulary, and other embellishments of language and writing to those who are not, as I am, more accustomed to holding the brush than the pen and more used to thinking about drawings than compositions. And if I have scattered through my work many words specific to the arts that may not perhaps have contributed towards greater clarity and illumination in our tongue, I have done so because I could not do otherwise and in order to be understood by you artisans, mainly for whose sake, as I said, I undertook this task.

As for the rest, having done the best I knew how, accept it willingly and do not ask of me more than I know or am capable of, and be satisfied with my good will, which is and always will be to help and to please others.

THE END

EXPLANATORY NOTES

Preface to the Lives

3 *Preface to the Lives*: along with several dedications to Vasari's patron, Cosimo I, Grand Duke of Tuscany (1519–74), and to his fellow artists, Vasari's original book contained an introduction and a treatise dealing with the arts of architecture, sculpture, and painting. All of this material has been omitted from this edition. The three sections of the lives of the artists followed, each with a separate introduction. The first preface actually serves to introduce the whole work.

the first form of sculpture and painting: artistic creation thus follows God's original creation of the world and of man. In this implicit comparison of the artistic enterprise with divine creation, Vasari lays the foundation for the Renaissance concept of the artist as a divinely inspired genius rather than merely a skilled artisan, the perspective most typical of the late Middle Ages.

and perfection they seek. . . .: this edition omits a long discussion of the arts among the various peoples of antiquity.

4 *beginnings to perfection? . . .*: this edition omits a long digression on the gradual decline of the state of the arts during the Roman Empire.

5 *the physical appearance and name. . . .*: this edition omits a brief discussion of the invasions of the Visigoths and Vandals.

the result of its ardent zeal: Vasari's description of the treatment of ancient art by the Christian religion anticipates some of the criticisms of Edward Gibbon. This edition omits a long and detailed account of the state of the arts among the Lombards and the Italians down to the time of Cimabue.

6 *in our own times*: here Vasari presents his influential thesis concerning a 'rebirth' or 'renaissance' of antique art in Italy. This concept eventually gave birth to the very notion of a Renaissance period style popularized during the nineteenth century by such historians as Jules Michelet and Jacob Burckhardt. This edition omits Vasari's brief closing address to his reader.

The Life of Cimabue

7 *Cimabue*: documents of the period refer to this artist as 'Cenni di Pepi, called Cimabue', and they note his presence in Rome (1272) and Pisa (1301, 1302). Vasari's dates are therefore approximate. Most of the works attributed by Vasari to Cimabue have been taken away from him by modern scholarship. Two masterpieces, however, are universally accepted as his and form the basis of our modern appreciation of Cimabue's genius— the crucifix of Santa Croce and the *Madonna and Child* done for Santa Trìnita, now in the Uffizi Museum. The first work (*c.*1274) was heavily damaged during the 1966 flood but is now restored; the second was probably completed around 1280.

8 *awkward, modern style of their times*: for the first time, Vasari here refers to a clumsy modern style brought to Florence by certain Greek painters of Cimabue's day, what modern historians would call the Byzantine style. He continues to refer to this as the 'Greek style'.

11 *Bardi di Vernio Chapel*: modern scholarship universally attributes this 'Rucellai Madonna' (1285), now in the Uffizi, to Duccio.

12 *this same name ever since*: Vasari's account seems impossible, since King Charles of Anjou (brother of Saint Louis) was in Florence in 1267 before the construction of Santa Maria Novella began. Furthermore, Borgo Allegri was probably so named because of its seedy reputation as a spot frequented by the city's prostitutes.

now the heavenly stars/Are his: Cimabue's epitaph was probably inspired by the verses from Dante that Vasari subsequently cites.

13 *Dimming the lustre of the other's fame*: Dante, *The Divine Comedy*, vol. ii: *Purgatory*, trans. and ed. Mark Musa (New York: Viking Penguin, 1985), p. 121 (*Purgatory*, xi. 94–6).

Don Vincenzio Borghini: Vinzenzo Borghini (1515–80), a Benedictine scholar and close friend of Vasari.

14 *then lord of Poppi*: the frescos in the Spanish Chapel of Santa Maria Novella are attributed today to Andrea di Bonaiuto (also known as Andrea da Firenze, active 1343–77) and were completed around 1355. Vasari's identification of the artist as Simone Martini and his attempt to find historical characters in this fresco cycle are therefore without any basis in fact.

14 *his work*: Vasari's collection of drawings, illustrating in chronological order the development of Italian art as it is described in his *Lives*, was dispersed in the seventeenth century and was probably absorbed into the drawing collection now conserved by the Uffizi Museum.

The Life of Giotto

15 *Florentine Painter, Sculptor, and Architect*: in the earlier (1550) edition of the *Lives*, Vasari attributed fewer works to Giotto, and his additions in the second and longer version (many of which have been disputed by modern scholarship) were probably made to enhance Giotto's stature. However, Vasari's estimation of Giotto followed a long tradition that had already begun during the Trecento. Giotto's fame today rests solidly upon a number of works which Vasari praises: the design of the Campanile of Santa Maria del Fiore (Florence); the fresco cycle in the Arena Chapel in Padua; the frescos in the Bardi and Peruzzi chapels in Santa Croce (Florence); and the Ognissanti Madonna (now in the Uffizi Museum). Some scholars deny Giotto the authorship of the frescos in the basilica of San Francesco at Assisi.

16 *One day Cimabue*: what follows is a fictitious account of the origin of Giotto's relationship to Cimabue, already found in Lorenzo Ghiberti's *Commentaries*, one of Vasari's favourite sources.

Messer Forese da Rabatta and Giotto himself: in one of Boccaccio's tales from *The Decameron* (Day 6, Story 5), Boccaccio provides the following judgement of Giotto's important contributions to the revival of Italian art: 'Now, since it was he who had revived that art of painting which had been buried for many centuries under the errors of various artists who painted more to delight the eyes of the ignorant than to please the intellect of wise men, he may rightly be considered one of the lights of Florentine glory' (Giovanni Boccaccio, *The Decameron*, trans. and ed. Mark Musa and Peter Bondanella (New York: New American Library, 1982), p. 392).

21 *as I have already described*: the *Life* of Pisano is not included in this edition.

the life of patient Job: Vasari had attributed this fresco cycle to Taddeo Gaddi in the first edition of his *Lives*, an attribution that most modern scholars accept. This reversal was probably motivated by his desire to increase Giotto's stature.

the present day: the *arriccio* was an initial coat of rough plaster to smooth a wall and make it suitable for painting. Upon this *arriccio*, the fresco painter usually made outlines with charcoal or with a special red ochre dissolved in water (a *sinopia*, so named because of the origin of the red ochre). Patches of fresh wet plaster, with the technique of true or *buon fresco*, were then added, and the paint pigment suspended in lime water was applied on the wet wall, resulting in a chemical bond that guaranteed the longevity of the painting. Such a patch of new plaster was called an *intonaco*, and each new patch was called a *giornata*, since no more space was covered than could be painted in a single day. Almost all compositions in *buon fresco* were touched up with tempera when they had dried. The other method of fresco painting, *fresco secco* or dry wall painting, was less permanent but faster: in this process, the painter applied tempera (a pigment suspended with an egg vehicle or with an adhesive made with lime) in much the same manner as was done in panel paintings. *Fresco secco* painting tended to flake off with the passage of time.

22 *what his paintings were like*: Vasari probably means Benedict XI (1303–4), but Giotto actually went to Rome during the reign of Boniface VIII (1294–1303). In his first edition of the *Lives*, Vasari mentions Benedict XII (1334–42).

24 *mine is far less*: Dante, *the Divine Comedy*, vol. ii: *Purgatory*, trans. and ed. Mark Musa (New York: Viking Penguin, 1985), p. 120 (*Purgatory*, xi. 79–84).

25 *several works*: upon the death of Benedict XI (not Benedict IX), Clement V moved the Holy See to Avignon in 1305, but it is doubtful that Giotto followed him there. He was, however, summoned there in 1334 by Pope Benedict XII but failed to obey.

26 *with the noblest paintings*: Giotto's presence in Naples during 1328–33 is documented, the frescos Vasari mentions were subsequently covered.

27 *rebuilt the church*: Gismondo or Sigismondo Pandolfo Malatesta (1417–68) was primarily responsible for the radical changes in the church of San Francesco in Rimini during the fifteenth century designed by Leon Battista Alberti (see Alberti's *Life* in this edition). This church is now better known as the Tempio Malatestiano.

30 *in the proper place*: Giotto recommended Agostino di Giovanni and Agnolo di Ventura to the bishop's brothers, and the tomb was completed in 1330. Vasari discusses these two sculptors from Siena in the biography immediately following his life of Giotto in the complete *Lives*.

31 *valued too little*: in *Paradise* (iv. 103–5), Dante makes the following remark which seems to be the origin of Vasari's citation:

> so Alcmeon, moved by his father's prayer,
> killed his own mother: so as not to fail
> in piety, he was pitilessly cruel.

(Cited from Dante, *The Divine Comedy*, vol. iii: *Paradise*, trans. and ed. Mark Musa (New York: Viking Penguin, 1986), p. 46.)

32 *much honour and profit*: Giotto's masterpiece, painted in the Arena Chapel for Enrico Scrovegni, was probably completed around 1305. However, in contrast to the works Vasari attributes to Giotto at Assisi (which are disputed by some modern art historians), he says almost nothing about this major fresco cycle. Possibly the chapel was closed to the public during Vasari's visits to Padua in 1566.

33 *bear witness to this....*: following the description of Giotto's burial, Vasari provides several pages of details concerning Giotto's pupils which have been omitted from this edition. They include Taddeo Gaddi, Ottaviano da Faenza, Pace da Faenza, Guglielmo da Forlì, Pietro Laureati, Simone Memmi, Stefano Fiorentino and Pietro Cavallini.

34 *Novella*: the novella Vasari cites from Sacchetti is novella 62 in the collection, which Vasari had read in manuscript form before his *Lives* were published.

The Life of Simone

37 *he used his drawing pen*: Francesco Petrarca, or Francis Petrarch as he is known in the English-speaking world (1304–74), was the author of the single most important collection of love poetry in any European language—the *Canzoniere* or 'Songbook'. It celebrated, in 366 poems of various types (primarily sonnets, but also odes, sestinas, and madrigals) his unrequited love for a beautiful but unattainable woman named Laura, who became his poetic muse and the occasion for most of his Italian poetry. The sonnets Vasari mentions are respectively number

77 and 78 in the *Canzoniere* (we cite from the forthcoming translation by Mark Musa).

38 *'I am nobody'*: *Letters on Familiar Matters* (v. 17); for the complete letter in English translation, see Francesco Petrarca, *Rerum familiarium libri I–VIII*, trans. and ed. Aldo S. Bernardo (Albany: State University of New York Press, 1975), pp. 272–5.

for all time: Vasari's estimation was probably accurate throughout the nineteenth century, when all educated people read Petrarch's love poetry.

Simone Memmi: in 1323, Simone di Martino (his actual name) married Giovanna di Memmo di Filippuccio, sister of Lippo Memmi, another Sienese painter. This explains the confusion with Simone's full name. In fact, the second and briefer part of this *Life* (omitted in this edition) contains a consideration of Lippo Memmi.

copied Giotto's style: Vasari erroneously links Simone Martini's style to the school of Giotto, while he and other Sienese painters of the period were more profoundly influenced by Duccio. However, Vasari places Duccio some time after Giotto, thereby confusing the chronological and stylistic relationships between these medieval masters.

the pope's court in Avignon: Simone went to Avignon before 1339 and remained there until his death.

the greatest praise and profit: Simone completed his remarkable *Maestà* in 1315 but retouched it in 1321. It is interesting that Vasari does not mention the fresco traditionally attributed to Simone and usually dated in 1328, *Guidoriccio da Fogliano*, located in the same Sala del Mappamondo of the Palazzo Pubblico of Siena on the opposite wall.

39 *kill the wolves*: the frescos of the Spanish chapel in Santa Maria Novella were actually painted around 1355 by Andrea di Bonaiuto (also known as Andrea da Firenze).

40 *made him immortal*: although Vasari correctly interprets the conceit of the black and white dogs ('the hounds of the lord', or the *domini canes*—a pun upon the name of the order which combated heresy), his attempts to see portraits drawn from life of both Laura and Petrarch in the frescos of the Spanish Chapel are products of his fantasy.

the architect Arnoldo: Arnoldo di Cambio (*c*.1245–1302), was the architect of the initial project of Florence's Santa Maria del

Fiore, as well as that city's Palazzo Vecchio and possibly the church of Santa Croce. In his collection Vasari's *Life* of Arnoldo (not included here) followed that of Cimabue.

40 *Buonamico his master*: a painter named Buonamico di Martino, called Buffalmacco, is recorded as a member of the same apothecaries' guild in 1320 that Giotto had joined. He apparently had quite a reputation as a wit and a practical joker and is immortalized not only in a number of *novelle* from Boccaccio's *Decameron* (Day 8, Stories 3, 6, 9; Day 9, Story 5), but also in various stories by Franco Sacchetti (*novelle* 161, 169, 191, 192). Little is known of him, and few works can confidently be attributed to him, but it is unlikely that he was ever Simone Martini's teacher.

42 *and other works...*: this edition omits a passage devoted to Lippo Memmi.

praised so highly: since Malatesta died in 1326 and Simone was in Avignon only by 1339, Malatesta could not have sent him there.

The Life of Duccio

43 *Sienese Painter*: Duccio di Buoninsegna was trained in Cimabue's workshop between 1275 and 1285; Vasari fails to recognize that he was a contemporary of both Cimabue and Giotto.

the imitation of the old style: Vasari appreciates Duccio's style far less than that of Giotto, since it appears old-fashioned to him. Moreover, he praises Duccio primarily for beginning the marble floors of the Sienese cathedral although they were not begun until around 1359 well after Duccio's death. Duccio did not provide the designs for the floors, although the oldest stained glass windows with Italian narratives, dating from 1288, were executed in the Duomo of Siena from his designs.

44 *Francesco Di Giorgio*: Francesco di Giorgio Martini (1439–1502).

which are on it: Duccio's masterpiece, the *Maestà*—the Madonna and Child surrounded by angels and saints with numerous scenes from the Passion on the reverse side of the panel—was commissioned in 1308 and completed by 1311. Today, what remains of the work (minus several fragments located in major museums around the world) is conserved in Siena's Museo dell'Opera del Duomo.

Preface to Part Two

47 *the true goal of history*: before Vasari's biographies of great artists, such descriptions of artists' lives were not normally considered to be as noble a task for the historian as were the deeds and lives of great historical or political figures. With his preface to the second part of his *Lives*, Vasari seeks to elevate the study of great artists to the highest possible level, comparing his task to that of the classical historians of ancient antiquity or the contemporary historians of the Italian Renaissance, such as Niccolò Machiavelli or Francesco Guicciardini.

48 *and among different peoples*: for Vasari, art history requires more than mere listing of titles, dates, and attributions; it requires aesthetic judgement and taste—what contemporary art historians occasionally denigrate as 'connoisseurship'.

from the rebirth: with the term 'rebirth' (*rinascita*), Vasari once again underlines a view which will eventually give birth to the modern notion of a renaissance of the arts, accompanied by the concept of period styles which evolve through different stages of development—an important aspect of all art history after Vasari.

50 *than the ear*: once again, Vasari asserts that the basis of art history lies in connoisseurship and first-hand observation of the works themselves, rather than in reliance upon written sources no matter how authoritative. If modern scholarship has uncovered a number of mistaken attributions, erroneous chronologies, and various slips of the pen in Vasari's biographies, his work nevertheless represents one of the most comprehensive attempts to understand and organize Western art's most brilliant period through direct observation of the works themselves.

51 *of the word*: here Vasari refers to the etymological meaning of the Italian word *statua*, which derives from the verb *stare* ('to stand'), underlining the static, motionless quality of early sculpture.

54 *even greater ones*: this battle took place in 212 BC.

55 *the Duomo in Urbino*: the architect was Luciano di Laurana, not Francesco di Giorgio.

58 *the order of styles*: Vasari groups the artists in his *Lives* according to their style rather than obeying a strict chronology.

The Life of Jacopo della Quercia

59 *the Sienese countryside*: Jacopo's father was Master Pietro d'Angelo di Guarnieri (not di Filippo), who was probably born in Quercia Grossa, a castle (now destroyed) a few miles outside Siena.

he died: Giovanni d'Azzo Ubaldini died in 1390, while Gian Tedesco followed him shortly after in 1395.

60 *Orlando Malavolti*: the Malavolti family was exiled from Siena in 1391.

the memory of the Guinigi: Guinigi's wife, Ilaria del Carretto, died in 1405, and Jacopo probably completed this work before Guinigi's subsequent third marriage in 1407. Lucca freed itself from Guinigi's rule in 1430.

61 *Arte della Calimala*: the Cloth Dyers and Finishers' Guild, one of the seven major guilds in Florence; membership in this or in another major guild was a prerequisite for public office in Florence.

as we said earlier: Vasari discussed Andrea Pisano in a biographical sketch not included in this edition. The temple of San Giovanni is the famous Baptistery of San Giovanni which stands directly in front of the Duomo of Florence.

turned out otherwise: the competition for the Florentine baptistery took place in 1401 and was won by Lorenzo Ghiberti (Donatello did not compete); it is described in Ghiberti's *Life* included in this edition.

62 *another saint*: the third figure is of Saint Ambrose and was completed in 1510 by Domenico Aimo da Varignana who imitated Jacopo's style. Jacopo worked at the church in Bologna until 1438.

up to that time: the lower part of the 'Porta della Mandorla' was actually constructed at the end of the fourteenth century by a number of artists, while the lunette over the door was done between 1404 and 1409 by another group (with Nanni di Banco completing most of the work). Some scholars claim Jacopo may have worked for Nanni on part of this project. A mandorla is an almond-shaped glory surrounding a figure.

63 *Her girdle*: in a popular version of the Assumption of the Virgin, the mother of Christ drops her girdle down to an

adoring worshipper as she ascends. This description becomes a popular theme in Italian Renaissance art.

Jacopo della Fonte: originally in the Piazza del Campo, this work, known as the Fonte Gaia, was moved to the loggia of the Palazzo Pubblico in 1904.

64 *worthy of praise*: in addition to Jacopo's work on the baptismal project, Ghiberti, Donatello, Turino di Sano, and Giovanni Turini also received commissions. Jacopo completed the scene of Zacharias in the Temple, while the Presentation to Herod of the Head of the Baptist was later given to Donatello.

which can be seen above: Vasari's edition of the artists' *Lives* contained a wood print bust portrait of each artist to introduce each biography. Many were fanciful portraits, although as Vasari approaches his own age in his narrative they are more than likely true-to-life reproductions of each artist's features.

65 *their native lands . . .*: the last two paragraphs of Jacopo's *Life* discuss his pupils and followers: Matteo di Giovanni Civitali (1436–1501) and Niccolò d'Antonio da Bari (d. 1494).

The Life of Luca della Robbia

66 *in the year 1388*: records from Florentine tax collections reveal Vasari's date to be incorrect.

Leonardo di Ser Giovanni: since Leonardo di Ser Giovanni was probably already dead in 1377, it would be impossible for Luca to have been apprenticed to him.

67 *his dead wife*: Sigismondo Malatesta (b. 1417) began the renovation of the church of San Francesco, better known as the Tempio Malatestiano, in 1447. Since there are no tombs of his two wives in the church, Vasari may be referring to that of his mistress Isotta degli Atti, constructed by Agostino di Duccio (b. 1418).

by Andrea Pisano: these scenes were commissioned in 1437 and paid for upon their completion in 1439.

for music: this figure represents Orpheus.

of this same church: payments for Luca's famous choir-stall or *cantoria*, now located in the Museo dell'Opera del Duomo, were made between 1431 and 1438, the date by which the work was installed.

68 *learned Bembo*: Pietro Bembo, a Venetian humanist and cardinal, the most important Petrarchan poet of the sixteenth century (1470–1547).

69 *on the outside*: this crucial passage on artistic inspiration—employing such terms in the Italian original as *furore* (frenzy, inspiration) and *concetto* (conception, the philosophical idea behind a plastic work of art)—owes an obvious debt to Vasari's mentor, Michelangelo, whose lyric poetry and correspondence employ these terms in much the same manner. For a discussion of the terms, see David Summer's *Michelangelo and the Language of Art* (Princeton, NJ: Princeton University Press, 1981).

of the same sacristy: the commission was given in 1446 to Michelozzo di Bartolomeo (1396–1472), Maso di Bartolomeo (1406–57), and Luca, but after Maso's death Luca was issued a new contract to complete all of the work himself, and final payment was made to him in 1468–9.

in his debt: it should be remembered that in classical antiquity and before Luca, complicated works of sculpture were rarely done in terracotta.

71 *the Cardinal of Portugal is buried*: the chapel was commissioned in 1460 and dedicated in 1466.

72 *from the fire*: commissioned in 1454 and completed by 1458, this work was moved to Santa Trìnita in 1896.

before his time.…: this edition omits a discussion of Luca's family and disciples, many of whom were artisans who, like Luca, worked in terracotta.

The Life of Paolo Uccello

74 *Florentine Painter*: Paolo di Dono, called 'Uccello'.

75 *mazzocchi*: wooden hoops or circles which were covered with cloth and part of the headgear worn by higher magistrates in Quattrocento Florence.

in intarsio: inlaid woodwork.

76 *Saint Dominic*: these works have been lost.

Masaccio: this work was done by Masolino, not Masaccio.

terra verde: a natural green earth employed in monochromatic frescos. The term is used throughout this *Life*.

77 *younger than Paolo*: being younger, these two monks were able to run fast enough to catch up with the fleeing Paolo.

78 *drawn from life*: this may be a reference to the famous depiction of the Battle of San Romano, today found divided between the National Gallery of London, the Louvre, and the Uffizi Museum.

 Santa Maria Novella: Paolo's versions of the Flood, the Sacrifice of Noah, and Noah's Drunkenness were perhaps his most influential masterpieces. Heavily damaged in the flood of 1966, they have since been restored and now hang in the same cloister. They have been dated between 1450 and 1460.

80 *Giovanni Acuto*: Sir John Hawkwood, an English *condottiere* who fought for Florence and died in 1394; Paolo's fresco was completed in 1436. He was actually forced to paint the work twice, and later (1456), when Andrea del Castagno completed a similar work devoted to Niccolò da Tolentino, Paolo was required to retouch his own fresco.

81 *Giuliano Bugiardini*: Florentine painter (1475–1554), described by Vasari in one of the *Lives* not included in this edition. These panels are probably not to be identified with the famous *Battle of San Romano*.

 in highest esteem: Paolo was in Verona around 1425–30 and again in 1445, a year after Donatello arrived there to work.

82 *ungainly beast*: in Italian, Vasari employs the words *camaleonte* and *camello*, but even in English the sound of the words 'chameleon' and 'camel' underlines Paolo's lack of erudition.

 the problems of Euclid: this work, now in the Louvre, was attributed by Vasari in his first edition of the *Lives* to Masaccio; at that time he also said the last portrait was of Antonio Manetti, not Giovanni Manetti.

83 *Santa Maria Novella*: Paolo actually died in 1475 and was buried in Santo Spirito.

The Life of Lorenzo Ghiberti

85 *son of Bartoluccio Ghiberti*: Ghiberti was the son of Cione di Ser Buonaccorso Ghiberti and Mona Fiore, who later married Bartoluccio, Lorenzo's stepfather. Ghiberti was also alleged to be the illegitimate child of Bartoluccio and Mona Fiore before her first husband's death.

 a Florentine gentleman: late in his life (after 1447), Ghiberti wrote his *Commentaries*, a work in three books which contains an autobiographical section upon which Vasari drew heavily for his life of Ghiberti.

85 *in Rimini*: Lorenzo worked not in Rimini but in Pesaro, and not for Pandolfo Malatesta but for his son.

86 *the first door*: this famous contest was held in 1401.

called Simone de' Bronzi: although Vasari lists Donatello as one of the competitors, given his very young age at the time (15), it is doubtful that he entered the competition. In Ghiberti's own *Commentaries*, the seventh artist is listed as Niccolò Lamberti and not Donatello.

87 *an admirable sense of design*: the competition panels by Brunelleschi and Ghiberti are still conserved today in the Museo Nazionale del Bargello in Florence.

88 *on those doors*: at the end of 1402 or the beginning of 1403, Ghiberti was assigned the commission on this pair of doors to the Baptistery of San Giovanni. The original contract was given to both Ghiberti and his father, but in 1407 the contract was revised, making Ghiberti the principal artist. The doors were finally installed in 1424.

92 *his own name*: the work was cast in late 1414, placed in the niche in 1416, and finally finished in 1417.

of that church: Lorenzo di Pietro, known as Il Vecchietta (1412–80), did not work on the Sienese baptismal font.

93 *he had already completed....*: this edition omits a section devoted to several minor works Vasari attributes to Ghiberti: a bronze tomb in Santa Maria Novella for Leonardo Dati; a memorial in Santa Croce for Lodovico degli Obizzi and Bartolommeo Valori; a bronze reliquary for the Medici family; a tomb for the body of Saint Zanobius in Santa Maria del Fiore; and various works for several popes, including a golden mitre for Pope Eugenius IV (1431–47), which cost a total of 30,000 gold ducats.

at his disposal: the doors were commissioned in 1425 and the work began no earlier than the end of 1428; the scenes were cast in 1436 or 1437, but the entire project was not completed until 1452.

94 *thirty-four in number*: the recumbent figures are four and the decorative heads twenty-four in number (including a self-portrait of Ghiberti himself).

96 *to Pharaoh*: Joseph is actually sold to the captain of Pharaoh's guard.

98 *with the most painstaking efforts*: Ghiberti worked upon the second set of doors for twenty-seven years (from 1425 to 1452), but if the time employed for the two sets of doors is calculated (1403 to 1452), the total is forty-nine years in all.

of their city....: this edition omits several paragraphs devoted to Ghiberti's progeny; although his family died out in the sixteenth century, Vasari notes that his fame 'will live for eternity'.

99 *sixty-fourth year*: Ghiberti died at the age of seventy-seven.

Mira Arte Fabricatum: 'created by the marvellous skill of Lorenzo di Cione of the Ghiberti family.'

The Life of Masaccio

102 *everyone called him Masaccio*: Masaccio is both a diminutive (Tommaso = Maso) and a pejorative ending (-accio endings in Italian render a pejorative sense): Masaccio might be translated as 'sloppy Thomas', 'Thomas the mess', or 'bad Thomas'.

103 *Masolino da Panicale*: Tommaso di Cristofano di Fino, called Masolino (1383–1440), an artist whose life and fame are closely connected to that of Masaccio. Between 1424 and 1427 (with an interruption in Rome in 1425), Masolino worked with Masaccio on the frescos of the Brancacci Chapel.

104 *to have holes in it*: subsequent restoration of this famous work revealed the figure of a skeleton lying upon a sarcophagus with an inscription directed to the viewer.

killing his father and mother: Saint Julian the Hospitaller murdered his parents by mistake and spent the rest of his life in atonement for his crime.

105 *his student*: Fra Filippo Lippi (the work in question has been lost).

Saint Catherine the Martyr: this work was done by Masolino, who enjoyed Masaccio's assistance on the project: first begun in 1425, Masolino later completed the scenes from Saint Catherine's life between 1428 and 1430.

the troubles in Rome: probably during the Sack of Rome in 1527.

at his side: Martin V (1417–31) and Sigismund I (1410–37). 'Our Lady of the Snows' was a title given to the Virgin which

grew out of the legend that Santa Maria Maggiore was con-
structed upon the spot where snow fell in Rome one August.

105 *returned to Florence*: since Cosimo was not recalled until 1434,
six years after Masaccio's death, Vasari's chronology in this
biography errs here and in a number of other places.

107 *with Saint John*: Vasari's description of this famous fresco is
somewhat confusing in the original Italian, and he seems not to
have understood all of the details of this fresco in the same way
modern critics have explained it.

Filippino: Filippino Lippi, son of Fra Filippo Lippi.

108 *Toto del Nunziata*: Vasari's complete *Lives* contains biographies
of all these artists, with exception of Alonso Spagnuolo and
Toto del Nunziata.

the lesser ones: Vasari's high opinion of Masaccio should not
lead the reader to believe, however, that Masaccio's reputation
was great during his own lifetime. In fact, his commissions
were relatively less important than other contemporaries, and
his fame was largely posthumous.

109 *in the year 1443*: Masaccio actually died in Rome, probably in
the autumn of 1428.

The Life of Filippo Brunelleschi

110 *Forese da Rabatta and Giotto*: a reference to Boccaccio, *Decam-
eron* (Day 6, Story 5), a story comparing Giotto's ugly physical
appearance to his skill as an artist, which Vasari mentioned in
his biography of Giotto.

111 *was not completely dead*: the view that ancient virtue was
dormant within the Renaissance genius and had only to be
reawakened was a common belief in Italy. It is expressed in the
last line of Petrarch's sonnet 127 ('for ancient valor/In Italian
hearts is not yet dead'), and that line is cited at the very
conclusion of Machiavelli's *Prince* (XXVI), a work which even
more forcefully than Vasari's argues for imitation of the
ancients not only in the plastic arts but in social and political life
as well.

in those days: Vasari's source for this information, as for most of
the biography of Brunelleschi, is the *Vita del Brunellesco* by
Antonio di Tuccio Manetti (1423–97).

until the year 1377: 1377 is the correct year, the one listed by Vasari in the first edition of the *Lives*; the second edition (perhaps because of a printing error) gives Brunelleschi's birth-date as 1398.

112 *at niello*: the art of engraving upon silver.

the officials of the Monte: the Monte was a form of institution which raised funds and managed the public debt.

113 *a very crude state in Tuscany*: nothing remains of this work in the Palazzo Vecchio. It is interesting to note, however, that Vasari's source (Manetti) specifically states Brunelleschi did not employ here the style derived from ancient models which would later characterize his architecture.

a sketch of Piazza San Giovanni: this work has been lost.

the cialdone makers: the *cialdone* is a crisp wafer-cake.

114 *Messer Paolo dal Pozzo Toscanelli*: the great scientist and mathematician (1397–1482) who returned from Padua to Florence around 1424.

115 *Donatello executed them perfectly*: of the two statues of Saint Peter and Saint Mark, only that of Saint Mark is today attributed to Donatello.

116 *the Money-Changers' Guild*: the competition panels of Ghiberti and Brunelleschi now hang in the Museo Nazionale del Bargello in Florence; Donatello never actually competed in this contest in spite of Vasari's claim.

to go to Rome: the trip took place between 1402 and 1406.

117 *in his times*: the 'barbarous German' style would be the Gothic style.

after the death of Arnolfo Lapi: Arnolfo di Cambio (c.1245–1302).

they were practising geomancy: the art of divination by figures or lines formed by a handful of earth cast upon the ground.

118 *during the same year*: Brunelleschi actually prepared a model for the dome in 1417; in the following year the city announced a competition for the project (Brunelleschi was paid for it in 1419). In 1420, Brunelleschi, along with Ghiberti and Battista d'Antonio, were commissioned to construct the dome. By 1436, Brunelleschi's model for the lantern of the dome was selected over the models by Ghiberti and others. Thus, the

project was an on-going enterprise and in reality work has never ceased since the fifteenth century.

119 *the Fat Man and Matteo*: this practical joke, based upon causing the victim to doubt his own identity, is the subject of one of the longest and most popular *novelle* of the period, *La novella del grasso legnaiuolo* ('Fatso the carpenter'), probably written by Antonio di Tuccio Manetti, also the author of the life of Brunelleschi which is Vasari's main source in this biography. For an English translation of the novella, see *Italian Renaissance Tales*, ed. and trans. Janet Levarie Smarr (Rochester, MI: Solaris Press, 1983), pp. 105–33.

121 *the twenty-sixth day of May in 1417*: a document dates this disbursement as 19 May 1417.

126 *for Bartolomeo Barbadori*: the Barbadori Chapel, built in 1420, was one of Brunelleschi's first projects.

128 *a carpenter named Bartolomeo*: probably Bartolommeo di Francesco (Bartolomeo di Marco did the model created by Lorenzo Ghiberti mentioned a few lines later).

129 *to the building project*: the discrepancy between the two payments was actually due to the fact that Ghiberti was paid for his time and expenses during the construction of the entire model, while Brunelleschi received only time and expenses for the additions to his previously existing model.

133 *head for life of the entire structure*: this occurred on 12 April 1443.

one hundred florins a year: while the first gift of one hundred florins dates from 27 August 1423, the allowance for life was made in December of 1445, shortly before his death.

Master Antonio da Verzelli: a carpenter employed at the Works Department of the Duomo; documents show he was paid one florin for a weight-lifting device in 1423.

136 *by the San Giovanni district*: he was actually elected for the term of May through June 1425.

138 *four armslengths*: the original copper ball was made by Andrea del Verrocchio in 1468 but fell in 1601 when struck by lightning; it was replaced in 1602 and was again destroyed in the same fashion and again replaced in 1776.

in all: the Florentine measurement for length, the *braccio* (plural, *braccia*), corresponds to an armslength, but as Quattrocento Florentines were somewhat smaller than contemporary

Italians, it was probably around two feet and certainly less than the English yard or the European metre. Employing 'arms-length' here and elsewhere in this edition will alert the reader to the fact that the unit of measurement was not only rather subjective but also differed between various Italian cities.

for the Pazzi family: begun in 1429, the interior and the portico of the famous Pazzi Chapel were completed by 1443.

great variety and beauty....: this edition omits several pages which list a number of minor projects Vasari attributes (sometimes incorrectly) to the architect: the Palazzo Bardi-Gerzelli (formerly Busini) in Via dei Benci; the Ospedale degli Innocenti, completed in 1444; the Badia of Fiesole; the Fortress of Vicopisano; the Citadella of Pisa; and plans for Milan's Duomo.

139 *who constructed them*: Giovanni Bicci de' Medici, the founder of the long-lived Medici dynasty and its banking fortunes, died in 1428. The San Lorenzo project began in 1418, along with the project for the Old Sacristy, which was completed by 1428, in time to house Giovanni's tomb.

141 *the other palace*: the Medici-Riccardi Palace, constructed by Michelozzo (1396–1472).

than Filippo....: in a section omitted from this edition, Vasari discusses several other projects, including a villa at Rusciano and the Palazzo Pitti, which may have been influenced by a wooden model built by Brunelleschi.

144 *to do so*.....: the present edition omits a brief passage which treats several minor projects: dams on the River Po for the Marquis of Mantua, and a number of palaces in Florence.

in those days: while Brunelleschi received the commission to build a new church for Santo Spirito in 1436, his original plans were actually changed during the construction of the building, and by the time of his death, only several columns had been set up. The fire Vasari mentions took place in 1470, damaging the old structure but giving impetus to the completion of the new project.

146 *to their original forms*....: this edition omits a brief discussion of artists Vasari cites as the disciples of Brunelleschi, as well as two Latin epitaphs and one in Italian.

146 *the church he began*: the church of the Twelve Apostles, begun in 1434 but never completed.

Niccolò da Uzzano: Vasari's book contains no biography of Niccolò da Uzzano (d. 1432), who headed the aristocratic faction opposing the Medici family; he is discussed, however, in the life of the artist Lorenzo di Bicci (d. 1427), which is not included in this edition.

The Life of Donatello

147 *in the year 1303*: the date is a printing error, since Vasari probably meant 1383. Donatello himself used three different birthdates in tax documents.

in the grotesque style: the work is still located in Santa Croce: the relief is in stone, with six cherubs or putti in terracotta. It may be dated between 1430 and 1440.

149 *for me to make peasants*: another version of this anecdote is to be found in Vasari's *Life* of Brunelleschi included in this edition.

of this same Coscia: Baldassare Cossa, elected pope in 1410 as Pope John XXIII, died in 1419 after making an act of submission to Pope Martin V. The tomb was begun in 1425 and probably finished by 1428. Documents from the period show that Donatello probably did the figure on the tomb and perhaps designed the figures of the three Virtues.

Saint Mary Magdalene in Penitence: executed around 1455, this work was removed from the baptistery in 1688 and returned there in 1735.

150 *received high praise*: commissioned in 1408, Donatello received payment for this statue in 1415.

by time and toil: probably Joshua, now inside the Duomo, which is also attributed to both Bernardo di Piero Ciuffagni and Nanni di Bartolo. Via del Cocomero, where Giotto's workshop once stood, is called Via Ricasoli today.

to be living and moving: the famous *cantoria* or choir-stall now in the Museo dell'Opera del Duomo which was almost finished by 1438 (see Vasari's *Life* of Luca della Robbia for his famous comparison of the very different styles employed in this set of choir-stalls).

that go around the frieze: actually by Benedetto da Maiano.

as can clearly be seen: in 1434, Donatello's design was selected over that by Ghiberti; it was executed by Domenico di Pietro da Pisa and mounted in 1438.

151 *with Filippo's consent*: commissioned in 1411.

known today as 'Il Zuccone': the two statues identified with the faces of Donatello's contemporaries are Jeremiah (Soderini), executed between 1423 and 1426; and Habakkuk (Cherichini), completed between 1427 and 1436.

152 *in the act of sacrificing Isaac*: done with Nanni di Bartolo in 1421.

the head of Holofernes: this is a later work, executed after Donatello's return from Padua around 1455–63.

the palace of these signori: the Palazzo della Signoria or dei Signori is usually known today as the Palazzo Vecchio to distinguish it from the 'new' palace—the Palazzo Pitti.

not moulded around a living body: now found in the Museo Nazionale del Bargello, this masterpiece has an uncertain date: some scholars place it around 1430, while others date it from 1442 or 1455.

is in his hand: now in the Museo Nazionale del Bargello; originally commissioned for Santa Maria del Fiore in 1408, this work was completed in 1409 and transferred to the Palazzo Vecchio in 1416.

154 *three armslengths high*: an incomplete statue now in the National Gallery of Art in Washington: some scholars attribute it to Donatello between 1432 and 1434, while one attribution gives the work to Antonio Rossellino.

protected and encouraged it: now located in the Museo Nazionale del Bargello, this statue (dated around 1445) is also attributed by some scholars to Desiderio da Settignano and dated after 1453.

deserves endless praise: tax documents reveal that this work, still located in the church, was done for Rainaldo Brancacci (who died in 1427) by both Donatello (who executed the bas-relief and other details) and Michelozzo; several other artists helped in setting up the tomb in Naples between 1428 and 1433.

an ancient work: now believed to be a Hellenistic work and located in the Museo Nazionale of Naples (Goethe was

therefore correct when he identified it as such during his travels through Italy).

154 *sacked the town*: commissioned to Michelozzo and Donatello in 1428, the entire work was completed by 1438. The Sack of Prato took place in 1512.

155 *Church of Sant'Antonio*: Erasmo da Narni, called Gattamelata ('Tabbycat'), was a Venetian *condottiere* who died in Padua in 1443. Donatello's famous equestrian statue to his memory was probably completed by 1450.

diminished perspectives: the altar, consecrated in 1450, has been remodelled several times, and its final composition (completed in 1895), while still employing Donatello's scenes, changed the original design.

his great mind: now in the Palazzo della Regione, this structure was probably created around 1466 for a festival and represented the Trojan Horse; it is not by Donatello.

156 *greatest care and diligence*: still in the church of Santa Maria dei Frari and dated before his return to Tuscany in 1453.

with Andrea Verrocchio: actually by Verrocchio.

in Saint Peter's: now in the Sacrestia dei Beneficiati in Saint Peter's, this tabernacle is actually dated around 1432–3, that is, from an earlier trip to Rome.

157 *the full payment*: actually, Donatello left behind more than this statue (still in the Duomo of Siena)—most particularly his masterful bronze panel of the Feast of Herod in the Baptistery.

to perfection: Bertoldo di Giovanni (1420–91). The pulpits were completed between 1460 (Donatello's return from Siena) and 1466 (his death) and were installed between 1558 and 1565 behind the church's pillars (apparently Donatello's intention). Their location today, isolated and resting upon four columns, is due to a change made in the early seventeenth century.

as decoration: since destroyed.

to become a monk: originally designed to fill a tabernacle owned by the Merchants' Guild for Orsanmichele, the statue of Saint Louis of Toulouse (1274–97), now in the Museo dell'Opera di Santa Croce, was completed by 1423, then moved and placed on the door of Santa Croce before 1460.

the proper place: the works of Fra Bartolomeo (1472–1517) are discussed in a *Life* not included in this edition.

159 *Donatello's brother Simone*: it seems Donatello had no brothers
and only one sister; this figure has been identified by at least one
scholar as Simone di Giovanni Ghini, a Florentine goldsmith
(1407–91).

from Pope Eugenius IV: his coronation took place on 31 May
1433.

160 *on 13 December 1466*: in the first edition of his *Lives*, Vasari
recounted a death-bed visit to Donatello by his friend
Brunelleschi (an impossible occurrence, since Brunelleschi's
death preceded Donatello's); his second edition suppressed this
anecdote and added the material that follows, including a
number of epitaphs in both Latin and Italian, not included in
this edition.

161 *Vellano da Padua*: Bertoldi di Giovanni (1420–91); Nanni di
Banco (*c*.1390–1421); Bernardo Gambarelli, called 'Il Rossellino'
(1409–64), and his younger brother Antonio Rossellino (1427–
78); Desiderio da Settignano (*c*.1434–64); and Bartolomeo
Bellano (*c*.1434–*c*.1497).

in Paolo's life....: here Vasari cites three epitaphs, two in Latin
and one in Italian and not included in this edition, testifying to
the high esteem in which Donatello was held in Florence.

162 *in this church....*: the final paragraph of Vasari's life of
Donatello reports a comparison of Donatello and Michelangelo
written in Greek and Latin and printed in a book owned by
Vasari's friend, Don Vincenzio Borghini. It summarizes Vasari's
judgement of Donatello and states that either Donatello's spirit
inspired Michelangelo or the spirit later manifest in Michelan-
gelo's work was anticipated in Donatello.

The Life of Piero della Francesca

163 *his native town*: three autograph works by Piero have been
preserved: *De perspectiva pingendi*; *Libellus de quinque corporibus
regularibus*; and *Del abaco*.

in painting: Luca Pacioli del Borgo San Sepolcro (born before
1450), who translated and popularized Piero's Latin *Libellus*;
whether he plagiarized Piero's works is open to question.

164 *Guidobaldo da Montefeltro*: since Guidobaldo da Montefeltro
(1472–1508), the son of the famous Duke Federigo (1422–82),
was born too late to have been Piero's first patron, Vasari prob-
ably means to allude to Guidantonio da Montefeltro, Lord of

Urbino between 1404 and 1443. He was succeeded by Oddan-tonio da Montefeltro (killed in 1444), who was in turn followed by the celebrated Federigo.

164 *in the modern style*: Duke Borso d'Este (1413–71); Duke Ercole d'Este (1431–1505).

had executed there: Bartolomeo Suardi, called 'Il Bramantino' (c.1465–1530). After Vasari mentions Bramantino, he devotes a long paragraph to this painter but does not later devote a chapter of his book to him. This section has been omitted from this translation.

165 *was widely praised*: commissioned in 1454 by Angiolo Giovanni di Simone Angeli and paid for in 1469. The work was dispersed in 1555: while the central panel is still missing (it probably contained a Madonna), parts of the altarpiece, most representing various saints, are scattered all over the world in Lisbon (Saint Augustine), New York (Saints Andrew and Monica, plus a Crucifixion), London (Saint Michael), Milan (Saint Nicholas of Tolentino), and Washington (Saint Apollonia).

in fresco: even though Vasari refers to this panel as a fresco, it is surely the famous panel painting now in the Pinacoteca Comunale in Borgo San Sepolcro commissioned in 1445. The image of the Madonna della Misericordia ('Our Lady of Mercy')—the Virgin with her cloak spread around her followers—was a popular form often associated with protection from plagues.

his other works: commissioned around 1463, this work remains in the same palace today, which has become the Pinacoteca Comunale of Borgo San Sepolcro.

with Domenico Veneziano: c.1440–61, whose *Life* is included in this edition; these frescos have been lost.

in the proper place: actually Luca Signorelli (c.1450–1523), whom Vasari subsequently treats in a separate *Life*, included in this edition.

Lorenzo di Bicci: active between 1370 and 1427.

into Jerusalem: the Legend of the True or Holy Cross is a medieval legend with little or no basis in Holy Scripture, extremely popular in Tuscany and especially in Franciscan churches dedicated to the Holy Cross (such as Florence's Santa Croce or Arezzo's San Francesco). Much of its narrative was found in the popular *Golden Legend* (c.1275) by Jacopo da Voragine (c.1230–c.1298), a compilation of saints' lives, legends, and tales related

to feast days. The story may be summarized as follows. (1) Expelled from Paradise, Adam takes with him a branch from the Tree of Knowledge, and this eventually becomes the pole on which Moses raises the brazen serpent; (2) the wood finds its way to Jerusalem, where it serves as a bridge over a stream until the Queen of Sheba recognizes it and worships it; (3) the wood is later found in the pool of Bethesda and is taken from there to make the Cross of Christ; (4) Saint Helena, the mother of Emperor Constantine the Great, rediscovers the cross in the Holy Land after forcing a Jew to reveal its location in a well, and the True Cross is distinguished from the other two crosses of Golgotha because, when a corpse is placed upon each one, it alone brings the dead man back to life; (5) after his victory over the Emperor Chosroes of Persia, Emperor Heraclius recovers the cross and raises or 'exalts' it on the hill of Golgotha, executing the Persian emperor for refusing baptism.

167 *in various ways....*: here, Vasari interrupts his life of Piero to list a number of Piero's followers, including Pietro Lorentino d'Andrea of Arezzo (active from 1465 until his death in 1506); Pietro di Cristoforo Vannucci, called 'Il Perugino' (*c.*1450– 1523); and Luca Signorelli.

 in the main church: the Badia of Borgo San Sepolcro.

The Life of Fra Angelico

169 *known in the world as Guido*: Guido di Pietro, born in Vicchio di Mugello but known to posterity as Fra Angelico.

 most experienced in painting: Fra Angelico's brother Benedetto (d. 1448) was a calligrapher, not an illuminator.

171 *with greater delicacy than these*: painted between 1439 and 1440, the main panel is located today in the Museo di San Marco, while a number of the sections of the predella are scattered around the world in various museums (Munich, Dublin, Washington, Paris).

172 *located in the same church*: now in the Louvre in Paris and dated around 1435.

 executed with great care: commissioned around 1448, they were paid for by 1462. The six panels (each containing six stories, except for the central panel's five scenes) were done not only by Fra Angelico but also by Alesso Baldovinetti (1425–99) and his shop.

172 *a panel of the Deposition*: now in the Museo di San Marco of Florence and dated around 1435 or earlier.

173 *in the guild office*: commissioned in 1433, this work is now in the Museo di San Marco.

by Luca da Cortona: the decoration for this chapel was commissioned to Fra Angelico in 1447 and was begun with the assistance of a number of painters, including Benozzo Gozzoli (*c*.1420–97); Luca Signorelli completed the frescos between 1500 and 1504.

eternal punishments of hell: this *Last Judgement* is now in the Museo di San Marco.

extremely beautiful books: he was probably summoned to Rome by Pope Eugene IV, who died in 1447; the chapel, the Cappella Niccolina, was probably completed by 1450.

174 *if Giovio*: Paolo Giovio (1483–1552), historian and humanist, at whose suggestion in 1543 Vasari began his collection of lives of the great Italian artists.

177 *also his students. . . .*: Zanobi Strozzi (1412–68); Domenico di Michelino (1417–91); Gentile (*c*.1370–1427) was not one of Fra Angelico's followers; this edition omits a paragraph providing a simple list of works by the artist's pupils.

from life. . . .: this edition omits a Latin epitaph for Fra Angelico, as well as a long treatment of an illuminator from Fra Angelico's times named Attavante Attavanti (1452–*c*.1517).

The Life of Leon Battista Alberti

178 *in practice*: the word *pratica* ('practice'), employed in the first edition of the *Lives*, was changed to *patria* ('native country') in the second edition, probably by mistake. Since the sense of Vasari's argument clearly calls for a reference to practical experience, this edition retains the wording of the first edition.

179 *in Florence*: actually in Genoa, where his family was in exile for political reasons.

discussed elsewhere: in the *Life* of the artist Parri Spinelli (*c*.1387–1453), not included in this edition.

provost of San Giovanni in Florence: *De re aedificatoria*, written around 1450, was published posthumously in 1485 and subsequently translated by Pietro Lamo in Venice in 1546; Cosimo

Bartoli (1503–81) published an Italian edition with his own illustrations in Florence in 1550.

by Messer Ludovico Domenichi: *De pictura* was first written in Latin in 1435 and later in Italian in 1436, but the original Italian version was not discovered or published until 1887. Domenichi translated an Italian version of the Latin edition and published it in 1545 and 1565.

in both prose and verse: the book on the 'civic life' is probably the Italian *Book of the Family* (1433–9).

scorn us: from the letter entitled *Di amicizia* containing verse written for a poetry contest held at Santa Maria del Fiore in 1441.

Antonio, his brother: Bernardo Gambarelli, called 'Il Rossellino' (1409–64), perhaps best known for his work in Pienza for Pope Pius II; Antonio Rossellino (1427–78).

180 *the Roman people*: work on the aqueduct took place in 1453, 1466, and 1472; work on the Trevi took place around 1453, and Alberti refers to it in his *De re aedificatoria* (x. 6); the Trevi fountain was altered by Niccolò Salvi between 1732 and 1751, taking on its present shape.

of that city: the first part of the remodelling of San Francesco, now better known as the Tempio Malatestiano, was begun in 1446, but by the time of Sigismondo's death (1468) the project had not yet been completed. Alberti did not supervise the construction personally.

181 *ordinary effort*: the marble façade for Santa Maria Novella was begun in 1456 to cover the older Trecento façade; on the façade itself, the date is given as MCCCCLXX or 1470.

182 *plans and his model*: Ludovico Gonzaga, Marquis of Mantua and a soldier serving the Florentine Republic at this time, began the project in 1444 but completed it in 1455, using a design by Michelozzo in its final form, since Alberti's plans had aroused a great deal of opposition.

183 *in Leon Battista's style*: Alberti was in Mantua in 1459 with Pope Pius II, and later in 1463, 1470, and 1471. He designed the church of Sant'Andrea, which was begun in 1472 by Luca Fancelli (1430–95); Fancelli also built another of Alberti's projects there, the church of San Sebastiano, which was designed in 1460. Fancelli (mistakenly called Salvestro Fancelli by Vasari) was originally sent to Mantua by Cosimo de' Medici when the

duke of Mantua needed an architect; he also served as head master of the Works Department of Santa Maria del Fiore from 1491 until his death, and his daughter married the painter Perugino.

The Life of Antonello da Messina

185 *they had imagined*: Alesso Baldovinetti (*c.*1425–99) and Giuliano di Arrigo di Giuocolo Giuochi, called Pesello (1367–1446), are treated in Vasari's *Lives* in chapters not included in this edition.

186 *Giovanni da Bruggia*: Jan van Eyck (*c.*1390–1441), the founder of the Flemish school of painting, whose works date from after 1432.

187 *the subject of oil painting*: Ruggieri da Bruggia is Rogier van der Weyden (*c.*1400–64), who visited Italy in 1450 and took on as a pupil a Lombard named Zanetto Bugatto (around 1460); Ausse is Hans Memling (1425/40–94), who did most of his work in Bruges.

188 *went off to Flanders*: some modern critics consider this visit to Flanders an invention on Vasari's part and underline, instead, the influence upon Antonello of his master, Colantonio of Naples.

exactly to his liking: Antonello was certainly in Venice in 1475 until the first months of 1476. Florentines of Vasari's day often viewed Venice as a city of lax morals.

without sparing any of his time: in 1476, Galeazzo Maria Sforza, Duke of Milan, wrote to his ambassador in Venice to bring Antonello to Milan to take the place of Zanetto Bugatto. The work was dismembered at the beginning of the seventeenth century, and fragments remain in the Kunsthistorisches Museum in Vienna (the Madonna Enthroned as well as Saints Dominic and Ursula).

189 *a very good painter*: Domenico Veneziano, whose *Life* is included in this edition; the following account of this friendship is inspired by Vasari's fantasy.

to Francesco di Monsignore of Verona: Francesco Bonsignori (1453–1519).

putting his hand to the work: actually, Antonello had already returned to Messina, where he died. This edition omits a brief

EXPLANATORY NOTES

Latin epitaph and the reaction of Antonello's friend, the
sculptor Antonio Rizzo—whom Vasari confuses with Andrea
Riccio—to his death.

The Life of Fra Filippo Lippi

191 *at the Carmine Church*: Fra Filippo apparently took his vows in 1421.

192 *the rule of the Carmelites*: the pope probably represented Eugenius IV who modified the rules of the order in 1432; Masaccio's fresco was whitewashed over, with fragments being discovered in 1860.

at the age of seventeen: Fra Filippo may have left the Florentine monastery by 1432, but he never renounced his vows or the wearing of his habit.

the guard is now posted: painted not in Naples but in Florence in 1457 and later sent to the king; the central panel has since been lost.

193 *his very close friend*: representing the Coronation of the Virgin, this work is now in the Uffizi Museum in Florence (dated 1441–7).

chapter house of Santa Croce: c.1442–5, now in the Uffizi.

in the Medici palace: now in Berlin, this *Nativity* may be dated around 1459, the date Benozzo Gozzoli did the fresco cycle decorating the chapel.

act of piety: the work was actually commissioned by Lucrezia Tornabuoni, wife of Piero de' Medici, in 1463 and is now in the Uffizi.

Eugenius IV of Venice: pope from 1431 to 1447.

194 *our own masters today*: commissioned in 1437; the main section of the panel is in the Louvre, while the predella is in the Uffizi Museum.

another Annunciation: completed around 1440 and still in San Lorenzo.

by Fra Filippo: now in the Vatican Museum and datable around 1445.

of the Nativity: done around 1455 and now in the Uffizi.

194 *still be seen*: Fra Filippo was in Padua around 1434, but his
 frescos there have been lost.

195 *Fra Diamante of the Carmine*: Fra Diamante di Feo da Terranova
 Bracciolini (1430–*c*.1498), another Carmelite monk who
 worked with Filippo in Prato and later in Spoleto.

 famous painter: Lucrezia Buti (b. 1435) entered the convent in
 1454 as a nun (not a ward) along with her sister Spinetta; she
 left with Filippo, accompanied by Spinetta and three other
 nuns, returning towards the end of 1458 , but again leaving
 in 1461, once again with her sister. Her father Francesco died
 in 1450 and consequently could not even have known of this
 scandalous affair. Their son was Filippino Lippi (*c*.1457–1504),
 whose life is treated in Vasari's complete *Lives*.

196 *that pious institution*: Francesco di Marco Datini (d. 1410), im-
 mortalized by Iris Origo as 'the merchant of Prato', was the
 town's foremost citizen and businessman. The Ceppo, a charit-
 able trust taking its name from the log into which contribu-
 tions were placed, is still in existence today, and the painting
 —containing the Madonna and Child, Saints Stephen and John
 the Baptist, with the donor Francesco Datini and other men at
 their feet—is now in the Museo di Prato. Filippo was paid for
 this work in 1453.

197 *without being moved*: Fra Angelico was first asked to execute this
 fresco cycle, but when he refused, the choice fell on Fra Filippo,
 who began work in 1452. The scenes in Prato's Duomo rep-
 resent the Four Evangelists and stories from the lives of Saint
 John and Saint Stephen.

198 *in Duke Cosimo's wardrobe*: Vasari has mistakenly identified
 Botticelli's portrait of Saint Augustine (now in the Uffizi) as a
 painting by Fra Filippo; the portrait he mentions of Saint
 Jerome actually contains the portraits of Jerome and Francis and
 is attributed by some scholars to Pesellino (1422–57) rather
 than to Fra Filippo.

 on the main altar: commissioned in 1451 but since lost.

 and two of his sons: done between 1443 and 1445 and now
 located in the Metropolitan Museum of New York, the panel
 represented Saint Laurence between Saints Cosmas and Damian
 with three donors of the Alessandri family.

 taught this art: Jacopo del Sellaio (1442–93).

199 *in 1438*: Fra Filippo arrived in Spoleto to decorate the Duomo in 1466 and began work by 1467; his death in 1469 was not caused (as Vasari reports) by poisoning.

as his legitimate wife: neither man was alive when Fra Filippo died. The pope who actually gave a dispensation to Fra Filippo was Pius II (1458–64).

200 *director of the Medici bank....*: a Latin epitaph composed by Angelo Poliziano for Fra Filippo has been omitted from this edition.

The Life of Andrea del Castagno and Domenico Veneziano

202 *Bernardetto de' Medici*: 1395–c.1465.

203 *the siege of Florence*: 1527–30.

still there today: usually dated around 1443, this painting was taken down in 1952–3, and part of it was damaged during the work. It is now in the Ospedale di Santa Maria Nuova.

a few other small details: this work is now in the Cenacolo di S. Apollonia but has been badly damaged.

the chapel of Master Luca: Luca di Bartolo, a professor of grammar, who died in 1502.

in a hall: done around 1450.

Saint Julian: done around 1454–5.

Saint Jerome: around 1454–5.

204 *very good figures*: some scholars attribute these works to Domenico Veneziano or Antonio del Pollaiuolo (1432–98).

Niccolò da Tolentino on horseback: Niccolò Maurucci da Tolentino, a Florentine soldier, was taken prisoner by the Milanese in 1434 and died in captivity in the following year; the fresco was begun in 1456.

205 *a Last Supper*: done in 1457 and no longer in existence.

the main altar: no longer in existence: first Domenico (with the assistance of Piero della Francesca) worked there between 1439 and 1445; Andrea followed from 1451 to 1453; and finally Baldovinetti in 1461 agreed to complete the work.

out of the way: Vasari's account of Andrea's envy and his eventual assassination of Domenico is entirely fanciful and based

upon an extrapolation of the rough character of Andrea's work to his personality, as well as upon the fact that he believed the two men were working side by side.

206 *in Florence*: there were twenty-five figures of illustrious warriors, philosophers, and legal experts, probably done around 1438.

Santa Maria Novella: this fresco was taken down in 1851 and is now in the National Gallery of London.

207 *in his actions*: many of the historical characters mentioned by Vasari here seem to have taken part in either the imprisonment or the eventual release of Cosimo de' Medici. Cosimo was sent to the high tower of the Palazzo della Signoria, called the Alberghetto or 'Little Inn', because of his opposition to the policies of Rinaldo degli Albizi, but Antonio di Vieri (Il Falgavaccio) succeeded in bribing the Gonfaloniere, Bernardo Guadagni, to ensure that Cosimo's life would not be endangered. Malavolti had opposed the suggestion that Cosimo be poisoned or strangled in the tower.

208 *we would still not know*: Andrea actually died four years before Domenico.

209 *'Andrea of the Hanged Men'*: Vasari has confused the Pazzi Conspiracy of 1478, occurring some twenty years after Andrea's death, with a less serious threat to Medici power which occurred earlier. The best-known surviving visual record of this terrible punishment can be found among the sketches of the young Leonardo da Vinci.

age of seventy-one: records show that Andrea died around the age of thirty-five, probably from plague.

Saint Lucy: the main panel is now in the Uffizi, while parts of the predella are scattered between New York, Berlin, and Cambridge.

Giovanni da Rovezzano, etc.: works by Il Marchino (Marco del Buono, 1402–89) and Jacopo del Corso (1427–54) are unknown; Piero del Pollaiuolo (d. *c*.1496) and Antonio Pisanello (*c*.1395–1450) are treated by Vasari in chapters omitted from this edition; Giovanni di Francesco del Cervelliera (d. 1459) is also identified by some scholars as the anonymous Master of the Carrand Triptych.

211 *who navigated the Indies*: still in Ognissanti, this work was completed around 1473. While it may not be true that one of the figures includes the famous Italian sailor for whom the New World is named, the figures certainly represent members of the Vespucci family.

in fresco: still in place in Ognissanti, this work was completed in 1480.

the life of Saint Paulinus: this tabernacle dedicated to Saint Paulinus of Nola no longer exists.

and loving care: this famous chapel, still preserved virtually intact, was completed in 1485. Besides the scenes from the life of Saint Francis (which, as Vasari's description makes clear, link sacred stories to contemporary Florence and the city's leading citizens), the chapel also contains facing tombs of the donor, Francesco Sassetti (a director of the Medici bank), and his wife Nera, as well as a very beautiful panel on the altar of the Nativity, also done by Ghirlandaio (1485).

212 *the main altar of the Jesuate friars*: in the life of Perugino, Vasari describes the Church of the Gesuati (Jesuates) destroyed during the siege of 1529–30. The 'Poveri Gesuati' ('Poor Jesuates') were a religious order that was suppressed by Pope Clement IX in 1668 and should not be confused with the Jesuits (members of the Society of Jesus) founded by Saint Ignatius in the sixteenth century.

213 *delightful and beautiful*: for the Chapel of Lorenzo Tornabuoni in Santa Maria del Cestello in 1491, now in the Louvre.

the Mother of the Son of God: done in 1488.

with care: the *Last Supper*, sometimes attributed to Benedetto Ghirlandaio (1458–97), is a copy of the *Last Supper* in Ognissanti.

he executed with care: identified with a painting bearing the date 1487 in the Uffizi.

into the choir: still in this church and executed in 1480.

214 *in his chapel*: that is, the Sistine Chapel.

in the life of Andrea del Verrocchio: Vasari actually states 'as was discussed', forgetting that he changed the order of his *Lives* between the first and the second edition: in the second edition, Verrocchio's *Life* follows that of Ghirlandaio.

215 *that is, in 1485*: the work actually began in 1485 and ended in 1490. This famous fresco cycle is still behind the main altar at Santa Maria Novella and contains scenes from the lives of the Virgin and Saint John the Baptist.

218 *even where it had truly died*: perhaps a reference to Dante's *Inferno*, xx 28: 'in this place piety lives when pity is dead' (Musa translation).

219 *quite lifelike and lively*: Ficino (1433–99), the renowned Neoplatonist, was responsible for the first complete translation of Plato's works from Greek into Latin; Landino (1424–92), another humanist scholar, composed a famous commentary on Dante's *Divine Comedy* which was illustrated in part by Botticelli's drawings; Demetrius Calcondila (1424–1511) was a scholar called to Florence by Lorenzo de' Medici in 1472 to continue the teaching of ancient Greek there; and Angelo Poliziano (1454–94) was both a learned humanist and Italian lyric poet whose vernacular emphasizes the bitter-sweet passage of time which should be spent falling in love.

 a very beautiful detail: many Renaissance artists decorated birthing trays (*deschi da parto*), upon which these traditional gifts would be presented.

221 *his brothers*: today, sections of this altarpiece are divided between museums in Berlin and Monaco as well as various private collections.

 at Casso Maccherelli: this villa, actually called Chiasso Maceregli, also contained some frescos by Botticelli done around 1483 which are now in the Louvre in Paris.

 with the most beautiful costumes: Ghirlandaio worked in the Sala dei Gigli from 1481 to 1485, completing a number of frescos (Saint Zenobius, the Virgin, a group of figures from classical antiquity of republican backgrounds); some scholars attribute these works to Domenico's brothers as well.

 in every enterprise. . . .: this edition omits a list of minor works Ghirlandaio executed in Tuscany.

223 *as the worthy men they really were. . . .*: this edition omits a long list of other mostly minor commissions done by Domenico and his brothers in various towns, ending with Domenico's death from the plague.

He died in 1493: 1493 according to the old Florentine calendar, which began the year with the Incarnation: therefore, 1494 following the modern calendar.

although few in number: Vasari's emphasis upon mosaics is somewhat puzzling, since very little in the biography prepares the reader for Domenico's prowess as a worker in mosaics. The mosaics for the façade of Siena's Duomo were commissioned to David (not Domenico) in 1493; in that year, Domenico restored mosaics in the Duomo of Pistoia. But subsequent generations of scholars and art-lovers remember Domenico primarily for his frescos and altarpieces.

The Life of Sandro Botticelli

224 *in those days*: Alessandro di Mariano Filipepi thus became known to posterity as Sandro Botticelli because of this goldsmith. But the Botticello Vasari identifies as a friend of his father's was actually Sandro's older brother, and he took care of Sandro because his economic status permitted him to do so.

Antonio and Piero Pollaiuolo: this work, now in the Uffizi, was commissioned in 1470.

225 *with loving care*: completed around 1485 and now in Berlin.

for the nuns of the Convertite Convent: while scholars disagree over whether this panel should be identified with one in the Courtauld Institute in London or another in the Uffizi, most agree that the predella is located in the Johnson Collection in Philadelphia. If this is the case, the painting may be dated around 1490–5.

the nuns of Saint Barnabas: done between 1483 and 1488, this work is now in the Uffizi.

for the Vespucci family: if, as documents claim, this work was done concurrently with Ghirlandaio's Saint Jerome, it can be dated to 1480.

and also completed: done around 1488–90, this work is now in the Uffizi. The Por Santa Maria Guild included the rich shopkeepers from the street of Por Santa Maria as well as the silk merchants.

and a Saint Sebastian: done in 1474, the work is now located in Berlin.

225 *her Cupids to land*: this famous work, now in the Uffizi, is usually dated around 1485.

by the Graces: the famous *Primavera*, now in the Uffizi, was done around 1478.

226 *beautiful and lifelike figures*: scholars usually identify the works alluded to by Vasari here with two specific *spalliere* or wall panels: *The Tragedy of Lucretia* (c.1495–1504, now in Boston); and *The Tragedy of Virginia* (same date, now in Bergamo). Both works reflect the Florentine republicanism with classical roots typical of the period after the expulsion of the Medici from Florence at the end of the Quattrocento.

most lovely and delightful: Boccaccio's *Decameron* (Day 5, Story 8): three of the panels are located in Madrid's Prado Museum, while the fourth is in England in the Watney Collection in Charlbury. Probably executed in 1483 for the wedding of Giannozzo Pucci and Lucrezia Bini, they may have been done by Botticelli's pupil Bartolomeo di Tommaso from the master's designs.

a tondo depicting the Epiphany: a relatively early work, done around 1470, now in the National Gallery of London.

in one of their chapels: done in 1489 and now in the Uffizi, this work is from Botticelli's shop according to some scholars.

a learned and worthy man: Matteo Palmieri (1406–75), a noted humanist and political figure in Florence; the work (often attributed to Francesco Botticini (1446–97) and now in the National Gallery of London) dates from around 1474–6.

the grievous sin of heresy: the painting represents one of Palmieri's theories (condemned by the Church) concerning the angels who remained neutral during Lucifer's rebellion against God.

through the middle door: now in the Uffizi, this work is generally dated around 1475.

227 *in the niches above*: by 1481, a group of painters (Botticelli, Ghirlandaio, Cosimo Rosselli, and Perugino) had executed a series of stories for the Sistine Chapel and were to complete a matching series. Vasari's description of the content of Botticelli's scenes is somewhat inaccurate.

in his life: the edition of *The Divine Comedy* printed in 1481 contained Cristoforo Landino's commentary and Botticelli's

illustrations of the first nineteen cantos. Ninety-three of them survived in Berlin and the Vatican Library; after the Second World War all but three of the drawings in Berlin were taken to the Soviet Union.

228 *which kept him away from his work*: Savonarola's adherents were contemptuously referred to by their Florentine opponents as 'snivellers', 'whiners', or 'cry-babies', for their excessively pious principles.

almost have starved to death: the works done at this villa by the same painters who had earlier worked in the Sistine Chapel have been lost.

a most beautiful painting: this is probably the famous *Madonna del Magnificat* now in the Uffizi and done around 1482.

one of his dependants named Biagio: probably Biagio d'Antonio Tucci (1466–1515).

and Jacopo: perhaps Jacopo del Sellaio (*c*.1441–93).

230 *took his name in vain?*: once again, Vasari mistakenly attributes Landino's commentary on Dante to Botticelli.

in the year 1515 in Ognissanti: actually in 1510.

Lorenzo's own wife: Simonetta Vespucci was Giuliano's mistress; a portrait popularly believed to represent her is in the Pitti Palace Museum and may be one of the two portraits Vasari mentions. Lucrezia de' Tornabuoni was Lorenzo's mother, not his wife.

he left it unfinished: completed in 1474, this fresco was destroyed in 1583.

231 *Rossellino's Saint Sebastian*: the angels have more recently been attributed not to Botticelli but to Francesco Botticini.

and it of him: now in the Uffizi, this work can be dated around 1495; the painting was probably done for Antonio Segni (b. 1460) and was inherited by his son Fabio (b. 1502), who apparently wrote the Latin inscription added to the painting.

The Life of Andrea del Verrocchio

232 *a fine reputation*: Verrocchio executed only one scene (the *Decapitation of the Baptist*, 1480) which today is in the Museo dell'Opera del Duomo in Florence.

233 *in San Giovanni in Laterano*: this is the famous equestrian statue of Marcus Aurelius (AD121–80), which Michelangelo later moved to the piazza on the Capitoline Hill, where, until a restoration completed in 1988, it remained.

in Santa Maria sopra Minerva: Francesca Tornabuoni died in 1477; the tomb has since been taken down, but several works in the Museo del Bargello of Florence and the figures of the Virtues in Paris may well have come from this project.

earned him great praise: now in the Museo del Bargello, this work was acquired from Lorenzo de' Medici by the Signoria in 1476; it was therefore done around 1473–5.

the entire work in marble: in an earlier biographical sketch of Antonio and Bernardo Rossellino (not included in this edition), Vasari had also claimed that Verrocchio executed part of the project, completed around 1450, but most scholars reject the idea.

234 *hanging over a door*: perhaps the work now in the Museo del Bargello and probably a copy by a student of a similar terracotta work which Verrocchio executed in 1480 (also in the Bargello).

in each one: a marble relief of Alexander is located in New York.

the greatest care: this work, completed in 1472, remains in its original location.

235 *well fashioned*: commissioned around 1465, the two figures were placed in their niches in 1483.

the greatest respect: as was noted in the *Life* of Donatello, the niche created by Donatello originally contained his statue of Saint Louis of Toulouse, which was subsequently removed.

in colour upon a wall: it should be noted that the use of cartoons to prepare frescos was not frequent until the end of the fifteenth century, when it was found that the initial design of the entire fresco could be easily transferred to a wall by this means.

236 *is truly marvellous*: done around 1470, this work today stands in the courtyard of the Palazzo Vecchio on the fountain designed by Vasari himself.

of the populace: erected in 1471, the ball and cross were destroyed by lightning in 1601 and eventually replaced by copies.

had turned out very well: this work from the church of San Domenico del Maglio is usually attributed to Verrocchio's workshop and is now in a museum in Budapest.

by Saint John the Baptist: this famous work, in which the artistic presence of the young Leonardo can be seen, as Vasari was the first to note, is now in the Uffizi.

of Marsyas: a satyr and flute-player who lost a musical contest with Apollo and was punished by being tied to a pine-tree and flayed alive; a Hellenistic sculpture of Marsyas discovered in Rome was frequently copied during the Renaissance.

237 *Bartolomeo da Bergamo*: Bartolomeo Colleoni (1400–76), one of the most important *condottieri* in the service of the Most Serene Republic.

SS Giovanni and Paolo: the work was commissioned in 1479 but had yet to be cast when Verrocchio died in 1488; it was finally cast in 1490 by Alessandro Leopardi, a Venetian artist, and unveiled in 1496, where it still stands today in the square beside the church.

238 *Lorenzetto, the Florentine sculptor*: Cardinal Niccolò Forteguerri of Pistoia died in 1473, and Verrocchio was commissioned to execute a cenotaph to his memory in 1476; work began by 1483 but was interrupted by Verrocchio's death; the project was partially completed by Lorenzo Lotti, called Il Lorenzetto (1490–1541), one of Verrocchio's pupils.

Francesco di Simone: Francesco di Simone Ferrucci (1437–93).

239 *Messer Alessandro Tartaglia, the lawyer from Imola*: Alessandro Tartagni (d. 1477).

Messer Pier Minerbetti, a knight: Piero Minerbetti (1412–82).

Agnolo di Polo: Angolo di Polo d' Angelo de' Vetri (1470–?).

Lorenzo di Credi: Lorenzo Barducci, called Lorenzo di Credi (*c*.1459–1537).

241 *a most excellent sculptor....*: in a final paragraph, Vasari notes almost in passing that a certain Benedetto Buglioni (1461–1521) learned the secret of glazing terracotta sculpture from his wife (who was a Della Robbia) and then passed it on to another artisan named Santi Buglioni (1494–1576), one of the last men in the sixteenth century to practise the style discovered, and not readily divulged to others, by the Della Robbia family.

The Life of Mantegna

242 *the Carrara, the Lords of Padua*: Francesco (not Jacopo) Squar-
cione (1394–1468); the source Vasari cites has been lost.

243 *incentive in learning*: Marco Zoppo (b. 1432); Dario da Treviso
(*c*.1420–*c*.1498) was actually from Pordenone; Niccolò, called
'Pizzolo' (*c*.1420–*c*.1453), worked with Donatello for two
years.

in Padua: completed in 1448.

to Andrea: the Ovetari Chapel was virtually destroyed in 1944
by an air raid (the Assumption and the scenes of the Martyr-
dom of Saint Sebastian, done by Mantegna, were saved). But
Squarcione was never given this commission: the widow of
Antonio Ovetari (the donor) gave half the chapel to Pizzolo
and Mantegna, and the other half to Giovanni d'Alemagna and
Antonio Vivarini.

Gentile's sister: this occurred between 1453 and 1454.

245 *in Santa Justina*: 1453–4, now in the Brera Museum of Milan.

signed his name: 1452.

in San Zeno: the first panel, signed as having been done in
1497, is now in Milan's Museo del Castello Sforzesco; the sec-
ond panel was completed around 1459: its main panels are still
in situ, while parts of the predella are to be found in the Louvre
and in Tours.

very beautiful figures: usually identified as the triptych now in
the Uffizi (*c*.1464) which contains the Adoration of the Magi,
the Circumcision, and the Ascension.

with great skill and care: thus, Vasari treats in a single sentence
what most scholars today consider to be Mantegna's master-
piece, the Camera degli Sposi in the Ducal Palace of Mantua
(begun around 1472).

246 *the best work he ever did*: this series of nine works was painted
(but never actually completed) between 1484 and 1494; it is
now part of the Queen's collection at Hampton Court.

commissioned to do: Mantegna was presented to the pope by a
letter from Francesco Gonzaga, son of the Marquis Federico, in
1488.

247 *in that place*: Pope Pius VI (1775–99) destroyed this chapel to
erect the Museo Pio-Clementino.

very honourable rewards: in 1491; Vasari refers to Mantegna's patron here as a duke, whereas elsewhere he mentions the lower rank of marquis. This confusion results from the fact that the marquis of Mantua was elevated to the rank of duke by Emperor Charles V.

the tip of a fine brush: the *Madonna of the Grotto* (*c*.1488–90), now in the Uffizi.

by Andrea: 1491; still conserved in the Uffizi today.

248 *against the French*: this work, commissioned as an ex-voto, was probably done in 1495; now in the Louvre, it refers to the battle of Fornovo (6 July 1495).

until his death....: this edition omits a paragraph devoted to some of Andrea's rivals and contemporaries: Lorenzo Canozio da Lendinara (1425–77); the already-mentioned Dario da Treviso and Marco Zoppo; and Stefano of Ferrara (no information available).

he died: period documents make the date 15 September 1506.

249 *Gian Bellino*: Ludovico Ariosto's *Orlando Furioso* (XXXIII. ii).

who have ever lived: Vasari's remark emphasizes the importance copper engravings of art works began to assume during the sixteenth century, not only for the diffusion of a great artist's work but also for the teaching of art to future generations of pupils who might not be able to examine the works *in situ*.

The Life of Pinturicchio

250 *Pinturicchio from Perugia*: Bernardino di Betto di Biagio, called 'Pinturicchio' and sometimes 'Sordicchio'.

Pietro da Perugia, his teacher: Vasari places the pupil's life before that of his master, Perugino.

in the Duomo of that city: Enea Silvio Piccolomini (1405–64, elected to the papacy as Pius II in 1458) was the humanist pontiff who also planned the construction of Pienza, his birthplace (formerly Corsignano); Francesco Todeschini Piccolomini (elected to the papacy as Pius III in 1503, serving only 10 days), was Pius II's nephew. Pinturicchio signed the contract for this project in 1502, and the fresco decorations still stand in the Sienese Duomo in a remarkable state of preservation. None of the many drawings extant from this project are by Raphael's

hand, as Vasari claims, in an attempt to undercut Pinturicchio's originality.

251 *into a city*: this famous example of urban planning in the Renaissance was entrusted by Pius II to Bernardo Rossellino.

appointed First Secretary: Felix V was elected by dissident bishops in 1439 at the council of Basle and was the last antipope.

252 *order of Preaching Friars*: Caterina di Jacopo (1347–80), Italy's patron saint, was canonized by Pius II in 1461.

in great esteem: the statue is still in the Piccolomini Library.

253 *who is adoring her*: Don Rodrigo de Borja y Doms (1431–1503) was made a cardinal in 1456 and elected to the papacy as Alexander VI in 1492; not only was he the father of the legendary Cesare Borgia, the model prince in Machiavelli's classic treatise, but he was also the lover of Giulia Farnese, wife of Orsino Orsini. However close the relationship of the two was in reality, Vasari has erroneously placed their two portraits in the same painting (implicitly accusing the pope of idolatry in the process), while in fact he should have referred to two different works.

254 *of those times*: Isabella d'Aragon (1470–1524), wife of the Duke of Milan and *not* the Spanish ruler; Niccolò Orsini (1442–1510), Count of Pitigliano and a *condottiere* in the service of the papal army; Giangiacomo Trivulzio (1441–1518), a *condottiere* who served the Sforzas in Milan and Naples, and the King of France; and Cesare Borgia (1475–1507).

by Pinturicchio: executed around 1510 and now in the Museo di Capodimonte in Naples.

the vault of the main chapel: besides the Doctors, he did the Four Evangelists, Sibyls, and a Coronation of the Virgin—all dating between 1508 and 1509.

as a result....: this edition omits two paragraphs devoted to minor pupils of Pinturicchio—Benedetto Bonfigli (1420–96); Gerino d'Antonio Gerini (*c.*1480–?); and Niccolò di Liberatore, called 'L'Alunno' (*c.*1430–1502).

The Life of Perugino

256 *The Life of Pietro Perugino*: Pietro di Cristoforo Vannucci, called 'Il Perugino', the major Umbrian painter of the Quattrocento.

258 *a panel of the dead Christ*: 1495; now in the Palazzo Pitti.

259 *before going on with this Life....*: San Giusto alle Mura was destroyed during the siege of Florence in 1529; the Jesuate order was suppressed in 1668. The long description Vasari provides of the church has been omitted from this edition.

260 *the moment Pope Boniface*: Urban V, and not Boniface, recognized this order.

261 *a Crucifixion with some saints*: the first work, done around 1506–8, was destroyed by fire in 1655; the second work, completed in 1506, is still *in situ*.

 just now completed it: this work was removed from the wall in the eighteenth century and sold to a non-Italian in the next century; it is now presumed lost.

262 *a panel for the main altar*: an *Assumption* and various saints, done in 1500 and now in the Uffizi Museum in Florence.

 a similar panel for those friars: this polyptych, completed no earlier than the end of 1499, remains partially *in situ*, with some portions also in the National Gallery of London.

 of the bishop's palace: done around 1506, this work is still in the Duomo of Naples.

 on the shoulders of porters: an *Ascension* still in the Duomo of Borgo San Sepolcro (before 1509).

 San Giovanni in Bologna: now in the Pinacoteca of Bologna (done around 1495–6).

 the abbot of San Clemente in Arezzo: Pietro d'Antonio Dei (1448–1502).

 Baptism of Christ: some critics believe that only the major figures are by Perugino, with the rest of this work by Pinturicchio.

 were torn down: The *Giving of the Keys* which still remains was by Perugino, while the other works which were not destroyed are, in large measure, done by his assistants; Michelangelo began the *Last Judgement* in 1536. A drawing remains which shows what Perugino's *Assumption* was like.

 for its excellence: in the Borgia apartments now better known for Raphael's *Fire in the Borgo*, Perugino frescoed the vault with allegorical paintings around 1508.

262 *in that city*: these two works are now considered to be by
 Melozzo da Forli (*c.*1470).

 and other saints: probably completed in 1495, this work is di-
 vided today between the Vatican Mueum and the Galleria
 Nazionale dell'Umbria (Perugia).

263 *the Resurrection of Christ*: completed around 1502, this work is
 now in the Vatican Museum.

 and other saints: done during the first decade of the Cinque-
 cento, this work is now in the Galleria Nazionale dell'Umbria.

 the first works he executed: both works today are in the Galleria
 Nazionale dell'Umbria: the first was completed by 1517, while
 the second was done much earlier around 1475. Both were
 done for Santa Maria dei Servi in Perugia, then moved in 1543
 to Santa Maria Nuova, passing eventually from there to the
 museum.

 is preserved: done between 1500 and 1504 (but also attributed
 by various scholars to Lo Spagna or Andrea da Assisi), this
 work is in a museum in Caen.

264 *from their native city*: the decoration of the Collegio del Cambio
 (the palace of the Money-Changers' and Bankers' Guild) was
 commissioned in 1496; the painting was probably done
 between 1497 and 1499. The many Roman republican figures
 mixed with biblical characters and personages from classical
 mythology were typical representations in the civic art of the
 self-governing city-states in Tuscany and Umbria. For a treat-
 ment of Roman republican and imperial mythology during the
 Renaissance, see Peter Bondanella, *The Eternal City: Roman
 Images in the Modern World* (Chapel Hill: University of North
 Carolina Press, 1987).

 with great care: commissioned in 1502, this project was not
 completed before Perugino died. Today, the panel has been
 dispersed, the largest part remaining in the Galleria Nazionale
 dell'Umbria, while other sections are held in the Louvre and
 collections in Toulouse, Lyons, and Birmingham (Alabama); a
 portion in Strasbourg was destroyed during the siege of the city
 in 1870–1.

 the Chapel of San Niccolò: actually painted for Bernardino di
 Ser Angelo Tezi in 1500, the panel is in the Galleria Nazionale
 dell'Umbria, while the predella is in Berlin.

and Saint John: the first work (*c.*1490–4) may be that in Munich; the second was probably completed around 1496.

very highly praised: 1493; now in the Uffizi.

265 *their faith in him*: originally commissioned in 1503; after Lippi's death in 1504, Pietro received the commission in the following year, and he worked on it for several years, perhaps as late as 1512. The polyptych is divided between Florence (the Galleria dell'Accademia), Rome (Galleria Nazionale), and several other cities in Europe.

some of the figures: between 1505 and 1507 Raphael did the top section of the fresco (Jesus with angels and saints), while Perugino painted six saints much later to complete the fresco around 1521.

266 *for the main altar*: Perugino took over this project from Giovanni di Domenico of Verona in 1495, completing it by 1500: the central picture of the Ascension and a lunette are in Lyons, while two tondi are in Nantes.

and the Resurrection: the three main sections of the predella are in Rouen; other figures of saints are still in San Pietro (Perugia) or the Vatican Museum, while one figure was stolen in 1916.

in the year 1524: actually Perugino died of the plague at Fontignano in 1523 and was buried in the countryside.

267 *always adhered to Pietro's style. . . .*: this edition omits a lengthy list of other pupils, including: Rocco Zoppo (Giovanni Maria di Bartolomeo, d. 1508) of Florence; Roberto da Montevarchi (known only through Vasari's mention of him here); Gerino d'Antonio Gerini; Bartolommeo Ubertini, called 'Baccio' (b. 1484); Francesco di Umbertino di Bartolommeo, called 'Il Bachiacca' (1495–1557), the goldsmith; Giovanni di Pietro, called 'Lo Spagna' (d. 1528); Andrea di Aloigi da Assisi (last recorded in 1516); Eusebio di Giacomo di Cristoforo, called 'da San Giorgio' (b. 1465); Domenico di Pari de' Alfani (*c.*1480– after 1553) and his son Orazio (*c.*1510–83), who was one of the founders of the Accademia del Disegno in Perugia; Giannicola di Paolo da Perugia (*c.*1460–1544); and Giovanni Battista Caporali (c.1476–1560). This meticulous documentation of Perugino's school was added to the second edition of Vasari's book.

The Life of Luca Signorelli

268 *pupil of Piero della Francesca*: Vasari calls Piero 'Pietro from Borgo San Sepolcro', but there is little doubt he means Piero della Francesca. Vasari is unusually fond of Signorelli for personal reasons; Signorelli's link to his family and his own artistic education are discussed in this *Life*.

his uncle Lazzaro Vasari: Lazzaro di Niccolò de' Taldi (*c.*1396–1468) declared himself a saddle-maker in the tax records from Cortona in 1427, and there is some doubt that he was ever a painter (although he may have decorated *cassoni*). Nevertheless, in his *Lives*, Vasari provides an artistic biography of his ancestor, declaring that Lazzaro was a close friend of Piero and took Signorelli into his home. Lazzaro's son Giorgio (father of the author of the *Lives*) was actually a potter (*vasaio*) who later changed the family name to Vasari.

for Messer Francesco: Francesco Accolti (1416–88).

269 *tuning a lute*: done in 1484, this work is preserved in the Museo del Duomo in Perugia.

less beautiful than the original: here, Vasari may have confused the panel now in the National Gallery of London (*c.*1491) with a fresco; the panel was, in fact, restored around 1539–40, perhaps by Il Sodoma (Giovanni Antonio di Jacopo Bazzi or de' Bazzi, 1477–1549).

considered extraordinarily beautiful: completed in 1491 and now in the Galleria Comunale of Volterra.

he did a Nativity: probably the work in the National Gallery of London done around 1496.

with a Saint Sebastian: now in the Pinacoteca Comunale of Città di Castello (1498).

one of his most unusual paintings: painted in 1502 and now in the Museo Diocesano in Cortona.

the Host in his purse: this and the other two panels are in Cortona's Museo Diocesano (done in 1512).

270 *panel of the Assumption*: *c.*1519; now in Cortona's Museo Diocesano.

Stagio Sassoli d'Arezzo: probably around 1504; little is known of Stagio.

EXPLANATORY NOTES 557

above the Chapel of the Holy Sacrament: still preserved in Castiglion Fiorentino and done after 1502.

which were highly praised: the famous *School of Pan*, painted between 1488 and 1497, and destroyed by the bombardment of Berlin in the Second World War.

Duke Cosimo's villa in Castello: *c*.1490–5 (now in the Uffizi).

the leaders of the Guelph party: now in the Uffizi (last years of the Quattrocento).

around one side of the cloister: ten scenes are still visible (two in fragments); done between 1497 and 1501.

of the parish church: a *Coronation of the Virgin* still *in situ* and the last work of Signorelli, completed by 1523.

on that last dreadful day: perhaps Signorelli's most important work, the frescos of the Last Judgement representing Hell, Purgatory, and Paradise were begun by Fra Angelico in 1447 in Orvieto's Duomo; Signorelli received the commission to complete the work in 1499 and finished it by 1504.

271 *as everyone can see*: in Vasari's first edition of his *Lives*, Luca's biography came after Filippino Lippi while the second section of the work ends with Perugino, an artist Vasari disliked and whom he considered far inferior to his idol Michelangelo. In the second edition, however, he apparently wanted to underline the continuity, rather than the disparity, between artists leading to Michelangelo's achievement of perfection. Thus, claiming that Michelangelo borrows 'generously' or 'kindly' (*gentilmente*) from Luca's work, Vasari subtly pays homage to the artist he met in his home as a young boy.

whose names are not known: Niccolò Vitelli (1414–86) was *podestà* of Florence, Siena, and Lucca and a governor of the Church in the Papal States under Sixtus IV and Innocent VIII; his son Paolo was a *condottiere* executed by the Florentines for treason in 1499; Vitellozzo was one of the *condottieri* murdered by Cesare Borgia at Sinigaglia in 1502, an episode treated in a celebrated passage of Machiavelli's *Prince*; Gian Paolo Baglioni, Lord of Perugia, was executed by Pope Leo X, and his son Orazio ruled Perugia for a time.

by Pope Sixtus IV: Francesco della Rovere (1414–84, elected pontiff in 1471); the frescos are generally dated around 1480.

271 *the other his death*: the work, done in 1482–3, was supervised by Luca but probably painted, in large measure, by Bartolomeo della Gatta (1448–1502).

and judge in the Rota: both paintings are in the Pinacoteca of Arezzo: the first was commissioned in 1518, while the second was commissioned in 1519 and consigned in 1522 (its predella, however, is in the National Gallery of London).

273 *at the advanced age of eighty-two*: Caporali's commentary on Vitruvius was published in 1536; Tommaso was Tommaso Barnabei, called 'Il Papacello' (d. 1559); the frescos are still visible and represent sixteen scenes from Roman history in the Villa Passerini; Luca's work (largely done by assistants) remains in a poor state of conservation.

which came in 1521: actually in 1523.

the finishing touches: this concluding evaluation of Luca Signorelli, defining him clearly as a precursor of the 'perfection' of painting which will be attained by Michelangelo, was a major change from the first edition of the *Lives*, which merely reported his death and an epitaph written for Luca by an Italian poet.

Preface to Part Three

281 *But what matters most*: Vasari added this emphatic phrase to the second edition of his *Lives* as if to underscore the qualitative leap in perfection he ascribes to this third phase of Italian art.

The Life of Leonardo da Vinci

284 *after his death*: in the first edition of 1550, Vasari's opening assessment is even more fulsome. He declares that men such as Leonardo are sent from heaven not as representatives of humanity but as reflections of divinity itself, so that others can, by imitating them, draw nearer to the divine intellect. Perhaps such praise was tempered by the realization that the final plan of the work's second edition would place Michelangelo, and not Leonardo, in this unique and divinely appointed role in the development of Italian art.

the son of Piero da Vinci: Leonardo was the illegitimate son of his notary father and a peasant girl named Caterina, who married another peasant in 1457; while Leonardo was taken into the paternal household (in the first edition Vasari calls him Ser

Piero's nephew), the artist was always extremely attached to his natural mother.

285 *from studying design*: the date of Leonardo's entry into Verrocchio's shop is uncertain but must have occurred between 1469 (when Piero moved to Florence) and 1476 (when documents show Leonardo already working with Verrocchio).

from Pisa to Florence: numerous designs for such a project survive and are usually dated around 1502–3.

286 *I myself have seen*: the largest collection of Leonardo's engineering designs may be found in the Codice Atlantico, conserved in the Ambrosiana Library of Milan.

Leonardus Vinci Accademia: some of these engravings still exist, apparently based upon a play on words between Vinci and 'vincire' (to tie, to knot); the intricate design would therefore allude to the painter's name.

287 *the movements of the sun*: in the first edition, Vasari had also remarked here that Leonardo held a heretical view of the soul and that he believed himself to be more of a philosopher than a Christian; this information was suppressed in the second edition of the work.

the figures by Andrea: dated around 1475 and now in the Uffizi; critics have detected Leonardo's intervention not only in the angel but also in details of the landscape.

by Leonardo's uncle: this cartoon has been lost.

289 *for three hundred ducats....*: this edition omits a brief section of the *Life* which discusses several works that are either no longer attributed to Leonardo, no longer exist, or exist only in drawings and copies.

in the year 1494: Leonardo was actually in Milan much earlier (probably in 1482); Lodovico Sforza, 'Il Moro' had been the actual ruler of Milan for some years before he took the title.

to the emperor: some scholars believe Vasari refers here to the famous painting known as the *Virgin of the Rocks* now in the Louvre, a work commissioned in 1483.

290 *laid down his brush*: the charming narrative in this long paragraph was added to Vasari's account of Leonardo for the second edition.

291 *the King of France*: Louis XII, who conquered Milan in 1499–
1500 but was driven out of Italy after the battles of Ravenna
(1512) and Novara (1513).

the duke, his father: Leonardo worked upon the model for this
projected equestrian monument to Francesco Sforza,
Lodovico's father, between 1490 and 1493; the statue was never
cast and the clay model was damaged in 1499 when French
troops used it for target practice; it was eventually destroyed.

as our Petrarch declares: a reference to a line in Petrarch's *Triumph of Love* (ii. 7–9).

292 *for his preparations*: numerous drawings of horses from various
periods of Leonardo's career are still conserved, primarily in the
collection belonging to the British royal family at Windsor.

Messer Marc'Antonio della Torre: professor of anatomy at the
universities of Padua and Pavia (1481–1512).

without a mirror: Leonardo's secretive nature found concrete
expression in this unusual manner of writing out his many
notebooks.

his happy memory: Melzi (1493–1570), who went to France
with Leonardo, was his executor and heir, and most of Leonardo's drawings passed through his hands before they were
acquired by various collectors and museums around the world.

of a Milanese painter: in the first edition of the *Lives*, Vasari does
not cite from the manuscript known today as the *Treatise on
Painting* and must have examined it before revising his work for
the second edition; the Milanese painter has been identified as
Il Lomazzo or as Aurelio Luini.

293 *as his servant Salaì*: in 1490, Andrea Salaì came to live with
Leonardo and stayed with him for twenty-five years.

Her earthly progeny become divine: dated between 1498 and 1504,
this cartoon is in the Royal Academy of London.

294 *of King Francis*: the famous *Gioconda* or *Mona Lisa* now in
the Louvre in Paris and dated during the first decade of the
Cinquecento.

295 *in the proper place*: Vasari discusses this project in the *Life* of
Cronaca, not included in this edition.

then Gonfaloniere of Justice: Leonardo received the commission
in 1503 to paint an episode from the Florentine victory over the
Milanese at the battle of Anghiari (1440) and completed the

cartoon in 1505, but both the fresco and the cartoons were later destroyed, although some preparatory drawings by Leonardo for the fresco remain.

296 *Pope Leo X*: in 1513, Leonardo went to Rome with Giuliano, the brother of Giovanni de' Medici, who had just been elected to the papacy, taking the name Leo X (1513–21).

297 *with promises*: Michelangelo reached Rome on 5 December 1516, while Leonardo left Rome for France after the death of Giuliano de' Medici on 17 March 1516.

as he should have: although Leonardo died at Amboise on 2 May 1519, Vasari invents this visit by Francis I to his death-bed.

298 *all their victorious band*: the epigram is based upon a play on words in Italian: Vinci (the artist's name) and the verb *vincere* (to overcome, vanquish). The concluding paragraph of Vasari's *Life* mentions two of Da Vinci's pupils: Giovanni Antonio Boltraffio (1467–1516) and Marco d'Oggiono (*c.*1477–1530).

The Life of Giorgione

299 *surpassed by far the Bellinis*: Vasari refers to three members of this Venetian family—Jacopo (*c.*1400–70) and his sons Gentile (1429–1507) and Giovanni (*c.* 1430–1516).

Giorgione: Giorgione's real name was Zorzo or Zorzi da Castelfranco, but he was given the name Giorgione in Paolo Pino's *Dialogo della pittura* in 1548, and it was thereafter used to refer to him. Giovan Mozenigo (1408–85) was doge of Venice during 1478.

301 *off with him*: Gonsalvo of Cordova (1445–1515) conquered the Kingdom of Naples for Spain; Doge Agostino Barberigo (1419–1501) was succeeded by Lionardo Loredano (1438–1521) in 1501.

302 *what it means*: Vasari seems to admire Giorgione more for his reputation than for any personal appreciation of his individual works; one wonders what Vasari might have thought of Giorgione's most enigmatic work, *The Tempest*, which he fails to mention.

his bronze horse: Verrocchio's equestrian statue of Bartolomeo Colleoni was completed in 1488; at this time, Giorgione was between ten and eleven years of age.

304 *to another life*: Giorgione's death actually occurred in 1510.

304 *in its proper place*: Sebastiano Viniziano would be called Sebastiano del Piombo after 1531, when he received the office of Keeper of the Papal Seal (*il Piombo*) from the pope.

The Life of Raphael

307 *by Raphael*: commissioned in 1502–3 for the Oddi Chapel, the work is now in the Vatican Museum.

then surpassed it: the two works for San Francesco are now respectively in the National Gallery of London (*c*.1503) and the Brera of Milan (1504).

by Pope Pius II: it was actually the nephew of Pope Pius II, Francesco Piccolomini (who later became Pope Pius III in 1503), who commissioned the famous library frescos to commemorate the deeds of his humanist relative in 1502.

308 *much better*: the famous competition for the decoration of the Sala del Consiglio in the Palazzo Vecchio: Leonardo's cartoon was of the Battle of Anghiari, while Michelangelo's depicted the Battle of Cascina (see the *Lives* of both artists in this edition).

to Florence: in 1504.

and others: Ridolfo Ghirlandaio (b. 1483), the son of the more famous Domenico; Bastiano (called Artistotele) di Sangallo (b. 1481), a relative of the more famous Giuliano and Antonio San Gallo.

Taddeo's heirs: critics now identify the two paintings respectively with a work in the Kunsthistorisches Museum of Vienna and a picture in Leningrad's Hermitage Museum.

offers a bird: the famous *Madonna del Cardellino* in the Uffizi.

309 *a great lover of art*: actually on 12 November 1547; other sources attribute the repair to Michele di Ridolfo del Ghirlandaio.

going to ruin: Raphael's mother and father actually died in 1491 and 1494 respectively.

and Saint Nicholas: now in the National Gallery of London (1504–6).

310 *very visible letters*: dated around 1505, although the saints were done by Perugino in 1521.

on either side of the Madonna: now in the Metropolitan Museum of New York (1504–6).

311 *near the corner of the Albertis*: now in the Palazzo Pitti of Florence (1506).

so tiny a son: now in Munich (1506).

Fra Bartolomeo di San Marco: Fra Bartolomeo della Porta (*c.*1474–1517).

This sublime painting: the *Deposition* (1507), now in Rome's Galleria Borghese.

312 *that was incomplete*: while the painting for Santo Spirito is the *Madonna del baldacchino* in the Palazzo Pitti, the painting sent to Siena seems to be a work now in the Louvre in Paris (1507).

moved to Rome: some time in 1508.

considered exceptionally beautiful: the painters Vasari says Raphael encountered were Piero della Francesca, Luca Signorelli, Bartolomeo della Gatta (either an artist of Vasari's invention or a man confused with Pietro d'Antonio Dei, 1448–1502); and Bartolomeo Suardi (*c.*1465–1530).

313 *presenting different arguments*: *The School of Athens* (1510–11).

315 *fixed and wandering stars*: that is, the planets in the Ptolemaic model of the universe.

316 *on the altar*: the *Disputation over the Sacrament* (1509).

317 *as well as other portraits....*: this edition omits a paragraph devoted to Fra Giovanni da Verona, an artist skilled in inlaid wood who made the panelling, doors, and chairs for the room.

318 *in Santa Maria del Popolo*: the portrait in Florence's Uffizi Museum is probably a contemporary (*c.*1512) copy of this work.

the figure of the prophet Isaiah: on the third pillar to the left in the main nave of the church of Sant'Agostino (completed 1511–12).

319 *and many sea-gods*: this famous fresco, derived from a theme from Theocritus and Ovid and located in the Villa Farnesina along the banks of the Tiber, was completed in 1511.

than the earlier one: completed in 1514, these frescos, after numerous restorations, remain in a poor state of conservation.

320 *or Bolsena, as it is called*: the fresco of the Miracle of Bolsena, depicting the event that gave birth to the Festival of Corpus Domini, was completed in 1512.

the Cardinal of San Giorgio: Raffaello Riario (1459–1521).

322 *driving Avarice from the Church*: the depiction of Heliodorus's flight from the temple was allegorically interpreted to refer to Pope Julius's tenacious efforts to retain control of Church fiefs (fresco completed in 1511–12).

 in the greatest veneration....: this edition omits a paragraph devoted to Francesco Masini, a collector of Raphael's cartoons who showed them to Vasari.

323 *was then made pope*: Giovanni de' Medici (son of Lorenzo, 'Il Magnifico'), elected to the papacy as Leo X (1513–21).

324 *accompanying Tobias*: completed between 1512 and 1514, this painting is now in Madrid's Museo del Prado.

 in the possession of his heirs: completed in 1518 and now in the Museo di Capodimonte of Naples.

 when joined with his skill: painted around 1514 and now in Bologna's Pinacoteca.

325 *even greater renown*....: this edition omits several pages that list rather than analyse numerous commissions and portraits, and mention Raphael's influence upon Albrecht Dürer and his subsequent interest in procuring engravings of his own works, many done by Marcantonio da Bologna.

 with his blessing: usually dated as done in 1514, much of this fresco was possibly the work of Raphael's assistants (Giulio Romano and others).

326 *to take him prisoner*: the scene of the Battle of Ostia (completed near the end of 1514) was largely completed by Raphael's assistants.

327 *along with the royal crown*: the *Coronation of Charlemagne*, completed in 1517, is also largely the work of Raphael's assistants.

 the coronation of this same king: not the coronation of Francis but the Justification of Leo III (an event that took place during the coronation of Charlemagne); this scene, also finished by Raphael's assistants, was completed in 1517.

 in developing his talent....: this edition omits several paragraphs describing decorations and minor works that Raphael completed for a variety of patrons, including the pope.

328 *the first loggia in his palace*: the loggia of the Villa Farnesina was done between 1515 and 1517.

329 *came back to Rome*: commissioned for the Sistine Chapel (1515–
 16) and displayed for the first time in 1519, these tapestries are
 now in the Vatican Museum, while the cartoons are housed in
 the Victoria and Albert Museum of London.

 to the height of perfection: commissioned in 1517, Raphael's
 Transfiguration, left unfinished at the master's death, was com-
 pleted by his students; it is now in the Vatican Museum.

338 *will be rewarded in heaven....*: the present edition omits two
 Latin epitaphs written by Pietro Bembo and Baldassarre Castig-
 lione on the occasion of Raphael's death.

The Life of Properzia de' Rossi

340 *the other branches of learning*: the best-known of the women
 Vasari cites, Vittoria Colonna (1490–1557), who married the
 Marquis del Vasto in 1509 and became a famous Renaissance
 poetess and a friend and correspondent of Michelangelo, and
 Veronica Gambara (1485–1550), have always been regarded as
 among the best writers of Petrarchan love poetry in the six-
 teenth century; the other women Vasari lists are somewhat
 obscure or even impossible to identify today. The claims Vasari
 makes for the potential equality of women and men in the arts
 are quite interesting, although Vasari could not actually identify
 any truly first-rate female artists in his period to contend with
 the men.

 and the Apostles: part of a necklace made of carved peach-stones
 in the Palazzo Bonamini-Pepoli gallery in Pesaro; eleven peach-
 stones carved by Properzia are in the Museo Civico of Bologna.

341 *more than admirable*: the depiction of Potiphar's wife and the
 chastity of Joseph was probably executed in collaboration with
 Niccolò di Raffaello, called 'Il Tribolo' (1500–50), around
 1525–7. It is in the Museo di San Petronio in Bologna.

 her own most burning passion: while male artists execute works
 without regard to their personal feelings throughout the *Lives*,
 Vasari seems unable to imagine a woman creating a work of art
 without a sentimental or romantic inspiration.

 except Maestro Amico: Amico Aspertini (1474–1552).

 the emperor in Bologna: Giulio de' Medici (1478–1534, elected
 pope in 1523) was reconciled to Emperor Charles V in Bologna
 on 24 February 1530.

342 *Sister Plautilla*: born in 1523, this woman lived until 1587 and
 was therefore alive when Vasari was writing her biography.

 are by her hand: one picture, an *Adoration of the Magi*, is in
 Parma; the other, a *Pietà*, is in San Marco in Florence.

 a large Last Supper: now in the cloisters of Santa Maria Novella.

343 *from Alessandro Allori*: little is known about this woman, except
 that Allori was her teacher and that she was active around 1560.

 Sophonisba of Cremona: Sophonisba Anguissola, a pupil of
 Bernardino Campi, was born around 1531–2 and died in 1626
 in Palermo.

344 *to which they set their hand*: Ludovico Ariosto, *Orlando Furioso*
 (XX. ii. 1–2, Reynolds translation).

The Life of Rosso

345 *Rosso, a Florentine painter*: Giovanni Battista, known as 'Rosso'
 because of his red hair.

346 *Michelangelo's cartoon*: the famous cartoon of the Battle of
 Cascina Michelangelo created for the projected decorations of
 Florence's Palazzo Vecchio.

 do a panel: in 1518, now in the Uffizi of Florence.

347 *at the Canto de' Bischeri*: Florence greeted the newly elected
 Medici pope on 14 November 1512.

 in Santo Spirito in Florence: dated 1522, this work is now in
 Florence's Palazzo Pitti Gallery.

348 *sent to France*: dated 1523, and now in Florence's Uffizi.

350 *but in many others*: Rosso reached Rome in 1523 and began
 work on the decoration of the Cesi Chapel in Santa Maria della
 Pace in the following year.

 Giacopo Caraglio: an engraver born around 1500 who may
 have died in 1551 or 1570; these prints were done in 1526.

 very badly treated: the Sack of Rome began on 6 May 1527 and
 continued until February of 1528.

 Domenico di Paris: Domenico di Paride Alfani (*c*.1480–1555).

351 *Raffaello dal Colle*: Raffaello di Michelangelo dal Colle
 (*c*.1500–66).

 this Deposition from the Cross: completed in 1528 and now in
 San Lorenzo in San Sepolcro.

a panel in Città di Castello: the Transfiguration, commissioned in 1528 and completed in 1530, is now in the town's main cathedral.

352 under Her mantle: this particular depiction of the Madonna was usually associated with protection from plagues and natural disasters (the drawing is in the Louvre in Paris).

354 went to Venice: in 1530.

356 Francesco Primaticcio of Bologna: 1504–70.

in that location. . . . : this edition omits several paragraphs listing various assistants who worked with Rosso in France.

properties in Écouen: this Pietà was done between 1537 and 1549 for Anne de Montmorency; now in the Louvre, it is one of the few surviving examples of Rosso's production in France.

358 in the year 1541: Rosso did not commit suicide in 1541, as Vasari claims, but died of natural causes on 14 November 1540.

The Life of Giulio Romano

359 than Giulio Romano: Giulio di Piero Pippi de' Jannuzzi, called Romano because he was born in Rome.

also assisted Raphael: for details on these projects (the papal apartments, the Borgia Tower, the Farnesina) on which Giulio assisted Raphael, see the Life of Raphael in this edition.

360 called Il Fattore: Gianfrancesco Penni (1496–c.1536).

gave the whole task to Giulio: in the Life of Raphael, Vasari says that Raphael executed the plans for the villa, while in that of Giovanfrancesco Penni, he claims that Giulio Romano and Penni completed the work after Raphael's death.

362 to dying from hunger: Adrian VI of Utrecht reigned only from 1522 to 1523.

364 the nuns of Monteluce: now in the Vatican Museum, this painting was delivered around 1525.

365 the Picture of the Cat: now in the Museo di Capodimonte of Naples (dated around 1524).

of Santa Prassede in Rome: the painting still in this church is a copy of the original, now lost.

a lion lying at his feet: completed around 1523, this painting is still at Santa Maria dell'Anima.

366 *or burned paper.....*: this edition omits several paragraphs listing some of Giulio's pupils, as well as several palaces he designed in Rome.

 took Giulio with him: in 1524.

 called the Te: the famous Palazzo del Te.

370 *as much as he could*: the famous Room of the Giants, conceived to honour the second visit of Emperor Charles V to Mantua in 1532.

373 *where the duke lives*: between the time Giulio went to Mantua and Vasari's composition of his *Life*, the marquis of Mantua had become a duke by an act of the Emperor Charles V.

 considered most rare: the decorations mentioned here by Vasari were done between 1536 and 1539. This edition omits a large section from Giulio's *Life* that treats some of his less important paintings, as well as a number that have since been lost, the construction of his home in Mantua, and some of his public works after a flood of the River Po.

 Duke Federigo: 28 June 1540; he was succeeded by his brother Cardinal Ercole Gonzaga.

374 *Duomo of the city*: the construction began in 1545.

 on the way to Venice: Vasari spent four days with Giulio in September 1541, during which time he received a guided tour of Giulio's works conducted by the artist himself.

 in the Sistine Chapel: in 1541.

375 *an excellent master*: 1505–75.

 named Tofano Lombardino: Cristoforo Lombardi (active during the first half of the sixteenth century).

 about that time in Rome: 28 September 1546.

376 *and living honourably....*: this edition omits a concluding paragraph listing a number of Giulio's disciples and a Latin epitaph on his tomb.

The Life of Domenico Beccafumi

378 *went off to Rome*: Beccafumi went to Rome in 1510 and stayed until 1512; Raphael arrived in 1508 and the Sistine Chapel was first opened to the public in October 1512 (but a portion had been unveiled earlier in 1510, and Beccafumi may have been able to view the work in progress).

Giovan Antonio da Verzelli, the painter: Giovanni Antonio di Jacopo Bazzi or de' Bazzi, called Il Sodoma (1477–1549).

379 *in the Palio*: the famous horse race still held in July and August in the city of Siena.

still highly praised: now in Pinacoteca in Siena, this work was done shortly after 1516.

380 *very natural style*: this *Vistitation* was probably done around 1513.

on the sides: the *Marriage of Saint Catherine*, now in Siena, seems to have been completed around 1528.

still may be seen: The *Fall of the Rebel Angels*, now in Siena's Pinacoteca, was done between 1524 and 1530.

381 *a rare painting*: this painting is still in the church of San Nicolò al Carmine in Siena (1524–30).

judicious style: the predella has been lost.

done in tempera: now in the church of Santo Spirito in Siena and presently without its predella, this *Coronation of the Virgin and Saints* was executed around 1533–7.

around the room: this fresco cycle, devoted to political and mythological themes similar to those Beccafumi later did in the Palazzo Pubblico of Siena, was completed between 1525 and 1529; it remains in a private home, the Palazzo Bindi-Sergardi.

of Torquatus: not Torquatus but Zaleucus, an ancient Greek legislator.

382 *petition … put to death*: it has been suggested that the word 'petition' should read 'punishment', and that the punishment in question (the theme of this section of the painting) could be the one inflicted upon Spurius Cassius, a conspirator against the Roman republic.

so much honour: here begins the description of the fresco cycle in the Sala del Concistoro of the Palazzo Publico, which can still be seen there and was completed between 1529 and 1535. The dominant theme of the cycle warns of the dire consequences to those who betray or undermine the republican institutions of Rome and, by implication, of Siena.

386 *great praise*: Charles V's original visit was scheduled for 1530 (the year of his coronation in Bologna); the African campaign

570 EXPLANATORY NOTES

was an attack on northern Africa in 1536; the actual arrival of the emperor in Siena took place on 23 April 1536.

386 *had worked*: Pietro di Giovanni Bonaccorsi, known as Perino del Vaga (1501–47); Giovanni Antonio da Pordenone (*c.*1483–1539); Girolamo da Treviso (*c.*1498–1544).

new style of workmanship: the work was actually begun after Duccio's death; Beccafumi spent a number of years on this project.

388 *quite unusual*: now in Siena's Pinacoteca (1530–5).

389 *Piazza de' Signori*: the panel, still in its original location, was done in 1537.

by the Apostles: by the end of 1518, Beccafumi had completed a *Marriage of the Virgin* and the *Assumption*; the painting of the Visitation is by Il Sodoma, not Beccafumi.

panels by Sogliani: Giovanni Antonio Sogliani (1492–1544).

390 *are very beautiful figures*: still in their original location, these works were completed between 1536 and 1538.

Adoration of the Magi: now in the Pinacoteca of Siena and dated around 1540.

of his decapitation: now in the Museo dell'Opera del Duomo in Siena (*c.*1515).

392 *1549*: actually 18 May 1551.

Giuliano the goldsmith: Giuliano di Nicolò Morelli, called 'Il Barba' (d. 1570).

The Life of Jacopo da Pontormo

394 *was born*: in 1494, not 1493.

395 *in the year 1512*: actually in 1517.

mentioned in his Life: the *Life* of Andrea del Sarto is not included in this edition.

396 *the name of Leo X*: in 1513.

the painter Andrea di Cosimo: Andrea di Cosimo Feltrini (1477–1548), whose *Life* is not included in this edition.

398 *up to that time*: the two figures are preserved in a very bad condition in Florence; begun in 1513 and completed in 1514, this project represents the first work by Pontormo that can be dated with any certainty.

that same year: 1513.

the brother of the pope: Giuliano de' Medici, Duke of Nemours (1479–1516), the man to whom Machiavelli first dedicated his *Prince* and whose famous statue by Michelangelo in the Medici Chapel of San Lorenzo remains a monument to his brief life.

Lorenzo the Elder: Lorenzo de' Medici, 'Il Magnifico' (1449–92).

the son of Piero de' Medici: Lorenzo de' Medici, Duke of Urbino (1492–1519), to whom Machiavelli dedicated the final version of his *Prince* after the death of Giuliano, Duke of Nemours, and whom Michelangelo also commemorated with a statue in the Medici Chapel of San Lorenzo.

Messer Andrea Dazzi: d. 1548.

399 *Raffaello delle Vivuole*: no information is available on this figure.

Carota the engraver: Antonio di Marco di Giano (1486–1568).

Leonardo's father: not Leonardo's father, who died in 1504, but Giuliano, identified as either Piero's son or half-brother.

Bernardino di Giordano: no information is available on this artist.

Pietro Paolo Galeotti, a worthy goldsmith: student and follower of Benvenuto Cellini (*c*.1520–84).

The years fly...: from a sonnet by Antonio Alamanni, published in 1559 in *Canti carnascialeschi*.

Jacopo Nardi, a noble gentleman of great learning: Jacopo Nardi (1476–1563), humanist and author of an important history of Florence in addition to carnival songs.

401 *Baccio Bandinelli*: the memorable antagonist of Cellini's *Autobiography* and a favourite artist of the Medici court in Florence (1488–1560).

402 *came to Florence*: 30 November 1515.

the trappings...: the present edition omits material here treating Pontormo's work in Santa Maria Novella, and a number of panels for various patrons.

truly beautiful: this celebrated bedchamber prepared for the marriage of Borgherini with Margherita Acciaiuoli in 1515 was decorated with works by Andrea del Sarto, Pontormo, and other artists; dispersed in the sixteenth century, a number of Pontormo's panels are today to be found in Great Britain, in

particular the panel of Joseph in Egypt, dated between 1518 and 1519, and now in the National Gallery of London.

403 *Bronzino, then a young boy and his pupil*: Angelo Allori, called 'Il Bronzino' (1503–72), Pontormo's favourite student.

the siege of Florence: the siege lasted from the summer of 1529 until September of 1530 and ended in the re-establishment of Medici rule over the city of Florence, governed between 1527 and 1530 by a republican regime opposed to the Medici.

404 *they were made....*: this edition omits a brief description of Pontormo's work at the Medici villa in Poggio a Caiano and several other minor paintings.

the Certosa: the Certosa or Charterhouse of Galluzzo, founded by the Acciaiuoli family in 1342.

408 *its grace and beauty....*: this edition omits brief mention of some painting Pontormo did for the guest quarters at the Certosa, as well as a reference to his pupil Bronzino.

to Pontormo: the work was begun in 1525; while the vault was destroyed in 1736, the masterful *Deposition from the Cross* is still in its original location in Florence.

the altarpiece: the *Deposition* is usually dated between 1526 and 1528.

409 *by all of Florence....*: this edition omits discussion of a number of works, many of which no longer survive, including the decorations at Carreggi and Castello.

His Excellency: Duke Cosimo I de' Medici, the founder of the Grand Duchy of Florence (1519–74).

size of the project: the frescos were done between 1545 and Pontormo's death in 1556, when they were completed by Bronzino; nothing remains of them today except for numerous preparatory drawings, most of which are conserved in the Uffizi Museum of Florence.

Francesco Salviati, a painter of great reputation: Francesco de' Rossi (1510–63), known as Francesco Salviati because his patron was an important cardinal of the Salviati family, was a great friend and contemporary of Vasari.

412 *sixty-five*: actually sixty.

413 *are expected*: Battista Naldini (1537–91), a pupil not only of Pontormo but also of Bronzino and an assistant to Vasari.

The Life of Michelangelo

414 *in architecture*: with this single complex Ciceronian period, Vasari announces the arrival of the 'divine' genius Michelangelo and also emphasizes his belief that the art of design provides the foundation for painting, sculpture, and architecture.

415 *the Counts of Canossa*: Michelangelo's mother was Francesca di Neri del Miniato del Sera, Lodovico's first wife; one of the Canossa family addressed Michelangelo in 1520 as a 'relative', and Ascanio Condivi's *Life of Michelangelo* (1553) also mentions his noble lineage. Given Vasari's propensity to praise Michelangelo, as well as the epic tone of his presentation, such a noble lineage would probably have been invented by the biographer if no such evidence had been available.

was podestà: an executive and judicial office of the Italian republican city-states, usually given to a foreigner to ensure impartial judgements.

416 *one of the best masters alive*: Vasari's *Life* of Ghirlandaio (1449–94) is included in this edition, while the *Life* of Granacci (1469–1543) has been excluded.

417 *let us return to the story*: Vasari's claim that his account of Michelangelo's life is superior to Condivi's biography rests upon a clear preference for archival documentation in addition to personal friendship with the artist. His *Lives* are therefore based not only upon connoisseurship but also upon a study of primary documents, letters, contracts, and the like. This combination of art historical methodologies is only one of the many ways in which Vasari was responsible for giving birth to the discipline itself, for he also placed his individual analyses of specific works or artists within the framework of an impressive *theory* of art and artistic development.

418 *Martin the German*: Martin Schongauer (1455–1491); Vasari's first edition of the *Lives* attributes the engraving to Albrecht Dürer.

Bertoldo the sculptor: Bertoldo di Giovanni (*c*.1420–91), a pupil of Donatello.

419 *had given him to do*: Pietro Torrigiani (1472–1528), a follower of Benedetto da Maiano, who was most famous for his work in England and who died in Spain, a victim of the Inquisition. Vasari's *Life* of this artist is not included in this edition.

420 *named Poliziano*: Angelo Ambrogini, called Poliziano (1454–
 94), the most important poet of Lorenzo's circle and a humanist
 whose writings appeared in both Latin and Italian. Poliziano's
 portrait is said to be inserted in the Florentine fresco cycles
 Domenico Ghirlandaio painted in the church of Santa Trìnita
 and Santa Maria Novella, respectively.

421 *a better sense of design*: both works are conserved today in the
 Museo di Casa Buonarroti in Florence.

 as was mentioned elsewhere: in Vasari's *Life* of Torrigiani, not
 included in this edition.

 to King Francis: now lost, this work was at Fontainebleau until
 the eighteenth century; see Vasari's *Life* of Pontormo in this
 edition for a more complete listing of the works of art sent to
 France at this time.

422 *that he subsequently possessed*: there is a crucifix in Santo Spirito
 today that some critics identify as the work of Michelangelo.

 thirty ducats for them: besides the angel and the candlestick,
 Michelangelo also did the figure of Saint Proculus.

423 *it can still be seen today*: the Cupid in question is now lost, but it
 passed through the hands of two very illustrious figures: Cesare
 Borgia or Duke Valentino (1476–1507), and Isabella d'Este
 (1474–1539).

 more attention to appearances than to realities: one of the most
 interesting ideas Vasari presents in his *Lives* is the argument that
 contemporary art can not only equal but surpass that of classical
 antiquity. Vasari thereby anticipates a major argument of the
 so-called Battle of the Ancients and the Moderns, a polemical
 debate that would take place in the eighteenth century. Vasari
 was able to make such claims for contemporary art largely
 because of Michelangelo's unique genius, before which even the
 extant works of the past paled in comparison.

424 *San Piero a Montorio*: the painting has since been lost or
 destroyed.

 up to that time: the Bacchus was later bought in the sixteenth
 century by one of the Medici grand dukes and returned to
 Florence; it is now in Florence's Museo del Bargello.

 in the temple of Mars: begun in 1498 and completed in the fol-
 lowing year, the *Pietà* was first placed in the Chapel of Santa
 Petronilla over that spot where the Temple of Mars once stood
 and where the cardinal was buried; it was moved in the eight-

eenth century to its present location. It was commissioned by Cardinal Jean Bilhères de Lagranles, cardinal not of Rouen but of Santa Sabina.

425 *Our Gobbo from Milan*: Cristoforo Solari (1460–1527).

Daughter and Mother: a madrigal by Giovambattista Strozzi il Vecchio (1505–71), composed in 1549 when a copy of the Roman *Pietà* was placed in the church of Santo Spirito in Florence.

426 *for life*: in 1502.

Simone da Fiesole: not Simone da Fiesole but Agostino di Duccio, who first obtained the block in 1464.

427 *govern it with justice*: the *David* remained outside the Palazzo Vecchio in Florence until 1873, when it was moved to its present location in the Accademia di Belle Arti. A copy presently stands in front of the Palazzo Vecchio.

428 *which Soderini then sent to France*: now lost. The Florentine Republic was constantly sending works of art to France during this period, since France was the government's most important foreign ally. The close cultural ties between republican Florence and the French monarchy would continue after the Medici restoration in 1512, strengthened by the marriage of Catherine de' Medici (1519–89) to the future Henri II, King of France from 1547 to 1559.

most worthy and admirable: the first tondo is today in London's Royal Academy, while the second is on display in Florence's Museo del Bargello.

429 *sent the work to Flanders*: done in 1506 in marble, not bronze.

painting a tondo for him: the *Holy Family* commissioned for the marriage between Angelo Doni and Maddalena Strozzi in 1503–4, probably completed a year later.

430 *the Pisan war*: Michelangelo's subject was the battle of Cascina (1364), where Pisans commanded by the English *condottiere* Sir John Hawkwood surprised the Florentines near the river Arno.

431 *with great reverence*: in the first edition of Vasari's *Life* of Baccio Bandinelli (not included in the edition), Vasari asserts that the cartoon was destroyed in 1512; now in the second edition of his biographies, Vasari maintains this occurred between 1515 and 1516.

432 *the pope's agents*: probably in 1505 rather than 1503.

as was mentioned elsewhere: in the *Life* of Giuliano da San Gallo, not included in this edition.

434 *in Écouen in France*: probably the two statues now conserved in the Louvre in Paris.

another five in Florence: the four Prisoners in the Accademia di Belle Arti in Florence were probably part of this group.

by Vasari: this work still stands in the Palazzo Vecchio in Florence.

the chisel has become a brush: the statue of Moses is located in the church of San Pietro in Vincoli in Rome.

435 *the Bologna affair*: in 1506, Julius II drove Giovanni Bentivoglio out of Bologna, restoring papal rule to that city.

437 *Il Francia*: Francesco Raibolini (*c*.1450–1518), Bolognese painter whose *Life* by Vasari is not included in this edition.

438 *in the duke's wardrobe*: erected in 1508, the statue was destroyed in 1511; the cannon was actually called *La Giuliana*, and the head was eventually lost as well.

439 *would succeed*: Michelangelo was called to Rome in 1508 to paint the Sistine Chapel; Vasari's description of the rivalry between Bramante, Raphael, and others follows Condivi's account, but other documents suggest, in fact, that as early as 1506, Michelangelo's friends approved of this new commission while Bramante actually opposed it.

440 *by masters who came before him*: two scenes were eventually removed during the reign of Pope Paul III when Michelangelo painted the *Last Judgement*.

441 *when mixed with pozzolana*: volcanic dust.

443 *a total of three thousand scudi*: in reality Michelangelo was paid six thousand ducats; the figure of three thousand *scudi* contradicts an earlier statement which set the price of the project at fifteen thousand ducats.

444 *And then below*: Vasari describes the entire Sistine Chapel from a single and fixed vantage point; thus when he states that a scene follows 'below' another, it is most often to be construed horizontally rather than vertically (as 'beyond' or 'next to').

451 *Cardinal Santiquattro and Cardinal Aginense*: Cardinals Lorenzo Pucci and Leonardo Grossi della Rovere.

452 *in the architecture*: the wooden model, executed in 1517, is still
conserved in the Museo di Casa Buonarroti in Florence; the
façade was never completed.

without a receipt: Vasari invents this episode to emphasize the
independence and authority of his figure of the heroic artist;
in fact, Michelangelo acknowledged receipt of the money on
3 January 1517. This edition omits a passage Vasari devotes
to Michelangelo's difficulties in obtaining marble, as Pope Leo
forced him to open a new quarry in Seravezza rather than pur-
chasing the marble from the quarries he preferred in Carrara.

remained incomplete: although Leo died in 1521, he had already
decided to abandon the project in 1520.

Clement VII became Pope: Adrian VI's pontificate lasted from
January 1522 until September 1523; he was succeeded by Giulio
de' Medici on 19 November 1523.

and in the year 1525: actually in 1524, as Vasari recounts in his
own *Life* at the end of his long work.

453 *but not better*: the dome was completed between 1523 and 1524.

his nephew: only two of the four originally planned tombs were
completed: that of Giuliano, Duke of Nemours; and that of
Lorenzo, Duke of Urbino.

454 *astonished by it*: when Michelangelo left Florence for the last
time to go to Rome in 1534, the Library was still incomplete;
the stairs were finally executed in 1559–60 by Michelangelo's
pupils, following designs he sent from Rome, and the entire
Library was opened to the public in 1571.

over all the fortifications: the Sack of Rome and the expulsion of
the Medici from Florence, with the re-establishment of a more
radical republican government, took place in 1527; Michelan-
gelo became involved with the city's fortifications in 1528 and
1529.

457 *lower your voice*: the unknown poet was Giovanni di Carlo
Strozzi (1517–70), who wrote the poem around 1545.

as has already been mentioned....: this edition omits a long
description of Michelangelo's practical chores during his work
on the fortifications.

had been signed: in 1530, after a three-year struggle, Medici
troops finally forced the capitulation of Florence, thereby

causing the fall of the anti-Medici government Michelangelo served and the restoration of the Medici house to power there.

457 *as the supervisor*: it was apparently Figiovanni (d. 1544) who hid Michelangelo while Pope Clement's anger subsided; a small room uncovered below the New Sacristy, where some scholars believe Michelangelo was concealed, may be visited today in San Lorenzo.

458 *not completely finished*: begun as the figure of David and changed in the course of the carving to Apollo, the work is now in the Museo del Bargello in Florence. This edition omits a passage Vasari devotes to Michelangelo's painting of Leda, sent to France and eventually destroyed there.

 Carota and Tasso, excellent Florentine woodcarvers and masters: Antonio di Marco di Giano, 'Il Carota' (1485–1568); and Battista del Tasso (1500–55).

 the Last Judgement: the work was apparently commissioned in 1533.

459 *an original flight of fantasy*: this painting no longer exists.

460 *came the death of Pope Clement*: Clement VII died on 25 September 1534 and was succeeded by Paul III (of the Farnese family) on 13 October 1534.

 until something came up. . . .: this editon omits a long discussion of the minor sculptures Michelangelo executed for the tomb of Julius II to accompany his Moses.

462 *the living seemed alive*: Purgatory, xii. 67; cited from Dante, *The Divine Comedy, vol. ii: Purgatory*, trans. and ed. Mark Musa (New York: Viking Penguin, 1981), p. 180.

464 *the laggard sinner*: Inferno, iii. 109–11; cited from Dante, *The Divine Comedy, vol. i: Inferno*, trans. and ed. Mark Musa (New York: Viking Penguin, 1971), p. 92.

465 *on Christmas Day*: actually on 31 October 1541.

 stupefied by it. . . .: the present edition omits a brief description of other projects Pope Paul arranged for Michelangelo, including work on the Pauline Chapel, the fortifications of the Borgo, and a marble figure of Christ.

467 *over the river in Parma*: in the first edition of the *Lives*, Vasari says these tolls came from Piacenza, the correct location.

469 *as will be explained below*: this edition omits a long section from Michelangelo's *Life* which describes the death of Paul III and the ascension of Julius III; various building projects undertaken by Michelangelo; and an exchange of letters between the artist and Vasari, some of which contained copies of Michelangelo's lyric poetry.

too old to continue....: this edition omits a brief passage dealing with Michelangelo's continued problems with jealous rivals on the project of Saint Peter's, in which Vasari announces with great satisfaction that Michelangelo had so well prevented others from making changes in his plans that the church was, as he writes, ready for its final vaulting.

470 *was left in charge*: Pius IV (1559–65) and Pius V (1566–72); Ligorio and Vignola were hired in 1564; both left the project late in 1565, while Vignola returned in 1567, remaining on the job for several years.

471 *to a better life*: actually on 18 February 1564.

472 *had been revolving*: Vasari refers to the Ptolemaic system of the universe, with the earth at its centre and the sun revolving around it.

473 *whenever it was appropriate*....: this edition omits a section of the *Life* of Michelangelo which lists his many friends.

did little good: Ascanio dalla Ripa Transone is better known as Ascanio Condivi; he was one of Vasari's main sources for this *Life*, even though Vasari often attacks his work.

474 *will not contain*: see Julia Conaway Bondanella and Mark Musa, ed. and tran., *The Italian Renaissance Reader* (New York: New American Library, 1987), p. 377, for the complete text; the lecture by Varchi (1503–65) on the sonnet took place in 1546.

Marchioness of Pescara: Vittoria Colonna (1490–1547); the three works Michelangelo made for her have not survived.

475 *and with his other property*....: this edition omits a list of gifts made by Michelangelo to others.

476 *a pity to see it*: Michelangelo's pun is based on the fact that in Italian, the word for pity and the generic name of the artistic figure of the Madonna holding the dead Christ are the same (*pietà*).

478 *a sculptor from that city*: Antonio Begarelli, called 'Il Modena' (1499–1565).

479 *second-rate painter from Valdarno*: Domenico da Terranuova, called 'Il Menighella', of whom there remains little trace or information, save some of his letters to Michelangelo.

480 *Topolino the stone-carver*: Domenico Fancelli, called 'Topolino', worked with Michelangelo on San Lorenzo.

481 *looked after him carefully*: Colombo was born in Cremona in 1520 and was summoned to the papal court by Pope Paul III in 1549; he was also the author of a treatise on human anatomy.

 as was explained in his Life: Vasari recounts how Torrigiani broke Michelangelo's nose in a *Life* not included in this edition.

484 *to Michelangelo's memory. . . .*: this edition omits a description of the dealings between Duke Cosimo and the Florentine Academy in preparation for the ceremony.

 the Sunday of the second week of Lent: the body arrived on Thursday evening, 9 March.

486 *in the casket*: as Michelangelo died on 18 February, he had been dead for twenty-two days, not twenty-five; it should not be overlooked that the delay in a body's decomposition was a traditional sign of a man's saintly life and condition at the time of death.

487 *of the many which were written. . . .*: this edition omits a very lengthy and detailed description of the funeral celebration.

 from nearby places: the decorations remained in place until August 1564.

The Life of Titian

489 *In the year 1480*: Titian's date of birth is still controversial, and scholars place it anywhere from 1487 to 1490.

 as we have said: in a *Life* devoted to Bellini not included in this edition.

491 *a painting by Giorgione*: usually identified with the portrait in the National Gallery of London (dated between 1508 and 1511–12) which in the past was thought to be a portrait of Ludovico Ariosto, the Italian epic poet and courtier.

 above the Merceria: the frescos on the Fondaco were done in 1508 and are almost completely destroyed (some fragments of this work are preserved in the Palazzo Ducale in Venice).

Our Lady's Flight into Egypt: identified with one of two early (1509) works: either that from the Contini-Bonacossi Collection of Florence, or another picture with the same subject in the Hermitage Museum of Leningrad.

a very beautiful painting: now in the Kunsthistorisches Museum of Vienna, and signed with the date of 1543.

light that illuminates him: some scholars identify this painting with one on the the same subject in Venice's Accademia Museum, although that work seems to have been done in 1543; others insist that the painting in San Marziale (previously attributed to other painters) is by Titian. Both works, however, are considerably later than the date of 1507 cited by Vasari.

492 *behind them*: probably inspired by Mantegna's *Triumphs of Caesar* and done around 1511 when Titian was in Padua.

the deeds of this saint: the three frescos executed by Titian for the Scuola del Santo in Padua in 1511 are the first of his works authenticated by archival documents; they treat three different miracles associated with Saint Anthony of Padua.

by Giorgione: done around 1511, the panel with Saint Mark and Saints Cosmas, Damian, Rocco, and Sebastian, was moved from Santo Spirito to its present location in Santa Maria della Salute in 1656.

493 *IOANNES BELLINVS VENETVS P 1514*: 'Painted by Giovanni Bellini, the Venetian, 1514.' This painting, *Feast of the Gods*, is actually dated around 1523 and is located in Washington's National Gallery of Art.

494 *signed his name*: Titian actually painted three scenes: two were eventually sent to King Philip IV of Spain and are today in the Museo del Prado of Madrid; the third, *Bacchus and Ariadne*, is now in London's National Gallery and may be dated around 1522–3.

Caesar's coin: probably the painting now in Dresden's Gemäldegalerie and dated around 1516.

a large artillery piece: this portrait is probably the one now in New York's Metropolitan Museum and can be dated around 1523.

Signora Laura: Laura Dianti, first the mistress and then the wife of Duke Alfonso (d. 1573).

494 *than Cador*: Canto XXXIII, stanza ii, lines 6–8 (*Orlando Furioso*, trans. Barbara Reynolds, Penguin: New York, 1977).

this same Giovanni: this painting has often been identified with the one in Edinburgh's National Gallery (done around 1512–13).

495 *can be seen*: now in Santa Maria Gloriosa dei Frari in Venice, the work was completed in 1518, and was done on a wooden panel, not canvas.

against the Turks: the painting, commissioned in 1519 and completed in 1526, is still in Santa Maria Gloriosa dei Frari; the naval battle was that of 1502.

by others: this panel, now in the Pinacoteca of the Vatican, is signed and probably dates from around 1542.

by a Jew: in the first edition of Vasari's *Lives*, this painting is attributed to Giorgione, and in the second edition (which this translation follows), Vasari continues to attribute this painting to Giorgione, although he here attributes it to Titian as well. Modern scholarship is divided on the question.

Titian had already painted: Pietro Bembo became papal secretary in 1513; Titian's portrait of him has been lost.

496 *the bank of a river*: now in the Accademia of Venice and dated around the middle of the century.

in the Sala del Collegio: the portaits of Grimani, Loredan, and Gritti were destroyed in the fire in the Palazzo Ducale in 1571; several portraits of Francis I exist that have sometimes been attributed to Titian but they may come from a later period.

and Venier: all lost.

brothers of the Priuli family: Lorenzo (1556–9) and Girolamo (1559–67) Priuli.

during his whole lifetime: completed in 1530, the work was destroyed by fire in 1867.

497 *and the most beautiful*: completed in 1538, it was destroyed in the fire of 1571.

a Madonna in fresco: if this was the fresco painted in 1523 for the church of San Niccolò at the summit of the Scala dei Giganti, it was destroyed in 1797.

with Cleopas and Luke: the *Supper at Emmaus*, completed around 1525–30 and now in the Yarborough Collection in Brocklesby Park.

in Lombardi's life: the first portrait of Charles V was completed in 1530 but later lost; Alfonso Lombardi (*c.*1497–1537) is treated in a *Life* not included in this edition.

Pordenone: Giovanni Antonio Pordenone (1483 or 1484–1539), a northern Italian painter who worked in Venice for some time.

in a bishop's robes: Titian's painting, still in the church of San Giovanni Elemosinario, was completed in 1545.

498 *in its place*: the work was lost during the French Revolution.

done by Titian: probably the portrait now in Madrid's Prado, done between 1532 and 1533.

in a Hungarian uniform: dated around 1532–3 and now in the Palazzo Pitti in Florence.

the cardinal: Aretino's portrait is usually identified with the painting now in the Galleria Palatina of the Palazzo Pitti, done in 1545; the portrait of Federigo Gonzaga (completed by 1530) and the one of his brother Ercole have both disappeared.

from their lives: see the *Life* of Giulio Romano for details of these decorations.

Titian himself kneeling: dated around 1545 and now located in a church in Piave di Cadore.

scattered throughout Italy: some historians identify the portrait of Paul III with the painting now in the Museo di Capodimonte in Naples; the copy for Guido Ascanio Sforza, Cardinal of Santa Fiore, has not been identified.

499 *face and breast of Alexander*: executed between 1536 and 1538, this portrait is now in the Uffizi in Florence.

her hair dishevelled: the first painting (executed around 1538) is in the Uffizi; the second in the Palazzo Pitti.

marble head by Donatello: some of the portraits Vasari lists here have been lost; that of King Francis has been identified with one in the Louvre, while those of Sixtus IV and Julius II are respectively in the Uffizi and the Palazzo Pitti; the work by Donatello has not been identified.

499 *over the altar*: the painting of the Pentecost (done between 1555 and 1560) is now in the church of Santa Maria della Salute in Venice.

on the sides: the *Averoldi Polyptych*, signed and dated 1522 and still in the church of SS Nazaro e Celso in Brescia.

in that city: done around 1535, the painting is still in Verona in the church.

in full length: some historians identify this painting with the one in the Palazzo Pitti in Florence, completed around 1541.

as a young man: Cristoforo Mandruzzo; the painting was probably done around 1542 and is now in the Museo de Arte di San Paulo.

500 *the duke's father*: the portrait for Marcolini has not been identified, while the other image of Aretino is probably the painting now in the Palazzo Pitti; the portrait of Giovanni de' Medici may be that in the Uffizi from Titian's workshop.

as we have mentioned: in *Lives* of Cristofano Gherardi and Michele Sanmichele not included in this edition.

his brother Abel: completed before 1544, the three canvases are now in the Sacristy of Santa Maria della Salute.

and Duke Ottavio: dated around 1546 and now in the Museo di Capodimonte in Naples.

501 *to his soldiers*: completed in 1541 and damaged by a fire, the work is now in the Museo del Prado in Madrid.

of the Annunciation: in 1546, now lost.

502 *from the Angel*: both the *Transfiguration* (1560) and the *Annunciation* (1564–6) are still in the church.

and which later: a rather surprising remark, given Vasari's painstaking efforts to be accurate in his work, probably due to the frustration he felt as a historian in being forced to track down numerous copies and versions of the same work.

while the duke was in prison: the portraits of Ferdinand, Maximilian, his brother, and Queen Mary of Hungary are lost; that of the Duke of Saxony, head of the Protestant troops defeated by Charles V at the battle of Mühlberg, has been identified as the painting done between 1548 and 1551 and now in the Kunsthistorisches Museum of Vienna.

503 *in an engraving*: completed in 1554, the work is in the Museo del Prado in Madrid.

 by the vulture: commissioned in 1548 only the pictures of Sisyphus and Tityus still remain, conserved in the Museo del Prado of Madrid.

 lifelike dogs: done in 1553 for Prince Philip and now in the Museo del Prado in Madrid; another painting of the same subject, considered the model for the painting in Madrid which had been acquired by Tintoretto, is in the National Gallery of London.

 into a stag: the painting of Andromeda and Perseus is in the Wallace Collection of London (1555–62); that of Diana and Actaeon is in the National Gallery of Edinburgh (1559).

 upon the bull: completed by 1562 and now in Boston's Isabella Stuart Gardner Museum.

504 *the old cardinal of Ferrara*: probably to be identified with the *Adoration of the Magi* in the Escorial of Spain which was sent to King Philip II in 1560; a number of copies of this work exist.

 in a chapel: now in the City Museum of St Louis and dated before 1570.

 at the column: now lost.

 are lighting it: now in the church of the Gesuiti in Venice and in place by 1559.

505 *had him paint*: still in the church of San Sebastiano in Venice and done in 1563.

 to send to the Catholic king: actually the original was shipped to Madrid in 1561 and the copy acquired by Badoer; both are lost, but a number of copies remain, including one in Leningrad's Hermitage Museum.

 named Sinistri: possibly the portrait in the De Young Memorial Museum of San Francisco and done between 1540 and 1550.

 Titian also painted: both lost.

 the writers of Italy: Irene di Spilimbergo, a painter and a student of Titian's; the painting is lost.

506 *held in high esteem*: Jacopo Bassano (1517 or 1518–92).

 after he was made a cardinal: already done in 1515, this second portrait is identified with a picture in the Museo di Capodi-

monte in Naples or with another in Washington's National Gallery of Art.

506 *from the Delfini family*: Danese Cattaneo (*c*.1509–73).

 near Santa Justina: now lost.

507 *of extraordinary beauty*: sent in 1564 to Philip II and now in the Escurial.

 to the Catholic king: sent in 1567 and now in the Escorial.

 the patriarch of Aquilea: now in the Palazzo Ducale in Venice and commissioned in 1555.

 both Brescian painters: desroyed in a fire of 1575; Vasari's discussion is in the *Life* of Garofalo, not included in this edition.

 of about seventy-six years: Titian died of the plague in Venice in 1576.

508 *the works Titian executed. . . .*: this edition omits a long discussion of Titian's disciples, including Jan Stephan von Calcar (1499–1550); and Paris Bordon (1500–71).

The Author: To Artists of the Art of Design

509 *of the Art of Design*: Vasari's parting message to his fellow artists comes at the end of a very lengthy section of the book entitled 'Description of the Works of Giorgio Vasari'.

510 *of no small assistance*: here, Vasari alludes not only to the previously mentioned *Commentaries* of Ghiberti but also to Ghirlandaio's *Ricordi* (since lost) and perhaps a treatise on architecture attributed to both Raphael and Castiglione.

THE WORLD'S CLASSICS

A Select List

HANS ANDERSEN: Fairy Tales
Translated by L. W. Kingsland
Introduction by Naomi Lewis
Illustrated by Vilhelm Pedersen and Lorenz Frølich

JANE AUSTEN: Emma
Edited by James Kinsley and David Lodge

Mansfield Park
Edited by James Kinsley and John Lucas

J. M. BARRIE: Peter Pan in Kensington Gardens & Peter and Wendy
Edited by Peter Hollindale

WILLIAM BECKFORD: Vathek
Edited by Roger Lonsdale

CHARLOTTE BRONTË: Jane Eyre
Edited by Margaret Smith

THOMAS CARLYLE: The French Revolution
Edited by K. J. Fielding and David Sorensen

LEWIS CARROLL: Alice's Adventures in Wonderland
and Through the Looking Glass
Edited by Roger Lancelyn Green
Illustrated by John Tenniel

MIGUEL DE CERVANTES: Don Quixote
Translated by Charles Jarvis
Edited by E. C. Riley

GEOFFREY CHAUCER: The Canterbury Tales
Translated by David Wright

ANTON CHEKHOV: The Russian Master and Other Stories
Translated by Ronald Hingley

JOSEPH CONRAD: Victory
Edited by John Batchelor
Introduction by Tony Tanner

DANTE ALIGHIERI: The Divine Comedy
Translated by C. H. Sisson
Edited by David Higgins

VIRGIL: The Aeneid
Translated by C. Day Lewis
Edited by Jasper Griffin

HORACE WALPOLE : The Castle of Otranto
Edited by W. S. Lewis

IZAAK WALTON and CHARLES COTTON:
The Compleat Angler
Edited by John Buxton
Introduction by John Buchan

OSCAR WILDE: Complete Shorter Fiction
Edited by Isobel Murray

The Picture of Dorian Gray
Edited by Isobel Murray

VIRGINIA WOOLF: Orlando
Edited by Rachel Bowlby

ÉMILE ZOLA:
The Attack on the Mill and other stories
Translated by Douglas Parmée